D1507779

DISCARD
DISCARD

SURREALISM and Quebec Literature

In 1948 the Quebec artist Paul-Emile Borduas published his famous mani-
festo *Refus global* – a plea on behalf of the powers of imagination and sensi-
bility in society and a revolt against rationalization, mechanization, and
other restraining influences, including the church. Borduas and his co-
signers were bitterly attacked. But the message of *Refus global* had far-
reaching and revolutionary effects on the culture of Quebec and ultimately
on its politics.

André Bourassa, in this important work, underlines the role played by
artists and poets during the 1940s and the relationships among various
groups. But his emphasis is on the literature of Quebec, from the first
novel in 1837 (also the year of Quebec's first revolution), through the
Quiet Revolution of the 1950s and 1960s, to the present. In manifestos,
poems, articles, and theatre pieces he examines the nature of Quebec sur-
realism and its international context.

Surrealism took three main forms in the province: one reflecting André
Breton's school of thought as defined in the manifestos from 1924 on;
another more generally related to movements such as cubism or revolution-
ary surrealism; and finally, the spontaneous use of surrealism in its timeless
aspect – as in cathedral gargoyles and African masks, religious myths and
communications with the spirit world, the dream imagery of Bosch and Goya,
or the automatic writing of Achim von Arnim and Gérard de Nerval.

An understanding of these kinds of surrealism is essential to understand-
ing the significance of *Refus global* and of the events and attitudes which
followed when surrealists took ideological stands, especially against Stalin-
ism and against Duplessis.

When first published in 1977, *Surréalisme et littérature québécoise* won
immediate critical acclaim, including the Prix France-Canada. Jean Ethier-
Blais, in *Le Devoir*, called it 'une vue spectrale, non seulement de nos let-
tres, mais mieux encore, de notre sensibilité.' For this English translation,
Bourassa has revised the text significantly to incorporate new insights and
new information. The updated and comprehensive bibliography will be par-
ticularly valuable for anyone studying surrealism.

ANDRÉ G. BOURASSA is Professor of Quebec Literature at Université du
Québec à Montréal.

MARK CZARNECKI is a translator, journalist, and theatre critic for
Maclean's magazine.

SURREALISM

and Quebec Literature

History of a Cultural Revolution

ANDRÉ G. BOURASSA
Translated by Mark Czarnecki

UNIVERSITY OF TORONTO PRESS
TORONTO BUFFALO LONDON

© University of Toronto Press 1984
Toronto Buffalo London
Printed in Canada

ISBN 0-8020-2336-3

University of Toronto Romance Series 50

Canadian Cataloguing in Publication Data

Bourassa, André-G., 1936-
 Surrealism and Quebec literature

 (University of Toronto romance series,
 ISSN 0082-5336 ; 50)
 Translation and revision of:
 Surréalisme et littérature québécoise.
 Bibliography: p.
 Includes index.
 ISBN 0-8020-2336-3
 1. Surrealism (Literature) – Quebec (Province) –
 History and criticism.
 2. Canadian literature (French) – 20th century –
 History and criticism.* I. Title. II. Series.
 PS8073.3.B6813 1984 C840'.9'0054 C83-099182-4
 PQ3917.Q4B6813 1984

This translation was funded by the Canada Council. Both this edition and the French original have been published with the help of grants from the Canadian Federation for the Humanities, using funds provided by the Social Sciences and Humanities Research Council of Canada. Publication of this edition has also been assisted by the Canada Council and the Ontario Arts Council under their block grant programs.

André G. Bourassa has revised the original work, *Surréalisme et littérature québécoise* (Montreal: Editions L'Etincelle 1977), for a possible second edition in French and these revisions have been incorporated into this translation. Hence there are substantial variations between this English version and the 1977 French-language edition.

Excerpts from the works of Saint-Denys-Garneau have been translated by John Glassco and are reprinted by permission of Oberon Press.

Cover: Ink drawing by Roland Giguère, 1954, reproduced by permission of the artist. Photo Centre de documentation Yvan Boulerice.

Contents

Author's Note

I wish to thank all those who made the original book and this translation possible. The researchers, artists, writers, and their families who assisted so generously with the original work are acknowledged in it, but I should like also to single out here M. Gilles Marcotte, who supervised, read, and reread my drafts for the book.

The research for the original version of the book was subsidized by the Collège Lionel-Groulx, the University of Ottawa, the Quebec Ministries of Education and Cultural Affairs, the Canada Council, and the Humanities Research Council.

In particular my thanks to Mark Czarnecki for his translation.

AGB

Translator's Note

Asterisks in the text indicate translator's notes and, occasionally, points at which the original French version has been supplied. These notes, and the author's notes, which are indicated by superscript numbers in the text, appear at the end of the book.

Thanks to Gail Burgess, Rob Dales, and David Homel for help with the translation. Advice and encouragement from André G. Bourassa, Ray Ellenwood, David Ellis, and Ron Schoeffel were especially appreciated.

MC

Introduction

Entering the Collège Sainte-Marie, or any other collège classique,* used
to be a very expensive way for young students like myself to join the 'elite.'
Fortunately, however, we were also provided with a unique opportunity to
make contact with the teeming, virtually clandestine world of downtown
Montreal's artists. We quickly learned that the textbook store, run by an
old friar, contained only new books and was prohibitively expensive, so we
had to rely on the services of more secular outlets pointed out to us by
older students. The closest and best known was the Librairie Tranquille on
Sainte-Catherine Street.

Henri Tranquille had been selling used books for a long time. We were
drawn there mainly by the prices, but also by the unique opportunity to
discover on the spot the contemporary Quebec art scene. In the fall of
that first year (September 1948), proudly placed in full view behind the
counter where we bought our Greek and Latin texts, were 400 copies of a
manifesto – *Refus global*. Of course, being only twelve years old, none of us
read it. In the years following, however, it was possible to meet Jean-Jules
Richard and Jean-Paul Mousseau, two employees at the Librairie Tran-
quille who discussed painting and writing with the customers. It was also
possible for us to see, displayed on top of the bookcases, the canvases of
almost all the '*maudit*' painters whose openings took place at the book-
store.

This bookstore became somewhat suspect in the eyes of the school
authorities. Our 'spiritual advisers' issued warnings about this supposed

'den of anti-clerics' and reiterated the harsh judgments passed on the ideo-
logy of that milieu by the Jesuit Ernest Gagnon (who lived at the school
but taught at the University of Montreal): 'An anarchist credo ... Nothing
good will come of it.'[1] A few months after *Refus global* appeared, two of
our fellow students were expelled for 'existentialism.' Their crime was to
have been seen at an exhibition of paintings by Jean-Paul Mousseau and
Marcelle Ferron in a neighbouring bookstore, the Comptoir du Livre.
From then on our limits were defined, and when I went with my friends
in 1953 to the Place des artistes exhibition across from the Librairie Tran-
quille it was in secret. A few weeks after this exhibition, undisclosed pres-
sures shut down Robert Roussil's studio, Place des arts, located opposite
the school. Since the studio was a meeting place for the left at the time, it
obviously posed a serious threat to our young souls.

 These memories of innocent contact with the literary milieu of 1948-53
were undoubtedly the most important motivating factors behind the re-
search subsequently undertaken: I wanted to interpret the events that took
place during this period and situate them in the history of ideas in Que-
bec. Some years later, in 1959, I took part in a seminar and wrote a paper
entitled 'L'Intuition créatrice en art et en poésie.' This was an inquiry
into the psychological domain inhabited by poets, located by Jacques Mari-
tain somewhere between the heaven of Plato's Ideas and the hell of
André Breton's automatisms.[2] Plato or Breton, an idealist vision or a
more materialist one: I felt more and more inclined to explore the latter,
and I was attracted by the growing significance of the program put forth
by Breton in *Position politique de l'art d'aujourd'hui*: 'Thwart once and for all
the coalition of forces insuring that the unconscious is incapable of any vio-
lent outburst: a society which feels itself under attack from all directions, as
does bourgeois society, is quite right in thinking that such an outburst
could prove fatal.'[3] Breton then pointed out in this work written in 1935
that surrealism's field of activity was not the conscious ego but the sub-
conscious id whose symbols, liberated by automatism, are preserved not
because of 'their unmediated strangeness or formal beauty' but because
they are decipherable.[4] The interpretation of these symbols was to aid in
replacing the creation of a personal myth in art with that of a collective
myth.

 The use of automatism in art therefore could polarize – and this I did
not expect – concepts concerning the unconscious, materialism, collectivity,
and revolution. I decided to observe its development in the individual
members of the group of Québécois brought to public attention by their
practice of automatism, an automatism that had advanced into both non-
representational and mechanical forms of expression.[5]

A DIALECTIC

My plan was as follows: establish from the start that surrealism is a state of mind;[6] adopt a methodology, a dialectic based on ascertaining facts; emphasize relationships, verifiable links with manifestoes and groups; provide documentation which would be especially useful considering the rarity of the texts and the fact that they are very often neglected in historical studies of the literature. Further to this final point, the historical aspects of the book did become more and more accentuated, yet there is much more than history here: there is, however implicit, the revelation of a dialectic underlying the history and gradually bringing to light the beginnings of a cultural revolution. This explains why the book is at once a history of art, literature, and ideas.

My approach to surrealism in Quebec began with the study of the Montreal automatist movement situated, as Paul-Emile Borduas said, 'en regard du surréalisme actuel' – that is to say, the surrealism of 1947. However, I would like to emphasize that 'automatism' and 'surrealism' are terms used here to designate a state of mind, as André Breton defined it, and not simply to classify a modern art movement – still less a style – as many people do. Moreover, automatism and surrealism were never limited to artistic activity alone, hence the occasional recourse to the history of art and ideas.

Only written documents (manifestoes, poems, theatrical pieces, articles) are within the scope of this study. Examples of visual art or musical works are mentioned only to illustrate an idea or serve as a starting-point for textual analysis and historical exposition: the examination of automatist and surrealist art in Quebec I leave to others.[7] This decision greatly reduced the importance to the book of artists such as Marcel Barbeau, Marcelle Ferron, and Jean-Paul Riopelle – obviously, the space they occupy here bears no relation to their actual significance.

How necessary is it to discuss socio-political ideologies like fascism and communism in such a book? I myself have done so only when certain works could not be explained other than by the presence or absence of ideology. The politicians of the time who harassed those poets and artists supporting *Refus global* knew intuitively that automatic writing had broken freedom's bonds for good. I discovered after the fact that these freedoms inherent in surrealism could be traced back through the literature to 1837, the year of Quebec's first novel and its first rebellion, a date which gives special significance to Albert Camus' famous line, 'Toute parole est révolte.'[8] The voice of our people was first heard in 1837, and this book begins with writings from that year.

After these initial comments on the genesis of the book, the introduction defines surrealism up until its post-war manifestations. The first chapter deals with the movements prefiguring surrealism from 1837 to 1924 and Quebec literature vis-à-vis pre-war surrealism (1924-37), a study never before undertaken in a systematic fashion. It reveals a valuable and dynamic culture and places certain nationalist academic movements, once much in vogue, in a more critical light since the spirit behind them made the birth of an original art difficult, if not impossible. In the end, then, the entire literary production of the years 1837–1937 became the subject of an investigation 'in relation to contemporary surrealism.' The negative viewpoint in the first chapter, which examines the abortive attempts of cabalistic romanticism, cubo-futurism, and dadaism in Quebec during this period, should come as no surprise.

The first chapter may be criticized for according too much importance to certain Quebec artists who spent time abroad early in the century, and for ultimately attributing a certain originality only to those nicknamed 'Parisianists' (with all its pejorative implications) by partisans of the *littérature de terroir*.* Nevertheless, the automatists, the first Quebec artists to achieve world-wide recognition, might never have emerged without them, hence the importance of Guy Delahaye, Jean-Aubert Loranger, and Ozias Leduc.

Many of the automatists also spent time in Europe, even before the publication of their manifesto. This European background is discussed in the second chapter in connection with the appearance of surrealism in Quebec. It is particularly interesting to note how avant-garde impulses were communicated from painting to poetry in the years 1937–47.

The third chapter examines ideological problems raised by surrealism above and beyond purely artistic concerns. Since world surrealism was deeply involved in important international democratic and pacifist movements, it continually opposed dictatorship of all kinds, whether of the left (Stalinist autocracy) or the right (fascism). Surrealism's advocates in Quebec also took stands against Stalinism and Duplessism, and since the Quebec automatists' manifesto is profoundly concerned with political and social questions, it was essential to describe the main features of this opposition. Such an approach greatly simplifies a study of the manifesto and other works by the same publisher, Mithra-Mythe. In addition, the surrealist manifesto brought back from Paris by Jean-Paul Riopelle – *Rupture inaugurale* – sheds light on *Refus global* and imposes a socio-political perspective on the automatists' manifesto.

The fourth chapter looks at movements which are often confused with automatism, but which are in fact much more closely related to other international movements parallel to surrealism. It is clear, therefore, that a

study of the influence in Quebec of 'revolutionary surrealism' deserves a place here, even though the movement was often considered unorthodox when it espoused Stalinism. The study of this surrealist movement is also relevant here because contributors to the periodical *Cobra* (and to Edouard Jaguer's *Phases*) did draw closer to the surrealism of Breton. This rapprochement in Europe coincided with one between certain signatories of Alfred Pellan's and Jacques de Tonnancour's *Prisme d'yeux* and those who signed Paul-Emile Borduas' *Refus global*.

The fifth and final chapter deals with the effects of surrealism in Quebec after Pellan and Borduas left. Since analysing them all was impossible, it seemed sufficient to deal with those poets who referred explicitly before 1968 to this 'state of mind' in their work or to their disciple / master relationship with the principal Quebec 'surrationalists' of the forties.

DEFINING THE PROBLEM

The following questions should be kept in mind at the outset: What was the impact of the surrealist movement in Quebec? Does the cultural history of Quebec include a surrealist phase? Did the movement in Quebec define itself in any special way? Did Quebec play a role in the movement on an international level?

Because surrealism's boundaries, like those of other great movements – classical, baroque, romantic – were extremely fluid, I did not want to restrict them to André Breton's group alone. On the contrary, it is possible to distinguish at least three kinds of surrealism, all of which will be examined in relation to Quebec.

Strictly speaking, surrealism refers to Breton's school of thought as defined in the manifestoes from 1924 on. There is rarely any mention of Quebec participation in this school in the histories of international surrealism. Such participation did take place, however, and several documents attest to the close relations between certain Québécois and this strictly defined surrealism.

In a more general sense surrealism most often refers to an earlier ideological movement to which Breton's manifesto was only a logical conclusion and, at the same time, a limiting factor. Surrealism also includes those who subsequently rejected Breton's authority, or were rejected by him for being unfaithful to the group's principles, especially regarding political disputes.

Several Québécois were influenced by surrealists before their time such as Guillaume Apollinaire and Yvan Goll, and by the schismatic surrealism of the Cobra and Phases movements. Some took part in rallies or contributed to the publications of revolutionary surrealism, which rose up against Breton's refusal to support communism.

In its broadest sense, surrealism is defined – as Breton himself did in his first manifesto – as the natural and spontaneous use, no matter how far distanced in space or time, of those means of expression used by the surrealist school: cathedral gargoyles and African masks, religious myths and communications with the spirit world, da Vinci's 'paranoiac screen'* and Rimbaud's visions, the dream imagery of Bosch and Goya or the automatic writing of Arnim and Nerval. In short, surrealism in its timeless aspect.

This perennial surrealism can be found in Quebec too, where black romanticism and cubo-futurism had their devotees and where religious mythology, verbal debauchery, and folk art produced very significant works.

Clearly there is no lack of material. For purposes of orientation the authors had to be organized around their manifestoes, periodicals, and publishing houses so that their common traits would stand out. However, a point to keep in mind is that certain groups, such as the supporters of *Refus global*, tended to be closed, while others, such as the contributors to the periodical *Ateliers d'arts graphiques*, were more open.

Alfred Pellan. Photo Centre de documentation Yvan Boulerice

André Breton in 1965. Photo by Suzy Embo

Paul-Emile Borduas in his Paris studio, 1959.
Photo by Janine Niepce, Paris

Pierre Gauvreau, *L'Autel du surmâle*, illustration for *Le Vierge incendié* by
Paul-Marie Lapointe, 1948

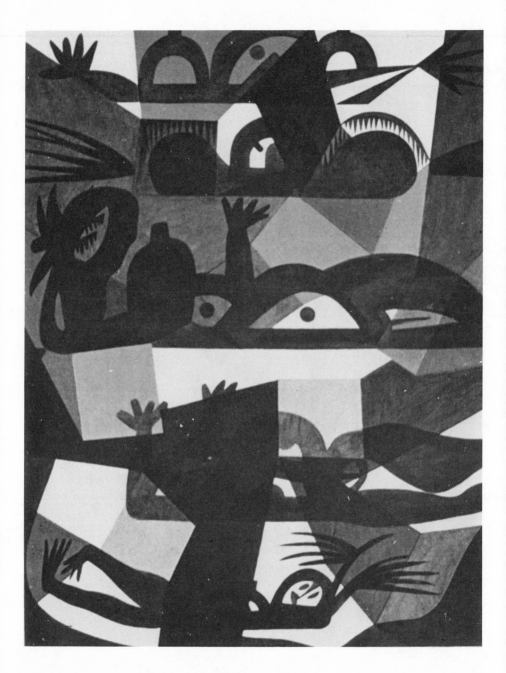

Alfred Pellan, drawing for *Les Iles de la nuit*
by Alain Grandbois, 1944

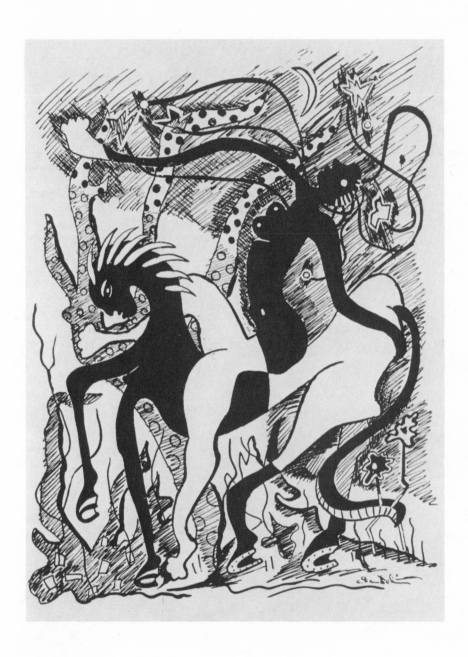

Charles Daudelin, drawing for *Théâtre en plein air*
by Gilles Hénault, 1946. Photo by P.-H. Reney

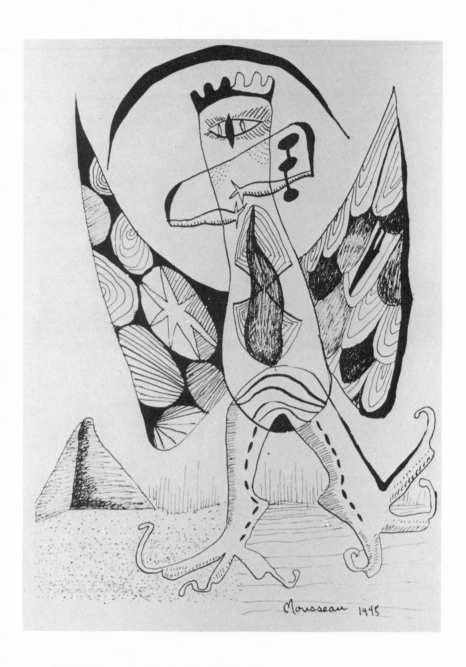

Jean-Paul Mousseau, drawing for *Sables du rêve*
by Thérèse Renaud-Leduc, 1945.
Bibliothèque Nationale du Québec

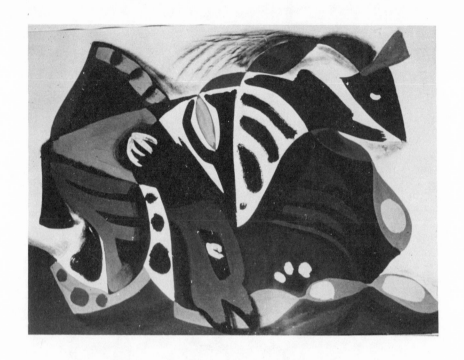

Paul-Emile Borduas, *Maldoror*, 1942. Collection Charbonneau, Montreal

OPPOSITE
Paul-Emile Borduas, *Sous le vent de l'île*, 1947. National Gallery of Canada
Paul-Emile Borduas, *Les Carquois fleuris*, 1947. Montreal Museum of Fine Arts

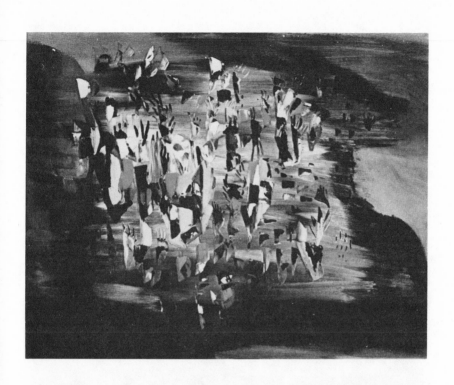

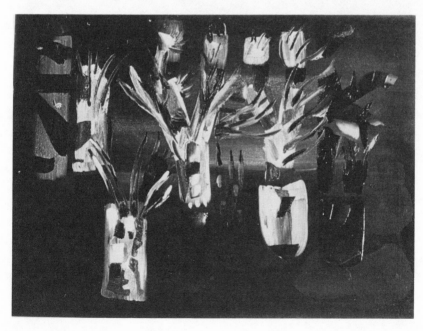

Alfred Pellan, *L'Amour fou*, 1948. Private collection, Montreal

Jean Benoît, Mimi Parent, Alfred Pellan,
*Crayons de couleurs sur papier, c*1945.
Collection Musée d'art contemporain, Montreal.
Photos Centre de documentation Yvan Boulerice

Léon Bellefleur, *Danse des noyés*, 1950

Albert Dumouchel, drawing for *Totems*
by Gilles Hénault, 1953. Photo by P.-H. Reney

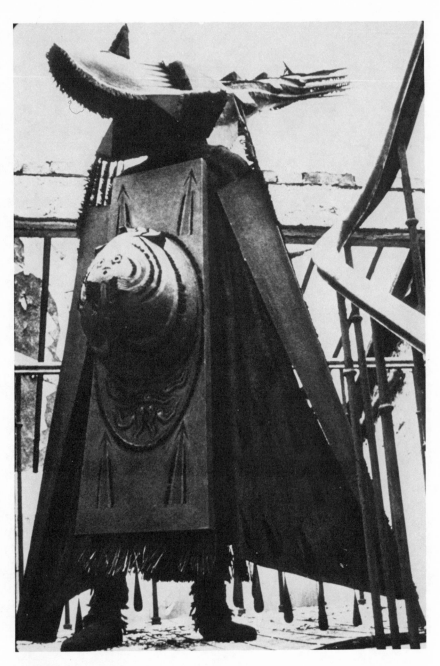

Jean Benoît, costume for
L'Exécution du testament du marquis de Sade, 1959.
Photo by Gilles Erhmann

Reynauld Connolly, illustration for *Je* by Denis Vanier, 1964.
Photo by P.-H. Reney

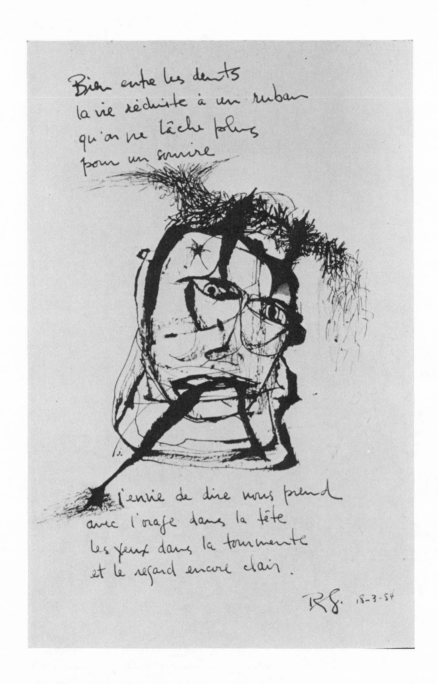

Roland Giguère, ink drawing, 1954.
Photo Centre de documentation Yvan Boulerice

SURREALISM and Quebec Literature

1

11

Precursors

We, scribes of poetry, are the REAL priests. Listen to our future well-being
staunch our welts of memory with starry poultices. Dream ... Dream ...
Dream ...

Gilbert Langevin, 'Canne-à-dada, Anywhere'[1]

This study of the surrealist revolution begins with an exploration of its
romantic, cubo-futurist, and dadaist precursors for two reasons:[2] first, it is
difficult to deal with a cultural revolution of this importance without situat-
ing it in time and space; second, except for a few scattered articles, very
little has been written on the pre-surrealist revolutions in Quebec and so
no complete study of the subject has yet been available. Such an approach
brings together authors who have rarely been discussed as a group before.
They have in common the fact that they participated in the evolution of
Quebec culture by gradually bringing it up to date with the rest of the
world; all of them were also quite unsuccessful in their lifetimes. Not until
their isolated attempts were replaced by group efforts did the revolution
succeed, and their successors took pains to pay them tribute.

There are few Quebec romantic writers whose work contains pre-surreal-
ist elements: Philippe Aubert de Gaspé *fils* (in one novel), Joseph Lenoir
and Octave Crémazie in several poems, and above all, Emile Nelligan.
Yet already in the nineteenth century these authors evoked a certain surre-
ality which lent an eerie quality to some of their works. The first three
were contemporaries of Gérard de Nerval, Achim von Arnim, and Edgar
Allan Poe, and like them were influenced by the cabala and by folktales.

Later on, at the turn of the century, Guy Delahaye and his circle joined the rebellion against the constraints of language: examples of these revolts, the legacy of cubism and literary futurism, can be found in the works of Delahaye, Marcel Dugas, and Jean-Aubert Loranger in particular, but the uprising was short-lived. They apparently knew little of dada's nihilist upheavals, and Loranger passed directly from Apollinaire to Saint-John Perse, coming in contact with surrealism only briefly in the twenties.

As far as 'true' surrealism is concerned, at most only Pierre Reverdy's spiritualist works and, more to the point, Paul Eluard's *Capitale de la douleur* were known and admired in Quebec, especially in the circles frequented by Saint-Denys Garneau. But this surrealist influence on Garneau and on the *La Relève* group was sporadic and largely academic. Only the critic Louis-Marcel Raymond knew Louis Aragon, André Breton, Yvan Goll, and Pierre Reverdy personally, and not until the painters had taken the initiative did Quebec's poets make close contact with surrealism. This chapter travels the long road from surreality to surrealism and in so doing covers a century of literature from 1837 to 1937.

'BOUCHES D'OMBRE'

> Physicist, but also cabalist, theosophist, and poet ... a surrealist before his time.

> André Breton on Achim von Arnim[3]

The close relationship between surrealism and cabalistic romanticism has often been noted. André Breton examined the subject at some length in an introduction written in 1933 for Achim von Arnim's *Die Kronenwächter* and concluded that the common ground between romanticism and surrealism can be found in their experimentation with non-rational methods of acquiring knowledge (spiritism, magnetism, hypnosis, cabalism) and with surrational modes of expression and creation (somnambulism, eroticism, dreams, automatic writing).[4]

Philippe Aubert de Gaspé fils

In Quebec, only one nineteenth-century writer seems to have been interested in this cabalistic aspect of romanticism: Philippe Aubert de Gaspé *fils* (1814-41). In 1837 he published a novel entitled *L'Influence d'un livre*. It seems unlikely that he had read Arnim, who died in 1831, since Théophile Gautier only introduced him to France in 1856. Had he read Poe? This seems unlikely too, since *The Narrative of Arthur Gordon Pym* first appeared in English in the same year Aubert de Gaspé *fils* wrote his

novel, and this novelist who often cites (in English) Shakespeare, Byron, Campbell, and Otway makes no mention of Arnim or Poe. Hence there must be a common source for Arnim, Poe, and Aubert de Gaspé *fils*: the romanticism of 'la bouche d'ombre' (the talking shade), as Victor Hugo put it.

L'Influence d'un livre refers to the philosophy of magnetism as revealed in *Le Petit Albert*, a famous cabalistic work. The first chapter of Aubert's novel is titled 'The Alchemist' and the second 'The Conjuration'; the epigraphs to the sixth and eleventh chapters contain morbid lines from Byron; here and there the author quotes 'occult' writers he was familiar with – Aloysius Bertrand, Crabbe, and Hugo. He chooses lines filled with *danses macabres* and incantations, both calculated to make errant souls shudder. Whether he is relating how the devil disappears 'with a deafening crash, leaving behind a smell of sulphur,'[5] or describing how his hero tries to make gold out of a sulphurous powder, having chosen a black hen stolen at midnight, some verbena, and a hazel branch cut with a virgin blade and dipped 'three times in lake water while a cabalistic formula was uttered in a low voice,'[6] the author shows how far cabalism will go in order to reinvent the word and its evocative power. 'With books one can call up spirits from the other world, even the devil himself,' he says.[7] But one must also be aware of 'real' literature, that of the initiated: 'I must warn the reader that this conjuration, as well as the means of changing metals into gold discussed above, cannot be found in readily available works by Albert-le-Petit, for these are counterfeit editions. Armand himself has assured me that he has a genuine copy of the original which was passed on to him by a Frenchman.'[8]

Given a cabalistic treatment, the old Quebec legends in the novel acquire an atmosphere that recalls the tales of Arnim and Poe. The story of 'Rodrigue Bras-de-fer' in 'L'Homme de Labrador' is presented with all the stage machinery peculiar to bizarre tales of the time (the awed hush, the ritualistic three knocks, the prefatory howl):

> A howl more terrible than the first nailed me to the spot. The little creatures disappeared, an immense silence fell, and I heard two knocks at the door; after a third knock, despite my precautions, the door burst open with a stupendous crash. A cold sweat poured over my body ... A second howl told me that my enemy was preparing to break down the next door, and at the third blow it opened like the first, with the same crash ... A third howl was heard, then all was silent again. This lasted about ten minutes. My heart was beating double time; I thought my head was split open and my brains oozing out drop by drop; my limbs tensed, and when at

the third knock the door burst into smithereens all over the floor, I stood dumbfounded. The fantastic creature I had seen pass by then entered with his dog ...

I had time to observe his satanic face: an enormous nose over-hung his upper lip and his cavernous mouth stretched from one temple to the other; his ears fell down to his shoulders like those of a greyhound. Two rows of teeth, black as pitch and sticking out almost horizontally from his mouth, ground together horribly.[9]

This novel was written during the winter of 1836-7[10] when the author and his friend Napoléon Aubin were hiding from law officers because they had insulted the Quebec legislature.[11] Soon after this young journalist's work was published an important political rebellion took place; the book is more than just a search for solutions in the alluring world of alchemy, it is a first refusal of traditional structures. For not only had Aubin and Aubert de Gaspé *fils* become entangled in various disputes leading to exile, but both in their works and in their politics one can see a continual denial of the established order.[12]

Joseph Lenoir

A review of oneiric or 'nocturnal' romanticism does not necessarily have to include Joseph Lenoir, but his *Génie des forêts*, published in July 1843,[13] the two editions of *Le Roi des aulnes* (1850 and 1859)[14] and other references to Goethe as well as to Byron and Hugo show that he and Aubert de Gaspé *fils* were reading similar material. Lenoir published startling and bizarre works like this in the newspapers:

Where do these outbursts of laughter come from? This phosphorus, why does it come to lick these two yellowed skulls which the worm still eats and which it must dry out?

Is it to see a night traveller pass by, that the huge black eagle over there has hastened to settle on the tomb whose urn he has broken?

Who knows? But each evening when the moon rises, two hideous skeletons uttering unintelligible cries tread the sand of the dune around him with their cloven feet.[15]

Nocturnal romanticism and surrealism have in common the practice of transcribing bizarre dreams and using images whose bizarre juxtaposition is deliberate in one and arbitrary in the other.[16] Certain romantic writers are also noteworthy for having taken extreme political positions, some of which foreshadow principles later defended by the surrealists. Lenoir

deserves mention in this regard: immediately after the events of 1848 (the Communist Manifesto, uprisings in major European capitals), he cited Lammenais in an epigraph ('I see the people rising up in a tumult'). The line introduced some inflammatory verse worthy of the poets of the First International; the following work preceded Pottier's celebrated call to arms in 'L'internationale' by more than twenty years:

> We must battle by undertaking bloody battles in which the mind overcomes the passions! Engender despair and agonizing sorrow, and conquer while unveiling the burning hatreds of future genera-tions' system of justice!
> Labour on! Workers of courageous works, may our wills make us strong! Let us raise the edifice before storms arise! May it be beau-tiful! ... May it match our enslavement in enormity and be worthy of the honours desired by liberty.[17]

Lenoir's stand did not refer only to the newborn struggle of the prole-tariat. A poem dated 31 December 1849, while regretting that social libera-tion had made so few advances, demonstrates quite clearly in an allusion to the United States' separation from Great Britain that the poet was also concerned about political liberation. Evidently Lenoir was referring to the 'troubles' of 1837 in Lower Canada and to the imposition of the Act of Union in 1841:

> Our destiny is to remain in servitude no longer! Let us rise! The hour strikes! Let us go! Brothers, courage! O! Let us not wait for to-morrow! Look! The land of the setting sun has torn away its veil and covered its forehead with thirty-four stars! Listen to the cry of the American eagle!
> Brothers, the year is fading and we are still fighting! The phan-tom is still standing, but shame devours those who still believe in him! Let us fight! Surely he has stirred up so much hatred, so many mocking insults, that today he can count on hardly any sup-port at all![18]

Just as the surrealists were ambivalent about a revolution in poetry and the poetry of revolution, an ambivalence which took a long time to resolve and was reflected in the successive titles of their periodicals (*La Révolution surréaliste, Le Surréalisme au service de la révolution*), so a similar ambivalence dogged the romantics: they sang about poetic liberation in philosophically liberal terms. And when it came to talk of politics, they also deployed the torn veils, phantoms, and eagle's cries which filled their poetry.

Octave Crémazie

Octave Crémazie had little to do with the romanticism of Aubert de
Gaspé *fils* and Lenoir, yet in speaking of one poem, 'Promenade de trois
morts,' he claimed to have endured the same anguish as Nerval: 'When
will I finish this poem? I don't know anymore, I'm a little like Gérard de
Nerval now. Dreams occupy a more and more important part of my life;
as you know, the most beautiful poems are those one dreams but never
writes down.'[19] These lines were written twelve years after the suicide of
the French poet in 1855; Crémazie, who refused to get down to the last
lines of 'Promenade de trois morts,' excused his inability to write by plead-
ing encephalitis, a disease he was pleased to claim in common with Nerval.

'Promenade de trois morts' infuses an atmosphere of uprootedness with
surreal dread, and to this extent the poem exhibits the 'surrealism' Breton
claims to find in Nerval, Novalis, and Germain Nouveau. Here Crémazie
presents the joys of exoticism and horror:

> Happy to see one another again, three lifelong companions shake stiff,
> withered hands and with their lipless mouths exchange horrible kisses.
> They walk in silence; just a few lonely old skeletons who groan
> as they feel remnants of their purple flesh catch on bushes.
> As they pass by, flowers wilt on the stem, dogs flee howling as if
> overtaken by vertigo, the startled passerby feels strange shivers.[20]

Crémazie never finished his poem but instead left the worms unsatisfied,
singing the delights of human flesh:

> To me your cadaver is the source of life where I quench my thirst
> each day; it is a rich banquet to which hunger invites me, and
> where I sit down with gusto.
> It's all mine, your body, your casket, your shroud, only your sor-
> rows are yours. Here I alone can state in a loud voice full of pride:
> 'I am the Worm, I am King!'[21]

These shouted elegies are certainly very different from the cabalistic
writings of Aubert de Gaspé *fils*, and there is an even greater gap be-
tween the hesitant, derivative style of Lenoir and Crémazie and the
confident, graceful lines of Arnim and Nerval. But the three Quebec
writers share this nocturnal romanticism, which was later denounced by
the reactionary critic Harry Bernard:

> It may seem strange, but we have had, and still do have, writers
> who play at being *poètes maudits*. They must take some pleasure in
> it, hard though it is to comprehend, otherwise they wouldn't waste

their time. But this taste is not a recent phenomenon. In his 'Promenade de trois morts,' Crémazie went as far as anybody could in experimenting with the bizarre and the macabre. And do we not find in Alfred Garneau, before Nelligan, numerous symptoms of an overheated sensibility? Both of them were on the lookout for novelty and thought they had found it in Baudelaire's and Rimbaud's murky precursors. Those who came after fell into line ...

All in all, to call a spade a spade, what we are confronted with here is a romantic movement pure and simple – the gross romanticism inspired by Shakespeare and German legends which provoked the events of 1830.[22]

So the romanticism of Hugo's 'bouche d'ombre' did have its adherents in Quebec from 1837 to 1867. One of Crémazie's letters in reply to the criticisms of Norbert Thibault is a clear statement of this former 'patriotic' poet's intentions: 'Thibault's literary gods are not mine; clinging to classical literature, he spurns that unhappy romantic school and barely deigns to acknowledge that it has produced some remarkable works. As for myself ... I adore with all my heart the romantic school, which has stirred in my soul the sweetest and purest joys it has ever known.'[23]

Crémazie, who rejected some of his former poems such as 'Drapeau de carillon,' went on to defend 'Les Morts,' a poem that went unnoticed in 1856, as well as his 'Promenade de trois morts.' He even added that his 'Trois morts' was inspired by Goethe's *Faust* in particular, which he called an 'impossible drama,' and 'an extraordinary ... gargantuan fantasy in which the strangest and most magnificent ideas clash on an enormous canvas.'[24]

Emile Nelligan

The term surrealism can be applied to Nelligan's work in so far as he was haunted by the same 'talking shades' as Aubert de Gaspé *fils*, Lenoir, and Crémazie in the months after he wrote 'La Romance du vin': 'Obsessed throughout interminable nights by the morbid visions of Edgar Poe and Maurice Rollinat, he too set down in rhyme hallucinations and nightmares, populating that universe where the clear, healthy reveries of his childhood had frolicked with phantoms and spectres.'[25] Nelligan drew on Rollinat for a poetic version of the legend of the Maundy Thursday bells. Into this he inserted the theme of another poem by Rollinat, 'Le Bon Fou,' and came up with 'L'Idiote aux cloches,' which he read in public on 9 December 1898.[26]

In a book on Nelligan, Paul Wyczynski devotes an entire chapter to the heritage of nocturnal romanticism and analyses three main states in its 'vertical dream' structure:

First, feeling is roused by a fear arising from the lugubrious atmosphere of funeral ceremonies: creaking coffins and long lines of hearses mingled with Chopin's funeral march and a backdrop of cemeteries. The second stage, constructed of hallucinations centred around various evocative objects, brings bizarre spectres surging out of the darkness – ravens, a parrot, cats, and a cow with glaucous eyes, all of which furnish the essentials of a phantasmagoria analogous to that of Rollinat and Poe. Finally, the third invasion of darkness, the tragedy of a hypochondriac night, marks the collapse of the intellect. Between the first two phases is interposed a brief interlude comprising three tombstones erected to the memory of Baudelaire, Chopin, and an unknown Negress.[27]

Nelligan liked Nerval's 'Les Cydalises.' He knew Poe's 'The Raven' by heart, used to recite it out loud, and spent long hours working out a translation of it.[28]

The poems by Nelligan which are closest to surrealism are those entitled 'posthumous':* located beyond reason, they find their expression, as in these verses from 'Trio d'Haridot,' in pure psychic automatism:

The days like an apotheosis
Shake the heavens in half
Nevertheless the frog wets
Its foot in the sleeping basin

Time passes and the one-eyed season
Reflects evil in a quid pro quo
For his summer mirror squints at
The duplicity of a double ko

Paul Kauvar (Emile Kovar)[29]

Nelligan is hesitant about his identity at the end of the poem. The use of his first pseudonym, Kovar, echoes these difficulties in determining his persona, which had become confused with the hero of James Steele Mac-Kaye's drama *Paul Kauvar*.[30] There is also some hesitation in identifying fall – the in-between season, a poor reflection of summer – with alienated middle age, a faulty mirror for the adolescence of a genius. There is misunderstanding and duplicity too in the autumnal setting sun's rays, whose gold and wine colouration constitutes a deceiving apotheosis. In this poem the origins of the double self might be found in the image of the moist frog beside the basin (= a sleeping intelligence?). Then there is the verbal

collage 'sosieko' (the final word in the poem), a result of the psychic apparatus having worked on verbal images. This obsessive word puzzle involuntarily brings to light an acoustic image recalling his pseudonym (sosie-Kovar).[31] Never was Nelligan so close to Rimbaud.

Nelligan's 'Poèmes posthumes' often use this doppelgänger technique. Occasionally he possessed a tragic lucidity which allowed him to write about his true condition as in 'Je veux m'éluder': 'Pity! What monstrous vampires suck you, my clouding heart! O I want to go mad, if only to defy my worst sorrows!'[32]

At this point Nelligan dreamed only of heaven and hell, angels and demons. In the poem cycle 'Frère Alfus,' he introduces 'Frère égaré,' a 'renegade monk' who, having 'fallen asleep,' suddenly realizes that 100 years have gone by without him. The cycle 'Suicide d'Angel Valdor' describes similar hallucinations brought on by a painful love affair: 'The bell ringer in October had his love faded / And went away, eyes wild, like a madman.'[33]

The image of the dead bell ringer hanging from the bells is joined with that of the 'Idiote aux cloches' found dead by the side of the road. To these obsessive images of bells can be added that of a screen upon which is projected a split personality, as in 'Le Spectre':

On winter nights in my green velour armchair beside the hearth, an enormous ghost sat smoking my clay pipe under the iron chandelier behind my funereal screen ...

When I asked him his name, my voice booming out like a cannon, the skeleton bit his purple lip, stood and, pointing at the clock, howled out his name behind my funereal screen.[34]

The author describes himself as a haunted house, a terrace where unhinged will-o'-the-wisps dance:

In the Dantean evenings my eye embraces
Some fantastical fire wandering around
Until I no longer see the lugubrious terrace
Where the towers rise up from a haunted castle.[35]

Nelligan's 'posthumous' poetry stems from an art of unreason clearly related to the spontaneous 'non-rational' experiments of the surrealists. It incorporates elements of Yvan Goll's definition of surrealism: anti-logic, negation of realism, the laying bare of instincts, and the revelation of hidden realities.

APPROACHING THE MODERN AGE

Impressionism and Expressionism

> We cannot know the fauna of future mornings but we are seated
> in the sky grey-cheeked warblers modulated song of blasphemy
> over the pointillist violet of cities

> Paul-Marie Lapointe, 'Le Vierge incendié'[36]

The relationship between impressionism and surrealism has often been dis-
cussed. Some critics insist that the act of painting oneself painting, of being
a painter / seer and a painting seen, of 'consciously restricting art to paint-
ing only those things seen'[37] are phenomena marking the transition point
from the former movement to the latter. In a talk published in 1943 Paul-
Emile Borduas summed up the significance of the impressionists: 'By ex-
perimenting with problems of colour and light they had a double effect on
the evolution of intellectual disciplines: they completed the cycle of the pos-
sible ways the visual arts could express the external world ... they also
pointed the way ... to subjectivism.'[38]

Alfred Garneau
Only one Quebec poet in the impressionist era, Alfred Garneau, produced
a body of work in which one can, to use Plotinus' terminology, 'see sight.'
Certain poems like 'Aimer' and 'La Jeune baigneuse,' which appeared in
the newspapers in 1863 – the same year as the Salon des refusés (Manet,
Cézanne, et al.) and the scandal of *Le Déjeuner sur l'herbe* – are written in
the same fresh spirit.
 'La Jeune baigneuse,' for example, opens with the Latin epigraph 'Ut
pictura poesis' affirming the relationship between poetry and painting. De-
spite the similarity in approach, there is no possibility that Renoir's art
had any influence on Garneau. Renoir's *Nu bleu* only appeared in 1880
and *Baigneuse* in 1881, yet their work definitely reveals a kindred spirit.
The opening lines of Garneau's poem are full of flashing light, and no bet-
ter illustration of the Gaspé landscape evoked here could be found than
Monet's *Etretat*. 'Dawn bursting over the bay still dallies and spreads
golden scales far and wide over the palpitating water. Already Cap Percé
shines: at its blue feet the splashing tide resounds harmoniously.'[39] Later
there appears what Breton would have called 'un personnage à halo' whose
sparkling hair and smile mingle with the light and the water. In one of those
blue roseate scenes Renoir was so fond of, the morning bather

> ... bursts out laughing
> and rolls about, brilliant and pearled,

in the lilac water ...
 Thus, when dawn's tears
bathe her breast,
 the iris blushes and
quivers over the basin.
 In the spray, a pink shell
clings to a rock ...
She flies, cries out, and dares not
 detach it.[40]

The rest of the poem is a delicate invitation to love: the bee drawn to per-
fumed honey, the soft touch of a gull's sunlit wing, undulating hair cling-
ing to a bare flank. The same emphasis on shimmering colours and the
luminosity of flowers can be found in 'Aimer,' 'Les Lilas (ou le mois de
mai),' and 'Folie.'

In an unusual declaration for his time, this Quebec poet had dared to
say, 'As far as the priests are concerned I am a delirious sinner.' He let
himself be guided towards a completely new aesthetic.[41] Even though
Degas only introduced Japanese prints in 1863, in 'Les Lilas' one could
already see – alongside young girls sitting on a balcony à la Renoir –
portents of the future in the image of a fan:

The air is sweet, no closed windows! Even the hoary old men are
tired of dreaming alone. People are talking ... It's lilac time.
 The wind palpitates with music. Faust, who over there is singing
your lies to Marguerite?
 My neighbour is at her window. What do I hear? She sighs:
Alas! Some silly worry perhaps ...
 I see her, head down, her fan over her arm like an enormous
wounded wing. It's lilac time.[42]

This is still quite romantic, however; the allusions are to Goethe and Ber-
lioz, whose *Damnation of Faust* (1846) is closer to 'bouche d'ombre' roman-
ticism than to impressionist experiments with light.

Louvigny de Montigny

Probably all that will remain of playwright Louvigny de Montigny's work
is a 1901 curtain-raiser, *Je vous aime*, and a whimsical dramatic sketch
from 1909, *La Gloire*. *Je vous aime* is based entirely on a poem by Sully
Prudhomme, whose work Leconte de Lisle condemned as 'hymns and odes
inspired by steam and the electric telegraph.'[43] The first piece of dialogue,
uttered by a lovestruck painter painting 'fashionable watering places,'[44]

recalls in a curious way the expressionist concepts being formulated at the time by the new masters of colour: 'The authority of purple, the irony of yellow, the unpleasantness of brown, the hope of green, the sadness of grey ... The horizon blue as your eye ... the dozing red sun like a cardinal swollen with sleep ... red like his lips, too.'[45]

Here painting from nature is no longer at issue. On the contrary, this painter creates nature, transforms reality through his painting. The point of the play is summarized in this one exchange: 'Have you undertaken to create a masterpiece from this bit of nature?' 'I have come here to grind the blue of this sky, its particular blue, plum blue ... And this evening I will paint a grey sky blue.'[46] Some eight years later, de Montigny circulated La Gloire, subtitled Comédies humaines, a play in four acts which filled exactly two pages! In the first act, 'La Procession de la Saint-Jean-Baptiste,' the director had to deal not just with factory workers talking about their union in the vernacular (this was not fashionable at the time) but with dialogues by bizarre 'characters' as well: 'A Lamb of Saint-Jean-Baptiste: Baaa! The Sun, aside: I'll never get hot enough to make all that melt. (He heats up).'[47] It would not have taken much for this co-founder of Montreal's Ecole littéraire (a literary club) to have overtaken everyone else on the road to dada. But a casual glance over his subsequent works is sufficient proof that nothing of the kind ever happened.

Reginald Fessenden
The competition provided by photography, and the discovery of the material nature of light and electromagnetic radiation, were important events in the evolution of the arts. In Quebec, as elsewhere, scientists began to conduct experiments in the field, and Reginald Fessenden was the first to transmit the human voice using radio waves. Born in East Bolton, he attended Bishop's University and later was hired by Thomas Edison, who made him chief chemist at his laboratory in Menlo Park, NJ. There he invented the electric gyroscope, which made the electromagnetic compass possible. When Edison's laboratory went bankrupt Fessenden took a job with the United States Weather Bureau and built an experimental wireless station. It was there in 1900 that his voice was transmitted between two towers. The following year, Marconi transmitted a Morse signal across the Atlantic Ocean between England and Newfoundland. Fessenden continued his research and on Christmas Eve, 1906, transmitted the world's first radio broadcast between Brant Rock, Massachusetts, and the Caribbean.[48]

As Marcel Jean has pointed out with regard to extended exposure photography,[49] by rendering the invisible visible and audible such discoveries transformed the world of art and literature, forcing reality to go one step farther into sur-reality. In spite of what the realists had claimed, it was

no longer possible to limit reality to the immediately perceptible, a fact already known to the impressionists.

Futurism and Cubism

> Vancouver
> Where the train white with snow and nocturnal fires flees winter
> O Paris
> From red to green all the yellow fades away
> Paris Vancouver Hyères Maintenon New York and the Antilles
> The window opens like an orange
> The beautiful fruit of light
>
> Apollinaire, 'Les Fenêtres'[50]

Quebec's cubist and futurist works are very rare, so rare that in a letter to Jean-Claude Dussault in 1950, Claude Gauvreau acknowledged only the influence of European cubo-futurists on Montreal's surrational automatists. This is how he explained the role of cubism in the rise of the non-representational movement in poetry to which he had devoted himself:

> People ended up constructing objects without any natural likenesses except geometric ones.
> The object was thus severed from any sentimental trait; this amputation, far from reducing the emotive force of the object, increased it a hundredfold.
> It was an extraordinary discovery.
> 'Abstract art' was born.
> Borduas defined the products of abstract art thus: 'Objects deliberately constructivist in a regularized form' ...
> There was also Italian futurism, which attempted to analyse the mechanisms of movement on an immobile surface.
> Cubism and its offspring, abstract art, benefitted us in so far as they revealed the intrinsic qualities of a perceived object: thanks to them we understood that a painting was an organization of masses in three dimensions, and that the permanent interrelations of such an object were contained within that reality.
> It was a giant step forward, really, a giant step we can never take back.
> And then there was dada, there was surrealism.[51]

Quebec learned about the futurist literary movement quite early on (1912), thanks to certain biased and self-righteous Paris newspapers. On 17

August 1912, *Le Devoir* reprinted an article by Georges Malet from *La Gazette de France* entitled 'L'Ecole futuriste – les nouvelles règles littéraires.' Malet's article ended with a quotation from Marinetti; a provocative condemnation followed, endorsed by *Le Devoir*: '"Create ugliness fearlessly," Mr Marinetti replies, "and murder solemnity everywhere. Futurist poets, I have taught you to hate intelligence while rousing in you divine intuition." They proscribe intelligence; we suspected as much.'[52]

Three weeks later, in *Le Devoir*, Marinetti's manifesto was creating a lot of controversy. In a lame pastiche of the 'prismatic' style, an anonymous critic gave an example of futurism and made a blatant attempt to win over scoffers by presenting a futurist poem: 'A French newspaper has provided a pleasant distraction by offering its readers a sample of prose (or poetry: no one knows but he) written by Mr Marinetti, the futurist poet (or prosodist: no one knows but he).'[53]

Then came the poem and a critique clearly reflecting the mood in the editorial room of the newspaper, which had been in existence only for two years:

> It reminds us of an opinion given by the late scholar Ledrain when he was a reader at the Lemerre publishing house. A manuscript had been submitted in which a word was invariably followed by countless suspension points.
>
> Ledrain pronounced judgment thus: 'Only the suspension points are worth a book. The rest doesn't matter. I recommend publication. It will make easy reading.'
>
> Mr Marinetti uses this technique only in moderation. Blank space allows him to rest. But, we humbly ask, does he have the same aversion to verbs as he does to adjectives? For in the fragment cited above, the nouns crowd together in one great 'hullabaloo' and not a single verb intervenes.
>
> Futurism seems to us a bit like the 'pidgin' of the future. But there is a more concise and more *substantial* language. A famous epigram written a hundred years ago by Lemerre, if I'm not mistaken, tells what it is: 'If your mind can hide the wonderful things it thinks, tell me, who can prevent you from employing silence?'[54]

A polemical debate then rose up around futurism. On 14 September, the anonymous critic of *Le Devoir* said that 'For some time the futurists have stirred much comment'[55] and gave an example of his own – a sordid story about camels – in order to provoke laughter at the expense of an art movement he apparently did not understand. Nevertheless, in the same year, the poet Guy Delahaye brought out a controversial work in which he was sympathetic to cubo-futurism.

The Futurism of Guy Delahaye
In 1908, two years after enrolling at the Montreal campus of Laval University, Guillaume Lahaise and his friends René Chopin, Marcel Dugas, Paul Morin, and Antoine Sylbert wrote articles for an issue of *L'Aube* on feminism and a collective work, now lost, entitled *L'Encéphale*.[56] Lahaise then took the pseudonym Guy Delahaye. In 1909, he, J.-B. Lagacé, and Marcel Dugas founded 'le Soc,' a literary circle over which he presided in 1910. The contributors to *L'Aube* and *L'Encéphale* were also part of le Soc. In that same year, Lahaise finished his medical studies, started his internship at Montreal's Hôtel-Dieu, and published his first collection of poems, *Les Phases; Tryptiques*.* He was twenty-two years old.

'This book is a starting-point – it inaugurates a new genre in Canadian literature,' declared Marcel Dugas.[57] But the poet Albert Lozeau called it a 'baroque book'[58] and Camille Roy, the well-known prelate and critic, proclaimed that it was 'obscure and even unintelligible verse ... whose symbolic tendencies are to be deplored,'[59] and elsewhere noted that 'the author has strayed into the vague fantasies of symbolism.'[60] There was nothing symbolist about it at all, in fact. The author himself had indicated what was relevant to his poetry: the use of leitmotifs as in the works of the 'nocturnal' romantic Wagner, Debussy's faceting, and the American concept of the 'prêt-à-porter' (off the rack) two years before Marcel Duchamp invented the 'ready-made'.[61] The president of le Soc was breaking new ground, especially considering that his poems, which appeared in 1910, preceded literary cubism. This is how one poem written in 1908 began:

<div align="center">

Love and science
Analysis and Synthesis: Physico-Chemico-Psychic

So smitten
Oxygen is a combustive
Troost
Love as well; moreover
both are ...[62]

</div>

Upon opening the first pages of *Mignonne allons voir si la rose ... est sans épines*, readers in 1912 were more than a little surprised to see the author denigrate not only Ronsard by sending up 'Mignonne'† but also da Vinci by presenting a reproduction of the Mona Lisa with the irreverent caption, *Notre Dame du sourire dédaigneux* (Our Lady of the disdainful smile).[63] This was five years before Marcel Duchamp gave the Mona Lisa a beard and a moustache along with the famous caption *L.H.O.O.Q.*‡ and eight years before Picabia reproduced Duchamp's Mona Lisa at the top of a dada manifesto in the review *391*.[64] *Les Phases* had bothered readers with its dotted

lines, blank spaces, empty pages, and scientific terminology; *Mignonne* bothered them even more with its photographs and enigmatic drawings by Ozias Leduc inserted between the poems – sixteen years before Breton tried reinforcing the descriptions in *Nadja* with photographs.

Delahaye excelled at enigmatic writing. For example, he states that *Mignonne* was written two-facedly, seriously and as a joke, just like the two faces of the god Janus (Mignonne's surname is 'Bifaciès'). Playing with the numbers 'two' and 'three,' 'Bifaciès' and 'triptyque,' he wrote apropos of Mignonne: 'We have adopted Janusism; occult reasons; the cabala teaches that in the Great-All-in-one considered under its triple aspect from a double viewpoint, there is a resolution in quaternity; we have been concerned with the *trine*, here is the *dual*, the *one* will come, the *other* ...'[65] But neither 'one' nor the 'other' ever came because this collection was Delahaye's last.

Lampooning critics who accused him of lacking originality, the author ironically described his use of the 'prêt-à-porter' as follows:

> We have had numerous collaborators; and it will be clearly established that, apart from our title taken from Ronsard, we have stolen a preface by Asselin, drawings by Leduc, the Mona Lisa by da Vinci (no less), three famous pieces from the prodigious author of an illustrious work which appeared in the memorable spring of the forever famous 1910 (as everyone knows), plus a sonnet from Gallèze, another from Verlaine, and finally one from de Hérédia; in the end all and sundry will be convinced that *Mignonne* can be found in its entirety – if not verbatim, at least as far as each individual word is concerned – in a comprehensive dictionary (cf. Mark Twain).[66]

Later Delahaye recalled the words of Nietzsche's Zarathustra: 'I have canonized laughter; supermen, learn to laugh.'[67] To further this goal he frequently employed puns: 'The joke is no protean matter, not just in the sense that it is fundamental to every living being, but because it assumes a thousand forms. To list the different kinds of jokes – fib joke, fill-in joke, cutting joke, dirty joke – would be too tedious ... all joking aside.'[68]*

Although he never reaches the level of black humour, the poet was not content just to make jokes. In a typical poem dated 1911, one 'pharmaceutical' stanza reveals a precocious futurism (not to mention the originality involved in rhyming 'parle' with 'par le'): 'Everybody's talking about it; tell me then, don't you have anything better than enesol? Yes; come see me and I'll treat you with dioxydiamidoarsenobenzol.'[69]†

Delahaye even wrote 'prescriptive' lines such as these: 'Argyrol, senega, leech, undergoing treatments ... / Ice, spinal tap, hypnol, and the impos-

sible.'[70] Of course such poetic licence drew jeers, insults, and even some prose employing dadaist effects before its time:

> The author of *Mignonne* is not a morphinomaniac nor a nympho-
> maniac, an etheromaniac nor an erotomaniac, a successomaniac
> (megalomaniac) nor a what-have-you maniac, unless being oneself
> (self-made man) (ipsomaniac, not dipsomaniac) is to be a *maniac-
> no-matter-what*, for there may still be some value in having pro-
> duced a book 'as bizarre as the start of a mental breakdown.'[71]

The critic Marcel Dugas exclaimed:

> He seems to be an Ariel enveloped in clouds, gliding over a guilty
> city immersed in the material world. With dust clouds of words and
> ghostly allusions he wants to goad the deaf and blind inhabitants
> towards poetry. This is the triumph of esotericism. All one can see
> is bombast or white pages blotted with delirious asterisks, lilliputian
> references, evanescent indexes, emaciated quotations, commas, and
> periods in splendid isolation. In short, pages which thrilled to
> remain unpolluted.[72]

In 1912 he left Montreal for Paris, leaving behind what he called his 'ultra-futuro-cubist painting' to the perplexed critics.[73]

Delahaye went to Paris to specialize in psychiatry. The year was full of cultural events: the first paper collages by Braque and Picasso, a futurist exhibition which went on a world tour, the publication of Arthur Cravan's pre-dadaist periodical *Maintenant*, the Section d'Or exhibition (with Picabia, Juan Gris, Léger, and Lhote) where Albert Gleizes refused Duchamp's *Nu descendant un escalier*.[74] But it is possible that Delahaye did not follow all this closely, having quickly contracted typhoid fever along with everyone else in the neighbourhood.[75] One thing is certain: during his specialization in psychiatry he did not meet André Breton, who took his medical exams in 1917 at the same time as Louis Aragon.[76] Once he had regained his health and returned home, Guy Delahaye, now calling himself Guillaume Lahaise again, wandered along the paths of Mont Saint-Hilaire, treated patients for free, kept up a mystical correspondence, and wrote the occasional sonnet.[77] His friends pleaded in vain with him to continue publishing.[78] Assigned to the Saint-Jean-de-Dieu Clinic in 1924, the young doctor nevertheless rendered poetry an immense service by taking care of a patient admitted on 23 October 1925 – Emile Nelligan, whose work Delahaye had revered since 1904.

The poet Alain Grandbois later paid Guy Delahaye an enviable homage:

Allow me to express my regrets on behalf of French poetry, and I do mean French poetry, that Guy Delahaye so early in life burned what he had once adored, and that this disdain, this scorn for his first gods moved him to withdraw forever from those who had been so generous and favourable to him, without even the customary tip of the hat sheer courtesy demands. But perhaps he had become perfectly serious, like Rimbaud when he went off to Ethiopia? ... With his keen, magical sense of what constitutes real poetry, Delahaye surpasses everything we have known until now.[79]

Delahaye had concluded his last collection with a cabalistic drawing by his friend Ozias Leduc (both lived in the village of Saint-Hilaire): a serpent in the shape of a heart, laughing satanically as it encircles the triangle of the Trinity in which the eye of God is half closed, a divine and diabolical farewell wink to his muse. The final poem of the collection, dated 1906, ends with the words 'Love is a sonnet to the unbeautiful downfall.'[80] These words of regret from Paul-Emile Borduas (also from Saint-Hilaire and also a disciple of Leduc) on the silence of Guy Delahaye, which he compares to that of Leduc, are understandable: '[Delahaye] also became aware of a dream. He experienced a moment of awakening so brutal he couldn't accept it. After a magnificent outburst, he turned back and found within himself an even more profound dream. There the terrible, isolating security of catholicism awaited him.'[81]

Futurism in Canada appeared to be over, but then, quite unexpectedly, it turned up again in another milieu. Strangely enough, William Van Horne, a Dutchman who had emigrated to the United States and then to Canada, made Montreal famous by applying futurist principles to naval architecture. On 28 August and 23 November 1912, Canadian Pacific Steamship Lines under his presidency launched two vessels of 'nihilist' design from Liverpool: the *Empress of Russia* and the *Empress of Asia* then went to sea in April and June 1913.[82] Because of the radical omission of any 'art' and the predominant concern for engineering in the design of these transatlantic liners, they languished for years before anyone found them beautiful. It took an article by Le Corbusier to open the eyes of futurists and other supporters of the new art movements, who then discovered in these vessels a practical application of their manifestoes. His piece appeared in the periodical *L'Esprit nouveau*, which included among its contributors devotees of literary cubism and futurism. His manifesto, published in the first issue (dated October 1920), began with these words:

No one today can ignore the aesthetic emerging from the constructs of the modern spirit. Industrial constructions and machines increasingly reveal in their proportions and interplay of space and materi-

als that many of them are true works of art ... The elite individuals who make up the world of industry and commerce, and who consequently live in that fertile ethos in which undeniably beautiful works are being created, consider themselves very far removed from any aesthetic activity. They are wrong, for they are among the most active creators of the modern aesthetic. Neither artists nor industrialists are sufficiently aware of this: general production is where the style of an era is found and not, as is too often believed, in a few reproductions serving ornamental ends, pure redundancies on a structure which in and of itself gives birth to style.[83]

Expanding on this thesis, Le Corbusier in a later issue praised the controversial lines of the CP ships for 'a style of architecture which is pure, clean, clear, apt, sane,'[84] and even eulogized the grain silos in the ports along the St Lawrence! Underneath a photo of a federal government silo he exclaimed, 'With their calculations American engineers are stamping out a dying architecture.'[85]

After 1912 futurism became strongly entrenched in Quebec in ways no one could have foreseen:[86] Mondrian's influence, for example, was not felt until much later in the circle connected with the periodical *Situations*.[87] Moreover, one branch of the Orphists – the name Apollinaire gave to those 'who concern themselves above all with these new, mobile, precise entities called *machines*, the modern sisters of Erichtonius, "the child born without a mother" ... Vulcan's son ... sprung from the ground'[88] – did not have much luck in Montreal until Léger's appearance during the Second World War for a lecture and a film:[89] five years earlier, an illustrated lecture on Apollinaire and cubism had not attracted nearly as much attention.[90] However, there were two branches of Orphism – the cubists, including Delaunay and Léger, and the futurists, who included Picabia and Marcel Duchamp – and ever since the day in the summer of 1912 when Marcel Duchamp created *La Mariée mise à nu par ses célibataires, même*, this mysterious mechanical sculpture had been machinating another revolution: dada.

Waiting for dada, Montreal critics were upset at the announcement of a futurist concert by the pianist Léo Ornstein, and *Le Devoir* warned that there might be a riot.[91] The concert took place as announced on 13 February 1916 and the public was less 'disconcerted' than the artistic mandarins had predicted.[92]

Dada in Montreal – Marcel Dugas

Rrose Sélavy et moi esquivons les ecchymoses des Esquimaux aux mots exquis.

Marcel Duchamp (1924)*[93]

After completing university in Montreal, the Quebec poet and critic
Marcel Dugas settled in Paris in 1912. There he rejoined René Chopin,
Guillaume Lahaise (Guy Delahaye), and Paul Morin (who was writing a
literary thesis), friends from his old literary club, le Soc.[94] Dugas' name has
often been mentioned in connection with surrealism, first by Auguste
Viatte[95] and later by Pierre de Grandpré and Jean Ethier-Blais,[96] all cit-
ing a collection published in 1916. While in Paris he appears to have read
everything, seen everything, tasted everything. Having fled the city during
the war, Dugas proclaimed upon his return that all 'essentially Canadian
poetry' was useless.[97] He was anxious to go back after the war; once there
he wrote, in 1921: 'My imagination, that adorable mistress – I bless her for
having destroyed me and saved me.'[98] Later, however, writing about Le
Nigog, a new Montreal periodical, he evoked the Paris of the years 1912-15
and the city he rediscovered in the twenties with some disenchantment:
'The appearance of an arts periodical in Montreal in January 1919 was an
event. In France there is no danger of such a surprise, since it's not
unusual to see five or six new periodicals start up each year. This plethora
of publications, even though of interest to certain groups, leaves others
mostly indifferent and only rouses minimal curiosity.'[99]

Dugas' disenchantment did not make him a whole-hearted partisan of
futurism and dadaism.[100] Nevertheless, while in Montreal in 1916, he had
brought out a collection whose subheadings alone were proof that he had
precociously recognized cinema's 'sadistic' possibilities. Dugas' taste was
quite similar to that of Dali and Buñuel in a later period, but his projects
were never followed up. What he expected from the cinema in 1916 went
far beyond what people were accustomed to at the time. His subheadings
included the following:

> Towards a voluptuous and ironic cinema, embellished with delicate
> sarcasm, flitting around soft, mobile virgins fluid as mirrors or lake
> water.
> Towards a bogus cinema which would show us men beating a
> lot of women to make them tasty.
> Towards a mysterious and terrifying cinema which would reveal
> the sea, the sky, and impenetrable unknowns.
> Towards a neapolitan cinema in which Poulbot would agree to
> make tiny papier mâché Italians dance on invisible strings.
> Towards a cinema in 1915 in which a sea of young severed
> heads would be seen behind bloody lights.[101]

Significantly, these are only subheadings: the texts referred to were no-
where near as audacious. Nevertheless, it was sufficient at the time to scan-

dalize the high-minded, especially when these prophetic announcements were accompanied by prose which for Quebec in 1916 – apparently unaware of dada's activities in New York and Zurich – was quite provocative.

Psyché au cinéma is an invitation to reject literary principles and moral constraints, just as dada encouraged 'disorder':

> Open the jack-in-the-box of your whims: sing, shout, dance with your feet and your intellect. Be incoherent about patience and tenacity; it's natural, and perhaps your way of ruling. Triumph, then, with petulance and candour! Flee overweening perfection, for who knows if lyric disorder does not hide several golden nuggets overlooked by stiff, dry, stuck-up masters? Undoubtedly this interests and captivates birds – the one with undulating plumage stock still in front of you, dumb, staring in astonishment.[102]

Dugas' allusion to the bird with undulating plumage must have disconcerted Paul Morin, by this time a literature professor and author of a book of poetry entitled *Paon d'émail*. Dugas frequently referred to friends in his prose and here he was apparently sending a warning to the overly precious Morin. He recalled the haunts frequented by the Soc alumni in Paris and the pleasures they sought but he was disappointed upon returning to Quebec to find only parnassian and sentimental tendencies, not to mention a definite penchant for *littérature de terroir*:

> Will you suppress the memory of Montmartre, the capital of sin, the splendid navel of joy? Wait – you must make it laugh, your doll stuffed with sawdust, blood and water, you must make it laugh ...
>
> Work hard at scandalizing that tiny goddess of chance and fantasy by singing of Mayol, of Fragson, until her hair bursts into flame. Then, afterwards, ask her to recite the prayers of Saint Ignatius – just for the sake of antithesis.
>
> Be incoherent, be incoherent! And to tease Nature, treat yourself in your imagination to the comedy of total perversity.[103]

In 1918, Dugas took part in meetings about *Le Nigog* and worked with Jean-Aubert Loranger, Ozias Leduc, and Robert de Roquebrune.[104] *Le Nigog* savagely attacked academicism in architecture, music, and painting. It stirred up students and worried teachers because of some of its supporters' 'left bank' – even socialist – tendencies.[105] Dugas was driven out of Paris by the war at about the same time as Duchamp, Picabia, and Cravan; in *Psyché au cinéma*, he appears to be more familiar with the Montmartre of the years 1912-15 and the futurism of Apollinaire and Marinetti than with the growing dadaist movement.[106]

Jean-Aubert Loranger and Alfred DesRochers

> At the very moment this rupture occurs in front of the prison
> which is his own reflection, indestructible cell of shadows, torn be-
> tween his becoming and that of the world, suddenly identifying
> himself with his prey – just then his needs save him.

> Paul Eluard, 'La nuit est à une dimension'[107]

Jean-Aubert Loranger
A descendant of Aubert de Gaspé and the grandson of Thomas J.J.
Loranger of the Ecole littéraire de Montréal (Nelligan was also a mem-
ber), Loranger brought an imposing heritage to *Le Nigog*. In the battle
raging in Quebec between the Parisianists and the regionalists, he became
a Parisianist like the others at the periodical.[108] In his first published
works, all evidence points to Jules Romains' unanimism and perhaps
Blaise Cendrars' simultaneism rather than local literature as major influ-
ences, so much so that his friend Marcel Dugas wrote:

> As remote as possible in his verse from any moral or political pre-
> occupation, completely at odds with the poetry of our past, he
> encloses within minuscule frames his vision of the universe. Nothing
> could be less local than this poetry. It seems exiled from that which
> gave it birth; in no way is it linked to a river, a mountain, a spe-
> cific place. Its specialty is the soul. External emotions, faces, and
> reflections – these are the riches in which it is bedecked. It estab-
> lishes a more defined connection between this knowledge of the uni-
> verse and ourselves; it and the universe are one.[109]

In the cycle 'Images de poèmes irréalisés' from the collection *Poëmes*
(1922), the simultaneous style gives way to a 'collage' of superimposed
images; in 'Intérieur' space and time explode, especially in the final image
of time chopped up by an axe:

> A 'grandfather clock,'
> O this standing coffin
> Enclosing time.

> This pale dial hidden in shadow,
> A face no longer old.

> The keyboard,
> A grin.

Crescent moon in the window,
A nail paring.

And the pendulum swings
Like a double-edged axe.[110]

This is literary futurism in the style of Cendrars and Apollinaire, who
reconciled poetry with the world of trains, automobiles, and planes. 'En
voyage' presents another futurist scene: a steamer, the smoke from tug-
boats, sirens, iron rings, and docks, as in Apollinaire's poem 'Les Fenê-
tres.'[111] But 'Les Fenêtres' is more cubist, whereas 'En voyage' is an
example of simultaneism – the superimposition of spittle and crows, tempta-
tions and engagement rings, the sea and dead sailors:

Steamer surrounded in spray,
As if sailing on foul spittle.

Smoke suddenly rises,
Like crows taking flight.

Two chunky tugboats.

The siren tempted the unknown.

Iron ring on the docks,
The engagement rings
Of sailors who died for the sea.[112]

Loranger's affinity for cubo-futurism did not mean he was close to sur-
realism as well, no matter what his friend DesRochers said: 'In ways ...
similar to what was happening in France, Jean-Aubert Loranger tried ... to
acclimatize surrealism to Canada. Les Atmosphères et le Passeur contain sev-
eral pages of documentary anthology. This is not surrealism in its purest
form – but does such a form exist anywhere except in dreams?'[113]
 Certainly Loranger's favourite authors were all French: Paul Valéry,
Paul Morand, Valéry Larbaud, and Saint-John Perse.[114] To this extent
DesRochers was right in saying that Loranger was more in tune with
what was going on in France, but it is debatable whether there are any
surrealist elements in Les Atmosphères, published in 1920.[115] Loranger did
follow the avant-garde closely; for example, he appears to have been imi-
tating Saint-John Perse when he wrote Terra Nova, of which six of ten
fragments are extant.[116] But from then on Loranger worked on his innova-

tive poems only in secret. He published just two fragments from *Terra Nova*[117] and simply distributed the rest in manuscript form to his friends Berthelot Brunet,[118] Charles Doyon,[119] and Thérèse Fournier.[120]

Alfred DesRochers
 It's stifling in the room
 Don't you think
 In the distance the station screams
 I will go away to Toronto

 Philippe Soupault, 'Etoile de mer'[121]

Alfred DesRochers shared some of Loranger's interests. Like Loranger he yielded to the advances of modernism, but then he too returned to the literature of the land and the people. In an article entitled 'L'Avenir de la poésie au Canada français,' he presented an anthology of his favourite poets. The ten Quebec poets he read with greatest pleasure were Paul Morin, Lucien Rainier, Jovette Bernier, Louis Dantin, Emile Nelligan, Alice Lemieux, Medjé Vézina, Jean-Aubert Loranger, Guy Delahaye, and Gonzalve Desaulniers: 'Each one of them, if placed in a favourable milieu, would have made an excellent French poet – several are anyway – but not a single one is Canadian other than by accident of birth. Not one iota of regionalism has been assimilated into their work.'[122] DesRochers goes on to include two works by Crémazie in this category because they too avoid being regional. More particularly, he claims that 'the real substance of his poetry can be found in an unrefined state in "Promenade de trois morts".'[123]

DesRochers acquired this critical perspective from substantial and varied reading. Here he relates how he and his friend Loranger had come to know surrealism in the years 1920-4:

> In the fall of 1923 or 1924 ... an avant-garde periodical to which I subscribed proclaimed the surrealist revolution. I then tried to invent a dissonant [sonnet] with eleven-syllable lines ... to which I applied the new theories as I understood them ... French surrealism and American imagism: Amy Lowell, Ezra Pound, H[ilda] D[oolittle], Carlos Williams, they were all in the air in my youth.[124]

The avant-garde periodical was very probably *La Nouvelle Revue Française*. The issue of September 1920, for example, published some haiku, including eleven by Paul Eluard; perhaps this is where DesRochers got the idea that he and Loranger had been imitating Eluard in 1920. The *NRF* had

quite a few subscribers in Quebec,[125] but the periodical was not very sympathetic to dada, which was born outside France. A note criticizing dada appeared in the 1 September 1919 issue (no. 72), and Gide passed very severe judgment on the movement in 1920; perhaps this is one of the reasons why DesRochers and Loranger became more sympathetic to Apollinaire's cubism than to the dadaism of Picabia, Duchamp, and Tzara.[126]

In December 1919, *La Nouvelle Revue Française* published 'Rose des vents' by Philippe Soupault,[127] and the following year Breton's *Pour dada* (an anthology and a collection of criticism)[128] and his notes on Aloysius Bertrand's *Gaspard de la nuit*.[129] Encouraged by Jacques Rivière, editor of the *NRF*,[130] Aragon published *Anicet* (1921), *Les Aventures de Télémaque* (1922) and *Le Libertinage* (1924); these works were already surrealist. Rivière had pointed out in 1920 that the three authors were not sympathetic to dada's nihilist demystification but were on the contrary creating new myths:

> The dadaists think of words only as accidents: they let words create themselves ... Language for the dadaists is no longer a means, it is a living entity. Scepticism in matters of syntax now goes hand in hand with a kind of mysticism. Even when they do not dare openly say so, the dadaists continually lean towards the *surrealism* which was Apollinaire's goal.[131]

The word 'surrealism' therefore appeared in the *NRF* in 1920 in relation to the French supporters of Dada. This could constitute another reason for associating Alfred DesRochers' poetry in the 1920s with surrealism, but the fact that he read Eluard's haikus and several dadaist works in the *NRF* does not justify calling him a surrealist, any more than does his friendship with Loranger. DesRochers abandoned his flirtation with the avant-garde before Loranger and moved on to *littérature de terroir* with his story 'Retour de l'enfant prodigue'[132] and several rural miniatures.[133] Later on he did not hesitate to say that 'Aragon and Breton [had] failed miserably in their experiments,'[134] but he regretted having rejected the Parisianists.[135]

Avant-garde literature was frowned on in Quebec at this time, witness a 1924 article by Armand Praviel in *Le Devoir* praising Louis Le Cardonnel at the expense of cubo-futurist and dadaist literature:

> Throughout this outburst of decadents, symbolists, free versifiers, futurists, dadaists, he has preserved the purity, the nobility, the harmony of our traditional poetry. Nothing has lured him from his goal. After so much shouting, stuttering, so many inarticulate cries, we find on his lips the strains of Lamartine.

Ah! How well he has understood the vacuity, the absurdity, the savagery of these undefined schools which depend on the unconscious to release their inspiration! While the literary circus performs monkey tricks all around him, he has never tired of preaching order, clarity, balance, harmony – all those qualities essential to a work of art.[136]

Several months later, the same newspaper reprinted a similar article taken from a Jesuit journal in France. The article ended on a triumphant note with these sublime words: 'So we see that scholasticism is still King! Cubism, futurism, and dada are non-existent.'[137]

THE DARK AGES

Not for a moment do we accept the watchword 'neither fascism nor communism,' whatever its present success ... True art ... cannot be not revolutionary ... at the same time we realize that only a social revolution can show the way to a new culture.

André Breton, 'Pour un art révolutionnaire indépendant'[138]

Party to neither a communist nor fascist revolution but to a change that will be spiritual, if we so desire, or materialist if we wait for the slaves to revolt.

Robert Charbonneau, 'Jeunesse et révolution'[139]

In the small, enclosed world of Quebec, modern art and literature were suffocating. Alfred Pellan felt he had to go and finish his art studies in Paris where, starting in 1926, he encountered cubists, futurists, and surrealists.[140] Generally speaking, criticism in Quebec was ruthless. The excerpt quoted above by Harry Bernard in the periodical *Le Canada français* attacking those who, like Crémazie, Alfred Garneau, and Nelligan, 'played at being *poètes maudits*' was a good example – even DesRochers' sonnets did not escape his censure.[141] Under the pretext of preserving religious morality, *Le Canada français*, published by Laval University, violently denounced critical works by Marcel Braunschvig, John Charpentier, and Frédéric Lefèvre on the twentieth century and praised instead Louis Reynaud on the nineteenth:[142] 'From Baudelaire to Proust, our literature includes far too many abnormals who have been promoted to the status of untouchable heroes, as well as too many artificial and deliberately mystifying minds (are not Mallarmism and Rimbaudism hoaxes?). By refusing these invalids and practical jokers any idolatrous homage, Louis Reynaud has contributed to the common good.'[143]

How could surrealist poetry survive in a country where Charles Maurras' periodical *L'Action française* reached more lost souls than *La Nouvelle Revue Française*? Typical of the situation was the story of Canon Lionel Groulx, a young Quebec priest who became a historian at the behest of his bishop and returned from Europe in 1909 imbued with the racism of the Action française movement. He then published a mystical essay, several historical studies, and other works whose contents are revealed in their titles: *Naissance d'une race* (1919), *L'Appel de la race* (1922), *Notre maître le passé* (1924), and *Dix ans d'Action française* (1926). He also edited a periodical in Quebec with the highly original title *L'Action française*. In 1921, the year in which the French surrealists condemned Maurice Barrès at a mock trial, Groulx summed up his doctrine: 'Latin and French culture are necessary for our intellectual elite. The former will provide us with teachers of truth. [The latter] seems to us an incomparable teacher of clarity, order, and finesse, the creator of a completely sane and most humane civilization, the highest expression of intellectual sanity and mental stability.'[144]

So there were to be two capitals, Paris and Rome, two teachers 'who provide rules for the mind, who raise aloft the shining principles without which there can be no firm direction, no sacred social institutions, no permanent order.'[145] There was no room here for surrealism, which did not sit well with 'law and order,' especially when Groulx, quoting Maurras, described the future as necessarily determined by the past.[146] The surrealist Maxime Alexandre, who claimed never to have missed an issue of Maurras' *L'Action française* in order to 'consolidate his revolutionary convictions,'[147] would have found fine food for thought in Groulx's periodical, which preached 'the kind of race created by history and favoured by God.'[148] Serious academic journals sometimes followed along to the point where they praised fascism.[149]

Then, on 25 August 1926, the French Cardinal Andrieu published a letter criticizing *L'Action française* which was followed shortly after by a condemnation of the movement in France by Pius XI. The pontiff warned against a form of nationalism that threatened to ruin the universality of the church, a warning which applied to Quebec as well. Henri Bourassa, an influential politician, orator, and editor of the nationalist *Le Devoir*, then decided it would be prudent to keep French fascism at arm's length. Not so Lionel Groulx, who merely changed the name of his magazine to *L'Action canadienne-française*: 'We had nothing in common with that royalist magazine in Paris,' he said. '... as for the rest, nothing will change.'[150] Nevertheless, the periodical had to change its name a second time to *L'Action nationale*.

In its quest to be the leading voice of Quebec, *L'Action nationale* never tired of quoting Parisian personalities such as Maurice Barrès, Charles

Maurras, and Philippe Pétain, whom surrealism was trying to ridicule.[151] It did not hesitate to eulogize fascist dictators: 'Happy Austria, which despite everything has found its leader and along with him the road to resurrection! We too urgently need a national front.'[152] But in an article expanding on Groulx's argument about the need to become a pure race, Arthur Laurendeau (father of André Laurendeau of the periodical *La Relève*) was careful to point out that he did not mean purity in the biological sense (a clear allusion to the German cult of the Aryan race); like Henri Bourassa, he denounced 'the myths of the Black Forest' for spiritual reasons.[153] These suspicions about Hitler did not extend to other dictators (a distinction was drawn between Nazis and fascists). Groulx never hesitated to wish upon his country a national leader who would recall 'the de Valeras and Mussolinis, whose policies are debatable but who in ten years have psychologically recast a new Ireland and a new Italy, just as Dollfuss and Salazar are in the process of reconstructing a new Austria and a new Portugal.'[154]

Replying to an open letter from Groulx addressed to the young editors of *Vivre*, Jean-Louis Gagnon, the periodical's editor-in-chief, surpassed all his master's hopes:[155]

> One day, in order to thoroughly frighten the free thinkers, Lenin set Europe on its ear with his now famous aphorism: the Bolshevik party does not need intellectuals. In 1934 Mussolini adapted the Leninist formula for his own purposes and told his fascists that he intended to kick all those brains imbued with too much higher learning out of the party. In 1935, Hitler said nothing but did exactly that, and for a long time Ataturk has been doing the same.
> I admire Lenin, Mussolini, Hitler, Ataturk ...
> By nationalizing public utilities and national resources, by transforming the arts, crafts, and industries of the new Italy into corporations, Mussolini has rid his country – for some time to come – of liberal economics and neo-capitalism ...
> Mussolini is the creator of a new world.[156]

Although Gagnon was a friend and colleague of the staff at *La Relève*, the open letters from Groulx and Gagnon started off a polemic which ended with this unequivocal statement by Gagnon:[157] 'All the masses want is an *acceptably* happy and standardized existence. They are the ones who need the revolution. Let me add that if I am more fascist than Bolshevik, it is only because the standard of life under Mussolini is closer to my human condition than that under Stalin.'[158]

In a special issue of *Etudes françaises* devoted to Saint-Denys Garneau, Gagnon later declared that he regretted the stance he took at the time against Garneau and *La Relève*.[159] But the truth is that even though *La Relève* in its second year did devote an entire issue to 'Fascism: spiritual pseudo-values,'[160] its first issues clearly cast fascism in a leading role.[161] Finally, André Laurendeau, an active member of the movement called La Relève which had formed around the periodical, returned from Paris.[162] He had been studying philosophy and social sciences and was able to observe the consequences in Europe of state corporatism; as a result, *La Relève* and *L'Action nationale* revised their positions.[163] Guy Frégault issued similar warnings about the newspaper *La Nation*, published by Paul Bouchard.[164]

1926

> You who pale at the name Vancouver
> Have only completed a banal voyage
>
> Marcel Thiry, 'Toi qui pâlis au nom de Vancouver'[165]

During these years of obscurantism, few free-thinking works were pub-lished in Quebec except by those who had tasted a little of Parisian life.[166] A case in point was Antonio Desjardins, who sojourned in Paris taking courses in literature and philosophy until the outbreak of war in 1914. His collection of poetry, *Crépuscules*, published in 1926, openly undertook to de-fend 'liberated words, drunk with life and loud yells.'[167] The prudery of those dark ages is absent from his poems, and this admirer of Verlaine, Valéry, and Apollinaire is still quite lyrical: 'Gently falling asleep on the bosom of visions, / Offering their naked throats to your heart's desires.'[168]

That same year in Paris, the Québécois Héliodore Fortin founded a strange religious sect based on cabalistic principles. He had just rejoined his recently divorced lover, Marguerite Constantin (the sister of Maurice Constantin-Weyer), having first met her while she was visiting her family in Canada. When he returned to Paris, Fortin bought a small bookshop in Montmartre containing a considerable number of books on various reli-gions and the occult. He immediately decided to found his own religion and make the store's back room its temple, which he called the Résur-rectoir. The room was decorated with twelve paintings by the painter and sculptor Nicolas Kolmakoff: Baal, Huitchtlipochtli, Mammon, Jehovah, Allah, Mithra, Osiris, Odin, Buddha, Brahma, Jupiter, Christ.[169] These twelve stations along the road to deification led to Dieu-Le-Grand, whose portrait adorned the central fireplace.

The sight of Fortin walking along the streets of Paris must have been a shock. Héliodore the First, who had his priests, bishops, and cardinals, wore 'a blue cassock with satin buttons that came down to the knee. Underneath he wore blue trousers with straps fastened over white spats. Occasionally he threw over his shoulders a kind of *cappa magna* which was the same blue as the rest of his outfit.'[170] He must have looked a little like that strange, defrocked Dom Gengenbach who wore a cowl while frequenting cafés and dance halls with the surrealists: 'He was seen at cafés such as Le Dôme and La Rotonde, a woman on his knee and a carnation in the buttonhole of the cassock he still wore as a provocation.'[171] But Fortin intended more than mere provocation. The prospectus of the Résurrectoir, incorporated in 1929 as the Association culturelle diviniste française, talked about 'relieving all human misery, without regard for race or religion';[172] inscribed on the tombstone of its founder, who died in 1935, were the words 'The greatest engineer of peace, who in his teachings never tired of preaching moral disarmament, the keystone of global disarmament.'[173]

In the same year that the Association culturelle diviniste française was founded, the surrealists took a stand against those who confused occultism and initiation rites with divinism. One target in particular was *Grand Jeu*, a periodical started in 1925 with these words reminiscent of Fortin's ideas: 'We believe that all roads lead to God and that our task is to recapture the lost unity.'[174] Breton could not accept this, for surreality could not be confused with what would be a superior reality – there could only be one indivisible 'absolute reality.'[175] There was only a superficial resemblance, therefore, between the Résurrectoir and the twelve altars dedicated to objects and persons worthy of devotion installed by the surrealists in the huge magic labyrinth of the 1947 surrealist exhibition in Paris.[176]

In addition to the publication of *Crépuscules* and the founding of the Résurrectoir, the year 1926 also marked the death of the poet Paul-Quintal Dubé, whose posthumous works appeared four years later. Stricken by tuberculosis in 1915 at the age of twenty, he abandoned his medical studies and wandered from clinic to clinic, from Sainte-Agathe high in the Laurentians to a small American village in the Appalachians, from the Jura Mountains in Switzerland to New Mexico. He might have been in Switzerland when dada appeared in Zurich, and he was in Paris taking a philosophy degree at the Sorbonne when the momentous events accompanying the birth of surrealism took place. At its best his writing conveys the same feeling of freedom as the work of Jean Cocteau (whose chapbook *Parade* appeared in 1917) and Raymond Radiguet (*Les joues en feu*, 1920), who were far from model surrealists. However, certain images inspired by Paul-Quintal Dubé's 'hypnagogic visions' are striking: 'I arrived, gaping, in the country I always see in dreams where, naked in your hair, before

my eyes, you go walking on the beach ... Finally, deceived, I was about to kiss you, when the radio went dead and the walls closed in, completely dark, alas! And you did not reply!'[177]

Saint-Denys Garneau

Dubé's collection did not appear until 1930, and from that year on none of the authors mentioned so far published any work which could be considered a precursor of surrealism except the five manuscript poems Loranger added to *Terra Nova*. The first of these had actually appeared in *La Revue populaire* before 1930; DesRochers' *L'Offrande aux vierges folles* and *A l'ombre de l'Orford* were also published before then. After that Quebec surrealism fell silent except for the poet Alain Grandbois, who had experienced many adventures while travelling around the world: his first collection, *Poèmes*, was published in Hankou, China, in 1934. But that edition was lost and only reprinted with much fanfare ten years later and is best dealt with in that context.

The silence in Quebec was broken in 1937 by Hector de Saint-Denys Garneau's *Regards et jeux dans l'espace*.[178] His earliest extant work is some correspondence which already in 1932 shows that he was fascinated by fantasy literature, having read Wilde's *Portrait of Dorian Gray* and Poe's poetry.[179] He then discovered Le Corbusier at a lecture given by Dom Bellot.[180] His *Journal*, begun in 1927, does not mention Cocteau, Satie, or Picasso until 1935, and even then little attention is paid them compared to his more elaborate reflections on Debussy and Stravinsky.[181] Garneau had been enrolled at the new Ecole des beaux-arts de Montréal from 1924 to 1927 and was extremely fond of art exhibitions: a Montreal show was the subject of a long article in December 1936.[182] He knew them all – Renoir, Cézanne, Gauguin, Monet, Sisley, Degas, and Courbet – and spent a long time discussing Braque and Picasso.[183] His first poems arose from his interest in styles of painting that gave pride of place to the effects of light:*
'O morning of my eyes on the water! / A luminous bathing-girl has drawn upon herself / all the light of the landscape.'[184]

All his early poems reveal the influence of impressionism; in 'Saules' the poet talks about 'the play of light,'[185] in 'Les Ormes' he refers to the elms' 'light shadow'[186] and in a second poem entitled 'Saules' the subject is the same:

> The wind
> Twirls their leaves
> Of silver
> In the light
> And all is a rutilant glitter
> And a motion.[187]

Later poems like 'Pins à contre-jour' also evoke this shimmering experience, which prompted his cousin Anne Hébert to comment:[188]

> Light, colour, form: he made them rise up in front of me. He called light by its name and light replied. He received the word from light, the word and the message. Light recognized him. He loved light so much: 'Don't hide even the smallest light.' He detached colour from the world so that he could look at colour intensely. Colour stepped forward when his look called, so that he could look and play.[189]

But when *Regards et jeux dans l'espace* appeared in 1937 Garneau had already moved beyond impressionism. He had attained a kind of 'cosmicity,' as described here by Claude Gauvreau:

> Saint-Denys Garneau is a man who had a premonition about the world under his feet, who opened his mouth and arms wide to embrace it and love it, who felt it with his outstretched fugitive fingers, the world with its centres, its passionate centre, its inexpressible centre. Saint-Denys Garneau became the rival of the known world. Once explored, the world had to be translated. Saint-Denys Garneau, fragile, having felt the world exiled in himself, was unable to resign himself to reducing it within the constrictions of any boundaries, not even within the confines of his heart. Not having fixed any constraint upon the centres of the world, any reduction, the man dealt in the inexpressible. Man melted in his hands with a sigh; warmed by every heat of birth, he was a unique and tenuous entity in which the exiled world continued to live. A life without rickets. The universe subsists in Saint-Denys Garneau, free from petty restrictions, the universe lives off his imminent vitality, not disfigured by the vice of prescriptive stigmata.
> Poetry teaches in an orb, not in jagged beams.[190]

Poems such as the following could be given a 'surrational' interpretation:

> Once I made poems
> That followed the whole radiant line
> From centre to circumference and beyond
> As if there were no circumference only a centre
> And as if I were the sun: all around me limitless space

This is to make the elemental force flash all along the radiant
To gain prodigious meteoric speed –
What central pull can then hinder our escape
What heavenly concave dome keep us from piercing it
When we have power to burst into the infinite?[191]

What is this 'beyond'? The surreal? Basically, Garneau himself is not
certain what he means. He searches, admitting that ever since his youth he
had felt 'this need to join with reality, to possess it more perfectly else-
where.'[192] He presents this conception of the poet: 'He is the prism. He is
beyond, he is outside, he is within. By containing him, words with their
magical relations make his presence shine above.'[193] Then the question
arose of 'the connection between the physical and the metaphysical, be-
tween the material and the spirit ... between the rational and the irrational,
between being ... which becomes entangled in the *ego* and non-
being ... between nature, super-nature, and anti-nature.'[194] In the poems
that followed it is clear that light no longer has anything to do with the
light of the impressionists:

And now

Wide-open eyes too carnally open-eyed and flooded
Survey the pilgrimage
Of eyes mouths hair
This light too vibrant
Stripping this pallor
From the autumn sky

And my gaze goes madly hunting
This splendour disappearing
This clarity escaping
Through the holes of time[195]

The poet sank progressively deeper into the nocturnal universe of
autumn and death. A poem from this period like 'Cage d'oiseau' reflects
the increasing influence of Poe and of 'nocturnal' poetry:

If he'd like to fly away
Is it you who'll make him stay
Is it I
Who can say?

He'll not go until he has
Eaten everything there is
My heart
The spring of blood
With life inside[196]

Until this point there was no hint of surrealism in Garneau's work. His discovery of it came late, and the word only appears in his journal for the first time in 1936: 'Surrealism. Art. Aesthetics.'[197] For Saint-Denys Garneau surrealism was defined as 'what is captured beyond things,' and he gave himself up to it all the more willingly because he was entirely captivated by the anxiety of the beyond: 'What in fact is this second reality we call *absolute reality*?'[198] He knew certain surrealist works through *La Nouvelle Revue Française*, which he began to read in 1933, and he knew Pierre Reverdy's *Le Gant de crin*, published in the *Chroniques du roseau d'or* series.[199] He also subscribed to *Hermès*, a periodical specializing in studies of poetry and mysticism.[200] The expression 'absolute reality' comes from Breton's first surrealist manifesto – unless Garneau took it from Novalis, just as Paul-Marie Lapointe did when he borrowed the title *Le Réel absolu*.

In the beginning Garneau considered surrealism a form of spiritualism. He was influenced in this regard by Maritain's interpretations, by Reverdy who tried to reconcile surrealism and Christianity, and perhaps also by Jacques Rivière's wife, Isabelle.[201] It is therefore not surprising to read above Garneau's signature: 'Would you send me as soon as possible several "spiritual" books: *Capitale de la douleur* ... all you've got.'[202] All he knew was the title.

Nevertheless, surrealism is definitely relevant to Garneau's work in so far as he placed great importance on play. More specifically, he appears to have observed a child at play, at least according to an article by Gabrielle Poulin, 'Surréalisme et le jeu,' which cites his famous poem 'Le Jeu' in support of its thesis:[203]

> Play is the kingdom of childhood. Nothing is impossible for a child at play: chance conforms to his will, the fantastic is constantly present in his smallest gestures. Don't disturb him, he is profoundly busy.
>
> As the game continues, as the dance of words progresses, the imaginary timidly approaches the real. Games of mirrors and reflections do not deceive the poet, who does not yet dare disturb the order and harmony of the universe; games, however, fascinate the poet by giving him glimpses of something marvellous he is reluctant to stir up within himself.[204]

In the end Garneau considers play with words important as a method of revealing the automatisms of childhood. The reflections published by his friend Le Moyne in the special issue of *La Nouvelle Relève* on Garneau in 1944 are relevant here:

> Who among us would ever have thought to judge our dear S.-Denys from a critical perspective ...
>
> How many times have his perceptions of things been my key to the joy of possession? What freedom I have learned from his games!
>
> I don't think I could pay any greater homage to S.-Denys Garneau than by pointing out the quality of his 'perceptions,' the value of his 'games' ...
>
> Here is something he wrote taken from 'Monologue fantaisiste sur le mot,' *La Relève*, January, 1937:
>
> 'I awoke face to face with the world of words. I heard the call of words, I felt the terrible demands of words thirsting for substance. I had to yield to them, nourish them from my very self. I was like a child who sits and listens to stories and the stories are perfect. They are not just noises in our ear accompanying our dreams; they are peopled with characters of real stature and their fairies, no matter how good and marvellous they may seem, have a ferocious, insatiable need for their sister fairies in us.'
>
> ... Everything led Garneau to this definition of poetry, to consider it the response of an interior openness to the call of the word.[205]

As Saint-Denys Garneau's creative experiences became more profound, so his fear of criticism grew. The positive response he received from Albert Pelletier and Henri Girard, who decided to publish his poems in the periodical *Les Idées* and the newspaper *Le Canada*, did not stop the poet from fearing the reaction of the extreme right. In particular he feared Claude-Henri Grignon, who wrote under the name Valdombre, and Garneau could only protest when Grignon took exception to an impressionist poem which the poet found extremely simple.[206] Maurice Hébert's critique of *Regards et jeux dans l'espace* appeared after a two-year delay:

> Certain images, certain turns of phrase, remind one at times of Supervielle or some other super-modern ... The analogy I am drawing on here is precisely that of a painter's work, a modern painter, for example. I may very well be disoriented when I first look at Picasso's experiments ... But is this any reason, without further consideration, to heap scorn upon him? ...

Personally I have faith in his destiny. Only he can make it bloom or destroy it. He won't dare do anything but make it bloom.[207]

He destroyed it. On 6 July 1936, during a stay in Paris, he was already speaking of his 'season in hell.'[208] Rimbaud, the douanier Rousseau,[209] Céline,[210] and Kafka[211] led him to the end of night, towards inner, visionary, absurd trials. Here more than ever the problem of the doppelgänger, an exercise which 'alchemical' poetry tries to avoid, becomes relevant:

But in secret I am plotting an exchange
Through all kinds of discoveries, alchemies
Transfusions of the blood
Rearrangements of atoms, conjuring tricks.[212]

Garneau, like Delahaye, took refuge in silence and Dugas reproached him for it in almost the same terms as he reproached Delahaye.[2] The man who in a letter once mistakenly called *Capitale de la douleur 'Capitale de la prière'*[214] could now only write words testifying that he had turned in on himself:

All words are becoming inward things for me
And my mouth is closed like a coffer holding treasures
No longer uttering these temporal words.[215]

This man who kept a treatise by da Vinci, to whose work André Breton applied Dali's paranoiac-critical approach,[216] like Rimbaud decided to close the curtain and withdrew to his retreat in Sainte-Catherine de Fossambault. Surrealism had to wait for Borduas, a student at the Ecole des beaux-arts at the same time as Garneau. With the help of Breton's *Château étoilé*, Borduas made a discovery in *Traité de la peinture* that changed his life.[217]

2

222

From Painting
to Poetry

Of all the manifestations of artistic and intellectual life in French Can-
ada, painting seems the most 'advanced,' the most confident, the one
demonstrating the most enduring maturity ... Its stunning break with
nationalist academicism ... is outrageous and reassuring.

Jean Le Moyne, 'Signe de maturité dans les lettres canadiennes'[1]

THE GREAT INNOVATORS

The story of surrealism in Quebec really begins during the Second World
War, which suddenly displaced many artists. Some Québécois had to
flee occupied France and return home; others served in Europe, where
they came in contact with various international movements. A number of
European surrealists were forced into exile in North America, mainly in
Martinique, Mexico, and New York, where surrealism entered its third
and final stage. The war therefore provided the first opportunity for sur-
realists from both continents to get together.

The return of the painter Alfred Pellan to Quebec in 1940 was a signifi-
cant event, all the more so because Alain Grandbois came back at the same
time and the two artists eventually combined efforts on a volume of illus-
trated poems, *Les Iles de la nuit*, published in 1944. The impact of Pellan's
return was reinforced because his revolutionary teachings at the Ecole des
beaux-arts supported those of Paul-Emile Borduas at the Ecole du meuble.
They were disseminated by Albert Dumouchel at the Ecole des arts gra-
phiques and by Jacques de Tonnancour through notices in the arts and

letters columns of the periodical *Amérique française* and the student newspaper *Le Quartier latin*. All at once the public saw a few newspapers and periodicals embracing modern art with open arms. Groups suddenly sprang up around leaders like the automatists, a well-defined and cohesive circle centred on Borduas. But there were casual groups too, such as the signatories to the *Prisme d'yeux* manifesto around Pellan and the contributors to the periodical *Les Ateliers d'arts graphiques* and the series of publications entitled *Les Cahiers de la file indienne*. Even the La Relève group revived under the name La Nouvelle Relève and established contacts through Louis-Marcel Raymond with the refugee surrealists in New York.

Alfred Pellan

Alfred Pellan had left Montreal for Paris on 4 August 1926. He kept company with the surrealists, favouring, as Claude Jasmin put it, 'the serious, the profound, and the wanton' and detesting 'morbid hoaxes';[2] he knew Breton and they were already old friends when Breton stayed in Gaspé in 1944.[3] Pellan was in fact one of those who steered Borduas towards discovering surrealist literature.[4] On a visit to Quebec City's Ecole des beaux-arts in 1936, Pellan included among his favourite painters cubists, futurists, and surrealists like Picasso, Braque, Léger, Ernst, Miró, and recounted how before 1932 he had been entranced by Klee's small canvases.[5] Coolly received because of the company he kept, Pellan returned to Paris, where he exhibited at the Galerie Jeanne Bucher with Braque, Ernst, Kandinsky, Léger, Picasso, and Arp.[6] He did not return again to Quebec until 1940, when he was warmly welcomed by a small group of intellectuals and artists who were better informed than the people he had met in 1936.[7]

Before Pellan, how much did people in Montreal really know about Max Ernst, Paul Klee, or Juan Miró? Perhaps they subscribed to *Minotaure* or pondered *Capitale de la douleur* – that was something at least, but the experience was academic. *Capitale de la douleur* was an anthology of essays, some of which – 'André Masson,' 'Paul Klee,' and 'Max Ernst' – had appeared in exhibition catalogues and were conceived as written objects to be read in relation to specific visual objects. The relationship between painting and poetry could not, however, be conveyed just by reading *Capitale de la douleur*, and Borduas himself gave Pellan credit for having helped him lift the veil of mystery from surrealism.[8]

Paul-Emile Borduas

In 1937, the year *Regards et jeux dans l'espace* was published, Paul-Emile Borduas joined the Ecole du meuble as professor of visual arts: during his stay there he initiated a cultural revolution which in ten years transformed

Quebec. Borduas had begun teaching drawing to children immediately
upon graduation from the Ecole des beaux-arts in 1927. After spending
the summer with artists in Boston and New York, he resumed his post in
1928, only to resign soon afterwards because of administrative politics. He
then returned to his native village of Saint-Hilaire to spend several days
with Ozias Leduc,[9] his first teacher. Leduc sent Borduas off to the Ecole
des arts sacrés in France run by Maurice Denis and Georges Desval-
lières and even helped pay for the trip, but Borduas only stayed in
Europe from 11 November 1928 to 13 June 1930.[10]

After leaving the Ecole des arts sacrés, Borduas started doing frescoes
again, first in France with Pierre Dubois and M.-Alain Couturier, then in
Quebec because he could not afford to stay in France. In Europe Borduas
had discovered Renoir, in Quebec James Wilson Morrice and John
Lyman,[11] but he had not yet gone beyond neo-impressionism. He then
became friends with the La Relève group, and Robert Elie apparently
introduced him to Lautréamont's *Œuvres complètes*, which had been repub-
lished in 1938 with an introduction by André Breton and illustrations by
a dozen surrealist painters.[12] It was love at first sight. He later found some
issues of *Minotaure*, among them the May 1939 issue (nos 12-13) on 'Docu-
ments inédits sur le Comte de Lautréamont et son œuvre' and the 15
June 1936 (no 8) issue complete with gouache illustrations on the surreal-
ists' adventures on Tenerife.[13] These experiences had inspired Breton to
write *Le Château étoilé*, the essay that gave birth to Montreal automatism.[14]

Pure psychic automatism as Breton defined it could be expressed in
very diverse forms: Arp's 'Cadavre exquis,'* which first appeared in *La
Révolution surréaliste* in October 1927, Dali's 'paranoiac' or multiple imagery
(1930), Arp's 'papiers déchirés'† (1932), Dominguez's decals (1935), and
Borduas' surrealist gouaches (1942). Automatism can even be found in
some ancient texts: Pliny the Younger reported the experiment of Protoge-
nus of Rhodes who, unable to reproduce a dog's frothing mouth, smeared
a sponge soaked in tempera onto his painting.[15] Leonardo da Vinci sug-
gested to his students that they derive inspiration from the cracks in an
old wall. Borduas had a copy of da Vinci's *Treatise on Painting* in which
this idea is discussed: 'One should be able to see strange creations in such
a stain; I mean to say that he who looks at this mark carefully will see
human heads, various animals, a battle, rocks, the sea, clouds, groves, and
other things too: it is like the ringing of a bell in which the imagination
hears anything it pleases.'[16]

In *Château étoilé* Borduas discovered parallels between da Vinci's 'the-
ory' and Dali's 'paranoiac-critical' method:[17] 'Paranoia-criticism is not just a
creative technique in which one easily recognizes Max Ernst's "means of
forcing inspiration" and Leonardo's examination of an old wall but an
attempt at disorganizing the external world, a kind of feverish rush

towards disorientation.'[18] The surrealists experimented with various means of achieving disorientation – dissoluteness, disgust, hallucination – all of which Borduas was familiar with.

Borduas' Exposition surréaliste
Until the publication of *Refus global* Borduas was supported by members of both La Nouvelle Relève and the Contemporary Art Society, and by certain clergy. Foremost among them was Robert Elie, who wrote an important preface to Garneau's *Poésies complètes* (1949) and a book on Borduas, the second in the 'Art Vivant' series from L'Arbre, the book publishing arm of *La Nouvelle Relève*. There are many spiritualist elements in this book – less, though, than in the Garneau preface – but Elie also drew connections between the surrealists and their possible ancestors which were very advanced for his time. These included Rimbaud, da Vinci's wall, and even the influence of Nerval, Lautréamont, and Baudelaire:

> In one sense, the surrealist artist is continuing the work of the great baroque painters. What was Delacroix, that impassioned and inquiring spirit, pursuing if not some inner dream ... For the surrealist artist too, the destiny of art is intimately linked to that of man.
>
> In between were the romantics, Nerval and his chimeras, Rimbaud and his flashes of inspiration, Lautréamont who wanted to penetrate that no-man's land between life and death.
>
> At the beginning of this momentous venture, one finds Baudelaire, Delacroix's friend, the faithful and prophetic witness ... Baudelaire talked of the surreal, even though he did not know the word, and this essay could have been introduced with the following quotation from *Curiosités esthétiques*: 'This painting has faith, faith in its own beauty – it is absolute, convinced painting ...'[19]

As a postscript to this book (virtually a eulogy), Elie cites without naming its title a poem by Eluard in which he claims to recognize Borduas. This was 'Pour se prendre au piège,' taken from the collection *Mourir de ne pas mourir* which appeared in 1924 and was dedicated to Breton. In it there is an astonishing parable about the ties that bind a painter and a critic who are friends even though they are worlds apart:

> A traveller places his clothes on a table and confronts me. He is wrong, I know no mystery, I do not even know the meaning of the word mystery, I have never looked for anything, found anything, he is wrong to insist ...

The traveller tells me I am no longer the same. No longer the
same! I gather up the debris of all my wonders. The great woman
told me they are debris ...

Great woman, speak to me about forms, or else I shall fall asleep
and lead the great life, hands secured inside my head and head in
mouth, in my firmly closed mouth, inner language.[20]

Mystery, wonders, the silent language of forms and colours – all this
drew Elie to Borduas' paintings. In *Projections libérantes*, Borduas in turn
paid tribute to the 'purity-integrity' of the La Relève spiritualists and cer-
tain priests like Fathers Couturier, Corbeil, and Maurault, to whom he
owed a great deal. There was one qualification, however: 'All these Chris-
tians want to maintain spiritual values both now and in the future, in the
light of Christianity. That light no longer shines on us.'[21]

Borduas had read *Le Château étoilé* and discussed it in the spring of
1941 with Dr. Henri Laugier.[22] In the fall he was asked to judge an exhi-
bition mounted by the students of the Collège Sainte-Marie, where he
awarded first prize to a painting by Pierre Gauvreau; around the same
time a dramatic poem by Bruno Cormier, a friend of Gauvreau, also won
a prize. Borduas then told his student Guy Viau at the Ecole du meuble
to invite Gauvreau, who had enrolled in the Ecole des beaux-arts that Sep-
tember, to come to his studio.[23]

A group was about to be born: its members were students of the Ecole
du meuble, the Collège Sainte-Marie, and the Ecole des beaux-arts. *Le
Château étoilé* and Lautréamont's *Les Chants de Maldoror* were discussed at
Borduas' studio, and the group was the first to see the gouaches later dis-
played by Borduas at the end of the school year in his surrealist exhibition
on 1 May 1942.

This exhibition drew laudatory comments from Charles Doyon of *Le
Jour*. Although the true influences on Borduas were badly explained in his
article, the word 'automatism' appeared with reference to a Quebec work
for perhaps the first time:

He marches under the banner of the arcane, escaping towards the
subconscious and devoting himself to fantasy ... Borduas roams the
borders of dreams ... In Borduas one feels a restraint, a delicate reti-
cence which is liberated yet obedient to his carefully planned com-
mands, a reticence conceived to express the inexpressible and
tinged with discreet confessions. The almond inside the shell's real-
ity. Fruit ripe and present under the peel. He comes to the isthmus
of our encounter surrounded by a revitalized ethos. Borduas' paint-
ing is full of poetry; it lures us into a trap which defines our limits.

To please some close friends, I have described this event in vivid terms – to put it mildly – so that we can recognize the timeless nature of unreality. The arrow of the guiding finger points to the identifying word: automatism is thus recaptured by reference points which will help fix this work in our memory.[24]

A friend of the group, the critic and art patron Dr Paul Dumas, later described 'this unforgettable series of gouaches' which inspired Doyon to 'a passage overflowing with lyricism' and recalled what had inspired them: 'At that time, Borduas had read *Les Chants de Maldoror* and Breton's *Le Château étoilé* ... Let's not criticize Borduas for his literary allegiances. Lautréamont is an inexhaustible diviner of images; Breton handles words and phrases as if they were colours and shapes as he conjures up both his imaginary universe and the real landscapes of Tenerife or Ile Bonaventure.'[25]

Already in 1946 Dumas was aware of the surrealist experiments with decals on Tenerife and the passages about a visit to the famous Ile Bonaventure bird sanctuary in Breton's *Arcane 17*. In 1957 Dumas elaborated on Borduas:

> There is an ascetic in Paul-Emile Borduas, but an ascetic whose staple diet is the works of Lautréamont, Breton, Sade ... Borduas was guided by Pellan's paintings, *Les Chants de Maldoror* and André Breton's manifestoes. He dedicates himself to discovering his inner universe with the aid of what he calls automatist painting, analogous to the automatic writing espoused by André Breton and Paul Eluard.[26]

The connection with Eluard had been made before,[27] but the influence of the manifestoes was more questionable; they were not available in Montreal and Claude Gauvreau maintained that Borduas did not possess a complete text of these until much later.[28] Borduas sensed their spirit, though, if only through Pellan. Lautréamont's influence was undeniable, and Gauvreau mentioned it again in the special issue of *La Barre du jour* on the automatists.[29] As for his awareness of the Tenerife experiment, this was confirmed by Borduas' own writings on the decals,[30] by his use of gouache (1941-2), and by his definition of automatism which cited da Vinci's old wall and Dali's paranoiac screen.[31] The influence of *Les Chants de Maldoror* is especially important. It was Lautréamont's famous phrase, 'lovely as the chance encounter on a dissecting table of a sewing machine and an umbrella,'[32] that inspired the surrealists to collage. The 'cadavre exquis' was justified by citing Lautréamont too: 'Poetry must be made by all.

Not by one.'[33] Also well known is the role of Lautréamont's 'discours-à-côté,' to which Dali resorted in justifying his 'paranoiac-critical' method, a method intended, in Lautréamont's words, to 'abrutir le lecteur.'[34] How can one interpret without referring to Lautréamont the titles of Borduas' canvases such as *Viol aux confins de la matière*, *Eclosion de l'hyppocombe*, *Le dernier souffle*, *Saccage de monstres primitifs*, *Le rêveur violet*, *Les trois formes hérissées*, *Le félin s'amusant*, *Un cri dans la nuit?*[35]

In the same year (1942) that Borduas held his own surrealist exhibition, the Fifth International Exhibition of Surrealism took place in New York. No Quebec artists attended.* Nevertheless, after 1941, on the Montreal periodical *Amérique française*, founded by Pierre Baillargeon, made an effort to publicize modern art with articles like 'La volonté du cubisme,'[36] 'Peinture canadienne d'aujourd'hui,'[37] 'Plaidoyer en faveur de l'art abstrait,'[38] 'Manières de goûter une œuvre d'art,'[39] 'Alfred Pellan.'[40] Maurice Gagnon published two works mentioning his friend Borduas, a book[41] and a catalogue for his one-man exhibition of 2-13 October 1943. *Le Jour* remained faithful; Charles Doyon reviewed the same exhibition, noting the influence of the 'surrealist Zodiac' on Borduas and paying particular attention to the titles, which were just as evocative as those in his previous exhibition: *Message à l'oiseau symbolique*, *L'Arbre de corail*, *Coquilles*, *La Fleur safran*, *Nœud de vipères*, and especially *La Cavale infernale*.[42]

'The Borduas Group'

The idea of a group exhibition including Borduas' disciples entitled 'Les Sagittaires' and organized by the professor and critic Maurice Gagnon came from Guy Viau. A certain amount of reconciliation was required to overcome the different kinds of training the artists had received at their respective schools. First of all from the Ecole du meuble came Guy Viau, Pierre Pétel, and Gabriel Filion, and later Charles Daudelin, Fernand Bonin, Réal Maisonneuve, Marcel Coutlée, Julien Hébert;[43] from the Ecole des beaux-arts Pierre Gauvreau, Fernand Leduc (converted to modern art by Gauvreau), Adrien Villandré who was then practising dadaism, Marcel Baril who had the reputation of a tormented mystic, their friends and fellow students Françoise Sullivan, Magdeleine Desroches, Louise Renaud (who became governess to the children of the art dealer Pierre Matisse in New York and paved the way for contacts with New York surrealism),[44] and her sister Thérèse, who later married Fernand Leduc.

The Sagittarians' exhibition opened 30 April 1943 with a lecture by Father Couturier. The twenty-three young artists, all less than thirty years old, probably found little to agree with in Couturier's spiritual ideas apart from these very pertinent words quoted in *Le Jour*:

Whatever[in the artist] limits and destroys freedom, terminates and destroys youth. There will be nothing left of the artist, neither youth nor the fruits of experience, if each and every day he does not respond to the demands of absolute freedom: freedom vis-à-vis reality, freedom vis-à-vis others, freedom above all vis-à-vis himself and his former successes ... The old masters do not provide formulas, they teach us on the contrary to dread and flee them: they teach us courage, audacity, risks, and the desire for limitless adventure.[45]

Unfortunately, in 1943, no upheavals had yet occurred in poetry to provide a literary equivalent to the upheavals in the visual arts, with one exception: at the end of December, the ephemeral Rémi-Paul Forgues published a poem in Le Jour, which was also attempting to launch even lesser-known writers such as André Béland and Jean-Jules Richard.

The Sagittarians' cultural revolution progressed quickly, and initial contact was immediately established with the European surrealists exiled in America.[46] Breton wrote to Fernand Leduc from New York on 17 September 1943 in response to a letter ordering several copies of the New York surrealist periodical VVV: 'Nothing would please me more than to record your support and that of your friends for the surrealist movement, and I would be grateful to you for expressing it in a letter which could be printed in our periodical.'[47]

Leduc's reply did not provide the support Breton expected from these people who were, after all, practising automatism. Leduc in fact discreetly refused the invitation:

At the present time surrealism is the only movement endowed with sufficient reserves of collective power to unite all its productive energies and channel them towards the full blooming of life; accept that we are young, fervent, and magnanimous ... At the moment, experimenting with surrealist techniques does not much matter to us ... Each person expresses himself in a discipline matched to the particular rhythm of his own evolution ... Rest assured that we want to learn about your activities and are even more eager to support them in word and deed ... Formulating our participation in the surrealist movement is no easy task; our faith is that of neophytes.[48]

From then on VVV became, according to Françoise Sullivan, an important publication for the group to read and study.[49] Their rejection of Breton's invitation might have been the reason why he did not try to contact the automatists when he visited Montreal, Gaspé, and Sainte-Agathe during the summer and fall of 1944; however, Breton himself later indicated

this was not the case when he praised *Refus global* in 1953: 'This publication was inspired by our friend Paul-Emile Borduas, whom I deeply regret not having met during the summer of 1944 when I was strolling about Montreal before leaving for the Gaspé and upon my return from Sainte-Agathe.'[50]

André Breton and 'Arcane 17'

During his visit to Quebec in 1944, Breton met neither Borduas nor the automatists. However, he had already made contact with another Québécois, Louis-Marcel Raymond, through Yvan Goll, an exile in New York who became good friends with Raymond. Breton and Goll both realized that, since the Borduas group was still quite isolated, it was easier to approach the Quebec intelligentsia through Raymond. Of these, Pellan was not the only Québécois to return during the war. Dumas[51] also came back at this time, as did Robert de Roquebrune, Fernand Préfontaine, and Léo-Pol Morin,[52] all former editors of *Le Nigog*. Literary circles like those centred around *La Nouvelle Relève* and *Amérique française*, both founded in 1941, and *Gants du ciel* in 1943, drew the surrealists' attention. Roger Caillois, a one-time surrealist exiled in Buenos Aires and publisher of the periodical *Lettres françaises*, regularly listed these three Quebec publications in his survey of literary magazines, though Louis-Marcel Raymond was virtually the only contributor to them who found favour in his eyes.

Raymond, who added 'Louis' to his given Christian name 'Marcel' to avoid being confused with the Swiss critic of the same name, was a literary critic at *La Nouvelle Relève*. He met and carried on a correspondence with Goll, Breton, Aragon, Saint-John Perse, and many others. Breton regularly sent him the post-war surrealist manifestoes,[53] while Goll and Caillois sent the periodicals *Hémisphères* and *Lettres françaises*.

Raymond was a botanist as well as a critic and he first met the surrealists in New York while attending a botanists' convention. He called on the Golls and they discussed not just botany but also the 'surrealist' dimension of certain plants as revealed in the experiments on Tenerife in 1935. Raymond wrote Goll afterwards:

> Did I never mention those dreadful phallic mushrooms? I find in my papers a very suggestive photograph taken by somebody or other which speaks volumes and will make you understand the role certain plants played in the witchcraft of the Middle Ages. You know that the sexuality of plants was not discovered until very late and was only suspected after the phallic appearance of several

plants had been noted. At first it was imagined that all these sexual flora assembled on dark nights for obscure coitus, etc. The medieval books of science with this perspective are quite hilarious.[54]

When Raymond met Breton during the same trip, the conversation was probably much the same:[55] the reference in *Aparté* by Elisa Bindhoff, André Breton, and Benjamin Péret to 'the *amanita muscaria* you find over there' (apropos a canvas by Riopelle)[56] undoubtedly comes from the same source. Breton kept in touch with Raymond and wrote him concerning an anthology of modern poetry Raymond wanted to publish.[57] Later on, a combination of circumstances resulted in Raymond being perhaps the only Québécois present at certain events involving the surrealists: the funeral of Robert Desnos,[58] the famous show organized for Antonin Artaud upon his release from the asylum,[59] and the funeral of Yvan Goll.[60]

Raymond and Goll became close friends during a summer the Golls spent in Quebec in 1946, two years after Raymond's initial invitation. They stayed first with Raymond's mother in Saint-Jean-d'Iberville,[61] then took his advice and spent the rest of the summer in the Gaspé, where Yvan Goll wrote the long poem *Le Mythe de la roche percée* and his wife Claire wrote a novel. The young botanist's enthusiasm was infectious, and the writers told him about their adventures on the Gaspé peninsula and Ile Bonaventure: 'The fishing is wonderful just now ... And then, the other wonders of the island: the agates on the beach, the birds I will devote myself to starting tomorrow, the flowers ... Enchantment! And to think we owe all this to you; without you, where would we have found the courage to choose Percé!'[62]

Breton had come to Quebec two years before Goll, probably on the same invitation Goll had delayed in accepting.[63] But according to Goll it seems he hesitated about going to the Gaspé, mainly because of the sea: 'Poets ... today are obliged to flee nature like the plague. Can you imagine a surrealist strolling in a field of lobelias? Last summer André Breton confided to me that he hated the sea, that it infuriated him.'[64]

Nevertheless, Breton came in the summer of 1944 with Elisa Bindhoff[65] to the shores of the Gaspé and to Sainte-Agathe, where he wrote *Arcane 17*. Breton was as crazy about Elisa as Aragon was about his wife Elsa; together they learned how to find agates and went to retrieve them as soon as the tide went out.[66] On the beach at Percé, Breton met a French actor in exile, François Rozet, who had come to work in Montreal during the war for the company France-film. After touring the Gaspé, André and Elisa visited Rozet at his Montreal apartment and Breton asked where they could find a quiet place to finish *Arcane 17*. Rozet named several Laurentian villages and later found out they had gone all the way to Sainte-Agathe.

Arcane 17 reflects Breton's stay in Quebec and especially the trip
he took with Rozet to Ile Bonaventure. As they approached the cliffs, Bre-
ton, despite the deafening cries of the Bassan gannets, listened with pleasure
as Rozet, an exceptional speaker, recited poetry. Some evenings Breton and
Elisa would go to Rozet's hotel and listen to news of the French Resistance
on the radio. There Breton met Robert de Roquebrune for the first time
and Alfred Pellan, whom he had known in France. Pellan told him about
his desire to unite impressionism, cubism, fauvism, and surrealism; accord-
ing to Rozet, Breton replied: 'That's absurd!'[67] Schools of thought do not
mix as easily as styles. Elisa has left a wonderful description of their visit to
Quebec, a paean to fall colours prompted by one of Riopelle's canvases: 'I
will never forget those Canadian houses in the valley. They are built from
the pearly grey wood the sea casts up on the beaches. There is always a
waterfall right nearby and in the voices that come to us, as in the voices of
our friend Riopelle, the wind's lovely creases fold and unfold.'[68]

The Automatists

While Breton was spending the summer of 1944 in Quebec, a group was
forming in Saint-Hilaire around Borduas, Leduc, and the three Renaud sis-
ters, one of whom, Louise, had come straight from Pierre Matisse's. They
had rented the Charbonneau farm where Jean-Paul Mousseau, Françoise
Sullivan, Mimi Lalonde, Magdeleine Desroches, and Bruno Cormier were
frequent visitors;[69] the Gauvreaus also had a summer house nearby.[70] The
ties uniting them grew stronger, but there was no intention of associating
the new group with the circle around Breton, whose presence in Quebec
was apparently unknown to them. After this vacation, events followed in
quick succession and the works of the Saint-Hilaire group, soon to be named
the automatists, were seen throughout Quebec thanks to a touring exhibit-
forum organized by Jacques Viau under Borduas' patronage. One of these
exhibitions took place at the Collège Sainte-Croix in Montreal (23 April–1
May 1944); it next appeared at the Collège St-Thomas in Valleyfield
(October 1944) and at the Séminaire de Sainte-Thérèse in January 1945.

In November 1944, after having four canvases refused by the Contem-
porary Art Society, Leduc withdrew from the Society. As an alternative to
the young people's section of the CAS, which had accepted him eighteen
months earlier (along with Mousseau and Claude Vernette who were
accepted at the ages of sixteen and fifteen),[71] he considered setting up an
autonomous group with the automatists as its nucleus:

> Very probably Borduas will have to leave the CAS. He really cannot
> carry on the struggle – this time he's taking on the young people ...
> We must regroup.[72]

The time has come, my dear Guy, for us to band together, to assume an unequivocal attitude, to take clear-cut stands. Whatever the cost we must form a group which is restricted, uncompromising, respects what is essential in a work of art and is prepared to exhibit as a group. You, Bonin, Gauvreau, Mousseau, Morisset, Magdeleine, and myself ... Borduas thinks this is the only possible approach at present.[73]

Whatever part Leduc's touchiness may have played in formulating this plan, it had an effect. Leduc was encouraged in his attempts by Louise Renaud, who sent him parcels from New York. Since Françoise Sullivan and Mimi Lalonde were also in that city, their Montreal friends made the most of this pied-à-terre for brief stays during the Matta, Gorky, Donati, Tanguy, and Ernst exhibitions. Their visitors included Leduc and Cormier, Claude Gauvreau, and two new recruits, Jean-Paul Riopelle and his wife. Gauvreau wrote about one trip with Riopelle:

At that time, you couldn't see any painting in New York as advanced in technique as Riopelle's works; the tiling in Motherwell's paintings, for example, seemed completely outdated to me. Riopelle went to show his ink drawings to Ozenfant ... whose comments seemed singularly weak by comparison with what I was used to hearing from Borduas ... Riopelle also went to see Pierre Matisse, who was not hostile to the drawings but didn't really take them into consideration because Riopelle didn't have any well-known backers. Shortly afterwards, when Riopelle returned with Breton's imprimatur, Matisse welcomed him unhesitatingly with open arms.[74]

Claude Gauvreau got to know Riopelle personally only in the spring of 1945, when he was dazzled by Riopelle's non-representational contribution to the Exposition du printemps. Riopelle was then sharing a studio with Barbeau and Mousseau in a house also occupied by Rémi-Paul Forgues. It was during this period that the poets Gauvreau and Forgues finally managed to meet each other at Fernand Leduc's studio on rue Jeanne-Mance, even though both had published pieces in the 9 February 1945 issue of Le Quartier latin at the request of Jacques Dubuc and Gabriel Filion.[75] The same spring that Gauvreau and Riopelle became friends, Leduc met Breton in New York. Arcane 17 had just come out. Leduc expected a serious talk about automatism; instead they discussed the possibilities of extending the international surrealist revolution to include Mont-

real. Jealous of the group's autonomy, and astonished to realize that in Breton's mind Arshile Gorky henceforth appeared more important than the surrealist painter Matta, Leduc came back to Montreal deeply disappointed.[76] Upon his return he devoted himself to mechanical automatism, which Barbeau, Mousseau, and Riopelle were also practising in their Studio de la Ruelle.[77] The automatist group was becoming more and more coherent and defined.

Holidays in Saint-Hilaire came around again, and the frequent visits of Barbeau and Riopelle to Borduas' home eased their entry into the group at the neighbouring farm which included Leduc, Mousseau, and the Renaud sisters.[78] There they prepared to do battle in *Le Quartier latin*.

A Polemic on Surrealism

For two years the newspapers had served as the forum for a heated debate. First came Forgues' defence of Stravinsky[79] and jazz[80] in *Le Jour*. Then Jean-Charles Harvey, managing editor of *Le Jour*, wrote some sardonic articles attacking abstract art.[81] Later, Harvey again took on the painters, confusing dada, Marxism, and surrealism so that they all took on highly negative connotations.[82] Pierre Gélinas, book editor of *Le Jour*, insulted Borduas even more by discussing him along with Charles Maurras: although Gélinas rejected Maurras' fascism,[83] his criticism of Elie's *Borduas* was merely a pretext for crossing swords with the art editor, Charles Doyon, over the latter's comments on the surrealist exhibitions of 1942 and 1943.[84] From then on Borduas' friends avoided *Le Jour*. Rémi-Paul Forgues, who discovered Borduas thanks to Elie's book, stopped writing for it and turned to *Le Quartier latin*, whose new managing editor, Jacques Hébert, and editor-in-chief, Jean-Louis Roux, seemed more receptive.

In 1945 *Le Quartier latin* also became involved in the quarrel over surrealism. First Jean-Louis Roux wrote these inflammatory words: 'Surrealism was prolific, but as Sartre has pointed out, the movement has nothing left to say.'[85] François Lapointe replied:

> These movements become distorted if they are regarded exclusively as artistic movements. André Breton writes in *Pas perdus*: 'Cubism was a school of painting, futurism a political movement: dada is a state of mind ...' Although the futurist Marinetti and his disciples extol mechanization, industrialism, speed, etc., they also affirm above all the necessity of disorder, war and violence. Surrealism focuses on psychological investigations into the mind's subconscious activity, but let us not forget that it possesses its own metaphysics.[86]

Returning to the attack, Roux indicated he was not interested in considering surrealism as a philosophy; however, after citing Breton's definitions, he added,

> According to André Breton himself, surrealism cannot do without some externalization. Surrealism is not just lived, it must also be expressed. And even 'apart from all aesthetic or moral considerations,' is poetry not the best way of expressing the 'omnipotence of dreams,' whether in painting, literature, sculpture, or even better in dance and cinema?[87]

Forgues then echoed Jean Le Moyne's use of the word 'rupture,' linking it directly to the surrealism in question and 'man's absolute access to the marvellous': 'It is gratifying to think that several of us have broken with all those masters and idols responsible for the destruction of the spirit ... From now on, we are converts to surrealism; we will be those 'horrifying workers' Rimbaud talks about, united in the desire for human emancipation.'[88]

Bruno Cormier, a friend of Pierre and Claude Gauvreau who later signed *Refus global*, also used the word 'rupture' with reference to surrealism. He wanted a complete break:

> The solution to filling the gap between contemporary events and our outdated ideologies is not a return to the past. The only possible response to this problem is to break all ties. Religious and national prejudices, narrow-minded ways of thinking, the stupidity passed on from fathers to offspring, unreasonable support for a philosophy, all thought not founded on man ... All these are ties of bondage.
>
> We are a moored vessel, life is at sea; let us cut the lines. Only after this severance will our situation become beautiful, honest, alive; all our uncovered potentialities will evolve towards their reality. The refusal to precipitate a rupture confines us 'like a bird in a cage.'[89]*

'Refusal,' 'rupture,' 'breaking all ties,' 'absolute access to the marvellous': all these expressions were in the air.[90] The direction the controversy was taking did not please *Le Devoir*, which decided to intervene. Jacques Delisle denounced the Borduas group and the titles of their paintings,[91] drawing on Dominique Laberge's reactionary *Anarchie dans l'art*.[92] Louis Franchet's[93] reply, refused by *Le Devoir*, appeared in *Le Quartier latin*. In the same month (March 1946), Jean-Louis Roux, now reconciled with the

Sagittarians, gave a talk entitled 'Les monstres sacrés.'*[94] Still in 1946,
Father Gérard Petit carried on Delisle's attack with this pearl from the
fourth chapter in his book *L'Art vivant et nous* entitled 'Anarchie des puis-
sances: le surréalisme': 'In general, the surrealists suffer from a genuine
obsession with sex and paranoiac disorders.'[95]

Nothing stopped the Borduas group from carrying on, however, and an
exhibition in 1946 revealed definite similarities between the Leduc-Mous-
seau and Barbeau-Riopelle studios. Claude Gauvreau described its genesis:

> Leduc ... had read a lot of Breton and he was the one who hoped
> for the formation of a group of autonomous painters all heading in
> the same direction who would be at the cutting edge of artistic evo-
> lution. The plan for a group exhibition demonstrating one particu-
> lar trend was decided on and so the Amherst Street exhibition took
> place in 1946 ... Just as Leduc wished, the group exhibition along
> with Borduas' solo exhibition took place at 1257 Amherst Street on
> premises recently vacated by my mother's personal entourage. The
> seven exhibitors were (in alphabetical order) Barbeau, Borduas,
> Fauteux, Gauvreau, Leduc, Mousseau, Riopelle.[96]

Not until the Sherbrooke Street exhibition of 1947 were the Borduas
group and several new friends clearly referred to as the 'Automatists,' even
though this designation was retroactively applied to the Amherst Street
exhibitors.

WORD AND IMAGE

Quebec painting thus cast off its moorings, and Quebec poetry too
entered a new phase in 1944, breaking the silence which followed *Regards
et jeux dans l'espace* in 1937. Collaborative works began to appear: Alfred
Pellan illustrated poems by Alain Grandbois; Gabriel Filion illustrated
poems by his friend Pierre-Carl Dubuc; and Jacques de Tonnancour illus-
trated stories by Réal Benoît. A series of such works also appeared – *Les
Cahiers de la file indienne*, edited by poets Gilles Hénault and Eloi de
Grandmont – which included collections illustrated by Pellan, Charles
Daudelin and Jean-Paul Mousseau. Finally, a periodical was launched, *Les
Ateliers d'arts graphiques*, which linked poetry to painting, engraving, and
sculpture. The culmination of this activity was the pamphlet *Refus global*
in which all these arts were represented along with theatre and dance.
Next came very beautiful editions from Roland Giguère's publishing
house Erta, which included several great names in Quebec poetry, paint-
ing, and engraving.

A sensible approach to this period in Quebec poetry is to view it as part of an overall rapprochement of the arts. This rapprochement has never been sufficiently emphasized yet it embodies the ideas of the surrealists, who were among the first in Quebec to embrace such a fusion of the arts.

Alain Grandbois

The first poet to 'cut the lines' was Grandbois. No one in Quebec was more accustomed to breaking loose from his moorings than this poet, who for twenty years had criss-crossed the globe. In 1926, he met Alfred Pellan and Blaise Cendrars in Paris. Having established a pied-à-terre on the Hyères Islands in the Mediterranean in 1929, this new inhabitant of Port-Cros was always travelling. 'Life is at sea,' Cormier had said, and no one knew this better than Grandbois, who left Port-Cros each year to go to Italy, Africa, and, in 1929, to Quebec. He was in Indochina, India, and Tahiti in 1930; in China, Manchuria, Russia, and Japan from 1933 to 1934; he visited Spain in 1935, Italy in 1936, Berlin and Paris in 1937.[97]

In 1944, when Grandbois published Les Iles de la nuit in Quebec, René Chopin, formerly of le Soc and Le Nigog, saw surrealist tendencies in it.[98] According to Chopin, this work of cosmopolitan inspiration owed its unity to Breton's vision of surrealism. Certainly parts of Les Iles de la nuit do create effects of disorientation and hallucination, but Jacques Brault was right to question the oversimplification involved in too readily labeling Grandbois a surrealist, as Auguste Viatte did ten years after Chopin: 'His Iles de la nuit in 1944 moved Canadian poetry into the realm of surrealism.'[99] Wrote Brault: 'Certain critics (Viatte, Baillargeon) try to clarify the issue by situating his poetry within the surrealist movement. This solution is too pat and misleading. Free verse incorporating surrealism's most valuable contributions is not necessarily incoherent.'[100]

But Brault went too far: first by implicitly equating surrealism with incoherence, as if a poetry of the un-conscious was a poetry of in-coherence; then, in the second edition of his book on Grandbois, by replacing the above passage with this uncompromising assertion: 'Surrealism, exoticism, and everyday naturalism are virtually absent from Grandbois' poetry.'[101] After all, Grandbois' friends were people like Bill Carlton, a character in the poem Le 13 who used to recite 'tirelessly, as a kind of private monologue, [lines by] Guillaume Apollinaire, Saint-John Perse, Paul Eluard.'[102]

It would be interesting to explore the influence on Grandbois of Cendrars'[103] literary cubism, Apollinaire, or even Aragon and the early Eluard. He attached particular importance to his compatriot Guy Delahaye, who knew the cubo-futurist manifestoes,[104] and several poems in Les Iles de la

nuit were written in the years immediately following Grandbois' contacts
with the cubists. But Grandbois was not an imitator and his interest in
these matters does not imply servitude, witness his preface to Sylvain Gar-
neau's *Objets trouvées* in which he warned readers against thoughtlessly imi-
tating Eluard, Aragon, Jules Supervielle, or – Grandbois.[105]

The hallucinatory quality of Grandbois' poetry has been discussed with-
out specific reference to surrealism.[106] Breton had written about such experi-
ences in the 1924 *Manifesto*: 'Hallucinations, illusions, etc. are a substantial
source of pleasure. Even the most ordered sensuality plays a part in it. Many
an evening I would restrain that pretty hand which, in the closing pages of
Taine's *L'Intelligence*, yields to strange wrongdoings.'[107] Just because Grand-
bois employs imagery reflecting hallucination and disorientation does not
mean that everything in *Les Iles de la nuit* is surrealist: 'Les Mains coupées'
may end with an evocation of the 'black sun' but it still retains a formal
shape with five stanzas in octosyllabic couplets. Still there is great hallucina-
tory power in *Tunnels planétaires*:

> I was returning to giant gates
> supported by fire
> Dark foams rolled back
> an overflowing river towards spaces
> swarming with worlds torn open
> And those lofty columns of joy
> Memories O Memory
> Tumbling down suddenly like
> molten lead
> O beloved captivities Bonds blessed
> with madness.[108]

The images in *Les Iles de la nuit* are often images of exile, foreign lands,
and insularity.[109] Beyond darkness is the *danse macabre* and praise for mad-
ness and ultimate wisdom:

> Your shape arises like a wound from blood
> Your outstretched arms create silence
> Your white face halts time
>
> Beyond, the hopeless
> Destroying the eyes of storms
>
> Beyond, Darkness fleeing like
> a thousand rivers
> Snatches ultimate wisdom.[110]

It is impossible to discuss Grandbois without talking about 'his long extraordinary journey / across the incantation of time.'* [111] In the opening poems of *Rivages de l'homme*, he frequently conjures up 'ces Iles fantômes' [112] or 'les doux fantômes de la nuit': [113] he returns again and again to the 'jeux de la colline magique,' [114] and the 'sortilèges de la nuit'; [115] his verse so often refers to 'blasphèmes ténébreux' [116] or the 'ensorcellement de l'aube,' [117] that the description 'surreal' is unavoidable. Grandbois' poetry cannot be understood without the notion of incantation, of spells which conjure up the surreal world:

> But it is enough perhaps
> O Earth
> Lightly to scratch your surface
> With fingers of innocence
> With fingers of sun
> With fingers of love
> Then all the melodies
> Are risen at one time
> Then all the loved skeletons
> All those that set us free
> Their violins all in tune
> First sang
> Without laments or tears† [118]

In the collection *L'Etoile pourpre* (1957), where erotic images are perhaps more numerous or evident than in previous collections, one again encounters tropes explored by the surrealists. For example, in 'Noces,' the amorous bestiary of wolves, jellyfish, octopi, and serpents recalls works by Miró:

> Sinking together straight down
> Into the watery depths
> Her long hair floating
> Above our heads
> Like thousands of quivering snakes
> We stand straight
> Bound by our ankles our wrists
> Bound by our dumbfounded mouths
> Bound by our soldered flanks ...
>
> The absolute lies in wait
> Like a devouring wolf ...

Ah more darkness
More darkness still
There are too many purple octopi
Too many anemones too crepuscular.[119]

This descent into darkness passes through twilight into absolute pitch in
an occult search for darkness visible, the cave of magic stone, the black
crystal of 'l'amour fou':

Stiff and smooth like two corpses
My inert flesh in her hollow flank
Our eyes closed as if forever
Her arms my arms do not exist any more
We sink like lead
Into the prodigious caverns of the sea
Soon we will reach
The strata of perfect darkness
Ah black and absolute crystal
Ageless pupils.[120]

Some of the games and spells which in Garneau have been ascribed to
a surrealist influence can also be found in Grandbois. The following game
leads to the same occult caverns described in 'Noces':

Close the cupboard with its magic tricks
It is too late for all those games
My hands that are no longer quick
No longer aim directly to the heart
The world I conjured had its own
Has left me blind
My world and I will both go under
I will sink into the deep caves
Night will inhabit me and its tragic snares
No neighbouring voices will reach my ears
I will possess the impassivity of minerals.*[121]

Hallucination, disorientation, 'amour fou,' an ithyphallic bestiary, black
stones, and black suns – all this justifies placing his poetry 'in the tradition
of moderate surrealism.'[122] As Jacques Blais points out, Grandbois, like Pel-
lan, 'does not practise automatic or dream writing systematically: he revises
the dictates of the subconscious.'[123]

Gabriel Filion and Pierre-Carl Dubuc

1944 also witnessed the publication of *Jazz vers l'infini* by Pierre-Carl Dubuc, illustrated by the Sagittarians Gabriel Filion and Fernand Bonin. The Dubuc-Filion friendship and collaboration related the book to some extent to the experiments of the Sagittarians.

Filion and Dubuc both attended the Collège Jean-de-Brébeuf; from there François Hertel sent Filion to Borduas at the Ecole du meuble in 1941. They collaborated on two projects in 1944 – Filion illustrated Dubuc's book, and Dubuc reviewed an exhibition organized by Filion at the University of Montreal in *Le Quartier latin*: 'Some forget that young, independent painters, because they are young, are incapable of dogmatism and, because they are independent, are incapable of acquiring a following.'[124] This reasonable statement (the least enigmatic in an article which showed that Dubuc was a master of irony) was aimed at reassuring upset visitors who might have been overwhelmed by this revolutionary exhibition. It also indicated that, one year after their first exhibition, the Sagittarians still believed in absolute freedom and that Dubuc was sympathetic to them.[125]

Dubuc's collection of poems was no less disconcerting than the Sagittarians' exhibition. The mention of jazz – an essentially improvised music using popular means – in the title already suggested a surreal atmosphere. But why did the collection include sonnets – one on the Muses and one on Phidias? By toying with brazen contrasts, Dubuc was perhaps attempting to induce disorientation. Take, for example, his classical sonnet on the futurist Le Corbusier, or the closing lines from 'Prière aux Muses' which transform the poem into a kind of anti-sonnet:

> But aren't you waiting for the strange humanity
> Who will bellow on the day when spitting at the Muses
> Will show drunken contempt for ancient beauty?[126]

In his preface to the book, Pierre Vadeboncœur wrote that he enjoyed the tendency of these poems to reject restrictive aesthetic laws which were irrelevant to life and humanity: 'Aesthetics seems to me clearly an occidental idea. It is rather superficial. In the West, beauty is an idol. In a curious way I feel a work is cheapened by calling it beautiful ... I like these barely aesthetic verses. They are beautiful, but they weren't made for the aesthetes at all.'[127]

Vadeboncœur's opinion applies especially to Dubuc's long series of ballads:

> I am not intelligent:
> I am allowed to be baroque

When I want to be eccentric ...

In this apocalyptic world
Where my madness is a siphon
Which squirts in tiny spurts, unique;
I want to be crazy to the core.[128]

But Dubuc was not an automatist. Filion himself, even though one of Borduas' first disciples, did not sign *Refus global*, preferring instead Pellan's and de Tonnancour's manifesto, *Prisme d'yeux*.

Jacques de Tonnancour and Réal Benoît

The following year Réal Benoît published a book of stories, *Nézon*, illustrated by Jacques de Tonnancour. The painter later claimed that he did not 'accord any particular importance'[129] to his contribution to *Nézon*; like *Jazz vers l'infini* by Dubuc and Filion, the book provided two examples of juvenilia. It was none the less the first contribution to the literature by de Tonnancour, a friend of Borduas and a disciple of Pellan who wrote the manifesto signed by Pellan and his group.

After Pellan's return to Quebec in 1940, de Tonnancour joined the revolt against academicism by writing a remarkable article in *Le Quartier latin*, 'L'Ecole des beaux-arts ou le massacre des innocents.' When an examiner at the Ecole, Charles Maillard, set up a still life for the fourth-year examination, de Tonnancour left in a huff and composed his inflammatory article. In 1944, his piece in *Gants du ciel*, 'Propos sur l'art,'[130] was haughtily criticized by *Lettres françaises* as 'clumsy and pretentious, obscure in thought and expression.'[131] He was better received in *Le Jour*, where Charles Doyon compared him to Pellan and Borduas and said he should be immediately ranked 'among that excellent group of painters who make the Montreal School a credit to our country.'[132]

In an article published in 1941, 'Alfred Pellan, Propos sur un sorcier,' de Tonnancour tackled the question of surreality, emphasizing that 'Pellan said to forget external reality more and more in order to draw closer, on one's own, to the other reality.'[133] When Borduas exhibited his surrealist gouaches at L'Ermitage in 1942, de Tonnancour published a 'Lettre à Borduas' in *La Nouvelle Relève* warmly praising the artist; Borduas never forgot this and they remained friends even during their later intermittent quarrels.[134] Borduas responded at the end of that year[135] with an equally encouraging review of de Tonnancour's work. A year later, Julien Hébert, who shared de Tonnancour's first studio with him, also wrote an article, 'Surréalité,' in which he emphasized Borduas' importance and what he termed, without any pejorative connotation, his 'dark, spiritual exercises.'[136]

J. de Tonnancour himself declared that 'he did not identify with surrealism,'[137] respecting in others a choice which was never entirely his own. If surrealism did influence him at all it was not in painting, since for him surrealism was literary, not visual.[138] In this he agreed with the French surrealist Pierre Naville, who had always disputed the application of automatic writing, the surrealists' initial tool, to the visual arts. Claude Jasmin wrote of de Tonnancour, 'He wants the dream, the mystery. But not in the manner of Tzara or Breton, or Dali-the-intellectual-clown.'[139]

Nézon was a collection of fantasy tales which had been appearing since 1941 in the periodical *Regards*,[140] where Benoît served as secretary. They are not surrealist, though some of the endings plunge directly into surreality and 'Tout en rond – Tout en jaune' is written entirely in this spirit.[141] Benoît's whimsical writing so often appears to be the transcription of some magical thought that it is readily distinguishable from the more realistic prose of the period. Novels and short stories 'of the soil' like Ringuet's *Trente Arpents* (1938) and Germaine Guèvremont's *En pleine terre* (1942) were still being published:

> I had arrived in the city with the eyes and ears of a young man I had never known ... I would meet this young man and not the black and white cow, a piebald horse who would run up to greet me with some well-turned English phrases ... And so it was that I arrived in the city mounted on a giant pumpkin drawn by two likeable and cheerful blacks, descendants of the race of Bicephalus* ... I was already a pumpkin seed on the backs of two ungrateful ants ... Two young Chinese lovers savoured me shortly afterwards in some bird's nest soup.[142]

This tale is a dreamy erotic fantasy, a marvellous nightmare in which the description of a melting girl, for example, is the product of polished artistry à la Dali:

> I had a dream: a tiny girl flashed eyes of fire at me, lowering her head as if to hide her diminutive golden bosom with her chin ... Then she gestured mincingly in my direction. I didn't understand a thing. Without further ado she assumed an inexpressible air and began to fade before my very eyes, melting away with a melancholy look. Goodbye, small breasts, she seemed to say; goodbye small bum ... Nothing was left except her hair, navel and knees.[143]

Only in 'Julie' does the author explicitly mention his aesthetic secrets: charm, surprise, humour. Here he reveals his intentions in an aside:

You will create, I said to myself in my heart of hearts, a kind of crescendo leading up to some charming surprise-dénouement never to be found in the dictionary of 18,000 novel plots and intrigues. Then, I added, still speaking in my heart, you can finish off with a full-length portrait of your heroine drawn with love, grandiloquence, and unconcealed voluptuous pleasure and at the same time challenge all young Canadian authors to a game of describing throats, breasts, thighs, and crotches.[144]

In fact, the erotic descriptions are rarely more than allusive, and the work is notable more for dreamlike fantasy than erotic upheaval.

The conclusion to the tale 'Fenêtre ouverte sur le monde,' formerly entitled 'Elzéar,' is one of the most mysterious and disconcerting. In it the story of Icarus or the Angel flying over the city, a favourite of Chagall and Pellan, is told in a surrational poem whose lines are interleaved with silences:

He smote his chest terribly, let out a loud cry, tore off his smock of gold and blood, and, sticking out his horribly thin and concave chest, rested two snow-white hands on my desk. Having warned me what tone he would use – that of prayer and entreaty – he said to me, half chanting:

The Moon awaits me at this door

...

May the market gardeners think of me in this house

...

For three months I have not eaten Jerusalem artichokes

...

O silver disk, my loves rise up to you

...

Slowly he let his trousers slide down. He was completely naked except for the lavallière blooming around his neck, frightfully thin, dreadfully emaciated, his body green and grey ... Then, without a word, before I could make a move, he stepped through the window in a single leap and disappeared like an Indian's arrow.[145]

These experiments in fantasy perhaps explain why Benoît later appeared in the table of contents of *Les Ateliers d'arts graphiques* alongside the disciples of Borduas and, especially, the disciples of Pellan.

Eloi de Grandmont

Les Cahiers de la file indienne inaugurated a new era in 1946. Founded by Gilles Hénault and Eloi de Grandmont, who wrote the first two volumes

in the series, these periodicals provided a forum for works of automatic writing.[146] The texts were all illustrated by painters who in one way or another had practised surrealism or automatism: Alfred Pellan, Charles Daudelin, Jean-Paul Mousseau, Toni Simard, and André Pouliot.

Eloi de Grandmont, author of the first volume illustrated by Pellan, had just finished writing a foreword to *Cinquante dessins d'Alfred Pellan*. The fact that Pellan returned the favour by illustrating de Grandmont's *Le Voyage d'Arlequin* suggests that they held views in common about surrealism. Discussing the importance of surrealism in his work, de Grandmont was vague but reaffirmed his close ties with Pellan: 'Automatism is a game played nearly twenty years ago. Definition: I call it a game. This game is stuffed with surprises ... Surrealism was a surprise. A magical one, I think. But let's be clear about one thing: it wasn't Borduas who discovered surrealism, it was Pellan.'[147]

Whether or not there is automatism or surrealism in *Le Voyage d'Arlequin*, the poetry seems to evoke above all shimmering enchantment, deftly complemented by Pellan's drawings of harlequins. This enchantment becomes surrational when, for example,

> Harlequin shakes
> With both hands the wind
> And the languor of relapses.[148]

The travelling Harlequin's mode of locomotion is most often dance and leap, as it should be, and is always associated with luminous effects (star, moon, lamp, fire):

> The window lowered its eyes.
> On the green table, the lamp
> Died of thirst. You, dear Harlequin,
> Your mask falls from the stars ...
>
> Come let us stretch out our new arms,
> Between strangers, to undertake
> The dance of the apple on fire,
> A dance flushed with joy.[149]

This explosion of form and light connects de Grandmont's poetry (as it does Pellan's paintings) to cubism as much as to surrealism. For example, the following metaphor prompted Pellan to draw a Harlequin floating in the air upside down (this image of an aerial character, a sort of floating angel, was to appear again in Pellan's work):[150]

All three of us have been suspended

In the sky by the gimmick of mystery ...
Harlequin thought he'd been stuck
To the earth like a set-square.[151]

This astral dance in the sky is all surprise and surreality, a fairy-tale reminiscent of Benoît's stories. Certainly Harlequin's voyage is a magic voyage, but the Harlequin character is above all cubist, as in 'Polichinelle,' a poem André Béland dedicated to de Grandmont in which the clown is described as 'This fantastically mauve domino / Decked out for a gala.'[152]

Pellan is said to have dreamed of bowling Paris over with an art that would synthesize the impressionist explosion of light, the contrasts of fauvist colours, the vectors of cubist structure and surrealist dream imagery.[153] Some of this syncretism appears in *Le Voyage d'Harlequin* which, like certain canvases by Pellan, drew on various contemporary schools, including surrealism.

Charles Daudelin and Gilles Hénault

Charles Daudelin was asked to illustrate the second volume in *Les Cahiers de la file indienne* entitled *Théâtre en plein air* by Gilles Hénault. Since Daudelin was Borduas' student at the Ecole du meuble and had exhibited with the Sagittarians in 1943, his collaboration on *Théâtre en plein air* emphasized Hénault's already acknowledged participation in the automatist movement. In fact, the critic Jean-Charles Harvey, in commenting on the Sagittarians' exhibition, only remembered one canvas – by Daudelin – out of the entire show.[154] Bernard Teyssèdre has pointed out Daudelin's connections with surrealism: he attended the Tuesday meetings at Borduas' home where *Une Saison en enfer, Les Changs de Maldoror, Le Château étoilé*, etc. were discussed; moreover, Fernand Leduc moved into Daudelin's former studio on 25 November 1944. On the other hand, when Borduas hesitated to take charge of the group forming within the Sagittarian movement, according to Claude Gauvreau 'he was afraid of excluding or discouraging certain young painters with slightly different approaches, Charles Daudelin in particular.'[155] This rather ambivalent attitude (shared by Gabriel Filion) perhaps explains why Daudelin's illustrations for *Théâtre en plein air* are somewhat representational.

This representational mode did not conflict with the collection of poems by Hénault, who viewed it as an experiment in automatic writing, yet its automatism bore no resemblance to the non-representational poetic objects later created by Claude Gauvreau. Hénault and the automatists experienced different influences. Pierre Baillargeon, founder of *Amérique française*,

introduced him to the works of Valéry,[156] and through the poet Jean-Aubert Loranger he got to know the work of Saint-John Perse.[157] Hénault also wrote for *La Nouvelle Relève*, and among the other contributors were Louis-Marcel Raymond (who introduced those around him to Aragon, Breton, Goll, and the periodicals *Lettres françaises*, *VVV*, and *Hémisphères*),[158] and Robert Elie (who lent his friends the works of Lautréamont, Eluard, and Reverdy). Hénault also acquired six complete years of *La Nouvelle Revue Française* in which he found works by Breton, Eluard, Pierre-Jean Jouve, Henri Michaux, and Sartre. He was particularly struck by Breton's manifesto, *Limites non-frontières du surréalisme*, written after the Second International Surrealist Exhibition in London in 1936.[159]

Hénault had Borduas read this document,[160] perhaps the only surrealist manifesto Borduas did read in its entirety before Riopelle brought back *Rupture inaugurale* from Europe in 1947. In those days Borduas categorically refused to give pre-eminence to matter over mind, and a meeting of the automatists at which the communist leader Tim Buck apparently spoke to them about materialism did not seem to change their priorities. Breton himself admitted later that this philosophy 'implied appreciable sacrifices for several of us,' adding, with regard to Marxism, 'This violence I had to perpetrate on myself shortened the time I toed the line.'[161] Between the spiritualist monism of Hegel and the materialist monism of Plekhanov and Marx, the surrealists chose a permanently open dialectic,[162] while the automatists, Claude Gauvreau in particular, later talked about 'atheistic monism.'[163] Borduas was against the disciples committing themselves to any one party because the commitment necessary to support the 1936 manifesto in any way constituted for Borduas an impediment to spontaneity and to the more profound commitment of personal experience.[164] However, Borduas and Gauvreau immediately took from this manifesto the notions of 'hasard objectif' (objective chance) and 'nécessité' (inevitability), as well as the distinction between manifest and latent content in a work of art.[165]

Hénault participated regularly in the activities of the automatists and took part in Claude Gauvreau's play *Bien-être* in May 1947[166] but was not asked to sign *Refus global* in 1948. He was alienated from the automatist movement at the time because of his membership in the Communist party, which dated back to 1946.

Hénault's contribution to the first issue of *Les Ateliers d'arts graphiques* '1 + 1 + 1 = 3 poèmes,' and the second poem in particular, perhaps reveal its author's revolutionary preoccupations:

Two and two only make four
The cats o' nine tails mewl under the gutters
Place your helmeted head under the guillotine

The mob, that's you, arms dangling
But the real man is the one who lifts a hammer
You must strike while the iron is hot.[167]

Certain images are quite obvious – the raised fist, the hammer and sickle, the alley cats with nine lives, and the heads under the guillotine; the poem is hermetic, but not as automatist as might appear at first sight.

Nevertheless, when certain Communists reprimanded the automatists for not being 'populist' or 'democratic' enough, Hénault defended Borduas, principally against Pierre Gélinas.[168] The quarrel assumed such proportions that Claude Gauvreau situated the 1946 Amherst Street exhibition within the context of this ideological struggle:

> The exhibition took place in a working-class area and I will never forget how ordinary people, without many preconceived ideas, managed to appreciate readily enough the legitimacy of this undertaking after some sincere explanations; on the other hand, as soon as some personality in patent leather boots appeared, out came the stupid pretentions and the mockery, a display made all the more contemptible because they were so blind.[169]

In *Théâtre en plein air*, Hénault's social commitment was already evident in allusions to brotherhood and communication, but it remained low-key. His style had little to do with 'pure psychic automatism,' despite the claims of *Les Cahiers de la file indienne*, and 'Simple Monologue' is perhaps the only automatist poem in the entire collection. But *Théâtre en plein air* did occasionally tread the line between the real and the surreal. The most evocative surreal images, repeated several times, included hair (at various points sidereal, spiritual, and surreal) and 'talking shades.' Dream effects and word plays also exploited the rich resonances of certain syllables.[170] The connection with the surreal is most explicit in 'Simple Monologue':

> The man said nothing. What we call monologues are dialogues with some unknown part of ourselves. But this haughty man whom we know well is only a deaf king reigning uncomprehendingly over a nation of shadows. Even if the king reigns with commands like two-edged swords, he still reigns over shadows who pull his luminous chariot along inextricable paths to surreal hells.[171]

These surreal hells are a jungle of shadows violated by the inner eye uncovered by automatic writing; here automatist poetry penetrates to the heart of the subconscious, to its twilit purity, going back in time to the earliest adolescent experiences:

Ah, indeed, we have never seen tropical forests, the network of lianas around thousand-year-old trunks, the stagnant ponds covered with green scum and poisonous flowers with hundreds of eyes; we have never shivered on muggy, vibrant nights full of voices on the move; we have never opened our nostrils, eager to breathe in things and detect the slow pulsating of saps. And yet, this jungle is not unknown to us. We have violated its virgin mystery. The more we descend into ourselves, the more we penetrate it. Even further. In these infinite autumnal twilights, when our adolescence walked its anguish along paths slowly staggering into darkness – this scream and this supreme fright, this obsession with all being, where did they come from?[172]

Over this hell reigns a mythic shadow. The human element plumbed by automatist poetry is not a shining intelligence reflecting a greater Light, a conceit preached in Quebec at the time; influenced by dialectical materialism, Hénault on the contrary sings of the unfathomable physical body: 'And the body at bay so near to dying to being only the sign and the breath and the blood and the shadow of a Shadow in the mirror.'[173]

The second *Cahier de la file indienne* extended the debate over surrealism without providing clear-cut support for Breton's 'pure psychic automatism.' A lecture by Hénault on 21 March 1966 at the University of Montreal threw more light on the Quebec poet's relationship to surrealism:

Breton ... wrote the following sentences which could be accepted as general truths by all artists, even by those who refuse to accept the surrealist perspective. 'I hope people believe surrealism has attempted more than just the insertion of a conducting wire between the overly dissociated worlds of waking and sleeping, external and internal reality, reason and madness ... I believe in the future resolution of dream and reality – two states apparently so contradictory – into one kind of absolute reality, a surreality ...'

Be that as it may, the form reality will take tomorrow is already latent in the sensibility of those who realize their dreams by creating works of art today.[174]

The following reference by Hénault to Breton regarding the future of surrealism in Quebec art applies to Hénault as well. He wrote it in 1946 for an automatist periodical which was never published (probably the one that was to have been called *lllll*):

> With our infinitely more mediocre resources, we do not intend in
> any way to follow the route already travelled by surrealism between
> the two world wars. We have even less intention of transplanting
> holus-bolus the conclusions of the surrealist movement as expressed
> by Breton in his most recent articles. But what we are adopting
> immediately in all our endeavours is the surrealist attitude and the
> processes of thought it determines ...
> This periodical is the first collective expression of our position,
> one we would very much like to see considered surrealist.[175]

Nothing could be more explicit. The spirit of this piece, originally in-
tended for a collective periodical, is very similar to that of *Refus global*,
which began to take shape towards the end of 1947.

Fernand Leduc, Jean-Paul Mousseau, and Thérèse Renaud

The third *Cahier de la file indienne* is clearly the first in the series directly
linked to the automatist tradition. Written by Thérèse Renaud and illus-
trated by Jean-Paul Mousseau, it was called *Les Sables du rêve*.[176]
 Thérèse Renaud was barely eighteen years old when she published her
first automatist poem in *Le Quartier latin*; at that time her sister Louise was
at the Beaux-arts before going to work for Pierre Matisse in New York.
Thérèse Renaud was especially interested in theatre and poetry, and, as
mentioned above, she and her sisters spent several vacations at Saint-Hilaire
with Fernand Leduc. Almost immediately upon publication of her book,
Renaud left Quebec to settle in Paris, arriving on 22 October. Leduc fol-
lowed on 7 March 1947 and they got married.
 His friend Claude Gauvreau said of Leduc at the time:

> After Borduas, Leduc was the first to experiment with automa-
> tism ... A painstaking worker, he was extremely hard on himself. Car-
> ried away by surrealism. Renounced Christianity completely. He was
> part of Amherst Street – it was his idea to hold that exhibition. His
> studio was frequented for a long time by the youngest members of
> the group ... During the Sherbrooke Street exhibition, he left for
> France ... He signed the surrational manifesto from Europe ... To me
> he is still the classic example of a rigorous thinker, a bit rigid.[177]

Even though he was passionate about surrealism, Leduc nevertheless sig-
nalled his refusal to join the movement per se in a letter to André Breton

on 5 October 1943, which he signed on behalf of his friends: 'Right now, we don't care much about working in a surrealist mode.' Later, in a letter to Borduas dated 22 March 1947, he passed harsh judgment on a conversation he had had with Breton at the Deux Magots restaurant: 'For us, the emphasis is on the authenticity of the works; for them, works serve ideas.'

Leduc states his reservations most clearly in an essay entitled 'La Rythmique du dépassement et notre avènement à la peinture.' His editor, André Beaudet, believes it was written in late 1946 or early 1947, and certain ideas in it reappear word for word in a letter dated January 1948 to André Breton:

> Surrealism has wronged art – and especially painting – not in having used it, obviously, but in not knowing how to bridge science and art on the poetic plane, in falsifying the meaning of art by only considering it valuable as a proof of something else ... Surrealism should have distinguished between logical proofs literally expressed in pictorial form and the authentic expression of visually formulated intentions.

A long list of painters followed, divided according to those who gave proofs and those who expressed. The letter is more discreet than the essay on this subject, but with two minor typographical variants the following paragraph from the letter to Breton was copied directly from the essay:

> The imagination liberated by automatism and enriched by all the surrealist premises may finally surrender to its own power of transformation in order to organize a world of completely new forms, conceived without regard for recollections whether representational, anecdotal, or symbolic. Here only the human link with the meaning of the diverse elements of the cosmos endures and hence is exalted. The 'space-time' relationship, source of the secrets of a new morphology, no longer exists between images but at the very heart of the object.[178]

Borduas did not agree with all of Leduc's criticisms of surrealism. An epistolary dialogue ensued in which Borduas' last word was itself in the form of a dialogue. Between two speeches he inserted this parenthesis: 'We cannot reproach surrealism from a historical perspective for not being able to give back to the activity of art the value "passion" we accord it. Nevertheless [the surrealists] have recognized this passion in the beauty of the

works and in exceptional poetic activity. We have only extended to paint-
ing the freedom they have brought to literature.'[179]

As André Beaudet suggests in a note to 'Rythmique du dépassement,'
Leduc was far from rejecting experimental or exploratory surrealism.[180] On
the contrary, he unequivocally told the revolutionary surrealists that 'the
evolution of thought today requires the poetic experience known as *sur-
realism*.'[181] Speaking to Borduas of *Rupture inaugurale*, the manifesto signed
by the Cause group, Leduc twice repeats the necessary distinctions be-
tween an 'ethical position' and an 'attitude vis-à-vis the works,' between
the 'occasion to applaud theoretical developments' and the 'disenchant-
ment upon seeing the works.'[182] Hence Leduc was called *the* theoretician
of surrealism in Montreal. Even though he denied this, he gave a very
positive assessment of the movement and of the relevance of *Les Sables du
rêve* to it:

> It is true that we were captivated, bewitched by surrealism: the
> enterprise, with all its magic, fascinated us. Benjamin Péret and
> Lautréamont were guides to the marvellous, to mystery. But if Bre-
> ton had come to the Amherst Street or Sherbrooke Street exhibi-
> tions, he wouldn't have seen any surrealism. For him, painting had
> to be anecdotal, giving rise to the possible decipherment of a magi-
> cal expression. For us, the issues were different: painting did not
> convey a message, it spoke directly, unaided. But I still admire
> Breton ... The truth is that the only genuine surrealist work in
> Montreal at the time was Thérèse Renaud's collection, *Les Sables
> du rêve*.[183]

Mousseau, the illustrator of *Les Sables du rêve*, had begun his study of
painting at Collège Notre-Dame with Brother Jérôme in 1940 at the
age of thirteen.[184] This teacher displayed Mousseau's work in his exhibi-
tions of 1941, 1942, and 1943.[185] Invited to judge one of these, Borduas
encouraged Mousseau in his work and had him take part in the 'Art
Moderne' exhibition at the Séminaire de Joliette (1943) along with him-
self, Leduc, and Pierre Gauvreau. That same year, Mousseau was admitted
to the Contemporary Art Society at the age of sixteen. In 1945-6, he
attended the Ecole du meuble for three months and visited a surrealist
exhibition in New York with Marcel Barbeau, Fernand Leduc, and
Claude Gauvreau.[186]

In a note to Jean-Claude Dussault, Gauvreau recalled that Mousseau
'frequented the studio of Leduc, who had a great influence on him. He
hoped to convert Leduc to Christianity – but it was Leduc who converted

him to monism.'[187] Mousseau took part in all the automatist events using the most simple materials – the only ones, in fact, his extreme poverty allowed:

> While he plays an integral part in the automatist movement to the point where he is one of the most dynamic participants in all its activities and a signatory of *Refus global*, in his personal development he will always remain a brilliant improvisor on his own distinctive themes. All tasks seem worthwhile to him provided they allow him to express himself. In his work he always uses whatever is at hand with the greatest ingenuity.
>
> I can still see him on the floor of the studio he shared with Riopelle drawing those strange cabalistic symbols destined to embellish Thérèse Renaud's small volume of poems, *Les Sables du rêve*.[188]

Mousseau made a very clear distinction, as did all his friends at the time, between surrealism and automatism. For him, as for Leduc, surrealism was an exploitation (always verging on academicism) of representational dream imagery; automatism, on the contrary, aimed at exciting an emotion through non-representational expression obtained by purely mechanical means such as folding, scraping, rubbing, dropping, smudging, gravitation, and rotation.[189]

Les Sables du rêve is situated in a universe of contrasts (tiny giant, snaketie, eye-nostril, water-dye, and bush-woman) whose incoherence evokes that disorientation so dear to the surrealists:

> Between the skin and the nail of a giant I have built my house. My husband is short and dark. He loves snakes and always wears one as a tie. He is handsome and on his nape horsehairs grow instead of hair.
>
> One day he comes home with his eyes in his nostrils: 'Hello my darling bush.'
>
> We have gone to the river to rinse our linen and dye our hair.[190]

The dream-like techniques of collage and superimposition are most evident in the first poems, which read like surrealist canvases. The lines provoke disgust (snake around the neck, horsehairs on the head), as does Dali's work, and the superimposition of human, plant, and animal forms recalls the paintings of Félix Labisse, Léonor Fini, Paul Delvaux,[191] and the frontispieces of *Minotaure*,[192] with which the automatists were very familiar. A similar process is at work in the poem 'à Jeannot' which includes one person passing through two doors, feet soaking in vinegar, and a

man walking down the street, revolver in hand.[193] A poem dedicated to
Fernand Leduc, with its opening rhymes taken from Tom Thumb, finishes
off with a return to the dream style in which appropriate punctuation is
suppressed:

> I found a clear starlit night, three pebbles which I put in my
> pocket today I took them out after having forgotten them three
> days ...

> My feet are longer than storm clouds which stops me from dancing
> but I can drum all kinds of folk tunes with my trombone nose ...

> I have never been able to walk on my head or my stomach because
> my hands are made of flying cactus.[194]

Cabalistic numbers, child-like naïveté, the marvels of folklore, and
even Magritte's trombone-face[195] are all elements in this work, not to men-
tion the collage and superimposition resulting in a cactus-woman and a
negro-forest. The author described her experiments as follows:

> My sister Louise ... brought back to Montreal a copy of *La Sauterelle
> arthritique* by Gisèle Prassinos, and she told me about Eluard's
> famous image of the earth, 'blue like an orange': This was literally
> love at first sight for me, a kind of release, a catalyst for a style of
> writing which was just being born. From Eluard's image I realized
> it was possible to create a poetic image by contradicting reality. So
> I began to write short poems with incoherent images to express a
> painful reality; these are sad, heartrending poems.[196]

Not just another poet of disorientation and surreality, Thérèse Renaud
in fact found herself Quebec's first automatist writer. The others were not
known to the public until the following year: Claude Gauvreau through
Bien-être and Rémi-Paul Forgues through the poem 'Tu es la / douce yole
iris / de ma fin' published in *Les Ateliers d'arts graphiques*, to which Mous-
seau contributed two illustrations from *Les Sables du rêve*.

Les Ateliers d'arts graphiques

Quebec publishing was able to take advantage of truly fine-quality print-
ing only from 1946 on. Luckily a sizable grant to volume 8 of the periodi-
cal *Impressions* published by the Ecole des arts graphiques transformed it
into an important art journal; in issue number 2 of volume 8 (1947), the
name *Impressions* was replaced by *Les Ateliers d'arts graphiques*.[197] With

Albert Dumouchel as art director and Arthur Gladu as production manager, this journal included many great names from the Quebec avantgarde in its table of contents: Pellan, Borduas, Hénault, Mousseau, Rita Bellefleur, Armand Vaillancourt, Pierre Ouvrard, Albert Dumouchel, Robert La Palme, Emile-Charles Hamel, Jean Léonard, Réal Benoît, Rémi-Paul Forgues, Pierre Gauvreau, and Mimi Parent.

Rémi-Paul Forgues

Les Ateliers d'arts graphiques included Forgues' first automatist publication, a poem dated October 1946. This work and others which appeared later were composed in the summers of 1945 and 1946 when he used to visit the studios of Borduas, Leduc, and Riopelle.[198]

A student at the Ecole des beaux-arts in Montreal, Forgues sometimes stayed with François Hertel or with Barbeau and Riopelle at their studio. Claude Gauvreau's description of him in 1950 reveals what an exceptional personality he was:

> He used to be a regular visitor to Leduc's studio. It was there I met him. He was already a legendary figure. His connections with surrational thinking began by pure chance: idly browsing in a bookstore one day he came across Robert Elie's small volume on Borduas. The illustrations were enough to set him on fire. He had found the promised land. The surrational community, which had no standards of practical or rational virtuosity, allowed him a certain period of adjustment. Forgues never realized how valuable his poems were: he was always trying to massacre them and destroy the best. His creativity was at its peak while he stayed with me at Saint-Hilaire. Forgues was a great disciple of surrealism; he even wrote to Breton.[199]

Fortunately, friends kept some pieces dedicated to them and thus saved them from destruction.[200]

During group discussions of the magazine *VVV*, Forgues discovered Aimé Césaire and Arthur Cravan. His devotion to Freud was nothing short of Freudian.[201] He seems to have been attracted by the immateriality of Borduas' canvases, a quality apparently corresponding to Forgues' needs during this surrational period in his life; however, his poems do reveal a strict automatism similar to that displayed in the canvases of Borduas, Marcelle Ferron, and Leduc.[202] Less reminiscent of their work are Forgues' images of tongues and naked limbs against backdrops of moon and stars which evoke instead Dali's dream imagery:

The long hands of silence
the death rattles of stars
lick my heart and throat ...
All the vales of tears are filled with moons and daphnes
All the arms of fear.[203]

Twisted arms
Naked
Creak against the wobbly sky
Beauty, in golden stars you gaze at yourself.[204]

Like wandering stars
Their naked arms embrace.[205]

Neither sweet moons of fleshy xylophones ...
Nor innumerable snakes of yuccas' lampposts
Nor imploring eyelashes of liquid buttocks ...
Nor shadow of stars stir my heart.[206]

For a while, Forgues seems to have experienced a profound liberation
through automatism which apparently facilitated his verbal release. This
was an example of the pure sublimation Breton had described in the *Sec-
ond manifeste du surréalisme*, in which he cited Freud's ideas on sublimation
through art.[207] In Forgues' poems, the figure of woman, sublimated by
automatism, becomes a 'flower-woman,' albeit an extremely ambiguous
'fleur de feu' with her naked body set against a celestial backdrop:

Woman
Your automatic body
Your hands
Your automatic body
Dance in the sky like a flower of fire.[208]

The image of woman-pistil – sometimes a flower of ice, sometimes a
flower of fire or light – is repeated endlessly:

Chrysanthemums of ice
drink the naked flesh of my shoulders.[209]

The bewitching shade of an adolescent girl
slips among luminous violets.[210]

Your supple body
Dances in the sky like a flower of fire
and gold.[211]

Pure fingers
light the fires of a rose.
A smile
Descends from fields of clover and peonies.[212]

Forgues' poetry seems to be primarily a poetry of sublimation, a spontaneous expression of the subconscious, an automatic expression of inner emotion. This surrational automatism produces completely new collages like 'yole-iris,'[213] an image which conjures up a woman who is both a small boat and a water flower, a mother who bears and a girl to be plucked.

Pierre Pétel

Little has been written about the early automatist Pierre Pétel, and it was only in 1962 that André Goulet's printshop brought out several of his poems for the publishing house A la page. The poems trace Pétel's development as he took his place in the ranks of Borduas' disciples. Though still in the representational mode, 'Petites annonces' provides a good example:

Wntd. fr speedy propos.
Serious customer. Pretty poems
Pleas. With / without rhymes
Free ver, Alexandr
Condition tru. impecc.[214*]

Like many surrealists, Pétel punned prolifically and was proud of it, especially in 'Jeux de maux.'[215†] At times these plays on words lapse into the facile associations resulting from intoxication:

If I no longer had my little bar
To go to and dream
And fight over boredom with the nights

If I no longer had my little bar
To go to and drink
And fight over verse with the glasses

I think for sure I'd die
Oh I know I'd be raised on high above altars
In the glorification of breasts

But far from my little bar
From then on I'd have to
Fight over my verse with the worms.[216]*

This kind of automatism associating words and images, which Forgues also practised, is related to jazz:

On the merits of the good tea Salada
The announcer
Having saluted God's tender love
Preferred it to supreme beauty
The fiancee of the Love he loves
Carter's little liver pills
Heard it confessed
That the Lord has been updated.

O feast! feast!
That no neighbouring ear heard
That no echo could pick up at first
A second jazz tune.[217]

André Béland: 'Orage sur mon corps'

André Béland wrote a novel, *Orage sur mon corps*, which differed from contemporary works in two respects: not only was it the first erotic novel ever published in Québec, but its form was very unusual. The novel itself is situated between two other texts by the author: an introduction (in which the problem of the first-person novel is clearly set out) and a selection of poems (heralded in the introduction, which emphasizes the intertextual link between these poems and the novel).

In the introduction, the author presents his novel as the fruit of six months' observation in a particular milieu:

For six months, I met all kinds – madmen, boyfriends, painters, abnormals, poets, poor people, sensual people, jokers. There were also those who had no one to confide their joys and troubles to, there were the purists who refused to prostitute their art and looked ridiculous and there were, finally, those poor friends who did not particularly like Woman.[218]

It is difficult to ascertain if these words referred specifically to the milieu inhabited by the young painters and poets in Montreal's Latin quarter. This is possible, but the stories set there in Emile-Charles Hamel's *Solitude*

de la chair and *Prix David*[219] using almost transparent pseudonyms and barely transposed situations do not convey the same impression at all. On the other hand, writers like Jacques Ferron, Claude Gauvreau, and Hélène Ouvrard[220] also spent some time in this circle and created very different works out of their experiences. Béland stated specifically that his writing was entirely subjective. The sources of his subjectivity included, on the one hand, his Gidean vision of reality (the narrator cites André Gide at least three times in a story obviously much influenced by him) and, on the other, the automatisms of dreaming as developed by the surrealists. Béland explicitly mentions the movement in one of the poems following *Orage sur mon corps*: 'With a clean brush I smeared my / Surrealist heart.'[221]

The novel is not a 'faux-roman' in André Breton's terms, that is, a novel with 'disparate characters ... in which observation, reflection, and the faculties of generalization [are] of no help.'[222] But Breton himself had only produced one work, *Poisson soluble*, in the particular genre which compressed together the literal and metaphoric sense.[223] To understand how Béland's writing stemmed from a certain kind of surrealism, the hypnagogic visions Breton discussed in relation to painting are more relevant: 'In order to respond to the need for an absolute reappraisal of real values ... the visual work must refer ... to a "purely inner model" ... There is no reality in painting. Potential images, corroborated or not by visual objects, fade more or less before our very eyes.'[224]

These observations cast light upon the following lines from Béland's introduction, which indicate that he did not start writing the novel without clarifying beforehand certain theories and establishing the importance of sleep: 'Lying on my bed, I endured the weight of all the hearts that had unburdened themselves to me for six months. All the secrets, all the troubles, all the young people who had initiated me into their mysteries merged into one single being who [sic] I called Julien Sanche.'[225]

The typographical 'error' in the preceding sentence is strange because the writing throughout the novel is defined by the multiplicity of meanings assumed by a pronoun which once object becomes subject. Béland's writing differs so completely in this respect from the omniscient narrator model that where the author disappears and the narrator enters in passing from the introduction to the novel itself, and from the novel to the poems, can no longer be determined. Who is 'I'?

I am not here to request mercy for myself and them, for myself who could not retreat when confronted with the risk of writing this novel, for them who constitute the origins of this life. If in some way I have become implicated by my widespread use of the first

person, by using these 'I's' and these 'my's,' it is because the memory of these young people forced me to recreate for myself a pile of situations and moods.[226]

In the novel the narrator asks himself the same question: 'Why, damned "I," have you thus upheld something which my deposed, revolutionary past and my lustful, puppet-like future strive to deny completely with this unqualified approval of the "me"?'[227] And so the games continue between author and narrator, between narrator-as-object and narrator-as-subject.

The novel takes place during a five-month storm lasting from 17 October to 4 March. During this time the narrator turns eighteen, a magic number as frightening to broach as the threshold of twenty years Nelligan dreaded so much:[228] 'There! The strokes of the hourly bell return to eternity. We have embraced, O my youth and my eighteen years! On the threshold of another era, we have allied the past with the present.'[229]

Although an unsympathetic reading might see in *Orage sur mon corps* only a series of scandalous episodes flaunting homosexuality, sadism, the adventures of a gigolo, incest, cynicism, and pederasty, it is much more than just a string of whorish descriptions (the novel certainly was not profitable and was never reprinted). Above all, clearly framed by the milestone of Julien's seventeen years at the beginning and that of his friend Michel at the end, is a long, narcissistic dream in which reality and illusion are one:

I fear lest an unexpected sound suddenly distract me. I have acquired a suspicion of furniture suddenly creaking in the dark and the inexplicable fall of knick-knacks. If another world of reality were to be created anew, my illusion that this present pain is not a dream would vanish too.'[230]

The act of writing is always centre stage. When the narrator describes his expulsion from a Jesuit *collège*, for example, the narrative mode itself assumes great significance:

If I try to reproduce the events of that famous afternoon, if I endeavour to live out those episodes, my fugitive brain can do no more than offer vague scraps. I have returned to it so often that soon it will escape me, like the lukewarm water I like to pour from one vase to another.[231]

Describing the moment when he decides to live his own life and not the life people tend to impose on him, he again talks about writing in words

that reveal the very structure of the work itself ('my end is my beginning'):[232]

> I would be content to open a large, very clean book with completely blank pages, uncreased, so that I could write in it: 'Today, October 17, I believe a happy life is about to begin ...' I would write nothing but that, as carefully as I could for fear of destroying the harmony. This would become a point of departure because it was a point of arrival.[233]

When he looks for support he addresses a writer, perhaps the author whose *La Nausée* had appeared five years previous and whose ideas spread through the Latin quarter somewhat entangled in a surrealist frame of reference. Receiving no reply, he becomes indignant and at the same time identifies with a scene from *La Nausée*:

> If he too had confided in a retiring novelist, and if this merciless novelist had not replied, why in turn should he not do the same to another ridiculous adolescent ... That ridiculous adolescent was surely me ... I pass by my mirror, saying, the ridiculous adolescent, there he is now staring at himself, pinching between two soiled fingers tiny mounds of purulent flesh.[234]

When the narrator finally meets a youth on a train a year younger than himself and hence on the verge of living the same experiences, he expresses his feelings in poetry[235] which is repeated in the collection at the end of the book.[236] The woman accompanying the youth, whose reflection Julien watches in the glass, is a double of the 'I / me,' as a digression in the story reveals: 'An elderly woman is reading some serialized dime store novel, the kind of literature enjoyed so much by people without worries, without problems, who have never lived ... her eyes widen appreciably each time a strange event in the novel catches her fancy.'[237] Some scenes in the novel are certainly erotic by Gidean standards of decency, but Béland is no Sade. The sexual descriptions are either so metaphorical[238] or so strewn with suspension points[239] that the zealous censors saw no need to intervene.

Béland dared fate a second time with his poems *Escales de la soif*, published in Paris in 1948. Closer in spirit to Jean Genet than to Cocteau or Radiguet in his dada period, *Escales de la soif* occasionally employs lettrism, for example in 'Derrière une cathédrale'[240] and 'Pour hypnotiser.'[241] Particularly memorable is the final banquet scene, worthy of 'Festin des cannibales,'* which along with Jean Benoît's 'L'Exécution du testament du

Marquis de Sade' was the pièce de résistance at the Eighth International
Exhibition of Surrealism in December 1959:[242]

> May someone cook me up a fetus in pure cicada honey
> And orphans' hearts garnished with parsley
> Eve will surely die soon enough so that I may feast
> On a bit of her tits hanging over the present day.[243]

The quality of the poetry in the afterword to the novel and those poems published in periodicals or in *Escales de la soif* may be questionable, but his skills
as a novelist are undeniable – and he was only eighteen years old.[244]

In the years 1938-47, the transformation of Quebec's cultural milieu,
where freedom was demanded with increasing tenacity, was due largely to
the painters: thanks to them, the classical 'stranglehold' began to loosen.
As far as poetry was concerned, these years were relatively fruitful. One
phenomenon was particularly noteworthy: the publication of collaborative
works by painters and poets, an obvious legacy of surrealism. Already
apparent in Grandbois, surrealism from *Les Iles de la nuit* to *Les Sables du
rêve* became increasingly influential as it laid the foundations for the
automatist movement in 1947.

Painters and poets were divided according to whether one was an
automatist of more or less strict persuasion. But despite this division of
young creative artists into the clans of Pellan and Borduas, the rapprochement between writing and painting benefitted writing immensely. It was
no longer learned just at school but in the studios as well, as demonstrated
in *Les Ateliers d'arts graphiques* and the novels *Orage sur mon corps*, *Solitude de
la chair*, and *Prix David*.

3

33

Refus global

Surrealism saw itself reflected in a Canadian publication as if in a mirror ... While pursuing his work as a painter, work which is currently very well received, Paul-Emile Borduas showed himself to be a first-class artistic entrepreneur by gathering around himself a constellation of young poets and artists whose fundamental inspirations were in line with those of surrealism, even though in the final analysis divergences did occur since they were of a different generation.

André Breton, 'Où en est le surréalisme'[1]

The end of the war reopened international communications for artists and writers. Paris again became the meeting place for the surrealists, attracting among others Quebec automatists like Jean-Paul Riopelle, Thérèse Renaud, Fernand Leduc and, later, Paul-Emile Borduas and Marcelle Ferron. But the relocation by Riopelle, Borduas, and others was not due to the attractive force of Paris alone. There was also a centrifugal force operating in Quebec, namely Duplessism, a term referring to the alliance of a clerical and a conservative nationalist power under the political authority of Maurice Duplessis, who had been re-elected several times. These two powers were sustained by virtue of the fear generated by a variety of hostile elements: the threat of the English, the threat of religious dissidents (Protestants and Jehovah's Witnesses), the threat of the atheists, and the threat of the Communists. Communism in particular was the pretext for indiscriminate witch hunts whose victims included Stalinists, trade unionists, and artists.

The problem of the relations between surrealists and Communists had often been broached in Europe and could readily be traced in the evolving attitudes of the surrealists towards the magazine *Clarté*.[2] It was raised again after the war by a group of young surrealist fellow travellers who forced Breton to issue a clarification in the manifesto *Rupture inaugurale*.

Meanwhile, in Quebec, Duplessis decided to enforce against newspapers, private libraries, and workshops an old anti-Communist law, the 'padlock law,' dating from his first term in power. Among others, he had the newspaper *Combat* padlocked, a newspaper to which certain trade unionists who were friends of the automatists had contributed. This situation explains why Borduas and the automatists, who had been invited by Breton to sign *Rupture inaugurale*, decided that signing Breton's manifesto was not the solution; they had to have their own manifesto. This manifesto would be written in the same spirit as *Rupture inaugurale* but, because of its references to the facts of the situation at home, the reader would not be allowed to ignore those facts, as he might given the predominantly European references in the international manifesto. The result was *Refus global*, drafted during the winter of 1947-8.

This chapter discusses both the history and the contents of the Quebec manifesto. A later part of the chapter is devoted to the literary works which accompanied it or were published immediately afterwards by the same basement press, Mithra-Mythe. Because the collection entitled *Refus global* presented for the first time the works of the writer Claude Gauvreau, and because almost all his works were in process during this period and were continually related to automatism, they will be discussed in the second part of this chapter. Also under discussion will be the works of Paul-Marie Lapointe, whose first book was published by Mithra-Mythe, and the works of Suzanne Meloche, who also belonged to the Borduas group.

'GLOBAL ACCEPTANCE'

> The meaning of this global refusal has been distorted; it merely means refusing to accept the facile, refusing to conform. Besides, there's never really a global refusal – the title isn't mine – it would have been much better to say *global acceptance* of life and its riches.
>
> Even the term *art libre* for which we were severely rebuked means nothing other than a fresh way of looking at the world, free from constraints, free from academicism, open to anything and everything! Didn't surrealism teach us to trust risk and chance?
>
> Paul-Emile Borduas[3]

In order to present a complete history of *Refus global*, mention must be made of various related events, among them a rapprochement between the

French surrealists and the Quebec automatists. This was initiated by Thérèse Renaud, Jean-Paul Riopelle, and Fernand Leduc upon their arrival in France when they contacted the participants in the international exhibition organized by Breton after his return to France. This exhibition also provided an opportunity for those surrealists returning from exile in America to reflect upon their life in that country.

The New Myth

On 12 January 1947, Breton had a letter sent to all members of the international surrealist movement inviting them to the Sixth International Surrealist Exhibition, which was to open in Paris on 7 July 1947 at the Galerie Maeght. Breton emphasized in this letter the significance myth had always held for him and how he had rediscovered its importance in America when he came in contact with Indian art.[4]

In Montreal Borduas was quickly informed of the project by Riopelle, who was in Paris. Borduas' first reaction was to accept the invitation, but with certain reservations. Concerning Breton and surrealism, he said in his reply:

> I'm very pleased to hear that you've been in touch with Breton. I've always considered him a fine, upstanding man. The invitation you passed on to me from him gave me the jitters (your letter arrived just a few hours before Fernand left for Paris via New York). We got together with Pierre and decided to put off until later any official participation with the surrealists.
>
> Our reasons:
> 1 The invitation arrived too late. Our canvases might miss the boat.
> 2 Contact with the leaders of the movement was too recent.
> I suspect nobody understands us as well as Breton. He's the one responsible for what little order there is in my head. But there's also a lot of disorder there too, and my disorder doesn't perhaps coincide with his. In any case he (Breton) has to get to know us better. This means arranging more meetings. And if it turns out that we can be useful to them, can offer them something, if he accepts our truth, our destiny, our integrity, whatever you want to call it, so much the better and we will happily participate in their next exhibition on an equal footing. Fernand will be in Paris at the beginning of March (the 4th) and he'll help you as much as he can in this project of making us better known to Breton ...
> If you want to participate in the exhibition in question we'll all be very pleased ... I'm not going to write Breton as I had intended. Inform Fernand accordingly.

But perhaps you'd be good enough to thank him and say whatever you think is appropriate regarding our reasons.[5]

Breton, who had already made initial contact with the Borduas group in 1943, had Riopelle pass on an official invitation to them in June 1947. But still Borduas hesitated, for reasons that had nothing to do with the idea of a new myth which was the theme of the exhibition. In February 1947 the second group show by the automatists (Barbeau, Borduas, Roger Fauteux, Pierre Gauvreau, Leduc, Mousseau, and even Riopelle – who was in Paris) had taken place and the group was becoming an increasingly autonomous reality. This show was actually the occasion when they became identified as 'automatists,'[6] and after some hesitation the name was accepted.[7] The members of the group realized that their approach was not quite the same as that of the surrealist automatists but the name stuck: 'We took issue with the surrealist painting of Dali, Tanguy, Max Ernst,' said Jean-Paul Mousseau. 'Surrealism is representational, automatism is non-representational.'[8]

Disputes over Automatism

The Montreal exhibition had just closed when Fernand Leduc returned to Paris with Thérèse Renaud and Jean-Paul Riopelle. Along with Frantz Laforest, they set about organizing an exhibition called 'Automatisme.' This name surprised the critic Guy Viau:[9]

> An imprecise term, and limited when it comes to describing the utilization, common to all painters, of ideas prompted by the material itself, chance discoveries, forms which appear on canvas without premeditation. By using this word as the title of their exhibition, the Canadian painters currently showing at the Galerie du Luxembourg apparently want to indicate that it fully describes their method and has become an absolute value for them. Fortunately their works belie such a statement.[10]

The exhibition lasted from 20 June to 13 July; among those participating were the organizers and their friends Borduas, Barbeau, Fauteux, and Mousseau (who, that same summer, was also exhibiting in Prague). Only Riopelle took part in the International Surrealist Exhibition in Paris which opened 7 July 1947; the others declined. In explaining the final refusal of Borduas and his friends, 'the possibility that he did not want to appear on the international scene in a subordinate role to Breton' cannot be dismissed.[11] Certainly Riopelle stated upon his return that as far as the surrealist exhibition was concerned, 'it was not a spectacular success and the

participation of the Montreal automatist group could have completely transformed the situation.'[12]

Breton had been confronted by Riopelle regarding conflicting interpretations of the notion of automatism and had admitted that the Montrealers were right to question the 'pure psychic automatism' of certain surrealists. It is therefore not surprising that Jean-Louis Bédouin, in discussing Riopelle's role, finds it necessary to discuss the polemics over the way this word should be interpreted.[13] Montreal automatism was in fact about to turn into lyrical abstraction, with Leduc and Riopelle in particular leading the way. In December 1947, they were both invited by Gérard Jarlot and Georges Mathieu to exhibit at the Galerie du Luxembourg in Paris 'as part of the new lyrical abstraction.'[14] Bédouin, who has his dates slightly wrong, points out that Montreal automatism was considered a kind of lyrical abstraction which was essentially surrealist in spirit.[15]

The dispute over automatism seems to have lasted much longer in Montreal than in Paris. To start with, the Paris automatists censured those in Montreal because the latter had contributed to the first issue of *Les Ateliers d'arts graphiques*.[16] Later on, the director of one of the few avant-garde galleries in Montreal at the time inexplicably criticized the automatists.[17] A further reason was the fact that Pellan and his friends rebuked Borduas, claiming that he 'had truly impoverished the state of automatism.'[18] This drew a counter-charge: 'Pellan rejected surrealism entirely, whereas for us it had been the one great discovery.'[19] Pellan even accused Borduas of 'indoctrinating his students.'[20]

It is unfortunate that these personal disputes could not have been resolved in a joining of avant-garde forces, but that is probably utopian wishful thinking. Instead, the disputes divided the forces working against Duplessism and compelled the automatists, both writers and painters, to work covertly or go into exile.

Rupture inaugurale

Those who left Montreal had barely arrived in Paris when they found themselves again embroiled in a dispute between the non-Communist surrealists and the revolutionary surrealists. In May 1947, the non-Communist surrealists had founded the group 'Cause,' which sent all its potential members (except obvious Stalinists like Tzara and Vailland)[21] a questionnaire presupposing separation from Communism in all its forms, even Trotskyist. In reaction to this, a revolutionary surrealist group (mainly Trotskyist) was formed and a meeting was called by Arnaud, Battistini, Daussy, and Jaguer for 31 May. They also invited the two Québécois who had just arrived in Paris and were setting up the 'Automatisme' exhi-

bition at the Galerie du Luxembourg scheduled to open 20 June. Leduc turned up but Riopelle declined.

Jean-Louis Bédouin says little about these revolutionary surrealists, perhaps because the role he played in the proceedings was criticized by Breton. It is Pastoureau who talks most about them and who points out that the republication of *Arcane 17* at the beginning of June 1947 had some influence on this dispute simply because Breton stated in it that he had already been less Trotskyist in 1944 than before the war.[22] The revolutionary surrealists published a manifesto on 7 June 1947, *Pas de quartier dans la révolution*. They held another meeting the following week, three days before the opening of the 'Automatisme' exhibition. Leduc refused to go and on 17 June wrote a letter to the revolutionary surrealists saying that he was withdrawing from the movement and criticizing the standing order for a 'common front' between avant-garde artists and the Communist party.[23] The poets Jaguer and Daussy, who had made much of their attempts to define a position between Stalinism and surrealism, were refused support by the party because their brand of surrealist ideology seemed like idealism to the Stalinists.[24]

On 4 July, three days before the opening of the Sixth International Surrealist Exhibition, a manifesto appeared: *Rupture inaugurale, a declaration adopted 21 June 1947 by the group in France in order to make explicit its fundamental opposition to partisan politics in any form. Rupture inaugurale* and, later, *Refus global*, sent their enemies on both right and left packing: while *Refus global* focused on the right, *Rupture inaugurale* concentrated on the left in what was perceived as an official, simultaneous rejection of the Stalinists, Trotskyists, and anarchists.[25] Here are some of its most violent attacks against the party:

> When we are asked by believers in Stalinist Russia about the compatibility of their political allegiance with surrealist activity, we can find no better justification for our resolutely negative reply than to remind those people with such short memories that we, for our part, have always been unflaggingly attached to the revolutionary traditions of the workers' movement – traditions the Communist party distances itself from more day by day ...
>
> We don't hesitate to proclaim once again, as we have many times in the past, that liberation through the revolution of the proletariat is eminently desirable – with reservations, of course, as regards the degeneration of a dictatorship of the proletariat into a dictatorship by one party.[26]

The same position was later defended by *Refus global*. This is not surprising since Jean-Paul Riopelle, a signatory of the Quebec manifesto, not

only signed the French manifesto (along with forty-seven others) but
helped write it as well (using the replies to the questionnaire issued by
Cause) and took part in the exhibition accompanying its publication.

Rupture inaugurale also attacks Christianity using a Marxist critique:

> The present state of the science of historical evolution does not yet
> allow us to predict when, and in favour of which new doctrine,
> Christianity will step down. Marxism as a conceptual framework
> apparently aims at assuring the perpetual renewal of knowledge
> through action and of action through knowledge – that is to say, by
> avoiding the nurturing of any new mythical doctrines. The problem
> is to know to what extent it will take the place of such doctrines. It
> seems to us there is a danger that if no successor to Christianity is
> found when it disappears as a religion, then the politico-economic
> revolution of the proletariat may not ipso facto imply the collapse of
> Christian civilization – which, after all, preceded capitalism and
> would like nothing more than to survive it ...
>
> This ancient Christian framework has been able to transform it-
> self many times throughout history and survive the successive dis-
> appearances of various classes. It has never yet collapsed.[27]

The automatists were invited to sign this manifesto and participate in
the exhibition. Although they refused, preferring to write their own docu-
ment, there remain important similarities between the two texts. This is
evident when the preceding lines by Breton (or the article by Pastoureau
inserted in the catalogue)[28] are compared with the following lines written
by Gauvreau, who later apparently wanted to give Borduas all the credit
for the ideas expressed in them:

> Was there really, as some have insinuated, a 'social disengagement'
> on the part of the signatories of *Refus global*? Obviously not. First
> of all, it must be noted that the publication of the manifesto was in
> itself a social act and remains so. Borduas certainly reached dizzy-
> ing heights in it. With a sense of prophecy unparalleled in the twen-
> tieth century he realized that all attempts at revolution, even when
> adopting an atheistic formulation, would be doomed to failure
> unless they made a clean break with all the mental habits inherent
> in the logical evolution of Christian civilization. The Pauline ethic
> exploited by materialism, and the bias in favour of rationalist effi-
> cacy, both stages in the shrivelling of Christian myth, were only
> shackles preventing the liberation of mankind.[29]

In its closing statement, *Rupture inaugurale* called for an all-encompassing revolution to make way for passion, dreams, and life. All the characteristics of surrealism can be found here:

> While its adversaries on the right and left follow, as if mesmerized, pitiful tactical considerations or get trapped in pointless strategies, surrealism looks to the future. Its animating passion remains its first and most important principle, *both protecting and exposing it* ...
>
> Surrealism demands that the Revolution encompass man in his entirety, not thinking of his liberation in one area alone but in all areas at once. Because of this, surrealism considers itself the only movement qualified to place in perspective the forces for which it first prospected then became a *marvellously magnetic conductor* – from the woman-child to black humour, from objective chance to the will of myth. These forces reside in a passion which is unconditional, overwhelming, mad, and which alone allows man to live unfettered, to evolve according to new psychological dimensions ...
>
> Dreams and revolution are made to unite, not exclude each other. To dream the Revolution is not to renounce it but to accomplish it twice over without mental reservations.
>
> To outfox the unbearable is not to flee life but to embrace it totally without looking back.[30]

After the exhibition closed in October, Riopelle returned to Quebec with *Rupture inaugurale*,[31] which had been simultaneously denounced in France by Christian periodicals (*Foi et vie*), Stalinists (*Lettres françaises*), and Trotskyists (*La Revue internationale*).[32] Claude Gauvreau had nothing but praise for *Rupture inaugurale*, and in a letter to Jean-Claude Dussault, reprimanded the position taken by Maurice Nadeau – a Trotskyist – in this affair:

> I assure you ... that the surrealists haven't 'fallen into the hands of the bourgeoisie.' This error in your thinking must come from Maurice Nadeau's stupid and subjective remarks (remarks which in any case I warned you about).
>
> Surrealism cannot be reduced to the behaviour of one or several individuals. Personal deficiencies and betrayals do not minimise the prophetic nature of the movement. Not all European surrealists are traitors – far from it. As for André Breton, he remains a model of incorruptibility and lucidity. There will always be Mabille, Péret, Pastoureau. Among others, two post-war manifestoes (*Rupture inaugu-*

rale and *A la niche les glapisseurs de Dieu*) prove that the surrealists in Europe are not letting themselves be taken over by idealists.[33]

The Montreal automatists were therefore fully in touch with the disputes raging in Paris. Instead of signing *Rupture inaugurale*, however, Borduas was inspired to draw up a manifesto conforming more to life in Quebec.

Surrational Automatism

Newspaper articles published in December 1947 were already defining Montreal automatism before the publication of Borduas' manifesto. Riopelle had returned from Europe – some of his and Leduc's canvases were being exhibited at the Galerie du Luxembourg – and he had a show in Montreal with Mousseau (back from Prague) at the home of Muriel Guilbault. A discussion took place to which Borduas contributed, and they decided that they had to reply to the public accusations against automatism.[34] Claude Gauvreau took it upon himself to write a defence during the Mousseau-Riopelle exhibition, which was to close on 14 December:

> Generally speaking there are three kinds of automatism: mechanical automatism, which involves the utilization of the human body's purely mechanical and functional movements ... psychic automatism, involving the utilization of the normal dictates of the unconscious which have been received in as complete a state of emotional neutrality as possible ... finally, and this is of particular interest to Canadians, it being their original creation, 'visual,' 'critical,' or 'inspired' automatism.[35]

'Surrational,' the adjective Gauvreau is looking for here, was found several months later and published in *Refus global*. The important point was that the automatists denied the state of emotional neutrality usually considered desirable in automatic writing, and so the notion of lyricism was also applied to such abstractions. These lines were written just when the first exhibition of lyrical abstraction was taking place in Paris, hence the importance of emotion in Gauvreau's definition of automatism:

> This is pure automatism in so far as the materials of the creative act are furnished exclusively by the free play of the unconscious. However, the act takes place in a particular emotional state, a state of inspiration one might say. In certain cases, as the work of art composes itself, the critical process takes its cue from the intuitive gesture, the unconscious gesture which provides the material of the

work and evaluates this material as it appears. The critical process does not precede the gesture but follows it ...

Experience has shown that automatist paintings, products of a steadfast feeling and rigorous submission to the imperious dictates of the unconscious, are visually impeccable. Only a flagging of feeling during its execution can produce wrong notes in a work of art. The problem, then, is to maintain the emotion, the feeling, in as pure and complete a form as possible throughout the execution of the painting. This is an exhausting and demanding undertaking.[36]

Here was something to reassure those who believed that automatism was just a facile way to solve artistic problems. Borduas later took up these ideas when he defined the word automatism in his 'Commentaires sur des mots courants,' an article in the *Refus global* collection.[37]

THE 'PRISME D'YEUX' EPISODE

The manifesto of Pellan's group, *Prisme d'yeux*,* has often been presented as one of the forerunners of *Refus global*.[38] But *Prisme d'yeux* was a pamphlet written for a particular occasion, and its author, Jacques de Tonnancour, has refused to grant it any more importance than it deserves.[39] It is true that the date of the exhibition 'Prisme d'yeux' and its manifesto (4 February 1948) predated the publication of *Refus global* by six months, but there is a lot of evidence that manuscript versions of Borduas' manifesto began to circulate immediately after the Mousseau-Riopelle exhibition.[40]

Apparently Suzanne Meloche, who was to marry Marcel Barbeau, a signatory of *Refus global*, attempted to obtain a copy of the manuscript for the Dominican Father Hyacinthe-Marie Robillard, not knowing that his intention was to denounce it before it appeared. In the end he received instead a surrealist 'object' entitled 'Cher Cocubillard'† which was signed by Claude Gauvreau and illustrated by Mousseau.[41] *Refus global* was also read and signed in Europe by Leduc and his wife before its publication.[42] Charles Delloye, who in 1960 was preparing a special issue of the magazine *Aujourd'hui*[43] along with Borduas, wrote at the time of the painter's death that the manifesto was 'published in 1948 and composed the year before under Paul-Emile Borduas' direction.'[44] There is also this statement by Maurice Perron: 'During the winter of '47–'48 ... a rough draft of *Refus global* had circulated around the group. Borduas withdrew this text and reworked it; the latter text was then published.'[45]

It is clear too from a letter Borduas wrote to Lyman dated 13 February 1948 that Lyman had a copy of the manifesto at the time.[46] The letter was

stern and made irrevocable one of the most important breaks in Borduas' personal relationships:

> Confronted with your lack of enthusiasm, not just in allowing but in engineering the results of last Monday's elections, confronted with the insult, not intended but real enough, implicit in your literary appraisal of a text I passed on to you as a friend (a text which unconditionally engaged my whole being), I find it my painful duty, in order to protect my need for hope and support, to end my relationship with you which has lasted almost ten years.
>
> Knowing you was a blessing from the gods mixed with cruel disappointments. I thank them.[47]

This letter undoubtedly refers to *Refus global*, or at least to an early version of the manifesto: Lyman felt that *Refus global* was 'a mixture of aesthetic and moral notions and emotions,' a judgment which Borduas considered an insulting 'literary appraisal.'[48] The last exhibition of the Contemporary Art Society took place in an atmosphere of nervous excitement because of the two manifestoes making the rounds and Pierre Gauvreau's article, 'Arbre généalogique de l'automatisme contemporain,'[49] which appeared during the exhibition.

At the Museum of Fine Art spring exhibition Pellan took first prize for his *Pot de tabac automatique*.[50] It was a strange twist of fate that awarded the prize to an 'automatist' work by Pellan, who was carrying on a running feud with the automatists. As Jean Bédard put it,

> The automatist movement presented a direct challenge to Pellan by seeming to question his architectural preoccupations and how he spent his working time. In reaction to all this, and because he had an assimilative temperament, Pellan profited from it and the fecundity of chance became a factor in his own revitalization. He called his experiments with chance 'controlled automatism.' From haphazard blotches he attempted to work out a modified representational object ... His paintings began to free themselves from their geometricity; this was replaced by material which expanded and blossomed in 1958 into the magnificent series 'Jardins.'[51]

THE SURRATIONAL AND SURREALISM

The initial idea was to accompany the publication of *Refus global* with a showing, but Riopelle insisted that the automatist manifesto be an autonomous act. Borduas himself felt that the act should be collective and comple-

mented by visual and sculpted 'objects.'[52] The group eventually agreed to Borduas' idea and on 9 August 1948 a collective effort was published. Several articles and reproductions accompanied the lead manifesto from which the collection as a whole took its name.

'Commentaires sur des mots courants'

In the article 'Commentaires sur des mots courants,' signed by Borduas, the word 'revolution' is defined with reference to Mabille: 'Revolutions mark the major stages in the decline of a civilization (of an egregore – Pierre Mabille).'[53] The word 'myth' is itself implicitly defined in relation to Mabille in so far as a myth is presented as having a moment of birth, an apogee, and a time when it must be replaced because of 'groups who use it once they have been rendered immobile by the prestige of past glories.'[54] These notions of the end of an egregore and the birth of a new myth are typical of surrealism's third phase.

Defined 'en regard du surréalisme actuel' (the title of an article signed by Borduas in *Refus global*), the revolution Borduas proposed clearly had nothing political about it. He was in fact criticized for this since people did not understand that the revolution he was talking about was an internal one. 'Life must be changed,' as Breton had said so often, and Borduas agreed:

> Friends of the regime suspect us of supporting the 'Revolution.' Friends of the 'Revolution' suspect us of being only rebels ...
>
> We are supposed to have the naïve intention of wanting to 'transform' society by replacing those in power with others like them. In that case, obviously, why not just leave them there!
>
> But the new leaders, they say, will not be of the same *class*! As if changing class meant changing civilization, changing desires, changing hopes![55]

The questionnaire which formed the basis of *Rupture inaugurale* had asked: 'What is your position regarding the revolutionary desire to "change the world"?'[56] Previous to this, in 1946, Breton had proposed to Artaud and others 'a threefold indivisible objective: transform the world, change life, rebuild human understanding from the ground up.'[57] Borduas accepted the surrealist position that 'changing the world' did not mean a change in political domination but, more profoundly, a change in civilization, in desires and hopes.

Recourse to magic then becomes a way to investigate passion-desire. When *Refus global* cries 'Make way for magic,'[58] it does so in the same

spirit as a surrealist-shaman trying to decipher hieroglyphs recounting those myths which reveal the passion-desires. In 'Commentaires sur des mots courants,' Borduas defines 'magic' as an 'unpredictable transformation brought about by passion-desire.'[59]

'En regard du surréalisme actuel'

'En regard du surréalisme actuel' defines automatism as a Montreal school distinct from the international surrealist movement. It acknowledges Breton's incorruptibility but stakes out Montreal's theoretical position beyond that of Paris:

> The surrealists showed us the moral importance of an act which is not preconceived. At the same time they emphasized that the workings of objective chance should supersede rational content. Their objectives haven't changed. Nevertheless, the statements made over the past few years increasingly reveal that attention is being focused on the author's intentions. Far more attention is given this aspect than the convulsive quality of the works. The result is repeated errors which did not occur when the emphasis was on an empirical approach.[60]

In discussing this article, Claude Gauvreau recalls that a dispute had taken place about the sentence, 'Only Breton remains incorruptible.'[61] Gauvreau took Breton's 'incorruptibility' for granted when he discussed *Rupture inaugurale* with Jean-Claude Dussault.[62] However, in an unpublished letter, Fernand Leduc stated that 'Breton as much as anyone else is corruptible,' and neither Riopelle nor Pierre Gauvreau accepted Borduas' attempt to gloss over a text which rejected all other surrealists en masse by delivering a final eulogy on Breton:

> Dear Borduas,
> We must express our disagreement with the main point in your critique 'En regard du surréalisme actuel,' which you propose to publish with the manifesto *Refus global*, namely that the attention the surrealists had previously given solely to a work's 'convulsive qualities' has recently been transferred to the author's intentions alone, and that this has adversely affected the clarity of their judgments ...
> Surrealist criticism never ceases to combat all rationalization of the movement. Of course, in guarding the movement against the danger

of rationalization, it is not always possible to deny the ever-present temptation to exploit acquired knowledge. An examination of the works themselves, therefore, impartial and unassailable testimony to the strict authenticity of creative activity, must still be done ...

Either surrealism since its inception must be dismantled entirely and arguments advanced to show that no poetic work was possible within its framework at any time (this has yet to be done); or, since you yourself state that the surrealist position regarding intention has not changed, and since we discern a continuing and keen interest on the surrealists' part regarding works which seem to be breaking new ground entirely (witness the attention paid the most recent works of Malcolm de Chazal, Pichette and indeed our own, at least those which they have been able to see and consider), errors of judgment in regard to works which have appeared over the past few years (errors which moreover you do not specify) cannot be used, in our opinion, against the surrealist movement ...

As regards a golden age at the beginning of the movement when errors of judgment were unknown, one has only to refer to the 1929 manifesto to realize that the judgments passed on works and individuals were nothing less than expressions of a sensibility which was always on the alert and of a growing awareness which was continually being questioned ...

Regardless of the forces within society which stultify and oppress our activities, as long as we continue to feel that substantial contributions are being made within the surrealist movement, our beliefs will remain compatible with surrealism.

Jean-Paul Riopelle
Pierre Gauvreau[63]

This dispute widened divisions among the automatists and emphasized the ambiguity in the title 'En regard du surréalisme actuel.' The expression 'en regard' could mean either that the automatists wished to define themselves in relation to surrealism or that they considered themselves members of a movement parallel to, rather than affiliated with, surrealism.

The other articles in *Refus global* are also concerned with the spirit of surrealism, for example, Fernand Leduc's proclamation 'Qu'on le veuille ou non,'[64] or again, Claude Gauvreau's poem 'Raie, fugue, lobe, ale' and his three surrational dramatic 'objects.'[65] Even Françoise Sullivan's 'La Danse et l'espoir' called upon a kind of magic to present a prophetic vision of the future.[66]

Refus global

The manifesto *Refus global* is much better known than the collection of articles named after it. The most important item in the collection, it was signed by fifteen followers (including seven women) and has been republished and debated many times. It seems that Borduas, after talking about 'a fine title, *Refus global*,'[67] regretted the negative interpretation given his manifesto (unlike the title *Rupture inaugurale*, which was completely unambiguous). Although he did write in the manifesto that 'we confront global refusal with total responsibility' the public was more struck by the notion of refusal than by the notion of responsibility.[68]

An analysis of the manifesto's structure reveals an extremely rigorous internal dynamic: Claude Bertrand and Jean Stafford were justified in describing it as 'utopian'[69] and in comparing it to Marxist efforts along the same lines.[70] Built upon a Hegelian dialectic applied to the unfolding of history, it invites comparisons with Marxist thought. *Refus global* is, in fact, composed of three parts:

– An account of the situation before achieving awareness: 'The offspring of humble families ...' The manifesto describes the sorry fate of a Jansenist colony abandoned by the defeated mother country yet confined within the alienating cult of a European past dominated by Catholicism and reason.

– A description of achieving awareness: 'Revolutions, foreign wars break open the sealed-in world ...' The different stages of achieving collective awareness follow, starting with revolutions and foreign wars and ending with inner rebellions against a fear which had reached the point of nausea.

– The outbreak of cultural rebellion: 'In the meantime our duty is clear. To break away completely ...' A new civilization must arise which refuses to be founded exclusively on those tools of reason, logic, and intention. It will make way for magic and the freedom of automatisms.

The manifesto's three parts coincide with the Hegelian dialectic (thesis, antithesis, synthesis) which Marx applied to history. But this structural relationship, even though it has misled several commentators (who have linked Borduas and his friends to Bolshevism), should deceive no one. There is nothing in *Refus global* – no more than in *Rupture inaugurale* – pointing to a rapprochement with the totalitarian dictatorships of the left, which are rejected along with those of the right. The magazine *Parti pris* later pointed out that Borduas was more concerned with rebellion than with revolution.[71]

The list of refusals drawn up by Borduas concerns disputes between automatists and surrealists (for example, on the question of 'intention' in

painting) as well as Borduas' disputes with the Quebec Communists over the refusal of his 'canvas revolutionaries,' as Pierre Gélinas ironically called them, to limit themselves to art alone, and over their willingness to affirm life. *Refus global* also attacks the Christian nationalists to a certain extent when it proclaims: 'Down with the assassination of the present and the future by the frenzied blows of the past.' Despite what critics and politicians thought, the manifesto is not a rejection of the future. On the contrary, it is basically conceived according to a dialectic which is oriented towards the future: 'Ours the total risk that is global refusal.'[72] The title of the manifesto, drawn from the text, is closely related to the ideas of risk and responsibility.

It is clear that Borduas preferred Mabille's vision of a new civilization, a new egregore, to that of Marx and the dictatorship of the proletariat. This was explicit in *Rupture inaugurale* as well. The anarchist fantasies of Breton's *Arcane 17* are also present in the final words of Borduas' manifesto:

> We can imagine, in the foreseeable future, man freed from his useless chains and fully realizing his individual gifts in resplendent anarchy under the inevitable if unpredictable rule of spontaneity.
>
> Until then, without rest or pause, sharing the feelings of those who thirst for a higher mode of being, unafraid of long delays, whether encouraged or persecuted, we will joyfully pursue our primordial desire for liberation.[73]

The rebellion preached by Borduas was an automatist rebellion and hence a rebellion of an essentially personal nature. Twenty years later the signatories still insisted upon this fact. Marcelle Ferron declared: 'Since *Refus global*, like automatism, was grounded in spontaneity and freedom it suited me perfectly, and that's still the way I am.'[74] Françoise Sullivan said that she would be willing to relive the experience, 'Precisely because it did emphasize love and freedom.'[75] It was a question of how to live, then, a question of personal choice. Borduas later passed a pessimistic judgment on his manifesto and downplayed its merits, but his comments were directed more towards automatism's global importance. As time went on, he felt its impact was minimal because, despite his efforts, it had been considered part of the mainstream of surrealism rather than parallel to it:

> Despite the spiritual elements in *Refus global* its effect on the world was negligible – French, English, Japanese, and American echoes notwithstanding. Foreign reactions immediately classified the text as part of the surrealist output which was receiving a lot of attention at the time, without recognizing the differences between the two

movements. Canadian critics were no more enlightened, quite the contrary, and that's where things were left. Later a similar movement, fortunately quite distinct from surrealism, arose in various places. This movement did have universal impact. New York was mainly credited with starting it, and obviously no acknowledgment was owed us. There remain only the invisible advances towards unforeseen consequences about which no one can speak, but messages about them of the strangest sort reach us from time to time.[76]

Surrealism Day by Day

Although the social and cultural effects of *Refus global* were slow to appear in Quebec, they turned out to be more considerable than Borduas had foreseen. Initially few critics reacted favourably. However, Madeleine Gariépy did publish a sympathetic interview with Borduas early on when the manifesto was already known within his circle before its publication.[77] Henri Girard was also sympathetic and attempted to apply to Borduas the notion of abstractionism as defined by Breton.[78] However, each month, each week, and sometimes daily the negative criticism mentioned by Borduas roused debates on surrealism which involved people in the very forefront of Quebec intellectual life. These people for the most part later mitigated the severity of their initial judgments.

The polemics surrounding the surrational manifesto began on 5 August with an article in *Montréal matin*.[79] It widened on 15 August, mainly as the result of an interview conducted by several journalists in *Le Petit Journal*, among them Pierre Saint-Germain, who grilled Claude Gauvreau.[80] Saint-Germain then ridiculed *Refus global*:

> A superior offshoot of cubism ('Picasso is still stuck there') and surrealism (already 'behind the times') transplanted from the pictorial plane where it was born, surrational automatism seems to be, in the words of the precious lexicon provided by its followers, the happy discovery of the Frenchman André Breton. The Montreal automatists have used this word as the cornerstone of a system that is the precursor of 'surrational monism,' a new religion which will bring an end to the 'splitting' of man's psychic and physical potential ...
>
> But our automatists may not have achieved the nec plus ultra, having just learned that a Rumanian named Trost has recently published a 'surautomatist' manifesto ...
>
> The accumulation of 'instinct-words' are not nearly as evocative and powerful when used by the young Gauvreau as they are when used by Miller in his famous *Tropics*. Nevertheless, the Montreal

author does regale us with 'hedgerow juice,' 'purple moo's' and the interjection 'Ear of woman and pink pigskin!'[81]

This article drew a violent response,[82] but several days passed before the critics moved beyond sensationalism and the debate became the subject of editorial comment in the newspapers.

In fact the articles published in the first month after the appearance of *Refus global* seem to have had little effect.[83] Then the newspaper *Notre Temps* took up the attack on Borduas with an article entitled 'Le Manifeste de nos surréalistes' by Father Hyacinthe-Marie Robillard.[84] Roger Duhamel, André Laurendeau, and Gérard Pelletier also joined the fray. Duhamel, the literary critic of *Montréal matin*, criticized *Refus global* in an article which appeared on 14 September.[85] Father Robillard attacked again in a Quebec City newspaper on the 22nd of the same month.[86] And the next morning in the newspaper *Le Canada*, writing about the founding of a poetry society, Guy Jasmin took the opportunity to make the following comment on the Borduas case: 'Let us note the fact that a professor at the Ecole du meuble has lost his job for having signed a cultural and artistic manifesto. With a government in power that enacts padlock laws it was only a matter of time before they tried to exercise controls over literature.'[87] Jasmin thus drew the sympathy of 'liberals,' a sympathy motivated not so much by the manifesto's contents as by the opportunity to attack the Duplessis regime. This stance was to provoke further polemics.[88]

André Laurendeau then took a stand, an item in his own newspaper regarding Borduas' dismissal having given him a new argument against Duplessis' autocracy:[89]

> It is easy to see how the minister's action will be defended. Morality will be invoked, and all the foolishness in *Refus global* – the 'surrational' manifesto which is at the heart of the affair – will be laid open to censure. The viewpoint expressed in the deputy minister's letter will be repeated and developed, namely that 'A demand for his resignation will be submitted to the Public Service Commission because the writings and manifestoes he has published, as well as his attitude, are not of a kind to encourage the education we wish to give our students.'
>
> But this issue does not concern us here. We do not want to discuss the justifications provided. We denounce this direct intervention in the field of education by a political power.
>
> The affair is all the more serious since Mr Borduas' ideas will not be received sympathetically anywhere. With his *Refus global* he has

separated himself from the world around him and from us in par-
ticular. The indignation his ideas have aroused will perhaps prevent
many people from viewing the case objectively ...

Clearly the issue goes beyond Borduas the individual and the
errors he has committed.

We are taking this stand all the more vigorously since, as far as
we are concerned, Mr Borduas is an enemy on both the intellectual
and moral level; no one can therefore pretend that we are only
defending a friend.[90]

This wide-ranging text (written in opposition to both Borduas' text and
the act of ministerial censure) was typical of *Le Devoir*'s attitude during the
months of polemic to follow. It delineates a line of conduct which was at
once strict, ambivalent, and sincere. The automatists, however, seem to
have ignored Laurendeau's position until Gérard Pelletier entered the
fray. Denouncing Roger Duhamel's article as 'in the stuffed-shirt tradition,'
Pelletier wittily attacked the contributions of Borduas' disciples to *Refus
global*. But his attitude towards the master was just as severe as Lauren-
deau's:

We have already encountered André Breton's *Manifeste surréaliste*
and his *Poisson soluble*; the magazine *VVV* with its weirdly designed
covers has also caught our attention. We are therefore familiar with
the kind of shock and scandal that burst over us recently with
regard to Claude Gauvreau's poems.

Why shouldn't we accept automatism as just a hobby after all?
When Gauvreau declares that 'the shurry bubblies,' I don't feel it
necessary to contradict him. In the first place, since it is impossible
to verify the truth of this assertion, there is no reason why it
shouldn't be so. Late in the evening after a hard day and a few
beers, the 'shurry' could very easily 'bubbly.' Why shouldn't it 'bub-
bly'? Especially if we admit that the 'Cléonte breltchère dans sa
nuée populiste et bouleversement' ... it's really all of a piece, isn't
it?

I can even accept as quite normal that young people will 'auto-
matize' furiously. The truth is that our country lacks teachers, that
a profound unease torments our youth and that they are alone in
their search for the light at the end of the tunnel. I would gladly
take issue then with Duhamel regarding his statement that these
verbal gymnastics are purely 'literary and reveal nothing except a
preoccupation with style.'[91]

Pelletier went so far as to question Borduas' honesty:

> Borduas pontificates like a prophet, completely scornful of any kind of demonstration or 'rational' proof ... Here is somebody who is no longer 'young' nor completely 'surrealist' and even less honest. Here is someone who would reinforce a sectarian state of mind and whom we would not find amusing. This new style of dogmatism is much too similar to that which the author condemns.[92]

Pelletier only roused further hostile debate by impugning Borduas' integrity in this way.

Two days later, Laurendeau came back to the subject and, attacking Duhamel's position, protested that the affair should not be considered closed:

> We have denounced this direct and unprecedented intervention by a political power in the field of education. The literary editor of a morning sports tabloid doesn't want to know what it's all about. He gives us lessons in morality ... The question is more serious than the literary editor of a sports tabloid could imagine. We must reopen this debate.[93]

Claude Gauvreau attempted to reopen it by invoking Flaubert's trial, Baudelaire's condemnation, and the stoning of Manet, at the same time pointing out that 'government schools aren't denominational.'*[94] This letter was immediately replied to in a note from the editors, who refused to continue the debate if Borduas' merits as teacher and artist were brought into it. As far as Borduas' 'extracurricular activities' were concerned, '*Le Devoir* has stated its position twice on the subject and does not intend to modify its stand.'[95]

Le Quartier latin continued the debate while *Le Devoir* got bogged down in a dispute for which Borduas in the end was only a pretext.[96] Taking his cue from the title of Gérard Pelletier's article on *Refus global*, 'Deux âges – deux manières,' Pierre Lefebvre in a piece entitled 'Notre manière' indicated the direction the new staff of the university newspaper intended to follow. Towards the end of the article Lefebvre wrote: 'To a limited extent, at all levels of society we find people who refuse to bow down before ancient traditions. Some even go so far as *Refus global*, which lays bare in an excessive and violent manner such as one might expect to find among artists the real weaknesses of our intellectual life.'[97] Three days later, in the same newspaper, a student defended Borduas' honesty:

A teacher is not just a teacher, especially in Quebec where one cannot survive merely by teaching. Borduas is a painter. Don't artists have the right any more to shoot their mouths off and write manifestoes? Why should one of the most important men in the history of our art be forced to remain quiet when he feels like theorizing? The problem might have been different if the author had used the authority of his teaching position in signing *Refus global*. He might also have been liable to censure if he had expounded on his theories in his lectures. But he was too honest for that, as his superiors are well aware. He has used his summer holidays to publish, separating as best he could his manifesto and his teaching.[98]

The tide began to turn. Esther Van Loo wrote in the French newspaper *Arts* on 15 October that 'Paul-Emile Borduas ... has fearlessly embraced surrealism – one could even say, without wishing any disrespect, that he's jumped in with both feet ... Borduas is the great Canadian avant-garde painter.'[99] On the 18th of the same month, an anonymous item in *Time* possibly written by the magazine's Montreal correspondent Stuart Keate stated that 'Borduas has become the leader of "the surrational automatists," a group of sixteen young artists.'[100] As for Breton, he reacted favourably to *Refus global*, saying that in the Quebec manifesto 'surrealism saw itself reflected as if in a mirror' and that its author had gathered 'around himself a constellation of young poets and artists whose fundamental inspirations were in line with those of surrealism, even though in the final analysis divergences did occur since they were of a different generation.'[101]

The tone of the debate in *Le Devoir* began to change. The support from *Le Quartier latin*, *Arts*, *Time*, and international surrealism undoubtedly had some effect. There was also an open letter by Jacques Dubuc which attacked his friend Pelletier's 'Deux âges – deux manières' because it had impugned Borduas' intellectual integrity:

> Your criticism of Borduas is very unjust ... Borduas is a man of admirable intellectual sincerity. (I don't want to talk about his high sense of morality, although it would be nice if someone were to render him this justice.)
>
> His text is a series of historical judgments which lead him to a refusal of life as it is lived today.
>
> He does not substantiate his judgments, not because he is unable to, but because they appear self-evident to him ... Let's examine his text as an art connoisseur might examine a painting, his senses on the alert, trying to place himself in sympathy with the work and making full use of his intuitive faculties. All of a sudden everything

changes. The text reveals its true worth, inspired in certain places, often quite admirable in its lucidity, revealing many things about life and the world; it is an almost prophetic glance into the future ...[102]

Since the rest of this letter is a rejection of surrealism, Jacques Dubuc and Gérard Pelletier (who, it should be noted, 'agreed with the charge of superficial criticism' but added, 'I am tempted to stand by my two main points')[103] were taken to task by five signatories of *Refus global*: the two Riopelles, Maurice Perron, Magdeleine Arbour, and Pierre Gauvreau.[104] Their letter was answered by Pelletier, who regretted that he did not have a magazine at his disposal to present his ideas. Perhaps one can see the genesis of the magazine *Cité libre*, founded by Pelletier and Pierre Elliott Trudeau in order to present the views of leftist Catholics, in this more sympathetic response:

> You ask us what we find acceptable in your manifesto and what values we are trying to defend against you. Unfortunately, our reply here must be very brief. We have at our disposal neither a magazine nor the 15 pages of your manifesto ...
> To a large extent we accept your criticism of our social institutions: the exploitation of the poor by the rich, the utilization of fear, the modern pretense that everything can be ruled by reason alone, pernicious intellectualism, the alienation of much contemporary thinking, the absurdity of war, the selfish exploitation of certain religious truths ... And the sympathy we feel for you is based upon these insights, since we deny all these mystifications too.
> However, as we have already said, our refusal is not global.[105]

Pelletier then shifted the debate onto religious grounds but in a perspective appreciably different from the Christianity the Québécois were used to, a perspective which would be reflected in *Cité libre* founded some months later. This approach drew a final warning from the five signatories mentioned above:

> You share our refusal to some extent, but only in so far as minor points are concerned; this is easy to do and leaves communication open between us. You reject the use of fear, but you believe in sin and grace. We believe your rejection is useless if you do not reject this fundamental fear of God which allows all kinds of exploitation while promising a deferred happiness.[106]

Like Pelletier, Jacques Dubuc centred his defence on Christian thought, a fact which leads one to believe that all these statements, both pro and

con, were falling on deaf ears.[107] Claude Gauvreau wrote the final text in this polemic but it was not published,[108] and the dispute dwindled away in a series of futile confrontations.[109]

In the course of time, however, several of the participants had a change of heart in Borduas' favour. This was the case with Rolland Boulanger, the editors of *Cité libre*, Pierre Vadeboncœur, and Jacques Ferron.[110] In February 1949 Vadeboncœur published an article in *Liaison*, a magazine whose official critic was the reactionary Géraldine Bourbeau. Certain comments in it were worthy of Bourbeau herself:

> I have a few things to say about Borduas and his disciples, who seem to represent Breton's school quite faithfully. Apart from a few beautiful works, their naïveté, their ridiculous messianism, their pretension, their slogans have led me to consider them, along with their European masters, as the perfect examples of men who use their authority, their ideas, and the prestige of a few famous names to proclaim all manner of foolishness, only to swallow it whole themselves.[111]

Twelve years passed before he retracted these words, stating in 1961 that 'Borduas' work in particular marks the beginning of a revolution.'[112] Then in his book *La Ligne du risque* published in 1963, he took a stand which won over many who had been undecided and explained the reasons for both his past rejection and his new acceptance:

> Several of us thought our history was over. We felt that within the mass of the people, within their institutions, there was an invincible inertia. Our admiration for Borduas was boundless, but we thought his efforts wouldn't lead anywhere. The future of French Canada seemed doomed to failure. This was the state of affairs less than ten years ago ...
>
> His act was unprecedented. The truth is that he broke up our institutionalized paralysis. He destroyed it in a single blow with his global refusal and he was the first, as far as I know, to do this. Nobody before him had ever shown any inclination to change. Everyone more or less dodged the issue. Virtually nobody had cared enough about the soul to finally attempt a worthwhile experiment. Borduas relied completely on the soul. He risked everything. French Canada as we know it begins with him. He taught us a fundamental lesson we never knew before. He let loose the liberty in us.[113]

Some intellectuals point to Pierre Vadeboncœur's reversal as the start of their own reconciliation with Borduas' thought. Jacques Ferron, for exam-

ple, who kept his distance from the automatists (even though his sister had signed *Refus global*), explains in his *Historiettes* the paradoxical nature of his relationship with Borduas and Pierre Vadeboncœur's role in the evolution of his thought:

> A small elegant man, with a badly-fitting set of dentures, a tiny bald gentleman who had his stomach removed because of ulcers. This was the man who acted out a vision of global revolution just to change the course of painting ... If it is true, as I now believe, that painting is in the vanguard of society, it is not surprising that Pierre Vadeboncœur, a politician with no feeling for the arts, a man almost touching in his seriousness and honest, of course, claims Borduas as a master and lines up all of Quebec, even the archbishops, behind him.[114]

As for Gérard Pelletier's and Pierre Elliott Trudeau's *Cité libre*, the viewpoint of the magazine and that of automatism were often similar[115] (Borduas always liked its frankness).[116] The attacks from the right never stopped, however. Clarence Gagnon, in a lecture whose title referred to the modernists' 'bluff,' decried those who attempt 'to create without the necessary qualifications or the creative ability to do so.'[117] Roger Viau (not to be confused with Jacques or Guy Viau at whose gallery Borduas exhibited from 14 to 26 May 1949)[118] denounced Borduas' 'tedious ... style,' Pellan's 'lack of proportion,' Jacques de Tonnancour's 'housepainter's brushes wielded by a child under ten.'[119] And Géraldine Bourbeau wrote of Borduas that 'his surrational art exists only in his imagination, masquerading as philosophy. Merely wishing to be a philosopher doesn't make it happen.'[120] She criticized Marcelle Ferron ('formless forms') and Jean-Paul Mousseau ('still knee-deep in automatism'), then threw both of them a superb bouquet of insults: 'Nothing good can be said about these two artists, since that's what we have to call them.'[121] As far as Baril was concerned, she had her doubts: 'Baril's surrealism is alarming.'[122] Denys Morisset attacked even more violently (if that were possible), and declared without beating about the bush that 'this hobby-horse of introspective mania ridden by the automatists yields nothing but very poor fruit ... I couldn't care less about Borduas' internal visions and other such hoaxes.'[123] Borduas was a continual thorn in their side, and the surrational manifesto was for several months the subject of an ongoing debate about surrealism.

It was not until fifteen years later that critics following in the footsteps of Vadeboncœur, Tougas, and others conferred a more positive and almost legendary reputation on *Refus global*.[124] *Situations* devoted an issue to '*Refus global* dix ans après' and another to Borduas when he died. *Refus*

global was almost twenty years old when *Parti pris* put out an issue entitled '*Refus global* lives' (April 1966) and older still when *La Barre du jour* devoted an issue to the automatists in 1969. Eventually *Refus global* became a mythic event in the eyes of a young generation searching for freedom. This myth, however, had nothing to do with the nationalist and often fascist ideology of L'Action française, no matter what Jean Ethier-Blais claims when he surprisingly presents Borduas as a disciple of Lionel Groulx and *Refus global* as a by-product of nationalism:

> *Refus global* took up the great nationalist themes in a new style marked by excess and sarcasm. The manifesto only appeared revolutionary to those who had not followed the progress of Abbé Groulx and his friends; it seemed dangerous to Maurice Duplessis precisely because it underlined the extent to which the ideas of L'Action française had entered the collective consciousness. In a way *Refus global* was the logical conclusion of Abbé Groulx's work ... But Borduas' offensive stopped short.[125]

The gap between Borduas and Groulx is as wide as the one between Breton and Maurras: Groulx's myths of race and religion are not to be confused with Borduas' new myth of an automatist egregore.[126]

Projections libérantes

After his dismissal from the Ecole du meuble, Borduas started drafting a second manifesto which he finished in February 1949. *Projections libérantes*, like *Refus global*, is a text with one dominant theme and, like the previous manifesto, its structure is based on a movement from the past to the future:

> Introduction: 'a reprieve'
> 1 Resumé of the situation: 'Let's go back to the end of September 1927 ...'
> 2 A description of reaching awareness: 'It is at this stage of development ...'
> Conclusion: 'After these liberating projections ...'

Here, as in *Refus global*, the title has been drawn from the text. Borduas' method is also similar: the first half is devoted to a historical account and the second to a judgment on this account. But instead of devoting the third part of *Projections libérantes* to the outbreak of cultural rebellion as in *Refus global*, Borduas preferred to invoke the former manifesto at the end of the second part:

The one great duty is to spontaneously order a new world in which the noblest emotions can flower in great numbers, *collectively*.

Only humans are humane. Each individual is responsible for all his brothers, now and in the future! For all his brothers, for their material and psychic ills, for their misfortunes!

It was in order to respond to this unique duty that *Refus global* was written.[127]

It is interesting to note the parallels in structure between *Refus global* and *Projections libérantes*, since this similarity in presentation and ideology pulls together what in other respects are quite different works. *Refus global* is a subjective interpretation of social and historical events, whereas *Projections libérantes* attempts to be an objective interpretation of a private life. *Refus global* is a new interpretation of Quebec history; *Projections libérantes* is a vindication of the attitudes taken before, during, and after the writing of *Refus global*, the vindication of a man who rejects the coalition of 'blind-egotistic'[128] forces and aligns himself with friends who have 'purity – integrity.'[129]

As far as surrealism is concerned, Borduas tells in *Projections libérantes* how the children he taught to draw 'opened wide the door of surrealism';[130] he writes, 'For us it had been the one great discovery.'[131] *Projections libérantes* also describes in detail the relationship between Leduc and Riopelle and the European surrealists:

> Riopelle returned from Paris. He was quite a hit with the surrealists who let him see what the future on that side of the ocean held in store. Fernand Leduc was still in France. Unlike Riopelle, he couldn't agree with André Breton. Leduc continually sought new contacts: non-orthodox Communist surrealists, the young poet Pichette and his friends, etc. His demanding nobility of spirit prevented him from attaining anywhere the sense of belonging he desired.[132]

Borduas' thoughts on the diverging tendencies of Riopelle and Leduc then lead him to explain his need to publish the collective manifesto *Refus global*.[133]

Projections contained other significant concepts as well: for example, the manifesto describes an education based entirely on personal experience, and these pedagogical ideas were considered new at the time. One short sentence in the manifesto, 'The consequence is more important than the goal,' was later picked up by Gauvreau who used it to explain his 'explorean'* language. The manifesto also included powerful prophetic passages such as the following:

My unshakable faith is proof that I will be victorious in the end ...
The route I have chosen will one day lead to victory, even if it
comes one hundred years after my death ...

Gentlemen, your power is in its final stages. I feel that very soon
hundreds of men will rise from the lower depths to scream their dis-
gust, their mortal hatred, in your face. Hundreds of men will
reclaim their inalienable right to life. Hundreds of men will reclaim
their right to passion-labour and will vomit up your meaningless
and sterile slave-labour. Hundreds of men will rebuild a society in
which it will be possible to move about without shame and to think
out loud and clear.[134]

Borduas had a presentiment of how important the automatist revolution
would be in Quebec's cultural future after the Duplessis era.[135] Already the
automatists had publicly opposed the Duplessis regime with regard to the
enforcement of the 'padlock law' in 1947, and later in 1949 they opposed
police intervention in the Asbestos strike.

A Personal Letter

After *Projections libérantes*, Borduas tried a third time to rally his group
around a written statement, *Communication intime à mes chers amis*. The
word 'amis' in the title underlined Borduas' attempt not to present himself
as a master nor think of the automatists any longer as disciples, but to
treat them as equals.

Communication intime à mes chers amis is a collection of three pieces written
between 1 and 9 April 1950. Guy Robert was the first critic to consider
these texts important, but he does not seem justified in concluding with re-
gard to the second text entitled 'En guise d'introduction écrite en post-
scriptum' that 'this is a far cry from the *Refus global* manifesto.'[136] On the
contrary, the following is still very much in the spirit of *Rupture inaugurale*:

The war must be carried on at the highest level, in full objective
mystery, at the burning centre of our native land; it must be car-
ried on with the most powerful love at our disposal, with the cer-
tainty that eternally renewed and delayed victory will be won by
the man who marches on over the man who halts, the man who is
open over the man who shuts himself in, a man most loving, most
luminous.[137]

The third piece, 'Ce n'est pas encore tout à fait ça,' like *Projections
libérantes* includes autobiographical events and reflections on certain events

subsequent to *Projections*, especially those concerning Borduas' disputes with Riopelle, who accused him of paternalism. Borduas points out that this so-called paternalism is in fact an entrepreneurial role, and again refers to the necessity for breaking away: 'As for this feeling of paternalism, I'm passing it on to the whole universe, to anyone who gives himself to the betterment we seek within our lifetimes. I feel I must break away from all those people who deny this need for improvement: by breaking away I mean a complete denial of those persons within myself.'[138]

The *Communication* completes the cycle of *Refus* and *Projections*. This need to break away can be traced back to his resignation from the position of drawing teacher in 1928. The following text from *Projections* deals with the breaks of both 1928 and 1948: 'My first break with the academic world, which was followed by almost total isolation, is no more than a memory. A social duty which passionately defines itself every day will lead us to a second awareness and a new break, the surrational manifesto.'[139]

THE POETS

On 20 May 1947, Claude Gauvreau's play *Bien-être* was performed at the Montreal Repertory Theatre; on 9 August 1948, it was published by Mithra-Mythe in the *Refus global* collection along with two other dramatic 'objects,'* *Au cœur des quenouilles* and *L'Ombre sur le cerceau*. On 3 April 1948, the automatists staged a choreographic interpretation of a poem by Thérèse Renaud read by Claude Gauvreau and set to music by Pierre Mercure, with costumes by Jean-Paul Mousseau. That same year, after the publication of *Refus global*, the automatists published *Le Vierge incendié*, a collection of poems by Paul-Marie Lapointe. Claude Gauvreau later had several radio plays produced on the CBC series 'Nouveautés dramatiques'; these included *Le Coureur de marathon*, broadcast 18 February and 15 June 1951 (for which he was awarded a CBC prize), and *L'Angoisse clandestine*, broadcast 24 August 1951. Rémi-Paul Forgues carried on with a poem published in the periodical *Place publique* in March 1952. Gauvreau then returned to radio with *Le Domestique était un libertaire* (28 August 1953), *L'Oreille de Van Gogh* (6 February 1954), *Lendemain de trahison* (27 August 1954) and *Les Grappes lucides* (12 August 1955). He subsequently published four dramatic objects in rapid succession brought together under the title *Sur fil métamorphose*, as well as a collection of poems, *Brochuges*.

Claude Gauvreau

Certain members of the automatist group achieved fame early, but while this may have been true of painters like Jean-Paul Riopelle it was not so for

the poets. Rémi-Paul Forgues and Bruno Cormier abandoned poetry after a few years. Thérèse Renaud only returned to writing in the late 1970s, while the two most prolific members of the group, Claude Gauvreau and Paul-Marie Lapointe, were so rarely discussed that their work remained in eclipse for decades.[140] Gauvreau's literary output was copious (some several thousand pages) and diverse: dramatic objects, 'pure poetry,' novels, plays, and essays both critical and polemical.

Gauvreau's first literary revelation came through Father Pierre Angers,[141] who introduced his friend Bruno Cormier to Claudel:[142]

> When I was fifteen, at the urging of my brother and Bruno Cormier, I discovered Paul Claudel.
>
> Considering my state of mind at the time, this was a revelation of the first order. I should add that Claudel's work as a playwright, especially in the early plays, is not without its virtues ... I discovered Claudel about the time I was beginning to write (a book by Francis Jammes prompted me to start).
>
> Curiously enough, Claudel never had an aesthetic influence on me except during a brief transitional period when his influence was genuinely unconscious.[143]

The Dramatic 'Objects'

This period of transition produced Gauvreau's first written work, *Les Entrailles*. It is composed of twenty-six dramatic objects, three of which were published in *Refus global*, four in *Sur fil métamorphose*, and three in *La Barre du jour*.

In 1950, Gauvreau stated in connection with *Les Entrailles* that he was 'absolutely determined to see these twenty-six separate objects published under one cover, since they represent a coherent progression which would be instructive if viewed as a whole.'[144] Indeed he was right, for the work shows how its author naturally evolved from Claudel's symbolism to Apollinaire's cubo-futurism before arriving at automatism. Gauvreau made the following observations about this progression:

> Assimilation of the past (mediated and immediate) makes innovation possible in the present. If we had to stick to formulas abstracted after the fact from real experiences in the past, how could a present form, suited to present opportunities for curiosity and investigation, ever see the light of day?
>
> If I say 'Mallarmé is a symbolist poet,' that means 'romantic experience + parnassian experience + something new.'

If I say 'Henri Pichette is an automatist poet,' that means 'romantic experience + parnassian experience + symbolist experience + cubist experience + surrealist experience + something new.'[145]

The stylistic evolution of Gauvreau's objects illustrates this process. *Les Reflets de la nuit*, for example, is a dramatic object somewhat reminiscent, as the author himself pointed out, of Claudel's early plays as regards structure, while the narrator calls to mind later plays such as *Le Soulier de satin* and *Le Livre de Christophe-Colomb*. In terms of sonority the names Frédéric Chir de Houppelande, Hurbur, and Corvelle in *Les Reflets de la nuit* recall the names Sygne de Coûfontaine, Simon Agnel, and Violaine by virtue of their oddity and appeal to the ear. But the Claudelian tone of this play is inspired less by the visionary experiences of Paul of Tarsus than by those of Rimbaud. It presents an infernal world where the tortured night of the soul is illuminated only by spectral light emanating from some murky deep: 'His words languish like tea leaves on the sea floor, he is brother to the owl and his voice is the owl's sister, his rhythm rests in the oil and twists therein and tempts the brains of the girls of the green fog, his panting hand is the spectre of coagulated nights ...'*[146]

Claudel's *L'Endormie* takes place in an undersea cave and exploits an image which reappeared in Gauvreau's work, that of astral milk:[147]

The moon will go down on my belly and the reply will flow from the squeezed udder of the star.[148]

The celestial creamery toils all night and the bright liquid flows from every corner in the universal sleep. Only drowned people can smell it. And the largest breast of all blooms in the centre. It is the moon.[149]

The second piece in *Les Entrailles*, *La Jeune Fille et la lune*, is not all that different in tone and style from Claudel's *L'Endormie* or his *L'Ours et la lune*. Like the other objects in *Les Entrailles*, its staging and short playing time also recall Claudel. *La Jeune Fille et la lune* takes place on the ocean floor and presents the image of 'green mist,' which Claudel links to an infatuation with the moon:

The city was raising its hunchbacked bulk into a headland and the drowned woman's lowered eyelids saw the touch of her coldness through the green fog ...

(Still floating, she begins to rise in the light of the moon ...)
Clutching the moonbeam lovingly she rises up to the moon. She
embraces the moon.[150]

In Claudel's *L'Endormie*, Danse-la-nuit relates how Galaxaure too escapes
from the green waves in order to offer her body to the moon.[151]

The style of Gauvreau's third object, *La Prière pour l'indulgence*, is com-
pletely transformed and seems to have been influenced by Apollinaire's
cubo-futurism.[152] Geometrical forms and mechanical symbols abound:

Hoops interlace, the tear blooms in stupor.
Yellow curtained door, the elk went through you.
The opaline ashtrays begin to dance.
Clock hands, auto bodies.[153]

Gone are the underwater settings and the season in hell with nymphs
and fauns drinking the Milky Way.[154] Gauvreau himself made explicit
Apollinaire's influence at this stage in his career:

The moment I managed to free myself from Claudel's grip, I began
to produce work that was valid in my own terms. An accidental
encounter with Apollinaire's poetry was very important in this pro-
cess of emancipation ... even though the objects in question, inspired
by the liberating force inherent in Apollinaire, have little in com-
mon with the great cubist poet's work when one compares them
now.[155]

The next object, *La Statue qui pleure*, also owes a lot to Apollinaire's
cubo-futurist style: the images include a bell, plow, hammer, saw, drill, a
mechanical bird with its feet tied down, tiles, pins, scissors and lighthouses.
But it is not so much the above battery of objects as the hallucinations,
the cemeteries, and the anguished howls of the surrealist universe which
characterize this object.

The asbestos palaces spinning in slow motion towards the hollow of
the poison skirts.
Green teeth hallucination! which stretch out like slobbered taffy.
The shelves where pusillanimous skulls are labelled.
Plough handles lost in the cemetery while dessicated poverty howls
melancholically at the dazzling polish of love.
The man with the evaporated cheeks listens to the hammer on his
skull. Man, I've shit tuns of laughter on you.

Today I see the saw which is tediously lopping the rotten legs.
Chapped hand wrinkled hand.
Are you one of those who drill out navels?[156]

There is a lot of Gauvreau and not much Apollinaire in *Le Drame des
quêteux disloqués, Bien-être,*[157] *Le Rêve du pont,* and *Au cœur des quenouilles.*
Nostalgie sourire, moreover, marked the first appearance of a language
which would assume increasing importance in *Les Entrailles* and in Gauv-
reau's later work – the language of surrationalism. These first traces of
automatism seem to have appeared when Gauvreau began frequenting
Fernand Leduc's studio.[158] There is, for example, the mysterious language
spoken by Gehur: '(The voice of an unknown man comes out of Gehur's
body.) / THE VOICE——Opal-Hung———serri-kamuzi-lel!'[159]
This might have amounted to nothing more than a parody of exotic
language as in Molière's *Bourgeois gentilhomme,* but the following object,
Le Soldat Claude, also makes occasional use of certain surreal words which
would become more and more frequent in Gauvreau's work: 'The bully-
boys' battlefield hangs over me and over him at the moment of a solemn
spiritual peepee. The ecstasies of the twentieth year, called fornicuntorial
galusheries, have answered to the echo of man.'[160]*
However, *Le Soldat Claude* still contains numerous cubo-futurist images
(icebreaker, mica, train), and Apollinaire is named explicitly: 'I am the one
who's talking now: Tell me, O Apollinaris, am I carnivorous? ... Ivory
rattles, Apollinaris of the Poets chirps in the feline air.'[161]
In the following object, *La Nymphe,* the twelfth in the series, the names
of Fernand Leduc and Jean-Paul Riopelle have been transformed into Fer-
nando and Xiopelle, just as Apollinaire became Apollinaris in the passage
above. There is little doubt that Leduc's mechanical objects and Riopelle's
lyrical abstraction worked their influence on Gauvreau, who then set about
trying to perfect his own brand of non-representational literary automa-
tism. Here is an example:

FERNANDO – The mesh Bonnard let fall on his model.
THE NYMPH – Xiopelle, hear me yell!
GUSTAVE – Why not Gustave?
THE NYMPH – Attention, circusive chimpanzees! Ti-Ro thought I
wouldn't give birth again; but touch the belly of my conscience,
palpate the newborn baby's cry. I'm delivering like a cornucopia.[162]

In *La Nymphe,* Gauvreau continues speaking of consciousness in symbo-
list and representational terms. In *Apolnixède entre le ciel et la terre,* however,

the influence of 'Fernando' and 'Ti-Ro Xiopelle' elicits a non-representational language which was Gauvreau's own discovery:

APOLNIXEDE – Now brook myjellisdance
The bits, the butts offeye finance.
Down downadown come the time when pallor downs the adon.
I'm dying chiefs. To the god of craifs.
Apolchidance. Crapried ovgreen.
Air clean on the greenfeed screen ...
And thair izere to the son of the Even Eeng.
Down downadown derry down to the slogg of the eiderdown.
Downim in the paradeye of the dry lyin.
Pit to the pit of the undarm. They will speak the tongue of the
 kneeling drept. [163]*

Gauvreau is, in fact, speaking a cryptographic language ('langue du crepte') widely used by the cubo-futurists. In *Les Peintres cubistes*, Apollinaire had emphasized the importance of this language in the 'explanatory' titles accompanying cubist paintings. Francis Picabia subsequently created titles like *L'Œil cacodylate*.[164] With the same idea in mind, Max Ernst used verbal collages (for example, *Phallustrade*) to title his canvases.[165] Gauvreau practised this art of the explanatory, non-representational title too, especially for an exhibition of paintings by his brother.[166] Nevertheless, he seems to have arrived at this form of surrealism through his own efforts: 'In Leduc's studio, I found myself announcing that, without ever really knowing anything about surrealism, I felt I had already outgrown it, poetically speaking, in the book I was writing. I hardly knew the surrealists, of course; but perhaps my intuition wasn't so far off the mark after all.'[167]

Since Gauvreau wrote only one book before Leduc's departure for Paris, Apollinaire's influence and the personal events which followed in its wake can be dated very precisely. This was the period of *Les Entrailles*, and Gauvreau has described what his life was like then:

I was very isolated at the time. In the space of a few years, I experienced (sometimes in a frightening way) everything that had been experienced by the great poets of the twentieth century, even though they were still unknown to me. When I finally encountered them through their books, making their acquaintance was a most wonderful and comforting confirmation. Yes, they were all there, all the great prophetic writers in the surrealist tradition: Lautréamont, Alfred Jarry, Jacques Vaché, André Breton, Arthur Cravan, Antonin Artaud, Aimé Césaire, and so many others! ...
 And now, after much effort and many adventures, I have landed on territory which is still virgin: surrational automatism.[168]

Gauvreau's dramatic pieces are difficult to analyse, as he himself said: 'Since the latent content of explorean works is not easy to classify, explorean poetry saves the poet from that analytic mania which reduces art objects to the level of jigsaw puzzles.'[169] The point was that traditional criticisms continually sought out an 'intention,'[170] whereas the automatists put more faith in 'consequences':

> Put into practice Borduas' wonderful discovery, namely that 'the consequence is more important than the goal.'[171]
> There is no doubt that the object's authenticity depends on the author's liberality and discipline, but these constitute a reality distinct from the object itself. To a perspicacious observer, the work will say more about the author than the author about the work.[172]

Gauvreau insisted that his objects could be interpreted. It was important not to give up trying to understand something that did not happen to fit the criteria of intention: 'All my objects, including the most non-representational, are perfectly understandable and assimilable ... My objects have a rhythm, they have proportion, they have a tangible form; everything tangible is assimilable by an autonomous human being.'[173]

In commenting on the objects which make up *Les Entrailles*, Jean-Marcel Duciaume has isolated certain features which would turn up later in the radio plays: 'Man's cruelty to his fellow man, the salvation we carry within ourselves and, lastly, this image of elevation or final ascent.' Duciaume lays considerable stress on this final ascent and is hopeful that 'its meaning will eventually be deciphered [because] it is a constant which must be utilized if we wish to shed any light on Gauvreau's mental landscape.'[174] Examples include the girl who grabs hold of a moonbeam and climbs up to the moon (*La Jeune Fille et la lune*); Grisha burying herself in a book and disappearing through the ceiling (*La Prière pour l'indulgence*); Apolnixède rising into the air with his hand extended towards the arm of a man who has stepped out of a painting which Apolnixède has suspended in the sky (*Apolnixède entre le ciel et la terre*); the human shape suspended in the sky on a ladder and crying out 'I'm thirsty' (*Le Prophète dans la mer*); and Marvaux taking off on a big blue carpet and shouting 'I've just died' (*Le Coureur de marathon*).[175]

Pure Poetry

Gauvreau called *Etal mixte, Brochuges, Poèmes de détention, Les Boucliers mégalomanes,* and *Jappements à la lune* his 'pure poetry,' an expression referring to a research project in literary criticism he began in 1945. Purity, of course, has an ethical connotation as well; it is not restricted to 'pure poetry,' though Gauvreau does introduce it in connection with the poet

Saint-Denys Garneau. As a reader of Garneau's work, Gauvreau likens himself – and all potential readers – to a sun whose eye radiates clarity, candour, and purity:

> When your impatient hands first uncover Saint-Denys Garneau, is your heart pure enough ... In order to accost this vessel scintillating with love and eternity you must be modest, you must be human. Don't scrabble away at this imperturbable purity with dirty fingernails, you'll hurt nobody but yourself.[176]

The moral purity of the reader finds its counterpart in the purity of the writer. This undoubtedly explains why, some weeks before publishing a review of Garneau's book *Regards et jeux dans l'espace*, Gauvreau made public his own poetic design which employed similar images of purity and the rising sun:

> Purity chills, terrifies; purity in art is unconvincing. Covered over with a sleek veil, its hermetic self-sufficiency inspires mistrust. Negation and contempt. Those who lack trust shall be my enemies. This is necessary, fated. Life is and always will be my law. The day of painful schisms will leave stains on our floors if integrity in living demands bloody dismemberments.
>
> There is a sword within me, luminous as a jet of water or a silvery fountain, an eloquent wound. A sword has risen with the day. The light of day. The bronze arm cuts short curb-side mourning; concrete, torrential life subservient to no law, primitive and rebellious rattling bursts forth, bellicose brightness on the cracked gums of earth. The earth is cut, the saw of men's golden and introspective fervour, which rebels in the effervescent purity of the dawning day, cuts the earth. This golden peace is the light inseminating life. And liberty.[177]

Nothing here suggests the quest for a Superior Being. On the contrary, the passage presents a Nietzschean vision in which Gauvreau is the demiurge, the Batlam, the 'terrifazing'* moose, the Cyclops.

But purity also has an aesthetic connotation. To define, or rather to describe pure poetry from this perspective means that Gauvreau is enunciating a poetic which does not rely upon the traditional distinction between prose and poetry. These ideas recall André Breton, as Gauvreau pointed out in discussing Giguère:

> Giguère acknowledges ... Breton's work when he uses a language lacking traditional poetic punctuation, lacking an equilibrium in

which blank spaces as a rule provide an obligatory sense of mystery, lacking a ragged profile, when he writes in a helter-skelter fashion, when he seems to be creating prose ... In Giguère's work, poetry and prose are indistinguishable for both are endowed in equal measure with verbal fluency, material carried over unedited from dreams and equal doses of miraculous sonorities and unsayable sayings.[178]

This description brings to mind the words of *Refus global*, 'Make way for magic! Make way for objective mysteries!', suggesting a poetic whose only rule and ultimate intention is to have neither rule nor ultimate intention. It is a poetic in which the reality of colours, forms, and words is expected to insinuate itself as little as possible so that the sur-real (the collective and individual unconscious), whose natural tendency is to express itself, can flow forth automatically instead.

Certain critics have claimed that all this amounted to was an experiment in lettrism.[179] Gauvreau denied this. For him, lettrism was related to geometric abstraction in painting, to experiments in spatial formalism. Hence any Québécois exponent of Piet Mondrian's theories would be diametrically opposed to the signatories of the surrational manifesto, and especially to Claude Gauvreau. However, the term lyrical abstraction used in relation to Jean-Paul Riopelle's painting is also more suited to describe Gauvreau's work.

'Etal mixte'

Claude Gauvreau's first collection of pure poetry, *Etal mixte*, was written between June 1950 and August 1951. It was not, however, published until 1968 (by Editions de l'Orphée) and was only distributed in 1977. The collection contains Gauvreau's first raw efforts in the field of literary automatism. He was attempting to follow the example set by Breton, Artaud, and Tzara, whose poetry he had discovered after 1949. About the latter of these three Gauvreau said: 'Tzara had a very definite influence on my first book of pure poetry – *Etal mixte*.'[180]

Three of the poems in *Etal mixte* have been the object of close critical scrutiny: Paul Bernier has analysed 'Grégor Alkador Solidor,' Nicole Hurtubise 'Sous nar,' and André Gervais 'Sentinelle-Onde.' Bernier has this to say about 'Grégor':

Familiarity with matters psychic is linked to a rejection expressed in sexual and scatological terms which can be grouped conveniently along the same paradigmatic axis: ass, whore, eat shit, salute of the tail, sprinkling hose, all prevented from farting, he peed, they beat the meat, he shat, an underpants bassoon.

But what is the ultimate target of this aggressive attitude? Society itself and the following aspects in particular: women with chrome-plated pubic hair, an old negro, curates, priests who promise ap(ostasy)ostleship, a cruel stepmother, the national anthem, corsets, cassocks, everybody, them, theirs, the head of some Jesus or other, 'pincers which starch the pimp,' the faith of b(ottom)uttocks, dukes, duchesses, bigots, everywheresies, everyweirdos, humanity.

Hostility directed against society thus forms the backdrop of the mural 'Grégor Alkador Solidor' ... but why? A cruel stepmother is rendered up by the poet's memory; a false, impotent, and perjured society leads him to the gallows.[181]

Jacques Ferron has made some off-the-cuff comments on the subject of Gauvreau's unconscious which could be used by psycho-critics working in this area. These have been repudiated by people afraid of seeing Gauvreau's stature diminished,[182] yet his poetry is undoubtedly charged with images revealing a deep fear of castration. This is evident in the titles *Les Entrailles* ('entrails / womb'), *Etal mixte* ('chopping block, mixed / of both sexes') and *Le Vampire et la nymphomane*.

But it is the collective unconscious, the universal rather than the individual self, that must be plumbed in Gauvreau's work. The images of eunuchs, for example, are related to images of the woman-child and the woman as masterpiece. These recall one of the famous myths extolled by the surrealists:

Ah sleep heartybi
Child phallege oneti
Cry a poof!
Morening
My sweet
my child
my pear
Schotte!
child dick hard child my pear dick hard dic child yes o
Child
Masturbate the girl
the sabre
the child in the unique brain
bargains
the child who laughs
the girl works hard
The girl-dreama

The girl
Girl
Masturbated in the barge of brave winter cut out like glassworks.[183]*

Gauvreau and Borduas exchanged correspondence on the subject of the woman-child and her role, and Borduas' analysis was intended to clarify (by implicit comparison) certain passages in Gauvreau's own poetry. At the same time, Borduas had an ideological disagreement with Breton, who until then had been the only person he considered incorruptible:

> As far as the Breton of *Arcane 17* is concerned, like you I find great beauty in the 'revelation' of the 'redeeming' role of the 'woman-child.' Add to that the idea of 'resurrection' which you find there as well and tell me if we aren't dealing with Christian poetry of the purest sort? Revelation, Redemption, Woman-Virgin, Resurrection, and Eternal into the bargain! ... All the same, it's not the poet I find fault with. It's Breton the thinker who, as far as I could see, until now was always true to his personal experience. He breaks away from personal experience in *Arcane 17*, while pursuing his belief in an encounter, a definitive choice. He knows better than I what this choice means yet he repudiates the encounter, the choice posed by Jacqueline. Nevertheless, that choice had been acknowledged as a definitive one; it was also the inspiration for *L'Amour fou* and any number of magnificent texts which Breton certainly does not repudiate. It is undoubtedly a matter of emotional necessity for him. I can only defer to such a necessity ... but I don't have to share it.[184]

Neither Gauvreau nor Breton can be criticized for the images of women presented in their automatist experiments as long as their 'conscious' ideologies remain acceptable. Gauvreau often denied any belief in interpretations based on Christian mythology.

In addition to the theme of the woman-child, a poem like 'Grégor Alkador Solidor' illustrates in its very title, torn between gregariousness ('grégaire') and solitude-solidarity ('solitaire-solidaire'), the poet's aggressive attitude towards the dominant culture. Nicole Hurtubise points out that 'Sous nar' also 'seems to present us with the "climate" of tension experienced by an oppressed figure when confronted by his oppressor. This "climate" eventually dissipates when the oppressed manages to carve out a situation for himself not unlike that of the oppressor.'[185]

Apart from what it reveals about the author by way of his fantasies, *Etal mixte* is at times nothing but a series of inchoate cries or 'paronymous

variations on common words, somewhat in the style of Michaux.'[186] But occasionally too there are limpid images which express the difficulty in striking a balance between lyricism and delirium, between power and the inability to rebuild a ruined world:

> In the field
> a man
> reads
> and raves while sanding the remains of the feast of the equinoxes*
>
> It is raining
> But he can no longer love the ash where lap his
> hopes and myths.[187]

This delicate balance is conceived on a cosmic scale: life itself must be changed. Marcel Bélanger has aptly described the connections between Gauvreau's text and that of Borduas:

> *Etal mixte*, the lyrical counterpart of *Refus global*, cannot really be dissociated from it ... it is the impassioned and irrational version, no less trenchant, but written in a spirit of felt compulsion rather than in the dogmatic tone adopted by the manifesto. It is moved by the same concerns, the attacks are directed against the same institutions; it savagely reveals a similar need for liberty and liberation. It is a response to a social situation deemed unacceptable, a vehement denunciation of all the taboos and fears underlying this society, a society powerless to turn its back on neurotic stereotypes and create myths potentially capable of playing the indispensable role of mediator between past and future. This book also quite naturally takes as its watchword a radical rebellion in which can be heard many echoes of Borduas' manifesto. 'C'est la révolte / C'est la révolte,' exclaims the poet.[188]

'Brochuges'†

Brochuges has often been termed abstract, but it is no more so than certain poems in *Etal mixte* (for example, the last lines of 'Crodziac dzégoum apir'). *Brochuges* does in fact contain one very pronounced and hallucinatory image, that of the imperial eye:

> Eye
> Tiberius
> And ooff Arroottoof poof pif

Eye Nejan
Return from Hell
where kneyels the Fatherland-Eye from the diversion of lyric
 avalanches ...
I am Nero ...
Eye ear slate.[189*]

Eye of Tiberius, eye of Nero, eye of Trajan, eye of the emperor-god, eye of the sun; the 'I' of the cyclops, the 'I' of Batlam. A text Gauvreau wrote on the 'law of the eye' helps explain this image:

> Even if the vision which kept company with my own is imperfect, mine is inevitably fated to continue making its way along this rocky road like a perpetual convict. Vision and convict: there is the knot from which we cannot escape. If another's axiom raises doubt, if some bold principle, tempting as the tomb, belittles the universal embrace which was always the law of my eye, one man alone is inevitably fated to join battle. Temporarily alone, but alone as long as he is alive. I will fight the fight all alone if necessary, if the probity of friends channels their generosity along another path, but the testimony shall not be eclipsed.[190]

The law of the eye is therefore the law of universal embrace, the law of testimony without eclipse. It is the law of the sun. In *Brochuges*, the poet, like an exterminating angel, 'pins down' or 'skewers' the enemies of light, liberty, and life.

One cannot help but be taken aback by texts like these in which every conceivable code is simultaneously violated and respected. Michael Riffaterre claims that such writing is founded on the principle of the running metaphor and attempts nothing except a juxtaposition of 'signifiers incompatible with the things signified' while substituting 'a *structural* meaning for lexical meaning.'[191] Marguerite Bonnet believes that we must search for the internal logic, the special code peculiar to automatic writing, and reject the notion of the running metaphor because it relates to an activity that is both deliberate and factitious.[192] Clearly there is no end to the decoding of these texts.

Brochuges does reveal, however, symptoms of a deeply-rooted revolt and, like *Etal mixte*, of a global refusal in the fullest sense of the term. Also evident is an intertextuality which links Gauvreau's writing to his friends' art and to the text of their manifesto.

'Poèmes de détention,' 'Les Boucliers mégalomanes,'
and 'Jappements à la lune'
After the publication in 1956 of *Sur fil métamorphose* and *Brochuges*, Gauvreau regained some of his lost vitality:

> The lyricism which I thought had been smashed to smithereens
> came bursting in on me again. In spite of obstacles, I drafted a
> major work: *Le Rose enfer des animaux* ... Nevertheless, there
> were difficulties with radio projects and a slight misunderstanding
> with Borduas. I sank into a black depression.
> Later, *Poèmes de détention* came along. After attempts at suicide
> prompted by my financial state, there finally came a sunny, vital
> work, *Faisceau d'épingles de verre* (an automatist work for radio).
> A series of prose writings for radio, *L'Imagination règne*, more or
> less rounds out the picture.
> In May 1965, I wrote a dramatic piece forty-five minutes long:
> *L'Etalon fait de l'équitation*.
> Recently, numerous poems have seen the light of day ... they will
> probably be called *Les Boucliers mégalomanes*.[193]

The *Poèmes de détention*, as might be expected, are particularly interesting for their leitmotif of liberty. The word 'liberté' appears repeatedly and is reflected in the totally liberated quality of the writing:

> I am god for my secret smiles
> And in truth I am myself
> Honest noble and full of liberty
> Draggammalamalatha birbouchel
> Ostrumaplivi tigaudo umo transi Li.[194]

Noteworthy here is the 'demiurge' in love with purity, with liberty and truth. Above all, these syllables should not be viewed as some kind of neutral lettrism taken over directly from cubism but rather as that form of lyrical abstraction which Gauvreau called explorean language. Like Riopelle in his paintings, Gauvreau in his poetry insisted on the distinction between surrealist and surrational automatism:

> Surrealist automatism – which is a kind of psychic automatism ...
> when pushed to the limit, as I myself have done in experimenting
> with it, always ends up yielding only syllables ...
> The idea is to achieve as complete a state of emotional neutrality as
> possible. It then becomes a matter of recording the habitual every-

day flow of subconscious thought associations. One is therefore obliged to strive for impassivity and oblivion, and leave logic behind ...

But in order to penetrate more deeply into the unconscious, in order to blast away seemingly insurmountable barriers, one needs nothing less than the fury of an emotional volcano.

To allow a strong emotion to build up until, without any preconceived idea or methods, it shakes the brain's fortifications, drives them mad, and then to write down one after another all the links in a chain that will uncoil like an uninterrupted reptile ... This is surrational automatism.[195]

The aim of *Les Boucliers mégalomanes* is not to present a neutral kind of lettrism but, on the contrary, to unwind the fuse of an explosive charge. Sometimes a poem begins with a string of syllables which catch fire and blow up the powder magazine; the vessel of the reader's consciousness then explodes in images as deliberate and explicit as 'Françoise Arnoul's twin thighs.' At other times, however, there are reference points, like the image of Goya or that of the barrel hoop (which recurs often in Gauvreau's work), or totem words like 'rosamiondée' or 'Zogrotammbabarmandragore'[196] which mark out the route, and the reader soon finds himself swept down the rapids at top speed between hiccups, collywobbles, and paronyms as the journey becomes more and more perilous. *Les Boucliers mégalomanes* are war poems; nothing about them suggests an exercise in geometric abstraction.

Attempts at interpreting Gauvreau should not be abandoned, for at least two reasons. First of all, the passages of explorean language in *Les Oranges sont vertes* and *La Charge de l'orignal épormyable* delivered on stage by the Théâtre du nouveau monde have revealed a sonorous plasticity of a very high order, especially when set to music and performed by Jazz libre du Québec in the film *Claude Gauvreau poète*. Second, an analysis of certain texts, such as the following excerpt from the opera *Le Vampire et la nymphomane*, which Gauvreau used as a model in a letter to Dussault, reveals that they are sometimes far more structured than an initial reading might indicate:

I java on three horns is the emblem of my hoop and
the afghan with gorilla mucus glands is the stereoscope
of my grammannered games.
A lasso thrown into the frisson of April weathers
traces the probes
of my mastiff snout.
I pirouette like the star on Frenchwomen's weathercocks.[197*]

This passage contains three images, all illuminating one another when superimposed just as images in a stereoscopic viewer take on new depth when seen together. 'Je java' (a popular waltz) is picked up again in 'un lasso jeté' and 'je pirouette': these images describe someone groping about and at the same time turning in on himself, trusting his instinct's automatist reflexes as a dog trusts his 'flair de molosse' (watchdog nose), his 'muqueuses d'afghan' (Afghan mucus membranes). The 'je' is described as entering himself in a concentric motion like the motion of the 'cerceau' (barrel hoop), the 'étoile des pignons' (weathercock) and the 'sondes' (probes). These are his dances ('java'), his rodeo ('lasso jeté'), and his games ('cerceau'): these are the plays on words ('jeux grammanaires') with which poets in the surrealist tradition attempt to dynamite the unconscious. This excerpt, which Gauvreau quotes at greater length in his letter, contains within itself all the elements of an original poetic design which had few, if any, exponents in Quebec.

Some claim that Gauvreau began to have doubts about this kind of poetry which, perhaps more so towards the end of his life, defied all linguistic classification and left little room for verbal communication.[198] But the lyrical abstraction he practised with sound was closely analogous to that practised by painters such as Riopelle and Leduc with form and colour. It must be noted, however, that Gauvreau's images were gradually reduced to the repeated ga's, go's, and lul's found in *Jappements à la lune*. Here lyrical abstraction is reduced to a word game based on sounds simultaneously recalling the howl of a solitary wolf at night and the main syllable of the word 'lune.' The poem opens with the first letters of the name 'Gauvreau':

> garagognialullullulululululullulu-
> lullulululululullululululullullullululululululululululullulululululuuuuuuu[199]

These same sounds occur in the names Claude and Muriel and in the two syllables of Guilbault. This is perhaps not an exercise in surrealism, at least not in representational automatism; instead, 'pure psychic automatism' of the non-representational sort is given full rein here. But what bothers Gauvreau far more than the problem of neutrality or emotionalism in automatism is the problem of purity, without which life is impossible for him:

> My first silence will be the silence of my death.
> This is like a last will and testament. In fact, this is a last will
> and testament. It is the last will and testament of the dead men

within me. It is the last will and testament of deaths falling back into the void, expelled by life.[200]

Silence would only come with death. This was part of the poetic design of *Le Soldat Claude* who, like Vaché, Rigaut, Roussel, Crevel, Dominguez, Paalen, Duprey in the surrealist camp, or like Guilbault, Pouliot, Sauvageau in Quebec, was a mercenary in 'suicidal causes without glory, remuneration or hope.'[201]

The Novels

After his first attempts at pure poetry in *Etal mixte*, Gauvreau wrote a novel, *Beauté baroque*. It is difficult to say whether or not this is a surrealist novel given that surrealist prose is 'a somewhat obscure zone, perhaps because the relative scarcity of texts has forestalled analysis or because this prose has been reduced to a discourse fundamentally similar to that of surrealist poetry.'[202] Gauvreau, for his part, spoke of a 'monist' novel,[203] which at first glance seems to throw hardly any light at all on the question. Nevertheless, if Laurent Jenny's conclusions on surreality and its narrative signs are taken as a reference point, the idea of 'monism' construed in its linguistic sense might correspond to the abolition of any form / content dichotomy and to a kind of intertextuality crowning 'the play of signs moving back and forth along the axes of the rhetorical and paradigmatic grids.'[204] It is also relatively easy to uncover connections between Gauvreau's *Beauté baroque* and Breton's novel *Nadja*, in which automatism influences not only the linguistic elements in the discourse but also the relationships between situations and characters.

Gauvreau has left a description of the circumstances surrounding the writing of his novel. These provide important clues to the definition of a monist novel because *Beauté baroque* was written in connection with an experience that tore him apart (the dialectic of the many and the one), and because the manuscript was transcribed without a single error at a time when Gauvreau was suffering from amnesia (the paradox of a blocked memory still subject to linguistic automatism):

> Very early in 1952, Muriel Guilbault, who had been ill for a long time, committed suicide. I was irreparably torn apart ...
> During the summer of 1952 at Saint-Hilaire, I made a superhuman effort to write my monist novel *Beauté baroque*. Finishing the draft in November as it began to snow, I returned to Montreal to make a typescript of the novel.

I had still not finished the work when, as the result of some domestic quarrel, I came down with amnesia. I instinctively kept on typing out the text and I noticed recently that it did not contain a single mistake.[205]

The connection between Muriel Guilbault and the novel *Beauté baroque* was not just coincidental. A letter from Gauvreau to Dussault shows that the name 'Beauté baroque' had already been applied by him in 1950 to Muriel Guilbault. Gauvreau's description of her helps explain certain events in the novel:

Muriel is a perfect baroque beauty (I use the term in its purest sense). Muriel's features are as unusual as one could imagine; their physical organization is positively acrobatic. A frank, ardent nature ... The life of this essentially surrational woman has been marked by intense personal tragedies. She has had disastrous love affairs and a broken marriage. It's quite true, there is a lot of Breton's *Nadja* in her.[206]

Thus Gauvreau links Muriel and Nadja. Her connection to surrealism and to the novel is explained in the same letter: 'I was the one who introduced her to surrealism. She immediately recognized echoes of it in herself: without knowing anything about surrealism as a historical movement, she had nevertheless lived it in her private life. At the same time, a prodigious novel began to take shape in my mind.'[207]

It was a novel of mad passion, a novel in the broadest sense of the word which Gauvreau hastened to transform into a novel in the strictest sense after the death of Murifou, as he used to call her. Gauvreau has provided many descriptions of Muriel's enthusiastic nature, as in this account of how she agreed to play in *Bien-être*:

She was sold on it! Muriel Guilbault has never been easily intimidated, and she has never been one to stick to the beaten path. Confronted with something too disturbingly surreal for other people, she feels right at home and latches on to it with a furious passion.[208]

The impossible happened. Right from the start, Muriel was enthusiastic about my strange compositions. She told me they were a revelation to her. She accepted the role of the woman in *Bien-être*.[209]

The convulsive beauty Breton speaks of, however, is the beauty of final moments as in fatal passion, or the beauty of a flower cut just before it

starts to wither: 'The word 'convulsive,' which I use to describe the only kind of beauty in my opinion worth serving, would lose all meaning for me if it were applied to the process itself rather than to the very moment this process expires.'[210] The death of Murifou, the baroque beauty, was therefore the perfect catalyst for the creation of a surrealist novel in the manner of *Nadja*.

This love of Gauvreau's did inspire a number of remarks very reminiscent of those made by Breton on the subject of convulsive beauty. In an unpublished letter, he reveals to what extent the joy of his love was inseparable from his admiration for Muriel as masterpiece:

> A number of times, I had the feeling of having been betrayed by Muriel – as much spiritual as physical betrayal. With Muriel, however, my supply of liberality will never run out. She is the kind of human masterpiece who must be allowed to live without restraints ... Even today – and this constitutes virtually a tragedy for me – she is dearer to me than any woman in the world.[211]

In the same letter, Gauvreau reveals an unusual characteristic of his love:

> A problem which sometimes (often even) troubled me whenever I felt certain 'vague yearnings' was the frightening development of my critical sense.
>
> Women are not all equal and, as with paintings and poems, masterpieces don't grow on trees.
>
> I'm much too demanding psychologically – something I owe to the process of artistic creation – to allow myself to be seduced by any cheap floosie. I've never been one to frequent brothels.
>
> Basically, I'm a very finicky person. With women, as with art, I'm always looking for the ultimate masterpiece. This impossibility, at any given moment, of finding something sufficiently desirable.
>
> I was passionately in love with a woman (of inexpressible charms) who is still for me the unsurpassable ideal (an ideal, alas, which does the competition an injustice). This intense affair left a deep impression on me.
>
> The desire exists within, but in itself it is not enough. It needs to make connections with the outside world. In art, the material is shaped in accordance with the demands of such a connection. In love, to modify the woman and bring her in line with the imperatives of this connection is virtually impossible. It therefore becomes a matter of finding objects which are already perfect analogues of desire (in a word, ready-mades); this is often a very trying task.[212]

The search for the 'ready-made' in love, an expression taken from the dadaist experiments of Marcel Duchamp and his associates, relates directly to basic elements in *Beauté baroque*. Throughout this novel there are also continual echoes of certain elements in *L'Amour fou* and *Nadja* such as the convulsive,[213] the automatic,[214] and the beauty in *liebestod*, which is in fact convulsive beauty: 'Impeccable admiration stuck to the alarming vision ... I understood ... Only one thing struck me as essential: the preservation at all costs, for as long as possible, of the dying masterpiece.'[215]

The narrator often dwells on this image of the masterpiece in *Beauté baroque*, and it also appears in Gauvreau's correspondence concerning Muriel: 'She was a masterpiece of a woman. She was a fantastic woman. Fantastic: "who inspires awe".'[216] At the end of the novel, Gauvreau deliberately introduces a biographical element relating to Muriel (who committed suicide by hanging) when he evokes the great, convulsive beauties discussed by Breton:

> Vertical death. Hanging ...
> Adieu, ineffable!
> Aurelia, Eurydice, Nadja.[217]

Nothing is known of the novel *Lobotomie*, which Gauvreau apparently wrote while hospitalized. Either deliberately or in an unwitting gesture of self-defence, he kept it hidden from public scrutiny.[218]

Dramatic Works

After the breakdown precipitated by the death of his friend Muriel Guilbault, Claude Gauvreau's literary output became very sporadic. Sojourns in institutions alternated with periods of productivity, yet he was considered a regular contributor to the experimental radio program 'Studio d'essai.'[219] Of the works from this period, the plays *La Charge de l'orignal épormyable*[220] and *Les Oranges sont vertes* have become well known since their revival on stage.

'La Charge de l'orignal épormyable'

Written in 1953-4, this play did not appear until February 1968, when it was given a public reading, and it was not staged until May 1970. It reveals a Gauvreau haunted by the problem of the relationship between art and madness, and by the very sources of a creative act founded on the automatisms of the unconscious mind. A critical introduction to the play by the author entitled *Réflexions d'un dramaturge débutant* was distributed to the audience on the evening of the premiere. Gauvreau prefaced his thoughts with a quotation from Michel Foucault, who claims that where

there is art, there is no madness. To see madness as a theme in the play is not therefore merely a question of biographical interpretation; it is, according to certain remarks by the author himself, the very essence of the drama.

The whole play in fact pivots around the notion of consciousness in relation to literary activity. Using the language of lyrical abstraction, the text at times passes harsh judgments on consciousness in its primary and superficial state by contrast to the richness of the unconscious. There are moments during the principal character's monologues, couched in Gauvreau's explorean language, when the audience moves into what could be described as an altered state of consciousness.[221] Is this altered state what the public looks for in Gauvreau's plays? Might it be a sign that the mythical egregore, which Gauvreau wanted to see the automatists and their friends attain, is within reach?

The play unfolds in a closed environment (an oppressive workshop or insane asylum), where the poet Mycroft Mixudeim and some of his 'friends' are in seclusion. The poet is experiencing a certain state which the others are attempting to fathom. Is he a paranoiac, a megalomaniac, a schizoid, a hysteric, a schizophrenic, a sexual maniac, a sadist, a masochist? After many hostile experiments, rather than concluding that his state is that of a poet, they decide he is an imbecile. Misunderstood by those around him, he wages a never-ending battle against stupidity. As he hurls himself against locked doors, Mycroft sometimes evokes the image of Don Quixote tilting at windmills: it is no coincidence that both characters are madly in love with an inaccessible woman-child. Jean-Marcel Duciaume has interesting comments to make about the way Mycroft 'charges,' noting for example how, at the end of the play, Gauvreau, 'in a final charge, rams us into our seats in order to leave his mark. He wreaks vengeance for our intolerant attitude, he blames us and this is disturbing. The hunted man gains freedom while we become the pursued. We experience the theatre of cruelty à la Artaud, a theatre which overwhelms and assails us.'[222]

When the characters try to rid themselves of the poet's cumbersome body and realize that the only way is to throw it down a sewer, they hurl him in among the spectators[223] – very few of whom will have made the connection between their orchestra seats and a sewer. There is a lot of violence in *La Charge*, violence of all kinds and at all levels: between the characters themselves, on the part of the author towards the characters, the spectators towards the characters, the author towards the spectators. Duciaume comments:

> It is important to understand the meaning of this double-edged violence. We realize that Gauvreau is dealing symbolically with his own

downfall and demise, which he blames on the uncomprehending and intolerant attitude of those around him. His aim is not to lay bare the pathos in his own life and (anticipated) death, but rather to bring about a change for the better by allowing us to see the violence which man perpetrates upon man. He presents us with the aberrant image of man's downfall, a downfall all the more serious for being blinding and neglected. Thus, the virulent attack he mounts against the audience reveals in part the desperation he feels concerning the human condition, but it justifies itself in one last attempt to bring about an Aristotelian catharsis.[224]

The play at times achieves epic proportions and, as the characters loom larger than life, the spectator is forced to keep his distance. The moose and the sadist, for example, are both 'terrifazing' and bewilder the spectator, who feels that the theatre has suddenly shrunk alarmingly. He finds himself confronted with all the heavens and hells of the new egregore mixed together, as well as with familiar characters taking part in a new mythology – Orpheus in front of his mirror, Pygmalion's doll come to life, and caricatures such as the Beast of Beauty.[225]

To the extent that lyrical abstraction appears more realistic than realism and to the extent that the play exalts the merits of convulsive beauty and the unconscious, it is undoubtedly in the surrealist tradition. The explorean language utilized even more in *Les Oranges sont vertes* prompted Bruno Cormier to remark that it is the language of an 'outsider':

> The words, the sounds, the rhythms which he created, especially in the most inaccessible parts of his work – those written towards the end of his life – cannot be defined by biographical and psychiatric studies. This is the vocabulary of a poet who, eye trained on his era, suddenly leaped over the barrier of everyday words which were no longer sufficient to express the anguish overwhelming him as he contemplated a world which he loved, but in which he felt himself becoming more and more an outsider. We must try to join him, for men are always most anxious and anguished when they do not understand their poets.[226]

An interpretation based on the critical notion that art 'reflects' society might suggest that this outsider's language, as the title of Cormier's article puts it, is a mirror of our era's alienation. But the explorean language might also be interpreted as a surrealist attempt (one in a long tradition) to 'speak in tongues,' as did the sibyls and seers whom Breton so frequently defended.[227] This glossolalia typifies the persistent human urge to

express something more real than the real. Gauvreau himself dreamed of a
world whose preoccupations would extend beyond material self-interest
and which would be open to the values of the inner world as revealed by
automatism.

'Les Oranges sont vertes'
Les Oranges sont vertes seems less a continuation of the work which pre-
ceded it *(Les Boucliers mégalomanes)* than a synthesis of all Gauvreau's work.
The audience is confronted with characters bearing fantastic names such as
Yvirnig and Cégestelle. Close friends can catch the thinly veiled and
rather overblown references to certain well-known figures such as the critic
Boulanger[228] and Father Legault.[229] But most important of all, a strange
myth provides a counterpoint to the play, evoking visions of Mabille's
egregore. In 1947 Breton had lauded the search for this new myth, em-
bodied here in Batlam.

Batlam is mentioned at the very beginning of the play: 'Yvirnig, do you
think Batlam will be back soon?'[230] The wait for Batlam in Gauvreau's
play may put the spectator in mind of the wait for Godot in Beckett's
play. But Godot is the sum total of all the absurd deliverances which
never take place and never can take place; Gauvreau's Batlam, on the
other hand, has already come and will come again. In a letter to Marcel
Sabourin,[231] Gauvreau refers to a historical character he had discovered in
a work on Victor Hugo and his contemporaries.[232] This man apparently
took part in the battle of *Hernani* and died in a duel at Lyon after having
provoked opponents of the revolt for greater literary freedom. Gauvreau
called him 'Batlam,' which could have been his real name or a collage
Gauvreau invented, perhaps from the names 'Batman' and 'Bedlam.'

According to Gauvreau himself, then, Batlam appears as the avenger of
the automatists' egregore: he is both Gauvreau's avenger against the incom-
prehension of his own friends and, like Gauvreau himself, the avenger of
Borduas and his disciples against the intolerance of their contemporaries.
He is also the Jacques Vaché who fired blank rounds into the audience
at the premiere of Apollinaire's play *Les Mamelles de Tirésias* in 1917.[233] He
is the Cyclops (seeing the world with his one eye, that is to say from the
unique and deliberately subjective point of view adopted by Gauvreau in
the play), flinging himself at the Greeks, whose ruse is an attempt to over-
come brute strength.[234] He is the new angel with the flaming sword guard-
ing the door to a new egregore which is both libertarian and monist:[235]
'We are satisfied libertarians, our plump brains are those of atheistic
monists with breastplates coated in mica.'[236]

The play is occasionally carried away on a wave of lyrical abstraction
typical of Gauvreau's poetic work. 'We are the exploreans,'[237] cries Coche-

benne on one of these flights of explorean language in which can be discerned clear echoes of Gauvreau's own titles such as *Jappements à la lune*, *Les Boucliers mégalomanes*, and *Les Oranges sont vertes*:

> COCHEBENNE: Let's go. Let's howl at the moon.
> IVULKA: The mirror-memoirs of the rutabaga apostrophize the megalomanic symptom on the tomb pickled in the drunkenness of lobsters.
> COCHEBENNE: Greenish supuleppes, you're hawking on diamonds whose orange tonsure calamisters the importance of the vow-duvet. [238]

Mougnan, a committed character who plays the role of chorus, sometimes siding with the actors and sometimes passing judgment on them, in one of his rare moments of spoken dialogue draws parallels between the play and Mabille's ideas on the dialectic of the egregores: 'Wait, wait. Surely Yvirnig is going to talk to us now about the characteristics of the egregore. It's one of his infatuations.'[239]

And indeed, Yvirnig wastes no time in intoning a long monologue during which the poet recalls the merits of lyrical abstraction and the surrealist revolution:

> The egregore is raving abstraction and earth's ballsup without regrets. The egregore is revolution made of an opaque and stiffening substance ... The egregore is confusion of persons and the singular's completed accomplishment. The egregore is fraternal solidarity. The egregore is the massive stride and confinement of Roche Percé. The egregore is unknown vocation with the most complete independence.[240]

Batlam then takes his revenge and, following the 'eminently surrealist' example of Jacques Vaché, machine-guns the audience.

CRITICISM

> IVULKA: Oh, you can always scribble a few ethereal lines of poetry if you feel up to it ... it's harmless and can even be therapeutic. But not another syllable of criticism.[241]

Claude Gauvreau's work as a poet and playwright has been widely discussed. Those aspects of his output which various theatrical productions and films have helped bring to light are now even better known thanks to the appearance in 1977 of *Etal mixte* and *Œuvres créatrices complètes*. Gauv-

reau's criticism, like his creative writing, is of exceptional quality. At once violent and erudite, it brings together opposing forces in a baroque style which he identifies as such because the baroque style of the automatists found favour with him in criticism as well as in art and poetry.[242] It is worth pausing over this topical and wide-ranging canon, some of which remains unpublished and therefore inaccessible, if only to understand the significance of the word 'baroque' in this context.

Gauvreau's critical texts can be divided into three broad categories. There are the book reviews, particularly those which appeared in the column 'Masques et bergamasques' in the newspaper *Le Haut-parleur*; the major polemical writings, such as those published in *Le Quartier latin, Combat, Situations, La Revue socialiste*, and *Liberté*; and finally, the essays, letters, and lectures, such as *L'Epopée automatiste vue par un cyclope, Dix-sept lettres à un fantôme*, and *Débat sur la peinture des automatistes*.

The Reviewer

Gauvreau wrote the column on art and literature in *Le Haut-parleur* for one and a half years from 30 July 1950 to 22 December 1951. He had already been fairly widely published before he was taken on by T. Damien Bouchard as a columnist, and his articles included one on Cézanne in *Le Quartier latin* and another on Saint-Denys Garneau in *Le Sainte-Marie* (February and October 1945). There were also five polemical exchanges: in *Combat* with Pierre Gélinas (December 1946), *Notre temps* with Hyacinthe-Marie Robillard (December 1947), *Le Canada* with Agnès Lefort (November 1948), *Le Petit journal* with Pierre Saint-Germain (November-December 1949), and *L'Autorité du peuple* with John Steegman (March-April 1954). Finally, there were two letters to editors André Laurendeau of *Le Devoir* (September 1948) and T. Damien Bouchard of *Le Clairon* (October 1948) on the subject of Paul-Emile Borduas' dismissal from his teaching post.

In *Le Haut-Parleur*, Gauvreau dealt with subjects as diverse as Picasso, Cocteau, Dada, Giguère, Pirandello, and even Lili Saint-Cyr! On 14 January 1951, Gauvreau established pluralism as his critical point of reference: 'accepting the multiplicity of differences is natural and beneficial. Racists and nationalists only sow hatred.'[243]

Gauvreau attempted to relate this pluralism to a far-fetched kind of objectivity which he described in a rather naïve fashion to his correspondent at the time, Jean-Claude Dussault. In these letters he uses the words 'reality' and 'object' to designate the work, a nomenclature borrowed from the vocabulary of the automatist painters:

Nobody will ever be able to understand my critical position if they don't take into account the extraordinary dissociation whose power I have harnessed within me.

The critic who judges is distinct from the artist who produces. I have reached the point where I am able to size up any reality or any object – including myself – as if my person were truly non-existent, as if I were a benevolent observer from another planet.

When I contemplate an object from whatever country or whatever era, what I look for are not affinities with my own work (not that I deny them – that simply isn't the point). All I am on the lookout for is justifiable authenticity.[244]

What is involved in this theory of dissociation? It may be an attempt at objectivity, but above all it is an attempt to keep separate the object perceived and the object produced, the you and the me.

Gauvreau's very 'visual' conception of criticism is revealed in this letter by his use of terms like 'envisage,' 'observer,' 'look,' and 'on the lookout.' His conception of it was also very decisive, witness such terms as 'judge' and 'justifiable.' This tendency to set himself up as judge and play the role of observer as well was typical of Gauvreau, a writer influenced by a painter with very exacting standards. Even the word 'Cyclops,' which figures in the title of one of Gauvreau's later works, reveals the consistency of this visual criticism.

If objectivity ever was Gauvreau's aim, it was not his aim for very long. His personal preferences showed in his work: once he was attacked by Jacques Ferron for having been too kind to Paul Toupin and[245] on other occasions he waged a personal vendetta against the Jesuits in which settling scores took precedence over reviewing.[246] He even publicized an exhibition which he had helped organize (Les Rebelles, 7 April and 21 July 1951); spoke in glowing terms of a magazine (*Place publique*) founded by a group of friends which appeared only three times (7 April); wrote about his own exhibition, *Les Etapes du vivant* (26 May); discussed a book for which he had great admiration, namely Mabille's *Egrégores* (9 June); and talked about the work of various friends such as Jean-Claude Dussault, Roland Giguère, Guy Viau, and André Goulet. Gauvreau evidently became a critic with an increasingly large stake in a particular ideological position.

There was also special pleading for the baroque style, or rather the baroque state of mind, which he described with regard to his play *Magruhilne et la vie*, written in 1952: '*Magruhilne et la vie* is a baroque tragedy. In other words, the text is devoid of verisimilitude and especially devoid of anything comical. The text is serious and sensitive; it does not, however,

relinquish that very special sort of serenity typical of the unbridled imagi-nation.'[247] Gauvreau's neo-baroque thus signified total liberty, the imagina-tion run riot in the tradition of a movement which considered itself equal to the classics.[248]

After a period of seclusion, Gauvreau began to write for *L'Autorité du peuple*, a newspaper just as politically committed as those published by Bouchard. His articles, which included pieces about Fernand Leduc (May 1953) and the spring exhibition at the Museum of Fine Art (March and April 1954), revealed the same predispositions he had shown in *Le Haut-parleur*. His admiration for Fernand Leduc especially prompted him to sub-mit pieces to *Arts et pensée* (July-August 1954) and to the *Journal musical canadien* (May 1955), but these were not regular contributions. Gauvreau's criticism then took a different turn: he tried in particular to inject a little order into the story of automatism, which was already past history, in arti-cles appearing in *Situations* on the tenth anniversary of *Refus global* (Febru-ary 1959), and in those on Jean-Paul Martino (*La Réforme*, May 1957), Micheline Beauchemin (*Culture vivante*, 1966), and Denis Vanier (*Porno-graphic Delicatessen*, 1968). In between, as these dates indicate, there were long periods of silence.

The Polemicist

Side by side with Gauvreau's reviews is a series of polemical texts whose verbal violence does nothing to belie either the ideological leanings of his reviews or the aggressive nature of his poetry. His first major polemical text, published in 1945, was entitled 'Cézanne, la vérité et les vipères de bon ton.' In it Gauvreau described himself in the same bold, unsettling terms characteristic of him right up until his death, and which he was always fond of playing up:

> There are the shit disturbers, those who are moved by the gran-deur of life and the vitality of their own ideas, who cannot resign themselves to seeing their brothers smitten by egocentricity and a leprous lack of emotion without feeling the urge to make a place for them in the insatiable nobility of what they seek and find. The role of the shit disturber is to denounce, to feel remorse for station-ary beings, because he accomplishes what the others have not had the courage to accomplish themselves, because he braves the incom-prehension of pygmies and pedants so he can offer all those who hunger after enthusiasm and truth that which life has shown him to be good.[249]

This text, dating from 1945, fully indicates the critic's burden which Gauvreau described many years later in *Les Oranges sont vertes* in the same terms. This time, however, the reproaches were made by his hero's friends, not by adversaries of the automatist egregore:

> COCHEBENNE: Ah! Shit and goddam! This is becoming quite frankly intolerable.
> IVULKA: Yes ... he missed a fine opportunity to be forgotten ...
> COCHEBENNE: You're crazy, Yvirnig, so you're wrong about everything.
> IVULKA: All madmen have to do is go to hell, all they have to do is crawl back into their holes and be forgotten.
> COCHEBENNE: Let this be a lesson to you, my dear Yvirnig. We've dined on your elucubrations. Leave us in peace. Shut up and don't write another word! ... Ah! Piss on all those who're incapable of deciding for themselves.[250]

The shit disturbers are the critics like Gauvreau who never relent; their job is to not resign themselves, to denounce, to levy remorse and stand defiant.

Gauvreau's polemical texts are constructed in such a way that the reader moves abruptly from a lyrical passage to a didactic one, from the vocabulary of violence to the vocabulary of abstraction. The following excerpt from a rejoinder to Father Robillard, in which Gauvreau opens fire on his opponent on an ironic note, is typical:

> No need have I, by some murky intriguery with Lucifer, to usurp alchemical secrets merely in order to arrive at this plain and simple truth. No matter what certain discreet ecstatics, followers no doubt of Merlin the magician, may have said or thought about it, the word automatism is not laden with any hypnotic or magical powers, and all men of good will may read this article without having to fear the perfidious spells of Satan.[251]

After undertaking a defence of the 'rigorous and incorruptible Borduas,'[252] Gauvreau winds up by giving an analysis of automatism and situating it in the history of art and literature:

> The discovery of photography, which irrevocably decreed the death of representational art, virtually coincided with another scientific discovery, that of the unconscious by Sigmund Freud. Now that the offerings of the visible external world have been pictorially

exhausted, here we have the intimate internal world of man himself providing us with a panorama of possibilities and material every bit as rich ...

Automatism applies then to every art form in which the act of creation takes as its initial point of origin not the immediately known external world but the internal world of man (which is in fact the external world known mediately yet transformed in the unconscious and associated in a particular fashion). Because man's interior is an integral part of nature, the discipline of automatism does not spring from origins any more extraterrestrial than those of any other artistic discipline.[253]

Gauvreau's technique, in sum, relies on alternating blasts of hot and cold; it is the same baroque criticism found in similar articles such as 'Aragonie et surrationnel' and 'A propos de miroir déformant.' These polemical texts all share the same quality, the ability to 'charge' and 'take charge' which he had the courage and lucidity to describe in *La Charge de l'original épormyable*.[254]

The Theoretician

Gauvreau wrote many didactic texts. They include interpretations of history (for example, *L'Epopée automatiste vue par un cyclope*) which treated it much like a legend in a subjective fashion. In analyses of poetic works such as 'Les Affinités surréalistes de Roland Giguère,' he compares his own orientations as a poet with those of the poet he is discussing.

L'Epopée is a key text in understanding Gauvreau: its deliberate subjectivity does not prevent the author's gaze from penetrating reality in all its richness. In *Les Oranges sont vertes*, the play Gauvreau was working on while he wrote *Jappements à la lune*, it seems that the critic is the central figure of the group and that all activity concerning the automatist egregore depends on him. This egocentrism is absent from *L'Epopée*: here, on the contrary, Paul-Emile Borduas and the automatists evolve in a socio-historical perspective which is much less reductionist. (This does not mean that *Les Oranges* is reductionist, rather that its perspective would be reductionist if we were to see the play as an *objective* reconstruction of the era in question, which it is not and does not claim to be.) In *L'Epopée*, the major manifestoes – *Refus global* and *Projections libérantes* – are placed in a perspective as broad and bold as it is precise and at times anecdotal.

'Les Affinités surréalistes de Roland Giguère' was Gauvreau's second major piece on his painter-engraver friend. The first, 'Roland Giguère,

poète du Nouveau-monde,' already contained Gauvreau's essential judgments on Giguère:

> Roland Giguère is a poet.
> Are there ten French-Canadians about whom one can say such a thing?
> Roland Giguère is the most European of our living poets.
> By which I mean he is the least baroque ... Giguère has no volcanic, vociferous, barbarous, Milleresque fieriness.
> Giguère is not dense and outsized; Giguère is measured ...
> His instinct for musical harmony is the most subtle I've ever encountered on Canadian soil.
> His mature thinking has qualities which distinguish Giguère sharply from those magnificent brutes who usually honour our rough and ready art forms (I'm thinking primarily of Paul-Marie Lapointe) ...
> Lapointe, Giguère, that makes two. They aren't the only ones.[255]

It is clear from this passage that Gauvreau places himself and Lapointe among the 'baroque Canadians' writing in the tradition of Henry Miller, while Giguère seems to him closer to Paul Eluard, René Char, and André Breton (at least in his role as poet).[256]

In an address delivered 12 February 1970 at the Montreal Museum of Contemporary Art, Gauvreau explained the dichotomy between 'Canadians' and 'Europeans,' a dichotomy which separates the 'baroque' from the restrained, Borduas from Pellan:

> I see contemporary surrealism with Borduas' eye, Giguère sees it with Pellan's eye ... As a baroque primitive, I've always envied Giguère ... the subtlety of his phrasing, the restrained, meticulous fragility of his images, his conciseness which gives off more ecstasy-producing electricity than any amount of verbosity.[257]

The distinction between the baroque and the restrained is reinforced by another distinction Gauvreau had drawn before and repeated in the same talk. It appeared very early on in the poet's criticism and separated representational from non-representational abstraction:

> There is no abstraction properly so-called without an external model. Giguère is neither a geometric abstractionist nor an abstractionist plain and simple. His sources of inspiration and invention are internal; such an approach was quite unknown before abstrac-

tionism or during it. On the other hand, there is non-representation-alism without an external model; our vaunted automatism is in this vein.[258]

This distinction was even more explicit in another address given at the Museum of Contemporary Art on 21 June 1967. The theme was some-what historical and could have served as the basis for *L'Epopée automatiste vue par un cyclope*. In the 1967 talk, Gauvreau explained that the distinc-tions he drew between the various types of abstractionism were precisely those drawn by Borduas in *Refus global*. He quoted excerpts from 'Com-mentaires sur des mots courants' which were written with painting in mind but proved in Gauvreau's speech to be just as valid for literature. In fact, the 'Commentaires' appended to the surrational manifesto provided Gauvreau with a whole theory of literature which allowed him to carve a precise niche for himself as a baroque writer between the poles of psychic and geometric abstraction. He made a point of not allying himself with either the psychic (surrealist) abstraction of Pellan's group or the geometric abstraction of the Quebec neo-plasticists who formed a school in Montreal after the departure of Borduas and Pellan in 1953. Gauvreau said of the neo-plasticists in particular: 'The automatists were all convinced that un-regimented baroque abstraction was a form of expression which came much later than the regimented abstraction of Mondrian. Don't forget that twenty-five years separated geometric abstraction from baroque abstrac-tion.'[259]

The *Dix-sept lettres à un fantôme* were written between 30 December 1949, and 10 May 1950. They deal with all sorts of subjects, sometimes elaborating on suggestions or reflections from the recipient, Jean-Claude Dussault. The first, inspired by Breton's ideas in *Le Château étoilé*, discusses desire and convulsive beauty at some length:

> The revolution in 'art,' like all revolutions in fact, is not an end in itself; the revolution is a consequence, inevitable certainly but noth-ing more than an effect.
> The goal of artistic activity, or any important endeavour, is to externalize, to embody desire in a concrete form ...
> The only teacher who will not harm his students is one who always bases his criticism on tangible, objective qualities.
> The appearance of a work, the intellectual discipline behind it, the degree of the author's intellectual evolution – these are relatively unimportant. All that is important is the 'convulsive beauty' – of a strictly tangible kind – which has been objectively encoded in the material.[260]

This letter speaks of the poem as a concrete object. The next discusses the empirical nature of 'poetry in which language, instead of remaining a conventional signal for evoking previously recognized states of mind, organically becomes a tangible, autonomous, and absolutely concrete reality.'[261] Gauvreau also makes a distinction necessary to an understanding of both his critical work and his literary output, that is, the distinction between goal and result, the distinction between what a work *wants to say* (its intention) and what it *does say* (its effect):

> I think we are wrong to attribute power to 'intention' – 'good intentions' – a power it never possessed and never will.
>
> It is not enough just to caress the intended goals of helping others and increasing knowledge in order to realize these goals. Similarly, there is a host of exceedingly excellent results which are entirely unpredictable.[262]
>
> I emphasize this to put you on guard against the illusion of 'understanding' poetry when the only contact made with it has been analytic ...
>
> The poetic understanding of an object has nothing to do with the capacity to understand its origins. It resides in the indescribable capacity to VIBRATE with all its fluctuations, all its thicknesses and thinnesses, all its contrasts, all its explorations, internal and external.[263]

The use of the word 'exploration,' which later took on special meaning for Gauvreau, is noteworthy, as is the mention once again of the objective quality, the material nature of a work of art. These letters contain exceptionally rich critical material about the period but remain unpublished. In them, Gauvreau had already replied to those who later wondered about the problem of art / madness in his work, or indeed the applicability of interpreting any work through the artist's life:

> Please don't confuse, as people usually do, two very separate realities: first, the manner in which the work comes into being; and second, the distinctive, definitive reality of that work.
>
> Once the umbilical cord has been cut the child is an entity unto itself, independent of its mother. The same can be said about a work of art.
>
> Often there are men – blessed with a generous libido yet afflicted with a truly execrable ego – who misunderstand their own creations ...

One is forced to conclude that there are two independent series of problems: the subjective problems of the artist who produces, problems which interest only the artist and his colleagues; in addition, there are the objective problems of the works of art – problems both universal and collective which stimulate the intellect and critical faculties.

Is an anonymous work, one whose origins might even be unknown, less worthy of consideration? Of course not.

Let us therefore judge an object on its intrinsic tangible merits – this is the only way it can have social value, influence evolution, bring enjoyment, and enrich lives.[264]

Production, producing, objects, efficiency, workers – the vocabulary of the new criticism was already being used by Gauvreau and Borduas in January 1950! But Gauvreau, like Borduas, kept his distance from the materialists as well as the idealists:

As far as idealism and materialism are concerned, let me tell you that the term 'idealist' generally refers, or used to refer, to those who believe that society can be transformed by a simple change in awareness or by persuasion. 'Materialists,' on the other hand, are those who believe that the mere exercise of thought is incapable of changing anything, and that evolution is a function of material laws outside the realm of ideas.

It seems to me that a resolution for both materialism and idealism would lie in anthropomorphic realism ...

Personally I believe that the individual will is incapable of changing anything profound – at least not if it is being exercised against collective determinism. I also believe that periods of evolution are favoured, made possible, by the growth of individual awareness (concerning this same determinism) – an awareness which becomes generalized at the appropriate time.

It would be idealistic to believe that what surrealism has to offer could become social before the collective sensibility was sufficiently receptive to it.

On the other hand, without the growth of surrealistic awareness, periods of carnage might be followed by long, pointless periods of drifting and insoluble depression.[265]

The surrealist solution struck him as distinct from both the idealist approach and the Stalinists' materialist approach. For example, Gauvreau peremptorily rejects Zhdanovism:

Zhdanovism has been and will be (until a change comes about) the official doctrine of the USSR concerning aesthetics. Why is this doctrine what it is? It is what it is because the USSR has embodied a form of state capitalism fashioned by mediocre thinkers (including the seminary student Djougachvili) for some 35 years. It is a government established by and maintained for the benefit of a new privileged class: a class of bureaucrats, bureaucrats educated as petits-bourgeois whose conceptions and aspirations match those of the pre-soviet petit-bourgeois.[266]

Each of us will understand the necessity of creating a just economic system which will make economic exploitation impossible (we are its victims too). But every revolutionary will have to understand that no intellectual can tolerate, *at any price*, a regime which implies moral dirigism ...

Moreover, economic totalitarianism by itself need not imply annoying intellectual regimentation at all.[267]

This is a surrealist solution, inspired to a large extent by Breton's writings (eg, *Rupture inaugurale*), and centred around the concept of atheistic monism, or anthropomorphic realism:

By monism, I mean the belief that one basic principle is present in all possible phenomena occurring in the universe.

For the monist, in the final analysis, spirit and matter are the same thing. Only the appearances of external becoming change for the purposes of anthropomorphic lucidity.[268]

Anthropomorphic realism tends to resolve the contradictions inherent in surrealism's adherence to materialist thinking (especially in light of the fact that surrealism demanded total, anarchistic liberty for the artist). Gauvreau evidently derived the idea from 'open realism,' a term Breton used to define surrealism: '*Open realism*, or surrealism, leads to the destruction of the Cartesian-Kantian edifice and completely undermines consciousness.'[269] This definition appears in Breton's 'Limites non-frontières du surréalisme,' which the automatists discovered thanks to Gilles Hénault. In the same text a distinction is made between the manifest and latent content of a work, and Breton felt that socialist realism reduced the work to manifest content alone. Gauvreau took up this distinction and described it for Dussault:

Manifest content would be the object's intrinsic proportions: the progression and intermingling of rhythms. Verbal shocks, the spe-

cific generation of images, relationships ... Latent content would be
the subconscious preoccupations ... which dictate a certain choice of
epithets, accents, amalgams, caesuras, disjunctions, etc.[270]

'Anthropomorphic realists' like Gauvreau sometimes had to invent their
own critical vocabulary; for example, he defined an image as 'the associa-
tion or confrontation of any verbal element: syllable, abstract word, con-
crete word, letter, sound, etc.,'[271] and distinguished four basic types of
images which he named himself.[272] The first is the rhythmic image, that is,
an onomatopeia or percussive rhythm which would include the periodic
use of a colour or symbol as well as the purely aural. The second is the
image 'mémorante,' meaning the image-generating substance comprising
metaphors and metonymies.[273] The third is the transfiguring image, a lin-
guistic process analogous to the superimposition of photographic images,
to the verbal totemization practised by the surrealists (cf. 'Mattatoucantha-
ride'),*[274] and to verbal collage.[275] The fourth is the 'explorean' image,[276] a
sort of subconscious sarabande or verbal debauch:

> One speaks of an explorean image when the elements which consti-
> tute each specific, new element are no longer easily divined by an
> analytical approach. I would also say an image is explorean when
> psychoanalysis (in its current state) is unable – except perhaps
> through an elaborate process for which there are still no prece-
> dents – to discover the latent content in the poetic object.[277]

Studies have since appeared on the obsessional logogryph, so such a
process might now exist.[278] However, the most important point here is Bre-
ton's influence on Gauvreau's critical work:

> I strongly recommend – indeed I insist – that you read two of
> André Breton's books currently making the rounds in Montreal –
> *Nadja* and *L'Amour fou*.
> Breton ... constantly uses the technique of projection.
> Even in his numerous theoretical writings he expresses himself
> through projection. In this way he conveys nuances inaccessible to
> those who are highly oriented toward dialectic.
> Rational minds cannot stand Breton; surrational minds, on the
> other hand, are endlessly grateful to him.
> Try to obtain the surrealist manifestoes edited by Breton. They
> are packages of dynamite which have yet to really explode.[279]

Gauvreau's theoretical writings, like Breton's, and his creative works as well were probably realized using the same technique of projection. Both correspond to the projection of a desire.

Occultation and Counter-System

After the publication of an article by Paul Chamberland in 1967,[280] the 'occultation' of Claude Gauvreau's work was much discussed prior to the week of shows and readings at the Bibliothèque nationale organized by Claude Haeffely in 1968[281] ('La Semaine de poésie'), the 'Nuit de poésie' of 1970, the tour of *Chansons et poèmes de la résistance* and especially the production of *Les Oranges sont vertes*. Gauvreau had made his mark in the 'milieu' early on but in an almost clandestine manner:

> My unpublished creative works had a certain influence on some young poets who had become aware of it privately (Roland Giguère, Gilles Groulx, Jean-Paul Martino, Claude Péloquin, Denis Vanier, etc.)
>
> In all modesty, I think that my influence will grow as my works are published.
>
> I am only just beginning.[282]

While Gauvreau greatly admired Borduas and like him evolved more and more towards abstraction, both he and Riopelle traced their artistic development back to the automatists. In 1958, Borduas wrote him a letter clearly stating his position: 'Surrealism and automatism have a very precise historic significance for me. That's long gone now. They were states I had to go beyond.'[283] Although Gauvreau had similar feelings about surrealism, he stuck by surrational automatism, which he placed above and beyond surrealism:

> All automatists belong to a generation after surrealism; none the less, Breton and his friends were always kindly disposed towards us. Surrealism, properly speaking, is representational; automatism has always been non-representational.
>
> Especially since Breton's death, surrealism has not survived anywhere in the world. Surrealism, like romanticism, belongs to the invigorating past.[284]

The automatists and Gauvreau nevertheless held surrealism in the highest esteem:

The surrealist sensibility will surely become very widespread in society as soon as the community as a whole can assimilate it – as soon as the community is sufficiently open to it. The surrealists are the prophets of the hour ...

By the mere fact of its existence, surrealist dynamism is an irreducible subversive force.[285]

These professions of faith in the religion of Breton were uttered more than once by Gauvreau. Despite the distinctions he drew between surrational automatism and surrealism ('the surrational contributions are authentic and without precedent ... We are not vague imitators of surrealism'),[286] it is impossible to discuss Gauvreau without referring to this faith:

I don't believe ... (as Maurice Nadeau seems to imply) that surrealism was a more or less illegitimate, more or less mechanical, more or less inconsequential result of previous world crises.

No. Here is what I myself think: world crises are the normal result of the disintegration of Christian mythology. Surrealism results from an awareness – at first strictly empirical, then more and more thought out – of this state of mythic disintegration.

I don't deny that a huge world catastrophe – such as war – would be particularly apt to stimulate this awareness, but it would be at most 'the instrumental cause,' as some modern Thomist might say.

Surrealist behaviour cannot be explained (no matter what Nadeau thinks) as a nervous reaction to the aberrant behaviour inspired by the horrors of war. Surrealist behaviour is the only way of exercising an effective defence against the temptations of a corrupt collective sensibility – a situation which existed before the war and will long outlive it.

Jarry, Marcel Duchamp, Raymond Roussel, Cravan, Picabia were prophetically surrealist in their actions long before the outbreak of war.

Just as surrealism didn't actually *cause* our current social upheavals, it is no less true to say that its purest contributions will help fill the gap left by the rejection and destruction of all remaining outdated relationships.[287]

Michel Van Schendel made some interesting comments on Gauvreau's work as a whole which Gauvreau took very badly because they associated him with mysticism and sadism.[288] Gauvreau could not accept this, espe-

cially since Van Schendel's work was accompanied by biographical material which was bound to upset him.[289] Van Schendel's text examined Gauvreau's 'system' in great detail, quite apart from the questions of mysticism and sadism:

> There is a 'Gauvreau' system, which is in fact a counter-system completely contained in the baffling mask the poet assumes in order to explain his writing. This explanation has a double aspect: writing is a provocation, but it only fulfils this role by becoming the cryptic expression of the incommunicable. It is a permanent decoy, and no part of what it peremptorily affirms can have a definite meaning, because everything it encompasses is hermetically enclosed in as non-verbal a language as possible. Strictly speaking, this open / closed system is a deception, provoking a sense of ridicule which only emphasizes its opacity. However, this opacity is disturbing, and this disturbance is poetically illuminating. Considered in terms of its inner strategy, the 'system' is the radical form assumed by the adventure of poetry. Need I add that it is, very paradoxically, both a deception and an adventure? This absolute contradiction at the heart of the integrated text does not encourage acceptance of the work in a milieu unlikely to understand certain images which are the dialectical inverse of its own dreams ...
> The poetry of a madman? Mad poetry, certainly, yet best ascribed to lucidity.[290]

This 'mad' poetry is, however, not a poetry of unreason but of 'sur-reason' along the lines of *Refus global*.

Paul-Marie Lapointe

A new poet, Paul-Marie Lapointe, eventually joined the automatists' group, frequenting their studios and becoming involved with non-representational automatic writing. His first collection, *Le Vierge incendié*, was published in 1948 by the automatists through Mithra-Mythe after *Refus global* and before *Projections libérantes*, but his other collections did not appear until much later.

'Le Vierge incendié'
Lapointe wrote *Le Vierge incendié* in 1947 while he was in his last year at the Collège de Saint-Laurent. He had just read Rimbaud's *Illuminations*, Eluard's *Capitale de la douleur*, and poems by Léon-Paul Fargue. The

entire work was written in three months before he met the automatists.[291] The following year he enrolled in architecture at the Ecole des beaux-arts. Robert Blair and Jean Le Fébure, two fellow students with whom he had formed an 'openly dissident trio ... none of the three finished the introductory course,'[292] wanted him to show the manuscript to the bookseller and editor Henri Tranquille. Since Tranquille was away, Blair decided to give the text to Claude Gauvreau, a former classmate at Collège Sainte-Marie. This was not an automatist work in the sense that it came from the group evolving around Borduas, but the automatists recognized its affinities with their own work.[293] Pierre Gauvreau himself helped Lapointe type the stencils for these poems,[294] which he then illustrated with Surmâle's altar.[*295]

Lapointe's collection includes one hundred poems (seventy-nine prose poems, eighteen poems in free verse, and three in rhyming verse). They are divided into five sections whose titles reveal all the themes: 'Crânes scalpés,' 'Vos ventres lisses'; 'On dévaste mon cœur,' 'Il y a des rêves,' and 'La Création du monde.' While the alternation of prose and free verse is similar to other well-known works like *Illuminations* and *Capitale de la douleur*,[296] Lapointe's prose poems are unique in one respect: they look as if they were written inside an invisible, perfectly rectangular frame with blank spaces between certain words instead of punctuation and line changes.[297] Lapointe's use of blanks reflects the process of 'literal juxtaposition'[298] which also includes Rimbaud's 'verbal alchemy,' Pierre Reverdy's 'distant and exact' metaphors, and what has been defined by surrealists as 'that which produces the highest degree of arbitrariness.'[299]

Verbal Alchemy

To gain a better understanding of the 'literal juxtaposition' used in *Le Vierge incendié*, the poet himself suggests looking at the *Illuminations*. Jean Leymarie provides a preliminary clue by emphasizing the similarities between Rimbaud and the pointillistes,[300] then using the comparison to interpret the effects of decomposing light and the visionary attempts in the *Illuminations*. Luminous effects dominated by colours at opposite ends of the spectrum, a very simple form of juxtaposition, are used frequently in *Le Vierge incendié*: 'grey-cheeked warblers modulated song of blasphemy on the pointilliste violet of cities.'[301]

The prismatic style of pointillisme derives from the analysis or decomposition of colour through closely juxtaposed brush strokes. The most obvious representation of this effect – the brilliance of crystal, shimmering hues, shining stones, and metals – can be found in Rimbaud's work ('Fleurs,' 'Being Beauteous,' 'Marine') as well as in Lapointe's:

So we set forth to lay hold
of the crystal future
the castle gleaming with every hope
streaming like watered silk.*[302]

In fact, though one can say that Lapointe used pointillisme in 'paintings' which reveal the decomposition of colour through images like 'jardins versicolores,' 'mirage englouti d'une ville,' or 'reflets d'eau,'[303] above all he sought out the visionary effects created by the juxtaposition of images.

When Rimbaud in 'Mystique' uses images like 'herbages d'acier,' 'prés de flammes,' 'conques des mers,' or even (in 'Fleurs') 'disques de cristal,' 'tapis de filigranes d'argent, d'yeux et de chevelures,' 'dômes d'émeraudes,' 'bouquets de satin blanc,' 'verges de rubis,' and 'rose d'eau' he is definitely practising a poetry of juxtaposition – but he is also practising a 'verbal alchemy' which goes far beyond a straightforward neo-impressionist vision. 'Verbal alchemy' is the expression used by Gloria Feman Orenstein to define the surrealist image itself, an image which implies substituting one word for another just as the alchemists tried to change one metal into another, looking for the shiny brilliance of gold in the dullest metals like lead.[304]

In Eluard's *Capitale de la douleur* Lapointe discovered a similar kind of metaphor in which two words are brought close together but without emphasizing what some of Lapointe's friends called the 'prisme d'yeux': 'poissons d'angoisses,' 'anges des bouquets,' 'branches des fumées,' 'fruits du vent,' 'muscles des rivières,' 'toit des vents,' 'ciel lourd des mains, éclairs des veines.' André Vachon has discussed Eluard's famous image 'La terre est bleue comme une orange' and the observations usually made about this type of metaphor in the context of *Le Vierge incendié*.[305] Perhaps the juxtaposition of two clichés ('The sky is blue; the earth is like an orange'), clichés transformed by superimposition, produces what Gauvreau called a 'transfiguring' image. Gauvreau claimed, wrongly, that Rimbaud never achieved this type of image and that Lapointe never went beyond it:[306] although *Illuminations*, *Capitale de la douleur*, and *Le Vierge incendié* do not use 'verbal collage' in the strict sense, they do employ juxtaposition to achieve verbal alchemy. This technique moves Lapointe closer to surrealism and also sets him apart from automatism, which he used only in a few unpublished works dating from this time and made public some twenty years later.

Pictures
Another aspect of literal juxtaposition in *Le Vierge incendié* gives Lapointe's poems the look of certain surrealist paintings in which not just two but a

multitude of images are juxtaposed in a metaphoric grid. Some of the texts in *Capitale de la douleur* and most of those in the *Illuminations* preserve the unity of a story: occasionally there is even a sort of dramatic scene, as in Rimbaud's 'Scènes,' 'Parade,' and 'Veillées ɪɪ' or Eluard's 'Dans le cylindre des tribulations' and 'Les Gertrude Hoffman Girls,' to mention only those specifically referring to the stage. But often the dream-like accounts given a temporal dimension by Rimbaud are presented by Eluard more in the manner of paintings. These poems ('André Masson,' 'L'icône aérée,' or 'Le diamant') are like pictures; the poet seems to have scattered words on the page like the motifs in paintings by his surrealist friends. In fact five of the texts from *Capitale de la douleur*, including 'André Masson,' were composed for exhibition catalogues. The full impact of Lapointe's 'rectangular poems' can be felt by comparing them with Rimbaud's dream 'stories' and Eluard's surrealist 'pictures.' These poems are pictures too. If Masson's canvases and Eluard's transposition of them can be interpreted in terms of form and colour and can suggest time and space through concrete objects or perspectives, then Lapointe's 'pictures' can also be interpreted in relation to their figuration and sonorities, suggesting time and space as well. Lapointe's rectangular poems are like metaphorical grids; Jean-Louis Major, borrowing the idea of interaction from Max Black and Henri Meschonnic, describes them this way:

> A nominal structure frames the vision; the relationship between one nucleus and another is based on analogical free association. A field of interaction is created through equivalence and opposition. The combination of apparently distant and incompatible elements, units of a material which recreates life in both scale and form, is not gratuitous. It is inscribed in the language, it is created from sounds calling and from the intimate relationship of images found in a particular presence.[307]

Particular elements are used as titles or anchors for the poems in almost the same arbitrary way as the elements employed as motifs or titles in surrealist paintings. Above all, perhaps, they serve as guides into the network: wherever one goes subsequently one is always in the labyrinth of dreams, and the only escapees are those who see invisible threads or know how to fashion wings.

Le Vierge incendié is a purification of dead flesh on the altar of love prior to a new life:

> When the pyres burst into black flames
> over the determined people

The cadavers purified by fire
and the splintering of concrete skulls

The horizon which I see freed
by love and for love.[308]

Consumed in the fire of love, man explores new dimensions, becomes plural, ceases to be fixed and immobile, dances on a tightrope, makes hot and cold coincide, provokes a cavalcade devoid of Edenic associations:

> Devil-festival; tom-tom of caustic drumsticks beating on nerves. Palpitation after the fault; two rags of posthumous thoughts. My head is wiped out with apocalyptic lives; cavalcade of purities on a steel wire. Rivers of crocodiles devour the brains of many pink flamingoes with resonant stems. Edens of bearskin igloos.[309]

Sterile, loveless virginity without liberty, without dreams, without wings is over. The image at the heart of the following rectangular text, the image of the 'virgin,' polarizes a paradigmatic sequence (calendars, saints, illuminated manuscripts, nuns, the superiors' consciences, cells, basilica, candelabras, patriarchal sacrifice) associating the sacred with the profane in a potent provocation which *is* a burning of the virgin (banned novels, twisted bars, rage, feverish grasp, mouth, saliva, hashish, wine, sex).

> Calendar leaves, saints in illuminated manuscripts, nuns made of benzoin gum yellow on the shelf of novels banned by the superiors' consciences. The bars of cells twisted in anger; find in the roundness of closed knees the feverish grasp under the linen. Faded bouquets. Mouth without lipstick. Tongue's saliva on the palate, persian carpet stolen from basilicas for virgins. All the smugglers' hashish comes down the path limping; I have pine needles, the eyelashes from ugly women hardened by my feeble remorses tasted at half-starved meals. Under the wine of the woods, a pleasure hung by the sex from the candelabras of patriarchal sacrifice.[310]

The provocation inherent in associating the sacred and the profane, fire and the virgin, is often related to jazz, that is, a music which conjures up violence to the extent that it is itself a marriage of percussion and melody, syncopation and modulation. One poem in *Le Vierge incendié* details the importance of saxophones to jazz,[311] while another says that the saxophone can chop down the barriers around a civilization barely 300 years old yet already decrepit:

Cushions in the temples
of soft women
of double basses unhipping
the three-century-old house
the saxophones saw the floorboards.[312]

Paul-Marie Lapointe's taste for – and knowledge of – jazz relate the poet
directly to the spontaneous expression of the automatists.[313]

The role of music and poetry is illuminated by some of the images of
violence in *Le Vierge incendié*. Scalped skulls, crash of skulls, and crash of
obelisks; fusillades and capital punishment; cities being scaled, asylums
taken by force – all these are thematic elements in the work.[314] It is a rebel-
lion, a war of words battering 'the walls of your mouth,' the

... walls behind us to be demolished
to be rebuilt tomorrow
blocked like a mouth[315]

Music (jazz?) will bring these walls tumbling down, or at least that seems
to be the reason for invoking 'the end of the world, biblical clarions,' 'the
collapse of the world, rejected by clarions,' and for the poet's assurance
that 'the wall will fall on the concerto of peace.' But painting and poetry
also allow the poet to speak of 'the wall breached by eyes.'[316]

The separation of the artist from violence nevertheless remains ambi-
guous. Lapointe is still attracted by what he rejects, and he achieves surre-
ality almost by accident:

The text leads ... to the magic of surreality, but it accuses, empha-
sizes the pleasure of reason by its own un-reason. In fact, it seems
to me that only a poetic revolution can lead to surreality: if rebel-
lion can lead us there – if, indeed, *Le Vierge incendié* leads us there –
it is by accident, unsystematically through a flash of insight.[317]

'Nuit du 15 au 26 novembre 1948'
The poems which followed – collected much later under the title *Nuit du
15 au 26 novembre 1948* in *Le Réel absolu* – were no longer entirely written
'without a system.' The time he spent with the automatists persuaded La-
pointe to join their revolutionary movement and practise some of their
techniques, keeping in mind above all the definitions Borduas had just pro-
posed for surrational automatism: 'Visual writing with no preconceptions.
One form leads to another until there is a feeling of unity' and 'an attempt
at visual awareness through writing.'[318] These poems, with their succession

of sonorous forms each suggesting the next then suddenly making way for a conscious thought, can only be placed in an automatist perspective:

> afiou lé fyme lé game lé chume
> lé jutryx o sabrite
> sen cha jé dutronyh my swee
> nobody can say anything
> against me.[319]

Lapointe did not dare publish some of the poems written immediately after *Le Vierge incendié* until the special issue of *La Barre du jour* on the automatists twenty-one years later. He was completely surprised at the interest expressed in them since most of the first edition of that collection had been rotting away in a basement for want of buyers. In the first published edition of the following poem in *La Barre du jour*, moreover, the three explorean verses are marked with an acrostic and the note 'ceci est du sauvage' (this is pidgin):

> its a lunie dan mirate
> kunt roubyt the geezzz etc
> inn woode o'weels and bazar strik
> I dont give a shit
> what could have been done with your
> clitoris.[320]

Elsewhere in the collection, which is not entirely explorean, themes, images, and motifs refer back to *Le Vierge incendié*. That book contained the following juxtaposition of wall and mouth (speech?): 'A wall no longer guards my doors. I make a meal of a wall. Heart of stone, lungs of stone, blood of stone. All the space behind the engulfed wall.'[321] These lines are taken up again and amplified in *Nuit du 15 au 26 novembre 1948*: 'You really would like to speak to a wall facing you but it is not really a wall, since all the walls have been engulfed and you are alone in your own country.'[322]

The following lines (in which the 'but' indicates a break in thought as in the lines above) contain other favourite images of Lapointe, among them the juxtaposition of virgins and walls:

> But to have drunk the whole ashtray
> The blue book of the shadow on the wall
> But to be two folded hands

And the smoke shape of one's illness
But to be brought down by virgins ...

to die to finish to desert through the walls of
the solitary virgin.[323]

Because of the similarities in theme with *Le Vierge incendié* and its use of
explorean techniques developed by Gauvreau, *Nuit du 15 au 26 novembre
1948* belongs entirely to the automatist movement.[324]

'Choix de poèmes': Arbres
Lapointe did not publish again until ten years after *Nuit du 15 au 26
novembre 1948* when l'Hexagone published his *Choix de poèmes*. The
themes previously noted recur again in these works. In 'Solstice d'été,'
the anaphora creates a musical quality, a sound and rhythm which recall a
litany or incantation:

breasts of the tranquil beach
breasts tender, breasts of wheat
mouths heavy with my thirst
breasts torrid ...

breasts I love you[325]

Like a jazz improvisation on a theme, the images mill about, sketching a
loving space and time within the syncopated rhythm of a saxophone solo.
The scope of this writing widens in 'Arbres,' a wood mosaic of all the
species illustrating our past and our present:

tree
tree for the tree and the Huron
tree for the hunter and tree for the hatchet
tree for the siren and tree for the wheat cargo ship
cart horse[326]

Here is a musician who improvises on all rhythms, in all modes, according
to his own personal automatism:

tree
poplar false aspen large-toothed trembling aspen
 wolf willow worrisome griffin immobile
 dredger of moss and earth narrow-leaved poplar
 low-browed scrub poplar upright Lombardi poplar
 dry old hack rancid blinkers

> balm of Gilead embalmer of tears poplar with
> spear-shaped buds cottonwood pussy willow
> nonmedicinal swabs and catkins bird's-foot of
> small rachitic birds matchsticks windbreakers
> of the forest bodyguards and barrel makers
> winter's white coal*[327]

Pour les âmes, published by l'Hexagone in 1965, multiplied the effects achieved by improvisation on a theme. In 'Psaume pour une révolte de terre,' for example, the line 'ô psalmodie, ô psaumes' is used eleven times and the same process of modulation is apparent:

> muscles and strength are for the heart
> and the anger
> are for the heart and the belfry of sweat
> for the anger of scowling cities
> for the bread of cities
> and the bread for the compost
> the compost for stones and rain
> the rain for the stones
> and even the stones are crumbling
> and the anger and the muscles and the heart.[328]

The same holds true for the poem 'Le Temps tombe,' in which time is modulated by spaces.[329] Finally, as if to emphasize the presence of jazz in certain poems, Lapointe included in *Pour les âmes* a long 'Blues' reminiscent of the automatisms in black music:

> Your working death undermines a house
> a city
> a tree
> a bird
> the love you bring to love
> your working death lets you sleep
> roof of house, roof of city
> roof of tree and of bird
> it will be enough to remove it from you.[330]

Lapointe's work could be termed a poetry of improvisation: speaking of *Le Vierge incendié*, Guy Laflèche maintains that this improvisation 'is precisely automatic writing as André Breton defined it.'[331] It also seems that after a few attempts at explorean writing in *Nuit du 15 au 26 novembre 1948*, Lapointe returned to the style of improvisation which characterized

Le Vierge incendié. This reversal prompted G. André Vachon to comment on the 'tone' (ie, distance, separation) of 'Solstice d'été' in *Choix de poèmes*: 'This poem is scarcely more representational, and almost as automatist, as the great rectangular works in *Vierge incendié*. The material, the subject, even the style may vary, at times substantially, but the "tone" remains remarkably even.'[332]

Lapointe's connection with the automatist group is truly reflected only in *Nuit du 15 au 26 novembre 1948*. Throughout his work, however, the poet made use of automatisms which drew him closer to surrealism, as did *Le Réel absolu* taken as a whole. The very title (from Novalis) recalls the experiments of the surrealists, 'La poésie est le réel absolu,'[333] and Breton also speaks of 'a sort of absolute reality, a surreality.'[334] Subsequent works differed somewhat; for example, on the back cover of the first volume of *Ecritures* (published by Obsidienne in 1980 in two large volumes of 406 and 899 pages) Lapointe states plainly:

> No sentence is generated by the preceding one; its origins should remain obscure, otherwise unfolding logic creeps in, endangering the possibilities of access. Utter gratuitousness – differing none the less from the automatist prescription in so far as there is no progression of thought, no mental dictate in its word-elements – should preside over the linking, the writing-reading.

These ideas, which had already appeared in the October 1977 issue of *La Nouvelle Barre du jour*, show that Lapointe had gone far beyond what he had practised in the era of *Refus global*.

Suzanne Meloche

The January 1980 issue of the periodical *Les Herbes rouges* contained a collection of poetry by Suzanne Meloche called *Les Aurores fulminantes*. The manuscript dating from 1949 had been kept in Borduas' papers along with a work by Marcel Barbeau, who was Suzanne Meloche's husband at the time.[335] There is no clear explanation of why the collection was never published; some believe the automatists did not consider it good enough, but it is also evident from the correspondence in that year concerning the publication of *Projections libérantes* that Mithra-Mythe's financial situation was precarious.

Except for two poems in the periodical *Situations* in 1959,[336] it took thirty years before Suzanne Meloche's writing became generally known: 'Will I finally discover myself in the clamour of thought?,' she asks in the introduction. Because they are essentially representational, the poems in *Situations* and *Les Aurores fulminantes* are closer to Breton's surrealism than to

Borduas' automatism. 'Vague de peau de mouton' and 'lutin d'émeraude' from the first poem in the collection, as well as 'donjon des donzelles' and 'nacelle à la langue de rubis' in the third, are closer to the imagery of *Le Vierge incendié* than to that of *Nuit du 15 au 26 novembre 1948*.

In some of Meloche's poems – for example, 'Je saute,' 'Persil enve-nimé,' and 'Légendes préhistoriques' – many lines begin with 'Je' (12 out of 21 in the first poem). This clearly differentiates Meloche's writing from that of Renaud, Gauvreau, and Lapointe: subjective qualities are much more apparent in her work, even if the 'I' may be someone other than the poet. The introduction also suggests that her work is concerned more with the pursuit of a personal than a collective mythology.

The reader can obviously identify with the 'I' or transpose it to a 'he' or 'she,' but these poems do not possess the 'objectivity' found in the work of the three automatists mentioned above. Like their painter friends, the others presented various 'screens' on which the reader is invited to project (as much as or even more than to perceive). Meloche explicitly says she is trying to project herself:

> I shout the galloping smoke
> my shadowy love!
> I tear myself from a succession of silences.
> ...
> I possess the poignant voice of blackened workers.
> ...
> I shout the words like a piquant sauce.
> ...
> I yelp the perfidious serpent on my tangled mouth.
> ...
> I mirror my shadow in vertical incantations
> burden of my flowing absinthes.
> ...
> O my voice like a bone adjusted to the length of agrippina.[337]

It was impossible to have spent so much time with the automatists and the defenders of explorean language, whose get-togethers are depicted in *Les Oranges sont vertes*, without being influenced to some extent; hence the 'neologisms' in Meloche's poems:

> Owalls that howl.

> The voice of hopes sated me
> with oozing saditions.

I discover the genuine tornado's
succinct ablutions.

The catastrophic look
of wondrobic fate.[338]

From 1946 to 1956 – from *Les Sables du rêve* by Thérèse Renaud to *Les Aurores fulminantes* by Suzanne Meloche – the automatists produced many works. In fact, they continued writing until the beginning of the eighties when the most recent works of Lapointe and Meloche were published.

Chapter 4 will examine the work of some successors, starting in 1949 with a group in Montreal quite distinct from that of Borduas. Initially influenced by Edouard Jaguer rather than André Breton, this group started surrealism off in other directions. Following first in the 'schismatic' footsteps of the periodical *Cobra*, it returned to Breton via the 'Phases' movement and the periodical of the same name, which brought together Théodor Koenig, Roland Giguère, Albert Dumouchel, Léon Bellefleur, and Norman McLaren. Meanwhile, the automatists dispersed.

4

44

New Movements

and to continue living in our solitary, silent cells we began inventing a
world with the shapes and colours we had given it in dreams

Roland Giguère, 'Continuer à vivre'[1]

The automatists were not the only ones in Quebec to claim kinship with
the surrealist revolution. Gradually, another group took shape until it
came out in 1948 with a manifesto, *Prisme d'yeux*, and two shows: the first
near the Museum of Fine Arts and the second at Tranquille's. Although
the manifesto's title and the fact that its initiator was Pellan indicate cubist
influences,[2] several of the signatories were later found in the revolutionary
surrealist movement. Their shared experiences in the interim included
their collaboration on the third issue of *Les Ateliers d'arts graphiques* and the
periodical *Place publique* (published by Tranquille), and, most important,
their participation in the founding of Les Editions Erta.

The poet Roland Giguère and two young Belgian immigrants,. Christian Lapeyre and Théodor Koenig, joined the Cobra movement which
was part of the young revolutionary surrealists' struggle against Breton's
refusal to join the Communist party. When their periodical *Cobra* became
the *Revue internationale de l'art expérimental*, Albert Dumouchel and Norman
McLaren also joined the movement.[3] Then, when the *Revue* was renamed
Phases and Breton became more amenable, Léon Bellefleur, Marcelle
Ferron, Fernand Leduc, and Jean-Paul Riopelle turned up in the table of
contents of *Phases* along with Giguère. One of the Phases movement's
modern art shows was even part of the 1961 New York surrealist exhibition to which Giguère contributed (with Jean Benoît and Mimi Parent).

Roland Giguère – poet, engraver, and publisher of Les Editions Erta –
seems to have been the link joining *Les Ateliers d'arts graphiques* and *Phases*.
One of his recollections of the time is worth quoting:

> I remember the 50s as a time of extraordinary effervescence; there
> was something clandestine in the activities of certain isolated
> groups. Remember, this was during the *Grande Noirceur*.* We were
> a little like moles digging a tunnel towards the light, and this might
> account for the dramatic tone – which seems prophetic in retro-
> spect – of the poems I was writing at the time: 'La main du bour-
> reau finit toujours par pourrir' [The hangman's hand sooner or
> later must decay].
>
> One of our havens was the Tranquille bookstore, where exhibi-
> tions of paintings as well as book and manifesto launchings took
> place. That was where the automatists got together along with the
> crew from the periodical *Place publique* and the *Arts graphiques*
> group of which I was a member, being a student at the Institut
> (these meetings were awash in *caribou* of the finest vintage).†
>
> Despite the encroaching desert, despite an oppressive silence, we
> pursued our courses – literary, artistic, and political – with determi-
> nation, as if the world hung in the balance ... For us, certainly for
> me, those years were crucial and filled with work, friendships, and
> activities of all kinds. Despite the scatter-brained side of it – impro-
> vised, poor, amateur – I believe it was our Golden Age. Without a
> public, without galleries and publishers, without anything except
> beautiful, youthful revolt, we had so much to do and we did it all.[4]

Giguère points out the proliferation that followed the automatists'
manifesto and the fact that the poets and painters of his generation tended
to divide into three groups (the automatists, *Place publique*, and *Les Ateliers
d'arts graphiques*). All worked to some extent in secret, but a major focal
point was the Tranquille bookstore where Jean-Paul Mousseau and Jean-
Jules Richard were employed and where several openings took place. This
chapter will concentrate on the groups centred around *Place publique* and
Les Ateliers d'arts graphiques.

THE PRISME D'YEUX CIRCLE

The first 'Prisme d'yeux' show took place 4 February 1948, at Lismer
School near the Montreal Museum of Fine Arts. It was only on for one
evening. A short manifesto was distributed, signed by eleven artists (not all
were Pellan's disciples): Louis Archambault, Léon Bellefleur, Jacques de
Tonnancour, Albert Dumouchel, Gabriel Filion, Pierre Garneau, Arthur

Gladu, 'Je anonyme' (Jean Benoît),[5] Lucien Morin, Mimi Parent, Alfred Pellan, Jeanne Rhéaume, Goodridge Roberts, Roland Truchon, and Gordon Webber.

Prisme d'yeux was not a surrealist manifesto but an attempt to define an independent artistic movement. Four of its signatories later joined Breton. Jean Benoît and Mimi Parent soon became good friends with him and were later mentioned in the final edition of his celebrated work, *Le Surréalisme et la peinture*. Léon Bellefleur and Albert Dumouchel also were friendly with Breton from time to time after associating with the revolutionary surrealists and contributing to *Cobra* and *Phases*.

The manifesto, written by Jacques de Tonnancour and printed in galley format, read in part as follows: '*Prisme d'yeux* has not been organized in opposition to any one group. It takes its place beside other organizations seeking to affirm an independent art and does not preclude the privilege of belonging to these other groups as well.'[6]

This statement was designed to protect not only certain signatories whose names were associated with an exhibition put on by the Contemporary Art Society but Gabriel Filion as well, who was upset about *Refus global* and had not dared sign it, though at the same time he did not want to abandon Borduas.[7] Another signatory of *Prisme d'yeux*, Lucien Morin, noted that he was part of a team of 'worthy artists with strongly defined personalities – too well-trained, too well-defined, and too diverse to evolve for very long within one group. The group was short-lived.'[8] In the seventies much was made of the group,[9] but the fact was that each person's participation, including Morin's own, was minimal: 'Like the other members I attended some meetings (four or five) and participated in some shows (one or two). Laughter always took the upper hand, and the meetings often dissolved in general hilarity.'[10]

Despite Jacques de Tonnancour's denials of any special meaning in his manifesto,[11] Guy Robert was right in drawing attention to the group around Pellan, however temporary it may have been, and in demonstrating that, in a certain sense, they were hostile to Borduas. Lucien Morin's opinions on this subject are very revealing:

> The automatist group was much more important *qua* group, not because its individual members were better artists or because its numbers were greater but because it was far more unified as a group. Their relationships were so tight that at times almost all its members practically lived together. They were very sectarian.[12]

Inevitably it was later said of Pellan that 'while in Paris he had participated in the abstract surrealist movement,' that, in Montreal, 'surrealism would triumph with Pellan,' and that his canvases 'drew inspiration at times

from modern poetry, especially Paul Eluard's surrealist work.'[13] But, according to Pellan, only his 'garden' period (1958), and perhaps a brief period of tachism around 1956,[14] owed anything to surrealism.[15] Pellan himself, therefore, did not really subscribe to surrealism as such until ten years after *Prisme d'yeux* and after Bellefleur, Benoît, Dumouchel, Giguère, and Parent, who then formed part of his entourage, had already done so.

The *Prisme d'yeux* manifesto, distributed at the 4 February exhibition in Lismer School, was noted in the newspapers.[16] The second *Prisme d'yeux* show at Tranquille's bookstore from 15 to 29 May 1948 was not accompanied by a manifesto but still attracted critical attention.[17] Later the group got together again at *Les Ateliers d'arts graphiques*.

Les Ateliers d'arts graphiques

The second issue of *Les Ateliers d'arts graphiques* in 1949 was largely an undertaking of the *Prisme d'yeux* signatories. Another experiment along the lines of the 1947 issue had been projected for the first semester of the 1948-9 school year. At a meeting with the Borduas group, it was decided that the latter would have a section to themselves and would not be censored at all.[18] But as Dumouchel, the editor of the magazine,[19] recalled, they had already had a lot of trouble getting by the mandatory government censors, who were reluctant to allow the reproduction of nudes, for example.[20] One automatist text was refused by the Quebec censors and all the automatists withdrew their submissions; this put off publication until 21 February 1949. 'From now on, ruptures will occur one after the other,' said Borduas.[21]

The 1949 issue started off with a preface by Roger Duhamel praising the *Prisme d'yeux* signatories and condemning automatism in veiled terms. Borduas had previously cited the example of Protogenes of Rhodes' experiment, reported by Pliny the Elder and proposed by Leonardo da Vinci as a model for the concept of objective chance.[22] As it happened, Duhamel had unearthed a comment by the seventeenth-century *précieux* Georges de Scudéry condemning chance in art. Claiming that Valéry would have been in agreement with his condemnation, he noted unctuously:

> Paul Valéry would have appreciated this thought which I gleaned from Georges de Scudéry's writings: 'I have no idea what sort of praise the Ancients thought they were heaping on the head of that painter who, unable to finish his canvas, completed it fortuitously by throwing his sponge at it, but I know I would not have appreciated [such praise] ... The operations of the mind are too important to leave their expression to chance, and I would almost prefer to be accused of having failed consciously than to have succeeded acciden-

tally.' This collection demonstrates that we can boast of artists and craftsmen who make no appeal to showy and inconsequential improvisation but who wish to do good work having carefully thought out their intentions beforehand.[23]

The man who described automatism in this way and denounced it as 'a mystifying undertaking' and 'showy improvisation' had obviously not examined the collection in depth.[24] Contributions to this issue from visual artists influenced by surrealism were numerous: *Femme à tête de galet* by Louis Archambault, the stained glass window *Osiris* by Jean Benoît, *Prélude au bosquet d'eau* by Claude Vermette, *Invention n° 1* by Suzanne Dumouchel, and Albert Dumouchel's works of mechanical automatism, *Le Miroir fumant* and *Les Îles nombreuses exulteront dans la joie*. Literary contributions included works by Roland Giguère and Gilles Hénault.

Critics who had previously attacked automatism did not hesitate to go after these new surrealist sympathizers. In discussing Louis Archambault, the critic René Huyghe noted quite objectively that he 'had close affinities with surrealism,'[25] but for the critic Géraldine Bourbeau the term at the time was one of reproach: 'Monsieur Archambault's Surrealism ... is authentic insofar as it reveals the unconscious stupidity of its author.'[26] Bourbeau was no more friendly to the members of *Prisme d'yeux* than she had been to the automatists: Roberts' work was 'A faulty ... and scatterbrained composition,'[27] Dumouchel's was 'bad, and stupid too.'[28] Her comment on the manifesto: 'I have read the manifesto *Prisme d'yeux* again and again. I have difficulty grasping an ideal steeped in contradictions and denials.'[29]

This kind of misunderstanding was very common. Another piece began: 'I don't know much about Cubism, Fauvism, Surrealism, or anything else on that long list of "-isms" in painting. I might find the name *Prisme d'yeux* pedantic and the signature "Je Anonyme" pretentious ... and be mistaken. But I recognize good will when I see it.'[30]

Jean Benoît and Mimi Parent

Then a great rumour stirred, the sky turned a lustrous bronze and carts arrived from all sides barking, 'We want little Chéniers! We want little Chéniers!'[31]

José Pierre, 'Le Ça ira'

Jean Benoît is not well known in Quebec except by specialists. At one time a professor at the Ecole des beaux-arts, he and his wife Mimi Parent

went into exile in France in 1947. Benoît is one of only three Quebec artists – the others were Parent and Jean-Paul Riopelle – who was granted a chapter in the final edition of André Breton's book, *Le Surréalisme et la peinture*.[32] In another chapter, 'Henri Rousseau, sculpteur?,' Breton recalls how, thanks to Benoît, he discovered the only known sculpture attributable to that celebrated naïve painter.[33] Benoît and Parent, along with Borduas and Riopelle, are the only Quebec surrealists Jean-Louis Bédouin mentions in *Vingt ans de surréalisme*;[34] René Passeron in *L'Histoire de la peinture surréaliste* includes only Riopelle and Benoît,[35] while Alain Jouffroy in *Une Révolution du regard*[36] and Robert Bénayoun in *Erotique du surréalisme*[37] include only Benoît. Not enough attention has been paid to Mimi Parent, although she is very well known among European surrealists and illustrated José Pierre's *Le Ça ira*. In 1965, Benoît took part in an important surrealist show at the Galerie de l'Oeil.[38] That same year, Breton was asked by the periodical *Arts* to name the ten most important surrealist painters under fifty and included Benoît on the list.[39] And in 1968, Benoît illustrated Vincent Bounoure's poems for Les Editions Surréalistes.[40]

Benoît first drew attention by performing a ritual ceremony which gave him a reputation as a hell-raiser. Realizing that nobody had ever respected the Marquis de Sade's will, he decided to execute it 'theatrically' himself, dressed in a costume he had 'fabricated' ten years before:

> *L'Exécution du testament du Marquis de Sade* took place by private invitation at Joyce Mansour's (2 December 1959). In front of a hundred guests, poets, painters, and writers, Jean Benoît, dressed in a ceremonial costume-mask ... proceeded with a minutely detailed execution of the will. Alain Jouffroy wrote that 'this event was unprecedented,' and that Benoît's final act (branding himself 'de Sade') constituted a challenge, 'A challenge to conformity, a challenge to lethargy, a challenge to sleep, a challenge to all forms of inertia in life and thought alike.'[41]

Jean-Louis Bédouin, a specialist in primitive masks,[42] situated Benoît's ritual ceremony in the context of a tendency in surrealism at the time to place high value on the primitive art of the American Indians, an art rediscovered by Artaud, Breton, Bounoure, and Péret during their exile in America:

> Their inventive spirit is most freely deployed in the context of the 'picture-object' and 'object' in the surrealist meaning of the word. For Jean Benoît, the object must be the locus of eroticism, poetic irrationality, and subversion. These elements culminate in the cos-

tume-mask which he conceived and executed in de Sade's honour and which recalls the masks of the Pacific and British Columbia.[43]

Passeron had similar praise, going so far as to place Benoît alongside Marcel Duchamp:

> The violent, religious import of surrealist eroticism, seen in the work of poets like Joyce Mansour, Guy Cabanel, Octavio Paz, and J.-P. Duprey, remains today one of the movement's most durable aspects. Niki de Saint-Phalle's *Nana* and the clothing-objects of the Canadian painter Jean Benoît (*costumes de nécrophile*, 1964), assimilate the human body into the nightmare of objects. *L'Exécution du testament de Sade* [sic], a ceremony presented before a sophisticated audience during which Benoît performed a solemn and flagellant strip-tease, makes Man Ray's objects and Duchamp's ready-mades appear rather innocent – real works of art![44]

This event preceded the opening of the Eighth International Surrealist Exhibition on the theme Eros in December 1959 at the Galerie Daniel Cordier. The panoply of Benoît's ritual was hung on backdrops designed by Duchamp for the exhibition, and as a sign of the reconciliation between himself and Breton, Matta also branded de Sade's name into his flesh. An object by Mimi Parent illustrated the advertisement for the exhibition, and she was also responsible for the room dedicated to fetishes.[45]

Albert Dumouchel

Albert Dumouchel was the editor of *Les Ateliers d'arts graphiques*. Speaking of Dumouchel's style as a whole, Guy Viau said that 'right away he was a practitioner of surrealism.'[46] Comparing him to Pellan, moreover, Guy Robert maintained that the 'surrealist movement ... was exploited here first by Pellan and then to a greater or lesser degree by Dumouchel.'[47]

Around 1947 and 1948 Albert Dumouchel was a practitioner of phantasmagoric art, publicly displaying birds of prey, monsters, and beasts with enormous limbs, and

> bringing back to the frontiers of consciousness all that mysterious world teeming inside each of us, furtive phantoms, familiar monsters. His characters, so to speak, were executed by Dumouchel in hieroglyphic signs which resonated in the depths of memory, awakening a hidden secret, a forgotten wellspring of fantasy and humour.[48]

A signatory of *Prisme d'yeux*, Dumouchel was always closely connected with the surrealist poetry published by Les Editions Erta: he illustrated two collections of Roland Giguère's poetry published by the author in 1949 and 1950, and in 1953 he illustrated Gilles Hénault's *Totems*. The 1964 Canadian Surrealist Exhibition, organized by Mrs Paddy O'Brien[49] in London, Ontario, also included Dumouchel's work: a *Martyre de Saint-Sébastien* made of ochre- and sepia-coloured stones in which the spilled blood did not entirely shroud the strained features of the face, a sinister work entitled *Remparts d'Avila* and a hodge-podge of objects, *Petits jouets pour enfants*.

Dumouchel joined the Cobra group after 1947-8, the years when surrealism had influenced his circle so strongly. His comments on the surrealism of that time show that he later stood by his revolutionary ideals:

> This was the most important movement because post-war society needed poetry, it needed to rediscover the constructive and optimistic forces which had remained latent within us during that brutal period. We needed to know that we were more than all that, we wanted to destroy conformity totally; it was a time of revolt against everything overrated, a desire to realize oneself completely.[50]

It is not surprising that, given such an ambitious plan of action, Borduas agreed to contribute to Dumouchel's periodical. Only government censorship prevented the automatists from contributing to the last issue.

Léon Bellefleur

Léon Bellefleur created his first 'cadavre exquis' in 1945 along with his wife Rita, Jean Benoît, and Mimi Parent at Cap-à-l'Aigle on the lower St Lawrence. In 1946, his work showed the influence of Klee and children's drawings. He became friends with Gilles Hénault and participated in several surrealist soirées with Albert Dumouchel, Jean Benoît, and Jean Léonard at which they created 'cadavres exquis.'[51] In 1947, he wrote an article 'Plaidoyer pour l'enfant' for *Les Ateliers d'arts graphiques* which extolled the virtues of spontaneity in children's art. He signed *Prisme d'yeux* in February 1948, and took part in the group show in May. After meeting Roland Giguère in 1948 he became interested in Kandinsky, Miró, and the surrealist theories of objective chance and automatic writing. In 1951, he took part in Cobra's second international exhibition in Liège. He drew closer to the automatists in 1952[52] and, in 1955, par-

ticipated in the show Phases de l'art contemporain at the Galerie Creuze in Paris along with his compatriots Dumouchel, Giguère, Riopelle, Leduc, and Marcelle Ferron. The French poet Jean Thiercelin, whose works were published in Quebec, followed more or less the same itinerary.[53]

In 1950, Claude Gauvreau wrote: 'Bellefleur's aspirations have been influenced by Albert Dumouchel, who is now a full-fledged mechanical automatist ... Rather awkwardly, he brings to his work echoes of Klee and memories of children's drawings.'[54] Bellefleur talked about the influences he had undergone:

> I had some difficulty getting away from Paul Klee's influence. I was also influenced by Pellan and sometimes even by Borduas. The behaviour of children, their total freedom, the exalted way they express themselves while drawing and painting moved me greatly, too, and made me understand many important things which served me well in my own development.[55]

Bellefleur, like Giguère, was influenced more than others by reading poetry; as Giguère said, 'Between canvases he returns to Nerval, Breton, Reverdy; he needs to be bewitched by colour.'[56] Bellefleur illustrated *Osmonde*, a collection of Martino's poems published by Giguère, and along with Dumouchel, Giguère, and seven of their friends published a collection of 100 silk screens (10 each) through Les Editions Erta.[57]

Quinze dessins de Léon Bellefleur was also put out by Erta.[58] In his preface, R.H. Hubbard states that 'Léon Bellefleur is a Canadian surrealist'[59] and analyses his work in that light. The painter himself expanded on the subject:

> My spirit and temperament led me more towards the Dream and 'objective chance,' Breton's surrealism, even though being very protective of my freedom I did not join the movement. My wife and I had met André Breton and even knew him – as well as many of his 'disciples' – quite well. Our respect for Breton, and even our indebtedness to him, is very great. Yet I followed my own 'Adventure' quite freely ...
>
> Dreams, the subconscious, automatisms of all sorts plus a great deal of presence (without which everything can become gratuitous and mechanical).
>
> In other words, surrealism with all its givens. To this must be added psychic concerns and research (which perhaps distinguish me from orthodox surrealism), all the symbolic systems, the myths which illustrate them, the Cabal, etc. ... For me, these elements still

constitute support for Clairvoyance, and I channelled everything through painting.[60]

He was a surrealist, then, employing all automatic techniques rather than the single, non-representational approach of Borduas' group.[61] Bellefleur is categorical when asked what automatism means to him:

> A very free investigative approach which can assume all sorts of forms. But automatism for me is just one approach. Many other concerns and even many other means (for example automagnetism) enter into my paintings. That's why it's wrong to classify me with the Automatist Painters.[62]

Alan Glass

After studying under Pellan at the Ecole des beaux-arts, Alan Glass went to France where he got to know the surrealists as well as Benoît, Giguère, and Parent. He even met Marcel Sabourin there, who was later involved in productions of plays by Ferron and Gauvreau.[63]

His 1958 surrealist exhibition at the Terrain Vague gallery in Paris was noted as far away as Montreal. Another exhibition at the Galerie du siècle focused even more attention in Quebec on his 'object art.'[64] He 'boxes' found objects (insects, waxes, eggs, etc.), framing them so that they look like reproductions of old reliquaries, sarcophagi within sarcophagi. Glass is still producing and exhibiting (as far away as Mexico), and contemporary critics consider him, along with Benoît and Parent, one of the few Québécois who is still a surrealist in the strictest sense of the word.

ERTA

Les Ateliers d'arts graphiques published literary works by several writers including Rémi-Paul Forgues, François Hertel, Emile-Charles Hamel, and Roland Giguère. Giguère stands out because he contributed to European surrealist periodicals and founded an art press where he revived the celebrated surrealist tradition of poets and painters collaborating to publish illustrated poems. Giguère, Gilles Hénault, Claude Haeffely, and Jean-Paul Martino were the most important poets published by Erta.[65]

Roland Giguère

While studying Claudel, Giguère came across a newly published work in which Michel Carrouges discussed Claudel and Eluard. Carrouges was not

then considered orthodox by the surrealists, much less so after his study
'Surréalisme et occultisme' appeared in *Cahiers d'Hermès* in March 1948:
he was even admonished in Breton's manifesto, *A la niche les glapisseurs de
Dieu*, published 14 June 1948. Giguère's first contact with surrealism
through Carrouges was therefore unorthodox, but he immediately started
reading *Capitale de la douleur*.[66]

In her thesis on *Eluard et Giguère*, Françoise Chamblas divides Gi-
guère's relationship to Eluard into three periods. During the first period,
which she calls the 'avant-poème,' she points out common features (simi-
lar titles, intellectual kinship, formulaic similarities, related themes) between
Eluard's *Capitale de la douleur* and Giguère's *Faire naître, Trois pas*, and
Les Nuits abat-jour. She then analyses Giguère's works from *Midi perdu* to
Le Défaut des ruines est d'avoir des habitants (1950-4), concluding that Elu-
ard's influence, though still visible in the similarity of certain titles and
lines, tends to decline in this second period:

> A diversity of influences and the growing surrealism in Giguère's
> work help us understand how the osmosis of knowledge leads to
> the progressive fulfilment of his personal vision. This growing sur-
> realism is accompanied on the thematic level by a profound ques-
> tioning of the power of words. At the same time Giguère's poetry
> begins to diverge from the intent of Eluard's work.[67]

In fact, the influence of *Capitale de la douleur* was declining to the advan-
tage of a new form of surrealism.

The three poems by Giguère which appeared in the February 1949
issue of *Les Ateliers d'arts graphiques* are striking because of their loosely
defined but tragic awareness of problems in Quebec society. Yet the last
line of each poem presents a different reaction each time ranging from
abandonment to resolution: 'A quoi bon continuer,'[68] 'Attendons sans
mourir,'[69] 'Rien n'est impossible.'[70] Although the first poem reveals a cer-
tain anxiety, the second anticipates a happy future, a kind of 'Grand Soir'*
and a regenerated humanity:

> Fair times will return
> With men who are more decent
> Women more full of laughter
> Children more playful
> A larger sky
> A rounder earth
> A sweeter sea.[71]

The third poem is a kind of synthesis of the first two given that the thesis of the first is a corrupt society and the antithesis in the second a poetic revolution. Here Giguère juxtaposes the absurd society around him and the ideal society whose inauguration he would support:

However
 This factional struggle cannot continue
 Man at the end of his tether begs for light
 Sunrises dawn rarely
 Death menaces us
 In an endless night
 Fashioned by madmen
Patience
 The gardens will return
 New flowers
 Will give birth to new men
 Smile-men Youth-men
 Hope-men.[72]

It was after coming in contact with unorthodox surrealism via Carrouges[73] that Giguère met the two Belgian intellectuals, Lapeyre and Koenig, both members of the revolutionary surrealist movement. Lapeyre came to Montreal on a UNESCO scholarship as a professor of architecture at the Ecole des beaux-arts. Théodor Koenig, a chemical engineer specializing in leather, came to Montreal and worked in the tanneries. Koenig was a friend of Pierre Alechinsky's, a member of Cobra, and he became Canada's official correspondent for the movement's periodical. *Cobra* published its first issue in 1949, to which Koenig contributed. It also included an insert, the 'Cinémasurréalifeste' signed by 'Le Groupe surréaliste-revolutionnaire, ses amis, ses voisins.'

In that same year Giguère founded Erta, and before his departure for Europe in 1955 published in limited editions his collections *Faire naître*,[74] *Trois pas*,[75] *Les Nuits abat-jour*,[76] *Yeux fixes*,[77] *Midi perdu*,[78] *Images apprivoisées*,[79] and *Les Armes blanches*.[80] He also published lithographs by Gérard Tremblay,[81] drawings by Léon Bellefleur,[82] poems written in collaboration with Théodor Koenig[83] and by Koenig himself,[84] and poems by Gilles Hénault[85] and Claude Haeffely.[86]

Giguère described the poems he wrote at this time as both premonitions and propitiations:

The age of the word – in the sense that we speak of 'the bronze age' – for me extended from 1949 to 1960. That was when I wrote

in order to name, to call, to exorcize, to open – but most of all to call. I called forth. And by dint of calling forth, what you call forth finally takes place ... Meanwhile I left Quebec for France, where I participated in numerous activities – literary as well as pictorial – with the Phases group and the surrealist movement. I returned a few years later 'to a strange country, to my own country' (Aragon), and I felt right away that you could breathe easier here. Something, a lot of things had changed ... I realized that these poems had taken on a new resonance, another dimension. Some written eight or ten years previous could have passed then for elucubrations but now fitted by themselves into their own reality, into reality. Premonition is certainly one of the properties of poetry, since the poet is really nothing more than a seismograph which registers the tremors of being. Or could it be that the world ends up resembling our poems ... Then it would be propitiation ... another magic quality of poetry.[87]

Automatism in poetry not only reveals the individual subconscious but inevitably allows the collective subconscious to come to light as well.[88] That Giguère realized the possibility of creating a collective myth when he returned from abroad seems clear from his description of the pre-exile poems as premonitions / propitiations. But by using this kind of vocabulary in his poetics, Giguère drew the same criticism directed at Breton and his disciples for employing words like myth, visionary, and other terms which were considered idealist.

When the magazine *Cobra* changed its name to *Revue internationale de l'art expérimental* (its subtitle remained *Cobra*), thereby indicating a new political non-commitment, Giguère continued contributing to it. Other Canadians – the engraver Albert Dumouchel and the film-maker Norman McLaren[89] – appeared in it as well. By 1954, most members of the Cobra movement were in Paris, where they renamed themselves Phases and officially joined forces with Breton. Koenig and Giguère then became correspondents for the periodical *Phases*, Koenig in Belgium and Giguère in Canada. While he was back in Montreal, Giguère's poem *Yeux fixes*, written in 1951, was published in the first issue of *Phases*. He then went to Paris and designed the second issue, which appeared in March 1955.[90] The close friendship between Giguère and the revolutionary surrealist poet Edouard Jaguer, who wrote the notes to three of Giguère's Paris exhibitions, began around this time.[91]

In Montreal, the automatists never accepted overtures by Koenig, Hénault, and Giguère on behalf of Stalinist communism. Claude Gauvreau made certain comments about Tzara in 1950 which give some idea of what Borduas' group thought about Stalinism:

Like Aragon and Eluard, he (Tzara) rallied around petty Stalinist dogma.

This man who had always been so intransigent, who was too much of an anarchist for the Barrès trial, who had always refused to rally around surrealism because for him it represented a backward step from Dada, who considered himself too pure even for Breton – there he is, well to the *right* of Breton.

You can see him snuggling up to all those assholes: Claude Morgan, Aragon, Hervé, Martin-Chauffier, Cogniot, Roger Vailland, Jean Kanapa – the whole gang of them ...

At one time or another, Aragon, Leiris, Chirico, Eluard, Desnos, Naville, Duits, Dali – all turned traitor and sought shelter under the maternal protection of an idiotic absolutism.

It's even more to André Breton's credit that he remained incorruptible.[92]

Giguère's surrealist poetry was influenced by communism during the Cobra period most of all. 'Vivre mieux' was a categorical rejection of a world that had already been deemed absurd in the *Ateliers d'arts graphiques* poems. In it, the author claims to be leaving forever 'les routes jalonnées de feux morts'[93] and in 'Le Grand jour' he describes what is in effect a 'Grand soir': 'Vous entrez dans le noir du dernier soir.'[94] He depicts the outcome of the revolution in these words:

later the pity of the starving
later the book like a white bird
later the cult of the innocents

much later
at the moment of dazzling light
at the moment of the great eclipse.[95]

But Giguère's revolt was essentially a poetic one. He exploded the rigid limits of thought with prophetic visions fashioned from oneiric imagery, as in this three-line poem:

He lived twenty years with a straw in his eye
Then one day he lay down
And became a vast field of wheat.[96]

With Giguère, the revolution is internal but expresses itself in the bloody imagery of political revolution:

My eye riveted to the tiny explosions
Which shook the galleries
I remember scattering mines everywhere
Inside.[97]

Nevertheless, the poet expresses a certain weariness when faced with the uselessness of open revolt, as in this 1951 poem which might explain a growing tendency to abandon revolutionary surrealism for a more integrated form of surrealism:

So many burst veins
So many body blows
So many hateful glances
So many broken blades
So many tears
So many footsteps
So many words
So many heartbeats
For so little light.[98]

While he was a revolutionary surrealist, Giguère only shot blanks. Above all he was a painter, but a painter for whom 'le paysage était à refaire,'[99] a painter-poet committed to the liberation of words and images. It was precisely this internalization of revolt which produced a rapprochement with automatic writing. When Giguère describes his concept of automatism, he refers to Breton's famous comparison:

> The poem is given to me by a word, a sentence which 'knocks at the window.' One word calls forth another, the plant grows, pushes out its limbs, develops from leaf to leaf, from line to line. A poem blossoms according to an outburst, a natural rhythm it carries within itself once the first word has been released. Premeditation in poetry has always seemed suspect to me because I believe much more in the flick of a switch, a sudden upsurge, than in reflexion. Reflexion is incidental to the poem.[100]

Given this kind of poetics, it is not surprising to find images common to surrealists cropping up in the author's work – for example, their beloved rose:[101]

A day of swelling pistil
Of a rose
When the wind no more goes whistling

Over the atoll
And in the hollow geode
There rests a medlar ...*
A final veil passes, conjuring up the return
But the gesture dies as it leaves the heart
And sight bogs down in its own mirage
The ultimate image and its transparency
The lily face of the avalanche
On the bodice of dragonflies
Shines the rose occult.[102]

Giguère met Breton and his friends and learned from experience that the 'Pope' was more accessible than many people in his circle. Breton's influence, Giguère recalls,[103] forced the surrealists to acknowledge the Phases group, thereby permitting Alechinsky,[104] Bellefleur, and Giguère to join 'orthodox' surrealism. The issue of *Phases* designed by Giguère contained an insert – the catalogue of the 'Phases de l'art contemporain' exhibition at the Galerie Creuze in Paris. Artists from Quebec included Bellefleur, Dumouchel, Giguère, Leduc, Riopelle,[105] and Marcelle Ferron (whose name does not appear in the catalogue).[106] Giguère is in almost all the succeeding issues, represented by the poems 'L'Echelle humaine,'[107] 'La Main du bourreau finit toujours par pourrir,'[108] 'Devant le fatal,'[109] and a lithograph.[110] During this time, he contributed to several avant-garde magazines including *Place publique*[111] in Montreal, *Phantomas*[112] in Brussels (edited by Théodor Koenig), *Temps mêlés*[113] in Verviers, *Boa*[114] in Buenos Aires, *Edda*[115] in Brussels, and *Documento Sud*[116] in Milan. Giguère's contributions to the exhibitions put on by the Phases group made his work known to larger audiences in Japan in 1958, and in Milan and New York in 1961.

In his later poems Giguère does not renege on revolt but creates a character named Miror whose painting is in itself a revolution:

Miror suddenly felt a desire to leave. He wrote on the bricks of the wall – in white letters as he did once on the school blackboard – the names of the countries and cities he wanted to visit, then he dislodged several bricks and slipped through the opening. On the other side was the void or its equivalent: an anemic, cloudy past ... Miror pulled back, replaced the bricks, and began writing on them, not just the names of countries and cities this time but also plundered drawings which were infinitely detailed ... He spent months drawing the places where he would have liked to live and forgot the wall.[117]

Although this text was published in 1957 it dates from 1950-1. It appeared in a collection with the sinister title *Le Défaut des ruines est d'avoir des habitants*. René Char wrote to Giguère regarding this collection, 'You are armed,'[118] and the critic Micheline Sainte-Marie said, 'He has tamed the monsters, he possesses the weapon of conquest completely: the poetic word serves him.'[119]

In 1966, Giguère used the revolutionary image of Black Power (foreshadowing Vallières' 'white niggers')* in a collection whose ambiguous title *Pouvoir du noir* suggested both social and visual dimensions. The poetry recalls the words and drawings of Miror:

> It is dark within us as it snows in the garden
> it is shadowy and we can't see a thing any more
> except the black anteater curled in the hollow of night
>
> the volcano expels its flow of smoking lava onto the earth
> which later will form circuitous paths
> where we lose our way, pen in hand ...
>
> Your universe, we used to say, is inflammable
> and your seasons unlivable
> it is true that we were at the darkest point of ourselves
> yet the light could be foreseen ...
>
> it was all in the lines
> black on white on the slate board.[120]

People have often remarked on – and sometimes criticized – the 'nocturnal' side of Giguère's poetry. Philippe Haeck, for example, has condemned certain 'idealistic' traits in *Pouvoir du noir*, faulting one poem for such epithets as 'grand,' 'noble,' and 'majestic,' and criticizing in another the image of a cuttlefish because its defence systems are passive:

> Again it's art as refuge, art not as an instrument of war but as a mollusc which defends itself by squirting black ink to cover its tracks. It's not easy to get your hands on a surrealist poet, the executioner's hand can only gesture in emptiness, in darkness ...
>
> The 'poet,' realizing that he doesn't possess the tools to transform the world, withdraws into isolation, repeating for his ears alone the ancient incantations, plunging into the poetic night, the poetic *ennui*, and now it's his turn to bring back and repeat for a few members of the elite the *poète maudit* routine, imitating those he read when he was young: Rimbaud, Baudelaire, Nerval, Lautréamont.[121]

As for the thorny question of the surrealists' idealism, especially as it related to the automatist creation of a collective myth, it remained to be seen whether a choice had to be made between changing the world and changing one's life. As a disciple and friend of Jaguer, Giguère was not the best example of a non-aligned surrealist: in his case, more so than for anyone else in Quebec, surrealism vacillated between 'avoiding either any deviation towards the apolitical level, where it would lose all historical sense, or any involvement solely on the political level, where it would simply become redundant.'[122] On the one hand, there can be no doubt that part of Giguère's inspiration links him to Nerval and Lautréamont, as Bellefleur himself pointed out:

> This work is ... profoundly dramatic, and the feelings it inspires bring to mind the 'soleil noir' of Gérard de Nerval. It is a continual search along nocturnal and subconscious pathways. The canvases and lithographs Giguère has done, and here I'm thinking of the most representative, have a special presence which often recalls African masks. It's no coincidence that Giguère is also an admirer and enlightened collector of primitive work from Africa and Oceania. There's always something serious and dramatic going on in his paintings, and this mysterious drama unfolds on a stage or in a space which is often disturbing. He's also a visionary artist, and the best example I can offer of this particular intuition, this gift, is his *Portrait de Lautréamont*,[123] which deserves to be better known.[124]

Guided by Bellefleur's observations, the critic François-M. Gagnon has examined 'a tripartite development of negative symbols: the black sun, the trap, and the bird of misfortune'[125] in Giguère's work. But from another viewpoint, these illustrations are also a way for Miror to tame life and reconstruct it.

Surrealism appeared very early on in Giguère's work, so early that François Ricard said of *Liminaires*, one of Giguère's first pieces:

> Right from the start, in *Liminaires*, the poet focuses his attention on what he calls 'totality' – an entirely renewed form of life, redeemed by the word, standing like a lighthouse on the horizon of his thought and desire: 'Each word spoken by a living person turned into an immense torch held in our joined hands. Everything was adding up and, poring over our calculations with the chambers of our hearts open, we awaited totality.'[126] This hope, conceived right at the beginning, inspires all subsequent pursuits; it is therefore similar to the 'surreality' which Breton, in the *Second Manifesto*,

accepted as the ideal in steadfastly preparing for the distant epi-
phany.[127]

Giguère's surrealism lives on, and *Forêt vierge folle*, his third retrospective
(1978), underlined this continuity more than ever.

However, there still remained a significant gap separating the Prisme
d'yeux and Erta groups from the automatists, notably Claude Gauvreau:

> 'Breton is dead,' Giguère stated. 'The surrealist movement has fal-
> len apart. But the spirit of surrealism lives on.' I respect Giguère's
> faith, I acknowledge and believe that surrealism is eternal, just as
> romanticism is eternal. But I'm convinced that the surrealist egre-
> gore ... no longer exists any more than the romantic egregore.[128]

Gauvreau concludes his appraisal with an enviable homage, even though
he considers his own work more suited to the changing times:

> Non-representational poetry is now considered avant-garde in 1970,
> but it would never have seen the light of day without surrealism
> and, by extension, without Giguère, who is part of surrealism. It's
> not an overstatement to staunchly maintain that all living poetry in
> Quebec flows with unstopped liberality from the poetry of Roland
> Giguère.[129]

Gilles Hénault

Gilles Hénault was part of just about every literary and artistic group of
his day, from the partisans of *La Nouvelle Relève* to those connected with
the publishing house l'Hexagone. His work can be dealt with in two
stages: the part preceding *Refus global*, discussed in the previous chapter,
and the works published in *Les Ateliers d'arts graphiques* and by Les Edi-
tions Erta.

When Erta published his book *Totems* on 15 December 1953, Hénault
was in Sudbury working with a small miners' union. Three of the poems
in the collection had appeared in the third issue of *Les Ateliers d'arts gra-
phiques* under the common title *Le Temps des illusions*. Hénault's poems
from this period no longer feel like gratuitous, automatist explorations but
denote an evolution towards revolutionary surrealism. Henceforth, it would
only be a question of 'revolt'[130] and 'daily bread';[131] free art, uncommitted
art, was thrown overboard like the tarot symbolizing it: 'L'Arlequin faisait
faux bond dans le ciel vide.'[132] In 'Le Jour du jugement,' Hénault evokes
the Nuremberg trials,[133] and in 'Cablogramme' the Sarajevo guerrillas[134]

immortalized by Eluard. In 'Bordeaux-sur-Bagne,' Montreal itself becomes a field of action for the guerrilla:

> And international man arisen from the burning mirror
> from the proletarian fused to the earth, to the hammer, to the
> mine ...
> Revolt must become the bread
> of all the imprisoned of Bordeaux-sur-Bagne
> of all those worn thin by the daily grind.[135]

This poem, which appeared with certain deletions (and no mention in the table of contents) in *Place publique* in August 1951, was not published in full until 1970 – the final verse inviting a lamb to devour the wolf was perhaps considered seditious!

The image of the totem appears in each of the new poems in the collection published by Erta in 1953: for example, 'Petite genèse apocryphe' tells the story of man's slow liberation from the clutches of barbarism:

> Man left the prehistoric night
> The age of stone and wood lice
> At the entrance to the cave
> He planted the totem of his destiny.[136]

The totem becomes the symbol of a tradition, of a new civilization, upon which the acquisitions of a newly recovered intelligence are piled one on top of the other. In 'Avec le feu, avec le vin,' the evocation is more hermetic. The totem is linked to its original function as a genealogical tree, tracing the descent of the tribe's guardian animals:

> The tree of presence ripened you
> More than the reasons of desire.
> I climb back through the centuries like a giant totem
> The lights are only symbols now
> The sphinx reads the telegraphs of smiles.
>
> Man takes root in the compost
> Which turns poppies into opium.[137]

Symbol of a new man planted in new earth, the totem in 'West India' demands the kind of hieroglyphic interpretation posited by Breton. There can be no doubt that Hénault tried in his own way to employ this Amerindian form of primitive myth.[138] A sense of belonging is established in 'Je

te salue,' which begins with an evocation of Amerindian civilization and emphasizes the harm done by the whites to the Indians, and the good deeds the Indians performed for the whites:

> Redskins
> Tribes vanished
> in the conflagration of fire-water and tuberculosis
> Hunted down by the pallor of death and the Palefaces
> Carrying off your dreams of manna and manitou
> Your dreams blown up by musket fire
> You have willed us your totemic hopes
> And now our skies are the colour
> of the smoke from your peacepipes.[139]

The meaning of the prayer which ends the poem is clear. Christian civilization has not converted the Indians; on the contrary, indigenous civilization will point the way to the new egregore, just as the International Surrealist Exhibition predicted in 1947:

> Hail to thee life full of grace
> The sower is with you
> Blessed art thou among all women
> and the child overwhelmed by his find
> holds you in his hand
> like the multi-coloured pebble of reality.[140]

There is no automatism here, but in its recourse to primitive myth *Totems* is linked (more or less consciously) to surrealism. This collection was the first in the series 'Tête Armée,' which also included *Sur fil métamorphose* by Claude Gauvreau with illustrations by Jean-Paul Mousseau.

The next collection, including *Sémaphore* and *Voyage au pays de mémoire*, is quite different. *Voyage* employs imagery inspired by Hénault's experiences in the Sudbury nickel mines and is written in a spirit of social revolution:

> Stacks, clouds of smoke hid a sun of nickel, a dream of new moon or dying planet ...
> What pit-gas blast would suddenly shoot up to the open sky its arthritic limbs, its fossils encrusted in chalky strata, its dislocated veins and the slow, blind progress of its labyrinthine tunnels! Have you ever breathed in the noxious dust of pulverized memory? Have you ever walked in the lair of imprisoned life, bumping

against the rough walls of a stone future? Have you pushed empty
carts the length of your underground days? Have you searched the
bottom of a pit for the metal content of a mineral strangely resem-
bling your soul?[141]

From now on what must explode, as if in a pit-gas blast, is the laby-
rinth, the hole where miners, workers, and peasants are thrown together,
people whose souls and landscapes have no place in the sun. This is the
meaning of the journey in the title 'Si je voyage, c'est dans la profondeur
des mots retenus.'[142] The man who had once dared defend 'canvas revolu-
tionaries' in the party paper now believed more than ever in the superior-
ity of rhetorical disarticulation over political rearticulation:

> Articulated speech withers as it extends its branches. Too many ara-
> besques trick us as to the hidden meaning of words, too many rhe-
> torical flowers braid artificial crowns around the baldest sentiments.
> I need the naked word.
> I need words like bullets and pure, cutting cries. Poetry tries to
> comfort the soul but it should mould things, allow to be heard
> above the religious, philosophical, moral, and political cacophony
> the naked cry of man.[143]

Hénault's admiration for Eluard is also understandable, and he dedi-
cated a poem to the French poet, whose work offers

> Hands mountains and marvels
> Miracle of eyes married to the world
> And fertile with promises of happiness.[144]

This is perhaps surrealism in the sense of a representational revolution, as
in these words: 'O geysers of boiling words shooting up along the borders
of sclerosis, render to the undaunted word the primal power to corrode,
erode, dismember reality rather than cover it over with a muddied
shroud.'[145]
Here the term 'pure psychic automatism' only applies in Breton's general
sense and not in terms of the non-representational abstraction intended by
Borduas. The following poem, for example, displays the characteristic main
themes and contrast-laden technique of the surrealists:

> The steps of those who pass by in mirrors
> The steps disappear at the borders of encounters
> And nothing remains but the reflection of a man reclaimed by the
> waves

By the wavering crowd.
The sun shines an instant on the crosshatch of gazes
– Desire is spinning her web –
A woman slips off towards the corridor of dreams
The forbidden glistens in jerky neon
The door closes
Automatically
The door closes
Automaton.[146]

Claude Haeffely

Claude Haeffely came to Quebec from Paris in April 1953, bringing with
him a unique background. While in his late teens, he had owned an art
press, Les Editions Rouge Maille. There he worked with Jean Cathelin,
who had benefitted the press with his comprehensive knowledge of surreal-
ism. Cathelin's father, the psychiatrist Emile Malespine, had been editor of
the periodical *Manomètre* from 1922 to 1928, and had published texts by
Soupault, Tzara, and Péret.[147]

Haeffely thus brought to Erta a new vision of surrealism and consider-
able skill in art publishing. His collection *Notre joie*, which included poems
originally published with Rouge Maille in addition to later works pub-
lished by Erta, was reprinted in 1973. His automatism is a shout bursting
with images of youthful revolt, jazz, and eroticism:

> The gesture is born
> with the shout
> fleeing along rivers
> DAY
> NIGHT
> fleeing over mountains
> and plains
> the shout seeking
> its resonance.[148]

Notre joie also reveals a sort of automatism inspired by jazz working modu-
lations on a cubist drawing:

> on a night like no other
> a hairy black man sings
> a Braque drawing:
> it's a jealous disorder

it's a patient rain
and bodies with blond wings
it's a man frozen to death
it's a black and white spindle
teetering in the wind
it's an exquisite woman.[149]

Automatism projected by desire, especially erotic desire, is found mainly in
the Rouge Maille poems, as in these lines from 'Sorcellerie':

Robinson alone of course
like a tube of toothpaste
ejected pink lines ...
in Paris in cafés
and sometimes on the lips of women
to make them more accessible
 Robinson alone of course ...[150]

The poems Haeffely published with Erta bear a certain resemblance to
those of Roland Giguère since their artistic interests were similar and
they spent a lot of time together. At one point he, Giguère, Bellefleur,
and Gérard Tremblay used to meet every evening, and one incident in
particular moved Haeffely to sympathize with Giguère's concerns. One
night Haeffely, his wife, and Giguère were thrown out of three cafés in
a row on Sainte Catherine Street because they spoke French instead of
English. Haeffely's response was similar to Giguère's and he reacted vio-
lently to the social crisis they were both experiencing. His work became
committed work, revolutionary work, deeply marked by the social conflicts
affecting French Canada:

Desert where not a word grows
the whiteness of this dead world
and myself surprised at decaying
without raising my voice[151]

Typical of this commitment is the poem with the English title 'Shoe
Shine,' echoing the shouts of the shoeshine boys in the luminous night along
Sainte Catherine Street. The Montreal street is suddenly ringed with barbed
wire like the streets of Paris and London and Berlin in former times:

night-smoke night of lilac-shots and pendant-breasts
overcooked night in our barbed-wire cities ...

remember in your dreams already
my retinas sheltered a nest of wasps and irony.[152]

In the nocturnal wanderings of the 'Chat perché,'* the same revolt evident in Giguère's work appears; however, in Haeffely's case, it is augmented by images of the Occupation which had been burned into the young Frenchman's memory:

Men armed with clouds
Men armed with blood with pavingstones
at times the city lights up its sandy plains
to sea stars its bays
across from us free air
and the calm remains of forest.
To live for the love of sky and clouds ...
but now comes war
may war be fashioned
to be thought infinitely detestable.[153]

Subsequent collections use similar images in a variety of different forms. There is, for example, the block of primordial matter which resists the buffing of a civilization rejected by the surrealists; in one of the early poems in *Notre joie*, Haeffely wrote 'first I was only / a great colourless BLOCK.'[154] In *Le Sommeil et la neige*, he again provides these images of the poet-sculptor:

Survival is accomplished when the senses finally
perceive only an untranslatable
inorganic block ...
It is the cry of plaster attacked by the knife or
the lament of the prisoner or matter
relieved of a costly liberty ...
I scooped out the quicklime of the cliffs to
reach the mails.[155]

Finally, only erotic desire seems able to master this block of granite in 'Des nus et des pierres.' Desire is pure spontaneity and undermines the rock:

it's a woman
breasts and napalm
fire crackles under the stone
thousands of scattered stones

all the tenderness of flesh
against the cruelties of granite[156]

Then, obeying desire, the painter-sculptor's poems take life, poems often
inspired by the representational automatisms of black music; at times they
are perfectly abstract:

I think ... of those who paint for
hours and hours without hope. I
remember those who sculpt the illustrious
funeral procession ...

Enav traorln flash maje wedding tremor ...
I speak alone. Simple percussion exercises ...
Awaiting the rhythm given by the
drums, we sense only the echo of
liberating tom-toms.[157]*

In *Rouge de nuit*, Haeffely's surrealism achieves a certain purity. Here is
the woman of stone, the woman with pendant-breasts sculpted by desire:[158]

Every Sunday, the statue gives me
a gumdrop. If I act cute,
paws under my chin, I'm rewarded with
a sly little smile. I'm telling you she's
completely naked under that stone ...
Fulvia in pink marble
too long desired and served naked
in broken undulating lines.[159]

In addition to these 'explorean' lines,[160] Haeffely's poetry reveals automa-
tist – and generally representational – characteristics, while placing itself
more and more at the service of a linguistic revolution:

Today I write as I probe
the reddest part of my instinct
in order to retrieve through the narrow
fissures of time that light
issuing from elsewhere at the moment
when love founders ...
a cry populates our dreams
a few burst words circulate or

exchange one another under the concreted earth
silence reigns
death amplified by automatic mirrors[161]

Jean-Paul Martino

With the exception of Jean-Paul Martino, surrealism is irrelevant to the
work of other writers published by Erta, including Alain Horic,[162] Fran-
çoise Bujold,[163] Gabriel Charpentier,[164] and Jean-René Major.[165] Mar-
tino's poems went unnoticed for years, and his work did not appear in any
anthologies or textbooks before 1969.[166] In *Osmonde*, published by Roland
Giguère in 1957,[167] Martino talks about his art: 'Rugged onomatopoeias
beat at my temples,' he said, and later spoke of 'effervescent liberation and
translucid exploration,' describing himself as a 'brazen vessel full of lunatic
songs.'[168]

 Osmonde is mad poetry in the tradition of Artaud's surrealism. The poet
dedicates impassioned lines to Artaud in which can be found the symbol
of the bone prison common in Alain Horic's work from the same period.
These lines recall Artaud's disorientation:

> What was this voice at my window on the last night of my twenty years
> It was you ANTONIN
> It was you ARTAUD
> From that moment on my spirit bloomed from its prison of bone
> Like blotches of sun on dark snow ...
> Visions inhabit me
> Risky to tempered reason ...
> Ha Ha Ha Ha
> Oh before I leave you ARTAUD I must tell you
> Yes ANTONIN she left me
> Plain enough
> But it does me good to know you know
> We understand each other so well
> That's it on the 21st between SCORPIO and SAGITTARIUS.[169]

 Martino's relationship to the automatists is most apparent in the collec-
tion *Objets de la nuit*, published by Quartz. Not only had he read Gauv-
reau's manuscripts, but Quartz's publisher, Klaus Spiecker, exhibited in
the 'La Matière chante' show in 1954. The poem 'Que d'émiettements
de rêves dans le casse-noisette,' for example, delineates a revolt even more
violent than that in *Osmonde*. After narrating his colonial childhood, the
poet shouts out this halting song:

One-armed adolescents eye klaxon solitude
immense how young we were in space
the mind flooded by a deep thirst
surrounded by blind thirsts baying entities
backs to the coping of the enigma
This thirst inside inside
striating the schist of dried-up foreheads
The crippled race staggering vomiting
its belly opened
in the periphery of a hieratic lamp
drowning in its sap.
We are adolescents eye klaxon
impeccable granite angels
treading the night towards the devil's auction.[170]

In this profound revolt waged against language nouns become verbs;

My Sundays pursue me along the extended border of
my hunger
I rustic memories and draw them
on eagle hooks
I make them bite the rafter which justifies
the top floor
I colonnade a strange, ginger-lacquered
delirium.[171]

The man who wrote 'Je refuge sur la roue les songes dans des cornets'[172] and especially 'Ozeau soniature moge bel'[173] is no stranger to automatist arcana.

Erta seems to have played an important role in the evolution of surrealism in Quebec, a role which for a long time paralleled that of the automatists. Giguère's work with *Cobra* and *Phases* and Haeffely's connections with *Rouge Maille, Manomètre*, and *Periscope* provided points of contact, admittedly somewhat tenuous compared to the automatists' *Refus global*, yet these publications did allow certain artists and writers to join together and rally under one banner. The scattered efforts of Erta and the automatists finally came together as the result of a series of exhibitions and events, mainly those put on by Claude Gauvreau and Robert Roussil after Pellan and Borduas left Quebec.

EVENTS IN THE NINETEEN-FIFTIES

Certain publications, shows, and exhibitions provided a focus around which these groups could form and grow together. Attempts at collaborat-

ing on the last issue of *Les Ateliers d'arts graphiques* were undermined by
the withdrawal of the automatists; however, the participation of painters in
Les Editions Erta, founded in 1949, was a slow but fertile process for pro-
ducing combined visual and literary works. As far as collective creations
were concerned, the musician Pierre Mercure and the automatists achieved
some impressive successes. These included a performance based on a poem
by Thérèse Renaud and choreographed by Françoise Sullivan in April
1948, and *Les Deux Arts*, a dance and theatre piece performed in May
1949 and choreographed by Sullivan with costumes by Mousseau. Mer-
cure's project for an opera based on Gauvreau's libretto, *Le Vampire et la
nymphomane* (November 1949), never came to fruition. However, that same
month Sullivan's successful ballet *Le Combat* played at the Théatre des
Compagnons.

Each year group shows appeared on a regular basis with one faction or
the other declining to participate for reasons of principle which sometimes
turned into bitter polemics. But as one exhibition followed another – 'Les
Rebelles' (1950), 'Etapes du vivant' (1951), 'The Borduas Group' (1952),
'Place des artistes' (1953), and 'La Matière chante' (1954) – the differences
diminished. Coming after Borduas' departure, 'Place des artistes' in particu-
lar marked the beginning of a reconciliation between the opposing groups.

During this period, three issues of the periodical *Place publique* were pub-
lished, and from February 1951 to March 1952 it attempted to consolidate
avant-garde efforts, which tended to go off in all directions at once. Just a
glance at the final issues of *Les Ateliers d'arts graphiques* (1949) and *Place pub-
lique* (1952) reveals both how precarious and how necessary such a com-
mon front was.

Le vampire et la nymphomane

The Montreal automatists came very close to producing an opera with
music by Mercure and libretto by Gauvreau. But the weekly *Le Petit Jour-
nal* spoiled everything by running a satirical piece in its column 'La Vie
montréalaise' entitled 'Deux chiens dans un opéra automatiste,' with
photos of gaping she-monkeys and German shepherds at a piano illustrat-
ing excerpts from the text.

Mercure had known Gauvreau since their sixth year at collège clas-
sique when they had competed in an intercollegiate public speaking con-
test. In 1946, when Mercure was only eighteen, Wilfrid Pelletier hired him
as bassoonist for the Montreal Symphony Orchestra, and the following
year he composed *Alice au pays des merveilles*. In 1948, he wrote the music
for one ballet, *Pantomine*, and in 1949 for another, *Kaléidoscope*.[174] That
year he left for Europe, but before his departure Mercure asked Gauvreau

to write an automatist text for which he would write a score. His description of his Paris research gives some idea of what this music would have been like:

> Concrete music, like 'accidental' music, enchanted me. Gabriel Charpentier and I spent hours and hours experimenting with chance compositions and improvisations. For example, we would each write half of a composition for two pianos with a vague idea of its form and length. We wrote in seclusion. Then we would meet the following day and play this music together; the bizarre results of our experiment were very exciting.[175]

Mercure was friends with Borduas, Mousseau, the Riopelles, Marcelle Ferron, Jean McEwen, and Charpentier,[176] to whom he said once, 'You'll see what beautiful things chance can throw together.'[177] Naturally he had been asked to sign *Refus global* but he refused[178] for personal reasons, although this did not prevent him from requesting the abovementioned libretto from his friend Gauvreau. But Pierre Saint-Germain, who had also acquired a copy, turned it into such an object of ridicule in the *Le Petit Journal* article by, among other things, running the most laughable expressions end to end[179] that Gauvreau sent a letter warning him to retract the piece.[180] Saint-Germain clarified his position,[181] but on 11 December 1949, the newspaper printed a not-so-gentle letter by Mercure himself:

> This ridicule of Claude Gauvreau and myself cannot stand without a rebuttal ...
>
> It matters little to me whether Gauvreau's text – *Le Vampire et la nymphomane* – is made to look ridiculous by an editor who seems to prefer neglecting the often disturbing power of its prose in favour of a more laughable side, namely its vocabulary. In any case, this text did not meet the request I made to Gauvreau last May, which was to give me a work I could put to music.
>
> What does matter to me is to let it be known that I have never belonged to the automatist group, and that even though I occasionally lent my services as a musician to some of their shows, I am in complete disagreement with several of their beliefs.
>
> Besides, the complete failure of surrealism in Paris seems to me sufficiently typical of the fate awaiting its products and by-products.
>
> As for the text I requested from Gauvreau, I wanted it abstract, short and, knowing the originality of his vocabulary, I counted on conducting a little experiment in the lyric analogous to Schönberg's *Pierrot lunaire*.[182]

Gauvreau, aware of Mercure's reservations, learned of his final decision through the newspapers. His reply appeared the following week. It was lengthy, recounting their undertaking in great detail and ending with a violent proclamation of faith in surrealism:

> Surrealism dead? Has anyone killed it by rendering it obsolete? Though it may be true that some European surrealists are showing signs of fatigue after striving for ... knowledge for nearly twenty-five years, how could the present status of these individuals compromise the great collective movement – impersonal and universal – which *advances every day* and has opened an unforeseen and irreplaceable window on an unknown plain, still virtually unexplored ...
>
> Nothing is eternal, but, please, let's not prematurely bury the only men left alive in our ruined civilization!
>
> It's also worth noting that these pseudo-liberating and gratuitous burials of surrealism always prepare the way for a regressive *return* to outmoded ways of thinking far preceding surrealism (Arnold Schönberg's *Pierrot lunaire*, which Mercure wanted to recompose, dates from 1923, before the collective surrealist movement was even born).[183]

This letter was signed 'Claude Gauvreau, signatory of *Refus global*,' and Leduc wrote to Borduas from Europe protesting this use of the manifesto; however, Borduas had already stated that 'the manifesto was for each according to his needs.'[184] Elsewhere in his letter Gauvreau talked about 'Surrealism ... in its different affiliations,' emphasizing more clearly than ever that in his mind automatism was directly descended from surrealism.

In 1955, Mercure presented *Dissidence* for piano and soprano based on three poems by Charpentier. The following year saw his *Cantate pour une joie*, seven poems by Charpentier which Giguère had published at Erta. Mercure finally had his *Pierrot lunaire*:

> alas I am but
> I am but desirant
> and find myself clown
> or moonless pierrot ...
>
> black pierrot yellow harlequin
> with guitar dances on carpet white
> as pierrot's face black
> on red carpet with floppy sleeves
> full of wind head bent
> over sad eyes a smile

above a trestle the entrechat of
harlequin thief with guitar
of the untitled suspended ballerina
clavichord little bell dry and hard
like street at night where pierrot
drags his black sleeve slips away
the guitar of harlequin the yellow.[185]

This poem was more or less cubist – exploding forms, exploding colours, exploding sounds – and the accusation that undertaking another *Pierrot* was regressive was well founded. However, the third poem of *Cantate pour une joie* was in the revolutionary surrealist mode:

They have destroyed the city ...

guttural cries and laughter booted in leather
old streets old houses old women
stone by stone rats and mice in the water
poor men and pregnant women
in grey water grey stones and smoke
you will see
a child mourning his dog dead beside
him.[186]

A later work, *Tétrachromie*, was inspired by a Borduas painting, and Mercure's biographers like to emphasize the automatist painter's influence on their subject. Mercure did in fact retain his admiration for Borduas and remained friends with several automatists.

The Exhibitions

Les Rebelles
In the Salon du Printemps of 1950, canvases by Jean-Paul Mousseau and Marcelle Ferron were not accepted. Mousseau then decided to organize a sort of Salon des Refusés called 'Les Rebelles,'[187] which was accompanied by a manifesto:

We're the refusal to participate in the screwathon of cunts and hemorrhoids. We're the refusal to masturbate the parvenus.
Artsy-fartsy juries, counterfeit juries, wallow alone in your tubs of diarrhoea! We refuse and will continue to refuse to contaminate ourselves by hanging around you.[188]

The only automatists who did not participate were Pierre Gauvreau and Jean-Paul Riopelle. But automatists were not the only artists in Les Rebelles: Robert Roussil and some of his friends, Paterson Ewen, and Maciej Babinski were also among the exhibitors.[189]

The critics' reaction – especially Rolland Boulanger's – was not long in coming. Denunciations rained down on all sides, as indicated in this letter by Claude Gauvreau written the day after the exhibition:

> As usual, we're accused of having been too intransigent or not intransigent enough, of having conducted an overly dictatorial and exclusive campaign or not having been firm and categorical enough ...
>
> Having read the history of Surrealism, you will not be surprised by such a state of affairs. In fact, the contrary would be more disturbing ...
>
> We've been convinced for a long time that any act directed towards an immediate end, towards a consciously determined goal, is a stillborn act. These kinds of acts don't interest us. We're convinced as well that worthwhile consequences are totally unpredictable and we're so convinced of the unpredictability of these consequences that we pay no attention to them either.
>
> Without goals or organized consequences, what then are the motives for our actions? As always – on any level – desire.[190]

This exhibition became a celebrated event in the annals of Quebec culture and is even considered, by virtue of its 'anti-artsy-fartsy' manifesto, as the third act in a process of liberation after *Prisme d'yeux* and *Refus global.* It also attracted attention because one of the exhibits was Roussil's group statue *La Famille*, which had already caused a scandal of its own.[191]

The refusal of Pierre Gauvreau and Riopelle to enter the 'Les Rebelles' exhibition was, in one sense, a first indication of the group's dissolution amid the rise of new forces (Borduas himself refused to enter the 'Etapes du vivant' exhibition the following year). Claude Gauvreau commented:

> The 'Les Rebelles' exhibition was not an automatist show – what could we ask of other participants beyond acceptance in principle of the invitation and the proclamation? Are we being blamed for lacking authoritarian brutality? Obviously we are. And those who are doing the blaming are precisely the ones who, in other circumstances, accuse us of being intolerable dictators.
>
> There are no books on how to be a 'good automatist.' Adherents to the discipline of automatism do what they can, according to the lucidity and demands of their conscience, with no mental restrictions and no preoccupation with casuistry.[192]

Les Etapes du vivant
In May 1951, a group exhibition called 'Les Etapes du vivant' organized
by Claude Gauvreau, Pierre Lefebvre, and Mousseau attempted to show
'how the visual arts evolved from Nature to the representational to auto-
matism.'[193] Contributors who were not automatists were welcome and so
Riopelle and Pierre Gauvreau decided to participate but not Borduas, who
was already thinking, apparently, of leaving Montreal for the United
States.[194] This exhibition, which took place in a workingclass district on
Ontario Street, showed that the avant-garde was more accessible to the
masses than people thought.

The Borduas Group
A few days after Muriel Guilbault's suicide in 1952, a show called 'The
Borduas Group' took place in Gallery XII of the Museum of Fine Arts
from 26 January to 13 February. Borduas, no doubt wishing to distract
Gauvreau, who was haunted by Guilbault's death, asked him to help
organize this exhibition: 'I accompanied Borduas to each painter's studio
and, during this tragic time, it was consoling to see the master at work.
He always went for the finest, the most original, the rarest.'[195] This mem-
ory stayed with Gauvreau a long time, so much so that he wanted to
renew the experience in 1954 with the La Matière chante exhibition and
asked Borduas to make his critical choices in public.
 The group had acquired new recruits to replace the dissidents and those
disciples who had left for France: it now included Babinski, Barbeau, Bor-
duas, Hans Eckers, Marcelle Ferron, Jean-Paul Filion, Pierre Gauvreau,
Madeleine Morin, Mousseau, Serge Phénix, and Gérard Tremblay.[196] The
return of Pierre Gauvreau, who had refused to appear in 'Les Rebelles,' was
noted, as was the presence of Gérard Tremblay, who had three works pub-
lished by Erta in 1951 (Horizons, Midi perdu, and Yeux fixes). Jean-Paul Filion
later turned up at l'Hexagone and, in the spring of 1953, Marcelle Ferron
left Quebec for Paris after helping with the 'Place des artistes' show.

Place des artistes
The 'Place des artistes' exhibition in May 1953, was set up by Fernand
Leduc, Marcelle Ferron, and Robert Roussil across the street from the
Tranquille bookstore. Any artist willing to rent space could hang a picture,
and several automatists took part. All in all there were eighty-two artists,
including Barbeau, Borduas, Marcelle Ferron, Giguère, Hénault (poster-
poems), Leduc, Rita Letendre, Denys Matte, McEwen, Guido Molinari,
and Mousseau. Borduas, Hénault, and several others were absent at the
time: Borduas had been in the United States since April and Hénault
was in Sudbury.

This show prompted a long socialist polemic. Roussil announced that he intended to cast a sculpture he was exhibiting called 'Peace' in aluminum and send it to Mao.[197] A peace demonstration was even organized, which some artists considered 'unalloyed obedience to Stalinism.'[198] Taken by surprise, Marcel Barbeau and several of his friends whose anti-Stalinist feelings were well known sent a protest manifesto from Quebec City to Montreal, but Roussil refused to post it.[199] Thanks to Claude Gauvreau, it was published in the newspaper *Samedi-dimanche* on the front page.[200] The following week Roussil's rebuttal appeared in the same paper with a note from Gauvreau, who was trying to arbitrate between Barbeau and Roussil.

La Matière chante
One might have thought after 'Place des artistes' that *Refus global* was out of date. However, in 1954 Claude Gauvreau tried to consolidate the movement Borduas had initiated:

> A final effort had to be made to save the automatist egregore and I saw only one man capable of doing this: Borduas. The great painter had been absent from Quebec just a short while and already the young knew him only by reputation. Several people had told me how curious they were to witness Borduas' famous critical judgment.[201]

Borduas accepted after some resistance, denouncing this 'show in which I'd play the clown'[202] when he learned that a public selection was expected. His behaviour during the 'La Matière chante' exhibition was described by Gauvreau himself as the behaviour of a man in transition:

> I had written up a number of rules for the show which were to serve also as an invitation to the eventual participants. Borduas rewrote this text almost entirely. Completely imbued with the 'abstract expressionist' atmosphere of New York at that time, Borduas wanted to stress the 'accident' which indicates the precise tone of 'matter's song.'[203]

Borduas' thought had evolved through his contacts with Jackson Pollock.
 The exhibition ran from 20 April to 4 May at the Galerie Antoine. The critic Paul Gladu wrote an ironic commentary on the show and the selection session in particular:

> I'll cite part of the rules of the show: 'All those objects will be deemed cosmic and eligible which have been conceived and exe-

cuted directly and simultaneously under the sign of *Accident* (the accident that sounds the precise tone of matter's song. Works usually called, in Canada, 'automatist', or 'surrational' and, more or less everywhere else, 'abstract expressionism.' Apart from these labels, some intuition is required to ascertain whether or not a work is cosmic and eligible, whether it sings chaos or universal harmony) ...'

As for me, I was thinking of the recent skirmish over the Salon du Printemps at the Museum of Fine Arts which appeared in the newspaper *L'Autorité* between Gauvreau and the Museum director, Mr John Steegman ...

I said out loud to my astonished companion that exhibitions like 'Place des artistes,' those at the Tranquille bookstore, and this one contain a totally admirable and necessary element of revolt and eccentricity.[204]

Towards the end of the year, Borduas wrote to Gauvreau: 'Here, as I've told you, Pollock, Kline and ten other young painters have gone beyond surrealism. Of course, only in the most rigorous historical sense. Nothing to do with Mondrian, certainly.'[205] The Quebec poet and critic Gérald Robitaille, who was Henry Miller's secretary and translator, later said Borduas was 'one of Pollock's best disciples.'[206] Guy Viau attempted to put matters in perspective again by commenting on surrational automatism, which the 'La Matière chante' exhibition had tried to perpetuate: 'This type of automatism had not been practised by the European surrealist painters ... it was born in Montreal and New York (Jackson Pollock's Action Painting) more or less simultaneously and without any collaboration between Canadian and American painters.'[207]

Gauvreau knew all too well that Borduas had removed himself from his work in Montreal and reproached him for it, eliciting as a result the following very clear explanation. Writing from Paris, Borduas considered his stay in New York a stage during which the need for awareness had *succeeded* mechanical automatism:

> You attribute a strange attitude to me in New York. As if I'd had some kind of power, and over language into the bargain. No! At that time, the term automatism was replaced by 'baroque abstraction.' Out of a desire, no doubt, to signal the need for awareness which succeeded mechanical automatism. I had nothing to do with it! It isn't up to me to change anything. That seems obvious enough. I painted and showed my paintings to friends and critics. They named it so they could make themselves understood: nothing simpler and more unexceptional than that.

Here Mathieu and his friends use the term 'lyrical abstraction' –
it's prettier. Do you see me doing battle for or against it? Not
likely! ... I care as little for that as for the harsher name. But I talk
in order to be understood.

Besides, my painting is moving towards another more *impersonal*,
more general world.[208]

Borduas later said to Charles Delloye: 'The true disciples of Mondrian
aren't today's neo-plasticians. They're Rothko, Newman, Kline, Clyfford,
Still, and myself.'[209] This is a surprising, almost contradictory statement
unless the events that occurred between his rejection of geometric abstrac-
tion and adoption of lyrical abstraction are taken into account. Here he places
himself squarely in the abstract tradition, and one can only imagine the ex-
pression on the faces of Montreal's neo-plasticians upon finding themselves
even mentioned in the same breath as Borduas, since they believed they were
different and totally separate from him. Paul Gladu wrote of them in 1960:

Their great merit was in reacting against the soft, facile painting
practised by Borduas' disciples. Ideas of construction and discipline
had completely deserted that formula art in which *Accident* was
placed on a pedestal and the presence of will was considered
shameful.[210]

A more accurate salvo could not have been fired at the 'La Matière
chante' exhibition six years before. Claude Gauvreau answered Gladu with
a virulent letter refused by *Le Petit Journal* but accepted by *Situations*, the
periodical of the Montreal neo-plasticians. Certain passages contain a bril-
liant summary of the main contemporary schools related to automatism:

Three analogous currents of thought were born simultaneously in
three distinct centres: automatism, abstract expressionism, and tach-
ism. In 1946, two of Borduas' disciples – Riopelle and Barbeau –
overtook their teacher and followed the path later taken by Jackson
Pollock; they were also several years ahead of Willem de Kooning. In
Paris, Nicolas de Staël invented a new form of expression fairly
similar to that of Borduas' pre-New York period and slightly pre-
dating him. But the forms employed by Riopelle and Barbeau were
freer and more vigorous than de Staël's. These analogies occurred
independently without reciprocal influences; they can be explained
by the evolutionary logic which made this a necessary phase after
abstractivism and surrealism. Only in New York, thanks to the
shock of making contact with Pollock, de Kooning, and Kline, was

Borduas himself able to catch up with these men and later go be-
yond them. But what he took in New York he could have received
several years earlier from some of his own disciples.[211]

Gauvreau may have been correct in stating that Borduas 'never resem-
bled either Mondrian or Kline'[212] but, paradoxically, the opposite could
also be true: he resembled them so perfectly – while remaining, as they
did, perfectly himself – that he was both completely similar and completely
different. Claude Jasmin, speaking of Riopelle,[213] said that surrealism was
made obsolete by geometric art and Pop Art, and Pellan said, 'I don't
believe in automatism as a doctrine, although its practice has many possi-
bilities.'[214] Possibly Borduas would have agreed with them, given that
while in New York he thought Pollock had gone beyond surrealism, and
while in Paris that he himself was in the process of going beyond Pol-
lock – and far beyond the abstractionism of Mondrian. The forces led by
Borduas and Pellan which had been considered divergent, as well as those
represented by the automatists and the neo-plasticians,[215] tended to flow
together in the end.

THREE SHARPSHOOTERS

Other personalities in Quebec letters are often mentioned in connection
with the automatists and revolutionary surrealists, among them Jean-Jules
Richard, Jacques Ferron, and André Pouliot, who all either influenced or
were influenced by surrealism. These three were assiduous frequenters of
the studios and backrooms where the automatists and other contributors
to *Les Ateliers d'arts graphiques* and *Place publique* could be found.

Richard's friendship with Henri Tranquille and Emile-Charles Hamel
dates from 1939 when a polemic on modern poetry surfaced in the news-
paper *Le Jour*. The periodical Richard edited and Tranquille published
will be discussed here prior to the work of Ferron and Pouliot, who was
brought to public attention by Ferron.

Jean-Jules Richard

Jean-Jules Richard is known as one of Quebec's first committed writers,
and he is very possibly both the first socialist writer and first modern
novelist in Quebec. This almost legendary personality was born in Saint-
Raphaël de Bellechasse in 1913, left his native village at age fourteen,
and wrote his first novel that same year. At the onset of the Depression he
cleared timber in Abitibi and then enrolled at a private school in Ottawa.

Turning hobo in 1932, he hopped freights around Quebec and Ontario. During the Bennett years, he took part in the hunger march on Ottawa, leading a delegation from Quebec to the capital,[216] and was considered a communist because he supported the social policies of the New Deal.[217] After each adventure he transposed his experiences into novel form, striving to create a new aesthetic, but unfortunately he destroyed all his manuscripts before he left for the war. When he returned in 1946 he wrote the novel *Neuf jours de haine* and submitted it to a literary contest in 1947. The book was disqualified and Richard claims that Les Editions de l'Arbre hesitated to publish it because of certain liberties in the text (it finally appeared in 1948).

In the novel, a soldier called Sade is also a painter. One of his canvases depicts the mental state of a soldier in his platoon in essentially surrealist terms:

> He composes a fantasy drawing.
> Sunbeams tangled up in leather strands. Balls of light half hidden by shadows. A mottled wing tries to escape a forked beak which is itself attached to cannon-shot. Sade offers the drawing to Manier.
> It is the surrealist image of his provincial Québécois personality. Manier's state of mind exploited by all sorts of profiteers. Manier turns serious. The balls of light are his crystal ball. How has Sade guessed what Manier was concealing? The crystal ball of his dream, no one knows it exists. All the same, that's what he thinks. His brain as he sees it in a calm moment. The way he wants it to be above all, limpid, welcoming ...
> The Scotch illuminates and veils his mind. Play of light and reflections, surrealism.[218]

Certain descriptions of a disturbed consciousness (Frisé seeing his brother Paul blown to bits by a shell) or a vanishing consciousness (Manier about to die) become genuinely surreal in Richard's writing: for example, this speech which Paul, fading away, addresses to his terror-struck brother:

> Yet I see. Better than with my eyes. I am possessed by a lucidity more pure. I perceive instead of hearing. I discern instead of seeing. I comprehend instead of feeling. It's strange.
> It reminds me of this book on spiritualism ... It talked about the elucubrations of the spirit after death arrives. Effortlessly I distinguish my state. I am free of matter.[219]

Jean Manier's death is treated in a similar fashion, somewhat like Malraux's description of Tchen's and Kyo's thoughts as they died in *La Condition humaine*.[220] But the images Manier perceives are the very balls and lights in the surrealist portrait Sade had painted of his mind. This loss of consciousness is above all a loss of reason, a surrational transition before darkness falls:

> Fortunately Jean no longer has his reason. Just a glimmer in his brain. His crystal ball rolls behind a cloud of blood. Now woodpeckers peck at his crystal ball. They peck at the glass. Glasspeckers. The Larousse is right.* The glasspeckers have diamond beaks. They make the crystal ball bleed. The ball descends or the bloody cloud climbs. The glimmer dims.[221]

The novel also contains many descriptions of, and reflections on, sadism,[222] eroticism,[223] and hallucinogens, especially the effects of morphine[224] and opium.[225] The author relives the ecstasy of those moments,[226] using the popular expression of a later generation ('trip') to designate the kind of hallucinations so celebrated in surrealist poetry, heir to Lautréamont's disorientation:

> His obsessive fear takes on certain dimensions. It's like childhood nightmares brought on by fever. As soon as he closes his eyes, his eyelids advance and retreat. Like the watch. No regulator for his eyelids. He doesn't know if he should advance or retreat. If they advance, they enter his head along with – unknown to them – mirages, strange perceptions of the continuum. If they retreat, they drag his head with them. His head empties, sucked away by the extravagant attraction of space.
>
> He feels himself depart on a trip inside his head. But he stays there, on the pallet, in the garage. Filaments link his nerves to his wandering eyelids.[227]

Richard often evokes the surreal in this novel. Just as his brother vanishes before his eyes, Noiraud cries, 'C'est de l'incantation. De la magie noire.'[228] Earlier, the narrator comments: 'The width, length, and depth of the previous night, the fourth dimension of the previous night culminate. Thwarted, Noiraud sets off for the future paradigm: the fifth dimension.[229]

References to astrology and prophesy are even more numerous in *Journal d'un hobo* (1965). A young vagabond searching for his identity visits an Indian shaman, who describes him in these words:

To change water, you need fire, a container, water. Fire is life. The container: your body subjugated by the minor senses. Water is your mind.

Your mind is consciousness, thought, intelligence, reason, judgment, will, instinct, understanding, taste, memory, imagination, desire – everything, in short, which is limpid within you and easy to understand.

When water is heated, it is transformed. These are the effects of life, the minor senses, and the mind. The water fills up with bubbles joined together, and in this more visible water you find the image of the major senses.

The major senses are intuition, clairvoyance, fascination, telepathy, ubiquity, enchantment, agility, incantation, evocation, hallucination, sublimation, abstraction and, finally, magnetism.[230]

All of *Journal d'un hobo* can be explained by the shaman's admonitions and the way he applies them to the mythic state of the androgyne, that is, the young hobo. The shaman's judgment is repeated throughout the novel, and its prophetic words are often evoked just by repeating its opening sentence:

So you are not good and gentle, you are seductive. You are not friendly and calm, you are magnetic. You are not wise, you are clairvoyant. You are not just, but telepathic. You are not passive since you know ubiquity. For you who are double, the secret of water transformed by life will be easy.[231]

The notion of magnetism celebrated here had already been evoked in *Neuf jours de haine* in an analysis of eroticism: 'Everywhere there are beings with generous hearts. They spring forth from themselves like a mystery. They radiate magnetism.'[232]

Richard was founder and editor of *Place publique*,[233] the avant-garde periodical in which Hénault and Giguère published some of their work. Its first issue appeared on 21 February 1951. Richard took the opportunity to defend his collection of stories entitled *Ville rouge*, published by Tranquille. He quoted denunciations by the clergy and *Time* magazine which called his visit to Warsaw to attend the Peace Congress and his presence at a socialist meeting in Toronto incriminating; he also quoted the clergy's warnings about the 'dubious' morality of *Ville rouge* and responded energetically to all these charges.[234] *Ville rouge* did have powerful defenders in the party like Pierre Gélinas, who had already published Richard's story 'Three Taxis' in *Le Jour*.[235] The political tone and popular appeal of the writing left no doubt about the author's sympathies:

He wants to know something else. Something that makes you feel good inside. Something you can't find in the country or even in the village. Something special in the city.

There are so many things. The rows of newspapers. The magazines. The books. Poets writing red violent words.[236]

Richard was also known because of the 'Procès du sans-culotte' which followed the incarceration by the Montreal police of Roussil's sculpture, 'La Famille,' on charges of vagrancy. This was a mock trial recalling the trials of Barrès by the dadaists and of Dali by the surrealists. Borduas wrote a letter to Jean-Jules Richard refusing to participate in the trial, but he did make one recommendation:

I would like your committee to organize a national campaign with the avowed aim of raising a temple around the colossus in order to shield his flowered manhood from the sight of the less gentle sex. A temple where only ladies would have the privilege of entering the Holy of Holies. This would be your monumental Maboula's eternal reward if acquitted, his eternal punishment if found guilty.[237]

In another letter, Claude Gauvreau gave a better indication of why the automatists were hesitant about this trial, which nevertheless was intended in the spirit of the spectacles put on by the surrealists:

I'd been invited to attend the preliminary meeting at which a decision was to be made about going ahead with the trial of Robert Roussil's statue ...

There's no doubt that Roussil fell into the hands of leeches who wanted to exploit his statue – at no risk to themselves – and derive their own worldly, clever, and profitable amusements from it.

This work cost Roussil a lot of physical effort and a big dose of social courage.

Nothing appeared more odious to me than this bourgeois vermin, having taken care to avoid any chance of being compromised, trying to turn a profit by commandeering the intellectual lifeblood of outcasts.

I thought the good Roussil would certainly need help in such company, so I went to this meeting, not really pleased about it but certainly with a lot of conviction.

Roussil wanted me to be his defender ... At the meeting, there were frankly only two people who were completely likable: Jean-Jules Richard and Roussil.[238]

Place publique immediately laid down a program for committed art which might have called forth the same accusations of gratuitous motivation Gélinas had levelled against Borduas:

> *Cahiers de la Place publique* does not propose a fixed program, much less a manifesto. What must be avoided above all are overly restrictive frameworks which risk limiting action ...
>
> In the *Cahiers de la Place publique*, literature and fine arts will never provide grounds for escape or self-defence. We must support the worker and his legitimate demands as well as the intellectual whose freedom of expression is threatened.[239]

This statement implied a division between certain classes on the one hand and certain interests on the other. However, the automatists no longer believed that the solution to social problems consisted in replacing one ruling class by another, or that intellectuals' and workers' demands were irreconcilable. It is therefore not surprising that no automatists appear in the table of contents of *Place publique*'s three issues.[240]

Jacques Ferron

The points of contact between Jacques Ferron and surrealism are numerous in so far as he had to define himself in relation to those around him, 'painter friends who, taking surrealist elucubrations as a point of departure, had done something completely different from surrealism by simply stripping away the representational element from the canvas.'[241] Unlike his sister Marcelle who signed *Refus global*, Ferron was never very close to Borduas. He went after Borduas in *Le Ciel de Québec*, a sky from which he plucks out almost all the stars, real and bogus, and said in addition: 'I never got along very well with him. I found him boring. I didn't get his jargon. In 1949 he was decked out in Breton, the Marquis de Sade, and Doctor Mabille, authors who didn't suit me.'[242] Ferron was deeply involved in socio-political struggles but he turned away from Stalinism, despite his first wife's attraction to it.[243] Only after rejecting this political option did he discover the value of *Refus global*, yet he never mythologized it.

Ferron published his first book, the play *L'Ogre*,[244] as one of the *Cahiers de la file indienne* series in 1949, but nothing in it derives from automatic writing.[245] His next work, the short story *La Barbe de François Hertel* published in 1951 by Les Editions d'Orphée, again mentions the dark legend of the Ogre. First there is a metamorphosis:

I entreated Zazou to return to his female incarnation. He graciously agreed. I closed my eyes so as not to embarrass him during his metamorphosis. When I opened them again, there before me, mocking and tender, was the girl who, under a sycamore and without any vulgar gestures, had showed me her white thighs ...

I told her the story of Tom Thumb, how the birds ate his bread; he lost his way and remained in the forest.

We are lost in existence like Tom Thumb in the forest: we live without leaving a trace and nothing on one side or the other sets us in motion or finishes us off. You've lost your Master; we never had one. Don't be alarmed; we're happy all the same ... Unhappiness, you see, lies in wanting more, in looking for the trail the birds have forever blurred, in opening up to infinity, that Ogre of the forest.[246]

Although Ferron frequently writes fantasy, he is probably closest to the surrealists in his marked predilection for folklore. In his *Contes*, he is less interested in storytelling than in interpreting Quebec life, as he does with the story of Tom Thumb; in this way he takes part in the search for new myths. There is also Ferron's 'unequivocating' side linking him to the revolutionary surrealists.[247] In fact, he seems to have assigned himself the mission of cutting down shallow, artificial myths (the puffing up of historical personages like Dollard des Ormeaux[248] and la Dauversière[249] for example) in order to revive others. According to Ferron, these have been concealed because they could harm the powers that be (cf. his great interest in André Chénier and the Rebellion of 1837).[250]

Ferron's *La Charette* is a fantasy novel. The characters 'have become acquainted with the powers of darkness and rather abruptly turn up in hell, somewhere around rue Saint-Denis,' as Réginald Martel put it.[251] Martel points out exactly how much *La Charette* owes to fantasy both in its style and plot, which brings back the devils of *L'Ogre*, *La Barbe de François Hertel*, and certain stories in the *Contes*: 'Their long verbal delirium is fascinating; it is inspired by the tragic and far-fetched mythology present in so many marvelous and moving tales.'[252] Archangels, sirens, Red Riding Hoods, elves, and witches were already rubbing elbows in the *Contes*:

These legends are only temporary liberations; all they require for the moment is the superimposition of a legendary country over the real one, pushing it to the rear. When the legendary has rejoined the real, one can imagine that the story has done its work, that life and dreams have finally been reconciled, and that the country has become livable again.[253]

Perhaps this idea of making the country 'livable' impelled Ferron to go into politics as a candidate for the Parti social démocratique in 1957 and 1958 along with Thérèse Casgrain, Michel Chartrand, and Gaston Miron.[254] Later he went one better and founded his own party, the Rhinoceros party,[255] conferring upon himself the title of 'Eminence of the Great Horn.' This was essentially a surrealist act, as were the foundings of the Parti Peau-éthique, le Parti des Poètes, and the Parti Parti, all of which came into existence during the 1970 provincial election.

The distance provided by writing fiction and fantasy allowed Ferron to better judge Borduas' importance and the importance of *Refus global* in Quebec's liberation as time went by. He discussed *Refus global* in 1959[256] and Borduas in 1960 and, as always in his work, words of praise were tempered with acid barbs hurled at an author whom some have deified:

> This clever, candid, astute, and delicate man knew how to make transitions. His passage from the school of interior design to the school of glory via a kind of artistic revolution, this global refusal which opened the mouths of those with the puniest appetites and, turning our censors upside down, showed them in their true light, is a marvellous piece of work.[257]

This was a complete about-face from his position in 1949. Influenced in this regard by Vadeboncœur, he explained the change:

> Painting is the magic book of spells in which the future may be read – after the fact, of course. You don't pass with impunity from the representational to the non-representational, and that's what's interesting about Borduas. In changing his style of painting he created an uproar which stunned the country. It was a global refusal of the contemporary situation and a turning to cosmic powers predating all civilization, to telluric influences and mad passion. A laborious and extravagant delirium which made me laugh ... I didn't know anything about art then. But I'm not laughing now. Painting isn't a toy. Borduas quite simply proved he was a genuine painter.[258]

Ferron also changed his mind about Claude Gauvreau, whom he described – in the midst of some bitter anecdotes – as 'the soul of automatism.'[259]

Marcelle Ferron

Marcelle Ferron is a painter in a family of writers who joined the automatists in 1947 and signed *Refus global* the following year. She exhibited with

Jean-Paul Mousseau in 1949 and took part in the public debate surrounding the 'Place des artistes' show in 1953. That year she left Montreal, as did Borduas: she went to Paris while he went to Provincetown, Massachusetts, and later New York. Her contributions to the 'Phases de l'art contemporain' exhibitions in 1954 and 1955 drew considerable critical attention. Ferron has commented on this era: 'Surrealist poetry and writings liberated us on an intellectual level. But there is no connection between surrealist painting and ourselves ... For us, surrealist painting was literary.'[260]

In her generous, expansive way she practised non-representational automatism, and her illustrations for Gilles Hénault's collection *Voyage au pays de mémoire* accentuate the poet's automatist qualities. In 1978 Ferron and Hénault created two objects – she a painting, he a poem – with the same title, *Le Tableau est toujours un inconnu*. Unmarked by literal surrealism, this painting seems to be searching for a verbal automatism complementary to it so that the visual traces of one could be superimposed upon the verbal signs of the other.

André Pouliot

The sculptor André Pouliot's automatist poetry did not appear until 1957, when Jacques Ferron published it under the title *Modo Pouliotico* in *Les Cahiers de la file indienne*. Two prose pieces later came out in 1959 in the periodical *Situations*.

Pouliot, who died in the fall of 1953 at the age of thirty-two, had been writing for several years (his earliest published poem is dated 29 November 1951). 'People from all clans and parties' (as the introduction to *Modo Pouliotico*[261] put it) came to his studio on Christin Square: Mousseau and later Robert Blair had once worked in the same studio, where drinking was pursued to the point of hyper-aesthesia.[262]

In Pouliot's work, ideas often evolve through assonances and puns:

> Nothingness, negation, total refusal ...
> We have invented pentothal!
> But there never was a total Pan
> And this feeble nembutal
> Is just a brutal lie.[263]*

Philosophical and religious problems are the subjects of his extremely ironic prose poems. Like the poem quoted above with its 'refus total,' the following text was probably influenced by automatism:

> Thomas Aquinas, father of the Church, was born of unknown fathers. His mother, Madame Parthenogenesis, was knocked up no

doubt through the workings of Saint Aristotle the Stagyrite. From
early childhood, a marked aversion for the Averrhoists. A strange
philosophy which, once its system rattles into motion,* depends on
the phantasmagorical presuppositions of revealed religion.[264]

This work and his 'Petit poème auto-matisse' shed light on a more
vigorous ideology than might appear at first. The author lets himself go
in this poem more than in 'Embarquement pour Cythère,' which is writ-
ten in rhymed verse (though some of the rhymes verge on the ridiculous).
There are, however, passages in the collection where the imagination is
allowed to roam free:

> but the madwoman is at home, she's left Chaillot
> All you saw there anymore was blood clots.
> Ah! Oh! Hey! Here comes a nigger, a vinegary nigger,
> Pissing vinegar on small-time crime
> While the white right-on-target
> The Flux-Flux-Flank crushes some black
> And in his White Sepulchre
> The somber Truman (do not confuse with True-man)
> Bombs away
> Atomic.
> Bastard avatars of lascars from caviar to radar!
> Vitriol on the chops of infamy.[265]†

Even when writing unrestrainedly, the author could produce relatively
logical sentences, such as the lines about Truman. The inherent continuity
of his imagination is most often based on spontaneous and violent eroti-
cism. In the following poem, an obsession with disorientation deforms the
words, at the same time exploiting all their image-generating potential:

> Zygmoid, schizoid (on the tightrope)
> (No tremas, hey, you have to depart this life)
> Not everybody can have a trematism that wants one.
> Lent's not a barometer nor a trireme
> Nor an apophthegm
> Nor a criterion nor a clyster
> But a shabby pied-à-terre
> A phalanstery,
> A phallus burying itself in earth
> Plant a gland, if it unchains itself
> From its scabbard
> (Plac-en-ta-earth).[266]‡

The imagery is beautifully worked out: at the start it works by sound linkages, at the end by visual association. For example, 'carème' evokes 'quadrirème,' which calls forth 'trirème' and 'barème' instead of 'birème'; 'clystère' brings in 'phalanstère,' whose sound evokes erotic images like 'phallus-en-terre,' augmenting the social imagery of a phalanstery. The splendid images of the 'chêne' in the ground and the human 'chain' facilitate an abrupt passage from the erotic to the social image.

One of the two texts published in *Situations*, '"Cows" que tu dis???,' is a typical example of Pouliot's fits of verbal delirium which were famous among his friends. The wordmill turns unchecked; the last words are first and the first last in this verbal carousel:

My yoyo, my kitty, my titty, my young pimp, my hoot owl, my ampersand, my holy, my jeepers, my old fart, my old fogey, my young urchin, my feather in the wind, my madwoman at mass, my rumbum, my frivolous ant, my ecstatic dragonfly, my arthritic lepidopterus, my bucolic kettle-drum, my honeyflower, my starfish, my free-running asteria, my pendulous flyswatter, my cowlblister, mellifluous mammary, my zeugmophagous muscadelle, my warren pine, the she-rabbit of Varennes, my canon balls, my hairy ½ ushion [sic], my plump cushion, my nodding pet, my Daudelind marionette, my lovey, my liquid bull, my teeny air drop, my flour algae, my front boob, my wine hive, my mustard plaster, my brat who catches flies, my hep sable, my whither-thou bohème, my beautiful weasel, my furtive tapir, my Jerusalem artichoke, my Chinese drum, my chewed-up honeybun, my worn-out crêpe, my trumpetless mole, my trunk without elephantiasis, my aurox-horn oasis, my dog-eared roc, my snivelling horncone, my wily hay, my weed, my sprig of oats, my loveseed, my ruffled flower, my ladybird fur, my Chick, my pineapple, my burning coal, my roguish gipsy tart, my doddering Chinese cocoon, my ciggypoo, soaksheet, my bilateral pumpkin, my Milky Weight, my glaucous galaxy, my hell with no bats, my scat your brain, my Yoyo, my kitty, etc. ...[267]

The second text, 'Essor et délivrance,' reveals the other side of Pouliot – the committed artist. Inspired by his initial experiences as a pilot, he headed this contemporary description with a line from Mallarmé, 'Je suis hanté! L'Azur! L'Azur!'

I was wading at the time through the muck of an anaemic spring. I was an adolescent troubled with material worries and 'burdened with chains.' But what I suffered from most was this *mal du siècle*, the daily realization that I was condemned to live in this shabby

world, to rub elbows with shabby human beings and to use magnificent stores of energy fighting shabby problems ... Fighting rotten politics, a shameful, slack-mouthed society whose motto seemed to be a revolting 'every man for himself.'

Nausea of prolonged adolescence.

Driven by circumstances towards the unacceptable, I watched all my ideas sink with me into this universal slime; through the intensity of my disgust, I felt the time coming when I had to tear myself from the viscosity. I was prey to dark thoughts when a throbbing made me look up; in a luminous sky I spotted, sporting through two clouds, a graceful yellow monoplane.[268]

Pouliot seems to have been both an automatist and a revolutionary surrealist. He took part in the experiments of both groups without being explicitly identified with either one – perhaps he wanted to unite these two tendencies. Though very little writing by him survives, he will be especially remembered for his sculpture, his union activities, his brazen participation in the plays put on by the automatists on 20 May 1947[269] and the notorious festivities celebrating the 100th anniversary of Balzac's death,[270] as well as for his countless and unforgettable recitations of explorean poetry.

CONCLUSION

The automatists were not the only ones in Quebec to consider themselves descendants of the surrealists. The circles around Les Ateliers d'arts graphiques and Les Editions Erta, as well as around individuals like Richard, Ferron, and Pouliot, evinced a more restrained surrealism which was still related to the automatist movement. This surrealism was, generally speaking, more politically involved than that of the automatists, who remained faithful to Rupture inaugurale and Refus global and refused to engage in partisan politics. To some extent, it resembled the revolutionary surrealism of the Cobra group.

This chapter has chronicled the attempts to bring together those people often (and unfairly) referred to as the heirs of either Borduas or Pellan. This unifying movement began to function, though with limited success, from 1949 to 1953, that is to say, the period between the last issue of Les Ateliers d'arts graphiques and the 'Place des artistes' exhibition. Chapter 5 will examine similar efforts subsequent to this period.

5

55

Further Downstream

Surrealism will die when it no longer produces through its various descendants original, authentic works, and when another more *progressive*, more *dynamic* intellectual movement *supersedes* it.

Claude Gauvreau[1]

Pellan left Montreal for Paris in 1952 and in 1953 Borduas left too, first to New York and then to Paris. In so doing they joined an impressive list of people exiled by the increasingly repressive climate of the fifties.

Once the two masters were gone, the polarities of influence changed. Between 1953 and 1963 appeared a new generation which called surrealism into question: even though it was discussed and experiments continued, surrealism was no longer taken for granted. One centre of activity, the group around the publishing house l'Hexagone, had few links with the surrealist movement in general, but it very soon took in the poet Paul-Marie Lapointe and carried on Erta's work by republishing some collections originally put out by Giguère. Two other centres, the publishing houses Quartz and Orphée, brought together authors who were friendly to, were influenced by or felt kinship with Borduas and Gauvreau.

Following them, another generation in the sixties gave birth to such movements as 'Le Nouvel âge,' 'L'Horloge,' 'Le Zirmate,' and 'Opération Déclic.' Although these groups claimed kinship with Gauvreau and Borduas, they prompted Gauvreau himself to admit that 'automatism has now been superseded.'[2] Surrealism yielded to something else, became something different. During this period its effects were felt everywhere to a

greater or lesser extent, but this chapter deals only with those movements, events, and works which seem to have had special affinities with it.

L'Hexagone

During the period of the avant-garde exhibitions following *Refus global* and *Prisme d'yeux*, publications were rare. However, one group, originally composed of six members who took the name l'Hexagone,[3] published its first work, *Deux Sangs*, by Olivier Marchand and Gaston Miron, in 1953. Claude Haeffely was present at the launching and became friends with Miron so that, soon after l'Hexagone started, a rapprochement developed between Haeffely's and Miron's friends, that is to say, between Erta and l'Hexagone.

It was understood from the beginning that l'Hexagone was not a 'school,' and that its name symbolized the diversity of views held by its six founding members.[4] Still, it is remarkable how quickly authors published by Mithra-Mythe (Paul-Marie Lapointe)[5] or by Erta (Horic, Hénault, Giguère himself) appeared with l'Hexagone, and the group was one of the few at the end of the fifties still receptive to the surrealist movement.

Influences
Although l'Hexagone followed no 'master' when it started, Grandbois did enjoy considerable prestige. In 1957 l'Hexagone brought out his *L'Etoile pourpre*, two years later the periodical *Liberté* devoted an issue to him,[6] and in 1967 l'Hexagone republished his entire work.[7] This led Pierre de Grandpré to comment that 'the young poets of French-Canadian post-surrealism have paid their respects to their leader and most important precursor.'[8]

The influence of Paul Eluard and René Char is also much in evidence, possibly as the result of Jean-Guy Pilon's arrival on the scene. Char's collection *Les Matinaux* provided l'Hexagone with a name for one of its own series, and Pilon persuaded Char (a supporter, friend, and literary successor to Eluard) to write a foreword for his *Les Cloîtres de l'été*.[9] According to one of its founders, Louis Portugais,[10] l'Hexagone was also influenced by Borduas, and his friend Patrick Straram claims that Portugais himself was influenced by Jarry and Eluard.[11]

La Poésie et nous
La Poésie et nous, a collection of talks given in 1957 at the first in a series of writers' symposia at which authors from l'Hexagone played a leading

role, gives some idea of how important surrealism was to their poetry. The contributions of Gilles Hénault, Michel Van Schendel, and Yves Préfontaine were especially representative.

Hénault mentioned his links to the European surrealists, mainly to those who were most committed politically. At the same time, however, he showed to what extent he intended to keep his distance from them since their causes were too dependent on specifically European events:

> I am thinking in particular of Desnos' last poems, poems by Eluard, Aragon, Loys Masson, Seghers, René Char, Pierre Emmanuel, Prévert, Marcenac, and a hundred others. They are not only politically committed poems, but dated too – 1945, 1946, 1947. Some are both a warning and a last call.
>
> You may say that things are not so simple. History doesn't determine everything. You forget, I will be told, all those who have continued to write beautiful poetry – very free, very pure. You forget that Tristan Tzara was Romanian, not French; you forget that the works of Engels and Freud preceded the surrealist revolution; you forget love. I forget none of that. I forget neither Jarry's revolver, nor the manifestoes, nor the medals Prévert pinned to his pants to show his contempt for decorations. I would even include ouija boards, if you like.
>
> What I want to emphasize here is that the line of descent is strictly a literary one. We witness these strange flowerings rising up before us without actively participating in the state of mind which gives them birth.
>
> Our deepest roots lie in our own life, and that is why we sometimes misunderstand the steps taken by the French poets and why we refuse to follow them into their areas of commitment.[12]

There was, then, a tradition in Quebec, a tradition which Michel Van Schendel described in *La Poésie et nous*,[13] emphasizing as he did so the exploratory aspect of Quebec automatist writing. As a partisan of a more polemical literature, he too was careful to express reservations:

> Culture only exists when straining at the bit. Poetry is proof of this, and it is in relation to this proof that one must judge the work of Saint-Denys Garneau, Alain Grandbois, Anne Hébert, and the efforts of the surrealists and automatists ...
>
> From that moment on, after the dykes broke, the flood had to run itself out. Attempts at liberating the language could no longer be contained. It seems to me it is in this context that we should try

to understand the experiments of the automatists. It is quite possible not to like the various works published by the automatists, but one can't deny them at least one merit: they started Canadian poetry down the road of experimentation ...

The principal merit of the automatists is to have created a laboratory of the word where its density and powers of suggestion could be tested, and where we would be at liberty to study the reactions between language and the Canadian sensibility.

I think of two outstanding works in this regard, two works with nothing in common except the use of the same basic techniques – *Sur fil métamorphose* by Claude Gauvreau and *Le Vierge incendié* by Paul-Marie Lapointe ...

Surely the great revolt by Canadian poets against formal verse was never more all-encompassing than in these two volumes by Gauvreau and Lapointe.[14]

Long before joining l'Hexagone, Gilles Hénault had been the first exponent of this local tradition in automatic writing and he gave the best description of it to participants in the 1959 writers' symposium. In three paragraphs he summarized the essential concepts in his poetry; this passage contains ideas previously embraced in Borduas' circle, which Hénault frequented around the time of *Théâtre en plein air*:

Destruction of schematized thinking, baring the subconscious, dynamiting the heart, refusal of descriptive and narrative modes, return to the philosophical sources of the changeable through an awareness of Heraclitean becoming, hypostasis of the imaginary – these are a few characteristics of the modern poetry movement ...

Automatism justified itself in this way: the conscious and unconscious 'self' mines poetic seams, perceptions encased in their sensory dross, and projects them in images, signs, and structures which, when read – or rather when perceived by another sensibility – reveal an all-encompassing, absolute experience.

This attitude, though very subjective, simultaneously revolutionized both poetry and language. It established a rapport similar to that of communicating vessels between these two elements while still permitting them to maintain a certain distance. This allowed language in itself to become both the stuff and matrix of all transformations.[15]

In *La Poésie et nous* Yves Préfontaine aligned himself with René Char (who supported Breton against the revolutionary surrealists) and spoke out

against the explicit militancy of poets such as Aragon. Just like Wilfrid Lemoine, who said 'I believe that in the end it is not always poetry classified as "social" which causes the most social upset,'[16] Préfontaine denounced Aimé Césaire for turning partisan, preferring Artaud as a model instead. Advocating a human poetry, he explained:

> Is it a question of 'Man' as Artaud speaks of him – 'Man drawn and quartered in space, Man with arms open wide and invisible, nailed to the four corners of the globe'[17] – or of man as a social being ...
> When René Char says 'I don't joke with pigs'[18] or 'I am the imbecile of cold cold ashes which believe an ember survives somewhere,'[19] he isn't necessarily taking aim at some adversary on the political level, some pitiless torturer of the average man; he isn't thinking of social revolution (even though such a thing may be tragically urgent). Social problems are the business of sociology, not poetry. If there must be commitment on the part of the poet and poetry, I don't think it should be on a social level but on the spiritual level, on the level of 'this cry of the spirit which turns in on itself, in desperation determined to smash its fetters' ...[20] To link poetry indissolubly with social consciousness as some people consider fashionable these days is a mistake which is not only stupid but shows an infantile need for completely specious dialectical prowess, viz. 'Man being fundamentally a social animal, poetry (a means of human expression) can only reflect the social context in which it flourishes,' etc. etc. (Aimé Césaire is a giant when he makes images glow in the crucible of his poem, not when he worries about fraternity under the red flag.)[21]

Not surprisingly, Préfontaine's collection *Boréal*, published the same year as the symposium, is a pure voyage into the underworld of a snowbound country. He summons up Rimbaud's revolt, describing the hell, the nightmare of the ice as if to tame the landscape and the spoken word for his own use.[22]

However, it is difficult to recognize the Préfontaine of 1957 in the following excerpt from a letter refused in 1960 by *Le Devoir* but published by *Liberté*: 'Students of Quebec, start accumulating arms and grenades now. Aren't you a little ashamed to see your comrades in Europe and South America overthrowing governments and rescuing people from death and oblivion?'[23] Préfontaine seems to have opted for Marx at the point where Breton refused to make a choice. That same year, Préfontaine prefaced a collection with these angry words: 'No more closet literature. We

must act. Or else *their* silence will reign over our apathetic aphasia.'[24] A change in direction had taken place:[25] 'Assassinate this myth'[26] are the last words of *L'Antre du poème*. The voyage into the underworld was over; for Préfontaine the temples had collapsed, and from the depths of the cave an Orpheus had emerged into the light to declare: 'As for the poet's role, I want to make clear that it no longer awakens in me the illusion of religion ... Magic, poetic or otherwise, has had no direct social efficacy except in primitive societies.'[27] This is why Préfontaine could keep *Refus global*, which proclaimed 'Make way for magic,' at arm's length: '*Refus global* has been superseded, agreed. However, *Refus global* remains a shining landmark in an intellectual darkness, in a desert of the mind beatifically and indulgently contemplating itself, where the most intense stupidity flattered the most cunning wielders of power.'[28]

Miron

Gaston Miron's thoughts on the European surrealists and the Quebec automatists did not differ greatly from those of Hénault, Van Schendel, and Préfontaine. Generally the members of l'Hexagone inclined towards the politically committed surrealists without going so far as revolutionary surrealism. When Miron was asked once to describe his ideal library, the founder of l'Hexagone and editor of the collection *Les Matinaux* named Rutebeuf, du Bellay, Eluard, and Frénaud. His reasons for selecting Eluard are both emotional (Nush) and ideological (fraternity):

> In November 1946 Paul Eluard lost his wife Nush in a brutal accident. His despair was immense. The year following this misfortune he published a collection of poems entitled *Le Temps déborde*. I feel very close to the poems in this collection as the summer fades. Here, again, I am projecting. I am reliving despair. I remember spring and the girl I loved and who left me ... Eluard experienced these feelings at their most intense. You always think you're the only one who's suffered. Was it not Eluard who said that poetry is practical? I also learn something from his work. I see him passing from extreme unhappiness into the normal rhythms of life. Following his example, I set out in that direction, for I live on – in order to find, as he did, comrades and a feeling of fraternity.[29]

Miron identified, then, with Eluard in his politically committed second phase, and in 1957 and 1958 he stood as a candidate for the Parti social démocratique.[30]

Refus global was an important event for Miron as well, though he too had his reservations:

Except for Marcel Dugas and Jean-Aubert Loranger, we have no
real forerunners ... The task of raising our poetry to the level of
modern involvement fell to two great poets, Alain Grandbois and
Saint-Denys Garneau ...

Until 1948, apart from *Regards et jeux dans l'espace* and *Les Iles de
la nuit*, all we saw were isolated efforts, timid attempts which didn't
really succeed, and reformulations of old styles of poetry ...

In 1948 *Refus global* appeared. Quite apart from certain aims
which inspired it and which at first I did not share, the manifesto
remains an important event. In terms of articulating violence,
revolt, refusal, and demands as well, it attacked (not fatally, of
course) our dogmatism and our sentimentality about academicism,
and this indictment covered every aspect of man and life ... Two
poets expressed the impulses of the time in a manner both exem-
plary and personal, ie, committed: Claude Gauvreau, the bulk of
whose work unfortunately has yet to be published, and Paul-Marie
Lapointe, whose *Le Vierge incendié* still haunts us. With the benefit
of hindsight it appears that the *Refus global* movement didn't have
the repercussions its promoters might have hoped for, at least not
in the domain of literature ...

The constellation of poets in 1953 will carry on these efforts,
affirm them and expound upon them, giving them a collective and
prolific reality.[31]

Liberté, 1959-61

For a long time the periodical *Liberté* was considered a publication of
l'Hexagone. Although the boards of directors of *Liberté* and l'Hexagone
were autonomous, certain members such as Jean-Guy Pilon and Gilles
Carle did sit on both, giving the two groups a common purpose – to pro-
vide an identity for the Quebec people by liberating their powers of self-
expression.

Liberté appeared in January 1959, and continued ostensibly as a publica-
tion of l'Hexagone until 1961.[32] The magazine was sympathetic to Quebec
painters and poets influenced by surrealism. For example, when Borduas
died, Jacques Godbout, who later made an important film on him, wrote:
'The phenomenon of Borduas goes beyond painting. In this land where
our leaders have no childhood because they have no parents, masters of
thought and life are a phenomenon of spontaneous generation like a
rocket or fireworks.'[33] After its separation from l'Hexagone, *Liberté* con-
tinued to honour Borduas: issues 19 and 20 carried a previously unpub-
lished piece as well as recollections by Robert Elie and André Jasmin,[34]

one-third of issue 22 was devoted to the correspondence between Borduas and Claude Gauvreau, and the main title of issues 59-60 was *Le Refus global: Vingt ans après*.[35]

Obscure Publishers

Certain small publishers like Les Editions d'Orphée and Quartz received very little attention and never became as famous as l'Hexagone despite their significant contributions. These houses made available works previously known only to habitués of the cafes frequented by artists such as La Hutte suisse, La Petite Europe, and l'Association espagnole. The two art publishers most relevant here are André Goulet of Orphée, who was expelled from Collège Sainte-Marie for associating with the automatists and the radicals exiled from Franco's Spain, and Klaus Spiecker of Quartz, who had been chosen by Borduas to exhibit in 'La Matière chante.'

Quartz
Les Editions Quartz published collections by Jean-Paul Martino (whose first book had been published by Erta), Diane Pelletier-Spiecker, Kline (Micheline) Sainte-Marie, Michèle Drouin, and Peter Byrne. In 1958 Klaus Spiecker published Diane Pelletier-Spiecker's *Les Affres du zeste* and, following in the surrealist tradition, he illustrated it as well:

> I will dance to delirium-memory[36]
> and in the intoxication of the holy mind
> may my voice languish
> and acrobat towards a heavy drowsiness.[37]

Here delirium, intoxication, and sleep are used to achieve disorientation, as in another collection published by Quartz, *Poèmes de la sommeillante* by Kline Sainte-Marie.[38] Pelletier-Spiecker uses the noun 'acrobat' as a verb and, further on, expressions such as 'le cauchemar s'ouvre au cri du sommeil'[39] and 'au plein du vol je chute tel le cri de l'oiseau,'[40] obviously owe a lot to surrealism without going as far as the abstraction of the automatists.

In Michèle Drouin's *La Duègne accroupie*, the verbal violence of *Etal Mixte* and *Les Boucliers mégalomanes* is largely absent. This work is more like 'L'Ombre sur le cerceau' in *Refus global*:

> useless words in armpit's shadow
> making a sound like a dress slipping off

 I pity the one who was a rigid hoop
 the trained dog never failing executes the leap
 which makes us trust
 the value of the trainer

 my temple which was a hoop not
 the one girls wear around their hips
 but the one lost and recovered from bewildering
 reputations

 would it have been necessary for the hoop to roll as far as
 the abundance of the sea.[41]

Les Editions Quartz gave some poets the opportunity to make themselves known, but only Martino, whose work was discussed in the preceding chapter, has so far escaped obscurity.

Orphée

André Goulet's publishing house is older, more prolific, and better known than Quartz. This art press also printed the periodical *Situations* and the first runs of books published by Delta Canada, l'Estérel, and l'Obscène Nyctalope.

Goulet has contributed greatly to the rapprochement of avant-garde groups too frequently torn apart by fruitless sectarianism.[42] Orphée's impressive catalogue includes works by a wide range of authors: Jacques Ferron, Yves Préfontaine, Claude Mathieu,[43] Jean-Claude Dussault, Gilles Groulx, Gérald Robitaille,[44] Louis Geoffroy, Ronald Després,[45] and Claude Gauvreau.[46] Some have already been mentioned, and Geoffroy will be examined in connection with Opération Déclic. Dussault, Groulx, and the periodical *Situations* – all associated at one time or another with Orphée – will be discussed here.

Jean-Claude Dussault

Jean-Claude Dussault contacted Claude Gauvreau on the day the last article in the polemic between Gauvreau and Pierre Saint-German over Pierre Mercure's commission appeared in *Le Petit Journal*. Dussault expressed support for Gauvreau and asked for more information about automatism, poetry, and contemporary culture. The correspondence ended with Gauvreau's seventeenth letter on 10 May 1950, when they arranged a meeting and Dussault began to participate in the automatists' activities.

Dix-sept lettres à un fantôme was profoundly liberating for Dussault.[47] Gauvreau's last letter answered Dussault's request to have Gauvreau incorporate him into the movement:

I don't have any authority to 'incorporate' anybody into any move-
ment ...

How do you think this 'movement' came to exist? Obviously,
through chance meetings involving individuals with similar aims.
The movement evolved through exchanges of opinion, conver-
sations, discussions, demonstrations, individual initiatives. It is incon-
ceivable that these relationships could be systematized.

The human environment is constantly renewing itself.

Those who are tired leave, to be replaced by those who hope.

Those who are aware and strong stay.

Our doors are open to everyone. It is not for us to decide
whether such and such an individual belongs to the surrational
movement; each individual decides for himself if he wants to partici-
pate in the movement (the movement itself being impersonal).

Of course, people interested in our movement don't always find
it easy approaching those already in it. This would be greatly
simplified by establishing a Centre, another project close to my
heart.[48]

Dix-sept lettres à un fantôme provides important documentation on the
history of automatism and is obviously of particular value in gauging the
literary origins of Dussault, whom Gauvreau called his 'first disciple.'[49]
On 13 January, Gauvreau wrote to Dussault: 'You must write and write
some more! Write with magnanimity, come what may! Make use of Bor-
duas' insight, namely that "the consequence is more important than the
goal".'[50]

After 10 May, Dussault attended all the gatherings of the automatic
writers (mainly at La Hutte suisse with Claude Gauvreau, Barbeau, and
Mousseau), and in that same year wrote his first automatist poems. Unfor-
tunately, most were later destroyed for want of a publisher. The only
poems extant are ones André Goulet practically tore from Dussault's
hands and published in the first part of *Proses* under a title taken from a
medieval text 'Tant ... que merveilles!' Others appeared in the newspaper
Le Haut-Parleur.[51]

The poems in *Le Haut-Parleur* clearly express the shock Dussault experi-
enced when he came in contact with the automatists. The repetition of
'baroque' in the following poems indicates that the shock was, among
other things, aesthetic:

Let us suspend the epiworld in a baroque hour-glass
The hours in clusters disgooze*
The imponderable juice of a mystery.[52]

Transplanting mucous membranes with baroque characteristics
Sweat impregnates the initiates' enthusiasm
right to the roots of their eyes
Will my strength suffice to meet the challenge
of these unknowns?[53]

Dussault's automatist imagery is already full of the religiosity (prayer
and sacrifice, for example) which haunted his investigations:

Communication of body and soul
The parapets of prayer pluck the armpit in vain.[54]

Mystification,
Banal song in down on lips
In the anguished reflex of the mind is posed
the insoluble problem of escape to an identical reality
Stagnation of souls completely taken aback by their solitude.[55]

The high priest pops the cat-child's eyes
The mummy describes spirals through the magic of
his bandages
But I can't see the back of the stage
Grovelling variations
Cracking of knees offered in homage to negation.[56]

A questioning of the Christian era, a return to point zero in order to
start a new civilization, desire as an essential link in a work of art – these
are the themes of 'Tant ... que merveilles!':

I have set the wheel back
 to zero
 crazy from turning.
Rethink desire.
 Nets, repatriate your knots
Languors are born in the mirror.[57]

Reek
 of cathedrals divining themselves
 brushes the earth.
Eternity promulgates.
Regenerating sphinxes in mirages;
 desert minions mount guard.[58]

These poetic images are essentially linked to Mabille's vision of the end of an egregore and the beginning of a new one. In addition to his experiments with automatism Dussault discovered oriental philosophy, whose spiritualism was in direct contradiction to the atheistic monism of the automatists. Even before his first meetings with them, he wrote:

> I am studying the history of ancient civilizations, India in particular. I have discovered very disappointing evidence of barbarism (the cult of Shiva, the assassin thugs). I have also discovered a somewhat troubling mysticism which consists of eliminating all passions and living a life of contemplation.[59]

Dussault's experiments with Hinduism paralleled his surrational experiments, but only superficially at this stage. These experiments lay at the heart of 'Conte Indien,' published in *Situations*,[60] and can also be traced in the following images, extracts in fact from 'Tant ... que merveilles!':

> The oracle speaks in the encircling
> of prophets,
> weaves hatreds.
> The science of having lived in the shadow of a secret;
> I continue the failure of revolt.[61]

> Hollows from the hatching of reminiscences.
> The grimaces were only china dogs,
> Sniff hashish:
> Reek of Indian hemp says
> The immortal one.[62]

These images of oracles, prophecy, Indian hemp, and occult science were perhaps originally an attempt to interpret the world through Hindu mythology, just as others used North American Indian mythology. In 1950-1 Dussault was in Paris and spent long hours at the Bibliothèque nationale reading René Guénon and his *Introduction à l'étude des doctrines hindoues*; following up on his research, he then contacted people in Guénon's circle. This explains why the second part of *Proses* blends his inquiries into Hinduism with automatist surrealism while the following collection, *Le Jeu de brises*, is concerned only with the mental state of the Hindu religion.

A critic once compared Dussault's poetry in *Proses* to that of René Daumal and René Gilbert-Lecomte,[63] poets associated with the periodical

Grand jeu who long before Dussault had followed a similar path from surrealism to a Hindu-like mysticism. But Dussault was actually following Guénon, since he then passed from Hindu to Islamic culture. His interest in Islam gave birth to *Sentences d'amour et d'ivresse*: the first part is a free translation of Sufi texts already published in English, while the second comprises his own works in the style of the sufi Omar Khayyam. But unlike Guénon, who became a Moslem high priest, Dussault has retained only a purely speculative, critical interest in these cultures, as he demonstrated in two essays written after that collection.[64]

As far as automatism is concerned, Dussault went from defending *Le Vierge incendié*[65] and Gauvreau's freedom of expression[66] to condemning (during his Hindu period) atheistic monism. In his *Dialogues platoniques*, the sage's words imply a belated rejection of Mabille's philosophy:

> *The Sophist*: The artist closest to perfection thus becomes the one with the deepest understanding of Order; the one who, using it as a model, possesses the most appropriate means for making its image visible ...
>
> Only Mind can give birth to Order, for Mind is above the similar and the dissimilar – in It there is no diversity: Mind is unity ...
>
> For example, someone who claimed man was made of a unique substance which he thought he could comprehend with his external senses, who claimed there is no hierarchy in man, no superior faculties, who claimed, finally, that the only reality and the only life was this substance of which he spoke and which he thought he understood – I say, do you think one day that if such a man got it into his head to create a work of art, that this work might serve to exalt the mind?
>
> *The student*: He would be the first to be surprised and incensed since he denies the existence of mind.[67]

Dussault's automatist friends were surprised and outraged to see him defending the dualism of mind and body in this way. A long time passed before he made a public statement on the subject: it was only in 1979 that *Lettre aux artistes*, in which he had defended traditional art, appeared under a new title *Eloge et procès de l'art moderne*, jointly authored by Dussault and Gilles Toupin. *Eloge* contains a clarification of his views on Mondrian (p 32), very clear distinctions between the Freudian and Marxist visions of art (pp 42-3) and between traditional and modern art (p 107), as well as grave reservations concerning automatism (p 55):

'Action painting' and the automatist techniques derived from
surrealism did, for example, reveal the importance of the physical
reflex, or what one might more accurately term 'muscular aware-
ness'; but without ... the access to symbolism that is part of tra-
ditional art, these techniques remain subservient to the forms of
the infra-conscious (which psychoanalysis very appropriately calls
the subconscious) and are condemned to the most tiresome repeti-
tion.

In recent years, several young critics have taken similar stands against
automatism and surrealism, but it is surprising to find these ideas in a
work whose original unpublished version dates from 1955. Also unpub-
lished is a study written prior to *Lettres* on surrealism and automatism
entitled *Le Sens du pathétique*. In 1960 Dussault discovered Norman O.
Brown (*Life against Death*), and through Brown works by Freud and Mar-
cuse which had not yet been translated into French (*Eros and Civilization*
did not appear in French until 1963). Dussault was the first to make these
books known in Quebec.

Gilles Groulx
Gilles Groulx wrote some automatist poems in 1953 and 1954 and, even if
Claude Gauvreau had not revealed that Groulx had read his manuscripts,
it would have been easy to spot the influence of Gauvreau's style on these
poems which appeared in 1957. The same paronyms, the same verbal
collages appear in the work of both poets:

occult on the rebound
 draw z on a little round hovel
 little wooden pin on fill-ament

occult TV-rebound
 urnified Eliazied
 ·orbionque
 and the sacred shrink

 vain to feign porpoises to bite
 and alchemical disorder
 of laughter

 grotesque and occult on the rebound.[68*]

Non-representational elements figure prominently in some of the poems:

 you flax
 you long-weary
 goody-goody
 icon meeowm
 trust and insiparts
 satisfied urik
 lesgo
 good lesgo
 sarlafiliaque
 good cabar.[69]

 basically fiac
 tobacco boulder
 ich urnificent
 urnifinecabal
 marnac andiron
 lubifibon
 BOULDER boulder slowpoke
 taper forflax
 boulder scrappy
 tries to chunify
 the dear scattered world.[70*]

Groulx, who has since become a filmmaker, apparently never published any
more non-representational poems. However, his work in film (like that of Guy
Borremans and Patrick Straram) occasionally reveals traces of surrealism.

Guy Gervais
Guy Gervais was another protégé of the publishing house Orphée. He
published his first poems, *Rets*, in the anthology *Veilloches* edited by students
of the Collège Sainte-Marie and published in 1965 by Les Editions de la
Cascade under Yves Dubé. Lines like 'Là, tout n'est qu'ordre et azur' and
'Quand partirons-nous ma sœur' show a strong Baudelairean influence, but
a poem like 'VII' reveals a mature mastery of language which daunted the
writer of the preface, Roger Duhamel. 'Words may become veritable
tyrants,' wrote the man *Le Devoir* once called the 'literary critic of a morn-
ing sports tabloid.' Here are several of these formidable lines which,
according to Duhamel, certainly would not have pleased Paul Valéry:

 Foul-tempered copper
 The unknown fashioned with blue plates
 Crossword of dislocated limbs.

Three years later, La Cascade published another collection by Gervais, *Le Froid et le fer*, with an introduction by Jean-Guy Pilon. In it can be found such images as 'mouse flesh,' 'dried bone wicker,' 'shadow-hymn,' 'cobblestone smear,' 'earth's cheek,' 'girl and currant frenzy,' 'wax mirages,' and 'clay memories,' recalling the Paul-Marie Lapointe of the late forties. Pilon was a more felicitous choice to write the preface since he did not feel compelled to invoke Valéry on the subject of Gervais, noting instead that it would be necessary to 'decode the compass and construct new bridges.' Later works included the collections *Thermidor* (Les Editions de l'Alicante 1958) and *Chants I et II* (Les Editions Orphée 1965). All were brought together along with *du pain de givre* and *signes* in the collected works *Poésie I*, published by Parti pris in 1969.

In *Thermidor*, the writing clearly carries on in the same vein as *Le Froid et le fer* with images such as 'contorted lakes,' 'burnt-out takeoffs,' 'sour corpse,' 'water stiff,' 'rock veil,' and 'iris repose.' Gervais had evidently read *Le Vierge incendié* (a work which at that time had only been circulated privately), as the following passage from *Signes I*, written in the summer of 1960, indicates:

> Unshakably lifting the iris above the algae-like and noctural anky-losis, the East with a thousand darts melts the hundredfolds, the issuable golds, the ivory-headed serpents, sand-coated chops, melts arborescent with flights of gold-nested detoxicating ions through contorted skulls which bow down immiscibly under the burning, roasting, invisible flaming silences insupportably miscible under the unslaked saphyr, with retroactive hymens and retirements resuscitating insubmersibly starry bones (*Poésie I*, p 51).

Gervais left the Collège Sainte-Marie for the Ecole des Beaux-arts. Like Fernand Leduc, he became interested in Raymond Abellio and studied philosophy under him. The *Anthologie de la poésie québécoise* by Laurent Mailhot and Pierre Nepveu notes several talks by Gervais on Radio-Canada on philosophy, poetry, and religion.

Situations

In the very early sixties Orphée administered the periodical *Situations*. In the beginning it was run by Jacques Ferron, Guido Molinari, Yves Pré-fontaine, and Fernande Saint-Martin and, like other works published by Goulet, was open to members of the avant-garde in general and the politically committed in particular. As the title suggests, its orientation was more existentialist than surrealist.

Although *Situations* always considered *Refus global* of great significance,[71] it remained open to revolutionary surrealists like Hénault and Haeffely. A piece by the journalist Jean Depocas preaching 'cultural naturalism'[72] was followed by a repudiation from Gauvreau (apropos of an article by the critic Paul Gladu),[73] just as Gauvreau later rejected the same ideas in an interview with Depocas in *Parti pris*.[74] With an editorial board at one time comprising Guido Molinari and Fernande Saint-Martin, and at another André Goulet and Michel Chartrand, *Situations* occasionally gave the impression of being in chaos. However, it did perhaps have a role to play in so far as instilling admiration for Borduas' sense of revolt in the younger generation was concerned. This admiration sometimes extended to an association with nationalist struggles contrary to the thinking of Borduas,[75] Gauvreau, and other signatories of *Refus global*.[76] However, in the end Borduas considered himself a neo-plasticist and always refused to be hemmed in by narrow ideology.[77]

The automatists and neo-plasticists were clearly related in their belief in the non-representational; for example, Fernande Saint-Martin had endless praise for Gauvreau's poetry in the first issue of *Situations*: 'This automatist poetry stood alone ... in providing us with the spectacle of a new form of literary expression completely up to date with values in France. Claude Gauvreau's texts were published in *Refus global* in 1948, the same year as Henri Pichette's *Les Epiphanies*.'[78]

In the second issue Saint-Martin analysed *Refus global*'s first ten years. She showed that *Refus global* had begun to serve as a rallying point for modern movements and emphasized for the first time the diversity of the manifesto's supporters:

> *Refus global* is the symbol of a coming together, a community, a union for the first time on our home ground of artistic and intellectual disciplines which refused to isolate the individual within the narrow confines of his specialty and aimed to redefine man by synthesizing all responsibilities.
>
> The group of painters, writers, actors, dancers and choreographers, psychologists, photographers, singers, and designers who signed *Refus global* laid the foundations in French Canada for a productive community at the crossroads of various ways and means of artistic and poetic commitment.[79]

Later, though, Saint-Martin became less enthusiastic about automatism and pointed out what seemed to her a defect in automatist thinking:

> Although Borduas and the automatists dissociated themselves from surrealism on many issues in the interests of purer ideology, they

nevertheless retained its fundamental tendency – that of a philosophy which, reacting against the nominal idealism of classical philosophy, returned to the concrete, to the understanding and suitable evaluation of the 'object.' For *Refus global* and Breton both, this object nevertheless continued to be defined in extremely subjective, not to say magical, terms, and constituted a stumbling block to both systems of thought.[80]

Saint-Martin's position vis-à-vis the automatists was therefore complex, and a strange series of events followed. Saint-Martin was present at the reading of *Beauté baroque* and liked it so much she suggested the author enter his novel in a competition organized by the Cercle du livre de France.[81] Gauvreau, however, violently criticized her husband, the neo-plasticist painter Guido Molinari: 'The nascent counter-revolutionary forces led by Molinari were very hostile towards the exhibition ('La Matière chante,' 1954) and towards Borduas personally – they even tried unsuccessfully to boycott the enterprise.'[82]

Situations then published an analysis by Gauvreau which attempted to clarify the positions of the automatists and neo-plasticists. Gauvreau considered the neo-plasticists 'Mondrian's epigones' and mere 'local innovators'; the automatists were different, certainly sharing the surrealists' wish to go beyond the representational but distinguishing themselves in wanting to abandon dream imagery. In this sense the automatists would be more than just disciples of Breton, whereas the neo-plasticists were only imitators, Mondrian's disciples:

> The automatists were, and remain, authentically creative ... The plasticists aren't creators, they are only local innovators ...
>
> In 1933, Mondrian himself talked about 'a more abstract figurative representation.' It is obvious that so-called 'abstract' art, descended directly from cubism, is the last imaginable 'figurative' stage. Starting with surrealism, the accent is definitively placed on the exploration of man's inner world. The shift in accent is most important: surrealism is definitely beyond the realm of the figurative, even though it does retain dream imagery. Automatism is transfigurative and concrete – it goes beyond surrealism ... To imply that automatism is only an imitative form of surrealism is patently untrue.[83]

However, Saint-Martin had the last word in this argument by showing how Borduas' painting, like Mondrian's, was related to cubism. This was not really a revelation since the surrealists – whom the automatists claimed to have superseded – always acknowledged their relationship to cubism.[84]

Saint-Martin described the effect Borduas' paintings created on the level of visual structure:

> Although he had rejected the surrealist thesis justifying the continued use of figurative imagery, a point of view which Pellan had accepted, Borduas revealed traces of its influence on the aesthetic level. This involved de-emphasizing symbolic values aligned in accordance with the visual structure itself in favour of an allusive world more appropriate to literature.[85]

Mindful of Borduas' contacts with American abstract art while in New York, Saint-Martin gave her version of Molinari's reactions to the 'La Matière chante' exhibition in 1954:

> Borduas admitted the extent to which his contact with the radically different pictorial world of American painting had made him aware that all his previous work stemmed from a cubist perspective. He recognized that American abstract expressionism presented a much more dynamic structuring of space, a disintegration of perspective, a break with cubist space, which Canadian automatism had not been able to attain.[86]

Despite differences of opinion between Gauvreau and Molinari (reminiscent of the struggles between Pellan and Borduas) and other disagreements, a true union of the automatists and neo-plasticists did occur thanks in some measure to *Situations*. This was unmistakably apparent ten years later with le Nouvel Age, les Trente A, l'Horloge, le Zirmate, and Opération Déclic.

TAKING UP THE CAUSE

Roussil's attempt to bring artists together at his studio (Place des arts) after Borduas' departure in 1953, as well as the informal gatherings at la Hutte suisse, l'Association espagnole, and around the periodical *Situations*, led to more and more organized efforts to achieve consolidation. In 1963, Serge Lemoyne brought avant-garde artists of every description to the Bar des arts for various literary and artistic events, especially Opération Déclic. Happenings, 'manifestes-agis' (staged manifestoes), and poem-objects succeeded one another until Déclic reconfirmed the relevance of *Refus global* on its twentieth anniversary in November 1968.

Several works influenced by surrealism appeared during this time, notably those by Langevin, Straram, Brunet, Péloquin, Hébert, Paquette, Sauvageau, Geoffroy, and Vanier. These poets and others too numerous to

mention took up the cause inherited from the signatories of *Refus global* and *Prisme d'yeux*.

Opération Déclic

Ever since the publication of *Situations* and the growing influence of the international situationist movement in 1959-60, people had been trying to touch off a cultural revolution in Quebec by claiming Borduas as a mentor while at the same time rejecting automatism and surrealism as outdated.[87] Gauvreau for his part was not ready to consider automatism outdated until Opération Déclic, which was directly descended from *Refus global*. Only then did he lower his flag.

The agenda for the initial Déclic meeting, 'Rendez-vous Refus global' on 7 November 1968, included a recital of *Etoile Noire* by François Morel,[88] readings of poems, a monologue and dramatic pieces ('Au cœur des quenouilles,' 'Bien-être,' and 'L'Ombre sur le cerceau') by Gauvreau, the screening of *Via Paul-Emile Borduas*, by Fernand Bélanger, as well as a discussion of *Refus global*.[89] *Le Devoir* summarized Opération Déclic's goals:

> The group has four points to make: (1) it claims Borduas' *Refus global* is still relevant; (2) it considers itself essentially an inquiry into the relationship Art-Society; (3) it considers itself an experiment, a centre for confrontation and a place for developing awareness; (4) it is a symbolic act, a 'manifeste-agi.'
>
> In a less sectarian mode, Opération Déclic wants to allow committed artists of all disciplines to *unite* and formulate their current concerns so that they can situate themselves in a socio-economic context. Opération Déclic would like to redefine the position of creative activity in Quebec society.[90]

A few weeks later on 8 December, the feast of the Immaculate Conception (already a red-letter day in surrealist mythology),[91]* a 'manifeste-agi' made the headlines and was linked in the press to surrealism and Opération Déclic:

> A 'surrealist event,' apparently part of 'Opération Déclic,' upset an investiture ceremony of the Knights of the Ordre du Saint-Sépulchre before some 1500 people ...
>
> Although the 'happening' surprised and shocked the audience in the church of Notre-Dame, it was not without precedent in this century's literary history and in the history of French surrealism in par-

ticular, whose ideas were tainted with anarchism and anticlericism. For example, the poet Aragon, at the time a disciple of Breton, was convicted by the courts for having, on a whim, emptied church collection boxes.[92]

The demonstrators read out a manifesto entitled *Place à l'orgasme*, subsequently released by a clandestine publishing house called 'Création à Dieu.' The manifesto's structure and vocabulary were similar to a passage in *Refus global*, especially the words 'Place à la magie ... Place à l'amour ... Place aux mystères objectifs.'[93]

Later the participants in the 'manifeste-agi' at Notre-Dame explained their actions: they felt Opération Déclic on 7 November had not gone far enough because it was too concerned with presenting immediate demands to the Ministry of Cultural Affairs. As one of them said to Jean-Claude Germain, 'After twenty years, Borduas' manifesto has finally met its match. The anonymous demonstrators at the church of Notre-Dame have answered *Refus global* with "engagement global".'[94] One of these demonstrators, Claude Paradis, later explained that it was not a provocation but an affirmation of parallel values, a kind of counter-culture: 'We want to "plant" political acts as if they were bombs. In doing so we want to emphasize the fact that other values exist. This is directly in line with Borduas' thinking. If we have a Guevara in Quebec, it is Borduas.'[95] Nevertheless, the meaning of this revolution was unequivocal – it was clearly a matter of intellectual terrorism, a revolution of 'signs': 'We must mark the paths with signs, a path which already exists and which Borduas was the first to uncover ... During the dark ages under Duplessis, one man remained lucid. A conscience. For us Borduas is a beacon in time. History is not words, history is actions.'[96]

A few months later Déclic continued with further demonstrations. Chickens with messages tied to their feet were released at the opening of the 'Rembrandt and His Pupils' exhibition at the Montreal Museum of Fine Arts on 9 January 1969.[97] The following month *Le Journal* ran a front-page headline, '"Nervous Shock for 600 spectators at la Comédie Canadienne":[98] during Françoise Loranger's play *Double Jeu*, which included one act of so-called psychodrama or sociodrama with audience participation, five members of the audience took advantage of the opportunity to make a public statement. With impeccable choreography, three men and two women undressed completely, strangled two doves, slit the throat of a black rooster, smeared themselves with blood, and disappeared. A journalist in the audience noted that "crowd reaction was divided three ways: some fled, some were incensed at this violation of morality and conventional behaviour, and the rest attempted to understand the ideas behind the

actions." '⁹⁹ However, the demonstrators had already arranged for an anonymous interview with a reporter to discuss the implications of their act on the day the event was reported: 'X, accompanied by his friend Y ... refuses to "explain" the meaning of this "manifeste-agi": "What happened last night constituted a kind of sign. In a way it is cultural terrorism. What we want to do is react violently – always on the level of signs – against the real violence of established culture." '¹⁰⁰ Later, when arrests were reported,¹⁰¹ it turned out that the demonstrators, including Claude Paradis, Monique Duplantie-Paradis, and Lucie Ménard, were apparently members of Opération Déclic.

This interruption of public theatre was not new in the annals of literature.¹⁰² Gauvreau recognized Paradis' group as kindred spirits and was so enthusiastic he gave them a copy of his unpublished play, 'La Charge de l'original épormyable.'¹⁰³ Gauvreau also acknowledged Jacques Giraldeau's film *Bozarts*, which embodied the spirit of the manifesto accompanying the 'Les Rebelles' exhibition (and borrowed part of its subtitle too). Giraldeau talked elsewhere about 'the collective process substantiated in his film by the symbolic linking of Borduas' *Refus global* and Opération Déclic.'¹⁰⁴ Several months after *Bozarts* opened, the sculptor Armand Vaillancourt, dressed in armour and mounted on horseback, read a manifesto onstage at Quebec City's Grand Théâtre in which certain phrases recalled *Refus global* and *Place à l'orgasme*: 'Make way for life. Make way for liberty. Make way for love.'¹⁰⁵ It took twenty years then, for *Refus global* to finally give birth to this counter-culture. Full of admiration and enthusiasm for these 'manifestes-agis,' Gauvreau exclaimed: 'At last, after waiting so many years, automatism has now been superseded. The cause could not have been carried on more admirably.'¹⁰⁶

Personalists and Situationists

L'Hexagone had some difficult moments after Miron left Quebec for France where he spent twenty months from 1959 to 1961. It became almost impossible for poets to count on being published by l'Hexagone and some of those who had been turned down were welcomed by Gilbert Langevin. In an attempt to unite Emmanuel Mounier's spiritualist 'personalism' with Karl Marx's socialism,¹⁰⁷ Langevin had founded l'Institut fraternalist and Les Editions Atys,¹⁰⁸ but when confronted with this problem of the one and the many certain members of the Atys circle quickly became pure Marxists. And when *Liberté* presented some of the young writers from Atys in order to make their work known, its publisher did so despite reservations about their political orientation:

In the following special section, *Liberté* and its usual contributors step back to let some younger people take the stage ... Yves-Gabriel Brunet, André Major, and Jacques Renaud have published collections with the recently-founded publisher Atys (Major was once its secretary) ... Although it is difficult to speak of an organized and homogeneous group, there seem to be recognizable tendencies representative of the whole. In fact there are not just six but some twenty members, two-thirds of whom at least are writers ...

They are extremely serious. Their project at the moment is to start their own publishing house and political periodical.[109]

That fall they did start their own periodical and publishing house, both called Parti pris.[110]

Gilbert Langevin

'L'Hexagone was to *Liberté* what Atys was to *Parti pris*,'[111] said Langevin, emphasizing the aspect of political commitment which he felt linked his publishing house to *Parti pris*. Atys was also related, however, to the Bar des Arts, which brought the poetry of Claude Gauvreau, Jean-Paul Martino, Claude Péloquin, and Louis-Philippe Hébert to public attention.[112]

Langevin published some automatist poetry under the name Zéro Legel, a pseudonym (or heteronym, as Langevin would call it)[113] he apparently only used when writing poems which focused on interior revolt and had nothing directly to do with his political commitment. This poetry links him to the automatists, and the following passage from 'Flashback' recalls Borduas and Gauvreau:

> Then Gilchrist Lengenoir raised a racket loud enough to shake the mummies in Le Perchoir d'Haïti ...
>
> I am caught between Calibre and Borduas. I stuff my eyes. I commit suicide in my own electric chair. I know how to do it. The it. You're thinking of Freud. I'm not talking about 'id' over there. I'm talking about the 'I' that I am, about the me you're gunning down, you bunch of idiots.
>
> Speaking of which, if they crucified Antonin Artaud and jailed Jesus Christ, I don't really see any reason to doubt that Maurice Duplessis or Caryl Chessman, or both of them, assassinated Wilbert Coffin, no matter what Jacques Duval or Ane [sic] Hébert say ... There is only one outdoor café in downtown Montreal – the Terrasse St Denis, the Den of CLAUDE GAUVREAU, a much more inspired poet and playwright than Claudel, etc.

My rebellious son André, the novelist, escapee from ennui, frantically enjoys himself. No one is full up. Straram monologues. Personally, I autologue.[114]*

In a similar vein are the handful of poems in *Torpilles sous cloches* which were published by Les Editions du Cerceau and later appeared in *Les Ecrits de Zéro Legel*, especially the litany entitled 'Eloge succinct d'un premier ministre mort en temps de paix':

I disdain your orgy
your snap-crackle-and-pop
hive of riches
terror of the poor
executioner without an axe
ark of finance
refuge of lies
shark for awards
bard without beard
scarecrow à go-go.[115]

The revolt against language, usually quite restrained in Langevin's writing, becomes ferocious in 'Peravilatte,' the final poem in *Les Ecrits de Zéro Legel*. It is a complete, automatist explosion of language:

Claqueder margintal
té marjoular à fliberdine
la derdapelle oloc en maffe
mais noz aballe carganboula

je frusse au mi du cicanmo
je daje les mandusses
orac orac je ter délixe
et les garvins me bellatisent.[116]

In the works following *Les Ecrits de Zéro Legel* there is a progressive departure away from the more literary writing in *Origines* towards the use of increasingly liberated and violent linguistic formulations which he acquired from the new groups he was associating with:

Employee of injustice through outrage
I unfulfil myself

cries the author of *Stress*,

> My dreams have thoughts of sand
> I arrange the moral pyre
> Where I shall immolate their vagueries.[117]

Ouvrir le Feu, a significant title, is perhaps the first book by Langevin in which violence is systematized. The images in it seem to be aligned along axes running between the poles 'desire' and 'delirium'[118] and the poles 'naked ape' and 'hairy angel.'[119] Desire / delirium is again the axis in *Novembre*, followed by *La Vue du sang*,[120] where images of violence also recur: revolt, war, anti-war, slaughter, and rape.[121] Even the angels are caught up in violence, battling storms and tempests.[122] This is poetry in the service of revolution, armed or not:

> Ink and ashes descend
> to the bottom of time
> defending the values
> of fire and blood
>
> Ameriquois
> with or without rifles
> through gestures and cries.[123]

In *Griefs*, a title as aggressive as the two previous ones, the desire / delirium theme[124] and the opposing images of ape versus angel (also god and the immortal body) are repeated,[125] implying a kind of metaphysical revolt.

Langenoir returns in the second and third volumes of *Les Ecrits de Zéro Legel*. In volume 2, *La Douche et la seringue*, automatic writing accentuates the angel / ape duality[126] and the desire / delirium theme[127] is related to the phenomenon of poetry:

> The temptation to cry louder than the invisible is related to the many phenomena of madness.
> Writing is not relevant to poetry. Writing beyond the bounds, yes ...
> Supreme peril: to commit suicide with a pen.[128]

The author tends to underrate his writing, like the Greeks who believed that poets were prophets because a god was destroying their mind (dementia) and blowing them full of en-thousiasm and in-spiration. The fol-

lowing pessimistic thoughts on automatic writing are very indicative of his state of mind:

> Cartebloc has quite simply locked away some jottings of no importance he'll never have the desire or the courage to write a novel from top to bottom some stories a few aphorisms some poems he never dared read to anyone this is what constitutes his work a half-hearted fresco of his laziness flaccid fruits already rotting.[129]

Only the angel and desire remain in *L'Avion rose*.[130] Here Langevin abuses overly facile 'automatisms' inherent in spoonerisms and puns while simultaneously defending his use of them in an 'interview' with himself.[131] Nevertheless, certain poems do ring true:

> Where has he fled
> This marvellous artist
> here he is again, here he is again,
> Transvestite dressed in a joke.[132]

Langevin was not really joking, though, when he rejected nihilism and anarchy in *L'Avion rose*[133] and persisted in defending fraternalist theories in a later work published in November 1974. In *L'Avion rose*, the fraternalism of Atys was linked to Borduas' second manifesto:

> The time has come, more so than ever, to enter the service of *Projections libérantes*.
> Can we ever get off the beaten track without ending up in an institutional morass? Will we have the courage to creage *places and relationships* where communication can mature and give birth to solidarity?[134]

Given this rapprochement with *Projections libérantes*, his recourse to automatic writing and the abundance of images relating to inner exploration, the critic and poet Pierre Nepveu associates Langevin with surrealism, especially the surrealism of Erta. Here Nepveu speaks primarily of *Origines*, though his comments apply to all of Langevin's work:

> There is a certain surrealism in Langevin's work, and from this point of view the author of *Origines* is closer to Roland Giguère than to any other Quebec poet. But this surrealism is not one of free association and automatic writing. I would define it more as a surrealism of representation wherein the efforts of the imagination

consist in immediately transposing the landscape of consciousness
onto the most brutally concrete level. This is a surrealism of puns,
of lucid playing with symbols.[135]

The poetry of Langevin therefore reveals a generally representational and
committed surrealism of a 'fraternal' kind.

Patrick Straram
The influence of Patrick Straram and situationism paralleled the influence
of Langevin and his philosophy of fraternalism. It has been said of Stra-
ram that he 'showed an exemplary critical attitude which in a way recap-
tured or made relevant again the great tradition upholding the values
shared by Gauvreau and the automatists.'[136] Straram was in fact influential
as a critic despite a 'metagraphic' style through which he projected himself
as much as he observed others. In January 1959, the same year that *Situa-
tions* first appeared, Straram started work on a pamphlet explaining
situationism.[137] He later became the editor of *Situations*.[138]

According to Straram, situationism went beyond surrealism. It took 'as
its principle ... collective decisionmaking,' proclaimed itself opposed 'to the
survival of forms such as the literary or art periodical,' and broke new
ground within Montreal's artistic community. Citing the periodical *L'Inter-
nationale situationniste*, Straram brought to light a new concept – communal
writing. Concerning those who nevertheless personally signed articles in his
pamphlet Straram wrote: 'Those articles written and signed by individuals
should also interest all our comrades as specific examples of their commu-
nal research.'[139] This process went far beyond the committed surrealism
Straram actually referred to in his *Cahier pour un paysage à inventer*, whose
contributors included Miron, Paul-Marie Lapointe, Gilles Hénault, and
Louis Portugais. The 'notebook' was inspired by two lines from Giguère
quoted in the epigraph:

the landscape, the beautiful landscape was no longer beautiful
the landscape had to be reconstructed.

But Straram certainly did not intend to stay within the confines of the
surrealist movement or the Cobra movement:

For us surrealism was only the beginning of a revolutionary cultural
experiment, an experiment which almost immediately came up
short both practically and theoretically. We had to move on. Why
is it impossible to be a surrealist any more? Not because of the
standing order issued to the 'avant-garde' to have nothing to do

with the surrealist scandal. We aren't surrealists because *we don't want to be bored*.

Boredom is a reality shared by aging surrealism, angry, ill-informed young people, and by privileged adolescents whose revolt has no future but professes many causes. The situationists will enforce the sentence which today's leisure activities pronounce upon themselves.[140]

Straram's notion that surrealism had to be superseded took hold. He was all the more influential since he had not only participated in the founding of the international situationist movement along with former lettrists Guy-Ernest Debord and Isidore Isou, but had also contributed to the Belgian surrealist magazine *Les Lèvres nues*.[141] This man, whose nickname 'Bison ravi' is an anagram of Boris Vian, was full of surprises.[142] A 'strange orange,'[143] to use his own expression, he fully supported Gilles Groulx and wrote a book on him,[144] linking his name in passing to Roland Giguère (films by Groulx and McLaren were screened at the opening of a showing of Giguère's work forming part of the exhibition organized by Phases.)[145] He can discuss André Breton and Michel Leiris, Jean-François Lyotard and Roland Barthes with equal facility,[146] and anyone who can compare Groulx to Mayakovsky knows how to get to the heart of the matter:[147]

> If we take *Othon, Sotte il segno dello scorpione, Eros + massacre*, and *Ice* (for example) to be definitive political films, it is because they are not satisfied, and do not satisfy us, with delivering a 'political message,' pure and simple. Instead, *beginning at the beginning* (one of the first conditions, also, of any political analysis), they carry out on their *very materiality* (not only the signifiers, which they call into question, but also the conditions and modes of production of these signifiers) *a kind of exegesis* which in and of itself constitutes a political process.[148]

Straram's writing certainly owes a lot to surrealism, not just in its abundant use of word play, which he justifies with references to Breton and Desnos,[149] but in the constant application of his own theory of collage:

> The only expression-exhibition which interests me, the only one through which I think I can communicate successfully, writing and spoken language all mixed up, ideas and information, one calling forth the other, interacting with each other, could perhaps be called *collage*. Except that by collage I mean an ethic, a method of approaching and participating in the world, a way, a style of life.[150]

These extracts have been 'decollaged' from his work and reassembled to underline his surrealist attributes:

> dissection-images of flash women
> collage-sensations
> hugging my cactus-ookpik
> or the giddiness of drinking
>
> the duration immensity of anxiety panic and
> the immense lasting sadness of not having told
> Mario before he left how beautiful the night was
> which he had instigated friend of chance and the
> reflection by chance of which I am aware to the
> point of being so unhappy for not having spoken
> out loud and clear if I really told him everything
> was quite perfect thus spake Zarathustraram
>
> Cactus-ookpik
> of course: consul Patrick ...
>
> and may our novel this blues be forever pursued
> and may cactus-ookpik and bison ravi live it thus.[151]

And so, what with anagrams, ookpik, Zarathustra, strange orange, and 'bison ravi,' a man is searching for himself, trying to understand the meaning of an enigma, like Leiris in front of the 'Objet de la Taverne du Bison' in *La Faim de l'énigme*[*][152] The Patrick Straram-Michel Leiris connection, as well as this acknowledged hunger and thirst for deciphering, are significant.

Straram is quite content to propose theories about the political value of his writing which are very similar to surrealist and automatist theories on the subject:

> Some people know it is impossible to change our lives without destroying capitalism / imperialism and replacing it with a socialist *means of production*, and that only a worker/peasant proletariat supported by a party (in Lenin's terms) can accomplish this ...
>
> Others think that all 'politics' is harmful because it 'erases,' annihilates the individual, and that it will never serve any purpose except to replace one coercive power with another ... Only man through his individual 'works' can change things, therefore – the revolution to be accomplished lies within me, in one's own self ...
>
> In the struggle to subvert the ideology of the ruling class, my principal task is to *produce writing* which is 'other,' which the System cannot co-opt.[153]

No better summary could be found of the conflicts confronting the literary avant-garde during the surrealist era. Straram personally experienced them while with the Belgian surrealists and again within the circle still to be discussed which includes Claude Péloquin, Denis Vanier, and Louis Geoffroy (Straram wrote an afterword for Vanier and published two books with Geoffroy's publishing house).[154] It would be instructive to examine more closely the intertextual links between Patrick Straram and Gilles Groulx or even Guy Borremans (whose film, *La Femme image*, some consider closely related to surrealist cinema).[155]

Yves-Gabriel Brunet
Yves-Gabriel Brunet attended the Collège Sainte-Marie more or less at the same time as Guy Gervais. Later he enrolled at the Institut d'études médiévales. However, his contribution to the issue of *Liberté* devoted to Langevin's circle resulted from his membership in the Institut fraternaliste.

His first collection of poems, *Les Hanches mauves*, published by Atys in 1961 and dedicated to Antonin Artaud, included four epigraphs by the author of *Le Pèse-nerfs*. Perhaps Brunet owes to Artaud his rejection of 'literature'; the following piece, one of many striking examples, illustrates this feeling:

> And I am dead
> the head in the bread box
> the cake which I had eaten
> which I had just drunk
> And my head has turned black
> a real crow's skull
> Into my shack
> for the first time
> two men in black have come
> – and I had to be dead –
> two men pallbearers
> who tied up the box
> with a string
> only living cord from my guitar (p 44)

Everything is inside everything else, the box inside the head and the head inside the box, death in the soul and the soul inside death. Noteworthy in Brunet's writing are scenes strongly influenced by the 'internal theatre' of surrealism. The following excerpts maintain the same distance found in Artaud's *La Coquille et le clergyman*, Cocteau's *Le Sang des poètes* and Buñuel and Dali's *L'Age d'or*:

On the other hand the mother of jesus christ
and the mother of Napoleon was playing her hand
with the children who aimed at cracked targets

Apocalyptic dogs mourned great organs
the infatuation of forests upheaving samaras
women wrung their white breasts
suspended from negro cafés
the undertow vomited by the throat of the damned
despite the face of God (p 61)

Les Nuits humiliées, written the same year *Les Hanches mauves* was published, was not made public until twelve years later. Nor did Brunet appear in the table of contents of the first issues of *Parti pris*: even though Straram's name very quickly turned up there, Brunet had chosen not to go along with his friends at Atys or with Langevin. He first surfaced with *Poésies I*, a collected edition published by l'Hexagone which made *Les Nuits humiliées* well known, followed by a collection of numerous unpublished works under the title *Poésies II*. An essay supporting demonstrations at the Comédie canadienne stemming from Opération Déclic on 15 February 1969 prefaced *Les Nuits humiliées*. The collection is dominated by suffering, articulated with a harsh diction and imagery reminiscent of Artaud:

My temples are valves which open and flap
A lie from my body to my body*
Six horses' heads which huff and puff
Asphyxia seizing my features
...
NO I do not smoke the pipe of eternity
My body is a lie to my body
The horses keep flowing from my temples
Six horses' heads which truly suffer. (p 113)

The works following *Les Nuits humiliées*, however, introduce a burgeoning esoteric mythology which turns the poet's spotlight on strange territory: Venus in *Les Métamorphoses d'Aphrodite* (1961-2), gods, angels, sinners, muses, and vampires in *Les Chants 1 à 7* (also 1961-2). His unpublished works reveal similar preoccupations.

Where the Stage Shapes Dreams into Reality

In the winter of 1963-4, artists and poets gathered at the Bar des Arts intending to found a non-conformist group in reaction to the academi-

cism they felt was undermining abstract art.[156] During the week of 20 April 1964, these artists organized 'Semaine A' at the Centre Social of the University of Montreal. The fifty participants took the name 'Nouvel âge' and the group was to include 'everything that isn't collapsing';[157] their immediate goal was to produce 'simultaneously improvised shows of music, dance, painting, and poetry.'[158] The influence of the situationists was evident in this notion of communal creation. At the same time, the seeds were being sown for the Fusion des arts group founded later by Richard Lacroix.

The following year the sculptor Serge Lemoyne tried to present a month of events, the 'Trente A,' but it did not succeed. However, an offshoot, the 'Horlogers du Nouvel âge,' did manage to put on a show every Friday evening from the end of February to the beginning of April 1965 at L'Association espagnole, usually featuring Claude Péloquin and baron filip.

Claude Péloquin
In October 1965, the Horlogers became 'le Zirmate' and the group performed in the Guillotine room of La Bastille discotheque. Le Zirmate climaxed during Expo '67, then carried on the 'Evénements' series of readings and shows (eg, 'Evénement infragalaxique') with Serge Lemoyne. A principal organizer of the Evénements, Lemoyne placed the group's activities in their proper context by invoking Refus global: 'We have enormous respect for Borduas; in his work he isn't afraid to break with the past, to try something different, to start all over again. We want to be a bit like that.'[159]

One of Zirmate's regulars, Philippe Gingras (a.k.a. 'le baron filip'), also linked the Evénements to the automatists but made it clear that l'Horloge had no intention of taking a stand in the quarrel between the automatists and neo-plasticists, who were sitting side by side in the audience:

> The literati have been chafing with impatience since the good old days of Borduas' automatists. (The great poet Claude Gauvreau was one of the troupe's most enthusiastic admirers, delighting in baron filip's fantasies, appreciating Péloquin's piercing, incisive wit to the full, admiring Lemoyne's work as an organizer ...).
>
> Some evenings, enemies as unyielding as Claude Gauvreau, the most faithful of Horloge's fans, and Guido Molinari, the Sarkastik Machiavel of artistik fauna, would sit at neighbouring tables.[160]

Baron filip even claimed that 'Lemoyne played the same catalytic role in his generation as Borduas did in his,' but it is perhaps too early to evalu-

ate such a judgment. In any event, Nouvel âge wanted to rely on Borduas and at the same time supersede the automatists and neo-plasticists:

> Lemoyne said that the surrealists were negative, entrenched in their values, whereas we are positive, we want to approach the public ... Those who preceded us ... felt an absurd need to get together in structured, elite little groups. They put themselves on a pedestal. We feel it is very important to reject such clannishness. All the same, we haven't lost our taste for adventure.[161]

Zirmate had its poet, Claude Péloquin; in fact, the truth is perhaps that Zirmate *was* Péloquin, a poet whose revolt went beyond political revolution to attack the failings of the human condition, psychological taboos, and the inadequacy of language. Péloquin described himself thus to Paul Chamberland:

> I consider myself more a language technician than a poet. Poetry is more contemplative. What I do is research – I am researching the nuclear, occult aspects of reality. Poetry must use all the modern techniques ... I abandoned the revolutionary side of surrealism ... I know very well where I'm heading. From *Jericho* to the present I believe I have become more demanding. Progress vis-à-vis investigation and receptivity. I want to create a new dimension and make it accessible. The here-there, that is to say the only reality, Reality, the occult aspect, forbidden in what is called reality. For example, schyzophrenia [sic] might be normal in other cultures. Penetrating the unknown.[162]

Alongside a published interview with Denise Boucher, the caption under a photograph of Péloquin discussing life and death with Gauvreau reads 'I've read Michaux and Artaud. That's a good start.'[163] But when he said to Chamberland, 'We must become disembodied' and Chamberland replied, 'That sounds like Artaud, doesn't it?' Péloquin said, 'No, I feel closer, really, to Michaux.'[164] Concerning Claude Gauvreau, all of whose work he had read (including the unpublished pieces), Péloquin said:

> He is a rather mystical poet (interior life). I am not heading in the same direction. His language is automatic. But you have to travel with symbols first. They must be defined in your mind, you must 'see' them. Symbols exist in other dimensions (eg, visual). I believe in technology more than in automatism. Poetry should be mathematical, deductive. The linking of symbols must be accomplished with great precision.[165]

Gauvreau's influence is really only felt in *Les Mondes assujettis*, in the use of nouns as verbs in 'Le Passant,' for example, or the 'explorean' images in 'Orchestre Afghan':

> The evening fogs up
> On impersonal roofs
> Pursued by spirals
> My step catafalques
> In all the voices of days gone by.

> Sitar yea ya Daïra Delroba
> In the Ritchak Wind Band
> Robab Sorang Centaur of Tabla
> Drum as much as you can
> Zerberali
> Bahor Pandarling at the Loggar
> In the city of Kabul.[166]

The Zirmates and their cohorts Gilles Chartier and Jean Sauvageau appear in the collection *Calorifère*, which contains graphics by Pierre Cornellier, Serge Lemoyne, and Reynald Connolly. *Calorifère* is more an object than a book, written by the same man who said, 'It's time to leave books behind ... I believe tape recordings and other media of this kind are becoming more important ...'[167] Péloquin himself recounted the history of Zirmate:

> All this started with the happenings (Nouvel âge, Horloge) and expanded into le Zirmate (the present group). The impact of several disciplines is indispensable, people from several disciplines working together; this has become indispensable. Zirmate is using a performance format at the present time. We should also use other means, principally laboratory research. It would be nice to have places – 'travel agencies' – where people could go to pursue their research in the spirit of Zirmate. The 'initiate' must pursue one essential idea: to be, and remain, open to the subconscious and to modern technology. Some could pursue their research in these places; the others, the initiates, would dream up more ideas. We are going one step further than *Refus global*; we have access to laboratories, we can undertake more rigorous work.[168]

In order to take this 'refus' even further than Borduas, Péloquin increased the output of manifestoes. One of them, *Manifeste subsiste*,

appeared in 1965 even before the publication of *Calorifère*:[169] '*Subsiste* strikes a particular attitude which also communicates a refusal. The slightest revolutionary act or gesture challenging the established order of things is capable of advancing the entire planet.'[170]

The beginning of *Le Manifeste infra*, signed by certain members of Zirmate (Péloquin, poet; Lemoyne, painter; Cornellier, painter; Sauvageau, musician; Gilbert Labelle, mathematician), recalls the very beginnings of surrealism in *Les Champs magnétiques*:

> Based on a search for the Other-Reality in the Real-Past through an absolute Possible.
>
> A movement to introduce an Other into cosmic Man through a continual questioning of the real; this movement evolves – starting from the Below, from infinitely deep, veiled zones – within a reality defined by its two forms of existence: (other and here).
>
> Starting also from the Below of the sciences psi and para, the cosmos, the real, magic, and the Awakening ...[171]

Manifeste infra then attacks all previous forms of poetry except the poetic investigations of Claude Gauvreau, which Péloquin considers profound and still relevant:

> Hugo, Aragon, Nelligan, Hébert, Lapointe (2),* Garneau (2)* and all the others (with the exception of Gauvreau), even the Chamberland of *Terre-Québec*, bypass poetic Magic ... the Unusual has been born, it's everywhere, and they aren't of it. Pity ...
>
> Surrealism is no longer above the real, it is in its bones ... It is the Real ... So many bedside poets, whether from l'Hexagone (to name only one publisher) or elsewhere, have come to nothing but grief in the white hell of investigative poetry, and the rosy reports disseminated by our genteel poetry in one collection after another are nothing but tears. The poetic trip is a grinding of teeth ... Guys like Edison, Gurdjieff, Poe, A.C. Clarke, Breton, Michaux, Wells, as well as Dali, Tinguely, and company, all had to cloak themselves in Fear to make their work ring true.[172]

Quebec critics and artists are denounced one after the other: 'A Ouellette can certainly have coffee with Varèse, a Giguère with Breton, a Jutra with everyone in movies, a Bellefleur-la-Pétanque† can certainly dabble in the occult, a Garant can easily consider himself the offspring of Stockhausen coupled with a bucolic Larouche,‡ the precious plasticists can surely claim a Mondrian, the maker of keys to which they have not yet found the doors.[173]

This manifesto was completely familiar with surrealism in all its forms: '*Infra* very politely asks everyone (authors, publishers, critics) to take a really serious look at their conscience and then sit down. These gentlemen are trying to foist upon us their own little Aragons-à-Elsa,* their two-faced Soupaults.'[174] It invokes Péret's stand vis-à-vis the Stalinism of Eluard and his comrades in rebuking Parti pris:

> Let's not associate poetry with the sensationalist will of the 'poet' in trance, the victim of outdated political systems. This is why even those working for a revolution here (Parti pris, for example), and all those writers who confuse poetry with polemical journalism, only end up sounding lyrical when they 'poetize' ... The commitment of the poet is not what they want it to be. Péret has already denounced such poetically honourable poets.[175]

It is not surprising to find words of gratitude for Borduas in *Manifeste infra*: '*Infra* will now speak frankly about exploration. Borduas' *Refus global* had to break away from a calcifying past, but for us a laboratory can be a reality; they didn't have time to realize it.'[176] As Péloquin himself pointed out, however, he felt he had gone beyond the rough-hewn stage, beyond revolt to living out his refusal, a refusal which differed from that of the automatists:

> Let's say I'm an anarchist. I want to demystify all systems ... I am not a rebel. I am oriented more towards refusal. I refuse everything which doesn't constitute research. Revolt turns in on itself too much, it's sterile. Refusal implies an infinite love for becoming; we must proceed as quickly as possible.[177]

In *Mets tes raquettes* there is an obvious desire to change the world in Breton's sense. '"Transform the world," said Marx; "Change your life" said Rimbaud: for us, these two precepts are one and the same.'[178] The aphorisms in this book give some idea of the scale of the project: 'If I write, if I think, and if I meditate, it is solely because there is a conflict within me, a conflict which goes back to the beginning of time. The Christian says we must respect the body; I say we must change it and preserve its life.'

Change one's life, discover all the body's resources, plunge into Rimbaud's adventure, into utter anarchy: 'It is precisely the non-existence of the forces of good and evil that nourishes my revolt, my libertism, and my anarchy.'[179] But Péloquin runs into resistance from the system and an impossible task which pushes him into obscurity. His next book, *Eternelle-*

ment vôtre, is full of these issues of occultation, madness, and the absurd, the awareness of self and others.[180] Péloquin's role in this world of absurdity is to write and make us see something legible on the surface of the real, something surreal which only he sees:

> TO WRITE:
> Is also to cross over and see
> what one's chances are of TOTAL RECOVERY ...
> It is being enough of a visionary to hold on
> while others pride themselves on living by
> scratching
> DEATH's back ...
> TO WRITE is to recognize, to com-prehend what
> is being lost
> To watch things pass by and retain a little
> TO WRITE is to shovel manure
> TO WRITE is to be crazy enough to put
> a surface of a different colour on another
> surface in order to make the first intelligible.[181]*

The role of the 'demented' poet is to contribute to the changing of what the surrealists called magnetic fields:

> The MADMAN devotes all his energy to being
> TO NO LONGER KNOWING HOW TO DIE
> TO NEVER DISAPPEARING FROM THE MAGNETIC FIELD OF
> HAPPINESS.[182]

Chômeurs de la mort includes 'ready-mades' and some meditations. The cut-outs, for example, of advertisements for multiple-use tombs or an 'annual winter sale' of gravestones provoke reflections similar to those of Camus in *Noces*. But unlike Camus, Pélo does not picture Sisyphus happily awaiting death in front of his cramped tomb or his flower-bedecked cave. Pélo denounces euthanasia, the business of death, and even René Char's fatalism, despite Char's statement that 'We have only one resource against death: create art before it arrives.'[183] Pélo invokes Breton ('But people are so happy drowning – don't ask them to grab the pole') and Artaud ('Reason, a European faculty, exalted out of all proportion by the European mentality, is always a mockery of death') just before the meditations to justify his denunciations.[184] 'Eternalistic,' a word often used in the book, best describes this work:[185] as Pélo himself said, he is searching more and more for a way to join the ranks of those 'who are doing something "eternifying".'[186]

The seventies were in fact particularly rich in 'eternifying' productions: a film *Pélo le magnifique*[187] with an accompanying record, *Pélo Krispé*;[188] a play;[189] an exhibition, Salon Claude Péloquin, in 1974;[190] and a collected edition of his works, *Le Premier Tiers*.

Louis-Philippe Hébert

The poet and novelist Louis-Philippe Hébert first turned up at the Bar des arts where surrealist events and poetry readings were frequently held. One night he was forbidden entry to the Bar, being under age, and so was unable to recite his own poem, 'A la mémoire'; fortunately, however, it was published along with the works of the other poets in the periodical *Passe-partout* (1965). The following year, at the age of eighteen, he won an honourable mention in a poetry contest sponsored by Radio-Canada for 'L'Amour, mon amour / La Queste des yeux,' two works later published in *Les Ecrits du Canada français*.

'A la mémoire' is not particularly noteworthy from a surrealist viewpoint; however, certain verses foreshadow the unbridled imagination Hébert displayed in his later work:

> don't stand guard
> at the iron gate
> and this mad servant
> who informs you of my departure
> nor this wide corridor
> where the empresses hang
> nor my face into which you disappear
> stand guard only over the invisible
> and not over its shadow ...[191]

'La Queste des yeux,' which Hébert described as 'a three-character poem,'[192] is more daringly structured with speeches by the two lovers and Coryphée alternating one after the other. Certain lines recall, unconsciously no doubt, the images of love and horror in *Le Chien andalou*:

> Your eye slipped heavily into
> my hand; you drank this torture.
> I heard the spasms of your joy.
> But you were reborn through hatred.
> ...
> I wanted to give you the eye of the
> dream. Bewitched by the knife,
> this devil singing in the

rain, your pupil. I know.
Each night demands black in
reverse. The moon only rises after
sunset. Did I know that?
Each gleam whipped me with a
rosary of demons.[193]

One year later, Hébert published a collection in which one of the
texts, 'L'Opéra sidéral,' contains images of an underworld where the
names of Orpheus and Eurydice evoke the function of song. This 'opera'
is once again staged poetry. In the following passage, the poet takes even
greater liberties with syntax in order to point out the extent to which
Orpheus and Eurydice are both parts of himself:

nor have I that love of liturgies but
the sacrileges
but the ancient sprays of divine melodies
nor have I love

and the light divines me
for the capricious seas why would I know
not the winds in all the phantoms
drowning me endlessly like a castaway's song
sorrowful white and black.[194]

In *Les Mangeurs de terre et autres textes* (1970), Hébert wrote highly origi-
nal prose rarely equalled by his contemporaries. Each text is built up from
smaller pieces; the poetry comes to resemble a narrative form with recur-
ring characters, words, and syntactical constructions. But looks are deceiv-
ing, and this is in fact poetry, prose poetry in which surrealism rises to the
surface several times, especially in the most important piece, 'Le Théâtre
des événements.' In this passage, a 'tragédienne' is observed on the scene
of the dream:

Then her robes stretch out their sagging panels, languishing, light
and fragile, over the grizzled heads they dismay. Through the trans-
parent fabric a group of old men closely observe her, cold or sen-
sual skins reflected in the bald parabola of skulls. They were, as
soon as they sat down, put to sleep by the delay, on joined chairs,
in an absence of noise which their even breathing failed to over-
come. The piercing cry had projected them onto the scene in a
single bound, stumbling on the steep staircase from the hall to the

stage. They squeeze in, despite their advanced age, further and further beneath her, punctuating their limbs' nervous tics with giggles.[195]

Some of Hébert's works in which he juxtaposes images in the most arbitrary way were collected by le Groupe Luci (where Gilles Hénault's wife worked) in *Le Puits*, 1969, and used in four-dimensional (3 visual, 1 aural) experiments. These pieces were titled *Le Roi jaune*, and started off with a very effective 'address to the people.' It is not likely that anyone unwilling to unleash their imagination while reading these texts or listening to them in the theatre would last long:

> May those who only have the stomach for three schoolgirl romances allow the little blue animal to approach their knees, repeating 'I left'; then, they will finally know what a hand in your hair feels like and will dream long hours in front of a mirror while greeting, as it floats by, a Dutch boat with a metal dog dangling overboard. They shall swim.[196]

'This is said in order to frighten only worthwhile speakers,' explains the next sentence; anyone else who becomes frightened very quickly finds another road to travel. However, the juxtaposition of images, as in 'pour ventre ... trois histoires,' 'animal bleu,' and 'chien de métal,' is typical of surrealist rhetoric, as are the blue and yellow 'personifications' of this imaginary country's inhabitants. Hébert's corruption of the fairy-tale genre is also typically surrealist: 'In your adorable country, I met the son of a local dignitary holding on a leash an ox hatching an egg. Though sitting on its tail, the ox stared fiercely at passersby and answered them: *bleu*.'[197]

Both the genre of fable (Lafontaine in this case) and the genre of proverb have been corrupted,* just as Breton's *Poisson soluble* is constructed on a fairy-tale model which is being continually torn down.[198] Here the structure has been profoundly disrupted, even more violently than in Jacques Ferron's *Mélie et le bœuf*[199] or Madeleine Grandbois' *Le Père Couleuvre*.[200]

Albert G. Paquette

Albert G. Paquette also took an interest in the relationship between surrealism and theatre. He participated in the events put on by Opération Déclic and countersigned newspaper articles defending le Groupe Zéro's production of Claude Gauvreau's *La Charge de l'orignal épormyable*.[201] Paquette died young and his only extant piece of writing is *Quand les québécoisiers en fleurs ...* , whose style recalls Hébert's *Les Mangeurs de terre*.

Like this latter work it is a collection of poetic texts, mostly in prose, which Paquette dedicated to Jacques Crète, former member of le Groupe Zéro and founder of the experimental theatre company l'Eskabel. A quick glance reveals under whose banner the poet marched:

> let's Bretoneer the Claudelis
> (whiteshitfaced latrine cleaners in scorched om-lettes
> lying around on tombs)
>
> let's nénuphar éluard
> let's capitalize GAUVREAU.[202]

This anger may arise from the feeling that the reader at large can co-opt everything, even Gauvreau, and that collections like Nénuphar can transform anything, even the work of Eluard, into a classic.* Paquette's rebellions are spectacular no matter what, especially when writing is in question:

> let's infiltrate the anaemics of the word
> let's infiltrate the hypocritical blondass brummels who
> haunt the hangars of literature
> (twatwattery carcinogenocides writing)
>
> let's infiltrate the diors of the elegant sentencette
>
> let's infiltrate the producers of proverbs-fleuves
> let's infiltrate the leprous thought which prostitutes itself
> and walks the streets in front of potbellied corporations.[203]

What cause is served by this rebellion? The answer lies in these lines: 'Systematized automatism orders me to do it;'[204] 'I'm more and more aware of automatic reflexes,'[205] says the narrator of 'Les Temps parallèles,' written in the form of a diary similar to those of Michel Leiris.

Yves Sauvageau

The works of the actor and playwright Yves (Hébert) Sauvageau appear beside those of Louis-Philippe Hébert in the issue of Les Ecrits du Canada français devoted to the writing contest held by Radio-Canada in 1966. Like Hébert, Sauvageau was eighteen years old and won first and third prize in the theatre section for Les Enfants and Le Rôle. In the first play, written in the style of René Clément's Jeux interdits, a girl kills her brother while they play a game and sings 'Frère Jacques' to him. The scene effectively illustrates the ideas expressed: 'Innocent children have no

conscience! What use is it to them! They don't do anything bad!'[206] The
theme of cruelty reappears at the end of the second play:

> COMMUN: I love you. Kill me! Kill me!
> DÉSESPER: No! I must drive you crazy first ...
> SEULE: I protest! I take his side. Kill him now. Get this cynical
> game over with, for heaven's sake! I've had enough! I'm tired!
> COMMUN: I beg you! Kill ... Kill me! ...[207]

Jean-Claude Germain wrote a preface to Sauvageau's next play, *Wouf
wouf*, in which he pointed out that its author 'bursts open traditional real-
ist structures and in so doing liberates the subconscious, the dream, and
the imaginary which have been imprisoned for so long by the naturalism
of Quebec theatre.'[208] *Wouf wouf* in fact unexpectedly combines lines like
'I'm afraid, mom, I'm dreaming,'[209] with dialogues in explorean language
like those in *Les Oranges sont vertes*:

> DANIEL – Entramme not cajour. Mais les clicchètes piaquent ...
> MARGOT – L'otage étiolir prissa et moulante et ronroumule ...
> DANIEL – Ticgnechi-tanteli, pipa toutes les zaque.
> MARGOT – Aimi dansou, mama noula.
> DANIEL – Briqueta miou-mion, tribut faimfi-faim.
> MARGOT – Hou-hou-ron-moulinat-luni-luna-arianne.[210]

There is no question of translating a code here, even though the language
sounds like children playing at speaking a 'foreign language.' But obsessive
words do recur like 'otage,' 'étioler,' 'tribut,' 'faim,' 'danse,' and 'ariane,'
as well as puns – very common in the play – on 'maman' and 'papa,' espe-
cially the quibble on 'pipi / papa.'

Noteworthy also is this monologue from *Wouf wouf*. Here the comic
strip, the fairy-tale, and the lullaby are superimposed one on top of the
other in a narrative which again functions much the same as *Poisson solu-
ble*:

> Tarzan arrived, rescued the doe, the beauty became a beautiful
> princess. Tarzan was taken to the court. The king knighted him
> and gave his daughter in marriage to her proud saviour. They were
> married; they were the occasion for joyful wedding ceremonies; the
> court tossed bread to the people. The couple retired and spent a
> beautiful night. The honey of the moon lit up the princess's skin.
> Her Tarzan loved honey. They had many children. Next morning,

Tarzan left for the Crusades. He locked up the chastity of his mar-
riage. The princess spends her days in the chapel ... One day, be-
cause her love for her love was too strong, she stole a statue. She
had to flee. She galloped through the steppes. Bandits followed
her ... She entered the grand canyon. Apaches tied her to the totem.
They lit a fire to burn her up. But she cried so hard that the wood
in her funeral pyre, completely soaked, wouldn't catch fire ... She
took a powder, losing the Indians in a potato patch.* Since she was
very tired she slept under the open sky. Next morning, the Indians
she had lost sprang up. Cobs of Indian corn stuck out from the
feathers in their headdresses. She plucked one for her baby to suck.
She rocked it tenderly, singing 'do-do, baby sleep, the baby will
soon fall asleep.'[211]

The method of the narrative is clear: the existence of a hero presup-
poses that of a princess, that of a princess a king her father who has a mis-
sion for the hero; a beautiful defenceless woman must fall prey to bandits
and bandits in America can only be Apaches;† if you leave (sow) Indians
behind you naturally they will spring up and this could only happen in a
field of Indian corn on the cob, a shape from which you draw milk. The
story closes with a lullaby, as in Les Enfants, and like the previous play
this one pays particular attention to the honeymoon myth. The insertion
of a reference to honeymoons (which occurs at the end) within Tarzan's
story is directly related to the role the image plays in the drama as a
whole: 'Just let me love you ... Then let me offer you the moon ... I believe
it is a honey moon.'[212]
 As with other passages in this genre the literal and metaphorical mean-
ings are compressed by homophony and imagery, typical attributes of
surrealism. In Wouf wouf especially, Sauvageau presents a marginal work
where the Quebec public can view its collective unconscious and makes
significant contributions to the inventory of new myths.

Tongues of Pentecost and Babel

Denis Vanier
Vanier has been much neglected by critics,[213] yet his output is more and
more imposing and the sense of disorientation it strives for and attains so
easily is quite unusual. In fact, the violence and feelings of disgust are so
intense in his writing that some of Dali's surreal effects pale by comparison.
 Vanier aptly describes himself (his passion, his de-mentia, and even his
totem, the Tongue of fire) in these lines which appeared in one of the first
issues of the periodical *Hobo-Québec*:

When I die having exploded
in my straitjacket lapped at by
tongues of fire
remember me as an adhesion to the body
of passion.[214]

This passage illustrates Vanier's linguistic terrorism, combining rape and violence with a fusion of the sacred and the erotic. A similar contrast has been pointed out in the interplay between illustrations and text in *lesbiennes d'acid*:

> The cover design is striking and unusual. This reclining woman wrapped in veils, surrounded by lilies and votive candles, brings to mind some kind of Ophelia. But she is a special Ophelia; she is smiling, her hands hold a rosary whose cross has been replaced by the trademark of a cigarette. I cannot resist quoting from the text itself: 'The children masturbate, laughing / and don't smoke Export A any more.' The cover, all lightness, modesty, and purity, is a real contrast to the rest of the illustrations. When you leaf through the book, the veils drop, the cigarettes are put aside; the illustrations display raw sex and preach marijuana.[215]

These illustrations readily bring to mind images from Buñuel's films, *Viridiana* for example, which mix the erotic and the sacred, the pure and the horrifying. But some of the images are peculiar to Vanier, such as the images of police and prison mixed in with swastikas and merchandise from sex shops. Police and prison are where transgression ends up, desire / prayer being the only antidote:

> Desire is prayer
> The body full of discharge like an abattoir
> I burn all the pushers, an epileptic fit
> in the perfume of police.[216]

Je, Vanier's first book, was published by Michel Chartrand's Presses sociales in 1965 with a preface by Claude Gauvreau and drawings by Reynald Connolly, a member of Zirmate.[217] His second collection, *Pornographic Delicatessen*, was published by Estérel with afterwords by Claude Gauvreau and Patrick Straram, who discussed the literary terrorism in the book and concluded: 'I believe Denis Vanier's cri-cœur is deflagratory, premonitory.'[218] Gauvreau for his part placed the young poet among the post-surrealist descendants of *Refus global*:

Denis Vanier's spontaneous élan takes him into areas of thought profound enough to make hypocrites uncomfortable. The themes arising from his ecstasy are upsetting enough to the owners of comfortable, superficial consciences that they can't be assimilated to what Borduas, in *Refus global*, had already termed 'flabby contemporary consciousnesses' ...

Vanier writes in such a state of emotional upheaval that he is able to pull the most secret and intimate human preoccupations from the depths of the subconscious ...

After surrealism and Art Brut* only pusillanimous provincials will be upset by such blatant reality.[219]

Already in *Je* two poems are dedicated to Gauvreau, another quotes a line from Tzara in an epigraph, and yet another mentions Claude Péloquin. Vanier seems to have assembled various links in the chain of surrealism so that he himself can extend it further: he does not use explorean imagery, for example, leaving that to the author of the preface, but he does refer to new methods of altering perception such as hallucinogenic drugs and provocation by disgust:[220]

A wound scabbing over
with deliria growing like plants
yellowed by the sun.

a wind breathing death

a sickness of being (Péloquin).[221]

In a poem dedicated to Gauvreau, the poet alludes to the ruination of the old conventional egregore and to the new age of language, a terminology very similar to that of the automatists:

people coloured in nuptial entrails
people foetus screaming at the hatching of a new word
in the language of 'those forbidden to speak'
who sounded out man before his flight
people demiurge
crucified in his mange and his fury
to die in the mire of dried-up vaginas ...
It is high time
to snort the dung of total tearing apart and to
enter into the disgust of conventional races.[222]

Five lines in homage 'to Muriel Guilbault, *Beauté baroque*' tell how her death (her 'caries') made the ink flow from those whose hearts were debased and also how this death spilled its 'acid,' its revealing and stimulating 'toxin,' into what used to be a desert land:

> Your caries nourishes some Bengalis with illegitimacy
> on inky chest straps
> *au suprême*
> when burned by baroque sting rays
> archives of sand get drunk from the ringing gourd.[223]

Gauvreau understandably considered this poet a disciple (there is a photo-montage of the two of them in *lesbiennes d'acid* holding photographs of female bodies), and he returned to the subject in a second preface on libertarian and surrational thinking:

> Denis belongs to the generation of young
> thinkers who are perfecting, in exemplary fashion,
> the destruction of all taboos.
> The moral freedom circulating in the young
> poet's objects is the result of a complete break
> with dried-up abstractions.
> A libertarian breeze sprinkles droplets of
> spring water over the hot images ...
> Denis Vanier is a marvellous surrational
> image-maker.[224]

Ready-mades abound in Vanier's work. They are taken from illustrated advertisements of obscure toilet accessories, recalling Marcel Duchamp's controversial dadaist urinal and the proposal in Apollinaire's periodical, *L'Esprit nouveau*, to install a room in a futurist museum filled with objects from a bathroom.[225] In *lesbiennes d'acid* there is an entire collection, to borrow one of Vanier's own titles, of 'objets de base' (underwear).[226]

What is this new spirit Vanier strives for? Jokingly he said, 'Since people started reading me, I get the impression that people are making love more, taking more acid and planting more bombs.'[227] Vanier wants his poetry to have an effect and he does not want it reduced to pure idealism or mysticism:

> It is both mystical and sexual. It is a poetry whose manipulation is
> essentially subversive and transcendant. I want the explosion of
> structures in the blood, forcible entry into the abattoirs of order,

pure illumination and supreme connection with the beyond ... I
write like an animal, by instinct. My perception of the universe is
therefore spontaneous and purely suggestive. My writing is not lib-
erated: it plunges voluntarily in among all symbols, all realities. I
want to capture all manifestations of the real, because I have a pre-
sentiment of a reality in equilibrium which I believe is genuine.[228]

Mysticism and sexuality, a spirit of subversion and transcendance, pure
illumination and animal instinct: Vanier's poetry is a crossroads, a dialecti-
cal game which recalls Gauvreau's definition of monism as a permanent
opening up to both matter and thought located between Hegel's idealist
monism and the materialist monism of Marx.[229] The prayer-desire duality
frequently found in Vanier's poems illustrates this dialectic:

Sacred religious pornography: with
marijuana the beginning of a kind of revolution,
strengthening of vagal tone.
Desire is prayer.
A book full of french kissing and women's diseases.
At a time when the police monopolize information
cultural terrorism and utopias which can't be co-opted are
necessary.
Language, style must be destroyed; work only
with the multisexual beyond of writing:
tribal and solitary images.[230]

Given such a dialectic, materialist critics do not have much to go on.
One preface by Straram ends on a note of uneasiness, a 'questioning,'[231]
and Thérèse Dumouchel, at one time a member of Parti pris, wrote an
accusatory article:

Vanier checks it out: businesslike relationships, unbearably mystified
images of the two sexes, sexuality cloistered within the confines of
capitalist rationality, vomit and marshmallow, solitary masturbation,
loneliness everywhere. Seeing that all this ugliness is a product of
the system, reducing sexual relations to a strict function of produc-
tion ... hot-shot Vanier produces a strategy to subvert this legalized
filth. The first material requirement in this strategy: *an implantation
of hemp and hop* ... He adds a second material requirement: a cell of
verbal terrorism inhabited by all the usual virtues of the code to be
subverted. Third material requirement: Santa Claus' assistant must
be provided, for the purposes of this strategy, with an artificial clito-

ris. Because this strategy is supposed to materialize in oral sexual practices, buddha-hotshot-Vanier also lays it out in code – a coding he calls poetic – for the initiates assured of finding the philosopher's stone of sexual liberation ... Santa Claus-buddha-hotshot-Vanier is an exact mirror image of the products of the system, not its contravention.[232]

Dumouchel and Straram, two of the first ten members in the collective which produced the magazine *Chroniques*, reacted in accordance with the logic of their own critical framework against this poet who considers himself both a materialist and a mystic, but it remains to be seen whether Vanier's mysticism is ideal or surreal. Claude Beausoleil, for example, places Vanier squarely in a surrealist perspective:

A text out of harmony with contemporary thought: sur-surrealism. An imagery based on juxtapositions which are incongruous but which refer back to an intrinsic requirement of words themselves ... pursuing the explosive(s) by attacking the conventional use of language, 'a corpse so brightly human / carried away on a tide of unreality.' The 'Flamencos' of *Je* have become 'toreadors', they do more strutting, but the violence of the early works is still there ... The context and its denunciation-enunciation are not left out despite the similarities to surrealism.[233]

The analysis seems appropriate to a poet who mixes together calvaries and other biblical images with bleats and screams:

Dissident cadaver of exploded forms

language
resides no longer in man's pores
the obsession is so bogged down in the scream

these soiled calvaries
make bleating blood 'snake'
from the luxurious throats
of biblical dogs.[234]

The bleating blood which pours out announces the death of John the Baptist's sheep, and this poet in whose hands 'art tends to become an act of terrorism' cries out as he watches the Saint-Jean Baptiste Day parade:[235] 'Land to be defined on mattress of bronze / seen from a void point.'[236]

Starting from scratch, reconstructing a country, rebuilding a life, rede-
fining the act of writing from the beginning with the nihilistic rejection of
what is as if to travel on one's own down the path leading from dada to
surrealism – this seems to be Vanier's program according to Beausoleil,
who derives it, not very convincingly, from his name (dénie; va nier =
refuse; going to deny). But this critic adds: 'A complete program of con-
vulsions ('Beauty must be convulsive, or it will not exist' – Breton), twists,
aggressions.'[237]

Louis Geoffroy

Louis Geoffroy is, in effect, Les Editions de l'obscène Nyctalope. He has
published poems with transposable parts: his first book, *Graffiti*, looks like
a deck of visiting cards and recalls Raymond Queneau's chopped pages
which work like shutters; it was soon followed by *Poker*, a poem-object
which functions like a venetian blind peephole for voyeurs.

Geoffroy also published *Les Nymphes cabrées* and a story, *Max Walter
Swanberg*, whose eroticism is clearly surrealist. Written in 1965 though not
published until 1972, the story takes place in a 'museum of surrealist art'[238]
– a euphemism for a brothel[239] – where the nocturnal visitors look as if they
had been painted by the Scandinavian painter.[240] *Empire State Coca Blues* ex-
plicitly refers to surrealism and to Henry Miller,[241] whose work was much
admired by Breton and his friends. In *Le Saint Rouge et la pécheresse*, Geoffroy
includes a list of works and authors, several of whom (eg, Breton's *Nadja*
and Swanberg)[242] are directly linked to surrealism. *Totem poing fermé*, which
mentions Gauvreau, is an exercise in automatism,[243] and his poem 'Medita-
tions,' among others, sounds like a jam session. There are obvious connec-
tions between his own work and Paul-Marie Lapointe's special kind of auto-
matism – Lapointe considered improvised modulation 'the highest form of
poetry, the highest form of art'[244] – for this lover of ad lib jazz. 'Phallologie'
inevitably recalls certain poems by Lapointe:

> Wedge-shaped trees with disconcerting abstractions
> magic trees with kitchen charms
> trees of a verbose meandering tenderness ...
> do you see columns virtual centipedes
> do you see revolutionary somersaults ...
> and the greyish hawthorn like a silky machine-gun
> others have trod muddy paths
> and their steps buried under various Greek capitals
> the trees shiver
> the trees hold out their hands to hallucinations
> the trees throb in bed's heavens.[245]

LSD is also written at one go in the style of an acid trip, a hallucinatory fabrication:

> fables occur at regular intervals
> fratricides looking for someone to convince
> the vinyl of your leg gives the distinct impression that you are a film
> by Andy Warhol and that I'm looking there for meanings without
> meanings
> you are reality and sharply reprimanded by your reality
> – the acid is having a strange effect today ...
> oooh I can't see anything anymore
> the leaves are eating me
> are engulfdevouring me
> I am being absorbed by my innards and my superego
> I quiver with indigestion ...
> coming back down
> you tear me apart beyond all mauve surtime
> towards the intrinsic beasts
> the abyss opens up
> and I phraseologize the abyss.[246]

Geoffroy calls his most recent publication, *Etre ange étrange,* an 'ero-stasis.' It includes three love stories surveying Geoffroy's world where Jean Béliveau, Black Horse ale, and Maple Leaf potato chips are all jumbled together. Also included are what he most enjoys as accompaniment to his pleasures with Elle, Emmanuelle: Georges Bataille, Dali, Miles Davis, The Doors, Gauvreau, Godard, Mingus – especially Gauvreau, to whom he dedicates the first story, which ends with these lines: 'It occurs to me to re-write the only love story ever published, *Toi ma nuit* (or above all *Nadja,* or *Beauté baroque,* or even *L'Ecume des jours, L'Histoire de l'œil).'[247]* Bataille, Breton, Gauvreau, and Vian thus accompany his automatist narrative which is written more or less in their style (assuming that their styles could ever be similar). Judging by the following statements, his relationship to the written word is physical and relentless:

> It is only the beginning of the long march without end and the
> trespass without permission ...
> To write of never writing again, to live out each and every inade-
> quate description, each and every relationship distorted from the
> very beginning by words, your open legs now only welcome my

words which I brandish as palliatives, phalliatives, and gaps mutually gratifying each other out of my reach ...

In order to write that I don't know how to write you anymore I die a little more each moment because of your body which my megalomaniacal delirium paints for me everywhere, in every page of every novel.[248]

Within the framework of the present analysis, Geoffroy's subversive conception of writing explains his recourse both to the scabrous in *Max Walter Swanberg* and to Déclic's spectacle-provocations on the twentieth anniversary of *Refus global*. For Geoffroy, writing 'is always subversive work. What you give of yourself in a given society is aimed principally at changing that society. In this sense, it is always subversive work; otherwise it's useless.'[249]

Babel, ToutArtBel, and bababababelllllll

Henri Jones, a former participant in European surrealism who signed his works Tristan Max Him, founded a movement in late 1968 devoted to exploding language. The movement produced a periodical, *babelians illustrations babéliennes*, of which three issues appeared between April 1969 and 1973. This professor from McGill University was very involved with surrealism: names connected with European surrealism such as Maurice Henry, Marcel Jean, and Henri Pastoureau crop up in his publications. Here is an extract from a poem by F. Kenneth-Charles Du Puis written on 5 February 1969, at Saint-Jovite:

why beat up Moscow? wasn't the music
enough for you anymore? diable diabelli diabotticelli
with beautiful (red-) skins which Rimbaud nailed
 upon the cross*
on the Mis-sis-sippi river ghosts and graveyard rubbings
charcoal Harvard Greece it's here why
rebel? because Christopher left me near a lutheran church
they called modern with bastions marchons marchons your
blood is cold aux armes citoyens de la table ronde
 let's taste and see
if the blood is good oui oui oui all the way home
the margueritas constellation mourn your dead father your
 marguerite you
chose her in the sweat of a telepanic booth hello
a dying Night is more beautiful than your brick box
 scorched earth the sun

by the Russians, to the sun, to the only eye, Plotinus*
is not a pantheist as you are accusing finger.[250]

Alongside such exercises in automatic writing characteristic of citizens
from a 'bilingual and bicultural' milieu it is surprising to find in the third
issue the names of Nicole Brossard, Gatien Lapointe, and Gaston Miron.
But like Henry, Jean, and Pastoureau, they too experimented with polylin-
guism in their own way.

As might be expected, *babelians illustrations babéliennes* ran a great risk
of drowning in academicism: however, poems like those by Jacqueline
Gladu, especially 'Karnack en famille,' are surprising in so far as they
show both how closely related and how far removed babelism was from
surrealism:

> carissimiunwinded
> my issime father† grand
> cowherd from the frater mosquit side
> andrapear?
> all homebodies mitten holders
> deadwood
> qué talisman
> listen dearnick dearnickbabushka yo have yo catacomb'
> butorfantasque my hatred
> she mounts on stabat mater
> andrapear?[251]

Here formal experimentation enters a work which otherwise unfolds like a
piece of automatic writing. Since Jacqueline Gladu was the daughter of
the man who both published the periodical *Les Ateliers d'art graphiques*
along with Albert Dumouchel and was a member of Pellan's circle, this
kind of controlled automatism could be referred back to Pellan's theories
as readily as to new techniques of polylinguism.

When students at the Collège Lionel-Groulx occupied their buildings
in 1968, they unleashed in Quebec a movement analogous to the May
1968 revolution in France, which was marked by a revival of Breton's
ideas. They were visited by a philosophy professor from the Collège de
Maisonneuve, Raoul Duguay, who had come to give a poetry recital in
occupied territory. On 19 October 1968, he also contributed a poem to the
show *Chansons et poèmes de la résistance* to be read and sung. The poem was
entitled 'Québec Si,' which had been adopted as the slogan for Quebec
resistance after the phrase 'Cuba Si.' The following lines are typical:

> I pour my voice into
> your ears as another over there some
> powder into the barrel of his rifle
> in order to understand you better to arm your mouth with
> words and cries for power
> and shells bombs or bullets shells bombs.[252]*

The poem is also an experiment in form in so far as Duguay, just as he did in his collection *or le cycle du sang dure donc* (1976), consciously ends each line with a particle which properly belongs to the first phrase of the next line. This is intended to convey the effect of 'swing' in jazz created by syncope or appogiatura. Duguay's work changed after 1968 when he joined Walter Boudreau's musical group L'Infonie. His *Manifestes de l'Infonie, le ToutArtBel* appeared in April 1969, and the record *Mantra*, on which he sings and plays trumpet, came out in September. Both played an integral role in the score for Jean-Pierre Lefebvre's film *Q-Bec My Love*, released in 1969,[253] and in the demonstration against Bill 63 in October of that year.[254] In 1970, the group appeared at the Nuit de la poésie and in Jacques Giraldeau's film *Bozarts, les arts plastiques et la société québécoise, du Refus global à l'Opération Déclic*.[255] Infonie's *ToutArtBel* is surrealist in that it seeks a new life and new mythologies, but its automatism is clearly controlled as indicated by Walter Boudreau in his comments on the repetitive form of the 'events' which make *Mantra*.[256] Some of the works in Duguay's *Babababellllllll III* come much closer to verbal debauchery:

> While Madame la Marquise buys a new electric toothbrush to clean her poodle's paws, while geese knit their nests, while ministers donate their jackets to grandpas, most of the players on the Canadiens trade in their cars in the months of February and March and the Honourable Judge plucks lice from his maid's hair. Since there is no continuity except within.[257]
>
> ... the bababa's, there, it's like the dadada's, the gagaga's, the hahaha's, the lalala's, the mamama's, the papapa's, the tatata's, the zazaza's of the CHILD learning to talk. Good. That's clear. Toulmonde understands that.† Madame, relax a bit ... take a good look at me. Now, the 'llllll's' the six 'l's,' the six 'L's,' that's to gargle with before you go to bed and when you get up: just like intellectuals.[258]

Recalling the time when he was experimenting with form, Duguay has said: 'I've changed so much I hardly recognize myself any more ... At that

time words flowed from my pen like jets of sperm, while today as far as possible they're like waves of light.'[259] This is a harsh judgment on the period when he wrote *Ruts* and *Le Cycle du sang*. As for his experiments in light, they occasionally smack of mystical quests as, for example, when the *Manifeste de l'Infonie* talks of Zen, prays to Brahma, and paraphrases the scriptures. But the manifesto cannot be considered apart from the objectives stated in its opening pages, namely a 'RRRevolution' which will abolish the imperialism of science, the betrayal of the intellectuals, and 'socio-politico-economic' totalitarianism. Unlike Péloquin's Zirmate, for example, l'Infonie did not hesitate to subscribe to specific political demands such as those made in the works mentioned above in connection with Bill 63 and the film *Q-Bec My Love*. Toulmonde's poetry recalls the Situationist International and Straram: 'Toulmonde is a Poet Who Transpires, in this Time or in an Other Aspiring to the Respiration of All Being. May Toulmonde be Poet.'[260] Duguay's Toulmonde is clearly not restricted to the Québecois, but he nevertheless first addresses himself mainly to them: 'My plea must become a jam session to unjam the Quebec consciousness. The project is analogous to that of Lautréamont: "Poetry will be made by everybody."'[261] The ToutArtBel and babababel project therefore relates to many other earlier projects in Quebec which had themselves been influenced by the surrealists.

POSING QUESTIONS

There was great interest in surrealism during the 1950s, so much so that people thought of establishing a Centrale Surrationnelle in Montreal in 1951. The name itself indicates that the Centrale would have been descended yet autonomous from Breton's organization, Les Centrales surréalistes:

> The thirst for liberation is so strong in such an extraordinary number of people that a Centrale Surrationnelle will be in operation starting next fall. Mousseau has finally decided to realize this project, which has been floating around for years. It would be hard to exaggerate the influence such an enterprise would have. The Centrale will probably be situated among the studios on place Christin.[262]

The Centrale did in fact come into existence, but it never achieved official recognition as did Breton's Centrales.[263] Borduas himself had serious reservations about any fixed format for a school or artistic and literary group:

> A school or movement with a specific name (for example, surrealism) only expresses (apart from the personalities involved) the

'fleeting link' between a form (in a fixed space and time) and a profound poetic absolute. You seem to be forgetting the link and identifying the word with the absolute. If we want to define ourselves in this manner, we would have to list all the schools in the past which have left traces alive in us. This would be awkward and useless: the present containing the past.

Surrealism (like any school) expresses a moment in man's spiritual adventure uniting through fresh new forms full of enthusiasm certain poetic values which have been renewed in this process. Before 1950 surrealism meant both the precise and appropriate expression and discovery (or defence) of these moral values. After 1950, surrealism no longer means anything but unpleasant academic formalism. The substance is in the form. When the form fades, becomes fixed, so does the substance ... The adventure of poetry, enriched by surrealism, has since taken other paths, other forms.[264]

Borduas' reservations vis-à-vis surrealism are the same reservations expressed by the poets of l'Hexagone, Orphée, and Quartz not only about surrealism but surrational automatism itself.

In spite of this there was a resurgence in the automatists' popularity around the end of the 1960s – especially on the twentieth anniversary of *Refus global* – coming from several sources. One was publications, mainly the special issues of the periodical *La Barre du jour*: there is no doubt that the efforts of Nicole Brossard, Marcel Saint-Pierre, Roger Soublière, and France Théorêt, for example, enabled the automatists (especially the literary automatists) to regain a certain notoriety. François-Marc Gagnon and Bernard Teyssèdre contributed to these special issues on the automatists and later published more extensive works on the subject.[265] Another more important source was at the level of artistic production. In addition to Opération Déclic, there was the Ecole des beaux-arts where les Satellites of Janou Saint-Denis presented *La Jeune fille et la lune* and *Les Grappes lucides* in 1959, and where *Refus global* was republished in its entirety to mark the manifesto's twentieth anniversary.[266] Yves Robillard presented plays along the same lines at the University of Quebec like the Apollo-Variétés show.[267] Finally, although the Groupe Zéro tried unsuccessfully to produce Gauvreau's *La Charge de l'orignal épormyable* and *Magie cérémonielle* by Duguay and Gauvreau,[268] the Théâtre du nouveau monde did succeed in mounting *Les Oranges sont vertes*. This last play was sold out so often that it played successfully for a month the following year, and a new TNM production of *La Charge de l'orignal épormyable* followed in March 1974.

When confronted with automatist literature the public no longer 'breaks out in universal and uncontrolled hysterical laughter,' no longer responds with 'the *épormyable* hilarity of hunchbacks in a trance,' the 'incredibly noisy thunderings of laughter' which greeted *Bien-être* twenty years earlier;[269] in fact, there has even been a tendency to go beyond it. In the meantime there has been a change of generations. Yesterday's children have carried the torch – quite literally, when one considers that Jacqueline Gladu's poems appeared in the same year that the sons of Maurice Gagnon and Maurice Beaulieu, François-Marc and Michel respectively, contributed critical essays to *La Barre du jour* on the automatists with whom both families had affiliations.[270] Later, Jérôme Elie, a Lautréamont specialist, helped edit the *Œuvres* of Robert Elie, which included several critical essays on Borduas and the automatists.[271]

The rise of a new generation, attracted to and at the same time disagreeing with the preceding one, is best described by Paul Borduas *fils* in this description of his father written in 1962 on the occasion of the Borduas retrospective:

It is, I believe, the meditation on the harsh truths regarding the sidereal space of silence and, at the same time, the tragic presence of humanity in his paintings that disorients us. The dialogue seems to take place only between the work itself and the artist. But this is false. The amazing thing about art is that this dialogue is always accessible and patiently awaits the consent of the spectator. Art constantly sends its message and awaits the light.

This feeling of solitude evoked by certain paintings is understandable. The very act of creation is solitude. The artist is then uniquely in his own presence; he is alone with his tools in order to combat the quasi-impossibility of expression and of experimentation in the impalpability of experience. Projected into the most intense part of himself, only then does the artist initiate a dialogue with the rest of the universe.[272]

For dialogue to take place, one must assume that the new generation has matured and that the work of one relates to the other. Paul-Emile Borduas himself placed his work 'in relation to contemporary surrealism.' In 1969 as in 1948, the Quebec public changed: 'pure psychic automatism' and 'surrational automatism' as practised in Quebec played a large role in that change.

Conclusion

The revolution in the province of Quebec will be global and ideological or it will not take place ... I am not speaking as a sociologist but as a friend of Breton, who wanted revolution to be all or nothing.

Marcel Rioux[1]

It can now be stated authoritatively that surrealism has had a profound influence in Quebec and that it even acquired connotations peculiar to Quebec.

PARTICULAR CHARACTERISTICS OF SURREALISM IN QUEBEC

Between the wars, the surrealists became known to Québécois living in France (Alfred Pellan and Alain Grandbois among others) and were known to the readers of *La Nouvelle Revue Française* and *Minotaure* in Quebec. Some Québécois met the surrealists at gatherings and exhibitions held in New York during the Second World War.

Paul-Emile Borduas' group in particular was greatly influenced by the New York surrealist periodicals *VVV* and *Hémisphères*, and the automatists also took advantage of Pellan's courses at the Ecole des beaux-arts.[2] Borduas initiated a movement which took as its starting point a 'surrealist' exhibition in 1942, expanded as the result of Jean-Paul Riopelle's participation in the 1947 International Surrealist Exhibition and the writing of *Rupture inaugurale*, and published a Quebec surrational manifesto, *Refus global*, in 1948. Another more diffuse movement started in Pellan's circle

with an exhibition and a manifesto, *Prisme d'yeux*, in 1948. It became involved with the Cobra and Phases movements, and eventually some of its members – Jean Benoît, Roland Giguère, and Mimi Parent – participated in the joint international exhibition put on by Phases and the surrealists in New York in 1960-1. However, the distinctions between the two Quebec movements became less and less clear as *Refus global* became a symbol of protest, pure and simple, against the establishment, and revolutionary surrealism abandoned Stalinism. This process continued until most of the Quebec avant-garde were gathered together on the twentieth anniversary of the surrational manifesto in 1968 during Opération Déclic.

Refus global was originally an autonomous act following upon other surrealist acts throughout the world, particularly *Rupture inaugurale* (1947). However, the greater importance accorded to dreams by the European surrealists as compared with the relative lack of attention paid this phenomenon by the Québécois should not be exaggerated in order to emphasize the originality of that act. Robert Elie goes too far when he writes that after a

> brief period of very personal cubism, surrealism would have led Borduas down the dangerous path of dreams towards a form of representation which opens the Pandora's box of literary allusion, as demonstrated in the work of Dali. But ... playing with symbols didn't interest Borduas for very long and the automatism which he fervently practised didn't seem to open wide the floodgates of the dream.[3]

Tzara's definition of surrealism is an important reminder of how numerous the surrealist choices were, and how the proposals for a surrealist revolution prepared the way for a specifically Québécois option:

> Love of phantoms, spells, occultism, magic, vice, dreams, whims, follies, folklore real or invented, mythology (even mystifications), utopias social or otherwise, trips real or imaginary, bric-à-brac, wonders, adventures, and mores of primitive peoples; generally everything which escaped the rigid framework where beauty had been confined so that it would be identified with the mind.[4]

Some might consider this reference to Tzara suspect in determining the lineage of surrealism. For them, definitions of the prospector / conductor's role as defined by Breton in *Rupture inaugurale* would be more to the point. Breton deals only with major themes, but by supporting the over-

throw of six traditional theories of western culture, he attempts to demonstrate how his conception of the Revolution might 'encompass' the others:

> To the extent that surrealism asks the Revolution to encompass all
> of man and not to imagine his liberation under any particular
> aspect but indeed under all aspects at once, then it declares itself
> uniquely qualified to weigh in the balance the forces regarding
> which it has played the prospector, then the *marvellously magnetic
> conductor* – from woman-child to black comedy, from objective haz-
> ard to the will of myth. These forces have as their chosen locus love
> which is at the same time unconditional, overwhelming, and mad.
> Only this allows man to keep an open mind, to evolve according to
> new psychological dimensions.
> Once they have been dug up, once they have been positioned so
> that they can join together and exalt one another these forces have
> a chance to finally reconcile human destiny and universal causality.
> They align themselves with the vanguard, they take part in the pro-
> gress of the most advanced disciplines of our time to which we owe
> non-Euclidian geometry, non-Maxwellian physics, non-Pasteurian
> biology, non-Newtonian mechanics – disciplines in their turn consoli-
> dated by non-Aristotelian logic and non-Judaic morality.[5]

This description left Borduas feeling very much at ease, as he explained in a letter to Leduc which also contained a copy of the manifesto.[6] But it is clear that for Borduas and Leduc, surrealists and automatists only agreed on an 'ethical position' and 'theoretical elaborations.'[7] Both shared a common 'state of mind,' to use a term from *Surréalisme et révolution*, a lecture by Artaud in which certain passages curiously foreshadow the 1947 manifestoes:

> One can say what surrealism is not, but in order to state what it is
> one has to use approximations and images, and surrealism is a
> movement clothed in images ...
> Refusal and violence.
> Violence and Refusal.
> ... Two poles indicating an impossible state of mind ...
> Refusal. A desperate refusal to live which nevertheless must accept
> life.[8]

This shared state of mind implies a revolution encompassing the whole of man. But even though they shout the same slogans – 'To thwart the unliv-

able is not to flee life but to throw oneself totally into it and never return'
(Breton),[9] 'refusal of facility, of conformism ... complete acceptance of life'
(Borduas),[10] 'on the one hand an art of refusal, on the other an art of
acceptance – refusal precedes acceptance' (Leduc)[11] – the truth is that on
the level of execution, there are appreciable differences between the sur-
realists and the automatists.

Although labels are always oversimplifications, one can say that the net-
work of automatist writers includes Thérèse Renaud, Claude Gauvreau,
Rémi-Paul Forgues, Suzanne Meloche, and Bruno Cormier (whose work
from this period is still unknown). All described their writing as baroque,
non-representational, or surrational. Other poets, mainly Paul-Marie La-
pointe, Jean-Claude Dussault, and Gilles Groulx, made brief excursions
into the genre around the beginning of the fifties.

The poets who gathered around Les Editions Erta (like Roland Giguère
and Claude Haeffely) were more closely linked to the international sur-
realist movement. Giguère joined the revolutionary surrealist movements
Cobra and Phases de l'art contemporain first, to be followed by his painter
friends Léon Bellefleur and Albert Dumouchel. Former automatists like
Marcelle Ferron, Fernand Leduc, and Jean-Paul Mousseau also partici-
pated in Phases, while Leduc and Riopelle took part, very briefly, in the
activities of the revolutionary surrealists in Paris. Notes for three of Gi-
guère's exhibitions in France (1961-2) were written by the poet Edouard
Jaguer, who had been the main spokesman for the revolutionary surrealists.
Not only Riopelle but Jean Benoît and Mimi Parent too enjoyed a cer-
tain prestige with Breton, receiving enthusiastic notices in the 1965 edition
of his book *Le Surréalisme et la peinture*. Other Québécois, for example
Léon Bellefleur, Fernand Leduc, Roland Giguère, and Marcel Raymond
were also acquaintances of Breton. Riopelle joined Georges Mathieu in the
first stirrings of lyrical abstraction, while Borduas became interested in
action painting and the work of Jackson Pollock. In poetry, however,
Giguère was the only one (with the exception of the former European
residents Claude Haeffely and Théodor Koenig) to publish poems in sur-
realist magazines (*Cobra, Boa, Edda, Phantomas, Phases*) originating in
other countries, and he even helped put out some issues of *Phases*.

THE GLOBAL REVOLUTION THIRTY-FIVE YEARS AFTER

Refus global was an attempt by the automatists to place themselves beyond
(certainly not between) the scope of both fascist and Stalinist revolutionary
movements. However, *Combat*, the Communist party newspaper in Que-
bec, had difficulty understanding the position of the surrational manifesto:
Pierre Gélinas labelled Borduas and his followers 'canvas revolutionaries'

but then Gilles Hénault defended them. The accusation that the automa-
tists were 'canvas revolutionaries' was based on the shortsighted view that
Borduas, like Breton, had turned bourgeois and opted for a psychic rather
than a social revolution.[12]

Claude Gauvreau explained in this regard how Borduas' group did in
fact mean to change the world by changing life, by making a general prac-
tice of shifting attention away from intentions to consequences, and the
group believed it was investigating this possibility.[13] People still talked,
however, about 'linguistic terrorism'[14] and 'instant tools for guerrillas'[15] in
connection with the poetry of Gauvreau and Vanier. Patrick Straram had
a more accurate estimate of the importance of these 'canvas revolutionaries'
and, unlike Jean-Pierre Roy, who classified them as members of the bour-
geoisie, he ranked them ahead of that class:

> It is not giving in to Trotskyism in the least to say how much ...
> Gauvreau, Ouellette, Langevin, Garcia, Duguay, and Vanier are
> real militants in a genuine Quebec Revolution, substantially abetted
> by Miron, Lapointe, Chamberland, and Godin. Other poetry is
> only the private property of an elite at the heart of a society built
> on class inequality and speaking a bourgeois 'language.'[16]

In the opinion of Pierre Vadeboncœur, one of the main contributors to
Cité Libre, Borduas was clearly the leader of the revolution which trans-
formed the Quebec of today: 'Virtually nobody cared enough about the
soul to finally attempt a worthwhile experiment. Borduas relied completely
on the soul. He risked everything. French Canada as we know it begins
with him.'[17]

All this suggests that concentrated work on the structures of language
gives better results than overturning parties in power. Borduas wanted a
global revolution, just as the surrealists did, the same revolution Marcel
Rioux hoped for in the first years of the Quiet Revolution when he
evoked Breton in its name.[18] For Breton, revolution through language
(verbal and non-verbal) started with the principle enunciated in this ques-
tion: 'Does the mediocrity of our universe not depend essentially on our
power of speech?'[19] He therefore attacks this power of speech so he can
eventually, thanks to automatic language, carry out its 'gentle destruc-
tion.'[20]

Who would have thought in 1948 that the Quebec automatists' mani-
festo would also carry out so much 'gentle destruction'? Most importantly,
it attacked false notions of order in art and literature, and therefore also in
life, in order to create new objects situated in a new conception of time
and space. Breton had persisted in believing that the revolutionary force of

automatism extended beyond fascist or Stalinist political revolution, and stated this on several different occasions in no uncertain terms.[21] Borduas and the Quebec automatists also believed in language as revolutionary force: automatism therefore appears as the instrument of psychic revolution, the probe which provokes the eruption.[22] In this sense Breton and surrealism in general, and Borduas and automatism in particular, contributed to a large extent in the break-up of the old order in Quebec.

Rupture inaugurale states that 'The dream and the revolution were made to join forces, not exclude each other. To dream the Revolution is not to renounce it but to make it twice over without mental reservations.'[23] The tendency of Quebec literature during certain periods to eschew realism is perhaps linked to a more or less conscious need to transform reality. Both the 'realistic' novels of André Malraux and the 'surrealist' poems of Roland Giguère show that there are days when reality begins to resemble fiction. 'Our passions spontaneously, unpredictably, inevitably shape the future';[24] with invocations such as this surrealists and automatists provoke us into prospecting our individual and collective myths, and realizing our dreams.[25]

Translator's Notes

In these notes, page numbers are in bold type and line numbers are in roman type.

INTRODUCTION

xi,2 Under the old educational system in Quebec, boys could enter a private collège classique after primary school for eight years of classical training in the humanities leading to the *baccalauréat*.

xiv,18 Literally 'literature of the soil,' an early twentieth-century movement in Europe and North America drawing its themes from agrarian rural life. Dali coined the phrase 'écran paranoïaque' to describe a surface which, if looked at intently, suggests images to the perceiver. He took the concept from da Vinci.

CHAPTER ONE: PRECURSORS

10,17 They were actually first published after Nelligan went insane but before his death.

17,11 The misspelling of 'triptyques' is intentional.

17,34 The first five words of Delahaye's satire and Ronsard's sixteenth-century invitation to love are identical.

17,38 The initials when pronounced in French create the sentence 'Elle a chaud au cul' (She's hot to trot).

18,32 The French original reads: 'La blague est une matière protéique, non pas surtout en ce sens qu'elle est fondamentale chez l'être vivant, mais parce qu'elle prend mille formes.' Détailler les différents genres de blague – blague-menterie, blague-emplissage, blague-à-froid, blague à tabac (terroir) – serait trop long ... blague à part. 'Protéique' refers to both 'protein' and 'Proteus'; 'blague à tabac (terroir)' plays on another meaning for 'blague,' viz. 'pouch'; 'terroir' suggests 'soil,' hence 'dirt'

18,38 Tout le monde en parle;
Dites donc, n'avez-vous rien de mieux qu'énésol?
Oui; venez me voir, je vous traiterai par le
Dioxydiamidoarsénobenzol.

21,40 'Rrose Sélavy and I sketch the bruises of Eskimos with exquisite words.'
This rendering makes no attempt to capture the multilayered puns and verbal
play of the original.

33,29 All translations are by John Glassco from his *Complete Poems of Hector de Saint-Denys Garneau* (Ottawa: Oberon Press 1974).

CHAPTER TWO: FROM PAINTING TO POETRY

41,25 A form of collage in which a piece of paper is folded, usually three times, and
different artists fill in the panels without seeing what has already been painted.
The final result is presented as an integrated work.

41,27 Automatic drawings which were torn up and the pieces rearranged at random

45,10 Riopelle later participated in the Sixth in Paris (1947); Jean Benoît and Mimi
Parent in the Eighth in Paris (1959); these three and Roland Giguère in the
Ninth in New York (1961).

52,31 The phrase 'like a bird in a cage' is in English in the original.

53,1 Echoing the title of a play by Cocteau, usually translated as 'The Holy Terrors'

56,2 Tr. by Peter Miller

56,22 Tr. by Peter Miller

57,31 Tr. by D.G. Jones

60,23 Literally, 'two-headed'; also a pun on Bucephalus, the horse of Alexander the
Great

74,23 Rech. pr proposit. rapide
Client sérieux. Jolis poèmes
Agréab. Avec / sans rimes
Vs libres, alexandr
Etat vraim. impec.

74,25 Literally, 'Games of evil'; 'maux' puns on 'mots,' so also 'Plays on words'

75,3 Si je n'avais plus mon petit bar
Pour y aller rêver
Et disputer l'ennui aux nuits
Si je n'avais plus mon petit bar
Pour y aller boire
Et disputer les vers aux verres
Je crois bien que j'en mourrais
Oh je sais on m'élèverait sur les hôtels
Dans la glorification des seins
Mais loin de mon petit bar
Il me faudrait désormais
Disputer mes vers aux vers.
The central conceit, among others, is on vers (= verse / worms) and its homonym
verre (= glass); also autels (altars) and hôtels (hotels).

78,38 A dish presented at a surrealist exhibition containing a woman's body prepared
for eating

CHAPTER THREE: 'REFUS GLOBAL'

89,15 'D'yeux' puns on 'dieu' = god
89,28 'Cocu' = cuckold
99,21 Certain educational institutions at the time, including art and technical schools, were under the jurisdiction of the Ministry of Youth and hence not run by the Church.
105,39 The French 'exploréen' is a neologism coined by Gauvreau.
107,20 In French, 'objets,' Gauvreau's preferred word for his short dramatic works
109,19 All poetic and dramatic translations on pp 108-13 by Ray Ellenwood from his translation of *Les Entrailles* entitled *Entrails* (Toronto: Coach House Press 1982).
111,18 Le champ de bataille d'argousin plane sur moi et sur lui au moment d'un solennel pipi spirituel. Les extases de la vingtième année qui s'appellent galouchuris fornicuteurs sont venus à l'écho de l'homme.
112,13 Apolnixède – Or ru magelcédance.
 Les brins, les bus dôte finance.
 Digue, diguedon à l'heure où la paleur digue l'adon.
 Je meurs les chefs. au dieu des crèfes.
 Apolchidance. Chirrie d'erbur.
 Air pur au mur des luzes ...
 Et lerre cédère au fils du Très Puscule.
 Digueron diguerondon didon au lantte des édredons.
 Digue lou au paradou des mou lou.
 Creux au creux des ezètes. Ils parleront la langue du crepte agenouillé.
114,31 The French 'épormyable' is formed from 'épouvantable' and 'formidable.'
117,3 Ah dormir droubi
 Enfant phallège unti
 Cri a pouf!
 Deulle
 Ma mie
 mon enfant
 ma poire
 Schotte!
 enfant dick dur enfant ma poire dick dur dic enfant oui ô
 Enfant
 Masturber la fille
 le sabre
 l'enfant dans la cervelle unique
 marchande
 enfant marchande
 l'enfant qui rit
 la fille masse
 La fille-drima
 La fille
 Fille
 Masturbée dans le chaland du brave hiver découpé comme de la verrerie.
118,8 For 'reads' and 'raves,' the French plays on 'lire' and 'délire.'
118,29 The title echoes the French words for 'brochure,' 'skewer,' and 'brocade.'

119,6 Oeil
 Tibère
 Et ouff Arrouttouf pouf pif
 Oeil Néjan
 Retour d'Enfer
 où kneuil la Patrie-Oeil du détournement des avalanches lyriques ...
 Je suis Néron ...
 Oeil oreille ardoise.
121,40 Je java à trois cornes est l'emblème de mon cerceau et l'afghan aux
 muqueuses de gorille est le stéréoscope de mes jeux grammanaires.
 Un lasso jeté dans le frisson des temps d'avril décrit les sondes
 de mon flair de molosse.
 Je pirouette comme l'étoile des pignons de françaises.
141,15 'Matta' was a surrealist painter; 'tatou' = armadillo; 'toucan' = toucan; 'cantha-
 ride' = Spanish fly.
145,11 Surmâle (cf. Nietzsche's Übermensch) is a character in a novel by Alfred
 Jarry.
146,4 Tr. by D.G. Jones
152,6 Tr. by D.G. Jones

CHAPTER FOUR: NEW MOVEMENTS

157,6 The Dark Ages of the Duplessis era
157,17 'Caribou' is a mixture of wine and distilled alcohol; the 'Institut' is the Institut
 des arts graphiques.
166,31 'Grand Soir' was an anarchist phrase denoting the night of revolution that would
 precede the dawn of a new age.
171,3 Trans. by C.G. Cappon
172,8 Pierre Vallières' *Nègres blancs d'Amérique* (1968) equated the status of the Qué-
 bécois in Canada with that of blacks in the United States.
180,3 'Chat perché' is also the name for the children's game 'off-ground tag.'
181,14 Enav traorln éclair maje noce tremeur ...
 Je parle seul. Simples exercices de percussion ...
 Dans l'attente du rythme donné par les
 tambours, nous ne percevons que l'écho des
 tams-tams libérateurs.
195,10 'Pic-verres,' literally, 'glasspeckers,' puns on 'pic-verts' = 'woodpeckers'
201,33 Le néant, la négation, le refus total ...
 Nous avons inventé le pentothal!
 Mais il n'y eut jamais de Pan total
 Et ce chétif nembutal
 N'est qu'un faux brutal.
 'Faux brutal' could mean either 'brutal lie' or 'false brute.'
202,3 The French 'se met à branler' also suggests 'starts masturbating.'
202,22 mais la folle est au logis, elle a quitté Chaillot
 On n'y voyait plus que des caillots.
 Ah! Ho! Hé! Voici un nègre, un aigre nègre,
 Il pisse du vinaigre sur la maigre pègre
 Tandis que le but-en-blanc
 La Flux-Flux-Flanc broie du noir

Et que dans son Sépulcre Blanci
Le sombre Truman (do not confuse with True-man)
Fait la bombe
Atomique.
Bâtards avatars des lascars du caviar au radar!
Le vitriol sur la gueule de l'infâme.

202,39 Zygmoide, schizoide (sur la corde roide)
(Y a pas d'tréma, faut passer de vie
A trémas)
Ne se paie pas de trématismes qui veut.
Le carème n'est ni un barème ni un trirème
Ni un apophtègme
Ni un critère ni un clystère
Mais un piètre-à-terre
Un phalanstère,
Un phallus-en-terre
Plantez un gland, s'il se déchêne
De sa gaine
(Place-en-terre)!

'Tréma' = diaresis; the reference is to the missing diaresis on 'schizoid,' which in French is spelled 'schizoïd,' that is, the poem was written on an English type-writer. 'Tréma' also puns on 'trépas' as in 'passer de vie à trépas' = to die.

204,18 Objections by a church official to a window display of Balzac's books, which were on the Index, led to street parades in the author's honour similar to those on the holiday of Saint-Jean Baptiste.

CHAPTER FIVE: FURTHER DOWNSTREAM

214,39 'Dégoutent' is a collage of 'dégoûtent' (disgust) and 'dégouttent' (drip down).

218,34 occulte rebondi
 fais Z sur un petit rond taudis
 petite épingle de bois sur fil-émane

occulte télé-rebondi
 urnifié éléazade
 orbionque
 et la sainte chrinque
 vain à feindre des pourpasses pour mordre
 désordre alchimique
 du rire

 grotesque et occulte rebondi.

219,21 tu lins
tu long-lasses
 bonnasse
 ichon mioum
 fiesque insipart
 satisfait uric
 à long
 bon salon

<div style="text-align:center">

sarlafilique

bon cabar

</div>

à fond fiac

<div style="padding-left:2em">tabac calot</div>

iche urnifique

<div style="padding-left:2em">Urnifiboncabale</div>

<div style="padding-left:2em">marnac éfer</div>

<div style="padding-left:3em">lubifibon</div>

CALOT calot lambin

<div style="padding-left:2em">lampion alin</div>

calot lamber

<div style="padding-left:3em">cherche à chunifier</div>

<div style="text-align:center">le cher monçe</div>

<div style="text-align:center">épars.</div>

224,29 Breton and Eluard published *L'Immaculée Conception*, a seminal surrealist work, in in 1924.

228,3 Le Perchoir d'Haïti is a Montreal bar; 'Calibre' is a pastiche of 'Charibde' and 'Scylla' from the *Odyssey*; read 'Hébert' (no relation) for 'Duval' (Jacques Hébert wrote a celebrated book on the Coffin Affair); 'Ane' should read 'Anne' – 'âne' = 'donkey'; the French for 'escapee from ennui' is 'l'évadé de l'ennui,' echoing the title of André Langevin's novel *L'Evadé de la nuit*; 'Oquin' puns on 'aucun' (= 'no one') and echoes 'Aquin' (Hubert), a celebrated Quebec novelist.

233,22 Leiris was an early surrealist writer and ethnologist who became intensely involved in his own private mythologies.

235,22 'Lie' in the French is 'mensonge,' a pun on 'mon songe' = my dream.

239,20 Gatien as well as Paul-Marie Lapointe, Michel as well as Hector de Saint-Denys Garneau

239,35 'Pétanque' is a form of lawn bowling; the implication is that Bellefleur is bourgeois and over the hill.

239,37 Jean Gauguet-Larouche, born 1935, a poet and sculptor

240,4 Elsa was Aragon's wife; Aragon's romantic side is being criticized here. Also an echo of 'Napoléon à Elba.'

241,18 The French 'intellisible' unites 'intelligible' and 'lisible'; hence 'intelligible' and 'legible' = 'intellegible.'

244,27 The fable is *Les deux rats, le renard et l'œuf*; the proverb is 'Qui vole un œuf vole un bœuf.'

245,12 The 'Nénuphar' collection is published by Fides and includes only Quebec classics.

247,9 The French 'semer' means both 'to lose' and 'to sow.'

247,18 The French 'apaches' = 'Apaches' and 'bandits.'

249,10 'Art Brut' is a general category covering the art of primitives, children, and madmen.

254,28 *L'Ecume des jours* and *L'Histoire de l'œil* were written by Boris Vian and Georges Bataille respectively.

255,27 The following phrases are in English in the original: 'nailed upon the cross,' 'ghosts and graveyard rubbings charcoal,' 'all the way home.'

256,1 'Only eye' in the French is 'seul œil,' punning on 'soleil' = 'sun.'

256,14 The following passages are in English in the original: 'father,' 'talisman ... dearnick,' 'yo ... catacomb.'

257,6 je verse ma voix dans
 tes oreilles comme un autre là-bas de la
 poudre dans le canon de son fusil
 pour mieux t'entendre armer ta bouche de
 paroles et de cris à pouvoir
 d'obus bombes ou balles obus bombes.

257,33 'Toulmonde' = 'tout le monde' = 'everybody'

Author's Notes

INTRODUCTION

1 Ernest Gagnon, 'Refus global,' *Relations*, Oct. 1948, p 292
2 Jacques Maritain, *L'Intuition créatrice en art et en poésie* 79
3 André Breton, 'Position politique de l'art d'aujourd'hui' in *Manifestes du surréalisme*, Ed. Pauvert 271
4 *Ibid.* 272
5 The redefinition of automatism from a materialist perspective using non-representational and mechanical Quebec automatist works is the subject of a doctoral thesis by Marcel Saint-Pierre.
6 Breton, 'Position politique' 251
7 A study undertaken by Jean Ethier-Blais, François-Marc Gagnon, Guy Robert, and Bernard Teyssèdre. See bibliography.
8 Albert Camus, *L'Homme révolté*, in *Essais* 430. Cf. p 662.

CHAPTER ONE: PRECURSORS

1 Gilbert Langevin, 'Place au poème,' *Quoi* 1 (1966) 50-1
2 As Marcel Jean (*Histoire de la peinture surréaliste* 9-114) and Patrick Waldberg (*Le Surréalisme* 14-54) have noted, the issue is not sources but precursors: 'In Quebec, as elsewhere, though perhaps more laboriously than elsewhere, modernity "worked over" the literature and signs of this process can be detected in the writings of an Octave Crémazie or an Emile Nelligan.' (André Laude, *Nouvelles littéraires*, 19 Jan. 1978)
3 André Breton, 'Introduction,' in Achim von Arnim, *Contes bizarres* 11-12; reprinted in Breton's *Point du jour* 125
4 Cf. the chapters on Alfred Maury and Pierre Janet in *Le Surréalisme désocculté* by Bernard-Paul Robert 47-128.
5 Philippe Aubert de Gaspé *fils*, *L'Influence d'un livre* 36
6 *Ibid.* 13

7 *Ibid.* 61
8 *Ibid.* 13 n1
9 *Ibid.* 67-9
10 Cf. Luc Lacourcière, 'Philippe Aubert de Gaspé *fils*,' *Livres et auteurs canadiens 1964* 153.
11 Jean-Paul Tremblay, *A la recherche de Napoléon Aubin* 23, 24, 156
12 *Le Fantasque* defended the second rebellion (1838) and the publisher of the newspaper was thrown in prison along with the printer (cf. Jules Fournier, *Anthologie des poètes canadiens* 37 [1920 ed.]).
13 Joseph Lenoir (pseud. Rolland), 'Le Génie des forêts,' *La Minerve*, 4 Jan. 1844, in John Hare, *Anthologie de la poésie québécoise du XIXᵉ siècle (1790-1890)* (Montreal: Hurtubise / HMH 1979) 170-2
14 Lenoir, 'L'Esprit du rivage,' *L'Avenir*, 30 Mar. 1850, p 1 and 'Le Roi des aulnes,' in Casimir Hébert, *Poèmes épars de Joseph Lenoir-Rolland*, 2nd ed. (Montreal: Malchelosse 1916) 63-4
15 Lenoir, 'La Légende de la fille aux yeux noirs,' *L'Avenir*, 20 May 1848, p 1; in Hare, *Anthologie de la poésie québécoise ...* 178
16 Pierre Caminade, *Image et métaphore* 32-3; cf. pp 20-1, 120-6.
17 Lenoir, 'Mil huit cent quarante neuf,' *L'Avenir*, 26 June 1849, p 2, c. 4
18 Lenoir, 'Adresse du jour de l'an,' *L'Avenir*, 3 Jan. 1850, p 1; in Hare, *Anthologie de la poésie québécoise ...* 180
19 Octave Crémazie, letter to l'abbé Casgrain, 29 Jan. 1867, in *Œuvres complètes* 57; cf. pp 25-6.
20 Crémazie, 'Promenade de trois morts,' *ibid.* 204
21 *Ibid.* 210; the Condemine edition reads 'ta bière et ton suaire.'
22 Harry Bernard, *Essais critiques* 8-11
23 Crémazie, letter to l'abbé Casgrain, 29 Jan. 1867; in *Œuvres complètes* 45. In Quebec City, Crémazie had in his possession a copy of *The Narrative of Arthur Gordon Pym* published in Paris in 1858.
24 Crémazie, *Œuvres complètes* 48-9. The preface notes that the poem 'made the mistake of appearing after Théophile Gautier's *Comédie de la mort* ... That is to say, too late' (*ibid.* 58-9). Emile Chartier passed similar judgment on it: 'From 1862 to 1864, between the ages of 35 and 37, Crémazie, depressed by his misfortunes, became the poet of the Horrible. During this period, he published the unfinished poem *Les Trois morts*, inspired by Théophile Gautier's *Comédie de la mort*.' (Emile Chartier, 'Octave Crémazie,' *Revue trimestrielle canadienne*, Dec. 1927, vol. 13, no 52, p 379) See also G. Marcotte, *Une Littérature qui se fait* 91.
25 Luc Lacourcière, 'Introduction,' Emile Nelligan, *Poésies complètes* 15
26 *Ibid.* 302-4; cf. Paul Wyczynski, *Emile Nelligan: sources et originalité de son œuvre* 211-12.
27 Wyczynski, *Emile Nelligan* 208-9
28 Lacourcière, in Emile Nelligan, *Poésies complètes* 252, 322
29 Nelligan, 'Trio d'Haridot,' *La Barre du jour*, no 16, Oct.-Dec. 1968, p 734
30 Cf. Wyczynski, *Emile Nelligan* 52.
31 René Major, 'Le logogriphe obsessionnel,' *Interprétation*, vol. 2, no 1, Jan.-Mar. 1968, p 6. On the 'néologismes' of Nelligan, see Jacques Michon, 'La poétique de Nelligan,' *Revue des sciences humaines* (Lille), no 173, 1979, vol. 1, pp 25-35 and André G. Bourassa, 'Crémazie et Nelligan au pied de la lettre,' in *Crémazie et Nelligan* (Montreal: Fides 1981) 145-51.
32 Nelligan, *Poésies complètes* 253

33 *Ibid.* 266
34 *Ibid.* 278. A ghost of the demiurge making 'something out of nothing' appears in an unpublished poem sent to his guardian, Bona Major:
 Fate wishes that I
 write verses about nothing
 and in order to write them well
 that nothing should give rise to something.
35 *Ibid.* 266
36 Paul-Marie Lapointe, 'Tentation ivresse,' *Le Vierge incendié* (Montreal: Mithra-mythe 1948) 59; in *Le Réel absolu* 73
37 Quoted by Marcel Jean, *Histoire de la peinture surréaliste* 11
38 Paul-Emile Borduas, 'Manières de goûter une œuvre d'art,' *Amérique française*, Jan. 1943; see also Paul-Emile Borduas, *Ecrits / Writings 1942-1958* 33-4. Fernand Leduc also found himself influenced by the impressionists: 'Révolution-évolution, dix ans de microchromies,' *Ateliers*, vol. 8, no 3, Apr.-May 1980, p 2, c. 1.
39 Jean Leymarie, *L'Impressionisme*, vol. 2, p 83
40 Alfred Garneau, 'La Jeune baigneuse,' *Poésies* 141-4; in Hare, *Anthologie de la poésie québécoise* ... 231-3
41 Garneau, 'Pensée de novembre,' *Poésies* 193
42 Garneau, 'Les Lilas (ou les mois de mai),' *Poésies* 206-8
43 Quoted by André Lagarde and Laurent Michard, *XIX^e siècle* 429
44 Louvigny de Montigny, 'Je vous aime,' in *Les Boules de neige* 16-17
45 *Ibid.* 4
46 *Ibid.* 13-14. Cf. also p 6: 'This mist enveloping Nature lends to the landscape a nuance ... a nebulous quality ... a melancholy ... Nature powders herself with sun after the rain.'
47 de Montigny, *La Gloire*, in Géo. H. Robert, *L'Annuaire théâtral* (1908-9) 204-5. The following lines give some idea of criticism at the time:
 '[Tolstoy], along with Dostoyevsky and Melchior de Voguë, is one of the authors partaking in France's spiritual renaissance. And because he is a spiritual person, he can be forgiven many things.
 M. Henry Bataille, who preaches immorality and adultery to the French in dramas which defy common sense and reality, has adapted Tolstoy's vigorous novel for the stage. M. Henry Bataille belongs to that group of artists who are leading France into the abyss to the sound of trumpets and the sighing of flutes ... Despite our French author's craft and his use of dramatic devices, this is a novel which seems to us to forfeit a great deal just to be in the limelight.' (Marcel Henry, *Le Théâtre à Montréal: Propos d'un huron canadien* [Paris: Henri Falque Ed. 1911] 158)
48 Joe Dupuis, 'Un Inventeur du Québec a raté la célébrité,' *La Presse*, 7 Mar. 1970, p 81
49 Cf. Marcel Jean (*Histoire de la peinture surréaliste* 16, 19) on the influence of photography and Doctor Marey's freeze-frame technique on Marcel Duchamp.
50 Apollinaire, 'Les Fenêtres,' *Calligrammes* 13
51 Claude Gauvreau, *Dix-sept lettres à un fantôme*, letter of 16 Feb. 1950, p 32, unpublished
52 Georges Malet, 'L'Ecole futuriste – Les Nouvelles règles littéraires,' *Le Devoir*, 17 Aug. 1912, p 4
53 'Un Echantillon de futurisme,' *Le Devoir*, 7 Sept. 1912, p 4
54 *Ibid.*
55 'Littérature futuriste,' *Le Devoir*, 14 Sept. 1912, p 4, c. 4

56 See Jules Fournier, *Anthologie des poètes canadiens* (1920) 270.
57 Quoted by Guy Delahaye, *'Mignonne allons voir si la rose'... est sans épines*, appendix, unpaginated
58 *Ibid.*
59 *Ibid.*
60 Camille Roy, 'La Littérature qui se fait,' in *Manuel d'histoire de la littérature canadienne-française* 100
61 Delahaye, *Mignonne* xxv
62 Delahaye, *Les Phases; Tryptiques* [sic] 125; completed in *Mignonne* 19-20: 'Incolore, inodore, insipide'
63 *Mignonne* viii
64 Cf. A. Breton, 'Genèse et perspective artistique du surréalisme' (1941), in *Le Surréalisme et la peinture* 58.
65 *391*, no 12, Mar. 1920; Cf. Jean, *Histoire de la peinture surréaliste* 82.
66 Delahaye, *Mignonne* xxiv. According to Maurice Lemire, Guy Delahaye 'knew the occultists well, Geoffroy Saint-Hilaire in particular.' (*Dictionnaire des œuvres littéraires du Québec*, vol. 2, p xxxix)
67 Delahaye, *Mignonne* xxxii
68 *Ibid.* xxxiii
69 *Ibid.* xxxiv
70 *Ibid.* 44; cf. Paul Dumas 'Un médecin psychiatre qui avait été poète: Guillaume Lahaise et son double, Guy Delahaye,' *L'Union médicale du Canada*, vol. 100, Feb. 1971, p 325, c. 1.
71 Delahaye, *ibid.* 34 (1910). On surrealism and black comedy, see Gérard Durozoi and Bernard Lecherbonnier, *Le Surréalisme* 209-15.
72 Delahaye, *Mignonne* xxvii, quoting, at the end, a commentary by Albert Lozeau which appeared in *Le Devoir*, 19 Apr. 1910; cf. Marcel Dugas, *Littérature canadienne: Aperçus* 47. An error in the first edition of *Surréalisme et littérature québécoise* gives the impression that the entire piece is by Lozeau; the *Anthologie de la littérature québécoise* is therefore incorrect in attributing the entire text to Lozeau rather than just the last part of the sentence (p 247).
73 Dugas, *ibid.* 45
74 Delahaye, *Mignonne* xxix
75 Patrick Waldberg, *Le Surréalisme* 5, and Jean, *Histoire de la peinture surréaliste* 25, 34
76 *Fernand Seguin rencontre Louis Aragon* 49
77 Delahaye, 'La Douloureuse prière qu'il ne faut pas exaucer,' *L'Etudiant*, vol. 4, no 4, 31 Dec. 1914, p 11
78 Dugas, *Paroles en liberté* 125-6
79 Alain Grandbois, 'Guy Delahaye brûla trop tôt ce qu'il avait si tôt adoré,' *Le Petit Journal*, 20 Oct. 1964. See also Jeanne Dansereau, 'Ses amis s'appelaient Nelligan, Paul Morin et Osias [sic] Leduc,' *La Presse*, 5 Oct. 1968, p 29, c. 1-6.
80 Delahaye, *Mignonne* 30
81 Paul-Emile Borduas, 'Lettres à Gilles Corbeil,' *Arts et pensée*, vol. 3, no 18, July-Aug. 1954, p 178
82 W. Kaye Lamb, 'Empress to the Orient,' *The British Columbia Historical Quarterly*, Jan. 1940, pp 100-1
83 'Programme de l'Esprit nouveau,' *L'Esprit nouveau*, no 1, Oct. 1920
84 Le Corbusier-Saugnier, 'Des Yeux qui ne voient pas ... Les Paquebots,' *L'Esprit nouveau*, no 8, p 855
85 Le Corbusier-Saugnier, 'Trois rappels à MM. les architectes – Premier rappel: le vol-

ume,' *ibid.* 95. Wilfrid Corbeil, a friend of Borduas, attributes this comment about the grain elevators to Maurice Denis; this could mean that Borduas and Denis discussed Le Corbusier's ideas. (Cf. Wilfrid Corbeil, 'Le Symbolisme dans l'art chrétien: respect de la matière et création des formes,' *Les Carnets victoriens*, Apr. 1954, pp 131, 136-7.)

86 Sir William Van Horne himself designed the flag for the Empresses, spurning the obsolete laws of heraldic science and having them sport instead a red and white six-squared chequerboard (George Musk, *Canadian Pacific Afloat: 1883-1968* 3). He also decided how the vessels should be built (Lamb, 'Empress to the Orient' 31), influenced perhaps by the lines of the ice-breakers in the new Vickers shipyard which opened in Montreal in 1910 (J.D. Scott, *Vickers: A History* [London: Weidenfeld and Nicolson 1962] 58-9). Van Horne had a clean prow replace the romantic stems decorated with a siren's bosom which were so dangerous in icy weather and which still adorned his first ships (Lamb, 'Empress to the Orient' 32).

87 Cf. Jauran (Rodolphe de Repentigny) and the manifesto of the plasticists at the Echouerie, 10 Feb. 1954, to be discussed later. The exhibition 'Five Centuries of Dutch Art' in Mar. 1944 at the Museum of Fine Art introduced Mondrian to the Montreal public. It is well known that Tousignant, Molinari, and Fernande Saint-Martin were interested in him (cf. Guido Molinari, 'Huit dessins de Claude Tousignant,' *Situations*, vol. 1, no 7, Sept. 1959, pp 52-3; Fernande Saint-Martin, 'Piet Mondrian ou le nouvel espace abstrait,' in *Structure de l'espace pictural – Essai* 83ff.).

88 Cf. Jean, *Histoire de la peinture surréaliste* 26.

89 28 May 1943: lecture at the Montreal Ermitage followed by the film 'Le Ballet Mécanique' (1924); (cf. Normand Thériault, 'Fernand Léger – Témoin de son temps, Témoin de notre lieu,' *La Presse*, 28 Feb. 1970, p 46; cf. also Maurice Gagnon, *Fernand Léger* [Montreal: L'Arbre 1945]). Léger stayed with Alfred Pellan and Maurice Gagnon, and visited Quebec again in 1945.

90 Camille Ducharme, 'Il y a vingt ans,' *Les Idées*, vol. 9, no 1, Jan. 1939, pp 91-2

91 *Le Devoir*, 27 Jan. 1916, p 7. Note that on 12 Jan. the public was put on guard against symbolism (p 3).

92 'Deuxième récital d'Ornstein,' *Le Devoir*, 16 Feb. 1916, p 2, c. 6. But pianist Léo-Paul Morin's interest in 'l'esprit nouveau' and in Debussy and Ravel continued to frighten the academics. Cf. Marcel Dugas, *Approches* 26-7.

93 Marcel Duchamp, 'Anemic cinéma' (1924); in *Marchand du sel: Écrits de Marcel Duchamp* 99

94 Pierre de Grandpré, *Littérature française du Québec*, vol. 2, p 67

95 Auguste Viatte, *Histoire littéraire de l'Amérique française* 183

96 Grandpré, *Littérature française du Québec*, vol. 2, p 80. With an unfortunate typo which made the quotation contradictory ('sois cohérent' instead of 'sois incohérent'); the typo is reproduced in *Anthologie de la littérature québécoise* 202.

97 Dugas, *Versions* 16

98 Dugas, *Confins* 113

99 Dugas, *Littérature canadienne – Aperçus* 109. *Le Nigog* appeared in 1918, not 1919.

100 *Entr'acte*, by Francis Picabia and René Clair, appeared in 1924, *Un chien andalou* by Buñuel in 1928.

101 Marcel Dugas, 'Un homme d'ordre,' in *Psyché au cinéma*, pp 7, 23, 31, 44, 69

102 *Ibid.* 14

103 *Ibid.* 20-1

104 Robert de Roquebrune was one of the few artists and writers to meet André Breton during his stay in Gaspé in 1944. Since Roquebrune's novel *Les Habits rouges*

had had the 'privilege' of appearing in Maurras' *L'Action française* thanks to its adulatory evocation of the monarchist regime, it probably was not mentioned in front of Breton, who had just escaped from Pétain's France.

105 Gérard Morisset, *La Peinture traditionnelle au Canada français* 200-1. Cf. Robert de Roquebrune, *Cherchant mes souvenirs* 94-7.

106 This was the case, for example, regarding the kind of music discussed in *Le Nigog*: '(Léo-Paul) Morin has introduced us to Debussy and Ravel. This pianist who used to live in the Latin Quarter took us back to the ambience of the Left Bank.' (Dugas, *Cherchant mes souvenirs* 96.) See, for example, what Morin had to say in 1935 about Erik Satie and the 'six' in Léo-Paul Morin, *Musique* 137. The huge scandal in the American press in 1917 over 'Fountain,' Duchamp's latest 'ready-made' (a urinal signed on the back with the name of the manufacturer Richard Mutt) was not duplicated in the Canadian press.

107 Paul Eluard, 'La Nuit est à une dimension,' *Œuvres complètes*, vol. 1, p 932

108 Auguste Viatte, *Histoire littéraire de l'Amérique française* 150-1

109 Dugas, *Littérature canadienne: Aperçus* 100-1

110 Jean-Aubert Loranger, 'Intérieur,' in *Poëmes* 105-6; quoted in *Les Atmosphères*, followed by *Poëmes* (1970) 169-70

111 Apollinaire, *Calligrammes* 26

112 Jean-Aubert Loranger, 'En voyage,' *Poëmes* 106. Reprinted in *Les Atmosphères* and *Poëmes* 170-1

113 Alfred DesRochers, 'La Tentation surréaliste,' *Liberté*, no 15-16, p 627. In *La Poésie québécoise des origines à nos jours* (1981), Pierre Nepveu and Laurent Mailhot are right to resurrect Arthur Guindon in the role of poet (pp 25, 127). As an article in *Vie des arts* has suggested, there are surrealist elements in his paintings as well as in the poems accompanying them (Arthur Guindon, *En mocassins*, 1920), especially from a formal perspective. Guindon's poems and paintings are intended to be an expression of Indian legends. He is concerned not so much with a state of mind but with the reading of a state of mind, and this is worth noting: 'Not knowing their speech, I can make use of necessarily imperfect translations, analogous perhaps to gross imitations of mocassins ... Following in the footsteps of Sagard, La Potherie, Lafiteau, all the old chroniclers as well as the more recent archivists, I venture into the virgin forest of the savage soul. I expect to find a great deal of shadow and grandiose disorder, as well as vistas opening on the blue; I won't complain that it's all a waste – dubious silhouettes also have their charm. Nevertheless, I will make a confession, one imposed upon me by the poetic and literary works comprising my modest course of study, namely that I have drawn from precious and abundant sources with too small a cup.' (*En mocassins* 4)

114 Jules Fournier, *Anthologie des poètes canadiens* (1933 ed.) 241. Louis Dantin talked about the 'futurism' in *Les Atmosphères* (see *Poètes de l'Amérique française* [1928] 137-9).

115 Brunet discusses unanimism at length, even though the term in its strictest sense only applied to the first collection, *Les Atmosphères* (Berthelot Brunet, '*Poèmes*, de Jean Loranger,' *Le Mâtin*, 22 Apr. 1922, p 2). See also Berthelot Brunet, *Histoire de la littérature canadienne-française* and *Portraits d'écrivains* (1970) 215-21.

116 Gilles Hénault recalls that it was through Jean-Aubert Loranger that he discovered Saint-John Perse, whose *Anabase* appeared in 1924, the same year as the *Manifeste du surréalisme*.

117 'Sur les Rocheuses,' *La Revue populaire*, Montreal, vol. 19, no 6, June 1926, p 6 and 'Ode processionnelle à Notre-Dame de Bonsecours,' *La Revue populaire*, Oct. 1927, p 6. See also Bernadette Guilmette, 'Les Textes retrouvés de Jean-Aubert Loran-

ger,' *Bulletin du Centre de recherche en civilisation canadienne-française* (Université d'Ottawa), no 15, Dec. 1977, pp 6-7.

118 The two poems 'saved' by Brunet are: 'Veilleurs de feux,' quoted in 'René Chopin, habile homme et poète narquois,' *Le Canada*, 31 Oct. 1933, pp 2-3 (reprinted in *Histoire de la littérature canadienne-française* and *Portraits d'écrivains* 206), and 'Incantation à la pluie,' quoted in 'Ma petite anthologie – Incantation à la pluie,' *La Nation*, 29 July 1937, p 3 (see also Bernadette Guilmette, 'Les Textes retrouvés de Jean-Aubert Loranger' 10).

119 'But in the next century on the Grand Banks, 300 ships wainscotted in Colombian pine will divvy up the horizon; scrap barges will tug at their cables. (At low tide, the cliff grew and the forest on the peninsula will thrust high its wooden spars.) The time it will take this dead wood to rot is the Age of Wood, the age of timeless joists, the age of lintels inserted in notches of stone. The hillside during the dog days, season of low tides, only gazes at the tips of its trees. If the standing timber on the shore has not been marked, foliage lies at its feet.'

This text was not published. It had been passed on by Charles Doyon to Henri Tranquille, who then gave it to Marcel Saint-Pierre at *La Barre du jour*.

120 A fragment appears in the 1933 edition of Jules Fournier's *Anthologie des poètes canadiens* 243-4, in which *Terra nova* is described as 'a collection of short verse, psalms, odes and elegies.' See also Bernadette Guilmette, 'Les Textes retrouvés de Jean-Aubert Loranger' 9.

121 Philippe Soupault, *Rose des vents* (1920)

122 Alfred DesRochers, 'L'Avenir de la poésie en Canada français,' *Les Idées*, vol. 4, no 2, Aug. 1936, pp 110-11

123 *Ibid.* 111

124 DesRochers, 'La Tentation surréaliste,' *Liberté*, no 15-16, May-Aug. 1961, p 627

125 Several institutions subscribed to it, including the Jesuits' Ecole supérieure de lettres et de pédagogie. But cubist, dadaist, and surrealist periodicals of the time could not be found anywhere in Quebec, among them *Les Feuilles libres* (1918-28), *L'Œuf dur* (1921-4), *Manomètre* (1922-8), *Interventions* (1924), *Surréalisme* (1924), *La Révolution surréaliste* (Dec. 1924 ff.). However, Robert de Roquebrune does mention subscribing to the periodicals *Mercure de France, Les Marges*, and *La Nouvelle Revue française* (*Cherchant mes souvenirs* 68) and notes especially the contributions by Apollinaire, Léautaud, and Gourmont to *Mercure de France* (p 41).

126 André Gide, 1 Apr. 1920, p 480. Cf. M. Sanouillet, *Dada à Paris* 199-206.

127 *La Nouvelle Revue française*, 1 Dec. 1919, no 75, Roger Allard

128 'Pour Dada' and 'Reconnaissance à Dada,' *La Nouvelle Revue française*, 1 Aug. 1920, no 83

129 *Ibid.*, 1 Sept. 1920, no 84, pp 455-8

130 *Ibid.* 346-82; cf. also Roger Allard on Aragon's *Feu de joie*, *NRF*, 1 Apr. 1920, no 79

131 *Ibid.*, 1 Aug. 1920, no 83, p 221. Cf. Michel Sanouillet, *Dada à Paris* 204-6.

132 Alfred DesRochers, 'Le Poêle noir aux larmes d'or,' part of 'Extrait du *Retour de l'enfant prodigue* qui doit paraître bientôt,' *Les Idées*, 1935, vol. 1, no 2

133 DesRochers, 'Le Cycle du village,' in *A l'Ombre de l'Orford*. In his analysis of *L'Offrande aux vierges folles*, Louis Dantin says he is pleased the poet liberated himself from 'isms and ... Cocteau.' (*Poètes de l'Amérique française*, II° series [1934] 101-2)

134 DesRochers, 'Notes sur la poésie moderne,' *Liberté*,' Nov.-Dec. 1964, vol. 6, p 419

135 'When I was ten or fifteen years old at least, I entertained ideas I no longer hold today on the subject of the pseudo-parisians.' (DesRochers, letter to Marcel Dugas, 5 Mar. 1943, *Etudes françaises*, vol. 7, no 3, p 321)

136 Armand Praviel, 'Un Poète d'aujourd'hui – Louis Le Cardonnel,' *Le Devoir*, 22 Mar. 1924, p 7, c. 2; extract from *Le Correspondant*

137 'Au pays de l'incohérence' (extracts and commentaries from an article with the same title by Paul Bernard in *Etudes*), *Le Devoir*, 23 Aug. 1924, p 7, c. 4-5

138 André Breton, 'Pour un art révolutionnaire indépendant,' *La Clé des champs* 43 (1938)

139 Robert Charbonneau, 'Jeunesse et révolution,' *La Relève*, 2nd series, volume 1, Sept. 1935, p 4. The quotations from Breton and Charbonneau are clearly contradictory.

140 On Pellan, cf. *infra*, chapter 2 *et seq.*

141 Harry Bernard, 'L'Idée baudelairienne au Canada,' *Le Canada français*, May 1929, vol. 16. See also *Essais critiques* 7-24.

142 Cf., for example, the book reviews by P.S. and H. Gaillard de Champris in *Le Canada français*, Sept. 1921, vol. 7, no 6 and Jan. 1928, vol. 15, no 5, p 371.

143 H. Gaillard de Champris, 'Un bilan du xixe siècle,' *Le Canada français*, May 1930, vol. 17, no 9, p 627

144 Lionel Groulx, in *L'Action française*, Jan. 1921, vol. 5, no 1, p 28

145 *Ibid.*

146 *Ibid.* 28-9

147 Maxime Alexandre, *Mémoires d'un surréaliste* 30

148 Groulx, *L'Action française* 30

149 'The dictator began his series of reforms by ordering that the crucifix and the king's portrait, which had disappeared long before because of anti-religious and anti-monarchist sentiments, be reinstated in all the public schools.' (Don Paolo Agosto, 'Pages romaines – Le Fascisme,' *Le Canada français*, Mar. 1923, p 105); 'This is a spiritual concept: fascist man is an individual who, by denying himself, by sacrificing his own special interest, achieves that completely spiritual state which validates him as a man.' (G.-A. Brigidi, 'Ethique du fascisme et son application pratique,' *Revue trimestrielle canadienne*, vol. 21, no 83, Sept. 1935, p 233). Cf. Richard A. Jones, 'L'Action catholique, 1920-1921,' in Fernand Dumont *et al.*, *Idéologies au Canada français, 1900-1929*, esp. 332-44, 'Trois mythes.' Brigidi was the Italian consul in Montreal.

150 Groulx, *L'Action canadienne-française*, Jan. 1928, vol. 13, no 3

151 Cf. Mason Wade, *Les Canadiens français* 328 (Wade, speaking of Quebec nationalism, is nevertheless wrong to ignore the Orangemen and white Anglo-Saxon protestants). On the Barrès case, cf. Paul Eluard, *Œuvres complètes*, vol. 1, p lxii and Michel Sanouillet, *Dada à Paris* 261-2. On the surrealists' battle with Maurras, cf. Maurice Nadeau, *Histoire du surréalisme* 69, 82-3, 159-64. On their battles with Pétain, cf. Jean-Louis Bédouin, *Vingt ans de surréalisme* 19-21, 29-32.

152 Jacques Brassier, *L'Action nationale*, vol. 3, Jan. 1934, pp 53-4. Brassier was the pseudonym of Lionel Groulx.

153 Arthur Laurendeau, *L'Action nationale*, May 1934, vol. 3, p 235, note

154 Lionel Groulx, 'L'Education nationale,' *L'Action nationale*, Sept. 1934, vol. 4, p 61

155 *Ibid.*, Nov. 1934, pp 175-6

156 Jean-Louis Gagnon, 'Politique,' *Vivre*, 16 Apr. 1935, p 2

157 Cf. Jean-Louis Gagnon, 'Lettre à Charbonneau,' *Les Idées*, Jan. 1936, pp 43-54; Robert Charbonneau, 'Réponse à Jean-Louis Gagnon,' *La Relève*, vol. 2, no 6, pp 163-5; Jean-Louis Gagnon, 'Deuxième lettre à Charbonneau,' *Les Idées*, Sept. 1936, vol. 4, no 3, pp 159-68; Pierre-Mackay Dansereau, 'Lettre à Robert Charbonneau,' *La Relève*, vol. 3, no 2, pp 58-62.

158 Jean-Louis Gagnon, 'Deuxième lettre à Charbonneau,' 167
159 Gagnon, 'En ce temps-là,' *Etudes françaises*, 1969, vol. 5, no 4, p 464. In an article analysing *La Relève* from a static rather than a dynamic viewpoint (cf. pp 72-3), Jacques Pelletier does not make the necessary distinctions when he says that, in retrospect, Gagnon was right in this debate (p 99). Nor is his explanation of why the corporatist solution became less attractive to *La Relève* in its final years correct (p 102). Cf. Jacques Pelletier, '*La Relève*, une idéologie des années 1930,' *Voix et images du pays V* (1972) 69-139.
160 Vol. 2, no 16, Jan. 1934. On *La Relève* and fascism, see André-J. Bélanger, *L'Apolitisme des idéologies québécoises* 167, 182-3.
161 Cf. Roger Duhamel, 'Pour un ordre nouveau,' *La Relève*, vol. 1, no 4, pp 83-4 and 'L'Ordre corporatif sous le signe du fiasco' [typo for 'fascio'], *La Relève*, vol. 1, no 8, pp 198-202.
162 Cf. André Laurendeau, 'Préliminaires à l'action nationale,' *La Relève*, vol. 2, no 1.
163 André Laurendeau, 'Introduction à la thèse de Rosenberg,' *L'Action nationale*, Sept. 1937, vol. 10, pp 14-15. André Laurendeau and the group 'Jeune Canada' were taken to task by Fernand Lacroix (cf. Fernand Lacroix, 'Le Jeune Canada parle,' *Vivre*, 16 Apr. 1935, pp 1 and 8) and Jean-Louis Gagnon, who writes: 'Le Jeune Canada' believes in evolution. *Vivre* believes in revolution ... When the changes one wishes to make in a country's constitution are illegal, logically one cannot bring them about except by illegal means. It's a waste of time trying to redress the economy when power resides precisely in that perverse economy. There is only one way to redress a nation's politics and economy: force ... One sole means: revolution. Only the people can bring about this revolution and preserve it. All that remains is to unleash popular indignation. Le Jeune Canada is wrong to remain above it all.' (Jean-Louis Gagnon, 'Le Jeune Canada,' *Vivre*, 26 Apr. 1935).
164 Pierre Savard, 'Une lettre de Guy Frégault, collégien' (Sept. 1936), *Bulletin du Centre de recherche en civilisation canadienne-française*, vol. 20, Apr. 1980, pp 1-4
165 Marcel Thiry, 'Toi qui pâlis au nom de Vancouver' (1924) in *Toi qui pâlis au nom de Vancouver – Œuvres poétiques 1924-1954* 35
166 Cf. the chapters 'Noonday of Ultramontanism 1867-1896' and 'Catching Up with the Modern Age' in Denis Monière, *Ideologies in Quebec; The Historical Development* 146-76, 228-86
167 Antonio Desjardins, 'Méditation philosophique,' *Crépuscules* 185. Images like 'le métro bleu du temps' (p 138) or 'triste ... comme la fumée de ce long train qui siffle' (p 147) and especially the title of one of the poems, 'Fantaisie sur *Alcools* de Guillaume Apollinaire' (p 89), reveal a certain familiarity with futurist and/or cubist practices. The characters in 'La lettre, fantaisie triste en un acte' (pp 67-84) recall those of Picasso in *Le Désir attrapé par la queue*, viz. the reverie of varnish on furniture, a silver sugar bowl, the blinds, the carpet, the eyes of logs closing sleepily in the fireplace, the hanging lamp, the sleeping cat's smile, silence turned emerald which wanders, sadness like a shadow, etc.
168 *Ibid.* 12. Desjardins 'translated into French verse all of Edgar Allan Poe's poetry' (André Gaulin, '*Crépuscules*,' in *Dictionnaire des œuvres littéraires du Québec*, vol. 2, p 307).
169 Armand Yon, 'Héliodore Fortin (1889-1934),' *Les Cahiers des Dix*, no 31, 1966, p 231
170 Pierre Geyraud, *Les Petites églises de Paris* 70
171 Maurice Nadeau, *Histoire du surréalisme* 102

172 Prospectus, 1938; quoted by Yon, 'Héliodore Fortin' 233
173 Quoted by Yon, *ibid.* 238
174 Cf. Nadeau, *Histoire du surréalisme* 112.
175 Breton, *Manifestes du surréalisme* (Ed. Pauvert) 27
176 Henri Pastoureau, 'Le Surréalisme de l'après-guerre (1946-1950),' in Henri Jones, *Le Surréalisme ignoré* 107. These objects or beings were: (1) 'Le Tigre mondain,' after Jean Ferry's story about an imaginary dressage manœuvre; (2) Falmer's 'chevelure' from *Les Chants de Maldoror* (final verse of canto iv); (3) the suspicious Héloderme; (4) Jeanne Sabrenas, the canteen woman from Jarry's novel *La Dragonne*; (5) Léonie Aubois d'Ashby, from Rimbaud's poem 'Dévotion'; (6) the secretary bird, 'beloved of Max Ernst' according to the invitation; (7) the Condylure, or 'starred mole described by ancient writers'; (8) Duchamp's 'Soigneur de gravité'; (9) Brauner's object, the 'wolf-table': a small elegant table with the head and tail of a miniature wolf attached; (10) Raymond Roussel; (11) Breton's 'Les Grands transparents'; (12) the window 'de Magna sed Apta' from Georges du Maurier's novel *Peter Ibbetson.*
177 Paul-Quintal Dubé, *L'Education poétique* 44-5
178 Jacques Ferron oversimplifies the issue when, wishing to show 'what tragic futility the sons ... of Abbé Groulx have devoted themselves to,' he includes among them without qualification this 'Saint-Denis [sic] Garneau, whose religious worries and venereal anguish only deceive fools.' (Jacques Ferron, 'Un miroir de nos misères – notre théâtre,' *La Revue socialiste*, no 5, spring 1961, p 30)
179 H. de Saint-Denys Garneau to François Rinfret, 19 Aug. 1932, in *Lettres à ses amis* 55; and to Jean Le Moyne, Jan. 1934, p 93. Cf. *Œuvres* 328.
180 Saint-Denys Garneau to Claude Hurtubise, Mar. 1934, *ibid.* 123. A text by Dom Paul Bellot, a Benedictine architect, appeared the same month in the Ecole polytechnique graduates' magazine; there is a reference here to Le Corbusier, as well as the following thoughts on art: 'It has been truly said, "realism hid reality from him, naturalism was incapable of grasping the essence of Nature"' ('L'Idéal et l'ascèse de l'art chrétien,' *Revue trimestrielle canadienne*, vol. 20, no 77, p 5). Dom Bellot rediscovered the golden section in 1910, a decade before Apollinaire's periodical and Le Corbusier (*L'Esprit nouveau*) began talking about it (cf. Nicole Tardif-Painchaud, *Dom Bellot et l'architecture religieuse* 40-3). His colleague Emile Venne recounted his life and appraised his work in the next issue ('L'Architecture religieuse canadienne,' *Revue trimestrielle*, vol. 20, no 78, June 1934, pp 181-2). Venne emphasized that this discovery had stirred the Renaissance (Pacioli, Kepler, da Vinci, Vignola) and that hence there was nothing new about it.
181 H. de Saint-Denys Garneau, in *Œuvres* 345, 355, 359, 367 (*Journal*) and pp 954, 1036-8 (*Correspondance*)
182 'Je ne puis manquer de voir du Derain, du Matisse et du Picasso.' Saint-Denys Garneau to Jean Le Moyne, Oct. 1936 (*Lettres à ses amis* 241)
183 Saint-Denys Garneau, 'Peintures françaises à la Galerie Scott,' *La Relève*, Dec. 1936, vol. 2, no 3, pp 45-50; *Œuvres* 285-6
184 Saint-Denys Garneau, 'Baigneuse,' in *Œuvres* 161
185 Saint-Denys Garneau, 'Saules,' *ibid.* 16. A poem entitled 'L'Aquarelle' leaves no doubt as to the impressionistic nature of these outdoor sketches (*ibid.*):

Is there nothing better to sing your praises fields
And you transparent trees
Leaves
And not hide the slightest ray of light

Than this clear watercolour,
Clear tulle of clear veil on paper.

186 Saint-Denys Garneau, *Œuvres* 17
187 *Ibid.* See Normand de Bellefeuille, '*Saules* de Saint-Denys Garneau: une esquisse?' *Voix et images du pays VII* (1973) 137-50.
188 Saint-Denys Garneau, *Œuvres* 18
189 Anne Hébert, 'De Saint-Denys Garneau et le paysage,' *La Nouvelle Relève*, Dec. 1944, vol. 3, no 9, p 523
190 Claude Gauvreau, 'Figure du vivant – Saint-Denys Garneau,' *Sainte-Marie*, 30 Oct. 1945, vol. 2, no 2, p 2, my emphasis
191 Saint-Denys Garneau, *Œuvres* 26
192 *Ibid.* 442
193 *Ibid.* 487
194 *Ibid.* 490
195 *Ibid.* 28-9
196 *Ibid.* 483
197 *Ibid.* 430. Cf. Gilles Marcotte, 'Saint-Denys Garneau; étude littéraire,' *Ecrits du Canada français*, vol. 3, 1957, p 205.
198 Saint-Denys Garneau, *Œuvres* 435. Cf. p 442.
199 Cf. Roland Bourneuf, *Saint-Denys Garneau et ses lectures européennes* 305.
200 Interview with Robert Elie, 19 Dec. 1969. *Hermès* was published in Brussels in 1933-5 and 1936-7; cf. Suzanne Lamy, *André Breton: Hermétisme et poésie dans 'Arcane 17'* 259.
201 Paul Lebel claims that Isabelle Rivière's writings were 'borrowed from the Evangelists, the Psalms, Pascal, Claudel, Péguy, Rivière, Breton' (Paul Lebel, 'Isabelle Rivière, *Sur le devoir d'imprévoyance*,' *Le Canada français*, Feb. 1935, vol. 22, no 6).
202 Saint-Denys Garneau to Claude Hurtubise, Aug. 1937; in *Lettres à ses amis* 279
203 Saint-Denys Garneau to Jean Le Moyne, 21 Nov. 1938, *ibid.* 391, from *La Nouvelle Revue Française*
204 Gabrielle Poulin, 'Le Surréalisme et le jeu,' *Critère*, no 3, Jan. 1971, pp 61, 63. Cf. Saint-Denys Garneau, 'Le Jeu,' in *Œuvres* 10-11.
205 Jean Le Moyne, 'De Saint-Denys Garneau,' *La Nouvelle Relève*, Dec. 1944, vol. 3, no 9, pp 514-19
206 Saint-Denys Garneau to André Laurendeau, 18 Mar. 1937, in *Lettres à ses amis* 257 and to Claude Hurtubise, Mar. 1937, *ibid.* 258
207 Maurice Hébert, 'Regards et jeux dans l'espace,' *Le Canada français*, Jan. 1939, vol. 26, no 5, pp 464-77. Cf. Saint-Denys Garneau, *Œuvres* 536, 1181.
208 Saint-Denys Garneau to Robert Elie, 6 July 1936; in *Lettres à ses amis* 275
209 Saint-Denys Garneau to Jean Le Moyne, 30 June and 7 Oct. 1938; *ibid.* 354-87
210 Saint-Denys Garneau to Jean Le Moyne, 21 Nov. 1938, *ibid.* 391; from la *Nouvelle Revue française*
211 Saint-Denys Garneau to Robert Elie and to Jean Le Moyne, 12 Apr. and 8 Nov. 1939; *ibid.* 396, 412
212 Saint-Denys Garneau, *Œuvres* 34. Cf. p 543.
213 Cf. Marcel Dugas, 'Saint-Denis [sic] Garneau,' in *Approches* 79-98.
214 Saint-Denys Garneau to Claude Hurtubise, 1938, in *Lettres à ses amis* 302
215 Saint-Denys Garneau, 'Silence'; *Œuvres* 156
216 *Ibid.* 818, 1243. Two of da Vinci's treatises published by Delagrave are mentioned: *Traité de la peinture*, 1910, by Breton and *Traité du paysage*, 1914, by Garneau. *Traité du paysage* is in fact an extract from *Traité de la peinture*.
217 Borduas enrolled in 1923, Garneau in 1924. Both left at the end of 1927.

CHAPTER TWO: FROM PAINTING TO POETRY

1 Jean Le Moyne, 'Signe de maturité dans les lettres canadiennes,' *Le Canada*, 12 Oct. 1943

2 Claude Jasmin, 'Je suis un sorcier,' *La Presse*, 14 July 1962, p 1 of the literary supplement

3 François Rozet, telephone interview with A.G.B., 26 Mar. 1970

4 Alfred Pellan addressing the poets (including Roger Soublière and Nicole Brossard) who gathered at his house after La Nuit de la poésie, 28 Mar. 1970

5 Quoted by Donald Buchanan, Introduction to the 1960 *Catalogue*

6 *Ibid.* and in Guy Robert, *Pellan, sa vie et son œuvre* 33

7 If this book had discussed impressionist painters, as Marcel Jean does in *Histoire de la peinture surréaliste* (pp 16-25), it would have been necessary to examine the work of James Wilson Morrice. John Lyman would have been mentioned too, as well as Aurèle de Foy Suzor-Côté and Rodolphe Duguay, though their work was only occasionally impressionist.

8 Paul-Emile Borduas, *Projections libérantes* 17-18

9 On the relationship between Ozias Leduc and Paul-Emile Borduas, see Paul-Emile Borduas, 'Quelques pensées sur l'œuvre d'amour et de rêve de M. Ozias Leduc' and 'Lettre à Gilles Corbeil' as well as Jean Ethier-Blais' lecture, *Ozias Leduc* (see bibliography).

10 Cf. 'Borduas, l'homme et l'œuvre,' *Etudes françaises*, vol. 8, no 3, Aug. 1972, pp 312-13. Turner erroneously gives the date of his return as Apr. 1929. The influence of Maurice Denis was also significant (cf. André Breton, *Le Surréalisme et la peinture* 362).

11 Evan H. Turner, *Paul-Emile Borduas, 1905-1960* 27

12 François-Marc Gagnon, 'Contribution à l'étude de la genèse de l'automatisme pictural chez Borduas,' *La Barre du jour*, Jan.-Aug. 1969, no 17-20, pp 217-19; Maurice Gagnon, *Peinture moderne* 107; Bernard Teyssèdre, 'Fernand Leduc, peintre et théoricien du surréalisme à Montréal,' *La Barre du jour*, *ibid.* 228 (reference to *Maldoror*), 231 (reference to *Minotaure* nos 12-13). Thérèse Renaud still has a Brazilian edition of *Maldoror* which was available at the time; Borduas' edition of 1926 had a dedication from Robert Elie.

13 In 1936, an entire issue of *Minotaure* (no 8) was devoted to the surrealist experiments on the Canary Islands; it included some decals, a tale of fantasy they inspired in Péret, and Breton's famous *Château étoilé*, for which Tenerife provided the inspiration. (Cf. Marcel Jean, *Histoire de la peinture surréaliste* 263-6.)

14 Issues 8 and 12-13 of *Minotaure* were in the library of the former Ecole du meuble. There is not much point in carrying on the debate concerning who drew Borduas' attention to *Les Chants de Maldoror* and *Le Château étoilé*. The relevant point is that there was an active circle around *La Relève* and the Ecole du meuble (Gagnon, Parizeau, Lyman, Elie, Hénault, Hertel, Dumas) even before Pellan arrived.

15 Cf. Marcel Jean, *Histoire de la peinture surréaliste* 23.

16 Quoted by Max Ernst, 'Au-delà de la peinture' (1936), in *Ecritures* 241

17 'Dali scorns the visual discoveries of Cézanne and the cubists. Instead, he employs photographic means of expression, expecting strangeness, the exquisite revelation: a telephone receiver in the middle of a desert. Also, in a violent reaction against hardness (the indigestibility of Cézanne's apple, to which he prefers the pre-Raphaelite Adam's apple, as he writes in an amusing article), he searches for the expression of unforeseeable softness. Dali, still, as well as a few young painters, is experimenting

with da Vinci's paranoiac screen.' (Paul-Emile Borduas, 'Manières de goûter une œuvre d'art' 43)

18 Marcel Jean, *Histoire de la peinture surréaliste* 208
19 Robert Elie, *Borduas* 16-17
20 *Ibid.* 22-3; cf. Paul Eluard, *Œuvres complètes*, vol. 1, pp 139-40
21 Paul-Emile Borduas, *Projections libérantes* 37-8
22 Gagnon, 'Contribution à l'étude de la genèse de l'automatisme pictural chez Borduas,' *La Barre du jour*, no 17-20, p 213
23 Claude Gauvreau, 'L'Epopée automatiste vue par un cyclope,' *ibid.* 49
24 Charles Doyon, 'L'Exposition surréaliste Borduas,' *Le Jour*, 2 May 1942, p 4, n 1
25 Paul Dumas, 'Borduas,' *Amérique française*, June-July 1946. A Quebec edition of Rimbaud's works dedicated by Dumas to Borduas with the date 16 VI 1943 was found in a used book store.
26 Dumas, 'Aspects de l'art canadien,' *Médecine de France*, no 87, 1957, p 31
27 Simone Aubry had compared Borduas with Eluard in 'A propos de *Peinture moderne*,' *La Relève*, 1941, vol. 5, no 8, p 255
28 Gauvreau, 'L'Epopée automatiste vue par un cyclope' 86
29 Claude Gauvreau to A.G.B., Dec. 1969
30 P.-E. Borduas, 'Manières de goûter une œuvre d'art,' *Amérique française*, Jan. 1943, vol. 2, no 4, pp 43-4
31 F.-M. Gagnon, 'Contribution à l'étude ...' *La Barre du jour*, nos 17-20, pp 212-19
32 Lautréamont, *Œuvres complètes* (Paris: José Corti 1961) 327
33 *Ibid.* 386. Cf. Maxime Alexandre, *Mémoires d'un surréaliste* 100.
34 Cf. Salvador Dali, *La Femme visible* (Paris: Ed. Surréaliste 1930).
35 Cf. Gauvreau, 'L'Epopée automatiste vue par un cyclope' 56. Guy Robert has given an explanation of why Borduas said 'The gouaches of 1942, which we thought were surrealist, were really only cubist' (*Le Devoir*, 9 June 1956). According to Robert, they are more experiments in pictorial space than in automatism (cf. Robert, *Borduas* 104). But this does not prevent one from seeing in these canvases indications that the painters had read Lautréamont, as well as a certain automatism perhaps more 'literary' than 'visual.'
36 Eliane Houghton Brunn, 'La volonté du cubisme,' *Amérique française*, Aug. 1942, vol. 1, no 7; for cubism's relationship to surrealism, see Brunn, pp 24 and 28.
37 Pellan and Borduas are mentioned in Marcel Parizeau, 'Peinture canadienne d'aujourd'hui,' *Amérique française*, Sept. 1942, vol. 2, no 1, pp 8-18
38 François Hertel, 'Plaidoyer en faveur de l'art abstrait,' *Amérique française*, Nov. 1942, p 14
39 Paul-Emile Borduas, 'Manières de goûter une œuvre d'art.' Cf. 'Automatic painting ... would allow the visual expression of images and memories assimilated by the artist and ... would reveal the sum of his physical and intellectual being.' (*Amérique française*, Feb. 1944, vol. 3, no 19, pp 35-48)
40 Antoine Bon, 'Alfred Pellan,' *Revista Franco-Brasileira*, reprinted in *Amérique française*, Feb. 1944, vol. 3, no 19, pp 35-48
41 See Maurice Gagnon, *Peinture moderne*. For Pellan and surrealism see p 101; for Borduas and surrealism, see pp 101 and 106-7, and for surrealism, see pp 69, 71, 99-109.
42 Charles Doyon, 'Borduas, peintre surréaliste,' *Le Jour*, 9 Oct. 1943
43 Bernard Teyssèdre, 'Fernand Leduc – peintre et théoricien du surréalisme à Montréal,' *La Barre du jour*, nos 17-20, p 228
44 *Ibid.* 250
45 Marie-Alain Couturier, 'Propos à de jeunes artistes canadiens,' *Le Jour*, 8 May 1943. Reprinted in M.-A. Couturier, *Chroniques* 140-1, where the lecture is dated 1 May.

Even H. Turner gives the date as 30 Apr. (*Paul-Emile Borduas, 1905-1960* 28). Cf. also *La Presse*, 1 May 1943, for an article and photographs of the group.

46 The case has not been overstated. For example, Borduas' library contained a copy of the Communist manifesto which belonged to Rémi-Paul Forgues, whose name is inscribed on the title-page. This work was read and discussed by the automatists.

47 Letter from André Breton to Fernand Leduc, 17 Sept. 1943; quoted in Teyssèdre, 'Fernand Leduc – peintre et théoricien du surréalisme à Montréal' 235-6

48 Letter from Fernand Leduc to André Breton, 5 Oct. 1943, quoted in Teyssèdre, *ibid.* 236

49 'Through *Triple V* we discovered Pleasure, the truth, strange and exciting. The periodical changed our plans. We read Breton, Pierre Mabille, the surrealists.' (Françoise Sullivan, unpublished letter to Christiane Dubreuil-Lebrun, Mar. 1968)

50 André Breton, 'Où en est le Surréalisme?,' lecture given on 'Revue des arts et des lettres,' Radio-Canada. Cf. the extract in *La Semaine à Radio-Canada*, 1-7 Feb. 1953, vol. 3, no 17. The quotation is taken from the complete text filed with the Borduas Papers, no 110 in Théberge's classification, National Gallery of Canada, p 1.

51 Paul Dumas, *Jean Dallaire – Rétrospective* 9. Dallaire, a surrealist whenever the fancy took him, spent the war in a concentration camp.

52 Robert de Roquebrune, *Cherchant mes souvenirs* 100

53 Interviews with Louis-Marcel Raymond, Oct.-Nov. 1969

54 Unpublished letter from Louis-Marcel Raymond to Yvan Goll, 11 Mar. 1944

55 'I spent two hours with Breton on my last day in New York. I liked him very much and we agreed immediately on all sorts of things. I thought he would be a sort of grand inquisitor of literature, but instead I found a gentle giant who was eminently lovable. Nevertheless, I can see how, after talking to him for a while, one could easily begin to disagree with him. But I like him just the same.' (unpublished letter from Louis-Marcel Raymond to Yvan Goll, 11 Mar. 1944)

56 Breton, *Le Surréalisme et la peinture* 219

57 Interviews between Louis-Marcel Raymond and A.G.B., Oct.-Nov. 1969

58 L.-M. Raymond, *Un Canadien à Paris* 47-9 (letter of 24 Oct. 1945)

59 This took place the following year, 7 June 1946. Raymond refused to allow the *NRF* to republish *Le Jeu retrouvé* because he felt he had not given certain theoreticians, including Artaud, the attention they deserved, and he did not have time to rewrite it. Fernand and Thérèse Leduc attended a public lecture at the Loeb Gallery during which Artaud read from his works.

60 Upon his return he received a note from Claire Goll with a story about Eluard: 'Jules Romains gave a marvellous speech at the funeral. Eluard had prepared one of his own and slipped it into my coat pocket. Politics even at the grave, apparently, since Eluard does not like Romains.' (unpublished letter from Claire Goll to L.-M. Raymond, 1 May 1950)

61 Told in an unpublished letter from Raymond to Goll, 11 Mar. 1944. Goll refers to it in a thank you note to Raymond, 25 June 1944 (unpublished).

62 Unpublished letter from Yvan Goll to Louis-Marcel Raymond, Percé, 2 Aug. 1946

63 However, no information is available about Soupault's visit to Canada in 1943; but he did visit Montreal and Ottawa on a mission to reorganize the Agence française de presse network in the Americas. (Cf. Henry-Jacques Dupuy, *Philipe Soupault* 77.)

64 Unpublished letter from Yvan Goll to L.-M. Raymond, 15 Oct. 1944

65 Cf. Gaëtan Picon, *Surrealists and Surrealism* 184. Elisa Breton maintains that they were drawn to Percé by a book on the agates of the Gaspésie. (Cf. Suzanne Lamy, *André Breton, hermétisme et poésie dans 'Arcane 17'* 19.)

66 François Rozet, telephone conversation with A.G.B., 26 Mar. 1970. During a chance meeting with Rozet in 1947 on the steps of a New York museum, Breton showed him a superb agate he always carried around with him. Suzanne Lamy has uncovered documents indicating that Breton and Bindhoff stayed in Sainte-Marguerite du Lac Masson, a tiny village off the highway from Sainte-Agathe to Montreal. A clipping from a Montreal newspaper dated 4 Nov. convinced her that this visit to Quebec extended beyond 20 Oct., the date Breton gives at the end of *Arcane 17*. (Cf. Lamy, *ibid.* 15.)

67 François Rozet, *loc. cit.* above

68 'Aparté' by Elisa, André Breton, and Benjamin Péret in André Breton, *Le Surréalisme et la peinture* 219

69 Teyssèdre, 'Fernand Leduc – peintre et théoricien du surréalisme,' *La Barre du jour*, nos 17-20, p 242

70 Claude Gauvreau, interview with Roger Soublière and A.G.B., Mar. 1969

71 The other members of the youth section were Léon Bellefleur, Fernand Bonin, Charles Daudelin, Pierre Gauvreau, André Jasmin, Lucien Morin, Louise Renaud, and Guy Viau. Cf. Maurice Gagnon, *Peinture canadienne* 37.

72 Fernand Leduc, letter to Guy Viau, 3 Nov. 1944 (in Teyssèdre, 'Fernand Leduc – peintre et théoricien du surréalisme à Montréal,' *La Barre du jour*, nos 17-20, p 246). The issue here was that Borduas wanted the entire output of the automatists considered as one piece; de Tonnancour later explained that he wondered whether certain ones would stand the test of time and refused to consider every work on an equal footing with the rest (Jacques de Tonnancour, interview with A.G.B., Apr. 1970).

73 Fernand Leduc, letter to Guy Viau, 22 Nov. 1944 (in Teyssèdre, *ibid.*). The person in question was Magdeleine Desroches.

74 Gauvreau, 'L'Epopée automatiste vue par un cyclope' 58-9

75 *Ibid.*

76 Teyssèdre, 'Fernand Leduc – peintre et théoricien du surréalisme à Montréal' 250-1.

77 *Ibid.* 260

78 *Ibid.* 253

79 Pierre Gélinas, 'Jeune poésie,' *Le Jour*, 25 Dec. 1943, p 4. Cf. Rémi-Paul Forgues, 'Stravinsky.'

80 Forgues, 'Le Jazz,' *Le Jour*, 8 Jan. 1944, p 7

81 Jean-Charles Harvey, 'La Peinture qui n'existe pas,' *Le Jour*, 1 Jan. 1944, p 4. A few months later, in *Le Devoir*, Alceste demolished Robert Elie's book on Borduas: 'These still-born paintings are worthless.' (*Le Devoir*, 18 Nov. 1944)

82 Jean-Charles Harvey, 'Nihilisme – l'économie surréaliste,' *Le Jour*, 18 Mar. 1944, p 1

83 Gélinas, 'Chronique des livres – *La Musique intérieure* par Charles Maurras,' *Le Jour*, 29 Jan. 1944, p 5

84 Gélinas, 'Chronique des livres – *Borduas* par Robert Elie,' *ibid.*

85 Jean-Louis Roux, 'Définissons nos positions,' *Le Quartier latin*, 5 Oct. 1945, p 3

86 François Lapointe, 'Jean-Louis Roux est dans les patates,' *ibid.*, 16 Oct. 1945, p 3

87 Jean-Louis Roux, 'François Lapointe m'engueule,' *ibid.*, 19 Oct. 1945, p 3

88 Rémi-Paul Forgues, 'Le surréalisme à Montréal,' *Le Quartier latin*, 19 Oct. 1945, p 3. Cf. Le Moyne's work cited above, n 1.

89 Bruno Cormier, 'Rupture,' *Le Quartier latin*, 16 Nov. 1945, p 4

90 Bernard Teyssèdre, 'Au cœur des tensions,' *La Presse*, 26 Oct. 1968, p 40. See also his lecture at the National Gallery, 22 Oct. 1968, and his 'Fernand Leduc – peintre et théoricien du surréalisme à Montréal' 254-7.

91 Jacques Delisle, 'Réflexions sur la peinture,' *Le Devoir*, 5 Feb. 1946
92 Dominique Laberge, *Anarchie dans l'art* 1945
93 Louis Franchet, *Le Quartier latin*, 8 Mar. 1946, p 3
94 The text appeared in *Les Cahiers des compagnons*, Oct.–Dec. 1946, vol. 2, nos 5-6, pp 102-17.
95 Gérard Petit, *L'Art vivant et nous* 200. There is no mention here of any Quebec artists, but Breton is singled out for criticism, pp 197-200. Eugène Lefebvre was just as harsh: 'The flood of pernicious, dangerous books has become more and more overwhelming. Up until the war, a few muddy trickles managed to filter across the frontier. Then a catastrophe befell France ... Our only consolation was the hope that the murky flow had been staunched. But cesspools were quickly emptied into Quebec soil as well and diseased waters spewed forth. The task of corruption continued ... Soon a stagnant pool formed, grew larger in our major cities, slowly rose and spilled out onto the whole province.' (*La Morale amie de l'art* 237)
96 Gauvreau, 'L'Epopée automatiste vue par un cyclope' 59
97 Brault, *Alain Grandbois*, 1st ed., 13-14
98 René Chopin, 'Le Surréalisme – *Les îles de la nuit*,' *Le Devoir*, 2 Sept. 1944, p 8
99 Viatte, *Histoire littéraire de l'Amérique française* 197
100 Brault, *Alain Grandbois*, 1st ed. p 8
101 *Ibid.*, 2nd ed. p 8
102 Grandbois, *Avant le chaos* 20. In an article written for the *Dictionnaire des œuvres littéraires du Québec*, Gabrielle Poulin draws some interesting parallels between the *Poèmes* published in Hankéou and Eluard's *L'Amour la poésie* (1929). In another ar-article, she compares the *Poèmes* (l'Hexagone) to, in turn, a de Chirico painting, Nerval's image of the black sun, Breton's crystal imagery and Eluard's use of mirrors. Cf. 'La Poésie d'Alain Grandbois: Une "tour dressée aux mains du silence",' *Relations*, Jan. 1970, pp 22-3.
103 Grandbois, *Avant le chaos* 20-1, where Grandbois cites the poem 'Jehanne de France,' from Blaise Cendrars' *Transsibérien*
104 Grandbois, 'Guy Delahaye brûla trop tôt ce qu'il avait si tôt adoré,' *Le Petit Journal*, 20 Oct. 1964
105 Cf. Sylvain Garneau, *Objets retrouvés* 178 (with a new preface).
106 Gustave Lamarche, *Liaison*, no 2, 1948, p 541: 'Macabre hallucinations courtesy of Pellan's stygian interpretations'; Guy Robert, 'Poèmes d'Alain Grandbois,' *Maintenant*, no 22, Oct. 1963, p 320: 'Islands, night, journeys, man and star, the hallucinatory chaos of creation.'
107 Breton, *Manifeste du Surréalisme* 17-18
108 Grandbois, *Les Iles de la nuit* 17-18
109 Two of Pellan's illustrations entitled *Les Iles de la nuit* and *L'Heure de plomb* are reprinted in Guy Robert's *Pellan* 68-101, in colour, unlike those in the original edition.
110 Grandbois, *Les Iles de la nuit* 20-1
111 Grandbois, *Rivages de l'homme* 92
112 *Ibid.* 26
113 *Ibid.* 31
114 *Ibid.* 14
115 *Ibid.* 20
116 *Ibid.* 22
117 *Ibid.* 13
118 *Ibid.* 16

119 Grandbois, *L'Etoile pourpre*, 69-70
120 *Ibid.* 71
121 Grandbois, *Les Iles de la nuit* 128
122 Jeanne Lapointe, 'Quelques apports positifs de notre littérature,' in Marcotte, *Présence de la critique* 109, n 1. On the same subject, see Blais, *De l'ordre et de l'aventure* 302, 312-13. It would be interesting to examine the elements of fantasy in the stories by Madeleine Grandbois (Alain's sister) which appeared in 1945 under the title *Maria de l'hospice*. See Bernard Dupriez, 'Du fantastique au délire,' in 'Lire,' *Revue d'esthétique*, Paris, 10/18, 1976, no 1091, pp 141-55.
123 Marcotte, *Le Temps des poètes* 53
124 Pierre-Carl Dubuc, 'Les jeunes peintres exposent,' *Le Quartier latin*, 10 Nov. 1944, p 1
125 He and Filion produced another work in 1946, *La fille du soleil*, a play with text by Dubuc and scenery by Filion. It played at the Collège Sainte-Marie 7-16 Nov.
126 Pierre-Carl Dubuc, *Jazz vers l'infini* 35
127 Pierre Vadeboncœur (sic), 'L'Art et la mort,' in Pierre-Carl Dubuc, *Jazz vers l'infini* 9, 11
128 Dubuc, *Jazz vers l'infini* 61-2
129 Interview by A.G.B., Mar. 1970
130 Jacques de Tonnancour, 'Propos sur l'art,' *Gants du ciel*, June 1944, pp 45-50
131 *Lettres françaises*, Oct. 1944, no 14, p 65
132 Charles Doyon, 'Jacques de Tonnancour,' *Le Jour*, 17 Apr. 1943, p 6
133 Jacques G. de Tonnancour, 'Alfred Pellan – Propos sur un sorcier,' *Amérique française*, vol. 1, no 2, Dec. 1941, p 21
134 Jacques G. de Tonnancour, 'Lettre à Borduas,' *La Nouvelle Relève*, July 1942, vol. 1, pp 608-13
135 Paul-Emile Borduas, 'Fusain,' *Amérique française*, Nov. 1942, vol. 2, no 2, pp 32-3
136 Julien Hébert, 'Surréalité,' *Amérique française*, Dec. 1943, vol. 3, no 18, p 51
137 'Jacques G. de Tonnancour, peintre surréaliste?,' interview reported by Jean-Marc Charlebois, Benoît Dufresne, Roger Vaillancourt, Mar. 1967, pp 11-12 (unpublished)
138 *Ibid.*
139 Claude Jasmin, 'Jacques de Tonnancour: En art il faut de l'innocence,' *La Presse*, 16 Apr. 1966, p 1, cols 5-6, suppl. 'Arts et lettres'
140 Réal Benoît, 'L'Empereur de Chine,' *Regards*, vol. 3, no 2, Nov. 1941; 'Elzéar' ('Fenêtre ouverte sur le monde'), *ibid.*, vol. 3, no 6, Mar. 1942; 'Allégories,' *ibid.*, vol. 3, no 7, Apr. 1942
141 Réal Benoît's *Rhum Soda*, which, according to Marcel Dubé, Blaise Cendrars urged should be published (cf. preface, p 8), deserves closer attention. In it can be found a quotation from Breton, verbal debauchery (Eglaïde's monologue, pp 50-1) and 'cabalistic secrets and ... diabolical concoctions.' *Rhum Soda* was first published in 1961 (*Ecrits du Canada français*, no 8).
142 Réal Benoît, *Nézon* 67-71
143 *Ibid.* 69-70
144 *Ibid.* 116-17
145 *Ibid.* 47-9
146 Gilles Hénault, Interview with A.G.B., Apr. 1969
147 Eloi de Grandmont, unpublished letter to Louise Robert, c30 Jan. 1968
148 De Grandmont, *Le Voyage d'Arlequin* 21
149 *Ibid.* 10, 13

150 Guy Robert, *Pellan, sa vie et son œuvre* 118, illustration no 166 (Icare); compare this with the harlequin on p 114, illus. no 254 (Espace). On Chagall's folkloric imagery and his (magical) relationship to surrealism, see Patrick Waldberg, *Le Surréalisme* 109.

151 De Grandmont, *Le Voyage d'Arlequin* 17

152 André Béland, 'Polichinelle,' *Le Jour*, 29 Jan. 1944, p 5. Also relevant here is Jean Léonard's *Naïade*.

153 Interviews with Jacques de Tonnancour and Roland Giguère, by A.G.B., Mar.-Apr. 1970

154 Jean-Charles Harvey, 'A l'exposition des Sagittaires,' *Le Jour*, 8 May 1943. See also Pierre Gélinas, 'Un peintre – Charles Daudelin,' *Le Jour*, 11 Dec. 1943.

155 Teyssèdre, 'Fernand Leduc, peintre et théoricien du surréalisme à Montréal' 228, 246-7

156 Interview with A.G.B., Apr. 1969. In his book published in 1945, the most recent author quoted by Baillargeon is Julien Green (p 145). According to him, Maurice Scève and Gérard de Nerval are 'precursors of Baudelaire and Mallarmé' (pp 155-6). He states that, in his circle at least, the new ideas began to take hold in 1922 (p 83). Cf. Pierre Baillargeon, *Les Médisances de Claude Perrin* (1945).

157 Interview with A.G.B., Apr. 1969

158 L.-M. Raymond, 'Un Cahier sud-américain sur la poésie française (*Lettres françaises*),' *La Nouvelle Relève*, Sept. 1943, vol. 2, pp 570-1; 'Notes sur la poésie: *Hémisphères*,' *ibid.*, May 1944, vol. 3, pp 250-1

159 Breton here referred to 'a fundamental and indivisible ensemble of propositions' which began with a formal adherence at that time to the principles of the communist revolution: 'Adherence to dialectical materialism, whose tenets the surrealists make their own: primacy of matter over thought, adoption of Hegelian dialectic as the science of the general laws of motion in the external world as well as in human thought, a materialist view of history ... the necessity of social revolution to put an end to the antagonism at a certain stage in their development between society's material means of production and existing relationships regarding production (class struggle).' (Cf. André Breton, 'Limites non-frontières du surréalisme,' in *La Clé des champs* 17.)

160 Interview with A.G.B., Apr. 1969

161 André Breton, *Entretiens* 124-5. Cf. Bernard-Paul Robert, 'Breton, Engels et le matérialisme dialectique,' *Revue de l'Université d'Ottawa*, vol. 46, no. 3, pp 299-304

162 Gérard Durozoi and Bernard Lecherbonnier, *Le Surréalisme* 84-7

163 'All the automatists were *monists*; that is to say, underhanded and often hypocritical dualism, which divides being into "matter" and "spirit" and condemns one or the other of the two, always seemed to them futile and contrary to reality.' (Gauvreau, 'L'Epopée automatiste vue par un cyclope' 68)

164 According to Gilles Hénault, interview with A.G.B., Apr. 1969. Quoted in Philippe Haeck *et al.*, 'Entretien avec Gilles Hénault: 30 ans après le *Refus global*,' *Chroniques*, vol. 1, no 1, p 20: 'For him [Borduas], social transformation was simply a kind of superficial change, just another shift if you like, and unfortunately history backed him up to a certain extent, and in some cases substantially so. As for myself, the social and political question ... remained relevant because I didn't see how one could act otherwise than by assuming a kind of personal well-being which is in the end very limited.'

165 André Breton, 'Limites non-frontières du surréalisme,' in *La Clé des champs* 20-1

166 Cf. *L'Envers du décor*, vol. 6, no 5, Mar. 1974, p 3.

167 Gilles Hénault, '1 + 1 + 1 = 3 poèmes,' *Les Ateliers d'arts graphiques*, no 2, 1947, p 30
168 On this polemic in the newspaper *Combat*, see Marcel Fournier, 'Borduas et sa société,' *La Barre du jour*, nos 17-20, pp 110-11. But Hénault enrolled in the party on the invitation of Gélinas.
169 Gauvreau, 'L'Epopée automatiste vue par un cyclope' 59. Gauvreau had participated in the *Combat* polemic, 21 Dec. 1947: 'La Peinture n'est pas un hochet de dilettante.'
170 Cf. André G. Bourassa, 'Sur le *Théâtre en plein air*,' *La Barre du jour*, nos 17-20, pp 322-3.
171 *Ibid.* 36
172 *Ibid.* 35-6
173 *Ibid.* 13
174 Hénault, 'Le Droit de rêver,' *Quoi*, vol. 1, no 1, p 62
175 Hénault, 'A propos de l'Automatisme (1946),' *Chroniques*, vol. 1, no 1, p 14
176 The title coincidentally recalls the subtitle of André Breton's collection *Etats généraux*: 'There will always be a spade to windward on the dunes of dreaming.' Dated Oct. 1943, New York, this work was apparently not known to readers of Breton until the 1947 edition was published in France.
177 Claude Gauvreau, letter of 26 Apr. 1950 to Jean-Claude Dussault, p 36, unpublished. Jean-Pierre Duquette's *Fernand Leduc* gives exact bio-bibliographical information.
178 Fernand Leduc, *Vers les îles de lumière* 10, 43, 47, 82. This first volume of his work was published in 1981.
179 Paul-Emile Borduas, letter to Fernand Leduc, 19 Mar. 1948; *ibid.* 246
180 Leduc, *Vers les îles de lumière* 232, nn 55-6
181 Letter of 17 June 1947, *ibid.* 57
182 Letters to Paul-Emile Borduas, 17 July 1947 and 23 Oct. 1947, *ibid.* 61, 68
183 Jean-Pierre Duquette, 'Entrevue – Fernand Leduc: de l'automatisme aux microchimies,' *Voix et images*, vol. 2, no 1, pp 4-7
184 For information on Brother Jérôme see Guy Robert, *Jérôme, un frère jazzé* (Montreal: Ed. du Songe 1969).
185 *Mousseau – Aspects*, catalogue of the retrospective at the Museum of Contemporary Art, 14 Dec. 1967, 28 Jan. 1968, biographical notes
186 Cf. Louis Bertrand *et al.*, *Le Surréalisme dans l'œuvre de Jean-Paul Mousseau* (unpublished)
187 Claude Gauvreau, *Dix-sept lettres à un fantôme*, letter of 26 Apr. 1950, p 36, unpublished
188 Gilles Hénault, 'Préface,' *Mousseau – Aspects* 8. The reference is to Leduc's studio, not Riopelle's.
189 Gérald Godin, 'Mousseau,' *Le Magazine Maclean*, Oct. 1968, p 88
190 Thérèse Renaud, *Les Sables du rêve* 7
191 Cf. Patrick Waldberg, *Le Surréalisme* 110-13 and Marcel Jean, *Histoire de la peinture surréaliste* 278.
192 Cf. Waldberg, *Le Surréalisme* 94 (on the frontispiece of *Minotaure* no 1, by Picasso) and Jean, *Histoire de la peinture surréaliste* 233, 241 (frontispiece of no 8, by Dali, and of no 10, by Magritte).
193 Renaud, *Les Sables du rêve* 8. The final image was apparently taken from *Second manifeste du surréalisme* (p 155).
194 Renaud, *Les Sables du rêve* 12-13

195 Waldberg, *Le Surréalisme* 80-1; Jean, *Histoire de la peinture surréaliste* 186, 241
196 Duquette, 'Entrevue – Fernand Leduc' 7-8
197 Roland Giguère wrote 'Persistance de la poésie' in *Impressions*, vol. 8 no 1
198 In the special issue of *La Barre du jour* on the automatists (17-20) and in *Poèmes du vent et des ombres*
199 Gauvreau, *Dix-sept lettres à un fantôme*, letter of 10 May 1950, p 32, unpublished
200 Teyssèdre, 'Fernand Leduc, peintre et théoricien du surréalisme à Montréal' 249, n 24. Forgues' poems were reprinted by l'Hexagone in 1974 with other works from the period when he was contributing to the newspaper *Le Jour* (1942-4); several of these latter pieces must have preceded his meeting with the automatists, since Robert Elie's *Borduas*, whose publication coincided with that meeting, only appeared in 1943.
201 'One of my friends – the poet Rémi-Paul Forgues – has promised to bring me soon Freud's fine book *Trois essais sur la théorie de la sexualité* so that I can pass it on to you. Forgues is charming but he's a bit crazy about his books, let me warn you. He washes his hands before opening them.' (Gauvreau, *Dix-sept lettres à un fantôme*, letter of 5 Apr. 1950, p 30, unpublished)
202 'I discovered Borduas' work. I remember, there was something delirious in my joy ... Until then, I had thought that my contemporaries, or rather my fellow citizens, were only working with material goals in mind.' (Rémi-Paul Forgues, 'Rêve éveillé' 277; *Poèmes du vent et des ombres* 58)
203 Forgues, 'Tu es la / douce yole-iris / de ma fin,' *Les Ateliers d'arts graphiques*, no 2, 1947, p 70; *Poèmes du vent et des ombres* 28-9
204 Forgues, 'La Rose aux rayons d'or,' *La Barre du jour*, nos 17-20, p 280; *Poèmes du vent et des ombres* 19
205 Forgues, 'Nocturne,' *ibid.* 281; *Poèmes du vent et des ombres* 27
206 Forgues, 'Recherche,' *Place publique*, no 3, Mar. 1952, p 28 (this edition gives 'xyliphones' and 'suppliants des fesses d'eau,' later amended to 'xylophones' and 'suppliants de l'onde'; cf. *Poèmes du vent et des ombres* 31).
207 Breton, *Second manifeste du surréalisme* (1930) 192. Marcel Jean applies this analysis of the phenomenon of sublimation to Dali and his images of tongues and limp watches, noting that 'the large number of crutches and limply deformed beings he takes such delight in painting' reveals in Dali compensatory ideas of power. (*Histoire de la peinture surréaliste* 218)
208 Forgues, 'Envoi à Borduas,' cited by Teyssèdre, 'Fernand Leduc – peintre et théoricien du surréalisme' 248-9; *Poèmes du vent et des ombres* 20
209 Forgues, 'Tu es la / douce yole-iris / de ma fin' 70; *Poèmes du vent et des ombres* 28, which amends: 'la chair nue de mon corps'
210 Forgues, 'Ombres,' *La Barre du jour*, nos 17-19, p 279; *Poèmes du vent et des ombres* 18
211 Forgues, 'La Rose aux rayons d'or,' *ibid.* 280; *Poèmes du vent et des ombres* 19
212 Forgues, 'Nocturne,' *ibid.* 281; *Poèmes du vent et des ombres* 27
213 Forgues, 'Tu es la / douce yole-iris / de ma fin,' *Les Ateliers d'arts graphiques*, no 2, p 70; *Poèmes du vent et des ombres* 28
214 Pierre Pétel, *Aïe! Aïe! Aïe!* 34
215 *Ibid.* 46
216 *Ibid.* 21
217 *Ibid.* 36. Since 1941 Pétel had defended what Louis Gay called 'the adventure which is diverting art away from impressionism towards surrealism' ('La Peinture moderne,' *Regards*, Feb. 1941, vol. 1, no 5, pp 229-31). In the same periodical Pétel replied: 'As for "the adventure which is diverting art away from impressionism

towards surrealism," let's concede at least that it's a healthy adventure since it has freed us from decadent classicism, museum hues, false grace, bastardized academicism – in short, from outdated principles which were bewitching art in order to render it servile.' (Pétel, 'Au sujet de *Peinture moderne*,' *Regards*, vol. 2, no 3, May 1941, pp 137-9)

218 André Béland, *Orage sur mon corps* (Montreal: Ed. Serge 1944) 9
219 Emile-Charles Hamel, *Solitude de la chair* (Montreal: CLF 1951) 242pp; *Prix David* (Montreal: Les Ed. de l'Homme 1962) 286pp
220 Jacques Ferron, *La Barbe de François Hertel* (Montreal: Orphée 1951) 40pp; *Le Ciel de Québec* (Montreal: Ed. du Jour 1969) 404pp; 'Maître Borduas,' in *Historiettes* (Montreal: Ed. du Jour 1969) 182pp. See also Claude Gauvreau, 'La Nymphe' in *Les Entrailles*; *Beauté baroque*, *La Charge de l'original épormyable*, *Les Oranges sont vertes*; in *Œuvres créatrices complètes* (Montreal: Ed. Parti pris 1977) 1503pp.
221 Béland, *Orage sur mon corps* 173
222 André Breton, *Manifestes du surréalisme* (Paris: Pauvert 1962) 46-7
223 Laurent Jenny, 'La Surréalité et ses signes narratifs,' *Poétique*, no 16, 1973, pp 505, 511, 517
224 André Breton, *Le Surréalisme et la peinture* (Paris: Gallimard 1965) 4, 28
225 Béland, *Orage sur mon corps* 10
226 *Ibid.*
227 *Ibid.* 72
228 Emile Nelligan, *Poésies complètes* (Montreal: Fides 1952) 48, 49
229 Béland, *Orage sur mon corps* 66
230 *Ibid.* 14
231 *Ibid.* 17
232 Jean Ricardou, *Le Nouveau Roman* (Paris: Seuil 1973) 61 ('Ecrivains de toujours,' no 92)
233 Béland, *Orage sur mon corps* 33
234 *Ibid.* 91-2
235 *Ibid.* 103
236 *Ibid.* 169
237 *Ibid.* 99-100
238 *Ibid.* 140
239 *Ibid.* 54-6
240 André Béland, *Escales de la soif* (Paris: Debresse 1948) 18
241 *Ibid.* 22
242 Cf. illustrations in André Breton, *Le Surréalisme et la peinture* 376 and 386-90, in René Passeron, *Histoire de la peinture surréaliste* (Paris: Librairie générale française, 'Livre de poche' 1968) 285-7 and in Robert Bénayoun, *Erotique du surréalisme* (Paris: Pauvert 1965) 216-18.
243 Béland, *Escales de la soif*, 22
244 Is Patrick Imbert correct in stating with regard to *Prix David* that 'it shows obvious signs of surrealist and automatist influence'? ('*Prix David* de Charles Hamel ou du plagiat à l'intertexte,' *Lettres québécoises*, no 23, Fall 1981, p 66). Certainly, especially since he also states that surrealism is one of the novel's 'major themes.' '*Prix David* gives us reworked Gauvreau ('bouzdouc, zdouc, nfounfa mbaak'), and one can sniff out numerous and varied authors parodied to a greater or lesser extent, including Eluard' (p 68). The book could also be described, from a formal viewpoint, as a collage of texts, multi-authored poetry or a 'cadavre exquis.' The subject-matter is somewhat flat, making so little effort to transform daily reality that friends of

Charles Hamel can make direct connections, recognizing Berthelot Brunet in Bruno Barthélemy, Gilles Hénault in Gérald Forestier, Robert La Palme in Rigobert LaFlamme, Alfred Pellan in Manfred Charlan, André Pouliot alias James in Jones. In the quarrel between the surrealists and the Quebec automatists, the only distance Hamel maintains is a literary one in his use of irony; otherwise, he clearly takes sides, often bitchily supporting the surrealists against the automatists. The poems entitled 'Projections dans l'avenir' in *Ateliers d'arts graphiques* reveal affinities with Apollinaire's cubism.

CHAPTER THREE: 'REFUS GLOBAL'

1 André Breton, *Où en est le surréalisme?*, talk on 'Revue des arts et des lettres,' *Radio-Canada*, 13 Jan. 1953. Cf. *La Semaine à Radio-Canada*, 1-7 Feb. 1953, vol. 3, no 17. Quoted from the complete text filed with the Borduas Papers, no 110 in the Théberge classification, National Gallery, p 1
2 According to Maxime Alexandre, a few months after Lenin's death in 1924 Breton refused to read his pamphlet *L'Etat de la révolution* and questioned at the time Marx's ideas on Feuerbach: 'Philosophers until now have only interpreted the world; the point is to change it.' (Maxime Alexandre, *Mémoires d'un surréaliste* 81)
3 Interview with Paul-Emile Borduas by Jean-Luc Pépin, *Le Droit*, 18 Oct. 1952, p 2
4 André Breton, circular dated 12 Jan. 1947, in Jean-Louis Bédouin, *Vingt ans de surréalisme* 99
5 Letter from Paul-Emile Borduas to Jean-Paul Riopelle, 21 Feb. 1947; cf. François Gagnon, 'Le *Refus global* en son temps,' *Ozias Leduc et Paul-Emile Borduas* 65-6
6 Tancrède Marsil, 'Les Automatistes – L'Ecole de Borduas,' *Le Quartier latin*, 28 Feb. 1947: 'Borduas is about to bring together our automatists.' Doyon said the same thing about the Sagittarians' exhibition.
7 Claude Gauvreau, 'L'Epopée automatiste vue par un cyclope' 64
8 Interview with J.-P. Mousseau by MM. Bertrand, Boyer, Dubeau, Martel, and Thibault, Apr. 1967
9 Bernard Teyssèdre, 'Fernand Leduc – peintre et théoricien du surréalisme à Montréal,' *La Barre du jour*, nos 17-20, p 264, n 8
10 Guy Viau, in *Notre temps*, 12 July 1947
11 Gauvreau, 'L'Epopée automatiste vue par un cyclope' 68
12 *Ibid.* 69
13 Bédouin, *Vingt ans de surréalisme* 148
14 Normand Thériault, 'Bernard Teyssèdre – Au cœur des tensions,' *La Presse*, 26 Oct. 1968, p 40, c. 5
15 But he ascribes this discovery to the 1949 Riopelle exhibition instead of the one in the Luxembourg in 1947. (Bédouin, *Vingt ans de surréalisme* 150)
16 Paul-Emile Borduas, *Projections libérantes* 35
17 Gauvreau, 'L'Epopée automatiste vue par un cyclope' 66
18 Guy Robert, *Pellan, sa vie et son œuvre* 54
19 Borduas, *Projections libérantes* 17
20 Robert, *Pellan, sa vie et son œuvre* 54
21 Henri Pastoureau, *Le Surréalisme de l'après-guerre* 99. The lecture by Tristan Tzara on 'Surréalisme et l'après-guerre' (11 Apr. 1947) and the intervention of Jean-Paul Sartre (May 1947) underlined the conflicts within the group; cf. Gaëtan Picon, *Surrealists and Surrealism* 185.
22 Pastoureau, *Le Surréalisme de l'après-guerre* 101

23 Thériault, 'Bernard Teyssèdre – Au cœur des tensions' 40, c. 3

24 Henri Pastoureau, *Le Surréalisme de l'après-guerre* 102. The complete text of this manifesto apparently has never been reprinted.

25 Bédouin, *Vingt ans de surréalisme* 99-100

26 Acker, Adolphe *et al.*, *Rupture inaugurale* (Paris: Ed. Surréalistes 1947) 3, 6

27 *Ibid.* 7, 8

28 Henri Pastoureau, *Le Surréalisme de l'après-guerre* 104

29 Gauvreau, 'L'Epopée automatiste vue par un cyclope' 75

30 Acker *et al.*, *Rupture inaugurale* 12-14

31 Cf. 'Fernand Seguin rencontre Jean-Paul Riopelle,' *Le Sel de la semaine*, Radio-Canada, 28 Oct. 1968, unpublished; and Gauvreau, 'L'Epopée automatiste vue par un cyclope' 70

32 Pastoureau, *Le Surréalisme de l'après-guerre* 107-8

33 Gauvreau, *Dix-sept lettres à un fantôme*, letter of 8 Feb. 1950, pp 22-3, unpublished

34 Gauvreau, 'L'Epopée automatiste vue par un cyclope' 69-70

35 Claude Gauvreau, 'L'Automatisme ne vient pas de chez Hadès,' *Notre temps*, 13 Dec. 1947, p 6

36 *Ibid.*, 13 Dec. 1947, p 6. The page is erroneously dated 6 Dec.

37 See also Claude Gauvreau, *Dix-sept lettres à un fantôme*, letter of 13 Apr. 1950, *La Barre du jour*, nos 17-20, p 358

38 Robert, *Pellan, sa vie et son œuvre* 52; Gérard Tougas, *Histoire de la littérature canadienne-française* 152. Guy Robert later changed his opinion in the face of much evidence to the contrary (cf. Guy Robert, *Borduas* 69, 135).

39 Interview with Jacques de Tonnancour by A.G.B., Apr. 1970

40 Gauvreau, 'L'Epopée automatiste vue par un cyclope' 69

41 *Ibid.* 72

42 *Ibid.* 85

43 Charles Delloye, 'In Memoriam,' *Aujourd'hui – art et architecture*, no 25, 1960, p 49. In a special issue which turned out to be posthumous, Charles Delloye quoted extensively from *Refus global* (these extracts later appeared in the second edition of Gérard Tougas' *Histoire de la littérature canadienne-française*, appendix 2. The reference is incorrect; Charles Delloye's periodical is only referred to here by its subtitle.)

44 Charles Delloye, 'Paul-Emile Borduas – Ecrits théoriques,' *Aujourd'hui – art et architecture*, no 26, Apr. 1960, p 6

45 Delloye, 'Quand les automatistes parlent ... des automatistes,' *Culture vivante*, no 22, Sept. 1971, p 29

46 This took place during the final exhibition of the Contemporary Art Society, 7-29 Feb., immediately after the Prisme d'yeux exhibition. (John Lyman, 'Borduas and the Contemporary Art Society,' in *Paul-Emile Borduas, 1905-1960* 41). The Society was dissolved 18 Nov. 1948.

47 *Ibid.*, letter from Paul-Emile Borduas to John Lyman, 13 Feb. 1948

48 *Ibid.* 40

49 *Le Quartier latin*, 17 Feb. 1948, p 3

50 Madeleine Gariépy, 'Salon du printemps,' *Notre temps*, 20 Mar. 1948

51 Jean Bédard, 'La Sauvagerie apprivoisée de Pellan,' *Culture vivante*, no 26, Sept. 1972, p 5

52 Gauvreau, 'L'Epopée automatiste vue par un cyclope' 72

53 Paul-Emile Borduas, 'Commentaires sur des mots courants,' in *Refus global*, under 'Révolution'

54 *Ibid.*, 'Mythe'

55 'Refus global,' *ibid.*
56 Pastoureau, *Le Surréalisme de l'après-guerre* 99
57 *Ibid.* 95
58 Borduas, 'Refus global'
59 Borduas, 'Commentaires sur des mots courants,' 'Magie'
60 Borduas, 'En regard du surréalisme actuel,' in *Refus global*
61 Borduas, 'En regard du surréalisme actuel,' *Refus global.* Cf. Gauvreau, 'L'Epopée automatiste vue par un cyclope' 71-2.
62 Gauvreau, *Dix-sept lettres à un fantôme*, letter of 8 Feb. 1950, unpublished. Cf. Jean Depocas, 'De l'amour fou à vénus-3; entretien avec C. Gauvreau,' *Parti pris*, vol. 3, no 9, p 18.
63 Cf. François Gagnon, 'Le *Refus global* en son temps,' *Ozias Leduc et Paul-Emile Borduas* 75-7.
64 Fernand Leduc, 'Qu'on le veuille ou non,' in *Refus global*
65 Claude Gauvreau, 'Raie, fugue, lobe, ale,' 'Bien-être,' 'Au cœur des quenouilles,' 'L'Ombre sur le cerceau,' in *Refus global*
66 Françoise Sullivan, 'La Danse et l'espoir,' *Refus global*, Editions Anatole Brochu, p 102
67 Gauvreau, 'L'Epopée automatiste vue par un cyclope' 71
68 Interview with Paul-Emile Borduas by Jean-Luc Pépin, *Le Droit*, 18 Oct. 1952. Cf. above, n 3.
69 Claude Bertrand and Jean Stafford, 'Lire le *Refus global*,' *La Barre du jour*, nos 17-20, p 127
70 *Ibid.* 128. Cf. Christiane Dubreuil-Lebrun, 'Sur le *Refus global*,' Mar. 1968, unpublished
71 Pierre Maheu, 'De la révolte à la révolution,' *Parti pris*, Oct. 1963, vol. 1, no 1, pp 11-14
72 Borduas, 'Refus global,' in *Refus global*
73 *Ibid.* Cf. Yves-Gabriel Brunet, 'Portrait d'un poète – Claude Gauvreau,' *Culture vivante*, no 22, Sept. 1971, pp 33-4.
74 Delloye, 'Quand les automatistes parlent ... des automatistes' 30
75 *Ibid.*
76 Paul-Emile Borduas, letter to the publisher of *Situations*, 11 Nov. 1958, *Situations*, vol. 1, no 2, Feb. 1959, pp 32-5; reprinted in *Aujourd'hui – art et architecture*, no 26, Apr. 1960, p 9
77 Madeleine Gariépy, 'Exposition Borduas,' *Notre temps*, 24 Apr. 1948, p 9
78 Henri Girard, 'Aspects de la peinture surréaliste,' *La Nouvelle Relève*, Sept. 1948, vol. 6, no 5, p 422
79 'Bombe automatiste chez Tranquille,' *Montréal-matin*, 5 Aug. 1948, p 5, c. 3, reprinted in *La Patrie*, 7 Aug. 1948, p 43. Then came 'Tranquille reçoit les Automatistes,' *Le Petit journal*, 8 Aug. 1948, p 41, c. 2; Rolland Boulanger, 'Dynamitage automatiste à la librairie Tranquille,' 9 Aug. (*Montréal-matin* 5-7); 'Les théories de M. Borduas: Les conférences sur l'automatisme sont suivies d'un manifeste,' *La Presse*, 10 Aug. 1948, p 4, cc. 7-8; 'Entre les lignes,' and 'L'Œil en coulisse,' *Le Petit journal*, 15 Aug. 1948, p 38, c. 4 and p 52, cc. 1-3; 'Dans le courrier,' *Le Canada*, 16 Aug. 1948, p 4, c. 4.
80 Gauvreau, 'L'Epopée automatiste vue par un cyclope' 77
81 'Drawn and quartered in tomato juice – our automatists announce the decline of Christianity and prophesy the commencement of the reign of instinct.' Unsigned. *Le Petit journal*, 15 Aug. 1948, p 28

82 Y.G., 'L'Avis de nos lecteurs. Amour, désir, vertige,' *Le Petit journal*, 5 Sept. 1948, p 44, cc. 3-4

83 Lafcadio, '*Refus global*, manifeste de l'automatisme surrationnel par Paul-Emile Borduas et compagnie,' *Le Canada*, 23 Aug., p 4, cc. 3-4; Charles Doyon, '*Refus global*,' *Le Clairon de St-Hyacinthe*, 27 Aug.; A. Lecompte, 'L'Oeil en coulisse,' *Le Petit journal*, 29 Aug., p 51, cc. 2-3

84 Hyacinthe-Marie Robillard, OP, 'Le Manifeste de nos surréalistes,' *Notre temps*, 4 Sept. 1948, p 4. This has been accepted as the date of Borduas' dismissal. (Cf. *Paul-Emile Borduas, 1905-1960* 30.) In fact, the deputy minister Gustave Poisson made the suspension official in a letter written 2 Sept. to the principal, Jean-Marie Gauvreau, with a copy to Borduas. Gauvreau had requested Borduas' resignation in a letter of 19 Aug. A second letter from the deputy minister on 21 Oct. read as follows: 'Please advise the person named below that in accordance with order-in-council no 1394, dated October 20, 1948, the Honourable minister of youth and social welfare dismisses him from his post as professor of drawing and interior design at the Ecole du meuble for conduct and writing incompatible with the function of a teacher in an institution of learning in the province of Quebec commencing 4 September 1948, and this in accordance with a resolution passed by the Civil Service Commission of the province of Quebec during the session of 29 September 1948.' (in 'Paul-Emile Borduas – Projections libérantes,' *Etudes françaises*, vol. 8, no 3, pp 290 n 112, and 304 n 145)

85 Roger Duhamel, 'Notes de lecture, *Refus global*,' *Montréal-matin*, 14 Sept. 1948, p 4, c. 3

86 H.-M. Robillard, OP, 'Le Manifeste de nos surréalistes,' *L'Action catholique*, 22 Sept. 1948, p 7, c. 3

87 Guy Jasmin, 'Autour et alentour: La Poésie devra peut-être se défendre elle-aussi,' *Le Canada*, 22 Sept. 1948, p 4. A caricature of Robert Lapalme, a friend of Pellan, appeared in *Le Canada* entitled *L'Ombre sur le cerveau* (parodying the title of a dramatic object by Gauvreau published in *Refus global*, *L'Ombre sur le cerceau*). The caricature was signed 'automatiquement, Prisme d'yeux ...!' (*Le Canada*, 13 Sept. 1948, p 4). A debate ensued: 'Garder notre élite chez nous,' *Le Canada*, 23 Sept., p 4, c. 1; P.-E. Vadnais, 'Ce que nous dit le lecteur. On devrait protester,' *Le Canada*, 24 Sept., p 4, c. 7; B. Morisset, 'Nous sommes avec vous, Borduas,' *Le Canada*, 2 Oct., p 4. 'Dans le courrier,' *Le Canada*, 9 Oct., p 5; 'De la vraie à la fausse censure,' *Le Canada*, 28 Oct. 1948, p 4 and P. Gagnon, 'La femme peintre Agnès Lefort est loin de croire à l'automatisme,' *Le Canada*, 28 Oct., cc. 3-4. Riopelle replied to this last article: ('Ce que nous dit le lecteur ... En marge des propos de l'artiste Agnès Lefort,' *Le Canada*, 5 Nov. 1948, p 4, c. 6) and C. Gauvreau 'Ce que nous dit le lecteur. De Mme Lefort et d'André Lhote,' *Le Canada*, 8 Nov. 1948, p 4, cc. 3-4).

88 Guy Jasmin, 'L'Opinion du lecteur,' in reply to a letter of 29 Oct. from P. Gauvreau, Riopelle, and Perron, *Le Clairon de Montréal*, 5 Nov. 1948

89 This 'miscellaneous item' appeared on 18 Sept. in *Le Devoir*: 'Borduas renvoyé de l'Ecole du meuble' (p 3, c. 3). The news later appeared in all the papers: 'Brièvetés,' *Montréal-matin*, 20 Sept., p 4, c. 2; '*Refus global*, M. Borduas proteste contre son renvoi,' *La Patrie*, 22 Sept., p 6; 'M. Borduas n'accepte pas cette sanction,' *Le Devoir*, 22 Sept., p 2, cc. 4-5; 'La Protestation de Paul-Emile Borduas,' *La Presse*, 22 Sept., p 37, c. 2; Harry Bernard, 'Le cas Borduas,' *Le Courrier de St-Hyacinthe*, 24 Sept., p 1, c. 2; 'Brièvetés,' *Montréal-matin*, 24 Sept., c. 3; H. Bernard, 'Encore M. Borduas,' *Le Courrier de St-Hyacinthe*, 1 Oct.

90 André Laurendeau, 'Bloc-notes – Intervention politique,' *Le Devoir*, 23 Sept. 1948, p 1

91 Gérard Pelletier, 'Deux âges – deux manières,' *Le Devoir*, 25 Sept. 1948, p 8
92 *Ibid.*
93 André Laurendeau, 'Bloc-notes,' *Le Devoir*, 27 Sept. 1948, p 1. On that morning, Duhamel had published 'Les Zélateurs d'une mauvaise cause' (*Montréal-matin*, 27 Sept., p 4, cc. 1-2).
94 Claude Gauvreau, 'Le Renvoi de M. Borduas,' *Le Devoir*, 28 Sept. 1948, p 5, c. 2. Gauvreau was later supported by Mercure: 'L'Actualité. Les grandes amitiés. Lettre addressé à M. le directeur littéraire, journal sportif du matin, ' *Le Devoir*, 5 Oct., p 1, cc. 6-8.
95 'Note de la rédaction,' *Le Devoir*, 28 Sept. 1948, p 5, c. 2. Cf. also André Laurendeau, 'Un individu quelconque,' *Le Devoir*, 29 Sept., p 1, cc. 1-2.
96 Charles Doyon also took up Borduas' defence against Harry Bernard's articles in *Le Courrier de St-Hyacinthe*. Cf. 'L'actualité artistique. Refus contre refus.' *Le Courrier de St-Hyacinthe* (24 Sept., p 5); 'Litanies de l'intolérance' (under the pseudonym 'Loup-garou'), *Le Clairon de Montréal* (1 Oct.) and 'L'Affaire Borduas. L'Ecole du meuble' (*ibid.*, 8 Oct.). Cf. also Pierre Gauvreau, Jean-Paul Riopelle, and Maurice Perron, 'L'Opinion du lecteur,' *Le Clairon de Montréal*, 29 Oct.
97 Pierre Lefebvre, 'Notre manière,' *Le Quartier latin*, 5 Oct. 1948, p 1
98 François Léger, 'L'Affaire Borduas,' *Le Quartier latin*, 8 Oct. 1948, p 1
99 Esther Van Loo, 'La Peinture canadienne,' *Arts*, 15 Oct. 1948, p 3
100 *Time*, 18 Oct. 1948, p 22
101 Reproduced by Gilles Corbeil, 'Notice biographique,' *Arts et pensée*, vol. 3 no 17, May-June 1954, p 136
102 Jacques Dubuc, letter to Gérard Pelletier, 23 Oct. 1948, *Le Devoir*, 30 Oct. 1948, p 5, cc. 2-3
103 Gérard Pelletier, 'N.D.L.R.,' *ibid.*, c. 3
104 Jean-Paul Riopelle, Maurice Perron, Magdeleine Arbour, Pierre Gauvreau, Françoise Riopelle, letter to the editor-in-chief, 1 Nov. 1948, *Le Devoir*, 13 Nov. 1948, p 9
105 Gérard Pelletier, 'Notre réponse aux surréalistes,' *Le Devoir*, 13 Nov. 1948, p 9; cf. Gérard Pelletier, 'Nota Bene,' *Le Devoir*, 6 Nov. 1948, p 7
106 J.-P. Riopelle, M. Perron, M. Arbour, P. Gauvreau, F. Riopelle, letter to Gérard Pelletier, 16 Nov. 1948, *Le Devoir*, 20 Nov. 1948, p 10; Pelletier's comments are interpolated in italics; he mentioned that the editors of all the newspapers had received a copy of *Refus global*.
107 Gérard Pelletier, 'N.D.L.R.,' *Le Devoir*, 4 Dec. 1948, p 13; Jacques Dubuc, 'La Peau du lion et de l'âne,' *ibid.*
108 Gauvreau, 'L'Epopée automatiste vue par un cyclope' 67
109 Rolland Boulanger, 'Jean-Paul Mousseau et les automatistes,' *Notre temps*, 20 Nov. 1948, p 4; Hyacinthe-Marie Robillard, 'Le Surréalisme – la Révolution des intellectuels,' *La Revue dominicaine*, Dec. 1948, vol. 54, t. 2, p 274; Robillard, 'Le Surréalisme et la révolution,' *Le Canada*, 18 Dec. 1948, p 14; 'Le Surréalisme est mort, dit le P. Robillard,' *Le Canada*, 20 Dec. 1948, p 16, c. 2; 'Le Surréalisme et la révolution des intellectuels,' *Le Devoir*, 20 Dec. 1948, p 10; 'Le Surréalisme au point de vue moral,' *La Presse*, 20 Dec. 1948, p 4; H.-M. Robillard, 'L'Automatisme surrationnel et la nostalgie du jardin d'Eden,' *Amérique française*, 1950, no 4, pp 44-73; P. Gauvreau, 'Le Surréalisme est-il mort?,' *Le Canada*, 27 Dec. 1948, p 4; H.-M. Robillard, 'Réponse à la lettre de P. Gauvreau sur la mort du surréalisme,' *Le Canada*, 7 Jan. 1949, p 4
110 Rolland Boulanger, *1941 – Contrastes – Aujourd'hui*, pp 20, 22

111 Pierre Vadeboncœur, 'Les Dessins de Gabriel Filion,' *Liaison*, Feb. 1949, p 109

112 Vadeboncœur, 'A propos de poètes,' *Situations*, Mar.-Apr. 1961, p 79

113 Vadeboncœur, *La ligne du risque* 205, 186

114 Ferron, *Historiettes* 179. Nevertheless, he defended the automatists in *Le Canada* (16 Feb. 1949) and surrealism in *Le Haut-parleur* (5 May 1951).

115 P. Emond, 'L'Automatisme: réalité compromettante,' *Cité libre*, Feb. 1957, no 16, pp 54-9; Guy Viau, 'Avec l'énergie du désespoir Borduas a vécu ses rêves,' *Cité libre*, Apr. 1960, vol. 11, no 26, p 25; Marcel Rioux, 'Faut-il réhabiliter la magie?,' *Cité libre, ibid.* 28; Guy Viau, 'Un ménage d'artistes,' *Cité libre, ibid.* 29

116 Interview with Roland Giguère, Apr. 1970

117 For his comments on surrealism, see Clarence Gagnon, 'L'Immense blague de l'art moderniste-II' (trad.), *Amérique française*, 1948-9, no 2, p 46; cf. no 4, pp 32-3. The article was published posthumously.

118 *Paul-Emile Borduas 1905-1960* 31

119 Roger Viau, 'Le Salon du printemps,' *Amérique française*, 1949, vol. 4, pp 35-6

120 Géraldine Bourbeau, 'Borduas – de Tonnancour – l'Ecole du meuble,' *Liaison*, no 26, June 1949, p 357

121 Bourbeau, 'Normand Hudon – Ferron-Mousseau,' *Liaison*, Mar. 1950, p 179

122 Bourbeau, 'Marcel Baril, peintre-graveur,' *Liaison*, Oct. 1950, p 429

123 Denys Morisset, 'Lettre sur notre peinture contemporaine,' *Arts et pensée*, vol. 3, no 16, Mar.-Apr. 1954, p 111

124 'The Challenge posed by this incisive document incited a goodly number of poets to launch themselves on surrealist adventures which burst open the traditional structures of Canadian poetry.'

125 Jean Ethier-Blais, 'Où sont mes racines ...,' *Etudes françaises*, vol. 8, no 3, p 264

126 Cf. 'Censorship of books has just been initiated by Duplessis' fascists! What would have happened if the secession of Abbé Groulx had not been aborted – and if a Laurentide government had been installed, autonomous and absolute! ...' (Gauvreau, *Dix-sept lettres à un fantôme*, letter of 26 Apr. 1950, p 28, unpublished)

127 Borduas, *Projections libérantes* 38-9

128 *Ibid.* 4. The masculine ending is deliberate. See Gauvreau's comment to Dussault (*Dix-sept lettres à un fantôme*, 13 Apr. 1950, *La Barre du jour*, nos 17-20, p 360).

129 *Ibid.* 37

130 *Ibid.* 11

131 *Ibid.* 17

132 *Ibid.* 37

133 *Ibid.* 37

134 *Ibid.* 5, 11, 39-40

135 Cf. 'Réactions de presse,' *Etudes françaises*, vol. 8, no 3, Aug. 1972, p 337. This article mainly dealt with open letters by Pierre and Claude Gauvreau to *Le Devoir* and *Le Canada*. The ensuing polemics lasted from 5 Feb. to 6 June 1949

136 Robert, *Borduas* 167

137 Quoted by Robert, *ibid.*

138 Borduas, *Projections libérantes* 17

139 Quoted by Robert, *Borduas* 168

140 Paul Chamberland, 'Fondation du territoire,' *Parti pris*, May-Aug. 1967, vol. 4, nos 9-12, p 41

141 Pierre Angers had been awarded a doctorate from the Université de Louvain for his *Commentaire à l'art poétique de Paul Claudel* (published in 1949).

142 Gauvreau, 'Notes biographiques,' *Le Journal des poètes* (Brussels), vol. 37, no 5, July 1967, p 18; André G. Bourassa, 'Claude Gauvreau – Eléments de biographie,' *La Barre du jour*, nos 17-20, p 336

143 Gauvreau, *Dix-sept lettres à un fantôme*, 8 Feb. 1950, p 14, unpublished

144 *Ibid.*, 13 Jan. 1950, p 18, unpublished

145 Gauvreau, 'Quelques poètes "inconnus",' *Le Haut-parleur*, 30 Jan. 1951, p 7, c. 1. Henri Pichette is in fact the pen name of Harry Paul. He was born in France of a French mother and an American father whose ancestors came from Quebec.

146 Gauvreau, *Les Reflets de la nuit*, in *Sur fil métamorphose* 18; *Œuvres créatrices complètes* 19

147 Paul Claudel, *L'Endormie*, in *Théâtre*, coll. 'Bibliothèque de la Pléiade,' vol. 1, p 5

148 Gauvreau, *Les Reflets de la nuit* 12; *Œuvres créatrices complètes* 20

149 Gauvreau, *La Jeune fille et la lune*, ibid. 27

150 *Ibid.* 24, 28

151 Claudel, *L'Endormie* 11

152 'Guillaume Apollinaire (along with Jacob, Cendrars, Reverdy) is the greatest cubist of them all.' (Claude Gauvreau, 'Quelques poètes "inconnus",' *Le Haut-parleur*, 30 Jan. 1951, p 7, c. 2)

153 Claude Gauvreau, 'La Prière pour l'indulgence,' in *Sur fil métamorphose* 19; *Œuvres créatrices complètes* 29

154 On the symbol of the Milky Way in Claudel's universe, cf. André G. Bourassa, *'Le Livre de Christophe-Colomb': un essai de théâtre total comme répresentation de l'univers claudélien* 127, 166-72.

155 Gauvreau, 'A propos de miroir déformant,' *Liberté*, no 68, Mar.-Apr. 1970, pp 100-1

156 Gauvreau, *La Statue qui pleure* p 11 of the manuscript; *Œuvres créatrices complètes* 34

157 The premiere of this piece or 'dramatic object' was a historic date in the history of Quebec theatre. It initiated a cycle similar to Artaud's theatre of cruelty just when the populist, nationalist cycle epitomized by Gratien Gélinas' *Tit-coq* was about to reach its peak.

158 'In 1944, I hung around Fernand Leduc's studio on rue Jeanne-Mance. I was going to school and writing *Les Entrailles*.' Gauvreau, 'L'Epopée automatiste vue par un cyclope' 54

159 Gauvreau, *Nostalgie sourire*, *Œuvres créatrices complètes* 61. The principal character is a painter at his easel.

160 *Le Soldat Claude*, ibid. 65

161 *Ibid.* 66

162 *Ibid.* 68

163 Gauvreau, *Apolnixède entre le ciel et la terre*, ibid. 71

164 Jean, *Histoire de la peinture surréaliste* 34

165 Max Ernst, *Ecritures* 259

166 Gauvreau, 'L'Epopée automatiste vue par un cyclope' 56

167 *Ibid.* 55

168 Gauvreau, *Dix-sept lettres à un fantôme*, 30 Dec. 1949, p 8; unpublished

169 *Ibid.*, 13 Apr. 1950, in *La Barre du jour*, nos 17-20, pp 360-1

170 Jacques Dubuc, 'La Peau du lion et de l'âne,' *Le Devoir*, 4 Dec. 1948, p 13

171 Gauvreau, *Dix-sept lettres à un fantôme*, 13 Jan. 1950, p 17; unpublished

172 *Ibid.*, 30 Mar. 1950, pp 22-3; cf. Borduas, *Projections libérantes* 26

173 Gauvreau, 'A propos de miroir déformant' 102

174 Jean-Marcel Duciaume, 'Le Théâtre de Gauvreau: une approche,' *Livres et auteurs québécois*, 1972, pp 332, 335

175 Eugène Ionesco, *Entre la vie et la rêve*, interview with Claude Bonnefoy, pp 33-7; like Gauvreau, Ionesco often considers his theatre to be abstract and non-representational (*ibid.* 84 and Ionesco, *Notes et contrenotes*, entry dated 10 Apr. 1951, p 254).

176 Claude Gauvreau, 'Figure du vivant – St-Denys Garneau,' *Sainte-Marie*, vol. 2, no 2, 30 Oct. 1945, p 2

177 Gauvreau, 'Le Jour et le joug sains,' *ibid.*, vol. 2, no 1, Oct. 1945, p 2

178 Gauvreau, 'Les Affinités surréalistes de Giguère,' *Etudes littéraires*, vol. 5, no 3, pp 504-5

179 Alain Bosquet, *La Poésie canadienne* 118. Cf. the interview in the film *Claude Gauvreau poète* by Jean-Claude Labrecque, broadcast previously on 'Femme d'aujourd'hui,' Radio-Canada, 13 May 1970.

180 Claude Gauvreau, unpublished letter to Jean-Marc Montagne, 6 Apr. 1968

181 Paul Bernier, 'Grégor alkador solidor,' Université Loyola, July 1974, unpublished. The poem also includes the name of Ravachol, a French anarchist guillotined in the nineteenth century.

182 Jacques Marchand, 'Lettre ouverte à Jacques Ferron sur Claude Gauvreau,' *Hobo-Québec*, no 19, p 7 (in reply to Jacques Ferron, *Du fond de mon arrière-cuisine* (1973) 201-81).

183 Claude Gauvreau, *Etal mixte*, 8-9, *Œuvres créatrices complètes* 214. Cf. pp 74 and 121 in Roland Barthes' *S/Z* for the relationships woman/child and woman/masterpiece.

184 Paul-Emile Borduas, letter to Claude Gauvreau, 25 Sept. 1954, *Liberté*, no 22, pp 236-7

185 Nicole Hurtubise, '"Sous nar" de Claude Gauvreau,' *La Barre du jour*, nos 39-41, p 188; cf. p 201.

186 Bosquet, *La Poésie canadienne* 118. See the article by André Gervais, 'Eaux retenues d'une lecture: "Sentinelle-Onde" de C. Gauvreau,' *Voix et images*, vol. 2, no 3.

187 Gauvreau, *Etal mixte* 12; *Œuvres complètes* 217, 220

188 Marcel Bélanger, 'La lettre contre l'esprit ou quelques points de repère sur la poésie de Claude Gauvreau,' *Etudes littéraires*, Dec. 1972, vol. 5, no 3, pp 483-4

189 Gauvreau, *Brochuges*, 13, 18. *Œuvres créatrices complètes* 612-14 (where two 'ff''s have been omitted).

190 Gauvreau, 'Le Jour et le joug sains' 2

191 Michael Riffaterre, 'La Métaphore filée dans la poésie surréaliste,' *Langue française*, no 3, Sept. 1969, pp 50-1

192 Marguerite Bonnet, *André Breton: Naissance de l'aventure surréaliste* 391, illus. no 198

193 Gauvreau, 'Notes biographiques,' in *Le Journal des poètes* 19

194 Gauvreau, *Poèmes de détention*, *Œuvres créatrices complètes* 871

195 Gauvreau, 'Dix-sept lettres à un fantôme' (letter of 13 Apr. 1950), pl. 358

196 Gauvreau, *Les Boucliers mégalomanes*, in *Chansons et poèmes de la résistance* 62; *Les Boucliers mégalomanes*, in *Le Journal des poètes* 19; *Œuvres créatrices complètes* 1250, 1260, 1230

197 Gauvreau, *Dix-sept lettres à un fantôme*, 13 Apr. 1950, p 359; *Œuvres créatrices complètes* 187 (where the text begins with 'Le Java')

198 Ferron, *Du fond de mon arrière-cuisine* 219

199 Gauvreau, *Œuvres créatrices complètes* 1492. The first syllables also recall one of Gauvreau's titles, 'Aragonie.'

200 Gauvreau, 'Le Jour et le joug sains' 2

201 *Ibid.*

202 Laurent Jenny, 'La Surréalité et ses signes narratifs,' *Poétique*, vol. 4, no 16, p 499

203 Gauvreau, 'L'Epopée automatiste vue par un cyclope' 69, 88

204 Jenny, 'La Surréalité et ses signes narratifs' 520

205 Gauvreau, 'L'Epopée automatiste vue par un cyclope' 69, 88

206 Gauvreau, *Dix-sept lettres à un fantôme*, 2 May 1950, p 26, unpublished. Note the reference to Nadja, who also appears in the final lines of *Beauté baroque*, written in 1952.

207 *Ibid.* 27

208 Gauvreau, 'L'Epopée automatiste vue par un cyclope' 65

209 Gauvreau, *Dix-sept lettres à un fantôme*, 2 May 1950, p 27, unpublished

210 André Breton, *L'Amour fou* 13. On convulsive beauty and the theory of surrealist narrative, see Claude Abastado, *Le Surréalisme* 144-5 and 165-9.

211 Gauvreau, *Dix-sept lettres à un fantôme* 2 May 1950, p 27, unpublished

212 *Ibid.* 17-18

213 'An uncontrollable, irrational act. An act of convulsive soothing.' (Claude Gauvreau, *Beauté baroque*, in *La Barre du jour*, autumn 1967, vol. 2, no 4, p 38)

214 'The feeling-woman wasted no time talking; not a second was devoted to pusillanimous rites. She didn't ask any questions. Born to live dangerously, born for tactile knowledge, born for spontaneous gifts: she was offered up by an automatic uprising.' (*Ibid.*, in *Parti pris*, Apr. 1966, vol. 3, no 9, p 26)

215 *Ibid.*, in *La Barre du jour* 41

216 *Ibid.*, in *Parti pris* 30

217 *Ibid.* 34-5

218 Ferron, *Du fond de mon arrière-cuisine* 225-6

219 Gauvreau, 'Notes biographiques,' *Le Journal des poètes* (Brussels), July 1967, vol. 37, no 5, pp 18-19. Cf. 'Quand la radio fait des experiences folles,' *La Presse*, 14 Feb. 1970 (Télépresse) 3.

220 The adjective 'épormyable' is important for Gauvreau. He described the grotesque laughter which greeted *Bien-être*: 'The laughter which today greets my alloys of far more complex words isn't worth a fart compared to that "épormyable" hilarity of hunchbacks in trance.' ('L'Epopée automatiste vue par un cyclope' 66) These lines bring to mind Jarry's 'hénaurme' laugh.

221 In a doctoral thesis on automatism written in 1889, Pierre Janet studied some of these secondary states. He described the case of a somnambulist who, when sleepwalking, was no longer myopic and talked in 'a new language formed of other images' (Janet, *L'Automatisme psychologique* 122). For the influence of Janet on André Breton and Philippe Soupault, see Bernard Robert, 'Pour une définition du surréalisme' and 'Le Surréalisme désocculté,' *Revue de l'Université d'Ottawa*, 1973, pp 297-306, 462-79, as well as Robert's *Le Surréalisme désocculté* 71-128.

222 Jean-Marcel Duciaume, 'Le Théâtre de Gauvreau: une approche,' *Livres et auteurs québécois*, 1972, p 336

223 Like Héliogabale in Antonin Artaud, *Héliogabale ou l'anarchiste couronné* (1934); *Œuvres complètes*, 1967, vol. 7, p 136

224 Jean-Marcel Duciaume, *ibid.* 339

225 The play prompted numerous polemics, notably one concerning the actors' refusal to complete the third performance. After prostrating himself in front of these actors – some of whom were his friends – to convince them to finish the show, Gauvreau 'charged' once again in the newspapers. Cf. *infra*, Opération Déclic.

226 Bruno Cormier, 'Miroir de l'aliénation de notre époque,' *L'Envers du décor*, Mar. 1974, vol. 6, no 5, p 2

227 Cf. Breton, *Manifeste du surréalisme* 61, 235-6.

228 Gauvreau, *Les Oranges sont vertes*, vol. 1, p 82

229 *Ibid.*, vol. 11, pp 209 ff.

230 *Ibid.*, vol. 1, p 6

231 Cf. interview with Marcel Sabourin and Robert Lalonde by A.G.B., Sept. 1972.

232 The work has not been identified, despite much searching. But Gauvreau's knowledge of the subject is not in doubt: 'For a long time I immersed myself in accounts of the opening of *Hernani* and the opening of *Sacre du printemps*' (Gauvreau, 'L'Epopée automatiste vue par un cyclope' 65). Jean-Pierre Ronfard remembers things slightly differently: 'Gauvreau said to me: "It's the name of a romantic hero!" I didn't ask further, perhaps not wishing to appear uneducated. I imagined it was a character from a fantasy by Nodier or Balzac.' (Jean-Pierre Ronfard, 'Le Personnage: dernière rencontre,' *L'Envers du décor*, Mar. 1974, vol. 6, no 5, p 5)

233 Maurice Nadeau, *Histoire du surréalisme* 25. Cf. Breton, *Second manifeste du surréalisme* 155.

234 In connection with the title of the article in *La Barre du jour* (cf. interview by Claude Gauvreau with Roger Soublière and A.G.B., Mar. 1969). 'Cyclops' was the name bestowed on Hugo by his wife and picked up by Sainte-Beuve in 'Des Gladiateurs en littérature,' June 1840. Cf. André Maurois, *Olympio ou la vie de Victor Hugo* 300-3.

235 See the references quoted above to Gauvreau and monism.

236 Gauvreau, *Les Oranges sont vertes*, vol. 1, p 7

237 *Ibid.* 15

238 *Ibid.*

239 *Ibid.* vol. 1, p 26. Cf. Claude Gauvreau, 'En art – Liberté avant tout,' *Le Haut-parleur*, 9 June 1951, p 5, c. 1, n 1: 'Pierre Mabille's book *Egrégores* is a masterful study of how civilizations evolve and their myths. Personally I agree with all his conclusions.'

240 *Ibid.*, vol. 1, pp 29-30. Mabille's egregores provide what is probably the best schema for establishing a structure to deal with protagonists. The isotopy of the hero would be the 'surrational' egregore and of the antagonist the 'canonical' egregore.

241 Gauvreau, *Les Oranges sont vertes*, in *Œuvres créatrices complètes* 1420. Note the chiasmus 'phrases de poésie ... syllabe de critique.' In Gauvreau's work, the word 'syllabe' usually designates poetry.

242 Gauvreau, 'Barroques [sic] canadiens dans les Pays-Bas,' *Le Haut-parleur*, 3 Feb. 1951, p 2

243 Gauvreau, 'Question de propagande,' *Le Haut-parleur*, 14 Jan. 1951, p 5

244 Gauvreau, *Dix-sept lettres à un fantôme*, 2 May 1950, p 13

245 For the affinities between Toupin and Montherlant see Jacques Ferron, 'Lettre ouverte à Claude Gauvreau sur les vaches,' *Le Haut-parleur*, 3 Mar. 1951; 'Lettre de Toupin à Gauvreau,' *ibid.*, 17 Mar. 1951; on certain aspects of fascism in Montherlant and Toupin see J. Ferron, 'Le Choix de Paul Toupin,' *ibid.*, 7 Apr. 1951.

246 Claude Gauvreau, 'Robert Gadouas a le courage de tenir tête aux censeurs,' *Le Haut-parleur*, 21 Apr. 1951; 'Ostracisme jésuitique – les coupures invraisemblables commandées par le Gesù' (28 Apr.); 'Au pays des Jésuites – Lili Saint-Cyr et les délectations moroses' (14 July); 'Au-delà de l'immondice jésuitique – André Goulet dit Goulo' (22 Dec.).

247 Gauvreau, *Œuvres créatrices complètes* 270

248 The term 'baroque' was so commonly used in Gauvreau's circle that Jean-Claude

Dussault used it twice in consecutive poems printed in *Le Haut-parleur*, 'Nuit d'été' and 'Sacrificial' (21 Jan. 1951).

249 Claude Gauvreau, 'Cézanne, la vérité et les vipères de bon ton,' *Le Quartier latin*, 9 Feb. 1945, p 5

250 Gauvreau, *Les Oranges sont vertes*, in *Œuvres créatrices complètes* 1420-1

251 Gauvreau, 'L'Automatisme ne vient pas de chez Hadès' (part 1), *Notre temps*, 6 Dec. 1947, p 3

252 *Ibid.*

253 *Ibid.* (part 2), 13 Dec. 1947, p 6. The page in the newspaper is dated the 6th by mistake.

254 Cf. the polemics on the play which in themselves became another 'charge.' For example, Claude Gauvreau, 'La Mort de l'Orignal épormyable,' *La Presse*, 16 May 1970, p 49; also Monique Du Plantie, Jacques Crête, Albert G. Paquette, 'Une nouvelle charge épormyable,' *La Presse*, 23 May 1970, p 41

255 Gauvreau, in *Le Haut-parleur*, 28 July 1951, p 5

256 See Gauvreau, 'Quelques poètes inconnus,' *Le Haut-parleur*, 30 June 1951, pp 5, 7. Discussed here are Lautréamont, Germain Nouveau, Arthur Cravan, Jacques Vaché, Guillaume Apollinaire, Max Jacob, Blaise Cendrars, Pierre Reverdy, Tristan Tzara, Francis Picabia, Paul Eluard, André Breton, Antonin Artaud, Gisèle Prassinos, Aimé Césaire, and Henri Pichette. The article was written as early as 1951!

257 Claude Gauvreau, 'Les Affinités surréalistes de Roland Giguère,' in *Etudes littéraires*, vol. 5, no 3, Dec. 1972, pp 502, 505

258 *Ibid.* 509

259 *Ibid.*

260 Gauvreau, *Dix-sept lettres à un fantôme*, 30 Dec. 1949, pp 24-6, unpublished

261 *Ibid.*, 7 Jan. 1950, p 3, unpublished

262 *Ibid.* 9, unpublished

263 *Ibid.*, 19 Apr. 1950, p 9, unpublished

264 *Ibid.*, 7 Jan. 1950, p 10, unpublished

265 *Ibid.*, 8 Feb. 1950, pp 26-7, unpublished

266 Gauvreau, 'Aragonie et surrationnel,' *La Revue socialiste*, no 5, spring 1961, p 67

267 Gauvreau, *Dix-sept lettres à un fantôme*, 26 Apr. 1950, p 27, unpublished

268 *Ibid.*, 10 May 1950, p 23, unpublished. On monism, see Gérard Durozoi and Bernard Lecherbonnier, *Le Surréalisme* 84-7.

269 André Breton, 'Limites non-frontières du surréalisme,' in *La Clé des champs* 18

270 Gauvreau, *Dix-sept lettres à un fantôme*, 1 Feb. 1950, pp 12-13, unpublished

271 *Ibid.* 8, unpublished

272 On this subject, see André Gervais' comments in 'Eaux retenues d'une lecture,' *Voix et images*, vol. 2, no 3, Apr. 1977, pp 390-406.

273 Gauvreau, *Dix-sept lettres à un fantôme*, 13 Apr. 1950; see pp 349-53 for the rhythmic image, p 353 for the 'image mémorante.'

274 Jean, *Histoire de la peinture surréaliste* 124

275 Cf. Ernst, *Ecritures* 262.

276 The term is perhaps clarified in this extract from a letter to Dussault in which Gauvreau explains in terms of exploration the idea behind Borduas' denial of 'intention': 'Surrational workers cannot deny this major discovery which opens up enormous gates upon the unexplored, namely that the result is more important than the goal.' (*Dix-sept lettres à un fantôme*, 30 Mar. 1950, pp 22-3)

277 Gauvreau, *Dix-sept lettres à un fantôme* 357-61

278 René Major refers to a kind of analysis which he traces back to Freud:
'Spoken words are always the vestiges of words seen or heard. Dreams often provide
us with examples of this. But, admittedly, in this regard the sources of the language
we use in conscious life may be more difficult to trace than those of dream lan-
guage, since in dreams verbal images very frequently yield to visual images and are
more circumscribed ...
 Certain formulations, true verbalizations of obsessions, provide excellent enigmas
for deciphering. Freud gives a good example in "L'Homme aux rats": an incanta-
tion in the form of an acrostic ("Glejisamen") uttered by his patient Lorentz con-
sciously expresses a magic wish: "May Lorentz be happy now and forever, amen."
The decoding of this acrostic shows that it hides the anagram of the revered
woman, Gisela, whom he brings in contact with sperm (semen) via this formulation.
The final amen finds its place in the condensed expression and punctuates his prayer.'
 Major then analyses patients' expressions: 'Ah! l'inceste!' ('Alain, cesse!'); 'ma
marie-jeanne' ('marie de Jeanne'; 'marijuana'; 'Marie Janet'); 'Sanzit-Montront'
('sans zizi, mon rond'). (René Major, 'Le Logogriphe obsessionnel,' *Interprétation*,
Jan.-Mar. 1968, vol. 2, no 1. The paragraphs quoted above are on pp 5-6.
279 Gauvreau, *Dix-sept lettres à un fantôme*, 22 Mar. 1950, p 10, unpublished
280 Paul Chamberland, 'Fondation du territoire,' *Parti pris*, May-Aug. 1967, vol. 4, nos
9-12, p 41
281 Claude Haeffely, 'La Poésie-bouge,' *La Barre du jour*, June-July 1968, pp 59-62
282 Claude Gauvreau, unpublished letter to Jean-Marc Montagne, 6 Apr. 1968. The
idea crops up again in an interview in the films *La Nuit de la poésie* and *Claude
Gauvreau poète*.
283 Paul-Emile Borduas, letter to Claude Gauvreau, Nov.-Dec. 1958, entitled 'Petite
pierre angulaire dans la tourbe de mes vieux préjugés,' *Liberté*, no 22, p 248
284 Claude Gauvreau, unpublished letter to Jean-Marc Montagne, 6 Apr. 1968
285 Gauvreau, *Dix-sept lettres à un fantôme*, 8 Feb. 1950, pp 24-6, unpublished
286 *Ibid.*, p 29, unpublished
287 *Ibid.*, 16 Feb. 1950, pp 2-3, unpublished
288 Claude Gauvreau, 'A propos de miroir déformant,' *Liberté*, Mar.-Apr. 1970, no 68,
pp 95-102
289 Cf. Pierre de Grandpré, *Histoire de la littérature française du Québec*, vol. 3, 1969,
p 243. François Bourdages attributes these words to Mme Irène Kwiatkowska-de-
Grandpré; cf. 'Pour réparer les erreurs passées,' *Le Devoir*, 17 July 1971, p 11.
290 Michel Van Schendel, 'Claude Gauvreau,' in Pierre de Grandpré, *Histoire de la
littérature française du Québec*, vol. 3, pp 239-40
291 Philippe Haeck, 'Chronologie de la vie et de l'œuvre de Paul-Marie Lapointe,' *La
Barre du jour*, no 17-20, pp 283-7. Haeck has analysed the influence of Eluard,
Fargue, and Rimbaud more extensively: 'The discovery of Rimbaud corresponds to
all the violent images, images which explode, open up; illuminations, baroque im-
ages are relevant here ... Under the sign of Fargue ... they are turned towards the
self, the past ... a moment of privacy, of casualness, of wanderlust, occasionally leav-
ened with a touch of humour ... Under the sign of Paul Eluard in *Capitale de la
douleur* ... clear images: dreams and fantasy here acquire precise contours. All is at
once simple and magical, words dream.' (Philippe Haeck, *L'Action restreinte / de la
littérature* 77-9)
292 Gauvreau, *Dix-sept lettres à un fantôme*, 2 May 1950, p 30, unpublished
292 One year after reading the collection, Jean-Claude Dussault reviewed it for *Le Haut-
parleur*: 'The words have become strokes of vibrant matter, the sound is often more

colour than music ... In this respect, Paul-Marie Lapointe is a pictorial poet, so to speak. But in order to be the least bit sensitive to the poetic form, pictorial or not, one's sensibility must be alerted to cast off the convention of words and take in its true nature, spontaneously ... By creating the appearance of form, Lapointe recalls the French surrealists without even being aware of them – Lapointe's poetry is a primitive poetry, and its formal evolution can only throw people off; it is the first explosion of a flavour combining word and image.' (Jean-Claude Dussault, '*Le Vierge incendié*,' *Le Haut-parleur*, 14 Mar. 1951, p 4)

294 Philippe Haeck, '*Le Vierge incendié* de Paul-Marie Lapointe,' *La Barre du jour*, nos 17-20, p 283

295 The 1947 International Surrealist Exhibition dedicated an altar to Jarry's Jeanne Sabrenas. Cf. Henri Pastoureau, 'Le Surréalisme de l'après-guerre' 107.

296 There was a Quebec edition of *Illuminations* and *Autres Illuminations* under the title *Œuvres de Jean-Arthur Rimbaud* (Montreal: Valiquette, nd). Pellan claims to have produced a series of drawings for a Quebec edition of *Capitale de la douleur*, but no evidence has been found of such an edition. *Poésie 46*, an anthology edited by Parizeau in 1946 with Segher's authorization, nevertheless includes four poems from *Lingères légères* (no 1, pp 27-30). Parizeau's catalogue for 1946 announced the publication of this latter collection in the series 'Les grands poètes d'aujourd'hui,' as well as *Anthologie des poètes de la résistance*, with a preface by Aragon.

297 The formal aspects of Lapointe's 'prose' have been the subject of numerous studies, especially André Vachon on the rectangular poems ('Fragments de journal pour servir d'introduction à la lecture de Paul-Marie Lapointe,' *Livres et auteurs québécois*, 1968, p 238, c. 2); also Pierre Nepveu on the 'blanks' (*Les Mots à l'écoute*, 1979, p 203): Philippe Haeck on the 'mots-flots' ('*Le Vierge incendié* de Paul-Marie Lapointe,' *La Barre du jour*, nos 17-20, 1969, pp 287-8).

298 Cf. Jean-Louis Major, *Paul-Marie Lapointe: la nuit incendiée* (1978) 22.

299 André Breton, *Manifestes du surréalisme* ('Idées,' no 23) 31, 52; Pierre Caminade, *Images et métaphore* 32-3

300 Jean Leymarie, *L'Impressionnisme*, vol. 2, p 86

301 Lapointe, *Le Vierge incendié* 59

302 *Ibid.* 68

303 *Ibid.* 75, 93, 25

304 Gloria Feman Orenstein, *The Theater of the Marvelous* 8, 25-6; cf. Anna Balakian, *Surrealism: The Road to the Absolute* 192.

305 Paul Eluard, *Capitale de la douleur suivi de L'Amour la poésie* ('Poésie / Gallimard') 153; cf. preface, p 8. See Vachon's article, 'Fragments ...' 236, c. 1.

306 Claude Gauvreau, letter to Jean-Claude Dussault, 13 Apr. 1950, in *La Barre du jour*, nos 17-20, pp 353-4

307 Jean-Louis Major, *Paul-Marie Lapointe: la nuit incendiée* 22

308 Paul-Marie Lapointe, *Le Vierge incendié* 5; *Le Réel absolu* 15-16

309 *Ibid.* 17; *Le Réel absolu* 30

310 Paul-Marie Lapointe, *Le Vierge incendié* 16; *Le Réel absolu* 29

311 *Ibid.* 77; *Le Réel absolu* 91

312 *Ibid.* 71; *Le Réel absolu* 85

313 'The highest form of poetry, like the highest form of painting, is improvisation; it allows no hindrance to expression, even though its excellence depends upon a prerequisite craftsmanship ... On a formal level (and this is perceived afterwards, as if to permit the verification of jazz in the poem) the reprise of a theme in different modes creates an identity. The theme might be extremely simple yet include within itself a

complexity permitting modulation ... This poetry is a new kind of lyricism, a North American form, a sister of jazz, with all that implies concerning borrowings from older cultures.' (Paul-Marie Lapointe, 'Notes pour une poétique contemporaine,' *Liberté*, Mar. 1962, pp 183-4; quoted in Robert, *Poésie actuelle* 202-3)

314 On this point, see Guy Laflèche, 'Ecart, violence et révolte chez Paul-Marie Lapointe,' *Etudes françaises*, vol. 6, no 4, pp 397-8, and Noël Audet, 'La terre étrangère appropriée,' *Voix et images du pays*, vol. 2, Apr. 1969, pp 31-42.

315 Lapointe, *Le Vierge incendié* 10 (*Le réel absolu* 23), and p 102(121).

316 *Ibid.* 51(65), 19(32), 78(93), 105

317 Guy Laflèche, 'Ecart, violence et révolte chez Paul-Marie Lapointe,' *Etudes françaises*, vol. 6, no 4, pp 414, 417

318 Paul-Emile Borduas, 'Commentaires sur des mots courants,' *Refus global*, Ed. Anatole Brochu, pp 31-2

319 Paul-Marie Lapointe, *Nuit du 15 au 26 novembre 1948*, in *Le Réel absolu* 158

320 Lapointe, 'Pauvres petites,' *La Barre du jour*, nos 17-20, p 309; *Le Réel absolu* 156-7

321 Lapointe, *Le Vierge incendié* 65; *Le Réel absolu* 79

322 Lapointe, *Nuit du 15 au 26 novembre 1948* 162

323 *Ibid.* 132, 140

324 Despite Jacques Ferron's denials (*Le Devoir*, 11 Mar. 1972, p 13); cf. Gaétan Dostie, 'Paul-Marie Lapointe: The Seismograph of Québec,' *Ellipse* 11, 1972, p 60.

325 Lapointe, *Choix de poèmes*, in *Le Réel absolu* 184

326 *Ibid.* 173

327 *Ibid.*

328 Lapointe, *Pour les âmes*, in *Le Réel absolu* 208

329 *Ibid.* 219

330 *Ibid.* 250

331 Guy Laflèche, 'Ecart, violence et révolte chez Paul-Marie Lapointe,' *Etudes françaises*, vol. 6, no 4, p 417

332 G.-André Vachon, 'Fragments de journal pour servir d'introduction à la lecture de Paul-Marie Lapointe,' *Livres et auteurs canadiens* (1968) 239

333 Quoted in the epigraph to Paul-Marie Lapointe's collection *Le Réel absolu* 7. But cf. the introduction to Achim d'Arnim's *Contes bizarres* (pp 13, 20) for a few of Breton's restrictions regarding 'mysticism' and 'the fairly confused but ultrareactionary doctrine' of Novalis.

334 Breton, *Manifestes du surréalisme*, Ed. Pauvert, p 27

335 Barbeau had a retrospective at the Museum of Contemporary Art in Mar. and Apr. 1969 (see *Barbeau*, catalogue of the exhibition, with an introduction by Bernard Teyssèdre). Along with Marcelle Ferron, he had publicly denounced the Stalinist nature of the Place des artistes exhibition in 1953 (see *Samedi-Dimanche*, 16 May 1953; quoted in *Québec Underground*, 1962-72, vol. 1, p 30). Later, in *La Revue socialiste*, he published an article on Borduas' death to go with the first of the complete re-editions of *Refus global*; see *La Revue socialiste*, summer 1960, no 4, pp 56, 57-63. These include several typos and errors, including the omission of Thérèse Renaud-Leduc's name from the list of signatories. An article by Barbeau, 'Face à la meute,' had appeared in issue 3, winter 1959-60. Barbeau's writings are few but incisive.

336 Suzanne Meloche, 'Poèmes,' *Situations*, vol. 1, no 7, 1959, p 89

337 Meloche, *Les Aurores fulminantes*, in *Les Herbes rouges*, no 78, Jan. 1980, pp 4-6, 9, 13. Barbeau's text was not included in this edition.

338 *Ibid.* 11

CHAPTER FOUR: NEW MOVEMENTS

1 *Les Armes blanches*, in *L'Age de la parole* 106. Giguère writes, 'I think that these few lines describe fairly well the ethos of that decade. My friends were painters, they reshaped the landscape because "The landscape had to be reshaped as well," they created ex nihilo those exemplary places where we went to dream.' (Roland Giguère, 'De l'âge de la parole à l'âge de l'image,' *La Presse*, 16 Apr. 1966, p 6)

2 The title *Prisme d'yeux* recalls the prismatic art of the cubists; Pellan was a well-known and ardent supporter of cubism: 'Pellan only believed in the cubism which was already there and, thanks partly to him, we were not mystified by it.' (Borduas, *Projections libérantes* 17-18) The text of *Prisme d'yeux* was reprinted in Guy Robert's *Pellan, sa vie et son œuvre* 49-50.

3 The name is a collage of the first letters in Copenhagen, Brussels, and Amsterdam. On the collaboration of Dumouchel and McLaren at *Cobra*, see 'Pour saluer Cobra' by Jean-Claude Leblond, *Le Devoir*, 18 Dec. 1976, p 21, c. 8.

4 Roland Giguère, 'A propos de ...,' interview by France Théorêt and Jean Stafford in *La Barre du jour*, nos 11-13, pp 164-5

5 An anagram of Jean Benoît

6 Taken from an original placard, as told to the author by Lucien Morin

7 'Filion tells us he likes Borduas' painting very much but cannot agree with all his ideas. His own Christian morality requires other perspectives and consequently a different kind of painting.' (Louise Daudelin, 'Gabriel Filion,' *Notre temps*, 23 Oct. 1948, p 4)

8 Lucien Morin, unpublished letter to Jacques Beauregard, 1 Dec. 1967

9 'A painter, Paul-Emile Borduas, issued three manifestoes from 1947 to 1949, *Prisme d'yeux* [sic], *Refus global*, *Projections libérantes*' (Auguste Viatte, *Histoire littéraire de l'Amérique française* 198). Pellan founded *Prisme d'yeux* in Feb. 1948, and Borduas published *Refus global* in Aug. 1949: the latter owed a lot to the slim manifesto *Prisme d'yeux* (Robert, *Pellan, sa vie et son œuvre* 52). For a restatement of the same idea, see Gérard Tougas, *Histoire de la littérature canadienne-française* 152.

10 Lucien Morin, letter to Jacques Beauregard, 1 Dec. 1967, unpublished

11 Interview with Jacques de Tonnancour by A.G.B., Mar. 1969

12 Lucien Morin, letter to Jacques Beauregard, 1 Dec. 1967, unpublished

13 R.H. Hubbard, *L'Evolution de l'art au Canada* 115-24; Guy Robert (*Pellan, sa vie et son œuvre* 50) notes the influence of Eluard's *Capitale de la douleur* on Pellan, which he read in 1948.

14 Donald D. Buchanan, 'Introduction,' *Alfred Pellan*, catalogue of the 1956 retrospective

15 Interview with Alfred Pellan by André-H. Gagnon, Mireille Filion, Louise Harel, and Jean-François Léonard, Mar. 1968. Cf. Robert, *Pellan, sa vie et son œuvre* 58.

16 Guy Gagnon, 'Pellan et Parent révèlent hier soir *Prisme d'yeux*,' *Le Droit*, 6 Feb. 1948, p 4; Jean Simard, 'Autour du *Prisme d'yeux*,' *Notre temps*, 14 Feb. 1948, p 5

17 Madeleine Gariépy, 'Exposition Prisme d'yeux,' *Notre temps*, 22 May 1948, p 5; 'Interview – Mimi Parent,' *Notre temps*, 12 June 1948, p 5. Archambault, Rhéaume, and Roberts are missing, but André Pouliot is included.

18 Borduas, *Projections libérantes* 35

19 Albert Dumouchel, interview with A.G.B., Apr. 1970

20 For example, *Nu* by Mimi Parent in the May 1947 issue and *Les jeux de la nuit* by Roland Truchon in the following issue

21 Borduas, *Projections libérantes* 35. The censored work has not been identified.

22 Cf. François-M. Gagnon, 'Contribution à l'étude de la genèse de l'automatisme pictural chez Borduas,' *La Barre du jour*, nos 17-20, p 215.

23 Roger Duhamel, *Les Ateliers d'arts graphiques*, no 3, 21 Feb. 1949, p 3
24 *Ibid.*
25 René Huyghe, *L'Art et l'homme*, vol. 3, p 476
26 Géraldine Bourbeau, 'John Lyman, peintre – Louis Archambault, sculpteur,' *Liaison*, vol. 1, no 5, May 1947, pp 307-8
27 Bourbeau, 'Goodridge Roberts,' *Liaison*, vol. 2, no 18, Oct. 1948, p 495
28 Bourbeau, 'Borduas – de Tonnancour – l'Ecole du meuble,' *Liaison*, vol. 3, no 26, June 1949, p 357
29 Bourbeau, 'Prisme d'yeux, Monsieur Borduas et l'automatisme,' *Liaison*, vol. 2, no 13, Mar. 1948, p 172
30 M. Trouillard, 'Prisme d'yeux,' *La Revue moderne*, May 1948, p 25
31 José Pierre, *Le Ça Ira*, illus. by Mimi Parent, 1967, p 9
32 André Breton, 'Mimi Parent' (1960), *ibid.* 390-1
33 André Breton, 'Henri Rousseau sculpteur?' (1961), *ibid.* 372, 375
34 Jean-Louis Bédouin, *Vingt ans de surréalisme* 289, 300, and 304 note 9
35 René Passeron, *Histoire de la peinture surréaliste* 284, 289-90, 350-1
36 Alain Jouffroy, *Une Révolution du regard* 34ff.
37 Robert Bénayoun, *Erotique du surréalisme* 8-9, 216-18, 228-31
38 Otto Hahn, 'Le Surréalisme à l'heure du musée ou de la jeunesse,' *Arts*, 1 Dec. 1965, p 20
39 *Arts*, nos 10-11, 23 June 1965, p 5. Passeron takes Breton's alphabetical ordering as a ranking by preference; *Histoire de la peinture surréaliste* 309.
40 Vincent Bounoure, *Envers l'ombre*, ill. by Jean Benoît, Ed. Surréalistes 1968
41 Jean-Louis Bédouin, *Vingt ans de surréalisme* 300. The story is also told by Bénayoun, *Erotique du surréalisme* 228-9.
42 Bédouin, *Les Masques*, coll. 'Que sais-je,' no 905 (Paris: PUF 1961)
43 Bédouin, *Vingt ans de surréalisme* 289
44 Passeron, *Histoire de la peinture surréaliste* 283-4
45 Annette Michelson, 'But Eros Sulks,' *Arts*, Mar. 1960, vol. 34, no 6, p 35
46 Guy Viau, *La Peinture moderne au Canada français* 58
47 Guy Robert, in *Vie des arts*, no 44, autumn 1966, p 41
48 Viau, *La Peinture moderne au Canada français* 58
49 Unpublished letter from Paddy O'Brien to Thérèse Labelle, 3 Jan. 1967. Cf. London Public Library and Art Museum, *Surrealism in Canadian Painting*, catalogue, London, Ontario 1964.
50 Interview with Albert Dumouchel by F.-M. Poirier, C. Lanthier, L. Varin, E. Joly, T. Labelle, 14 Dec. 1966
51 'Les Cadavres exquis des disciples de Pellan,' *Vie des arts*, summer 1967, no 47, pp 22-5
52 Jean-René Ostiguy, 'Chronologie' in *Léon Bellefleur*, catalogue of the 1968-9 retrospective, pp 10-11
53 Jean Thiercelin also contributed to the periodicals *Edda*, *Phases*, and *Documento Sud*. His collection of poems, *Demeures du passevent* (1974), was illustrated by Bellefleur.
54 Claude Gauvreau, *Dix-sept lettres à un fantôme*, 19 Apr. 1950, p 18, unpublished
55 Léon Bellefleur, unpublished letter to Jean Richer, 21 Feb. 1968
56 Roland Giguère, 'Léon Bellefleur, Eclaireur,' in *Léon Bellefleur*, catalogue of the 1968-9 retrospective, p 9
57 *100 Sérigraphies*, an album of 10 original silk-screens each by Bellefleur, Beaudin, Dumouchel, Ewen, Ferron, Giguère, Jasmin, Mousseau, Raymond, and Tremblay, published by Erta

58 *Quinze dessins de Léon Bellefleur*, published by Erta 1954
59 R.-H. Hubbard, 'Le Monde mystérieux du rêve chez Léon Bellefleur,' preface,
 Quinze dessins de Léon Bellefleur
60 Léon Bellefleur, unpublished letter to Jean Richer, 21 Feb. 1968. The ideas in this
 letter crop up again in another letter to Guy Robert, in which Bellefleur notes that
 his automatism is occasionally representational: 'Another point I wish to make with
 regard to this 1968 series *Lieux retrouvés* (with figures, why not?) ... With the aid of a
 large variety of automatisms, I tried to locate myself in the unconscious and retrieve
 the memory of places or scenes which had been experienced, perhaps even before my
 time. I was also as unconscious as possible when working, but with a presence as in-
 tense as I could muster ... All this is still very surrealist. It can't be helped!' (Léon
 Bellefleur, letter to Guy Robert, 7 Dec. 1972, in Guy Robert, *L'Art au Québec depuis
 1940* 101 note 5)
61 'In his work the surrealist light shines longer. Nevertheless, it stops playing the role of
 black magic; rather it beckons towards the discovery of a magically expanding uni-
 verse.' (Jean-René Ostiguy, 'Jeune peinture au Canada,' *L'Œil* [Paris], Apr. 1967,
 no 148)
62 Léon Bellefleur, unpublished letter to Jean Richer, 21 Feb. 1968
63 Marcel Sabourin, lecture in the course on Artaud, Université de Québec à
 Montréal, 7 Nov. 1979
64 Jean Gachon, 'Alan Glass, portier pour vivre, expose des desseins surréalistes,' *La
 Presse*, 10 Jan. 1958; Jean V. Dufresne, 'Un jeune artiste canadien à Paris,' *La
 Presse*, 25 Jan. 1958. Naïm Kattan also met the European surrealists in Paris before
 settling in Montreal. His fictionalized autobiography of a young Baghdad Jew who
 lands in Paris in 1947 was published in 1977 under the title *Les fruits arrachés* (see
 p 62).
 Furthermore, Auguste Viatte's note in *Culture française*, no 4, winter 1980, p 4
 indicates that the Haitian poet René Depestre published some of his surrealist works
 in Montreal. Well known for the role he played in the revolution which broke out
 after Breton visited Haiti in 1945 (cf. Bédouin, *Vingt ans de surréalisme* 73-8), De-
 pestre is closer to the surrealism of Port-au-prince (*Etincelles*, 1945; *Gerbe du sang*,
 1946) and Paris than to that of Montreal (see Viatte, *Histoire littéraire de l'Amérique
 française* 474-6).
65 Cf. Claude Gauvreau, 'Roland Giguère poète du Nouveau Monde,' *Le Haut-
 parleur*, 28 July 1951, and Wilfrid Lemoyne, 'Un jeune poète montréalais imprime
 ses livres – La belle aventure des Editions Erta,' *L'Autorité du peuple*, 30 Jan. 1954, p
 6.
66 Michel Carrouges, *Eluard et Claudel* (1945)
67 Françoise Chamblas, *Eluard et Giguère* 37-52
68 'The titles of some of the poems from this period seem to pay homage to the man
 who inspired the poetry of Giguère. 'Corps glorieux' (Giguère, *L'Age de la parole*
 44) recalls 'Corps mémorable' (Eluard, *Œuvres complètes*, vol. 2, p 119); 'Echelle
 humaine' (Giguère, *L'Age de la parole* 125) and 'La Pyramide diminue' (*ibid.* 128)
 are a homage to 'La Pyramide humaine' (Eluard, *Œuvres complètes*, vol. 1, p 201). Elu-
 ard's influence is also felt in 'Un amour au long cours': 'Woman of forever / I write
 your name in capital letters' (Giguère, *L'Age de la parole* 43). These lines recall the
 marvellous litany in *Liberté*: "I write your name".' (Françoise Chamblas, *Eluard et
 Giguère*, 59-60, unpublished).
69 *Ibid.* 68

70 Roland Giguère, 'Déborder les cadres,' *Les Ateliers d'arts graphiques*, Feb. 1949, p 26; 'A vrai dire,' *ibid*. 26 and 'Savoir voir,' *ibid*. 27

71 Giguère, 'A vrai dire,' *ibid*. 26

72 *Ibid.*, 'Savoir voir'

73 Later he became reconciled to Breton and wrote an article on him in Dec. 1949 in a commemorative issue published at La Baconnière de Neuchatel. He also wrote a book in 1950, *André Breton et les données fondamentales du surréalisme*.

74 Roland Giguère, *Faire naître*, illustrated with three silk-screens by Albert Dumouchel (Montreal: Erta 1949), 100 copies

75 Giguère, *Trois pas*, ill. with 4 engravings by Conrad Tremblay (Montreal: Erta 1950), 33 copies

76 Giguère, *Les Nuits abat-jour*, ill. collages on wood by Albert Dumouchel (Montreal: Erta 1950), 25 copies

77 Giguère, *Yeux fixes*, ill. by Gérard Tremblay (Montreal: Erta 1951), 180 copies

78 Giguère, *Midi perdu*, ill. by Gérard Tremblay (Montreal: Erta 1951), 20 copies

79 Giguère, *Images apprivoisées*, poems with 'found clichés' (Montreal: Erta 1953), 100 copies

80 Giguère, *Les Armes blanches*, with a drawing by the author and a silk-screen by Albert Dumouchel (Montreal: Erta 1954), 350 copies

81 Gérard Tremblay, *Horizons*, intro. by R. Giguère (Montreal: Erta 1951)

82 *Quinze dessins de Léon Bellefleur*, intro. by R.H. Hubbard (Montreal: Erta 1954)

83 Roland Giguère and Théodore Koenig, *Le Poème mobile*, ill. by Giguère (Montreal: Erta 1951), 100 copies

84 Théodore Koenig, *Le Jardin zoologique écrit en mer*, ill. by Conrad Tremblay (Montreal: Erta 1954), 300 copies

85 Gilles Hénault, *Totems*, ill. by Albert Dumouchel (Montreal: Erta 1953), 325 copies

86 Claude Haeffely, *La Vie reculée*, ill. by Anne Kahane (Montreal: Erta 1954), 100 copies

87 Roland Giguère, 'De l'âge de la parole à l'âge de l'image,' *La Presse*, 16 Apr. 1966, p 16

88 André Breton, *Position politique de l'art d'aujourd'hui* 271-2

89 *Revue internationale de l'art expérimental – Cobra*, no 10. In 1954, Koenig's brother, the director of a gallery in Liège, organized an exhibition of 'young Canadian painters' and there was no longer any reason why automatists like Mousseau should not have participated. Reviews appeared in *La Meuse* (Liège), 3 Nov. 1954; *La Gazette de Liège*, 5 Nov. 1954. A similar exhibition had taken place in Liège in 1950. Gauvreau reviewed it; see 'Barroques [sic] canadiens dans les Pays-Bas,' *Le Haut-parleur*, 3 Feb. 1951, p 2.

90 See 'Dessins surréels' in *Les Dessins de Norman McLaren* 19-32. Most of the drawings date from the end of the forties and the beginning of the fifties.

91 Edouard Jaguer, *Images à claire voie*, introduction to the exhibition at the Galerie Libre, 27 Mar.-8 Apr. 1961; Edouard Jaguer, *Des pierres où le regard s'affûte*, introduction to the exhibition at the Galerie Ranelagh (Paris), 21 Mar.-30 Apr. 1962; Edouard Jaguer, *A deux battants*, introduction to the exhibition held at Charles Zalber's house in Paris and including Biasi, Ginet, and Meyer-Peterson, 3-17 May 1962

92 Claude Gauvreau, *Dix-sept lettres à un fantôme*, 30 Mar. 1950, pp 24-5, unpublished

93 Roland Giguère, 'Vivre mieux,' in *L'Age de la parole* 11

94 Giguère, *Vieux jeux*, 1951, in *L'Age de la parole* 18

95 Giguère, from *Les Nuits abat-jour*, 1950, *ibid*. 65

 96 Giguère, from *Yeux fixes*, 1951, *ibid.* 87
 97 *Ibid.*
 98 Giguère, 'Pour tant de jours,' 1951, *ibid.* 15-16
 99 Giguère, 'Paysage dépaysé,' taken from *Armes blanches*, 1954, *ibid.* 111
100 'A propos de ...,' *La Barre du jour*, nos 11-13, pp 165-6
101 André Brochu, 'Commentaire de Roses et ronces,' *La Barre du jour*, nos 11-13, Dec.-May 1968, p 50
102 Giguère, 'Un jour de rose ovaire,' 1955 *L'Age de la parole* 37
103 Interview with Giguère by A.G.B., Apr. 1970
104 René Passeron, *Histoire de la peinture surréaliste* 320, 329, 351
105 *Phases*, no 2, Mar. 1955
106 *Panorama-Peinture au Québec – 1940-1946* 28 (where the date given is 1954)
107 Giguère, 'L'Echelle humaine' (taken from *Lieux exemplaires*), *Phases*, no 3, Nov. 1956
108 Giguère, 'La Main du bourreau finit toujours par pourrir,' *Phases*, nos 5-6, Jan. 1960
109 'Devant le fatal,' *Phases*, no 8, Jan. 1963
110 *Phases*, no 7, May 1961
111 'Au-delà' and 'Horizons' (the latter taken from a book already published by Erta), *Place publique*, no 1, 21 Feb. 1951, pp 19, 33 (the first does not appear in the table of contents); 'Le Visage intérieur de la peinture' and 'L'Homme et la poutre,' *ibid.*, no 2, Aug. 1951, pp 28-30, 46 (the second does not appear in the table of contents).
112 See Léon Koenig, 'Jeunes peintres,' in issue no 1, p 34, taken from the Liège catalogue. Roland Giguère, 'Comme un massacre,' *Phantomas*, vol. 1, no 6, 15 Dec. 1953
113 Giguère, 'Cendres' and 'L'Oeil en proie aux pires malheurs,' *Temps mêlé*, no 13, Feb. 1955
114 Giguère, 'Pequeño desastre de familia' and 'Un mundo blando,' *Boa*, no 2, June 1958
115 Giguère, 'Les Couleurs de l'oracle,' *Edda*, no 1, summer 1958; 'L'Ombre des jardins' and 'Dans l'attente d'une transfiguration,' *Edda*, no 2, Mar. 1959; 'Le Temps est à l'écho,' 'La Nuit aux fenêtres,' and 'Journée enfin domptée,' *Edda*, no 3, Mar. 1961
116 Giguère, 'Un monde mou,' *Documento Sud*, 1960
117 Roland Giguère, *Le Défaut des ruines est d'avoir des habitants* 35
118 René Char, letter to Roland Giguère, 17 Nov. 1957
119 Micheline Sainte-Marie, 'Qui est Miror? une étude sur Roland Giguère,' *Présence*, vol. 4, no 4, Dec. 1957–Jan. 1958, pp 7-10
120 Giguère, *Pouvoir du noir* 9-10
121 Philippe Haeck, *L'Action restreinte / de la littérature* 85-6
122 André Breton, *Position politique de l'art d'aujourd'hui* 273
123 Reprinted in *La Barre du jour*, nos 11-13, 'Connaissance de Giguère'
124 Léon Bellefleur, 'Giguère, peintre et artiste graphique,' *ibid.* 139. Cf. a few parallels to Lautréamont pointed out by Françoise Chamblas, *Eluard et Giguère* 66.
125 François-M. Gagnon, 'Le Soleil noir, le piège et l'oiseau de malheur,' *La Barre du jour*, 'Connaissance de Giguère,' nos 11-13, p 116
126 Roland Giguère, *La Main au feu* 9
127 François Ricard, 'Giguère et Ducharme Revisited,' *Liberté*, no 91, vol. 16, Jan.-Feb. 1974, p 96

128 Claude Gauvreau, 'Sur Roland Giguère poète,' lecture given 12 Feb. 1970, printed in *Etudes littéraires*, vol. 5, no 3, Dec. 1972, p 501

129 *Ibid.* 511

130 Gilles Hénault, 'Feu sur la Bête-angoisse,' *Les Ateliers d'arts graphiques*, 21 Feb. 1949, p 19

131 Hénault, 'On tourne,' *ibid.* 18

132 *Ibid.*

133 Hénault, 'Le Jour du jugement,' *La Barre du jour*, nos 17-20, pp 329-30

134 Hénault, 'Cablogramme,' *ibid.* 331-2. The poem is dated 1948.

135 Hénault, 'Bagne,' *Place publique*, no 2, Aug. 1951, p 31. See also *La Barre du jour*, nos 17-20, p 333; here the poem is dated 1948 and the title has been restored: 'Bordeaux-sur-Bagne.' Later editions give 'd'un prolétaire.' Cf. *Signaux pour les voyants* 46.

136 Hénault, *Totems* 10; *Signaux pour les voyants* 102

137 *Ibid.* 13; *Signaux pour les voyants* 106. There are two typos: 'T'a fait mûr' and 'télégraphes.'

138 Gilles Marcotte, *Le Temps des poètes* 85

139 Hénault, *Totems* 26. Cf.: 'For me Indians had a kind of subversive value, they weren't just folklore. I thought, "They were destroyed; are they going to destroy us too?," and when I said "us," I was thinking of French-Canadians, Québecois, but I was also thinking about all the workers there who were in danger of being destroyed.' (Philippe Haeck, Jean-Marc Piotte, and Patrick Straram, 'Entretien; 30 ans après le *Refus global*,' *Chroniques*, vol. 1, no 1, p 17)

140 *Ibid.* 27; *Signaux pour les voyants* 122

141 Hénault, 'Exil,' in *Voyage au pays de mémoire* 62. Cf. 'But why did you go to Sudbury?' 'Because here, of course, left-wing unions were increasingly rare and it wasn't a good time for someone in the communist party to work in a union that wasn't left-wing ... I had to go into exile.' (Haeck, Piotte, and Straram, 'Entretien; 30 ans après le *Refus global*' 19)

142 *Ibid.* 63 (*Signaux pour les voyants* 137)

143 Hénault, 'Bestiaire,' *ibid.* 56 (130)

144 Hénault, 'A la mémoire de Paul Eluard,' *Sémaphore* 46 (198)

145 Hénault, 'No Man's Land,' *Voyage au pays de mémoire* 53 (127)

146 Hénault, 'Miroir transparent,' *Sémaphore* 47-8. 'La soleil' in the original text was corrected when the poem reappeared in *Signaux pour les voyants* (p 200).

147 Haeffely stayed in touch with Cathelin and passed on his articles on the automatists to *Vie des arts*: 'Riopelle et le défi du peintre,' *Vie des arts*, autumn 1961, no 24, pp 44-51; 'Riopelle sculpteur,' *ibid.*, spring 1962, no 26, p 60

148 Claude Haeffely, *Notre joie*, in *Des nus et des pierres* 11

149 Haeffely, 'Poème à gratter au couteau,' *ibid.* 13

150 Haeffely, 'Sorcellerie,' *ibid.* 17-18

151 Haeffely, *La Vie reculée*, engravings by Anne Kahane (Montreal: Erta 1954) 23. Cf. the reference to Claude Haeffely in Jean Cathelin and Gabriel Gray, *Révolution au Canada* 275.

152 *Ibid.* 15

153 *Ibid.* 11. Haeffely also published a literary periodical, *Le Périscope*; cf. Haeffely, 'Le Périscope,' *Situations*, Mar. 1959, vol. 1, no 3.

154 Haeffely, *Notre joie*, in *Des nus et des pierres* 12

155 Haeffely, *Le Sommeil et la neige*, *ibid.* 47, 50, 57

156 Haeffely, 'Des nus et des pierres,' *ibid.* 71
157 Haeffely, *Le Sommeil et la neige*, *ibid.* 49, 52-3
158 Haeffely, *Rouge de nuit* 34
159 *Ibid.* 23, 34
160 For example:
 Ticmule my
 angicle
 under the spiced tuft
 malamoc talbasse' ... etc. (*Ibid.* 13)
161 *Ibid.* 24, 27
162 Despite the possible parallels between his verbal violence and that of Roland
 Giguère; for example, 'Blessure au flanc du ciel,' in *Les Coqs égorgés*, or again in
 L'Aube assassinée:
 words which kill
 like pebbles or blood
 which place death
 within reach. (p 36)
163 Françoise Bujold, *Au catalogue des solitudes*, with three engravings by the author,
 coll. 'La Tête armée,' no 5 (Montreal: Erta 1956); *La fille unique*, with three wood
 engravings by the author (Montreal: Goglin 1958). The author also designed the
 covers for Les Editions Goglin and published 3 collections of illustrated stories.
164 Gabriel Charpentier, *Cantate pour une joie* (Montreal: Erta, nd)
165 Jean-René Major, *Où nos pas nous attendent* (Montreal: Erta 1957), ill. by J.-P. Beau-
 din. Major was apparently the reader of the testament during Jean Benoît's *Execu-
 tion du testament du Marquis de Sade*.
166 Paul Chamberland, 'Fondation du territoire,' *Parti pris*, May-Aug. 1967, vol. 4, nos
 9-12, p 41
167 Jean-Paul Martino, *Osmonde*, frontispiece by Léon Bellefleur (Montreal: Erta 1957),
 unpaginated
168 *Ibid.* 17, 19, 21
169 *Ibid.* 31
170 Martino, *Objets de la nuit* (Montreal: Quartz 1959) 15-16. Martino also published
 'Bois le feutre,' an extract from *Kliklantin*, in *Situations*, vol. 1, no 1, Jan. 1959,
 p 37.
171 Martino, *Objets de la nuit* 23-4
172 *Ibid.* 34
173 *Ibid.* 36
174 His musical contribution to the two automatist shows in Apr. 1948 and May 1949 is
 discussed elsewhere.
175 *Trente-quatre biographies de compositeurs canadiens* 63
176 Interview with Gabriel Charpentier and MM. Boucher, Gagnon, François, and
 Robert Toupin, Feb. 1967
177 Charpentier, *ibid.*
178 Gauvreau, 'L'Epopée automatiste vue par un cyclope' 79
179 'La Vie montréalaise – Deux chiens dans un opéra automatiste,' *Le Petit journal*,
 20 Nov. 1949, p 35
180 Gauvreau, 'L'Epopée automatiste vue par un cyclope' 79.
181 'Etrange attitude – Gauvreau se fâche,' *Le Petit journal*, 27 Nov. 1949, p 56
182 'L'Opéra automatiste – le livret de M. Gauvreau n'a pas satisfait M. Mercure,' *Le
 Petit journal*, 11 Dec. 1949, p 48

183 'Encore l'automatisme – la Défection de Mercure est triste, dit Gauvreau,' *Le Petit journal*, 18 Dec. 1949, pp 56, 65

184 Gauvreau, 'L'Epopée automatiste vue par un cyclope' 79-80

185 *Cantate pour une joie* for soprano, choir, and orchestra, poems by Gabriel Charpentier, music by Pierre Mercure (Montreal: Erta nd); nos 4, 5

186 *Ibid.* no 3

187 Gauvreau, 'L'Epopée automatiste vue par un cyclope' 82-3

188 Mousseau, 'L'Exposition des Rebelles,' reproduced in *La Barre du jour*, nos 17-20, p 105; cf. pp 106-7.

189 Gauvreau, 'L'Epopée automatiste vue par un cyclope' 83-4; cf. *Dix-sept lettres à un fantôme*, 30 Mar. 1950, p 23, unpublished.

190 *Dix-sept lettres à un fantôme*, letter of 5 Apr. 1950, pp 6, 8, unpublished

191 During the Exposition des Rebelles, *Refus global* was translated into English by Simon Watson Taylor, a friend of Riopelle and a member of the Collège de pataphysique (Evan H. Turner, *Paul-Emile Borduas, 1905-1960* 31; Gauvreau, 'L'Epopée automatiste vue par un cyclope' 78). Taylor also translated Marcel Jean's *Histoire de la peinture surréaliste* (*The History of Surrealist Painting*, Grove Press 1967) and with Riopelle contributed to the Apr. 1949 issue of the periodical *Néon*.

192 *Ibid.* 9-11

193 Gauvreau, 'L'Epopée automatiste vue par un cyclope' 86

194 *Ibid.*

195 *Ibid.* 87

196 Cf. *Paul-Emile Borduas, 1905-1960* 32. Rolland Boulanger and Paul Gladu (quoted by Boulanger) wrote favourable reviews in *Arts et pensée*, Mar.-Apr. 1952, p 63.

197 Guy Robert, *Roussil* 58

198 Gauvreau, 'L'Epopée automatiste vue par un cyclope' 90

199 'I sense and divine a certain desire on the part of Roussil and his Stalinist friends to give this exhibition a politically committed orientation. But our activities, as far as we are concerned, are completely outside the excessively narrow, stifling framework of policies directed at immediate results. I asked Roussil straight out: "Are you making this political?" "No," he said. But his text, and the poems on the back wall, prove the opposite.' (Marcel Barbeau, letter to Marcelle Ferron, secretary, *Québec Underground*, vol. 1, p 30). Some of these poems were by Hénault, including 'Bordeaux-sur-bagne.'

200 16 May 1953, reprinted in *Québec Underground*, vol. 1, p 30

201 Gauvreau, 'L'Epopée automatiste vue par un cyclope' 93

202 Letter from Paul-Emile Borduas to Claude Gauvreau, *Liberté*, no 22, Apr. 1962, p 232 (dated 31 Apr. but announcing his arrival on 16 Apr.)

203 Unpublished letter from Claude Gauvreau to Nicole Ladouceur, 20 May 1968

204 Paul Gladu, 'A la galerie Antoine – Borduas, Paul-Emile, et l'accident,' *Le Petit journal*, 25 Apr. 1954, p 58. Cf. *L'Autorité du peuple*, 18 Mar. and 10 Apr. 1954, p 7. Also 15 May and 26 June

205 Letter from Paul-Emile Borduas to Claude Gauvreau, New York, 25 Sept. 1954, *Liberté*, Apr. 1962, no 22, p 237

206 Gérald Robitaille, *Un Huron à la recherche de l'art* 211 n 2

207 Guy Viau, *La Peinture moderne au Canada français* 49-50

208 Letter from Paul-Emile Borduas to Claude Gauvreau, Paris, 22 Dec. 1956, *Liberté*, Apr. 1962, no 22, pp 239-40. On 26 Feb. 1955, Borduas also put an end to a similar controversy with Leduc; Borduas' article, 'Objection ultime et fulgurante,' appeared on 12 Mar. 1955, in the Saint-Hyacinthe *L'Autorité du peuple*.

209 Charles Delloye, 'Témoignage,' *Situations*, May-June 1961, vol. 3, no 3, p 72
210 Paul Gladu, 'Les Pastels de Jérôme à la Galerie Libre – Un poète de la lumière et un magicien du mouvement,' *Le Petit journal*, 6 Nov. 1960, p 96
211 Claude Gauvreau, 'Paul Gladu, tartuffe falsificateur,' *Situations*, Jan.-Feb. 1961, vol. 3, no 1, p 45. For a summary of the quarrel between the automatists and the plasticists in Quebec, see Normand Thériault, 'La Peinture québécoise revécue à Terre des Hommes,' *La Presse*, 13 June 1970, p 42
212 Claude Gauvreau, 'Dimensions de Borduas,' *Liberté*, no 22, Apr. 1962, p 228
213 Claude Jasmin, 'Borduas et Riopelle chez Agnès Lefort,' *La Presse*, 25 Sept. 1965, p 23 of the supplement
214 Reproduced by Donald W. Buchanan, catalogue of 1960
215 The role of the periodical *Situations* in relation to automatism will be discussed in the next chapter.
216 Circa 1933. Bennett was in power from 1930 to 1935. See the fictional account in Jean-Jules Richard, *Journal d'un hobo* 270ff.
217 Pierre Saint-Germain, 'Au fil des lettres – l'écrivain hobo J.-J. Richard dit que l'art c'est la chair,' *Le Petit journal*, 8 Aug. 1948, p 40
218 Jean-Jules Richard, *Neuf jours de haine* 265-6
219 *Ibid.* 164
220 André Malraux, *La Condition humaine*, in *Romans* 354-5, 405-6
221 Richard, *Neuf jours de haine* 282. A similar account appears in *Ville rouge* 282-3.
222 Richard, *Neuf jours de haine* 237
223 *Ibid.* 199-201
224 *Ibid.* 251-2, 289
225 Richard, 'Qu'est-ce qu'elle dit,' *Ville rouge* 204; *Journal d'un hobo* 121
226 Richard, 'Prélude en si mineur,' *Ville rouge* 53. Another description of hallucinations can be found in *Carré Saint-Louis* 91-121.
227 Richard, *Neuf jours de haine* 145
228 *Ibid.* 143
229 *Ibid.* 71. The story 'L'Homme à sept têtes' (*Situations*, Mar. 1959, vol. 1, no 3, p 28) in which the tyrant of the country of Acabec and the province of Quémagog gets his just reward (the seven-headed tyrant is betrayed by the jewels in his seven crowns) is more fantasy than fantastical.
230 *Journal d'un hobo* 32
231 *Ibid.* 32-3
232 Richard, *Neuf jours de haine* 199
233 Jean-Jules Richard, publisher, and Jean-Maurice Laporte, editor, 'Introduction,' *Place publique*, no 1, 1951, p 3
234 *Time*, 1 Jan. 1951; reproduced by Jean-Jules Richard, 'La Seule guerre permise,' *Place publique*, no 1, Feb. 1951, p 5; *Time*, 16 Oct. 1950, reproduced by Richard, *ibid.* 4 n 1
235 *Le Jour*, 18 Dec. 1943, p 5, introduction by Pierre Gélinas
236 Richard, 'Le Rocher noir,' *Ville rouge* 11
237 Letter from Paul-Emile Borduas to Jean-Jules Richard, 'le 18 hêtre-frêne-chêne, (février) de l'an 2 à notre règne' (1950); *La Barre du jour*, nos 17-20, p 45
238 Claude Gauvreau, *Dix-sept lettres à un fantôme*, letter of 4 Mar. 1950, pp 1-3, unpublished
239 Richard and Laporte, 'Introduction,' *Place publique* 3
240 Except Marcel Barbeau, who replied to an article by Remi-Paul Forgues which made public the growing split within what he called the 'Ecole de Saint-Hilaire.' Cf. Rémi-Paul Forgues, 'A propos des peintres de l'Ecole de Saint-Hilaire,' *Place pub-*

lique, no 2, Aug. 1951, p 24 and Marcel Barbeau, 'Réponse à Rémi-Paul Forgues,' *ibid.*, no 3, Mar. 1952, p 40.

241 Jacques Ferron, *Du fond de mon arrière-cuisine* 246

242 Jacques Ferron, *Historiettes* 176-7. He also wrote a playlet, *Du refus global à l'acceptation sans vergogne*, which *Place publique* refused to publish (cf. Gauvreau, 'L'Epopée automatiste vue par un cyclope' 85).

243 Cf. interview with Jean Marcel, *Jacques Ferron malgré lui* 19-20 and Jacques Ferron, 'Adieu au P.S.D.,' *La Revue socialiste*, no 4, summer 1960, pp 7-14.

244 He had previously written a novel, *Jérôme Salvarsan*, which was published privately.

245 Jacques Ferron, 'Le Permis de dramaturge,' *La Barre du jour*, July-Dec. 1965, vol. 1, nos 3-5, p 66. Reprinted in *Du fond de mon arrière-cuisine* 209

246 Ferron, *La Barbe de François Hertel* 12-14

247 A term current in Breton's circle for the revolutionary surrealists (cf. Henri Jones, *Le surréalisme ignoré* 102). Ferron scolded Gauvreau for writing sympathetically about Montherlant apropos of a play by Paul Toupin (Claude Gauvreau, 'Première canadienne: le théâtre chicané de Paul Toupin,' *Le Haut-parleur*, 17 Feb. 1951, pp 1, 4, 5). Ferron also attacked Montherlant and Toupin for their former fascist sympathies ('Lettre ouverte à Claude Gauvreau – sur les vaches,' *Le Haut-parleur*, 3 Mar. 1951, p 4); Ferron charged again 7 Apr. 1951, p 4. But he later defended Gauvreau when the latter was accused of 'surrealism' by a reviewer on *Radio-monde* ('Marcel Larmec et le surréalisme,' *Le Haut-parleur*, 5 May 1951). See Toupin's reply in a letter to Gauvreau, *Le Haut-parleur*, 7 Mar. 1951, p 2.

248 Alain Pontaut, 'Jacques Ferron – Chénier a eu tort: il n'avait pas lu Guevara,' *La Presse*, 3 Feb. 1968, p 24, c. 4

249 Jacques Ferron, 'Saint Tartuffe,' in *Historiettes* 68-9

250 Ferron, *Théâtre I*, 'Les Grands soleils' (Montreal: Déom 1968)

251 Réginald Martel, 'L'Ami impitoyable des Québécois,' *La Presse*, 21 Dec. 1968, p 23, c. 5

252 *Ibid.*

253 Marcel, *Jacques Ferron malgré lui* 13-14

254 Cf. Gaston Miron, *L'Homme rapaillé* 155.

255 All publications concerning the Rhinoceros party were reprinted in a satiric work, *Le Parti Rhinocéros programmé*.

256 Jacques Ferron, 'Refus global,' *L'Information médicale et para-médicale*, vol. 11, no 11, 1959

257 Ferron, 'Paul-Emile Borduas,' *Situations*, vol. 2, no 1, 1960, p 21

258 Ferron, *Historiettes* 179

259 Ferron, *Du fond de mon arrière-cuisine* 211; cf. p 246.

260 Jean Royer, 'Marcelle Ferron – Pour la trace d'une époque,' *Le Devoir*, 10 Nov. 1979, p 21

261 André Pouliot, *Modo Pouliotico* 3

262 Gauvreau, 'L'Epopée automatiste vue par un cyclope' 81

263 Pouliot, *Modo Pouliotico* 8

264 *Ibid.* 25

265 *Ibid.* 33

266 *Ibid.* 40

267 Pouliot, '"Cows" que tu dis???,' *Situations*, July-Aug. 1959, vol. 1, no 6, pp 42-3

268 Pouliot, 'Essor et délivrance,' *Situations*, vol. 1, no 6, July-Aug. 1959, p 5

269 He played a role in Claude Gauvreau's *Bien-être* and in *Une pièce sans titre* by Jean Mercier (T.J. Maeckens). Cf. *L'Envers du décor*, vol. 6, no 5, Mar. 1974, p 3.

270 On the centenary of Balzac's death (1850), Tranquille set up a window display in

his bookstore which provoked the religious authorities since the books on display were on the Index. In reply to a request from the vicar-general of the Archbishopric to remove the books and the bust of Balzac, friends of the bookstore decided to carry the bust in a procession through the neighbouring streets.

CHAPTER FIVE: FURTHER DOWNSTREAM

1 Quoted by Pierre Saint-Germain, 'Encore l'automatisme,' *Le Petit journal*, 18 Dec. 1949, pp 56, 65
2 Claude Gauvreau, '15 février 1969,' *Liberté*, no 61, 1969, pp 96-7; see also *Quebec Underground*, vol. 1, p 386.
3 These were Gilles Carle, Mathilde Ganzini, Olivier Marchand, Gaston Miron, Louis Portugais, and Jean-Claude Rinfret.
4 Jean-Guy Pilon, 'Le Temps de notre jeunesse,' in Guy Robert, *Littérature du Québec* (1st ed.) 129
5 Paul-Marie Lapointe, *Choix de poèmes – Arbres* (Montreal: L'Hexagone 1960); *Pour les âmes* (Montreal: l'Hexagone 1964); *Le Réel absolu* (Montreal: l'Hexagone 1971)
6 *Liberté*, Oct. 1959
7 Alain Grandbois, *Poèmes* (Montreal: l'Hexagone 1967)
8 Pierre de Grandpré, *Dix ans de littérature au Canada français* 32
9 Jean Guy Pilon, *Les Cloîtres de l'été*, coll. 'Les Matinaux' (Montreal: l'Hexagone 1954). Pilon later joined *Liberté*, which devoted issue no 58 to René Char (vol. 10, no 4, Jan.-Aug. 1968).
10 L(ouis) P(ortugais), in *Cahier pour un paysage à inventer*, 1960, no 1, p 104
11 P(atrick) S(traram), *ibid.* 106
12 Gilles Hénault, 'La Poésie et la vie,' in *La Poésie et nous*, coll. 'Les Voix' (Montreal: l'Hexagone 1958) 35-6
13 Michel Van Schendel, *Poèmes de l'Amérique étrangère*, coll. 'Les Matinaux' (Montreal: l'Hexagone 1958); *Variations sur la pierre* (Montreal: l'Hexagone 1964)
14 Michel Van Schendel, 'Vues sur les tendances de la poésie,' in *La Poésie et nous* 16, 20-2
15 Gilles Hénault, 'Le langage est mot de passée,' *Situations*, vol. 1, no 8, 22-3; reprinted by Guy Robert in *Poésie actuelle* (Montreal: Déom 1970) under the title 'La Poésie est mot de passe'
16 Wilfrid Lemoyne, 'La Poésie et l'homme,' in *La Poésie et nous* 70
17 Antonin Artaud, 'Vie et mort de Satan le Feu (une Race-Principe),' annotated by Préfontaine
18 René Char, 'Moulin premier,' annotated by Préfontaine
19 Préfontaine, 'A une sérénité crispée,' annotated by Préfontaine
20 A surrealist message, Jan. 1925, annotated by Préfontaine
21 Préfontaine, 'La Poésie et l'homme: quelques aspects,' in *La Poésie et nous* 78, 85-7
22 Préfontaine, *Boréal* (1957) (Montreal: Estérel 1967) 15-19
23 Préfontaine, 'Lettre refusée au Devoir,' *Liberté*, no 12, Nov.-Dec. 1960, p 359
24 *L'Antre du poème* (Trois-Rivières: Ed. du Bien Public 1960) 10
25 Gilles Marcotte, *Le Temps des poètes* 94
26 Préfontaine, *L'Antre du poème* 85
27 *Pays sans parole* (Montreal: l'Hexagone 1967) 8
28 Préfontaine, 'Un Film de Jacques Godbout – Borduas au cinéma,' *Liberté*, no 27, Mar.-Apr. 1963, p 161
29 Gaston Miron, 'Ma bibliothèque idéale,' Radio-Canada, 16 Sept. 1961; in *L'Homme rapaillé* (Montreal: Les Presses de l'Université de Montréal 1970) 106

30 Renée Cimon, 'Chronologie de Gaston Miron,' *ibid.* 155
31 Miron, 'Situation de notre poésie' (1957), in *L'Homme rapaillé* 92-4
32 Jean-Louis Major, 'L'Hexagone: une aventure en poésie québécoise' 178. According to André Belleau, one of the editors of *Liberté*, the periodical was never connected to l'Hexagone (telephone conversation with A.G.B., 1 Dec. 1973).
33 J(acques) G(odbout) 'Paul-Emile Borduas,' *Liberté* 60, no 8, Mar.-Apr. p 133
34 Jacques Folch, 'Une vie de peintre,' 'Borduas parle'; Robert Elie, 'Témoignage'; André Jasmin, 'Notes sur Borduas,' *Liberté*, Jan.-Feb. 1962, nos 19-20; André Jasmin and Aubert wrote a documentary on Borduas broadcast on Radio-Canada 25 Nov. 1967, 'L'Histoire comme ils l'ont faite,' including interviews with Gilles Hénault, Robert Elie, Aline Legrand, and Pierre Vadeboncœur; cf. also Jacques Folch, 'Jean-Paul Mousseau,' *Liberté*, May-June 1963, vol. 5, no 3.
35 Claude Gauvreau, 'Dimensions de Borduas'; P.-E. Borduas, 'Lettres à Claude Gauvreau'; Jean Ethier-Blais, 'Epilogue et méditation,' *Liberté*, no 22, Apr. 1962
36 Diane Pelletier-Spiecker, *Les Affres du zeste*, coll. 'Les Refus de la colombe' (Montreal: Quartz 1958) 8, illustrations by Klaus Spiecker
37 *Ibid.* 12
38 Kline Sainte-Marie, *Poèmes de la sommeillante* (Montreal: Quartz 1963)
39 Diane Pelletier-Spiecker, *Les Affres du zeste* 18
40 *Ibid.* 19. Cf. also 'Sebia' in *Situations*, vol. 1, no 2, Feb. 1959, pp 8-9.
41 Michèle Drouin, *La Duègne accroupie*, with a drawing and frontispiece by the author (Montreal: Quartz 1959) v
42 Goulet had already exhibited some paintings and attended meetings at the studio on Place Christin; cf. Claude Gauvreau, 'Au-delà de l'immondice jésuitique – André Goulet dit Goulo,' *Le Haut-parleur*, 22 Dec. 1951, p 5.
43 Claude Mathieu refers many times to the surrealists Julien Gracq (p 30), André Pieyre de Mandiargues (pp 34-5, 40), and René Char (pp 21, 69-72) in *Vingt petits écrits ou le Mirliton rococo* (Montreal: Orphée 1960).
44 Gérald Robitaille used to be Henry Miller's personal secretary and translator.
45 Ronald Després wrote a strange masochistic farce in which victims of vivisection read Eluard and collected Picassos (*Le Scalpel ininterrompu* 41).
46 Gauvreau's *Etal mixte* was actually printed by Orphée on 2 Nov. 1968, but Gauvreau changed his mind and refused to sign the contract. Not until 1977 did 202 of the 1000 copies finally go on sale.
47 Interview with J.-C. Dussault by A.G.B., 9 Apr. 1970
48 Claude Gauvreau, *Dix-sept lettres à un fantôme*, 10 May 1950, pp 15-17
49 Gauvreau, 'L'Epopée automatiste vue par un cyclope' 79
50 Gauvreau, *Dix-sept lettres à un fantôme*, letter of 13 Jan. 1950, p 17; unpublished
51 The following appeared in the 21 Jan. 1951 issue of *Le Haut-parleur*: 'Nuits d'été' (26 July 1950), 'Attente' (11 Aug. 1950), and 'Sacrificial' (11 Aug. 1950).
52 Jean-Claude Dussault, 'Nuits d'été,' *Le Haut-parleur*, 21 Jan. 1951
53 Dussault, 'Sacrificial,' *ibid.*
54 Dussault, 'Nuits d'été,' *ibid.*
55 Dussault, 'Attente,' *ibid.*
56 Dussault, 'Sacrificial,' *ibid.*
57 Jean-Claude Dussault, *Proses (suites lyriques)* 13
58 *Ibid.* 16
59 Unpublished letter from Jean-Claude Dussault to Claude Gauvreau, 12 Mar. 1950
60 Jean-Claude Dussault, 'Conte indien,' *Situations*, vol. 1, no 6, July-Aug. 1959
61 Dussault, *Proses* 17-18

62 *Ibid.* 20
63 Gilles Marcotte, *Le Temps des poètes* 90-101
64 Jean-Claude Dussault, *Essai sur l'hindouisme, La Civilisation du plaisir*
65 Dussault, 'Le Vierge incendié,' *Le Haut-parleur*, 14 Mar. 1951, p 4
66 Dussault, 'Le Cas Gauvreau et la liberté d'expression,' *Place publique*, no 3, Mar. 1952, pp 45-6
67 Dussault, *Dialogues platoniques* 27, 29, 63-4
68 Gilles Groulx, *Poèmes* (Montreal: Orphée 1957) (11), dated Jan. 1954, reprinted in *Les Herbes rouges*, no 14, p 21
69 *Ibid.* 29, dated Feb. 1954, *Les Herbes rouges*, no 14, p 33
70 *Ibid.* 31, dated Feb. 1954, *Les Herbes rouges*, no 14, p 32
71 An analysis of automatism, which had just celebrated its tenth birthday (vol. 1, no 2, Feb. 1959); an article by Molinari claiming that automatism reached its peak with *Refus global* ('Les Automatistes au musée,' vol. 1, no 7); a special issue on the death of Borduas whom Ferron called 'the greatest artist we have ever had' ('Paul-Emile Borduas,' vol. 2, no 1) and whom Michel Fougères called a 'prophetic landmark' ('Borduas,' *ibid.*); the notes for the Borduas retrospective in Amsterdam ('Borduas,' vol. 3, no 3).
72 Jean Depocas, 'Une Nation et la littérature,' *Situations*, vol. 1, no 3, p 19
73 'Paul Gladu ... raises the question of Canadianism and Internationalism. In this connection I wish to quote a very apt comment by Claire France ... in a recent issue of the periodical *Situations* ... "Wishing to be Canadian already precludes being Canadian." In fact, a circumscribed will would already tend to ruin the authenticity of the act and no longer communicate more than an abstract residue of the reality one would like to address ... There is only one way to express what one truly is, and that is with total integrity. The universal makes impeccable authenticity obligatory, and necessary authenticity undoubtedly contains the milieu in which the universal was born, whether harmoniously or passionately. The automatists, unconcerned with anything but creating and precursors on a universal level, were profoundly Canadian; of course, this profound reality was communicated by spontaneously expressed spiritual qualities such as strength, a sense of the baroque, a rather unpolished aspect, and a primitive freshness far more than by the arbitrary introduction of picturesque details. It's hard to imagine a Frenchman striving to be French; he's content to be one without worrying about it.' (Claude Gauvreau, 'Paul Gladu, tartuffe falsificateur,' *Situations*, vol. 3, no 1, p 51)
74 Jean Depocas, 'De l'amour fou à vénus-3: entretien avec Claude Gauvreau,' *Parti pris*, Apr. 1966, vol. 3, no 9, p 16
75 'No, don't talk to me about nationalism, the word horrifies me. It's another matter to feel part of a country (vast, diverse, and somewhat confused), a continent, a particular time (which, alas, passes too quickly). Here are the various stages in this awareness, an awareness which in other circumstances might have been simplified. First of all I am part of my village, then my province; after that I am French-Canadian, more Canadian than French after my first trip to Europe, Canadian (just that, mysteriously similar to my fellow countrymen) in New York, North American quite recently, and from there I hope to "possess" the entire World!' (Paul-Emile Borduas, letter to Claude Gauvreau, Paris, 21 Jan. 1959, *Liberté*, no 22, Apr. 1962, pp 249-50)
76 'I am absolutely anti-anarchist and pro-republican. This means that as far as possible I favour a republic. I would like to be a citizen of the republic of Canada; I would be pleased to see our two cultures confront each other beyond the context of partial imperialist dependence. However, since the Anglo-Saxons of Canada might be too

sentimental to accept a republic, the republic of Quebec would be the only solution for us. I'm not forgetting the francophone minorities outside Quebec, but they would still welcome a republic. I would never oppose the republic of Quebec.' (Depocas, 'De l'amour fou à vénus-3: entretien avec Claude Gauvreau')

77 The Quebec neo-plasticists are Louis Belzile, Jean-Paul Jérôme, Fernand Toupin, and Jauran (pseudonym of the critic Rodolphe de Repentigny). The *Manifeste des plasticiens* can be found in Guy Robert, *L'Art au Québec depuis 1940* 107-9.

78 Fernande Saint-Martin, 'L'Aventure poétique,' *Situations*, vol. 1, no 1, Jan. 1959, p 11. She returned to this subject in the second issue: 'Gauvreau's poetry and his *Bien-Etre* introduced automatism into our literature; a Kirouac [sic], for example, has barely begun to explore the possibilities of this automatism.' ('Le manifeste de l'automatisme,' vol. 1, no 2, p 17)

79 Saint-Martin, 'Le Manifeste de l'automatisme,' *Situations*, vol. 1, no 2, Feb. 1959, pp 14-15

80 Saint-Martin, 'Le Manifeste de l'automatisme,' *Situations*, vol. 1, no 1, Jan. 1959, pp 15-16

81 Gauvreau, 'L'Epopée automatiste vue par un cyclope' 92

82 *Ibid.* 93

83 Claude Gauvreau ('Paul Gladu, tartuffe falsificateur' 38-9, *Situations*, vol. 3, no 1). Gauvreau later explained what he saw as the differences between surrealism and automatism: 'In 1942 Borduas called his exhibition of non-representational gouaches "Surrealist paintings." Borduas believed in magic and "convulsive beauty" ... but the objective correlatives between his work and surrealism were without question still imprecise.' (Claude Gauvreau, 'Exposé au Musée d'art contemporain de Montréal,' 21 June 1967 *Québec Underground*, vol. 1, p 65)

Guido Molinari has clarified his own position on the subject: 'The idea of automatism, as defined by Breton, struck me as far more radical than the works of the European surrealists, yet the automatist painting of Borduas' group was still extremely controlled. I did not see there the exploration of a "new object"; rather, I found that automatist painting retained the principles of classical painting, that is to say the dichotomy of object and ground as well as tonal structure ...

Since 1951, I have continually maintained in talks and in my writing that the automatism of Borduas' group was only a variant of surrealism since it retained the structures of the pictorial object ...

I believe automatism has been poorly defined in that too much emphasis has been placed on the neurological aspects of automatism, which are in fact practically innate gestures conditioned by receptivity. Personally I believe that all artistic activity always begins with a breakdown of the known structures of the object and the elaboration of an entirely different area of investigation allowing the creation of a "new object" which the structures of perception have not yet succeeded in illuminating, for example, the notion of series I'm working on at the moment.' (Guido Molinari, unpublished letter to Michèle Vanier, 12 Oct. 1968)

84 Aragon claimed categorically that surrealism was derived from cubism. Cf. *Aragon parle avec Dominique Arban* (Paris: Seghers 1968) 43.

85 Saint-Martin, *Structures de l'espace pictural* 135-6

86 *Ibid.* 137-8. This approach clarifies Borduas' paradoxical remark in 1956: 'The 1942 gouaches, which we thought were surrealist, were really only cubist.' (Apr. 1956; see *Le Devoir*, 9 June 1956; Guy Robert analyses the comment in *Borduas* 104ff.)

87 Molinari's evaluation of *Refus global*'s revolutionary merit is interesting: 'At that time the ideas behind *Refus global* were influenced much more by the example and

influence of Sartrean existentialism – Sartre had visited Montreal and his plays had been put on there. There was the double influence, therefore, of Breton on contemporary poetry and of Camus' and Sartre's sense of the absurd which pushed the signatories of the manifesto titled *Refus global* to deny society the right to censure the artist. In fact they claimed the right to become the determining factors in bringing about the transformation of Quebec society.' (Guido Molinari, letter to Michèle Vanier, 12 Oct. 1968, unpublished)

88 Presented for the first time in 1962 (cf. Claude Gingras, 'Trois scènes de Salomé et une création de François Morel,' *La Presse*, 14 Mar. 1962, p 25). François Morel had been called on to write the music for two programs dedicated to the memory of Borduas on Radio-Canada, 25 Nov. 1967 and 18 Oct. 1968 (cf. *La Presse*, 17 Oct. 1968, p 21).

89 *La Presse*, 7 Nov. 1968, in *Québec Underground*, vol. 1, p 376

90 *Le Devoir*, 7 Nov. 1968, in *ibid.*

91 Cf. André Breton and Paul Eluard, *L'Immaculée-Conception.*

92 Louis-Bernard Robitaille, 'Opération Déclic? Investiture troublée par un "happening" en l'église Notre-Dame,' *La Presse*, 9 Dec. 1968

93 *Place à l'orgasme*, Création à Dieu, 1968. Cf. *Refus global* 30.

94 Jean-Claude Germain, 'Le Théâtre québécois libre au pouvoir,' *Digeste éclair*, Feb. 1969, pp 8-13

95 Claude Paradis, in *Liberté*, Jan.-Feb. 1969

96 Germain, 'Le Théâtre québécois libre au pouvoir' 13

97 Cf. *Québec Underground*, vol. 2, p 467.

98 Claude Turcotte, '600 spectateurs ont un "choc nerveux" à la Comédie canadienne,' *La Presse*, Monday, 17 Feb. 1969, p 1, morning edition. The evening edition carried a slightly different headline which came closer to the truth: '600 spectateurs sont ébahis par un "happening" à la Comédie canadienne.'

99 *Ibid.* 2

100 Louis-Bernard Robitaille, 'Deux des auteurs du scandale s'expliquent,' *La Presse*, 17 Feb. 1969, p 1

101 Michel Auger, 'Couple accusé de s'être dévêtu à la Comédie canadienne et de cruauté envers les animaux,' *La Presse*, 27 Feb. 1969, p 3; Michel-G. Tremblay, 'Un autre des faux interprètes de *Double jeu* comparaît,' *La Presse*, 8 Mar. 1969, p 7

102 In 1917, Jacques Vaché frightened the audience of Apollinaire's *Les Mamelles de Tirésias* by shooting blanks at them (cf. André Breton, *Second manifeste du surréalisme* 155). The dadaists sabotaged Cocteau's *Les Mariés de la tour Eiffel* staged by the Swedish Ballet in 1921, and the surrealists hooted Tzara's *Le Cœur à gaz* in 1923 with the result that people were injured and charges laid (cf. Michel Sanouillet, *Dada à Paris* 284-5 and 382-5). They also threw tracts and streamers from the balcony onto the audience at Diaghilev's ballet *Romeo and Juliet* (cf. Jean, *Histoire de la peinture surréaliste* 156).

103 Réginald Martel, 'Gauvreau: Mort et résurrection,' *La Presse*, 2 May 1970, p 28. See also the polemic after the abrupt halt in the third performance of the play. Claude Gauvreau said, 'It is imperative not to restrain my admiration for Claude Paradis' ('La Mort de l'Orignal Epormyable,' *La Presse*, 16 May 1970, p 49). Monique Duplantie, Jacques Crête, and Albert-G. Paquette replied, 'Allow us to unconditionally profess our faith in Claude Gauvreau. Similarly with regards to Claude Paradis, we are profoundly indebted to him for any light which may have illuminated what was previously obscure.' ('Une nouvelle charge épormyable,' *La Presse*, 23 May 1970, p 41)

104 Luc Perreault, 'Du Refus au déclic,' *La Presse*, 14 Feb. 1970, p 39

105 Quoted in *Québec Underground*, vol. 1, p 56; compare *Refus global* 20.

106 'I know that this act was symbolic, and that it readily played a necessary part in this courageous global demonstration. Down with all censorship! As an aging artist who has often undergone hardships, I can do nothing less than express most categorically my absolute solidarity with the young poets acquainted with magic who have publicly signalled an individual and collective flowering. On Saturday February 15, 1969, at the Comédie canadienne, Prometheus was reincarnated in them. Finally – and we have waited a long time for this – automatism has been superseded. The torch has been passed on in a most admirable manner' (Claude Gauvreau, '15 Feb. 1969,' *Liberté*, no 61, 1969, pp 96-7). This piece had been refused by *La Presse*, *Le Devoir*, and *Le Journal de Montréal*; cf. *Québec Underground*, vol. 1, p 386.

107 'I founded a philosophy – fraternalism. It was a mixture of existentialism and Marxism ... We published five issues of *Silex*.' François Hébert, Marcel Hébert, and Claude Robitaille, 'Interview: Gilbert Langevin,' *Hobo-Québec*, nos 5-7, June-Aug. 1973, p 23. In *Silex* no 5 François Hertel is introduced as the European representative for Editions Atys; an extract from his book *Pour un ordre personnaliste* (p 7) was reprinted with the title listed in the table of contents as 'Pour un ordre fraternaliste' (p 5).

108 Hébert, Hébert, and Robitaille, 'Interview: Gilbert Langevin' 23

109 André Belleau, 'La Littérature est un combat,' *Liberté*, no 26, Mar.-Apr. 1963, vol. 5, no 2, p 82

110 This is not the place to discuss *Parti pris* at length. However, the first issue setting out the beliefs of *Parti pris* makes several important references to *Refus global*. In going over the history of what he called 'Quebec alienation' Pierre Maheu wrote: 'For us everything provided material for opposition; to repeat the phrase of a predecessor, it was a *Refus global* ... The meaning of our acts did not depend on us but was inscribed in the hierarchy of Values which oppressed us ... In revolt we could only find the solitude, ill-being, and inner void reflected in Borduas' last canvases, expressions of revolt pushed to the limit.' (Pierre Maheu, 'De la révolte à la révolution,' *Parti pris*, vol. 1, Oct. 1963, pp 11-12)

But *Parti pris* clearly intended to go further than the revolt of *Refus global*; it intended to bring about a revolution: 'In the end, our revolt will not have been an adolescent crisis but the first step in our journey towards a revolutionary attitude.' (*ibid.* 14)

111 Hébert, Hébert, and Robitaille, 'Interview: Gilbert Langevin' 23

112 *Ibid.*; cf. Langevin, *Griefs* 63.

113 Cf. Hébert, Hébert, and Robitaille, 'Interview: Gilbert Langevin' 23, 26. Cf. Gilbert Langevin, *L'Avion rose* 65, note.

114 Zéro Legel, 'Flash-Back,' *Quoi*, vol. 1, no 1, Jan.-Feb. 1967, pp 48-9

115 *Les Herbes rouges*, no 2, Dec.-Mar. 1968-9, pp 7-9. This was a revolt too, but carried on in 'Le temps des vivants,' *Le Voyage*, vol. 1, no 2, p 4 and sung by Pauline Julien (*Comme je crie, comme je chante*, Gamma Gs 125); Gilbert Langevin, *Chansons et poèmes* 43.

116 Gilbert Langevin, *Les Ecrits de Zéro Legel*, vol. 1, p 156

117 Langevin, *Stress* 15, 22

118 Langevin, *Ouvrir le feu* 15

119 *Ibid.* 23, 42

120 Langevin, *Novembre* followed by *la Vue du sang* 13, 20, 70

121 *Ibid.* 10, 22, 29, 37, 70
122 *Ibid.* 39, 81
123 *Ibid.* 51, 61
124 Langevin, *Griefs* 25, 44
125 *Ibid.* 24, 49, 52
126 Langevin, *La Douche et la seringue* 36, 46, 54, 82, 83
127 *Ibid.* 22, 73
128 *Ibid.* 73-4
129 *Ibid.* 21
130 *L'Avion rose* 30, 57, 63
131 *Ibid.* 15
132 *Ibid.* 71
133 *Ibid.* 15
134 *Ibid.* 101
135 Pierre Nepveu, 'La Poétique de Gilbert Langevin,' *Livres et auteurs québécois 1973* 316
136 *Québec Underground*, vol. 1, p 77
137 'Il est le premier à nous avoir fait connaître l'*Internationale situationniste*,' *ibid.*
138 Patrick Straram, 'Nationalité? domicile?,' *Parti pris*, vol. 2, nos 10-11, p 59. He also wrote a column on art: 'Une Ecriture géothermique,' *Situations*, vol. 1, no 6, July-Aug. 1959.
139 Straram, quoting l'Internationale situationniste, in *Cahier pour un paysage à inventer* 106. Straram and his friends later got into the habit of signing their writing with a totem.
140 Internationale situationniste, 'Situation d'un critique et d'une production,' *ibid.* 85-6
141 André Roy, Claude Robitaille, Claude Beausoleil, 'Entretien avec Patrick Straram – le bison ravi,' *Hobo-Québec*, nos 9-11, pp 28-9
142 Bison ravi. Cf. Labisse's painting on this anagram of Vian in Noël Arnaud, *Les Vies parallèles de Boris Vian* 265.
143 Patrick Straram, 'Strange orange,' *Les Herbes rouges*, no 2, p 12
144 Straram, *Gilles cinéma Groulx le lynx inquiet* 1971
145 *Ibid.* 30-1
146 Straram, *4 × 4 / 4 × 4*, in *Les Herbes rouges*, no 16, pp 3, 6-10, 62
147 Cf. *ibid.* 22 and *Gilles cinéma Groulx ...* 86, c. 1
148 Straram, *Gilles cinéma Groulx ...* 97, c. 1
149 Straram, *irish coffees au No Name Bar & vin rouge Valley of the Moon* 4, 17
150 *Ibid.* 8
151 *Ibid.* 20, 38, 40
152 Straram, *La Faim de l'énigme* 56-7, 165
153 Straram, 'Précisions maximales minimales,' *La Barre du jour*, no 42, pp 67-83. Cf. Straram, 'Nationalité? domicile?,' *Parti pris*, vol. 2, nos 10-11, pp 59-60.
154 Straram, 'to a strange night of stone,' in Denis Vanier, *Pornographic delicatessen*; Straram, *en train d'être en train vers où être* (Joliette: l'obscène Nyctalope éd. 1971); Straram, *irish coffees au No Name Bar & vin rouge Valley of the Moon* (l'Hexagone éd. / l'obscène Nyctalope éd. 1972)
155 Cf. 'Films de Jutra et Borremans demain à la Cinémathèque,' *La Presse*, 19 May 1970; Gilles Marsolais, *Le Cinéma canadien* 46, 50-1.
156 The Bar des arts was responsible for resurrecting Gauvreau, according to Gilbert Langevin in reply to the question, 'What was your relationship to Gauvreau and Martineau?' 'The Bar des arts began in 63-64. Everybody from Atys, everybody

who sympathized with what was going on went there, and that's where people started meeting one another. At the same time *Parti pris* started up, and in 1965 there was *Passe partout*. All this coincided with the Bar des arts and the Perchoir d'Haïti. At that time I was the producer, I introduced the others, I recited poems. 40 to 45 poets appeared, people as diverse as Gilles Constantineau, Michel van Schendel, Claude Gauvreau ... There were also happenings, experimental poem-objects, exhibitions of paintings, poems handwritten and pinned on the walls. One entire evening was dedicated to Gauvreau. That's when we made contact with him.' (Hébert, Hébert, Robitaille, 'Interview: Gilbert Langevin' 23).

157 *Québec Underground*, vol. 1, p 119
158 Cf. the study in *Québec Underground*, vol. 1, pp 172-349; also a few notes in Robert, *L'Art au Québec depuis 1940* 421-2.
159 Gil Courtemanche, 'Nouvel Age, Nouvel Art, vieux problème,' *La Presse*, Montreal, 18 Apr. 1964
160 Le baron filip, 'Quelques notes historiques sur "l'Horloge," troupe d'avant-garde, section arts intégrés,' 14 Feb. 1973, in *Québec Underground*, vol. 1, p 130
161 Courtemanche, 'Nouvel Age, Nouvel Art, vieux problème?,' *La Presse*, Montreal, 18 Apr. 1964
162 Paul Chamberland, 'Faire le voyage – Entretien avec Claude Péloquin,' *Parti pris*, Apr. 1966, vol. 3, no 9, p 41
163 Denise Boucher, 'Jean-Claude Péloquin, alias Pélo, poète de chez nous: "J'aime l'homme, le Québec, la bière et je déteste la mort,"' *La Presse*, supplement *Perspectives*, 11 Oct. 1969, p 27
164 Chamberland, 'Faire le voyage' 43
165 *Ibid.* 45
166 Claude Péloquin, *Les Mondes assujettis*, coll. 'Métropolitaine,' Montreal, private publication, 1965, ill. by R. Connolly (10, 22).
167 Paul Chamberland, 'Faire le voyage – Entretien avec Claude Péloquin,' *Parti pris*, Apr. 1966, vol. 3, no 9, p 42
168 *Ibid.* 41-2
169 Claude Péloquin, *Calorifère*, ill. by Cornellier, Lemoyne, and Connolly (Montreal: private publication 1965)
170 Claude Péloquin, *Manifeste subsiste* (Montreal: private publication 1965); quoted in Chamberland, 'Faire le voyage' 34
171 Claude Péloquin, *Manifeste infra* followed by *Emissions parallèles* (Montreal: l'Hexagone 1967) 11
172 *Ibid.* 19-20
173 *Ibid.* 19
174 *Ibid.* 17
175 *Ibid.* 26
176 *Ibid.* 26-7
177 Claude Péloquin, quoted in Chamberland, 'Faire le voyage' 43
178 André Breton, *Discours au congrès des écrivains*, in *Manifestes* 285. Quoted in André Breton and Paul Eluard, 'Marx,' *Dictionnaire du surréalisme* 17
179 Claude Péloquin, *Mets tes raquettes* 31, 112
180 Péloquin, *Eternellement vôtre* 23, 30, 48, 72
181 Péloquin, *Pour la grandeur de l'homme* 34, 54
182 *Ibid.* 56
183 Péloquin, *Chômeurs de la mort* 53
184 *Ibid.* 55

185 *Ibid.* 9, 23, 32, 43, 48
186 *Ibid.* 79
187 Broadcast on Radio-Canada, 14 Feb. 1974, 'Des goûts, des formes et des couleurs'
188 Les Disques Clic, CSN 1002; recorded live at Le Patriote in Montreal
189 Théâtre du Nouveau Monde, 11 Nov. 1974, 'Jour de l'Armistice'
190 Galeries Martal and Espace 5, Sherbrooke Street, Montreal, until 25 Dec. 1974
191 Louis-Philippe Hébert, 'A la mémoire,' *Passe-partout*, vol. 1, nos 11-12, Nov.-Dec.
 1965, pp 23-4
192 Hébert, 'La Queste des yeux,' *Ecrits du Canada français*, no 21, Mar. 1966, p 117
193 *Ibid.* 119-20
194 Hébert, *Les Episodes de l'œil* (Montreal: Les Ed. Estérel 1967) 49
195 Hébert, *Les Mangeurs de terre et autres textes* (Montreal: Ed. du Jour 1970) 211
196 Hébert, *Le Roi jaune* (Montreal: Ed. du Jour 1971) 9
197 *Ibid.* 100
198 Laurent Jenny, 'La Surréalité et ses signes narratifs,' *Poétique*, no 16, 1973, pp 500,
 503-4
199 Jacques Ferron, *Contes* (Montreal: HMH 1968) 25-38; cf. Jean-Marcel Paquette, 'Intro-
 duction à la méthode de Jacques Ferron,' *Etudes françaises*, vol. 12, nos 3-4,
 pp 198-200.
200 Madeleine Grandbois, *Maria de l'hospice, contes* (Montreal: Parizeau 1945) 41-57. Cf.
 Bernard Dupriez, 'Du fantastique au délire,' *Revue d'esthétique*, 1976, nos 2-3, coll.
 10/18, no 1091, pp 143, 154.
201 Paquette played the role of Becket-bobo and Crête that of Lontil-Deparey. See
 Claude Gauvreau, 'La Mort de l'orignal épormyable,' *La Presse*, 16 May 1970,
 p 49 and Monique Duplantie, Jacques Crête, Albert G. Paquette, 'Une nouvelle
 charge épormyable,' *La Presse*, 25 May 1970, p 41.
202 Albert G. Paquette, *Quand les québécoisiers en fleurs ...* (Montreal: Ed. du Jour 1973) 16
203 *Ibid.* 31
204 *Ibid.* 98
205 *Ibid.* 103
206 Yves Sauvageau, 'Les Enfants,' *Ecrits du Canada français*, no 21, Mar. 1966, p 183.
 Reprinted in *Théâtre* (Montreal: Déom 1977) 28
207 Yves Sauvageau, 'Le Rôle,' *Ecrits du Canada français* 252
208 Jean-Claude Germain, ' *Wouf wouf* c'est le premier printemps du théâtre qué-
 bécois,' in Yves Sauvageau, *Wouf wouf* (Montreal: Leméac 1970) 8
209 Sauvageau, *Wouf wouf* 15
210 *Ibid.* 95
211 *Ibid.* 65
212 *Ibid.* 105
213 However, there was Claude Bélanger's 'Pour baiser Vanier' in *La Barre du jour*, no
 38, 1973, pp 65-79.
214 Denis Vanier, 'Sulphate de magnésium alpha tocoférum 25. vl.,' *Hobo-Québec*, no
 3, p 2; reprinted in *Le Clitoris de la fée des étoiles, Les Herbes rouges*, no 17, Feb. 1974,
 p 37
215 Yves Bolduc, '*lesbiennes d'acid* de Denis Vanier,' *Livres et auteurs québécois*, 1972,
 p 160
216 Denis Vanier, 'Sulphate de magnésium alpha tocoférum 25. vl.,' *Hobo-Québec*, no
 3, p 2
217 For a while, Chartrand was editor of the periodical *Situations* along with Goulet. See
 vol. 3, no 3.

218 Patrick Straram, 'to a strange night of stone,' in Denis Vanier, *Pornographic Delica-tessen* 84
219 Claude Gauvreau, 'Préface,' in Denis Vanier, *Je* 7
220 Denis Vanier, *Pornographic Delicatessen* 29-30
221 Vanier, *Je* 12
222 *Ibid.* 18, 21
223 Vanier, *Pornographic Delicatessen* 37
224 Claude Gauvreau, 'Préface,' *ibid.* 57-8
225 Cf. '1925,' *L'Esprit nouveau*, no 24, 1925, pp 86-7.
226 Vanier, *lesbiennes d'acid* 8, 62, 64
227 Réginald Martel, 'Un Poète canadien chez les Beatles,' *La Presse*, 29 Mar. 1969, p 22, c. 8
228 *Ibid.* cc. 6-7
229 Gérard Durozoi and Bernard Lecherbonnier, *Le Surréalisme: théories, thèmes, tech-niques* 84-7
230 Denis Vanier, 'Préface refusée à *La Libération technique de Suzanne Francœur*,' *Hobo-Québec*, no 4, p 4; partially reprinted in Gilles Groulx's *Poèmes*, *Les Herbes rouges*, no 14, p 43
231 Straram, 'Voyages 2,' in Denis Vanier, *Le Clitoris de la fée des étoiles*, *Les Herbes rouges*, no 17, p 10
232 Thérèse Dumouchel, 'Le Père Noël et *Le Clitoris de la fée des étoiles*,' *Chroniques*, vol. 1, no 1, Jan. 1975, p 77
233 Claude Beausoleil, 'Le Texte vaniérien,' *Cul Q*, nos 8-9, p 39
234 Vanier, *Pornographic Delicatessen* 46
235 Claude Bélanger, 'Pour baiser Vanier,' *La Barre du jour*, no 38, p 67
236 Vanier, *Pornographic Delicatessen* 28
237 Claude Beausoleil, 'Le Texte vaniérien,' *Cul Q*, nos 8-9, p 31
238 Louis Geoffroy, *Max-Walter Swanberg* 9, 19
239 Michel Beaulieu, 'A bout portant,' *Hobo-Québec*, no 8, Sept. 1973, p 3
240 'Swanberg, it must be said, fills us in on a world which can only be called "sca-brous" in the most subversive sense of the word. Personally, I've always thought that a circumscribed shocking quality limited to the erotic plane, which in certain dreams sends us into ecstasy to the point of prompting the most cruel nostalgia, is all that could have given man the idea of paradise.' (André Breton, 'Max Walter Swanberg,' *Le Surréalisme et la peinture* 242)
241 Louis Geoffroy, *Empire State Coca Blues* 12-13
242 Geoffroy, *Le Saint rouge et la pécheresse* 30, 65
243 Geoffroy, *Totem poing fermé* 49
244 Paul-Marie Lapointe, 'Notes pour une poétique contemporaine,' in Robert, *Poésie actuelle* 202
245 Louis Geoffroy, *Totem poing fermé* 36
246 Geoffroy, *L.S.D.* 39-42
247 Geoffroy, *Etre ange étrange* 61
248 *Ibid.* 15-17
249 Claude Robitaille and André Roy, 'Entretien avec Louis Geoffroy,' *Hobo-Québec*, no 8, Sept. 1973, p 11
250 F. Kenneth-Charles Du Puis, 'J'écris ce ...,' *babelian illustrations babéliennes*, no 2, Centre d'études canadiennes-françaises, McGill University 1970, p 21
251 Jacqueline Gladu, 'Karnack en famille,' *babelian illustrations babéliennes*, no 1, 4 Apr. 1969, p 17

252 Raoul Duguay, 'Québec Si,' *Chansons et poèmes de la résistance* (Montreal: Orphée 30 January 1969) 29
253 luoar raoul duguay yaugud, *Manifeste de l'Infonie, le ToutArtBel* 76-8
254 *Ibid.* 79-95
255 Duguay, *Lapokalipsô* 115
256 Walter Boudreau, 'A propos du *Mantra* (in C)' in L'Infonie, *Mantra*, vol. 33, Polydor 2424 018, 33 Sept. 1970
257 luoar raoul duguay yaugud, *Lapokalipsô* 141
258 *Ibid.* 150
259 Duguay, *Ruts*, new edition 1974, p 9
260 Duguay, *Manifeste de l'Infonie* 96
261 *Ibid.* 16
262 Claude Gauvreau, 'Six paragraphes,' *Le Haut-parleur*, 26 May 1951, pp 5, 7
263 'In the fifties, Mousseau's studio on place Christin was a favorite rendez-vous for us. We spent nights drinking wine and cider, talking and improvising dances.' (Gauvreau, 'L'Epopée automatiste vue par un cyclope' 81)
264 Paul-Emile Borduas, letter to Claude Gauvreau, 21 Jan. 1959; in *Liberté*, no 22, p 249
265 Bernard Teyssèdre published 2 evaluations of Leduc (*La Barre du jour*, 1969; *Métamorphose et continuité de Fernand Leduc*, Musée d'art contemporain 1971, and the catalogue for this exhibition); François Gagnon has published 3 studies on Borduas (*La Barre du jour*, 1969; *Etudes françaises*, 1972, and the Conférence J.A. de Sève on *Ozias Leduc et Paul-Emile Borduas*), and has written two books as well.
266 During the occupation of the Ecole des beaux-arts (October 1968), the occupiers frequently referred to Borduas and quoted his works: 'We are joyously pursuing our savage desire for liberation.' (Cf. *Québec Underground*, vol. 2, p 115.)
 Another example can be found in the papers of the Université libre d'art quotidien: 'Spewing forth his disease, his alienation, a new man emerges from a new situation; a situation born of need in a climate of defiance and *Refus global*' (*ibid.* 263).
267 Claude Jasmin had this to say about *Apollo Variétés*: 'Going beyond Pellan and Borduas. This visual combat is true to the spirit of Pellan and Borduas. After a long stay in Paris, Pellan brought us back news of cubism from 1913 (hardly fresh), and news, not much fresher, of surrealism in the twenties. We very much needed this breath of fresh air and, having arrived, it had to struggle against the academicism in the institutions. Even today we have to wage these battles. Once again, the academy of a certain kind of modern art, now well documented, has to be overthrown.
 The theatre trainees at UQAM are engaged in this battle. It's about time. Borduas turned away from Pellan in order to go beyond Picasso and Juan Gris, orthodox and orphic cubism; he also wanted to join surrealism yet go beyond popular painters like Tanguy, Magritte, and Salvador Dali. So he found automatism and that coincided with the tachism of Pollock and Mathieu. In art, one must always be in the vanguard. Look even further.' (Claude Jasmin, '*Apollo Variétés*, faire voir vrai,' *Point de mire*, 4 Sept. 1971)
268 Zéro presented *La Charge de l'orignal épormyable* on 2 May 1970 and *Magie cérémonielle* (a homage to Claude Gauvreau with two pieces by Gauvreau and one by Duguay) in May 1972.
269 Gauvreau, 'L'Epopée automatiste vue par un cyclope' 65-6
270 *La Barre du jour*, no 17-20, Jan.-Aug. 1969, pp 206-23, 271-3
271 Jérôme Elie, 'et inversement,' in Robert Elie, *Œuvres* xix, 1-2
272 Paul Borduas, 'Borduas et la solitude,' *Feu nouveau*, Feb. 1962

CONCLUSION

1 In Fernand Dumont, Pierre Lefebvre, Marcel Rioux, 'Le Canada français – édition revue et corrigée,' *Liberté*, Jan.-Feb. 1962, pp 50-1
2 Pierre Gauvreau, Fernand Leduc, and Adrien Villandré took part in the fight against Maillard at the Ecole des beaux-arts; the break between Borduas and Pellan took place after this fight against the traditionalists. (Cf. Gauvreau, 'L'Epopée automatiste vue par un cyclope' 51-2.)
3 Robert Elie, 'Borduas à la recherche du présent,' *Ecrits du Canada français*, no 24, 1968, p 97
4 Tristan Tzara, 'Essai sur la situation de la poésie,' *Le Surréalisme au service de la révolution*, no 4, 1934
5 André Breton *et al.*, *Rupture inaugurale* 13
6 'I'm not surprised that you applaud the Cause manifesto'; in Fernand Leduc, *Vers les îles de lumière*, letter of 23 Oct. 1947, p 68. Cf. 'I'm sending you the text of *Rupture inaugurale* by surface mail,' letter of 17 July 1947, p 62.
7 Leduc, *ibid.* 62, 68
8 Antonin Artaud, *Surréalisme et révolution*, 26 Feb. 1936 (in Spanish) and 1963 (in French) in *Les Tarahumaras* (Paris: L'Arbalète) 172-3
9 Breton *et al.*, *Rupture inaugurale* 14
10 Paul-Emile Borduas, interview with Jean-Luc Pépin, *Le Droit*, 18 Oct. 1952, p 2
11 Fernand Leduc, 'Art de refus ... Art d'acceptation,' in *Vers les îles de lumière* 145
12 Jean-Pierre Roy told a Montreal audience that the revolution of Marx and that of Rimbaud were contradictory: 'André Breton, for example, is a typical example of an artist who wants to pose the problem of revolution but who cannot escape his class and ends up choosing Rimbaud ("change your life") over Marx ("change the world").' (Jean-Pierre Roy, 'Pour une problématique formaliste de l'art populaire,' *Québec Underground*, vol. 1, p 330)
13 'Thanks to the anarchists, I've just read a marvellous study which analyses in the greatest detail and with admirable rigour the functioning of the Stalinist Soviet economy. The article is entitled "Les rapports de production en Russie" and its author, Pierre Chaulieu, is a Marxist who is against state control.

Without wasting time over the subsidiary vices of Russian society (which are really only consequential), he goes right to the heart of the matter: the Soviet economy is not substantially different from the capitalist economy since it is also an economy of exploitation. This is why everything is as rotten in the USSR as elsewhere!

Evidently, on the question of infrastructure, Chaulieu is perhaps too orthodox in his Marxism. In my opinion, infrastructures are not exclusively determined by the means of production. The Marxists decidedly have too pronounced a tendency to consider morality a mundane infrastructure. As soon as I possess sufficient information I will try to comprehend this phenomenon.

But on the subject of the economy itself, Chaulieu's study is a masterpiece.

Another reassuring article, this one by an American anarchist – a quite formidable character – Holley Cantine. His ideas on freedom in art and on the importance of a disinterested, creative act in a liberated society are very close to our own.

Cantine is one of the few men outside of automatism and surrealism who seems to understand the nefarious role of intent and who appreciates the value of unpreconceived acts.

Ah, so there are men – totally isolated – whose deeds could walk shamelessly hand in hand with our own!

Here is the universe populated with unknowns, brothers who will help us clean out the plague-ridden ship!

Healthy energies are much more numerous than I had hoped! This dying world will fall apart soon enough and we will hear it go "phhht".' (Claude Gauvreau, *Dix-sept lettres à un fantôme*, letter of 10 May 1950, pp 26-7, unpublished)

14 Michel Van Schendel, 'Claude Gauvreau,' in Pierre de Grandpré, *Histoire de la littérature française du Québec*, vol. 3, p 242

15 Patrick Straram, 'to a strange night of stone,' in Vanier, *Pornographic Delicatessen* 72

16 *Ibid.*

17 See chapter 3, n 123. See also 'Borduas ou la minute de vérité de notre histoire,' *Cité libre*, Jan. 1961, pp 29-30.

18 See the lines cited in the epigraph.

19 André Breton, *Point du jour* 4

20 André Breton, *Les Pas perdus* 184

21 Cf. André Breton, 'Position politique de l'art d'aujourd'hui,' in *Manifestes du sur-réalisme* 271.

22 Breton, 'Le Maître de l'image,' *Les Nouvelles littéraires*, 9 May 1925: 'Real revolutions will come about in due course through the power of imagery. In certain images the first signs of an earthquake are already apparent.' (Quoted by Fernande Saint-Martin, *La Littérature et le non-verbal* 144)

23 Breton *et al.*, *Rupture inaugurale* 14

24 Borduas *et al.*, *Refus global* 20. A recent edition of an earlier work by Pierre Mabille on Leonora Carrington (*Fontaine*, no 56, 1946) indicates that this impulse can be defined in the same way Gauvreau defined 'monism': 'Leonora then read the *Miroir du merveilleux*; she was struck by my concept of monism. "Monist" is a word which imperfectly describes the desire to abolish the divisions between mind and body, between being and the external world.' (Pierre Mabille, *Traversées de nuit* [Paris: Plasma 1981] 35-6)

25 Superrealism seems committed to the opposite direction, giving rise to the statement that today 'all of reality – daily, political, social, historical, economic, etc. – has already incorporated the imitative dimension of hyperrealism: everywhere we are already experiencing the "esthetic hallucination of reality"' (Jean Baudrillart, 'La Réalité dépasse l'hyperréalisme,' *Peindre, Revue d'esthétique*, 1976, 10/18, no 1047, p 143).

Chronology

Jarry, *Ubu Roi*; birth of Breton and Artaud

1896 Birth of Loranger

Birth of Aragon

1897

1900 Birth of Grandbois

1901 De Montigny, *Je vous aime*

1903 Suzor-Côté's first pointillist painting

Apollinaire, *L'Enchanteur pourrissant*

1904 Dantin, *Emile Nelligan et son œuvre*

Fauvism (autumn salon)

1905 Birth of Borduas

1906 Birth of Pellan; Delahaye studies medicine; A. Garneau, *Poésies*

Cubism (*Les Demoiselles d'Avignon*)

1907 Lyman with the impressionists in Paris

Romains, *La Vie unanime*; Apollinaire, *Onirocritique*

1908 Chopin, Delahaye, Dugas, and Sylbert, pieces in *L'Aube* (periodical)

Marinetti, *Manifeste futuriste*

1909 Chopin, Delahaye, Dugas, and Sylbert, *L'Encéphale*; de Montigny, *La Gloire*

1910 Delahaye, *Les Phases*

Cendrars, *Pâques à New York*; Y. Goll, *Canal de Panama*

1912 Delahaye, *Mignonne allons voir si la rose ... est sans épines*; birth of Saint-Denys Garneau; polemics about futurism in *Le Devoir* (17 Aug., 7 and 14 Sept.); Delahaye at the Pasteur Institute in Paris

Apollinaire, *Alcools, L'Anti-tradition futuriste, Peintres cubistes*; Aragon and Breton study medicine; World War I (1914-18)

1913 Morrice visits Quebec and returns to France; birth of Richard

Tzara, *La Première aventure céleste de M. Antipyrine*

1916 Dugas, *Psyché au cinéma – Un homme d'ordre*

Apollinaire, *Les Mamelles de Tirésias*; Breton appointed to the Saint-Dizier psychiatric centre; *Parade* by Cocteau, Picasso, and Satie

1917

Apollinaire, *Calligrammes*

1918 *Le Nigog*

Tzara, *Cinéma calendrier du cœur abstrait-Maisons*; *L'Esprit Nouveau*, a new periodical edited by Apollinaire and Le Corbusier.

1920 Loranger, *Les Atmosphères*; Grandbois' first visit to Paris; Guindon, *En mocassins*

Breton and Soupault, *Les Champs magnétiques*

1921 Birth of Jacques Ferron

Breton-Tzara rupture; period of 'Les Sommeils'

1922 Loranger, *Poèmes*; Grandbois settles in Paris

Y. Goll, *Le Nouvel Orphée*

1923 Birth of Gérald Robitaille

St-John Perse, *Anabase*; Tzara, *Sept manifestes dada*; Picabia and Clair, *Entracte; Surréalisme* (published by Goll), *La Révolution surréaliste* (published by Naville and Péret); Breton, *Manifeste du surréalisme; Mercure* by Cocteau, Picasso, and Satie; Léger, *Le Ballet mécanique* (film); Harry Paul, known as Henri Pichette, born in Chateauroux

1924

Breton publishes *La Révolution surréaliste*; birth of Isou

Le Cadavre exquis; Eluard, *Capitale de la douleur*; founding of the Résurrectoir or Association diviniste française by Héliodore Fortin

Birth of Ludwig Zeller (Ataçama, Chile)

Breton, *Le Surréalisme et la peinture*

Second manifeste du surréalisme

Aragon, Sadoul, and Triolet attend the second international conference of revolutionary writers in Kharkov

Breton-Aragon rupture

New edition of von Arnim's *Die Kronenwächter*, preface by Breton, illustrations by Valentine Hugo.

Birth of Patrick Straram (Paris); Malraux attends the first congress of Soviet writers in Moscow

Eluard, *La Nuit est à une dimension* (les Esquimaux); Breton, Crevel, and Eluard attend the writers' congress for the defence of culture chaired by Gide and Malraux

Second surrealist exhibition (London); Breton, *Château étoilé* in *Minotaure*; the Moscow Trials; Spanish Civil War

Breton, *L'Amour fou*; birth of Suzana Wald (Budapest)

Lautréamont published by the surrealists; Breton meets Trotsky in Mexico; Breton-Eluard rupture; *Mandragora* (periodical of Chilean surrealists)

'Lautréamont et son œuvre,' in *Minotaure*; World War II (1939-45)

Péret arrested in Paris; Trotsky assassinated

Breton in Martinique (discovers Césaire), the Dominican Republic, and New York; Péret in Mexico

1925 Birth of Claude Gauvreau

1926 Pellan leaves for France; birth of André Béland

1927

1928 Borduas leaves for France; DesRochers, *L'Offrande aux Vierges folles*

1929 Grandbois at Port-Cros

1930 Borduas returns to Quebec; Dubé, *L'Education poétique*

1932

1933 Loranger, *Terra Nova*

1934 *La Relève* (published by Charbonneau and Beaulieu); Grandbois, *Poèmes*; C. Gauvreau, *Ma vocation*

1935 *Vivre* (published by Gagnon); Richard leads a march on Ottawa

1936 Pellan returns to Quebec and leaves again

1937 Garneau, *Regards et jeux dans l'espace*; *Le Jour* (published by Harvey); Garneau in Paris (July)

1938 Birth of Gilbert Langevin

1939 Debate between Richard and Tranquille on modern poetry in *Le Jour* (25 Feb., 18 Mar., 15 Apr.); Founding of the Contemporary Art Society (Borduas, Elie, Lyman); public lecture in Montreal in honour of Apollinaire

1940 Return of Pellan

1941 Dugas, *Pots de fer*; death of Nelligan; *Regards* (published by R. Benoît); *La Nouvelle Relève*; *Amérique française* (published by Baillargeon); open letter from Borduas, Gadbois, Pellan *et al.* to C. Maillard

Fifth surrealist exhibition; *VVV* published by Breton, Duchamp, Ernst

Letter from Breton to Leduc regarding *VVV* (17 Sept.); Léger in Quebec; Soupault in Canada; *Hémisphères* (published by Yvan Goll)

Breton to Percé, Montreal, and Ste-Agathe (writes *Arcane 17*)

Leduc visits Breton in New York (1 Apr. 1945); Picasso, *Le Désir attrapé par la queue*; Breton in Haiti; Louis-Marcel Raymond attends Desnos' funeral; Léger's second visit to Quebec

Goll visits Raymond in Percé; Breton, *Prolégomènes à un troisième manifeste du surréalisme ou non*; Louis-Marcel Raymond attends show in honour of Artaud; Isidore Isou founds lettrism

Le Surréalisme révolutionnaire (Dotremont and Arnaud); Breton's circular to the surrealists (12 Jan.); *Cause* (May); *Rupture inaugurale* (21 June); International Surrealist Exhibition (7 July); automatist exhibition in Paris (20 June-13 July); Leduc attends meeting of revolutionary surrealists; Breton's second edition of *Arcane 17* (along with *Ajours*) and *Ode à Ch. Fourier*; Pichette, *Epiphanies*; Leduc's letters about his rupture with the surrealists and revolutionary surrealists; Y. Goll, *Le Mythe de la roche percée*

Isou, *Réflexions sur M. André Breton*; death of Artaud; Breton, *Martinique, charmeuse de serpents*; Cobra (7 nov.); *Néon* (periodical); Benoît and Parent arrive in Paris; Leduc in the Salon des surindépendants

1942 Borduas exhibition in Joliette (11-14 Jan.); Borduas' surrealist exhibition (starting 1 May)

1943 Sagittarians' exhibition (30 Apr.); Leduc's reply to Breton (5 Oct.); death of Garneau; *Gants du ciel* (published by Sylvestre); Léger introduces *Le Ballet mécanique* in Montreal

1944 Raymond visits Goll and Breton; Sagittarian exhibition at the Collège Ste-Croix (23 Apr.–1 May) and in Valleyfield (Oct.); Grandbois, *Les Îles de la nuit*; Dubuc, *Jazz vers l'infini*; Béland, *Orage sur mon corps*

1945 Sagittarian exhibition at the Séminaire de Ste-Thérèse (Jan.); Grandbois, *Avant le chaos*; R. Benoît, *Nézon*; 'cadavres exquis' by Bellefleur, J. Benoît, Dumouchel, Léonard, and Parent

1946 Exhibit by Borduas' group at the Boas studio in New York (Jan.); 1st exhibition of the automatists (rue Amherst, April); Dubuc, *La Fille du soleil*; de Grandmont, *Le Voyage d'Arlequin*; Hénault, *Théâtre en plein air*; Renaud, *Les Sables du rêve*; Daudelin and Renaud leave for Europe; Claude Gauvreau finishes *Les Entrailles* (May 1944-Aug. 1946).

1947 Borduas' reply, via Riopelle, to Breton's circular (21 Feb.); automatists' Sherbrooke Street exhibition (15 Feb.-1 March); Leduc leaves for Paris (7 Mar.); *Les Ateliers d'arts graphiques* (vol. 8, no 2); Claude Gauvreau's *Bien-être* and Jean Mercier's *Une pièce sans titre* open 20 May; Borduas' *Automatisme 1.47* (canvas shown at the Sherbrooke Street exhibition, which bestowed the name 'automatists' on the group that first appeared together at the Amherst Street exhibition); 'Mousseau-Riopelle' exhibition (29 Nov.-14 Dec.); Parent exhibits at the librairie Tranquille and the Dominion gallery

1948 *Prisme d'yeux* exhibition (4 Feb. and 15–29 May); last exhibition of the CAS (7-29 Feb.); Borduas-Lyman rupture (13 Feb.); *Dualité* (recital and show put on by Renaud, Sullivan, and Mercure, 3 Apr.); Pellan wins first prize for *Pot de tabac automatique* (20 Mar.); Borduas, *Refus global* (9 Aug.; the text had been in circulation since the winter of 1947-8);

polemic on *Refus global* (Aug. 1948–7 Jan. 1949); Borduas fired from the Ecole du meuble (4 Sept.); P.-M. Lapointe, *Le Vierge incendié*; Richard, *Neuf jours de haine*; Lapointe writes most of the poems entitled *Nuit du 15 au 26 novembre, 1948*; Grandbois, *Rivages de l'homme*; Béland, *Escales de la soif*

Riopelle exhibition in Paris (*Aparté*, by Elisa Breton, André Breton, and Benjamin Péret serves as introduction); Th. Koenig works on *Cobra*, Riopelle works on the periodical *Néon* (no. 5)

1949 Giguère, *Faire naître*; Richard, *Ville rouge*; Ferron, *L'Ogre*; the automatists take part in the debate over the padlock law and the Asbestos strike (5 Feb.-6 June, *Le Devoir*, *Le Canada*); *Les Ateliers d'arts graphiques* (Feb., vol. 8, no 3); *Les Deux arts* (dance and theatre) of Sullivan, Mercure, and Mousseau (8-9 May); *Le Combat* choreographed by Sullivan for *Opéra minute* (Nov.); Claude Gauvreau's libretto for an opera by Mercure, *Le Vampire et la nymphomane*, and the debate over this libretto in *Le Petit journal* (Nov.); Gauvreau-Dussault correspondence after this polemic (cf. *Dix-sept lettres à un fantôme*); Borduas, *Projections libérantes* (July); Ferron-Mousseau exhibition

Quebec painters participate in an exhibition sponsored by Cobra in Liège (December)

1950 Giguère, *Trois pas* and *Les Nuits abat-jour*; *Les Rebelles* exhibition (18 Mar.–28 Apr.); Borduas, *Communication intime à mes chers amis* (9 Apr.)

Second issue of Edouard Jaguer's periodical *Rixes* and exhibitions by the Rixes group (including Pierre Gauvreau and Riopelle) in Lille, Brussels, and Berlin

1951 Dussault, *Nuit d'été* et al.; Giguère, *Yeux fixes* and *Midi perdu*; Giguère and Koenig, *Le Jardin zoologique écrit en mer*; Ferron, *La Barbe de François Hertel* and *Le Licou*; *Place publique* (published by Richard); radio plays by Claude Gauvreau on Radio-Canada (*Le Coureur de Marathon* and *L'Angoisse clandestine*), 18 Feb., 15 June, 24 Aug.; *Les Etapes du vivant* exhibition (May); C. Gauvreau writes *Etal mixte* (June 1950–Aug. 1951)

Bellefleur attends the second international Cobra exhibition; Pellan in Paris; death of Eluard

1952 Suicide of Muriel Guilbault; The Borduas Group exhibition (26 Jan.–13 Feb.); Canadian Radio Award to C. Gauvreau; Gauvreau writes *Beauté baroque* (summer)

Beckett, *En attendant Godot*; Giguère's poems in *Phantomas*; Borduas in Provincetown and New York (May-Sept.); M. Ferron in Paris; death of Picabia

1953 Giguère, *Les Images apprivoisées*; Hénault, *Totems*; founding of l'Hexagone; *Place des artistes* exhibition (May); Mousseau, *Eimotobol*, a masked ball (9 May); Sullivan, *Rose Latulippe*, Radio-Canada TV (14 May); Ferron, *Le Dodu*; C. Gauvreau writes *L'Asile de la pureté* (summer); radio piece by Gauvreau on Radio-Canada (*Le Domestique était un libertaire*, 28 Aug.); death of Pouliot (fall)

Giguère, Dumouchel, and McLaren contribute to *La Revue internationale de l'art expérimental* – *Cobra*; Edouard Jaguer founds the Phases movement; Giguère in Europe; Bellefleur in Paris

Bellefleur, Dumouchel, Giguère, Riopelle, Leduc, M. Ferron work on *Phases de l'art contemporain*; Giguère designs the cover for the second issue of *Phases*; Giguère's poetry in *Temps mêlés*; Borduas in Paris (Sept.); Dumouchel in Europe; death of Tanguy Giguère's poem in *Phases* no 3

Giguère in the Phases exhibition in Japan

Giguère's poems in *Boa* and *Edda*; Giguère in the Phases exhibition in Buenos Aires; Situationist International on Surrealism; Parent, *Masculin-Féminin*; Ionesco, *Le Rhinocéros*; Giguère's poems in *Edda*, no 2; Eighth International Surrealist Exhibition (EROS) in December; Parent designs the cover for EROS catalogue and supervises the hall of fetishism; *Exécution du testament du Marquis de Sade* by J. Benoît (2 Dec.); Giguère in the Phases exhibition in Santa Fé; suicide of Paalen and Duprey; death of Péret Giguère's poems in *Phases*, nos 5-6 and in *Documento Sud*; Péret, *Anthologie des mythes, légendes et contes populaires d'Amérique*; Parent and Benoît contribute to *Bief* (1958-60)

1954 Giguère, *Les Armes blanches*; Haeffely, *La Vie reculée*; radio pieces by Gauvreau on Radio-Canada (*L'Oreille de Van Gogh*, 6 Feb.; *Lendemain de trahison*, 27 Aug.); *La Matière chante* exhibition (20 Apr.-4 May); Gauvreau writes *Ni ho ni bât* and *Brochuges* (summer); arrival of Straram in Canada (Halifax-Vancouver)

1955 Espace 55 exhibition (11-28 Feb.) and Borduas-Leduc polemic; Dussault, *Proses* (*suites lyriques*); C. Gauvreau, radio piece on Radio-Canada (*Les Grappes lucides*, 12 Aug.); death of Louvigny de Montigny

1956 C. Gauvreau, *Sur fil métamorphose* and *Brochuges*; Richard, *Le Feu dans l'amiante*; Dussault, *Le Jeu de brises* and *Dialogues platoniques*; Gauvreau writes *La Charge de l'orignal épormyable* (summer); G. Gervais et al., *Veilloches*

1957 Grandbois, *L'Etoile pourpre*; Giguère, *Le Défaut des ruines est d'avoir des habitants*; Martino, *Osmonde*; Groulx, *Poèmes*; Horic, *L'Aube assassinée*, Pouliot, *Modo pouliotico*; founding of Atys; Ferron, *Le Cheval de Don Juan* and *Tante Elise*; Préfontaine, *Boréal*; Gervais, *Le Froid et le fer*

1958 Major, *Les Archipels signalés*; Dussault, *Sentences d'amour et d'ivresse*; Pelletier-Spiecker, *Les Affres du zeste*, l'Hexagone; *La Poésie et nous*; *Silex* (published by Langevin)

1959 Drouin, *La Duègne accroupie*; Ferron, *Les Grands soleils*; Martino, *Objets de la nuit*; Les Satellites play *La Jeune fille et la lune* and *Les Grappes lucides* by Gauvreau (20 Apr.); founding of *Liberté* and *Situations*; G. Langevin, *A la gueule du jour*

1960 Lapointe, *Choix de poèmes-Arbres*; Marcel Sabourin fails to find actors willing to put on eight objects from Gauvreau's *Les Entrailles* at the Théâtre des auteurs; Langevin, *Poèmes-effigies*; works from *Internationale situationniste* reprinted in *Cahier pour un paysage à inventer*; death of Borduas (22 Feb.)

J. Benoît, Giguère, and Parent at the Ninth International Surrealist Exhibition (Phases) in New York; Borduas retrospective in Amsterdam (22 Dec. 1960–30 Jan. 1961); between 1961 and 1965, the periodical *La Brèche* receives contributions from Giguère (no 4), Benoît (nos 2, 4, 8), and Parent (nos 1-8)

1961 Y.-G. Brunet, *Les Hanches mauves*

Poems by Giguère in *Phases* no 7 and in *Edda* no 3; Giguère in the Phases exhibition in Montevideo and Milan, Barbeau in Europe

1962 Hénault, *Sémaphores* followed by *Voyage au pays de mémoire*; Ferron, *Cotnoir*; Borduas retrospective (Montreal)

M. Ferron, Barbeau, and Leduc in the automatist retrospective in Rome (1962-3); Benoît designs costumes for Arrabal's *La Communion solennelle* (script published in *La Brèche*)

1963 Ferron, *La Tête du roi*; *Cazou ou le prix la virginité*; Sainte-Marie, *Poèmes de la sommeillante*; Le Bar des Arts; Parti pris; first issue of *Parti pris* (Oct.); G. Langevin, *Symptômes*; Péloquin, *Jéricho*; Guy Robert, *Pellan, sa vie et son œuvre*

1964 Ferron, *Contes anglais et autres*; Semaine A (20-7 Apr.); Canadian surrealist exhibition (London, Ont.); Marcel Sabourin reads *Refus global* and excerpts from *Les Entrailles* at the National Theatre School; Langevin, *Poéscope* (néo-dada); Péloquin, *Les Essais rouges*; Geoffroy, *Bagatelles pour un massacre*

J. Benoît in the surrealist exhibition at the Galerie de l'Oeil

1965 Péloquin, *Les Mondes assujettis*, *Manifeste subiste*, *Calorifères*; Richard, *Journal d'un hobo*; Ferron, *La Sortie*, *La Nuit*; Préfontaine, *l'Antre du poème*; Les horlogers du Nouvel Age (Feb.-Apr.); Vanier, *Je*; Giguère retrospective, *L'Age de la parole*

Death of André Breton; Benoît takes part in the 'L'Ecart absolu' exhibition

1966 Giguère, *Pouvoir du noir*; Ferron, *Papa boss*; Langevin, *Un peu d'ombre au dos de la falaise*; Y. Sauvageau, *Les Mûres de Pierre, Papa, Je ne veux pas rentrer chez moi maman m'attend, Les Enfants*, and *Le Rôle*

Bounoure, *La Peinture américaine* (ie, amerindian); Parent contributes to the periodical *Archibras*; Zeller, a member of the Mandragora group in Chile, founds the Casa de la Luna publishing house in Santiago

1967 Langevin, *Noctuaire, Pour une aube*; Péloquin, *Manifeste Infra* followed by *Emissions parallèles*; Préfontaine, *Pays sans parole*; Serge LeMoyne puts on Les Evénements; Le Zirmate (Oct.); Duguay, *or le cycle du sang dure donc*

Bounoure, *Envers l'ombre*, ill. by J. Benoît, Editions Surréalistes; Benoît takes part in the 'Le Principe du plaisir' exhibition and the Mostra internazionale del surrealismo

1968 Gauvreau, *Etal mixte*; Ferron, *Contes, La Charette*; Geoffroy, *Graffiti, Les Nymphes cabrées*; Vanier, *Pornographic Delicatessen*; public reading of *La Charge de l'orignal épormyable* at the Théâtre de quat'sous by the Centre

d'essai des auteurs dramatiques (12 Feb.);
Dussault, *Pour une civilisation du plaisir*; Opé-
ration Déclic, 'Rendez-vous *Refus global*' (7
Nov.), *Place à l'orgasme* (8 Dec.); Péloquin,
Pyrotechnies; Vallières, *Nègres blancs d'Amérique*

Pastoureau, *Le Surréalisme de l'après-guerre 1946-50*; *Lindberg* by Péloquin and Charlebois on the European prize list; the Olympia scandal (April)

1969 After Opération Déclic: 'Rembrandt et ses
élèves' (9 Jan.); *Double jeu* (16 Feb.); *Chan-
sons et Poèmes de la résistance* (1968-9, Montreal,
Hull, Quebec, Trois-Rivières, Sherbrooke);
Giraldeau, *Bozarts*; Ferron, *Historiettes, Le Ciel
du Québec, Le Cœur d'une mère*; Sauvageau,
Wouf-Wouf (public lecture); L.-P. Hébert *et
al., Le Puits*; Gervais, *Poésies I*

André Breton, *Perspective cavalière* (posthumous)

1970 *Manifeste de L'Infonie*; Geoffroy, *Le Saint rouge
et la pécheresse*; Ferron, *L'Amélanchier*; Richard,
Faites leur boire le fleuve; Péloquin, *Le repas est
servi, Pour la grandeur de l'homme*; La Nuit de
la poésie (27 Mar.); Dussault, *500 millions de
yogis*; Groupe Zéro presents *La Charge de
l'orignal épormyable* on 2 May; October Crisis;
Guy Robert, *Riopelle*; Fernand Leduc retro-
spective

'Borduas et les Automatistes' retro-spective in Paris (1 Oct.–14 Nov. 1971), Montreal (2 Dec. 1971–16 Jan. 1972); Charcoune retrospective, Paris

1971 G. Langevin, *Stress, Ouvrir le feu*; Richard,
Carré Saint-Louis; Geoffroy, *Empire State Coca
blues*; Lapointe, *Le Réel absolu*; Straram, *En
train d'être en train vers où être, Québec*; One +
One cinemarx & Rolling Stones; *Gilles-cinéma-
Groulx le Lynx inquiet*; Geoffroy, *Totem poing
fermé*; death of Claude Gauvreau; death of
Dumouchel; L.-P. Hébert, *Le Roi jaune*

1972 Langevin, *Les Ecrits de Zéro Legel* (1964ff.);
Dussault, *Le Corps vêtu de mots*; Straram, *Irish
coffees au No Name Bar & vin rouge, Valley of the
Moon*; Richard, *Louis Riel Exovide* (first
announced in 1956); Vanier, *lesbiennes d'acid*;
Geoffroy, *Max-Walter Swanberg*; Péloquin,
Mets tes raquettes, Eternellement vôtre; *Les oranges
sont vertes* opens at Place des arts (13 Jan.);
Zéro mounts Magie cérémonielle, works by
Duguay and Gauvreau (*Les Reflets de la nuit,
Apolnixède entre le ciel et la terre*); Francoeur, *5
10 15 et Minibrixes réactés*; Richard, *Le Voyage
en rond*; Pellan retrospective; L.-P. Hébert, *Le
Petit catéchisme* and *Récits des temps ordinaires*;
Hénault retrospective, 'Signaux pour les
Voyants'; Suzana Wald and Ludwig Zeller in
Toronto; Guy Robert, *Borduas*

1973 Giguère, *La Main au feu*; Brunet, *Poésies I*

1974 Lapointe, *Tableaux de l'amoureuse*; Hébert, *Le
Cinéma de Petite-rivière* and *Textes extraits de
vanille*

R. Passeron, *Encyclopédie du surréalisme*

1975 Hébert, *Textes d'accompagnement*; Wald and Zeller found Les éditions Oasis (Toronto) and publish authors from Mandragora and Phases

1976 Lapointe, *Bouches rouges*; Hébert, *Les Manufactures de machines*; election of separatist Parti Québécois

Special issue of *Obliques*, 'La Femme surréaliste,' with an article on Parent

1977 C. Gauvreau, *Œuvres créatrices complètes*; Sauvageau, *Théâtre*; A. Bourassa, *Surréalisme et littérature québécoise* and J. Fisette, *Le Texte automatiste* (doctoral theses completed in 1974); Guy Robert, *Borduas ou le dilemme culturel québécois*

1978 Giguère, *Forêt vierge folle*; F.-M. Gagnon, *Paul-Emile Borduas, biographie critique et analyse de l'œuvre*; Borduas, *Ecrits, Writings 1942-1958*; S. Ouaknine's production of Witkiewicz's *The Madman and the Nun* in Ottawa

Dali retrospective, Paris

1979 Lapointe, *Tombeau de René Crevel*; Hébert, *Manuscrit trouvé dans une valise*; Dessin et surréalisme au Québec exhibition in Montreal

1980 Quebec votes 'non' to separatism; Lapointe, *ecRituRes*; B. Lavoie's production of *Le Cœur à gaz* (Toronto and Montreal), J.-L. Bastien's *Victor ou les enfants au pouvoir* (Montreal), and Pierre Larocque's *Requiem* (combining Arrabal's *La Communion solennelle* and Verdi's *Requiem*) in Montreal; Les Dessins d'Alfred Pellan exhibition and panel discussion on 'Pellan et le surréalisme' in Ottawa; J.-P. Duquette, *Fernand Leduc*

'Permanence du regard surréaliste' exhibition in Lyon

1981 Alechinsky retrospective in Montreal; B. Marleau's production of *Le Cœur à gaz* and A. Hausvater's production of *The Madman and the Nun* in Montreal; Leduc, *Vers les îles de lumière, Ecrits (1942-1980)*

Biro and Passeron, *Dictionnaire général du surréalisme et de ses environs*, includes over 20 articles on Quebec surrealists as well as Wald and Zeller from Toronto

1982 Riopelle retrospective in Montreal; S. Ouaknine's production of Gombrowicz's *Operetta* in Ottawa; 'Paul-Emile Borduas et la peinture abstraite' exhibition in Montreal

Bibliography

This bibliography is limited to works mentioned in the text or referred to in the notes. Some titles of translations and of essays written in English have been added for the convenience of the reader.

POETRY, ART BOOKS, OPERA LIBRETTOS AND PLAYS, MANIFESTOS, SHORT STORIES, NOVELS

Arbour, Magdeleine, et al., *Danse dans la neige*. Montreal: Eds Vincent Ewen 1977. 25ff, ill.

Aubert de Gaspé *fils*, Philippe-Ignace-François, *L'Influence d'un livre*. Quebec: William Cowan et fils 1837. 122 pp. Re-edited in an expurgated version under the title *Le Chercheur de trésors (ou L'Influence d'un livre)*, in *Littérature canadienne*, Quebec: Desbarats et Derbishire, Vol. II, 1864, pp 123-220

– *Rose Latulippe*, ill. by Vernier. Quebec / Montreal: Bélisle / Beauchemin, n.d. 27 pp

Baillargeon, Pierre, *Les Médisances de Claude Perrin*. Montreal: Parizeau 1945. 197 pp

Beaudin, Jean-Pierre, et al., *100 Sérigraphies*, 10 silkscreen prints by Beaudin, Bellefleur, Dumouchel, Ewen, Ferron, Giguère, Jasmin, Mousseau, Raymond, and Tremblay. Montreal: Erta 1957. Unpaged

Béland, André, *Orage sur mon corps*. Montreal: Eds Serge 1944. 179 pp

– *Escales de la soif*. Paris: Debresse 1948. 292 pp

Bellefleur, Léon, *Quinze dessins de Léon Bellefleur*, introd. by R.H. Hubbard. Montreal: Erta 1954. Approx. 23 pp

– *12 dessins*. Montreal: Graph 1966. 12 pp

Benoît, Réal, *Nézon*, ill. by Jacques de Tonnancour. Montreal: Parizeau 1945. 131 pp

– *Rhum soda*, rev. and enlarged ed. with pref. by Marcel Dubé. Montreal: Leméac 1973. 127 pp (1st ed. in *Ecrits du Canada français*, no 8, 1961)

Borduas, Paul-Emile, 'Refus global,' countersigned by Magdeleine Arbour, Marcel Barbeau, Bruno Cormier, Claude Gauvreau, Pierre Gauvreau, Muriel Guilbault, Marcelle Ferron-Hamelin, Fernand Leduc, Thérèse (Renaud-) Leduc, Jean-Paul Mousseau, Maurice Perron, Louise Renaud, Françoise Riopelle, and Françoise Sullivan, in *Refus global*, 1948

– *Projections libérantes*. Saint-Hilaire: Mithra-Mythe Ed. 1949. 40 pp
– *Textes*. Montreal: Parti pris 1974. 71 pp; reprinted under the title *Refus global* et *Projections libérantes*. Montreal: Parti pris 1977. 155 pp (introd. by F.M. Gagnon and afterword by M. Fournier and R. Laplante)
– *Ecrits / Writings* 1942-58. Halifax / New York: Press of the Nova Scotia College of Art and Design / New York University Press 1978. 161 pp. Eng. trans. by F.M. Gagnon and D. Young
Bruneau, Kittie, *D'Iles et d'ailes*, lithographs and text by Leonard Cohen, Jacques Renaud, Claude Haeffley, and Michaël La Chance. Montreal: Eds de la Marotte 1980. 7 ff
Brunet, Yves-Gabriel, *Les Hanches mauves*. Montreal: Atys 1961. 77 pp
– *Poésies I: poèmes de 1958-1962*. Montreal: L'Hexagone 1973. 157 pp (includes *Les Hanches mauves* and *Les Nuits humiliées*)
Bujold, Françoise, *Au Catalogue des solitudes*, ill. by the author. Montreal: Erta 1956. 44 pp
– *La Fille unique*, ill. by the author. Montreal: Goglin 1958. 19 ff
– *L'Ile endormie*, ill. by the author. Montreal: Goglin 1959. 21 ff
– *La Lune au village*, ill. by the author. Percé: Eds Sentinelle 1960. 26 ff
– *Une Fleur debout dans un canot*, ill. by the author. Montreal: Eds Sentinelle 1962. Approx. 30 pp
– *Ah! ouiche-t'en plain!*, ill. by Kittie Bruneau. Montreal: Eds de la Guilde Graphique 1974. 8 ff
Byrne, Peter, *Once & Some Words between the Minutes*, ill. by Klaus Spiecker, Montreal: Eds Quartz 1960. Approx. 60 pp
Chansons et poèmes de la résistance, various authors. Montreal: Orphée 1969. 71 pp
Charpentier, Gabriel, *Aire*, ill. by Jacques G. de Tonnancour. Paris: Eds de la Revue moderne 1948. 18 pp
– *Les Amitiés errantes*. Paris: Seghers 1951. 35 pp
– *Le Dit de l'enfant mort*. Paris: Seghers 1954. 35 pp
– *Cantate pour une joie*, for soprano, choir, and orchestra. Montreal: Erta, n.d. Approx. 12 pp
Crémazie, Octave, *Œuvres complètes*. Montreal: Beauchemin et Valois 1882. 543 pp
– *Poésies*. Montreal: Beauchemin 1886, 230 pp; 1912, 236 pp; 1925, 202 pp
– *Œuvres I* – poetry; text established, annotated, and presented by Odette Condemine. Ottawa: Eds de l'Université d'Ottawa 1972. 613 pp; *Œuvres II*, prose, 1976. 438 pp
Delahaye, Guy (pseud. of Guillaume Lahaise), *Les Phases: tryptiques* (sic). Montreal: Déom 1910. 144 pp
– *'Mignonne allons voir si la rose'... est sans épines*. Montreal: Déom 1912. xlii, 68 pp
– *L'Unique voie à l'unique but*. Montreal: Eds du Messager 1912. 4 pp, under the pseud. Dr Joseph-Henri S***
Desjardins, Antonio, *Crépuscules*. Hull: Eds du Progrès de Hull 1924. 189 pp
Després, Ronald, *Silences à nourrir de sang*. Montreal: Orphée 1958. 103 pp
– *Le Scalpel ininterrompu*. Montreal: Eds A la Page 1962. 137 pp
– *Les Cloisons en vertige*. Montreal: Beauchemin 1962. 94 pp
Desrochers, Alfred, *L'Offrande aux vierges folles*. Montreal: Librairie d'Action Canadienne Française 1928. 60 pp
– *A l'ombre de l'Orford*. Montreal: Fides 1948. 116 pp; reprinted with a foreword by Victor-Lévy Beaulieu and Michel Roy. Montreal: L'Aurore 1974. 92 pp
– *Œuvres poétiques*, text established and annotated by Romain Légaré. Montreal: Fides 1977; Vol. I, 249 pp; Vol. II, 207 pp

Drouin, Michèle, *La Duègne accroupie*, ill. by the author. Montreal: Eds Quartz 1959. 42 pp

Dubé, Paul-Quintal, *L'Education poétique*, ill. by Roger Veillault, pref. by Joseph Bédier. Paris: Les Ateliers d'arts typographiques, *c*1930. 97 pp

Dubuc, (Pierre-)Carl, *Jazz vers l'infini*, ill. by Gabriel Filion and Fernand Bonin, pref. by Pierre Vadeboncœur. Montreal: Eds Pascal 1944. 93 pp

– *Brigandages, un livre pas sérieux*. Montreal: Le Cavendish 1950. 101 pp

Dugas, Marcel, *Psyché au cinéma* – *'Un homme d'ordre.'* Montreal: Paradis-Vincent Ed. 1916. 111 pp

Duguay, Raoul, et al., *Aux lyres du matin*. Montreal: Nocturne 1961. 59 pp

Duguay, Raoul, *Ruts*. Montreal: Estérel 1966. 93 pp. Repub. with ill. by lysôn vysôn, 'Lecture en Vélocipède.' Montreal: L'Aurore 1974. 97 pp

– *Or le cycle du sang dure donc*, ill. by Jacques Cleary. Montreal: Estérel 1967. 97 pp

– *Manifeste de l'Infonie, le Tout Art Bel*. Montreal: Eds du Jour 1970. 111 pp, ill.

– *Lapokalipsô*. Montreal: Eds du Jour 1971. 333 pp, ill.

– *L'Amour*, ill. by Jacques Brousseau et al. Quebec: Atelier de réalisations graphiques 1975. 21 ff

– *Suite québécoise*, ill. by Roland Pichet. Montreal: Songe 1976. n.p.

Dussault, Jean-Claude, *Proses (suites lyriques)*. Montreal: Orphée 1955. 123 pp

– *Dialogues platoniques*. Montreal: Orphée 1956. 133 pp

– *Le Jeu des brises*. Montreal: Orphée 1956. 51 pp

– *Sentences d'amour et d'ivresse*. Montreal: Orphée 1958. Unpaged

Ecrits de la Taverne Royal. Montreal: Eds de l'Homme 1962. 139 pp

Elie, Robert, *Œuvres*. Montreal: Hurtubise HMH 1979. 867 pp

Ferron, Jacques, *L'Ogre*. Montreal: 'Les Cahiers de la file indienne,' no 4, 1949. 83 pp

– *La Barbe de François Hertel*, followed by *Le Licou*. Montreal: Orphée 1951. 40 pp. Reprinted with *La Barbe de François Hertel* only. Montreal-Nord, VLB Ed. 1981. 59 pp

– *Le Dodu ou le prix du bonheur*. Montreal: Orphée 1953. 92 pp

– *Tante Elise ou le prix de l'amour*. Montreal: Orphée 1956. 103 pp

– *Le Cheval de Don Juan*. Montreal: Orphée 1957. 223 pp

– *Les Grands Soleils*. Montreal: Orphée 1958. 190 pp

– *Contes du pays incertain*. Montreal: Orphée 1962. 200 pp

– *Cotnoir*. Montreal: Orphée 1962. 99 pp. Reprinted with *La Barbe de François Hertel*. Montreal: Eds du Jour 1970. 127 pp; reprinted alone, VLB Ed., Montreal-Nord 1981. 113 pp

– *Cazou ou le prix de la virginité*. Montreal: Orphée 1963. 86 pp

– *La Tête du roi*. Montreal: Presses de l'Association Générale des Etudiants de l'Université de Montréal 1963. 93 pp

– *Contes anglais et autres*. Montreal: Orphée 1964. 153 pp

– *La Nuit*. Montreal: Parti pris 1965. 134 pp

– *Papa boss*. Montreal: Parti pris 1966. 142 pp

– *Contes*, unabridged version. Montreal: HMH 1968. 210 pp

– *La Charette*. Montreal: HMH 1968. 207 pp

– *Théâtre*, Vol. I; includes *Les Grands Soleils, Tante Elise, Le Don Juan chrétien*. Montreal: Déom 1968. 229 pp

– *Historiettes*. Montreal: Eds du Jour 1969. 182 pp

– *Le Ciel de Québec*. Montreal: Eds du Jour 1969. 403 pp. Reprinted, Montreal-Nord: VLB Ed. 1979. 408 pp

– *Les Roses sauvages: petit roman suivi d'une Lettre d'amour*. Montreal: Eds du Jour 1971. 170 pp

 – *Les Confitures de coings et autres textes*, including new versions of *Papa boss* and *La Nuit*, *La Créance*, and *Appendice aux 'Confitures de coings.'* Montreal: Parti pris 1972. 326 pp
 – *Tales from the Uncertain Country*, transl. by Betty Bednarski. Toronto: Anansi 1972. 101 pp
 – *Le Saint-Elias*. Montreal: Editions du Jour 1972. 186 pp
 – *Dr Cotnoir*, transl. by Pierre Cloutier. Montreal: Harvest House 1973. 86 pp
 – *Le Parti Rhinocéros programmé*. Montreal: L'Aurore 1974. 95 pp
 – *Théâtre*, Vol. ii; includes *La Tête du roi*, *Le Dodu*, *La Mort de M. Borduas*, *Le Permis de dramaturge*, and *L'Impromptu des deux chiens*. Montreal: Déom 1975. 192 pp
 – *The Juneberry Tree*, trans. of *L'Amélanchier* by Ray Chamberlain. Montreal: Harvest House 1975. 157 pp
 – *Wild Roses: The Story followed by a Loveletter*, trans. by Betty Bednarski. Toronto: McClelland and Stewart 1976. 123 pp
 – *The Saint-Elias*, trans. by Pierre Cloutier. Montreal: Harvest House 1975. 145 pp
 – *Quince Jam, Papa Boss, Appendix to Quince Jam*, trans. by Ray Ellenwood. Toronto: Coach House Press 1977. 262 pp
 – *The Cart*, trans. by Ray Ellenwood. Toronto: Exile Editions 1981
 – *Brick* special edition, 'Jacques Ferron, Historiettes,' Fall 1982, pp 1-47; excerpts from various works, trans. by Betty Bednarski, Ray Chamberlain, Elisabeth A. Darling, Ray Ellenwood (special editor for that issue)
Forgues, Rémi-Paul, *Poèmes du vent et des ombres*, pref. by Gaétan Dostie. Montreal: L'Hexagone 1974. 81 pp
Garneau, Alfred, *Poésies*. Montreal: Librairie Beauchemin 1906. 220 pp
Garneau, Hector de Saint-Denys, *Regards et jeux dans l'espace*. Montreal: privately printed 1937. 80 pp
 – *Poésies complètes*. Montreal: Fides 1949. 227 pp
 – *Nine Poems*, from *Poésies complètes*, trans. by Jean Beaupré and Gael Turnbull. Iroquois Falls: Contact Press 1955. 24 pp
 – *Journal*, pref. by Gilles Marcotte, foreword by Robert Elie and Jean Le Moyne. Montreal: Beauchemin 1967. 270 pp
 – *Œuvres*, critical edition by Jacques Brault and Benoît Lacroix. Montreal: Les Presses de l'Université de Montréal 1970. xxviii, 1,320 pp
 – *Complete Poems*, trans. by John Glassco. Ottawa: Oberon Press 1975. 172 pp
Garneau, Sylvain, *Objets trouvés*, ill. by Pierre Garneau. Montreal: Eds de Malte 1951. 93 pp. Re-edited in *Objets retrouvés*
 – *Les Trouble-fête*, ill. by Pierre Garneau. Montreal: Eds de Malte 1952. 77 pp
 – *Objets retrouvés*. Montreal: Déom 1965. 334 pp. Introd. by Guy Robert
Gauvreau, Claude, *Brochuges*. Montreal: Eds de Feu Antonin 1956. 63 pp
 – *Sur fil métamorphose*, drawings by Jean-Paul Mousseau. Montreal: Eds Erta 1956. 55 pp. Four dramatic pieces which are part of a collection of 26 of which the collective title is *Les Entrailles*
 – *Etal mixte*, with 6 drawings by the author. Montreal: Orphée 1968. 71 pp
 – *Les Oranges sont vertes*. Montreal: La Fondation du Théâtre du Nouveau-Monde, July 1971. 251 pp, privately printed
 – *La Charge de l'orignal épormyable*, dramatic fiction. Montreal: La Fondation du Nouveau Monde 1973. 248 pp, privately printed
 – *Œuvres créatrices complètes*. Montreal: Parti Pris 1977. 1,503 pp. Includes *Les Entrailles*, *Brochuges*, *Etal mixte*, *Les Oranges sont vertes*, and *La Charge de l'orignal épormyable*
 – *Entrails*, from *Œuvres créatrices complètes*, trans. by Ray Ellenwood. Toronto: Coach House Press 1981. 176 pp

Geoffroy, Louis, *Les Nymphes cabrées*, ill. by Jean Lepage. Joliette: L'Obscène Nyctalope 1968
- *Graffiti*. Joliette: L'Obscène Nyctalope 1969. 68 pp
- *Le Saint rouge et la pécheresse*. Montreal: Eds du Jour 1970. 95 pp
- *Empire State Coca Blues: triptyque 1963-1966*. Montreal: Eds du Jour 1971. 75 pp
- *Max-Walter Swanberg*, ill. by Lucus Pégol. Joliette: L'Obscène Nyctalope 1972. 41 pp
- *Etre ange étrange*, ill. by Emmanuelle Septembre. Montreal: Eds Danielle Laliberté 1973. 139 pp
- *LSD*, ill. by Jean Lepage. Montreal: Eds Québécoises 1973. 59 pp
- *Totem poing fermé*. Montreal: L'Hexagone 1973. 59 pp
- *Un verre de bière mon minou (Let's Go Get Stoned) Lmnogh-Tome zéro*, ill. by Lucus Pégol. Montreal: Eds du Jour 1973. 178 pp
- *Le Triangle frise*. Joliette: L'Obscène Nyctalope 1974. Unpaged
- *Press Club*, ill. by Jean Lepage. Montreal: Macbec 1980. 82 pp
- *Poker*. Joliette: L'Obscène Nyctalope 1981. Unpaged
Gervais, Guy, André Contant, and Pierre Desjardins, *Veilloches*. Montreal: Eds de la Cascade 1956. 92 pp. Foreword by Roger Duhamel
Gervais, Guy, *Le Froid et le fer*. Montreal: Eds de la Cascade 1957. 28 pp. Foreword by Jean-Guy Pilon
- *Thermidor*. Montreal: Eds de L'Alicante 1958. 20 pp, ill.
- *Chants I et II*. Montreal: Orphée 1965
- *Poésie I*. Montreal: Parti pris 1969. 129 pp
- *Gravité: poèmes 1967-1973*. Montreal: L'Hexagone 1982. 99 pp
Giguère, Roland, *Faire naître*, ill. by Albert Dumouchel. Montreal: Erta 1949. 38 pp
- *3 Pas*, ill. by Conrad Tremblay. Montreal: Erta 1950. 13 pp
- *Les Nuits abat-jour*, ill. by Albert Dumouchel. Montreal: Erta 1950. 48 pp
- *Midi perdu*, ill. by Gérard Tremblay. Montreal: Erta 1951. 10 pp
- *Yeux fixes ou l'ébullition de l'intérieur*, ill. by Gérard Tremblay. Montreal: Erta 1951. 20 pp
- and Théodore Koenig, *Le Poème mobile*, ill. by Giguère. Montreal: Erta 1951. 7 pp
- *Images apprivoisées*, ill. with 'found photographs.' Montreal: Erta 1953. 35 pp
- *Les Armes blanches*, ill. by the author and Albert Dumouchel. Montreal: Erta 1954. 25 pp
- *Eight Poems*, from *Les Armes blanches*, transl. by Jean Beaupré and Gael Turnbull. Iroquois Falls: Contact Press 1955. 24 pp
- *Le Défaut des ruines est d'avoir des habitants*. Montreal: Erta 1957. 108 pp
- *Adorable femme des neiges*, ill. by the author. Aix-en-Provence: Erta 1959. 12 pp
- *L'Age de la parole*. Montreal: L'Hexagone 1965. 170 pp. Includes *Les Nuits abat-jour*, *Midi perdu*, *Yeux fixes*, *Les Armes blanches*, *Lieux exemplaires*, *En pays perdu*, and *Adorable femme des neiges*
- *12 dessins*. Montreal: Graph 1966. 12 pp
- *Naturellement*, 8 poems and 8 silkscreen prints. Montreal: Erta 1968. 9 ff
- *Pouvoir du noir*. Montreal: Ministère des Affaires culturelles 1966. 23 pp
- *J'imagine*, ill. by Gérard Tremblay. Montreal: Erta 1976. 29 ff
- *La main au feu*. Montreal: L'Hexagone 1973. 145 pp. Contains *Au futur, Persistance de la poésie, Rêve à l'aube, Miror, Lettres à l'évadé, La Main de l'homme, Dialogue entre l'immobile et l'éphémère, Pouvoir du noir*, and *Naturellement*, and 1 silkscreen by the author in the limited edition
- *Abécédaire*, ill. by Gérard Tremblay. Montreal: Erta 1975. Unpaged

- *Mirror and Other Poems*, trans. by Sheila Fischman. Erin, Ont.: Press Porcépic 1977. 60 pp
- *Forêt vierge folle*, ill. by the author. Montreal: L'Hexagone 1978. 219 pp
- *A l'Orée de l'œil*, 50 ill. accompanying a text by Gilles Hénault. Saint-Lambert: Eds du Noroît 1981. 109 pp

Grandbois, Alain, *Poëmes*. Hankow, China: Yuan Heng Yin Wu Chü, ed. 1934. 32 pp, ill.
- *Les Iles de la nuit*, ill. by Alfred Pellan. Montreal: Parizeau 1944. 135 pp
- *Avant le chaos*. Montreal: Eds Modernes 1945. 203 pp
- *Rivages de l'homme*. Quebec: privately printed 1948. 96 pp
- *L'Etoile pourpre*. Montreal: L'Hexagone 1957. 78 pp
- *Poèmes*. Montreal: L'Hexagone 1963. 251 pp. Includes *Les Iles de la nuit*, *Rivages de l'homme*, and *L'Etoile pourpre*. Reprinted with 4 ill. by Richard Lacroix, Montreal: Fides 1970. 259 pp
- *Délivrance du jour et autres inédits*, ill. by the author. Montreal: Eds du Sentier 1980. 80 pp

Grandbois, Madeleine, *Maria de l'hospice*. Montreal: Parizeau 1945. 171 pp; republished, Montreal: Presses libres 1970

Grandmont, Eloi de, *Le Prince Marc*, ill. by Mascarille. Montreal: Fides 1945. 30 pp
- *Le Voyage d'Arlequin*, ill. by Alfred Pellan. Montreal: 'Les Cahiers de la file indienne,' no 1, 1946. 39 pp
- *Un fils à tuer*. Montreal: Eds de Malte 1950. 101 pp
- *Premiers secrets*. Montreal: Eds de Malte 1951. 91 pp
- *La Fontaine de Paris*, followed by *Le Temps des fêtes*, ill. by Normand Hudon. Montreal: Eds de Malte 1955. 85 pp

Groulx, Gilles, *Poèmes*. Montreal: Orphée 1957. 43 pp. Reprinted with uncollected poems and drawings. Montreal: Les Herbes rouges 1973

Guindon, Arthur, *En mocassins*. Montreal: Institut des Sourds-Muets 1920. 242 pp. Ill. by the author

Haeffely, Claude, *Notre joie*. Paris: Rouge Maille 1948
- *La vie reculée*, ill. by Anne Kahane. Montreal: Erta 1954. 22 pp
- *Le sommeil et la neige*, ill. by Gérard Tremblay. Montreal: Erta 1956. 26 ff
- *Le temps s'effrite rose*, ill. by Michèle Cournoyer. Montreal-London: Eds du Chiendent 1971. 40 pp
- *Rouge de nuit*, ill. by Gilles Boisvert. Montreal: L'Hexagone 1973. 50 pp. Includes *Le temps s'effrite rose*
- *Des nus et des pierres*. Montreal: Déom 1973. 80 pp. Includes *Notre joie*, *Poèmes-poilus*, *La Vie reculée*, and *Le Sommeil et la neige*
- *Glück*, ill. by Françoise Oleachea. Montreal: L'Hexagone 1975. 45 pp
- *Jusqu'au plomb*, ill. by Kittie Bruneau. Montreal: Eds du Chiendent 1976. 7 ff
- *Le Sang du réel*, ill. by Angèle Beaudry. Montreal: Eds Rouge Maille 1976. 13 ff
- *La Pointe du vent*. Montreal: L'Hexagone 1982. 221 pp

Hamel, Emile-Charles, *Solitude de la chair*. Montreal: Cercle du Livre de France 1951. 242 pp
- *Prix David*. Montreal: Eds de l'Homme 1962. 286 pp

Hare, John, *Anthologie de la poésie québécoise du dix-neuvième siècle (1790-1890)*. Montreal: Hurtubise HMH 1979. 410 pp, ill.

Hébert, Louis-Philippe, *Les Episodes de l'œil*, ill. by Louis McComber. Montreal: Esterel 1967. 97 pp
- *Les Mangeurs de terre et autres textes*. Montreal: Eds du Jour 1970. 235 pp
- *Le Roi jaune*, ill. by Micheline Lanctôt. Montreal: Eds du Jour 1971. 321 pp

– *Le Petit catéchisme: la vie publique de W et On*, ill. by Micheline Lanctôt. Montreal: L'Hexagone 1972. 95 pp
– *Récits des temps ordinaires*. Montreal: Eds du Jour 1972. 157 pp
– *Le Cinéma de Petite-Rivière*, ill. by Micheline Lanctôt. Montreal: Eds du Jour 1974. 111 pp
– *Textes extraits de vanille*, ill. by Micheline Lanctôt. Montreal: L'Aurore 1974. 86 pp
– *Textes d'accompagnement*, ill. by Micheline Lanctôt. Montreal: L'Aurore 1975. 81 pp
– *La Manufacture de machines*. Montreal: Quinze Eds 1976. 143 pp
– *Manuscrit trouvé dans une valise*, ill. by Martin Vaughn-James. Montreal: Quinze Eds 1979. 175 pp
Hénault, Gilles, *Le Théâtre en plein air*, ill. by Charles Daudelin. Montreal: 'Cahiers de la File indienne,' no 2, 1946. 41 pp
– *Totems*, ill. by Albert Dumouchel. Montreal: Erta 1953. 26 pp
– *Seven Poems*, from *Le Théâtre en plein air*, trans. by Jean Beaupré and Gael Turnbull. Iroquois Falls: Contact Press 1955. 20 pp
– *Voyage au pays de mémoire*, ill. by Marcelle Ferron. Montreal: Erta 1960. 36 pp
– *Sémaphore* followed by *Voyage au pays de mémoire*. Montreal: L'Hexagone 1962. 71 pp
– *Signaux pour les voyants*. Montréal: L'Hexagone 1972. Includes *L'Invention de la roue, Allégories, Dix poèmes de dissidence, Théâtre en plein air, Totems, Voyage au pays de mémoire,* and *Sémaphore*. 211 pp
Horic, Alain, *L'Aube assassinée*, ill. by Jean-Pierre Beaudin. Montreal: Erta 1957. 38 pp
– *Les Coqs égorgés*. Montreal: L'Hexagone 1972. 31 pp, ill.
Koenig, Théodor, *Le Jardin zoologique écrit en mer*, ill. by Conrad Tremblay. Montreal: Erta 1954. 31 pp
– *La Loco-émotive*, ill. by Robert Willems. Brussels: Phantomas 1973. 257 pp
– *Le Subjectif présent*, ill. by Vanni Viviani. Milan: Lettera amorosa 1973. 50 pp
– *Remblées*, preceded by *Anagrammaire* by Alain Borer. Paris: Cheval d'attaque 1979. 141 pp
– *La Métamorose*. Brussels: Phantomas 1980. 203 pp
– *Œuvres sémantiques*. Brussels: Phantomas n.d.
Langevin, Gilbert, *A la gueule du jour*. Montreal: Atys 1959. 28 pp
– *Le Vertige du sourire*. Montreal: Ateliers Pierre Guillaume 1960
– *Poèmes-effigies*. Montreal: Atys 1960 (portraits of Larsen, Miron, Carrier, Chatillon, Marguère and others)
– *Symptômes*. Montreal: Atys 1963. Approx. 55 pp
– *Un peu plus d'ombre au dos de la falaise 1961-1962*. Montreal: Estérel 1966. 81 pp
– *Noctuaire*. Montreal: Estérel 1967. 36 pp
– *Pour une aube*. Montreal: Estérel 1967. 75 pp
– *Origines 1959-1967*. Montreal: Eds du Jour 1971. 275 pp. Includes *A la gueule du jour, Symptômes, Un peu plus d'ombre au dos de la falaise, Noctuaire,* and *Pour une aube*
– *Ouvrir le feu*. Montreal: Eds du Jour 1971. 65 pp
– *Stress*. Montreal: Eds du Jour 1971. 48 pp
– *Les Ecrits de Zéro Legel*, 1st series. Montreal: Eds du Jour 1972. 156 pp
– *Chansons et poèmes 1*, Montreal: Eds Québécoises / Eds Vert-Blanc-Rouge 1973. 78 pp
– *La Douche et la seringue: écrits de Zéro Legel*, 2nd series. Montreal: Eds du Jour 1973. 115 pp
– *Novembre*, followed by *La Vue du sang*. Montreal: Eds du Jour 1973. 84 pp
– *Chansons et poèmes 2*. Montreal: Eds Québécoises / Eds Vert-Blanc-Rouge 1974. 76 pp

- *Le Premier tiers*; *œuvres complètes (1942-1975)*, Vol. I, *Les Mondes assujettis, Manifeste Infra, Emissions parallèles, Chômeurs de la mort*; Vol. II, *Jéricho, Manifeste Subsiste, Amuses crânes*; Vol. III, *Calorifère, Les Essais rouges, Pour la grandeur de l'homme*. Montreal: Beauchemin 1976, ill., 148, 314, and 290 pp
- *Pellan-Pellan*. Montreal: Eds Eternité 1976. ill.
- *Inoxydables*, ill. by Jordi Bonet. Montreal: Eds de la Frégate 1977. 52 ff
- *L'Autopsie merveilleuse*. Montreal: Beauchemin 1979. 205 pp
- *La Philarmonie du plaisir*, ill. by Stanley Cosgrove. Montreal: Eds Eternité 1980. 18 ff
- *Le Cirque sacré*. Montreal: privately printed 1981
- *Delirium concerto*, unedited text in English, ill. by Alfred Pellan. Montreal: Eds Eternité 1982. 8 ff
Petel, Pierre, *Aïe! Aïe! Aïe!* Montreal: Eds A la page 1962. 55 pp
- *Il n'y a plus d'Indiens à Hochelaga*. Montreal: Ferron Ed. 1968. 60 pp
Pilon, Jean-Guy, *Les Cloîtres de l'été*. Montreal: L'Hexagone 1954. 30 pp. Foreword by René Char
- *L'Homme et le jour*. Montreal: L'Hexagone 1957. 53 p. Orig. ill. by Juan Miró for the special edition
- *Comme eau retenue*. Montreal: L'Hexagone 1968. 195 pp. Includes *Les Cloîtres de l'été*, *L'Homme et le jour*, *La Mouette et le large*, *Recours au pays*, and *Pour saluer une ville*
Place à l'orgasme, manifesto of 8 Dec. 1968. Montreal: Création à Dieu 1968. Republished in *Québec Underground*, Vol. I, p 382
Pouliot, André, *Modo pouliotico*. Montreal: 'Les Cahiers de la file indienne' 1957. 44 pp, ill. by Robert Millet
Préfontaine, Yves, *Boréal*. Montreal: Orphée 1957. 102 pp. Republished, rev. and enlarged, with previously unpub. work by Eds Estérel, Montreal 1967. 42 pp
- *Les Temples effondrés*. Montreal: Orphée 1957. 83 pp
- *L'Antre du poème*. Trois-Rivières: Eds du Bien public 1960. 87 pp
- *Pays sans parole*. Montreal: L'Hexagone 1967. 77 pp
- *Le Grainier*, ill. by Marie-Anastasie. Paris / Lac Ouareau: privately published 1969. 9 ff
- *Débâcle*, followed by *A l'orée des travaux*. Montreal: L'Hexagone 1970. 79 pp
- *Nuaison*. Montreal: L'Hexagone 1981. 68 pp
Refus global, a collection of texts. Saint Hilaire: Mithra-Mythe Ed. 1948. 85 pp, ill. Reprinted in the catalogue *Borduas et les Automatistes, 1942-1955*. Quebec: Ministère des Affaires culturelles 1971. 153 pp and reprinted at Trois-Rivières: Eds Anatole Brochu 1972. 112 pp. Includes *Refus global*, the manifesto by Paul-Emile Borduas et al. and other texts by Paul-Emile Borduas, Bruno Cormier, Claude Gauvreau, Fernand Leduc and Françoise Sullivan. Photographs by Maurice Perron, drawings by Jean-Paul Riopelle
Renaud, Thérèse, *Les Sables du rêve*, ill. by Jean-Paul Mousseau. Montreal: 'Les Cahiers de la file indienne' 1946. 37 pp; reprinted in Montreal, Les Herbes rouges 1975. Unpaged
- *Une Mémoire déchirée*. Montreal: HMH 1978. 164 pp
- *Plaisirs immobils*, ill. by Raymonde Godin. Montreal: Eds du Noroît 1981. 117 pp
Richard, Jean-Jules, *Neuf jours de haine*. Montreal: Eds de l'Arbre 1948. 353 pp. Reprinted by Eds Cercle du livre de France, Montreal 1968 and Eds L'Actuelle, Montreal 1972
- *Ville rouge*. Montreal: Librairie Tranquille 1949. 285 pp
- *Le Feu dans l'amiante*. Montreal: privately printed 1956. 287 pp. Reprinted by Eds L'Etincelle, Montreal 1979. 212 pp
- *Journal d'un hobo*. Montreal: Eds Parti pris 1965. 292 pp

- *Faites-leur boire le fleuve.* Montreal: Cercle du Livre de France 1970. 302 pp
- *Carré Saint-Louis.* Montreal: Eds L'Actuelle 1971. 252 pp
- *Le Voyage en rond.* Montreal: Cercle du Livre de France 1972. 295 pp
- *Louis Riel Exovide.* Montreal: Eds La Presse 1972. 260 pp
- *Comment réussir à 50 ans.* Montreal: Eds Vert blanc rouge / Eds de l'heure 1973. 168 pp
- *Pièges – Trois épisodes dans la vie d'une femme.* Montreal: Eds L'Actuelle 1973. 173 pp
Riopelle, Jean-Paul, *Assemblages,* 7 lithographs, introd. by Pierre Schneider. Paris: Maeght Ed. 1968. 25 pp
- *Parler de corde,* 13 lithographs, introd. by Pierre Schneider. Paris: Maeght Ed. 1972. 17 ff
- *Lied à Emile Nelligan,* ill. by the author. Paris: Maeght Ed. 1979. 20 ff
Robitaille, Gérald, *Le Père Miller,* followed by *Le Grand Mariage.* Paris: Losfeld 1971. 190 pp
- *The Book of Knowledge.* Paris: Le Chichotte 1964. 90 pp
- *Images.* Montreal: Delta / Canada, nd. 44 pp, ill. by George Juhasz. Text dating from Montreal, Paris 1949-67
Roquebrune, Robert de (pseud. of Robert Larocque), *Les Habits rouges, roman canadien.* Paris: Eds du Monde nouveau 1923. 280 pp. Republished in Paris, *L'Action française,* 14 April-9 May 1926
Roussil, Robert, *10 bois gravés de Robert Roussil.* Paris: Erta 1958. Unpaged
- *Manifeste.* Montreal: Eds du Jour 1965. 91 pp
- *12 sculptures.* Montreal: Graph 1966. Unpaged.
Sabourin, Marcel (under pseud. Sarcel Mabourin), *Hélium,* ill. by Madeleine Morin. Montreal: Eds de la Guilde Graphique 1973. 10 ff
Saint-Aubin, Daniel, *Voyages prolongés,* ill. by the author. Montreal: Déom 1966. 89 pp
Sainte-Marie, Kline (Micheline), *Poèmes de la sommeillante,* ill. by Klaus Spiecker. Montreal: Eds Quartz 1963. Unpaged
Sauvageau, Yves (Hébert), *Wouf wouf,* pref. by Jean-Claude Germain. Montreal: Eds Leméac 1970. 109 pp
- *Théâtre.* Montreal: Déom 1977. 202 pp, ill.
Straram, Patrick, *en train d'être vers où être, Québec.* Joliette: L'Obscène Nyctalope 1971. 28 pp, ill.
- *one + one cinémarx Rolling Stones.* Montreal: Les Herbes rouges 1971. 109 pp
- *irish coffees au No Name Bar vin rouge Valley of the Moon.* Montreal: L'Hexagone / L'Obscène Nyctalope 1972. 254 pp, ill.
- *4 × 4 / 4 × 4.* Montreal: Les Herbes rouges 1974. 67 pp, ill.
- *la faim de l'énigme,* 'L'Amélanchier.' Montreal: L'Aurore 1975. 170 pp
-, Madeleine Gagnon, and Jean-Marc Piotte, *Portraits du voyage,* 'Ecrire.' Montreal: L'Aurore 1975. 95 pp
Sylvestre, Guy and Henry Gordon Green, eds, *Un siècle de littérature canadienne: A Century of Canadian Literature.* Montreal: HMH 1967. 599 pp
Thiercelin, Jean, *Demeure du passe-vent,* ill. by Léon Bellefleur. Montreal: L'Hexagone 1974. 76 pp
Tonnancour, Jacques G. de, *Prisme d'yeux,* Feb. 1948, duplicated, 1 p, countersigned by Louis Archambault, Léon Bellefleur, Albert Dumouchel, Gabriel Filion, Pierre Garneau, Arthur Gladu, Jean Benoît, Lucien Morin, Mimi Parent, Jeanne Rhéaume, Goodridge Roberts, Roland Truchon, and Gordon Webber. Reprinted in Guy Robert, *Pellan, sa vie et son œuvre,* pp 49-50, with an English version by George Lach
Tremblay, Gérard, *Horizons,* introd. by Roland Giguère. Montreal: Erta 1951

- *20 Lithographies*, introd. by Roland Giguère. Montreal: Erta 1951. 24 ff
- *Les Semaines*, engravings, pref. by Bernard Jasmin. Montreal: Erta 1968. 2 pp, 21 ff
- *Le Cœur dans l'arbre*, 20 drawings accompanied by a text by Roland Giguère. Saint-Lambert: Eds du Noroît 1980. 13 pp, 20 ff

Vanier, Denis, *Je*, 'Poésie,' ill. by Reynald Connolly. Longueuil: Image et Verbe 1965. 41 pp. Reprinted with a preface by Roger Des Roches. Montreal: L'Aurore 1974. 53 pp
- *Pornographic Delicatessen*, afterword by Claude Gauvreau and Patrick Straram. Montreal: Eds Estérel 1968. 90 pp
- *Catalogue d'objets de base*. Montreal: Eds du Vampire 1969
- *lesbiennes d'acid*, pref. by Lucien Francœur, Patrick Straram, Ed Sanders, and Claude Gauvreau. Montreal: Parti pris 1972. 73 pp, ill.
- *Le Clitoris de la fée des étoiles*, pref. by Patrick Straram, afterword by Josée Yvon. Montreal: Les Herbes rouges 1974. Unpaged, ill.
- *The Clitoris of the Fairy of the Stars*, transl. by Jack Hirschman. San Francisco: Golden Mount Press 1976. Unpaged, ill.
- *Comme la peau d'un rosaire*, pref. by Paul Chamberland. Montreal: Parti pris 1977. 61 pp, ill.
- *L'Odeur d'un athlète*, pref. by Claude Beausoleil. Montreal: Cul Q 1978. Unpaged
- *Œuvres poétiques complètes 1965-1979*, pref. by Jacques Lanctôt, André G. Bourassa et al. Montreal: VLB Ed. / Parti pris 1980. 337 pp

CRITICAL WORKS (INCLUDING PUBLISHED CORRESPONDENCE, ESSAYS, AND MEMOIRS)

Automatistes, Les, special no. of *La Barre du jour*, no. 17-20, Jan.-Aug. 1979, 389 pp. (esp. articles by C. Gauvreau, 'L'Epopée automatiste vue par un cyclope' and B. Teyssèdre, 'Fernand Leduc, peintre et théoricien du surréalisme à Montréal')

Baillargeon, Pierre, *Le Choix, essais*. Montreal: HMH 1969. 172 pp

Beaudet, André, *La Désespérante expérience Borduas*. Montreal: Les Herbes rouges 1981. 76 pp, ill.

Bélanger, André J., *L'Apolitisme des idéologies québécoises*. Quebec: Les Presses de l'université Laval 1974. 392 pp

Bergeron, René, *Art et bolchevisme*. Montreal: Fides 1948. 135 pp

Bernard, Harry, *Essais critiques*. Montreal: Librairie de l'Action canadienne-française 1929. 197 pp

Blais, Jacques, *De l'ordre et de l'aventure: La Poésie au Québec de 1934 à 1944*. Quebec: Les Presses de l'université Laval 1975. 410 pp

Bolduc, Yves, *Alain Grandbois: Le douleureux destin*. Montreal: Les Presses de l'Université de Montréal 1982. 187 pp

Bosquet, André, *La Poésie canadienne*. Paris / Montréal: Seghers / HMH 1962. 275 pp. Reprinted under the title *Poésie du Québec*, 1966. 271 pp

Bourassa, André G., 'Le Livre de Christophe-Colomb': un essai de théâtre total comme représentation de l'univers claudélien. Montreal: Université de Montréal 1968. xiv, 182 pp
- *Surréalisme et littérature québécoise*. Montreal: Eds l'Etincelle 1977. xxiv, 380 pp, ill.

[Bourbeau, Géraldine], *Géraldine Bourbeau, peintre, céramiste, critique d'art*. Montreal: Victor Barbeau Ed. 1954 (articles from the journal *Liaison*). 156 pp

Bourneuf, Roland, *Saint-Denys Garneau et ses lectures européennes*. Quebec: Les Presses de l'université Laval 1969. 333 pp

Brault, Jacques, *Alain Grandbois*. Montreal: Fides 1967. 96 pp
— *Alain Grandbois*. Paris: Seghers 1968. 190 pp
Brochu, André, *L'Instance critique, 1961-1973*, pref. by François Ricard. Montreal: Leméac 1974. 375 pp
Brunet, Berthelot, *Histoire de la littérature canadienne-française* followed by *Portraits d'écrivains*. Montreal: HMH 1970. 332 pp
Cathelin, Jean and Gabrielle Gray, *Révolution au Canada*. Paris: Les Presses du mail 1963. 322 pp
Charbonneau, Robert, *La France et nous, journal d'une querelle: Réponses à Jean Cassou, René Garneau, Louis Aragon, Stanislas Fumet, André Billy, Jérôme et Jean Tharaud, François Mauriac et autres*. Montreal: L'Arbre 1947. 79 pp
Charron, François, *Peinture automatiste* preceded by *Qui parle dans la théorie?* Montreal: Les Herbes rouges 1979. 135 pp
Corriveau, Hugues, *Gilles Hénault: lecteur de 'Sémaphore.'* Montreal: Les Presses de l'Université de Montréal 1978. 168 pp
Couturier, Marie-Alain et al., *Fernand Léger: la forme humaine dans l'espace*. Montreal: L'Arbre 1945. 96 pp
Couturier, Marie-Alain, *Chroniques*. Montreal: L'Arbre 1947. 191 pp
Dantin, Louis (pseud. of Eugène Seers), *Poètes de l'Amérique française*. Montreal: Louis Carrier et Cie 1928. 250 pp
— *Poètes de l'Amérique française, 2è série*. Montreal: Eds Albert Lévesque 1934. 193 pp
Dassonville, Michel, *Crémazie*. Montreal: Fides 1956. 96 pp
Derrière le miroir, Paris: Maeght Ed., special issues on Riopelle (1966 by André Du Bouchet, 1970 by Franco Russoli, 1977 by Paul Auster)
Desrochers, Alfred, *Paragraphes*. Montreal: Librairie de l'Action canadienne-française 1931. 181 pp
Dugas, Marcel (under the pseud. Marcel Henry), *Le Théâtre à Montréal: Propos d'un huron canadien*. Paris: Henri Falque Ed. 1911. 250 pp
— *Feux de Bengale à Verlaine Glorieux*. Montreal: Marchand Frères 1975. 43 pp
— *Apologies*. Montreal: Paradis-Vincent 1919. 110 pp
— *Littérature canadienne: Aperçus*. Paris: Firmin Didot 1929. 202 pp
— *Approches*. Quebec: Eds du Chien d'or 1942. 113 pp
— *Paroles en liberté*. Montreal: L'Arbre 1944. 174 pp
Duguay, Raoul et al., *Raôul Duguay ou le poète à la voix d'ô*. Montreal: L'Aurore 1979. 255 pp, ill.
Dumas, Paul, *Lyman*. Montreal: L'Arbre 1944. 31 pp, ill.
Duquette, Jean-Pierre, *Fernand Leduc*. Montreal: Hurtubise HMH 1980. 154 pp, ill.
Dussault, Jean-Claude, *Essai sur l'hindouisme*. Montreal: Eds d'Orphée 1965. 99 pp. Republished under the title *500 millions de yogis*. Montreal: Eds du Jour 1970
— *La Civilisation du plaisir*. Montreal: Eds du Jour 1968. 134 pp
— *Le Corps vêtu de mots*. Montreal: Eds du Jour 1972. 160 pp
— and Gilles Toupin, *Eloge et procès de l'art moderne*. Montreal: VLB Ed. 1979. 136 pp
Elie, Robert, *Borduas*. Montreal: L'Arbre 1943. 24 pp, ill.
Ethier-Blais, Jean, *Autour de Borduas: essai d'histoire intellectuelle*. Montreal: Les Presses de l'Université de Montréal 1979. 199 pp
Farand, Gilles, *Pour une lecture rhétorique de trois textes automatistes de Claude Gauvreau*. Ottawa: Bibliothèque nationale du Canada 1980. 2 microfiches
Ferron, Jacques, *Du fond de mon arrière cuisine*. Montreal: Eds du Jour 1973. 290 pp
Fisette, Jean, *Le Texte automatiste*. Montreal: Les Presses de l'Université de Montréal 1977. 83 pp, ill.

Fournier, Jules, *Anthologie des poètes canadiens*, adapted and prefaced by Olivar Asselin. Montreal: Granger 1920; previously unpublished work by J.-A. Loranger, 3rd ed., 1933

Fowlie, Wallace, *La Pureté dans l'art*. Montreal: L'Arbre 1941. 153 pp

Gagnon, François Marc, *Paul-Emile Borduas*. Ottawa: Galerie Nationale du Canada 1976. 95 pp, ill.

– *Paul-Emile Borduas: Biographie critique et analyse de l'œuvre*. Montreal: Fides 1978. 560 pp, ill.

Gagnon, Maurice, *Peinture moderne*. Montreal: Valiquette 1943. 143 pp, ill.

– *Pellan*. Montreal: L'Arbre 1943. 56 pp, ill.

– *Peinture canadienne*. Montreal: Eds Pascal 1945. 158 pp, ill.

– *Sur un état actuel de la peinture canadienne*. Montreal: Eds Pascal 1945. 158 pp, ill.

Grandpré, Pierre de, *Dix ans de vie littéraire au Québec*. Montreal: Beauchemin 1966. 293 pp

Greffard, Madeleine, *Alain Grandbois*. Montreal: Fides 1975. 191 pp

Guilmette, Pierre, *Bibliographie de la danse théâtrale au Canada*. Ottawa: Bibliothèque nationale du Canada 1970. 150 pp

Haeck, Philippe, *L'Action restreinte de la littérature*. Montreal: L'Aurore 1975. 111 pp

Hamel, Réginald, John Hare, and Paul Wyczynski, *Dictionnaire pratique des auteurs québécois*. Montreal: Fides 1976. 725 pp

Harpell, J.J., *L'Ordre nouveau vs l'Ancien système de l'exploitation*. Sainte-Anne-de-Bellevue: Le Cercle d'étude communal 1934. 244 pp

Harper, J. Russell, *La Peinture au Canada, des origines à nos jours*. Quebec: Les Presses de l'université Laval 1966. 446 pp. Transl. of *Painting in Canada*. Toronto: University of Toronto Press 1966, viii, 444 pp, ill. 1977.

Hertel, François (pseud. of Rodolphe Dubé), *Pour un ordre personnaliste*. Montreal: L'Arbre 1942. 333 pp

Histoire de la littérature française du Québec, dir. by Pierre de Grandpré, 4 vols. Montreal: Beauchemin 1967. 368, 390, 408, 428 pp

Hould, Claudette and Sylvie Laramée, *Répertoire des livres d'artistes au Québec 1900-1980*. Montreal: Bibliothèque nationale du Québec 1982. 241 pp, ill.

Hubbard, Robert Hamilton, *L'Evolution de l'art au Canada*, trans. of *The Development of Canadian Art*. Ottawa: National Gallery of Canada 1963. 137 pp both eds.

Imbeau, Gaston, *Bibliographie des écrits déjà publiés de Claude Gauvreau*. Montreal: Bibliothèque nationale du Québec 1977. 23 pp

Jones, Henri, *Le Surréalisme ignoré*. Montreal: Centre éducatif et culturel 1969. 164 pp; reprinted, Sherbrooke: Eds Naaman, n.d.

Laberge, Dominique, *Anarchie dans l'art*. Montreal: Eds F. Pilon 1945. 189 pp

Lamy, Suzanne, *André Breton: hermétisme et poésie dans 'Arcane 17.'* Montreal: Les Presses de l'Université de Montréal 1977. 265 pp

Lasnier, Louis, *La Magie de Charles Amand: imaginaire et alchimie dans 'Le Chercheur de trésors' de Philippe Aubert de Gaspé*. Montreal: Québec-Amérique 1980. 224 pp

Leduc, Fernand, *Vers les îles de lumière: écrits*. Montreal: Hurtubise HMH 1981. 280 pp

Lefebvre, Eugène, *La Morale amie de l'art*. Sainte-Anne-de-Beaupré: Eds Alphonsienne 1947. 295 pp

Lefebvre, Germain, *Pellan*. Montreal: Eds de l'Homme 1973. 159 pp, ill.

Lemire, Maurice, dir., *Dictionnaire des œuvres littéraires du Québec, de 1900 à 1939* (Vol. II) and *de 1940 à 1959* (Vol. III). Montreal: Fides 1980. 1,363 pp and 1982, 1,252 pp, ill.

Mailhot, Laurent and Pierre Nepveu, *Anthologie de la poésie québécoise, 1606-1980*. Montreal: Les Presses de l'Université du Québec and Eds de l'Hexagone 1981. 714 pp, ill.

Major, René, *Rêver l'autre*. Paris: Aubier / Montaigne 1977. 269 pp

Marchand, Jacques, *Claude Gauvreau, poète et mythocrate*. Montreal: VLB Ed. 1979. 443 pp

Marcotte, Gilles, *Présence de la critique*. Montreal: HMH 1966. 253 pp

– *Une Littérature qui se fait*. Montreal: HMH 1968. 307 pp

– *Le Temps des poètes*. Montreal: HMH 1969. 247 pp

– dir., *Anthologie de la littérature québécoise*. Montreal: Eds La Presse 1978. 4 vols

Marsolais, Gilles, *Le Cinéma canadien*. Montreal: Eds du Jour 1968. 160 pp

Maugey, Axel, *Poésie et société au Québec, 1937-1972*, pref. by Jean Cassou. Quebec: Les Presses de l'université Laval 1972. 290 pp

Monière, Denis, *Le Développement des idéologies au Québec, des origines à nos jours*. Montreal: Québec/Amérique 1977. 381 pp. Trans. by Richard Howard, *Ideologies in America: The Historical Development*. Toronto: University of Toronto Press 1981. 328 pp

Morin, Léo-Pol, *Musique*. Montreal: Beauchemin 1945. 440 pp

Morisset, Gérard, *La Peinture traditionnelle au Canada français*. Montreal: Cercle du livre de France 1960. 216 pp, ill.

Nepveu, Pierre, *Les Mots à l'écoute*. Quebec: Les Presses de l'université Laval 1979. 292 pp

Ozias Leduc et Paul-Emile Borduas, 'Conf. J.-A. de Sève,' no 15-16. Montreal: Les Presses de l'Université de Montréal 1973. 153 pp, ill.

Paquette, Jean-Marcel, *Jacques Ferron malgré lui*. Montreal: Eds du Jour 1970. 221 pp; republished in 1978, 285 pp

Périscope, Le, periodical, 1958-60, ed. by Claude Haeffely; reprinted, Montreal: Eds de l'Hexagone 1978. 150 pp

Petit, Gérard, *L'Art vivant et nous*. Montreal: Fides 1946. 410 pp

Poésie et nous, La, Michel Van Schendel et al. Montreal: L'Hexagone 1958. 93 pp

Poulin, Gabrielle, *Les Miroirs d'un poète*. Paris / Montréal: Desclée de Brouwer / Eds Bellarmin 1969. 170 pp

Raymond, (Louis-) Marcel, *Le Jeu retrouvé*, pref. by Gustave Cohen. Montreal: L'Arbre 1943. 241 pp

– *Un Canadien à Paris*. Montreal: A l'enseigne des Compagnons 1947. 167 pp

– *Yvan Goll, choix de poèmes* preceded by *La Vie et l'œuvre d'Yvan Goll*. Saint-Jean-d'Iberville: Le Canada français 1948. 47 pp

– *Géographies: Essais*. Montreal: HMH 1971. 211 pp

Robert, Bernard Paul, *Le Surréalisme désocculté (Manifeste du surréalisme: 1924)*. Ottawa: Eds de l'Université d'Ottawa 1975. 195 pp

Robert, Guy, *Pellan, sa vie et son œuvre: His Life and His Art*. Montreal: Eds du Centre de psychologie et de pédagogie 1963. 135 pp, ill.

– *L'Ecole de Montréal*. Montreal: Eds du Centre de psychologie et de pédagogie 1964. 151 pp. ill.

– *Littérature du Québec*. Montreal: Déom 1964, republished under the title *Littérature du Québec: poésie actuelle*. Montreal: Déom 1970. 403 pp

– *Jérôme, un frère jazzé*. Montreal: Eds du Songe 1969. 85 pp, ill.

– *Riopelle ou la poétique du geste*. Montreal: Eds de l'Homme 1970. 219 pp, ill.

– *Albert Dumouchel ou la poétique de la main*. Montreal: Les Presses de l'Université du Québec 1971. 96 pp

– *Borduas*. Montreal: Les Presses de l'Université du Québec 1972. 340 pp, ill.

– *L'Art au Québec depuis 1940*. Montreal: Eds La Presse 1973. 501 pp, ill.

– *Borduas*. Montreal: Eds Stanké 1977. 256 pp, ill.

Robidoux, Réjean and Paul Wyczynski, eds, *Crémazie et Nelligan*. Montreal: Fides 1981. 186 pp

Robillard, Yves, dir., *Québec Underground*. Montreal: Médiart 1973. Vols I-III 456, 474,
 and 124 pp
Robitaille, Gérald, *Un Huron à la recherche de l'art*. Paris: Eric Losfeld / Terrain vague
 1967. 216 pp
Roquebrune, Robert de (pseud. of Robert Larocque), *Cherchant mes souvenirs, 1911-1940*.
 Montreal: Fides 1968. 243 pp
Ross, Malcolm, ed., *The Arts in Canada: A Stock Taking at Mid-Century*. Toronto: Macmil-
 lan Company of Canada 1958. 176 pp
Roussan, Jacques de, *Jacques Ferron: quatre itinéraires*. Montreal: Les Presses de l'Université
 du Québec 1971. 91 pp
Roussil, Robert, *L'Art et l'Etat*. Montreal: Parti pris 1973. 103 pp
Russoli, Franco, *Riopelle*. Paris: Maeght Ed. 1970. 29 pp, ill.
Saint-Denis, Janou, *Claude Gauvreau, le cygne*. Montreal: Les Presses de l'Université du
 Québec / Eds du Noroît 1978. 235 pp
Saint-Martin, Fernande, *La Littérature et le non-verbal*. Montreal: Orphée 1958. 193 pp
– *Structure de l'espace pictural*. Montreal: HMH 1968. 172 pp
Schneider, Pierre, *Riopelle: Signes mêlés*. Paris / Montreal: Maeght Ed. / Leméac 1972.
 175 pp, ill.
Seguin, Fernand, *Fernand Seguin rencontre Louis Aragon*. Montreal: Eds Ici Radio-Canada
 and Eds de l'Homme 1968. 92 pp
Straram, Patrick, *Gilles cinéma Groulx le lynx inquiet*. Montreal: Cinémathèque
 québécoise / Eds Québécoises 1971. 142 pp, ill.
– *Questionnement socra/cri/tique*. Montreal: L'Aurore 1974. 267 pp, ill.
– *Bribes I*. Montreal: L'Aurore 1975. 153 pp, ill.
Tardif-Painchaud, Nicole, *Dom Bellot et l'architecture religieuse au Québec*. Quebec: Les
 Presses de l'université Laval 1978. xxii, 263 pp, ill.
Viau, Guy, *Modern Painting in French Canada*. Quebec: Department of Cultural Affairs
 1967. 93 pp, ill., trans. by Adrien Venne with the assistance of Francis Dufau-Labeyrie
Wade, Mason, *Les Canadiens français*. 2 vols. Montreal: Cercle du livre de France 1955,
 1963, 685 and 584 pp; trans. of *The French Canadians*. Toronto: Macmillan Co. of
 Canada 1955. 1,136 pp
Wyczynski, Paul, *Emile Nelligan: Sources et originalité de son œuvre*. Ottawa: Eds de
 l'Université d'Ottawa 1960. 349 pp
– dir., *Archives des lettres canadiennes*, Vol. IV, 'La Poésie.' Ottawa: Eds de l'Université
 d'Ottawa 1969. 701 pp

CATALOGUES, SLIDE SHOWS, RECORDS, FILMS (BY TITLE)

Abécédaire, slide show, text by Roland Giguère, ill. by Gérard Tremblay, photos by
 Robert Lussier. Montreal: Office du Film du Québec 1975. 80 slides, cassette
Alain Grandbois, slide show, by Léopold Leblanc. Quebec: Ministère des Affaires cul-
 turelles 1977. Prod. Claude Haeffely, 80 slides, cassette
Alfred Pellan I et II, Fernand Leduc, Jean McEwen, Paul-Emile Borduas I et II, monographes
 (text and slides) by le Centre de diffusion Yvan Boulerice
Alfred Pellan, peintre, film, 5 mins, 58 secs, 1974, colour. Montreal, Ottawa, National Film
 Board and Dept of External Affairs; abbreviated version of *Voir Pellan*
Alfred Pellan, catalogue, National Gallery of Canada et al. Ottawa: Queen's Printer 1960.
 56 pp, ill. Introd. by Donald W. Buchanan
Allô toulmônd, record by Raoul Duguay 1975. Capitol Emi ST 70.036, 1975
Anges maudits veuillez m'aider, record, dramatic cantata of poems by Emile Nelligan. By
 Richard G. Boucher, Radio-Canada International, RCI 522/SRC001

Barbeau, catalogue, introd. by Bernard Teyssèdre. Montreal: Musée d'art contemporain 1969. 20 pp, ill.

Borduas and America / et l'Amérique, catalogue, text by François Marc Gagnon. Vancouver: Vancouver Art Gallery 1977. 57 pp, ill.

Borduas et les Automatistes, 1942-1955, catalogue. Montreal: Musée d'art contemporain 1971. 154 pp, ill.

Borduas, catalogue by Charles Delloye. Amsterdam: Stedelijk Museum, 22 Dec. 1960-30 Jan. 1961. Approx. 32 pp, ill.

Borduas, film, dir. by Robert Millet, Paris, c1958, b/w, 5 mins

Bouche rouge, [1977] slide show, text by P.M. Lapointe, ill. by G. Verreault-Lapointe. Quebec: Ministère des Affaires culturelles 1977. Prod. by Claude Haeffely, 80 slides, cassette

Bozarts, film, dir. by Jacques Giraldeau, ONF, 1969, colour, 16 mm, 58 mins

Bruno Laplante, record, incl. 4 songs by Jean Vallerand based on poems by H. de Saint-Denys Garneau

Cantate pour une joie, music by Pierre Mercure based on a text by Gabriel Charpentier. Toronto: Ricordi 1960, RCI 155, 1956

Chants de l'éternité, Les, record by Claude Péloquin 1977. Polydor Stereo, 2424 156

Charlebois, record, including 'Trop belle pour mourir' by Claude Gauvreau, Barclay 80200Y

Claude Gauvreau, poète, film, dir. by Jean-Claude Labrecque and Jean-Pierre Masse, ONF 1975, b/w and colour

Collection Borduas du Musée d'art contemporain, La, catalogue. Quebec: Ministère des Affaires culturelles 1976. 97 pp, ill.

Colloque, music by Pierre Mercure. Toronto: Berandol Music 1950

Comme je crie, comme je chante, record by Pauline Julien of songs by Gilbert Langevin, Gamma, 6S 125

Correlieu, film on Ozias Leduc, dir. by Louis Portugais, ONF 1959, colour, 16 mm, 19 mins

Costumes d'Alfred Pellan pour 'La Nuit des rois' de Shakespeare, catalogue. Paris: Centre culturel canadien 1971. Unpaged, ill.

Dessin et surréalisme au Québec, catalogue, text by Réal Lussier. Montreal: Musée d'art contemporain 1979. 40 pp, ill.

Dessins d'Alfred Pellan, Les, catalogue by Reesa Greenberg. Ottawa: National Gallery of Canada 1980. 150 pp, ill. Transl. of *The Drawings of Alfred Pellan*

Dissidence, record, music by Pierre Mercure based on a text by Gabriel Charpentier, RCI 201, 1955

Divertissement, music by Pierre Mercure. Toronto: Ricordi 1970. 40 pp

Envol, L', record by Raoul Duguay, Capitol Emi, SKAO 70042

Esthétiques modernes au Québec de 1916 à 1946, Les, catalogue, text by Jean-René Ostiguy. Ottawa: Galerie nationale du Canada 1982. 168 pp, ill. Trans. as *Modernism in Quebec Art 1916-1946*

Etoile noire, L': Tombeau de Borduas, music by François Morel. Toronto: BMI Canada 1964. 31 pp, Columbia MS 6962

Evocation de la vie de Paul-Emile Borduas à travers les lieux et les gens qui l'ont connu, film, dir. by Charles Binamé, colour, 28 mins 50 secs, Interimage Inc. 1976

Femme image, La, film, dir. by Guy Borremans, 1960, b/w, 37 mins; dist. by Guy Côté

Fernand Leduc, catalogue of the 1970-1 retrospective at the Musée d'art contemporain, introd. by Bernard Teyssèdre. Quebec: Ministère des Affaires culturelles 1971. 60 pp

Fernand Toupin, quinze ans de peinture, catalogue, introd. by Gilles Hénault. Montreal: Musée d'art contemporain 1967. 12 pp

Françoise Bujold, catalogue. Montreal: Musée d'art contemporain 1982. 55 pp, ill.

Françoise Sullivan, rétrospective, catalogue, text by Claude Gosselin. Quebec: Ministère des Affaires culturelles 1981. 101 pp, ill.

GRAFFFITTTI PLUSSS, slide show, words and songs by Raoul Duguay, prod. by Claude Haeffely. Quebec: Ministère des Affaires culturelles 1975. 80 slides, cassette

Homme nouveau, L', film, dir. by Yves André and Claude Péloquin. ONF 1970, colour, 16 and 35 mm, 10 mins

Ils ont détruit la ville, record, music by Pierre Mercure based on a text by Gabriel Charpentier, RCI 35, 1950

Infonie, L', record, vol. 333, voice of Raoul Duguay, Kotai Music Inc., KOT 3303, 2 records, undated

Jacques de Tonnancour, catalogue. Quebec: Musée du Québec 1966. 16 pp, ill.

Jean Dallaire, Rétrospective, catalogue, introd. by Paul Dumas. Quebec: Ministère des Affaires culturelles 1968. 44 pp

Jean-Paul Riopelle, catalogue, introd. by Michel Martin. Paris: Musée national d'art moderne, Centre Georges Pompidou 1981. 96 pp

Kaléidoscope, music by Pierre Mercure. Toronto: Ricordi 1960. 62 pp, record, CBC BR, SM 132, 1949

Léon Bellefleur, catalogue. Ottawa: Queen's Printer 1968. 30 pp

Laissez-nous vous embrasser où vous avez mal, record by Claude Péloquin and Jean Sauvageau. Polydor stereo 1972, 2424 061

Lignes et points, music by Pierre Mercure. Toronto: Ricordi 1970. 71 pp, record, RCA, LSC 2980/RCI 230, 1965

M, record by Raoul Duguay. Capitol, ST 70.054, 1977

Mantra, record by l'Infonie, vol. 33, Polydor 1970, 2424 018

Marcelle Ferron de 1945 à 1970, catalogue. Montreal: Musée d'art contemporain 1970. 50 pp

Moi un savon, film, dir. by Claude Péloquin, ONF, colour 16 and 35 mm, 8 mins, 20 secs

Molinari, quantificateur, catalogue by David Burnett. Montreal: Musée d'art contemporain 1979. 24 pp, ill.

Monique Leyrac chante Nelligan, record, 1976, Barclay 9001

Mousseau, Aspects, catalogue, introd. by Gilles Hénault. Montreal: Musée d'art contemporain 1967

Nuit de la poésie, La, film, dir. by Jean-Claude Labrecque, ONF 1970, 16 mm, colour, 112 mins

Ouverture du paradis, L', record by Jean-Pierre Goussaud and Claude Péloquin. London, LFS 9030

Panorama-Peinture-Québec, 1940-1966, catalogue, introd. by Gilles Hénault. Montreal: Musée d'art contemporain 1967. 120 pp

Paul-Emile Borduas 1905-1960, catalogue, introd. by Evan H. Turner. Montreal: Musée des Beaux-Arts 1962. Approx. 64 pp, ill.

Paul-Emile Borduas 1905-1960, catalogue by Evan H. Turner. Hanover, NH: Hopkins Center Art Galleries, Dartmouth College 1967

Paul-Emile Borduas, esquisses et œuvres sur papier, 1920-1940, catalogue by Pierre W. Desjardins et al. Montreal: Ministère des Affaires culturelles 1977. 52 pp, ill.

Paul-Emile Borduas, œuvres picturales 1943-1960 (Musée d'art contemporain), text by François-Marc Gagnon and Fernande Saint-Martin. Brussels: Eds Lebeer Hassman 1983. 57 pp, ill.

Pellan, catalogue of the retrospective at the Musée d'art moderne, Paris 1955. 14 pp, 2 ff, ill.

Pellan, catalogue of the exhibition at the Hôtel de Ville, Montreal 1956. 8 pp, ill.
Pellan, catalogue, Montreal: Musée des Beaux-Arts de Montréal 1972. 172 pp, ill.
French and English text by Germain Lefebvre
Pélo Krispé, record by Kinchamali and Claude Péloquin. Clic Records Inc., CSN 1002, n.d.
Poèmes et chants de la résistance 2, record. Montreal / Toronto: Transworld, RE-604
Poèmes et chants de la résistance 3, record. Montreal / Toronto: Transworld, RE-603
Poésie, La, film, dir. by Daniel Bertolino, presented on Radio-Canada, 'Des goûts, des formes et des couleurs,' 14 Feb. 1974; some sequences from a documentary, *Pélo le magnifique*
Porches, Les, record by Maneige, voice and trumpet by Raoul Duguay. Capitol Emi 1975, ST 6438
Quarante ans de peinture de Borduas, film, dir. by Jacques Godbout, ONF, 1963, colour, 16 and 35 mm, 21 mins, 9 secs
Récolte de rêves, record by Marie-Claire and Richard Séguin 1975, including 'Les Saisons' by Raoul Duguay. Kotai, KOT 3307
Riopelle, Eté 1967, catalogue, text by Pierre Schneider. Quebec: Musée du Québec 1967. 72 pp, ill.
Robert Charlebois, record, including 'Lindbergh' and 'CPR Blues' by Claude Péloquin, Gamma Stereophonic, GS-120, 1968
Roussil, catalogue, text by Guy Robert. Montreal: Musée d'art contemporain 1965. 63 pp, ill.
Roussil, Robert, *Habitation sculpture*. Montreal: Musée des Beaux-Arts de Montréal 1971. 12 pp, ill.
Saint-Denys Garneau, film, dir. by Louis Portugais, ONF 1960, b/w, 16 mm, 28 mins
Sept costumes et un décor de Pellan pour 'La Nuit des rois' de Shakespeare, catalogue. Montreal: Eds de la Guilde graphique 1971. 11 pp, ill.
Tétrachromie, record by Pierre Mercure, Columbia MS 6783/ML 6163, 1964
Trio de Montréal, Le, record 1981, including 'Le Vaisseau d'or' by Emile Nelligan, music by Clermont Pépin. Transcription, Radio-Canada International, RCI 514
Triptyque, music by Pierre Mercure. Toronto: Recordi 1963. 57 pp; record, Columbia MS 6962, 1959
Trois générations d'art québécois – 1940, 1950, 1960, catalogue, text by Laurent Lamy and Fernande Saint-Martin. Montreal: Musée d'art contemporain 1976. 135 pp, ill.
Trop belle pour mourir, song by Robert Charlebois based on a poem by Claude Gauvreau, on *Charlebois*, record, Barclay 80200 Y, undated
Une Balle de gin, film, dir. by Claude Péloquin, ONF, colour, 16 and 35 mm, 7 mins, 55 secs
Vaillancourt sculpteur, film, dir. by David Miller and Pierre Vinet, ONF 1964, b/w, 16 mm, 18 mins
Via Paul-Emile Borduas, film, dir. by Fernand Bélanger, 30 mins, 1967
Vivant avec Toûlllmond, record by Raoul Duguay, 1978, Capitol Emi WBC 70.0057
Voir Pellan, film, dir. by Louis Portugais, ONF 1969, colour, 16 and 35 mm

OTHER WORKS: FICTIONAL AND CRITICAL

Abastado, Claude, *Le Surréalisme*. Paris: Hachette 1975. 320 pp
Acker, Adolphe et al., *Rupture inaugurale*. Paris: Eds Surréalistes 1947. Approx. 14 pp
Apollinaire, Guillaume, *Alcools*, *Calligrammes*, and *L'Enchanteur pourrissant* followed by *Les Mamelles de Tirésias* and *Couleur du temps*. Paris: Gallimard 1966, 1972. 190, 198, 248 pp

Aragon, Louis, *Le Crève-cœur*. Montreal: Variétés 1943. 73 pp
- *Le Mouvement perpétuel* preceded by *Feu de joie* and followed by *Les Destinées de la poésie* and *Ecritures automatiques*. Paris: Gallimard/Nouvelle Revue Française 1970. 158 pp
Arnaud, Noël, *Les Vies parallèles de Boris Vian*. Paris: Union générale d'éditions 1976. 499 pp
Arnim, Achim d', *Contes bizarres*. Paris: Julliard 1964. 257 pp. Pref. by André Breton
Artaud, Antonin, *Œuvres complètes*. Paris: Gallimard 1956-83, 16 vols (new editions for some vols)
Auster, Paul, *Unearth*, poems. New York: Living Hand 1974; bilingual reprint, trans. by Philippe Denis and lithographs by Jean-Paul Riopelle, Paris: Maeght Ed. 1981. 64 pp
Balakian, Anna, *Surrealism: The Road to the Absolute*. New York: Noonday Press 1959; reprinted New York: Dutton 1970. 256 pp, ill.
- *André Breton, Magus of Surrealism*. New York: Oxford University Press 1971. xii, 289 pp
Barthes, Roland, *S/Z*. Paris: Seuil 1970. 278 pp
Bataille, Georges, *Histoire de l'œil* (pseud. Lord Auch), ill. by André Masson. Paris: n.p. 1928. 105 pp; many reprints, including *Madame Edwards* followed by *Le Mort* and *Histoire de l'œil*. Paris: Pauvert 1977. 178 pp
Bédouin, Jean-Louis, *André Breton*. Paris: Seghers 1955. 226 pp
- *Les Masques*. Paris: Presses Universitaires de France 1961. 128 pp
- *Vingt ans de surréalisme, 1949-1969*. Paris: Denoël 1961. 326 pp
- *La Poésie surréaliste*. Paris: Seghers 1964. 326 pp
Benayoun, Robert, *Erotique du surréalisme*. Paris: Pauvert 1965, 245 pp; reprinted 1978. 190 pp
Biro, Adam and René Passeron, dir., *Dictionnaire général du surréalisme et de ses environs*. Freiburg: L'Office du livre 1982. 464 pp, ill.
Bonnet, Marguerite, *André Breton: Naissance de l'aventure surréaliste*. Paris: Librairie José Corti 1975. 460 pp
Bounoure, Vincent, *La Peinture américaine*. Lausanne: Eds Rencontre 1967. 207 pp, ill.
- *La Peinture américaine*. Paris: Cercle du Bibliophile, n.d. 208 pp, ill.
- *Envers l'ombre*, ill. by Jean Benoît. Paris: Eds Surréalistes 1968
Breton, André, and Philippe Soupault, *Les Champs magnétiques*. Paris: Au sans pareil 1921. Ill. by Francis Picabia; repub. with *Vous m'oublierez* and *S'il vous plaît*. Paris: Gallimard 1967. 192 pp
- *Les Pas perdus*. Paris: Gallimard 1924 (1949). 224 pp, new rev. edition, Paris: Gallimard 1969. 179 pp
- et al., *Manifeste du surréalisme*, followed by *Poisson soluble*. Paris: Simon Kra 1924; reprinted with *Second Manifeste du surréalisme, Poisson soluble, Lettre aux voyantes, Position politique du surréalisme, Prolégomènes à un troisième manifeste du surréalisme ou non*, and *Du surréalisme en ses œuvres vives*. Paris: Pauvert 1962. 363 pp (earlier publications done by Kra and Eds du Sagittaire). Trans. by Richard Seaver and Helen R. Lane, *Manifesto of Surrealism*. Ann Arbor, MI: University of Michigan Press 1969. xii, 304 pp
- *Le Surréalisme et la peinture*. Paris: Gallimard 1928; reprinted and enlarged, New York: Brentano's 1945 and Paris: Gallimard 1965. 428 pp, ill. (includes *Le Surréalisme et la peinture* [1928], *Genèse et perspective du surréalisme* [1941], and *Fragments* (1933-61); *Surrealism and Painting*, trans. by Simon Watson Taylor. New York: Harper and Row and London: Macdonald and Co. 1972. 416 pp, ill.
- *Nadja*. Paris: Gallimard 1928, ill.; new rev. ed. by Breton, Paris: Gallimard 1963. 158 pp, trans. by Richard Howard, New York: Grove Press 1960. 160 pp, ill. (same title, *Nadja*)
- *Second manifeste du surréalisme*, ill. by Salvador Dali. Paris: Eds Kra 1930. 104 pp

– and Paul Eluard, *L'Immaculée-Conception*. Paris: Eds Surréalistes 1930. 126 pp; republished, Paris: Seghers 1961. 95 pp
– *Qu'est-ce que le surréalisme?*, ill. by René Magritte. Brussels: René Henriquez Ed. 1934. 31 pp; trans. by David Gascoyne. New York: Haskell House Publishers 1974. 90 pp, ill.
– *Point du jour*. Paris: Gallimard 1934. 199 pp
– *Position politique du surréalisme*. Paris: Eds du Sagittaire 1935
– *L'Amour fou*, Paris: Gallimard 1937. 176 pp, ill.; republished 1968. 139 pp
– and Paul Eluard, *Dictionnaire abrégé du surréalisme*. Paris: Galerie des Beaux-arts 1938. 76 pp, ill.; reprinted, Paris: José Corti 1969. 76 pp, ill.
– *Arcane 17*. New York: Brentano's 1944, ill. by Matta; repub. as *Arcane 17 enté d'Ajours*. Paris: Le Sagittaire 1947. 222 pp; Paris: Pauvert 1971. 169 pp
– *Jeunes cerisiers garantis contre les lièvres*. New York: Eds View 1945; trans. *Young Cherry Trees Guaranteed against Hares*, trans. by Edouard Rodite, drawings by Arshile Gorky. Ann Arbor: University of Michigan Press 1969, 56 pp, ill.
– *Essais et témoignages*. Neuchatel. A La Baconnière 1950. 251 pp, ill.
– *Entretiens 1913-1952*. Paris: Gallimard 1952. 317 pp (copy in Borduas' library)
– *La Clé des champs*. Paris: Eds du Sagittaire 1953, 286 pp, ill.; republished Paris: Eds Pauvert 1967. 342 pp (contains 37 texts including *Limites non-frontières du surréalisme, Déclaration VVV*, and *Hommage à Antonin Artaud*)
Brown, Norman, *Eros et thanatos*. Paris: Julliard 1959; transl. of *Life against Death*. Middletown: Wesleyan University Press 1959. 368 pp
Bussy, Christian, *Anthologie du surréalisme en Belgique*. Paris: Gallimard 1972. 462 pp
Caminade, Pierre, *Image et métaphore*. Paris: Bordas 1970. 159 pp
Camus, Albert, *Essais*, ed. by Roger Quilliot and Louis Faucon. Paris: Gallimard 1965. xiv, 1,975 pp
Carrouges, Michel, *Eluard et Claudel*. Paris: Seuil 1945. 144 pp
– *André Breton et les données fondamentales du surréalisme*. Paris: Gallimard 1950; reprinted 1967. 376 pp. Trans. by Maura Prendergast, *André Breton and the Basic Concepts of Surrealism*. University: University of Alabama Press 1974. 294 pp
Caws, Mary Ann, *Le Manifeste et le caché: langages surréalistes et autres*. Paris: Lettres modernes 1974. 215 pp
Char, René, *Le Marteau sans maître*. Paris: Eds Surréalistes 1934. 142 pp (copy in Borduas' library)
– *Les Matinaux*. Paris: Gallimard 1950. 100 pp
Claudel, Paul, *Théâtre*, 2 vols. Paris: Gallimard 1956. 1,175 and 1,388 pp
Daumal, René, *Le Mont analogue*, pref. by Rolland de Renéville. Paris: Gallimard 1952. 211 pp (copy in Borduas' library)
da Vinci, Leonardo, *Traité de la peinture*. Paris: Delagrave c1910; reprinted 1934. 247 pp, ill. (copy in Borduas' library)
– *Traité du paysage*. Paris: Delagrave 1914. 3rd ed., 1921. xi, 174 pp, ill.
Depestre, René, *Alléluia pour une femme-jardin*. Montreal: Leméac 1973. 148 pp
– *Pour la révolution, pour la poésie*. Montreal: Leméac 1974. 225 pp
Duchamp, Marcel, *Marchand du sel, écrits de Marcel Duchamp*. Paris: Le Terrain vague 1958. 231 pp
Duits, Charles, *André Breton a-t-il dit passe*. Paris: Denoël 1969. 195 pp
Duplessis, Yves, *Le Surréalisme*. Paris: Presses Universitaires de France 1967. 128 pp
Dupuy, Henri-Jacques, *Philippe Soupault*. Paris: Seghers 1966. 221 pp, ill.
Durozoi, Gérard and Bernard Lecherbonnier, *Le Surréalisme: Théories, thèmes, techniques*. Paris: Larousse 1972. 286 pp

Eluard, Paul, *Lingères légères*. Montreal: Eds Parizeau 1946
– *Œuvres complètes*, 2 vols. Paris: Gallimard 1968. 1,663 and 1,505 pp
Ernst, Max, *Ecritures*. Paris: Gallimard 1970. 448 pp, ill.
Gauthier, Xavière, *Surréalisme et sexualité*. Paris: Gallimard 1971. 381 pp, ill.
Goll, Claire, *Les Tombeaux des amants inconnus*. New York: Eds de la Maison Française 1941. 182 pp
– *L'Inconnue de la Seine* and *Le Dîner de 500 francs*. New York: Les Œuvres nouvelles, no 4, 1944, pp 119-86
– *Chants peaux-rouges, le cœur tatoué*, ill. by Fritz Faiss, inspired by original Indian drawings. Paris: Seghers 1958. 47 pp
– and Yvan Goll, *Love Poems*, ill. by Marc Chagall. New York: Eds Hémisphères 1947. 64 pp
Goll, Yvan, *Le Mythe de la roche percée*, ill. by Yves Tanguy. New York: Hémisphères 1946
Gracq, Julien, *Le Rivage des Syrtes*. Montreal: Cercle du Livre de France 1949. 312 pp
Huyghe, René, *L'Art et l'homme*. Paris: Larousse 1957-61, 3 vols; trans. as *Art and Mankind*. London: Hamlyn 1963. 416 pp
Ionesco, Eugène, *Entre la vie et le rêve, entretiens avec Claude Bonnefoy*. Paris: Belfond 1977. 223 pp
Janet, Pierre, *L'Automatisme psychologique*. Paris: Ancienne Librairie Germer Baillière et Cie / Félix Alcan, Ed. 1889. 496 pp
Janis, Sidney, *Abstract and Surrealist Art in America*. New York: Reynauld and Hitchcock 1944. 146 pp, ill.; reprinted, New York: Arno Press 1969. 146 pp, ill.
Jean, Marcel, *Histoire de la peinture surréaliste*. Paris: Seuil 1959. 383 pp, ill.
Jouffroy, Alain, *Une Révolution du regard*. Paris: Gallimard 1964. 262 pp
Lautréamont, le comte de (pseud. of Isidore Ducasse), *Œuvres complètes*. Paris: José Corti 1961. 427 pp
Le Surréalisme dans le texte, colloquium. Grenoble: Université des langues et lettres 1978. 320 pp
Lemaître, Georges-Edouard, *From Cubism to Surrealism in French Literature*. Cambridge: Harvard University Press 1945. 247 pp
Leymarie, Jean, *L'Impressionnisme*, 2 vols. Geneva: Skira 1955. 119 and 137 pp, ill.
Mabille, Pierre, *Egrégores ou la vie des civilisations*. Paris: J. Flory 1938. 186 pp. Reprinted, Paris: Le Sagittaire 1977. 237 pp
– *Le Miroir du merveilleux*, pref. by André Breton. Paris: Le Sagittaire 1940; reprinted, Paris: Eds de Minuit 1962. 327 pp
– *Traversées de nuit*. Paris: Plasma 1981. 213 pp
Malraux, André, *Romans*. Paris: Gallimard 1947. 861 pp
Maritain, Jacques, *L'Intuition créatrice dans l'art et dans la poésie*. Paris: Desclée de Brouwer 1966. 420 pp, ill.
Marx, Karl and Friedrich Engels, *Manifeste du parti communiste* followed by *Contribution à l'histoire de la ligue des communistes* par F. Engels and *Index historique*. Paris: Bureau d'édition 1935. 64 pp (copy in Borduas' library)
Maurois, André, *Olympio ou la vie de Victor Hugo*. Paris: Hachette 1954. 604 pp; republished, Montreal: Cercle du Livre de France 1954, 2 vols
Miller, Henry, *Entretiens de Paris avec Georges Belmont*. Paris: Stock 1970. 160 pp
Nadeau, Maurice, *Histoire du surréalisme*, followed by *Documents surréalistes*. Paris: Seuil 1964. 526 pp, ill.
Orenstein, Gloria Feman, *The Theatre of the Marvelous: Surrealism and the Contemporary Stage*. New York: New York University Press 1975. 315 pp, ill.

Passeron, René, *Histoire de la peinture surréaliste*. Paris: Libraire générale française 1968. 381 pp

– *Encyclopédie du surréalisme*. Paris: Somogy 1975. 288 pp, ill.

Péret, Benjamin, *Anthologie des mythes, légendes et contes populaires d'Amérique*. Paris: Albin Michel 1960. 413 pp, ill.

Picasso, Pablo, *Le Désir attrapé par la queue*. Paris: Gallimard 1945. 70 pp

Pichette, Henri (pseud. of Harry Paul), *Epiphanies*. Paris: K 1947. 142 pp, ill.; republished, Paris: Gallimard 1969. 153 pp

Picon, Gaëtan, *Journal du surréalisme 1919-1939*. Geneva: Skira 1976. 229 pp, ill.

Pierre, José, *Le Ça ira*, ill. by Mimi Parent. Paris: Eds Surréalistes 1967. 43 pp

Reverdy, Pierre, *Œuvres complètes*. Paris: Flammarion 1980

Rimbaud, Jean-Arthur, *Œuvres*. Montreal: Valiquette, n.d. 199 pp (copy dedicated by Dr Paul Dumas to P.-E. Borduas, 16 June 1943, in Borduas' library)

Rodriguez Pampolini, Ida, *El Surrealismo y el arte fantastico de Mexico*. Mexico: Instituto de investigaciones estéticas 1969. 133 pp, ill.

Rosemont, Franklin, *What Is Surrealism? Selected Writings of André Breton*, ed. and introd. by Franklin Rosemont. London: Pluto Press 1978. xvi, 339 pp, ill.

– *André Breton and the First Principles of Surrealism*, companion vol. to *What Is Surrealism? Selected Writings of André Breton*. London: Pluto Press 1978. vii, 147 pp, ill.

Saint-John Perse, *Eloges* followed by *La Gloire des rois*, *Anabase*, and *Exil*. Paris: Gallimard 1967. 221 pp

Sanouillet, Michel, *Dada à Paris*. Paris: Pauvert 1965. 646 pp

Soupault, Philippe, *Rose des vents*, ill. by Marc Chagall. Paris: Au sans pareil 1920. 52 pp

Thirion, André, *Révolutionnaires sans révolution*. Montreal: Eds du Jour 1972. 579 pp

Thiry, Marcel, *Toi qui pâlis au nom de Vancouver: Œuvres poétiques 1924-1974*. Paris: Seghers 1975. 507 pp

Vailland, Roger, *Eloge du Cardinal de Bernis*. Paris: Fasquelle 1956. 123 pp (copy in Borduas' library)

Vovelle, José, *Le Surréalisme en Belgique*. Brussels: André Roche 1972. 373 pp, ill.

Waldberg, Patrick, *Le Surréalisme*. Geneva: Skira 1962. 151 pp, ill.

– *Chemins du surréalisme*. Brussels: Eds de la Connaissance 1965. 144 pp, ill.

Index

UNIVERSITY OF TORONTO ROMANCE SERIES